SIR JOHN SOANE'S MUSEUM

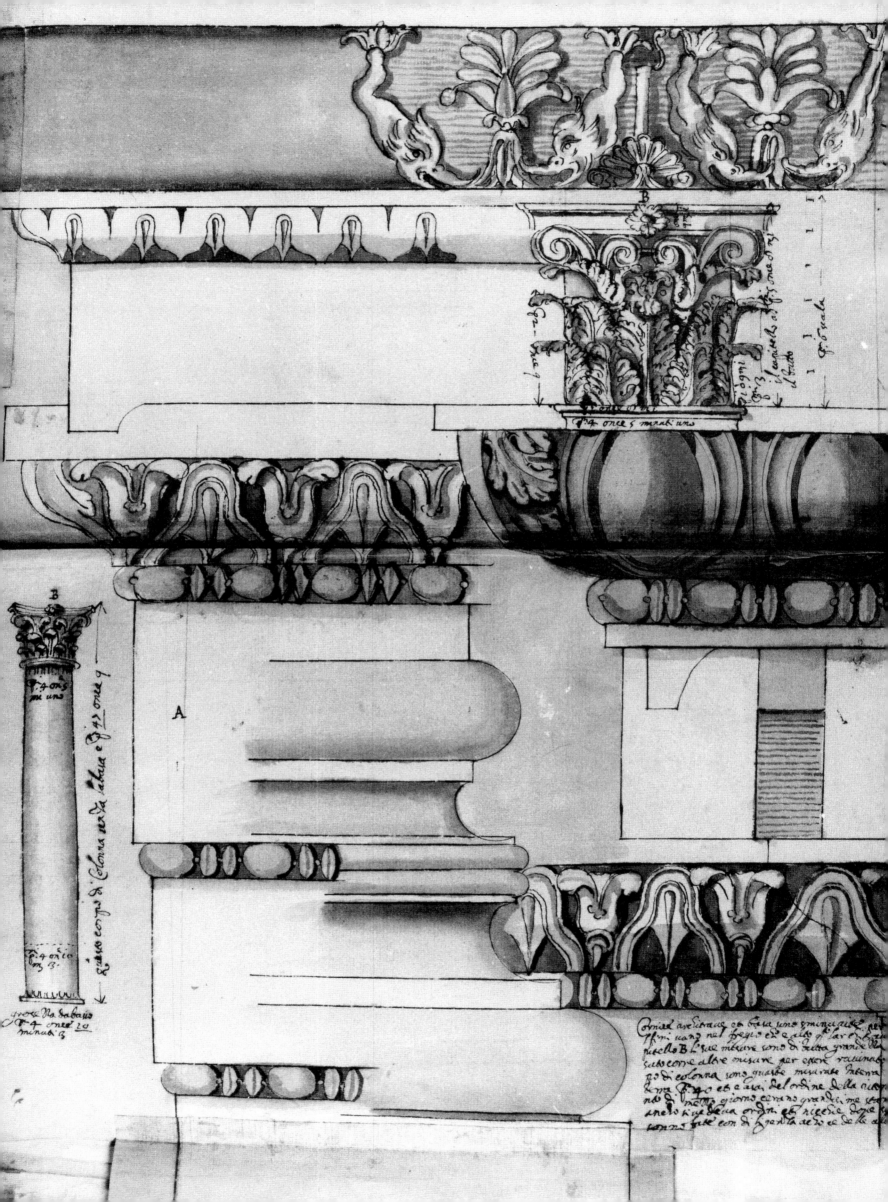

Italian Renaissance Drawings

FROM THE COLLECTION OF SIR JOHN SOANE'S MUSEUM

LYNDA FAIRBAIRN

VOLUME ONE

æ

AZIMUTH EDITIONS

ON BEHALF OF SIR JOHN SOANE'S MUSEUM

Published in the United Kingdom
by Azimuth Editions

Azimuth Editions
33 Ladbroke Grove, London W11 3AY, England
Edited by Delia Gaze
Design by Anikst Associates

British Library Cataloguing in Publication Data
Fairbairn, Lynda
 Italian Renaissance drawings from the collection of Sir John Soane's
 Museum
 1. Sir John Soane's Museum – Catalogs 2. Drawing, Italian –
 Catalogs 3, Drawings, Renaissance – Catalogs
 I. Title
 708. 2'142
 ISBN 1–898592–13–6

Library of Congress Cataloging in Publication Data
 (data applied for)
 ISBN 1–898592–13–6

Typeset by Anikst Associates and Azimuth Editions
Printed by PJ Reproductions, London

Frontispiece: Frammenti fols 5v–6r (cat.490)

Contents

THIS CATALOGUE IS DEDICATED TO

Mrs Drue Heinz

Foreword

Soane's important collection of Italian Renaissance drawings has for many years remained one of the hidden treasures of the Museum – just as it was in Soane's day, when the drawings were shelved at random in their volumes among the general books and architectural treatises in his ground-floor Library.

The volumes had been acquired with considerable foresight on Soane's part. The Codex Coner, the Vasari album, the three Montano volumes, the Francesco di Giorgio treatise and the volumes called *Frammenti* and *Meccanica* were all purchased at the Robert Adam sale in 1818; four of them also originally formed part of Cassiano dal Pozzo's collection in Rome. The Margaret Chinnery album came from a client, George Chinnery, probably in lieu of fees. The North Italian album and the volume containing drawings of Trajan's column were bought from Soane's friend John Britton, the antiquarian and collector. It is essentially, therefore, an architect's collection. The majority of the drawings, with comparatively few exceptions, are architectural designs and copies of different kinds and would have had particular appeal as exemplars to architects who were interested in the Antique and its Renaissance permutations.

Although the volumes were briefly listed in a succession of manuscript inventories of the Library compiled by the Museum's curators after Soane's death in 1837, there has never been any attempt to catalogue the drawings in a professional way and it was left to different curators to profer potential discoveries to visiting scholars.

In 1891, for example, the Curator James Wild drew Baron von Geymüller's attention to 'a volume of sixty-eight drawings on vellum…which he thought to be interesting'. Geymüller responded – eagerly one feels – by writing a letter to the President of the Royal Institute of British Architects, which was published in the *RIBA Journal*, identifying the drawings in the North Italian album as 'authentic sketches of Bramante'. Later, during his curatorship from 1945 to 1984, Sir John Summerson often showed the Renaissance drawings to scholars working in the field and, in particular, gathered attributions from Arthur E. Popham.

When Peter Thornton became Curator in 1984 he realized that the Italian Renaissance drawings formed a most important group in the collection and was determined that they should be catalogued in a professional way and form the first published volume in a series of catalogues that would eventually cover the whole collection of some 30,000 architectural drawings. This catalogue, therefore, covers the entire Italian Renaissance collection with the exception of the celebrated Codex Coner, which will form the subject of a separate monograph volume in due course.

Lynda Fairbairn, who had worked on the catalogue of Palladio drawings at the RIBA, undertook to catalogue the Soane drawings in 1990. For the last seven years she has worked tirelessly to identify the authorship, subject and purposes of the drawings in these complex volumes. Her careful physical descriptions of each sheet, as well as the general essays and lists of comparative material, will provide the primary source material for a wider public, as well as demonstrating that many of these volumes and individual drawings have a greater importance than was previously realized.

I would like to thank many people who helped to make this catalogue possible. To Peter Thornton we owe especial thanks because he conceived the project, which was close to his heart, and set it well on course for completion before he retired in 1995. Our publisher, Julian Raby, has given the design of the catalogue, with its complex format of entries, meticulous attention. Sir John Soane's Museum Foundation in New York, the Mark Fitch Fund and the Goldsmiths' Company have all generously contributed to the production costs of the volume.

Our greatest debt, however, is to Mrs Drue Heinz, who was first introduced to the Museum by Colin Amery in 1990. Her generosity, and the generosity of her Trust, which has steadily funded Lynda Fairbairn's work for more than six years – as well as contributing to the production of the catalogue – has made this serious work a reality. We dedicate this volume to her.

MARGARET RICHARDSON
Sir John Soane's Museum
September 1997

Introduction

In 1990, when Peter Thornton asked me to catalogue the uncatalogued Italian Renaissance drawings in Sir John Soane's Museum, I was very unclear about the contents of the collection, because except for Codex Coner, the subject of Thomas Ashby's famous catalogue of 1904, and a few outstanding individual drawings in the Chinnery album – such as the handsome elevation of a Netherlandish town house published by Sir Reginald Blomfield and the perspective of the portico of the Pantheon, which was believed to be copied from a famous drawing by Raphael, the subject of an article by John Shearman – Soane's large collection of Renaissance drawings were largely unknown to me, to most scholars and to the public at large.

At an early meeting with Peter Thornton, we estimated that the project would require four years for photography, research and the assessment of comparative material in other collections. Because of the generosity of my sponsor, Mrs Heinz, the task of funding the project was much more spontaneous and immediate than we could have hoped. We should consider giving some credit to the charm of the draughtsman Giovanni Battista Montano, whose entertaining and stimulating drawings of the antiquities of Rome have always prompted visual responses from architects, including Borromini, and whose quaint and candid portrait by Francesco Villamena seemed to engage our donor.

The collection is not made up of single or sets of drawings for buildings; its striking feature is that the drawings are in volumes and each volume deals with a theme. Most were acquired by Sir John Soane from the collection of Robert and James Adam. Only three volumes of drawings – the North Italian album, the Chinnery album and a long rolled drawing of the spiral relief of Trajan's column – were acquired separately by Soane. So the drawings are both interesting intrinsically and because of their place in the collections of two architects, both of whom trained in the academic tradition and travelled widely in Italy. They cover a very wide range of architectural, ornamental and mechanical subjects, and teach the fundamental role of drawing and copying in architectural education in the academies of art.

The North Italian album is an artist's model book of c.1500. It is not a repetitive book of copies as are many copy-books; rather it represents the craftsman's response to current ideas, worked into images that could be used as models for many different types of artefacts. Although some of the drawings have been frequently reproduced, they have been analyzed for the first time in this catalogue.

It is interesting that Robert Adam and Sir John Soane owned a manuscript of the first edition of Francesco di Giorgio's unpublished treatise on architecture. His unpublished theoretical work as a military engineer and architect was revived in the 19th century. Adam and Soane must have valued it for its own sake, for its themes – fortification, architecture, surveying and mechanics – as well as for the drawings, which are early examples of architectural illustration; it is the first fully illustrated treatise on architecture. The manuscript in Soane's collection is of special interest because it is closer to the prototype than other surviving copies. I have collated the manuscript with the two earlier prototypes, compared the texts and recorded the differences between the three manuscripts.

I have also written a commentary on the illustrations.

The volume entitled *Meccanica* is a historical collection of mechanical inventions of the Greeks and of those of Francesco di Giorgio, as well as examples of machines built in the 16th century that are taken from Agricola's *De re metallica* of 1556, the standard textbook on mining, which illustrates machines in use in the industry in the 16th century.

I recognized the volume dedicated to the spiral relief on Trajan's column as a 16th-century copy of Codex Ripanda in the Biblioteca dell'Istituto di Archeologia e Storia dell'Arte in Rome. In this case, since the scenes provide the source for Roman historical costume, weapons and heroic gesture, I decided that my main task would be to list other Renaissance representations of each scene, and to collate the surviving drawings of the whole relief to compare the way in which the scenes are framed in each of the series of drawings of it.

The volume called *Frammenti* contains handsome drawings recording capitals, entablatures, cornices and bases that were found in the ruins of Rome and which no longer survived at the end of the 16th century, because they were ground down to make cement or broken up for use in new buildings in Rome. I recognized the drawings as copies of the beautiful full- or half-size drawings by Alberto Alberti in the Gabinetto Nazionale Disegni e Stampe in Rome.

The three volumes of drawings by Giovanni Battista Montano, a woodcarver, architect and one of the first professors at the Accademia di S. Luca in Rome, supply simple formulae for the design of the orders suitable for non-specialists as well as a wider repertory of capitals, cornices and mouldings for the orders than had been offered by any other authority. His stock of immediately stimulating images of ancient architecture was also much more extensive than any other; it provided an unprecedentedly rich visual resource offering a variety of plans and sectional designs that came to have considerable influence in the Baroque period. Montano's designs present, in a popular form and stripped of scientific content, the archaeological research of Baldassare Peruzzi. The buildings are represented not as fragments but as whole modern structures that could stimulate a new architecture. The graphic sources of the designs are traced in the catalogue and listed with their inscriptions so that the contemporary comments on the buildings can be assessed. The table of sources for the reconstructions in Appendix 6 shows the derivations of the image as well as giving insights into the range of material available for architects to copy in Rome in the second half of the 16th century. Because Montano was a prolific draughtsman, who reproduced numerous drawings for sale in his lifetime, many drawings by him in other collections have survived, and are indexed according to the subject in Appendix 8.

Montano's albums were acquired by Cassiano dal Pozzo for his Museo Cartaceo, the paper museum, probably because they supplied the most complete collection of the antique tombs in the Roman Campagna; they document aspects of burial in the ancient world. Cassiano verified the existence of the buildings on the verso of the drawings in his own hand when they entered his museum. The Museo Cartaceo entered Cardinal Albani's collection in 1703 and was acquired in 1762 by James Adam for George III. It

is significant that the Adam brothers retained the three volumes of Montano's drawings and Codex Coner for their own use, when they passed on the rest of the Museo Cartaceo to the king. They almost certainly recognized the importance of the aggregate plans and the complex sections, which far overshadow their value as archaeological records.

The Montano albums will be further studied in the context of Cassiano's paper museum with essays by Lynda Fairbairn, Ian Campbell and Sebastian Schütze in the forthcoming catalogue, *The Paper Museum of Cassiano dal Pozzo*, edited by Francis Haskell and Jennifer Montague.

The Vasari album contains drawings by two almost unknown draughts-men who were both members of the Accademia del Disegno in Florence. The album gives a view of the work of two different kinds of architects who emerged from the Accademia: the first Teofilo Torri, a dilettante in the fullest sense of the word, one who takes pleasure in architecture and who used his expertise to act as a consultant socially within a career in public service; the second Orazio Porta, a painter from Monte S. Savino, who worked occasionally with Vasari and who used the materials available to him in the Accademia del Disegno to develop his talent and become a working architect, eventually designing and executing buildings. Two sketchbooks of drawings, one in Siena and the other in Venice, have been attributed to OrazioPorta and catalogued in Appendix 4 with drawings in other collections that can be attributed to him. Both artists were talented and prolific draughtsmen and the drawings catalogued here may help to attribute drawings in other collections.

I approached each topic systematically so that if the research yielded no precise conclusions, the ground covered would be clear to all. With the continued support of my sponsor Mrs Heinz over the last two years, and with the close collaboration of my publisher, Julian Raby, the catalogue has been edited and designed to achieve a clear relationship between the images and the text.

I should like to thank the following institutions and individuals for their help in preparing this catalogue.
Anna Maria Petrioli Tofani and her staff at the Gabinetto dei Disegni degli Uffizi, Florence, for giving me access to their vast holdings of 16th-century architectural drawings. The library and photographic collections of the Courtauld Institute of Art, the Witt Library and the Conway Library, London, with special thanks to Constance Hill and Geoffrey Fisher. The photographic department at the Courtauld Institute of Art, especially Janet Balmforth. The library and photographic collections of the Warburg Institute, London. The library and photographic collections of the Biblioteca Hertziana in Rome. Photographs in the Census of Antique Art were consulted in the photographic collections of the Warburg Institute and the Biblioteca Hertziana. The library and photographic collections of the Kunsthistorisches Institut, Florence. The library and archive of the British School at Rome for access to Thomas Ashby's notes. Geremy Butler for his photography of some of the drawings. Catherine Hassall and Libby Sheldon of UCL Painting Analysis, University College London, who analyzed the pigments and mediums of the North Italian album. Jane Wilkinson who traced the watermarks so carefully, recording the breaks and the density of the lines with exemplary objectivity. Margaret Schuelein, Drawings Conservator at the Soane Museum, for advice on conservation, on all technical matters and the resolutions to many problems. The editor Delia Gaze and the designer Misha Anikst.

ARCHIVES AND COLLECTIONS CONSULTED
Archivio Apostolico Vaticano
Archivio di Stato di Firenze
Archivio del Vicariato di Roma
Biblioteca Apostolica Vaticana
Biblioteca Civica, Arezzo
Biblioteca Comunale and Archivio Comunale di Monte S. Savino
Biblioteca Comunale degli Intronati, Siena
Biblioteca Marciana, Venice
Biblioteca Nazionale di Archeologia e Storia dell'Arte,
Palazzo Venezia, Rome
Biblioteca Nazionale Centrale di Firenze
Bibliothèque National, Paris
Cabinet des Dessins, Louvre, Paris
Cabinet Edmond Rothschild, Louvre, Paris
Cabinet des Éstampes et de la Photographie,
Bibliothèque National, Paris
Department of Manuscripts, British Library
Department of Prints and Drawings, Ashmolean Museum,
Oxford Department of Prints and Drawings, British Museum, London
Department of Prints and Drawings, Victoria and Albert Museum, London
Devonshire Collection, Chatsworth
École des Beaux-Arts, Paris
Fitzwilliam Musum, Cambridge
Fondation Custodia, Institut Néerlandais, Paris
Gabinetto Nazionale dei Disegni e Stampe, Rome
Galleria Estense, Modena
Istituto e Museo di Storia della Scienza di Firenze
Pinacoteca Nazionale, Bologna
Raccolta Martinelli, Castello Sforzesco, Milan
Royal Library, Windsor

Lastly to individuals: Colin Amery, Mirka Benes, Jacqueline Biscontin, Peter Bower, Ian Campbell, Alessandro Cecchi, Hugo Chapman, Amanda Claridge, William Clarke, Claudia Conforti, Alison Cooley, Elena Corradini, Luciana Borri Cristelli, Arnalda Dallaj, Sabine Eiche, Marzia Faietti, Amelio Fara, Geoffrey Fisher, Peter Fuhring, Renato Giulietti, Catherine Monbeig Goguel, Charles Hope, Paola and Wofgang Jung, Pia Kehle, Martin Royalton Kisch, Daniella Lamberini, Amanda Lillie, Peter Mellor, Lucia Monaci, Alessandra Mottola Molfino, Arnold Nesselrath, Pier Nicola Pagliara, Christina Riebesell, Jane Roberts, Charles Robertson, Ruth Rubinstein, Henrietta Ryan, Richard Schofield, Sebastian Schütze, Philippe Sénéchal, Wolfgang Siedel, David Scrase, Michael Snodin, William Stenhouse, Thomas Touhey, Giuseppe Veltroni and Michael Wright. I should also like to thank my colleagues in Sir John Soanes's Museum, especially Peter Thornton, Margaret Richardson, Susan Palmer and Eileen Harris. Wolfgang Jung was my first visitor at the Soane and he and his wife Paola have shown continuous interest and kindness for which I shall always be grateful.

The work involved in the preparation of this catalogue is dedicated to the memory of my parents.

LYNDA FAIRBAIRN
12 September 1997

Abbreviations

ACMSS	Archivio Comunale di Monte San Savino		CS	Castello Sforzesco, Raccolta Martinelli, Milan
ACVA	Archivio della Curia Vescovile d'Arezzo		DAI	Deutsches Archäologisches Institut, Rome
ASF	Archivio di Stato di Firenze		DC	Devonshire Collection, Chatsworth
ASR	Archivio di Stato di Roma,		GDSU	Gabinetto Disegni e Stampe degli Uffizi, Florence
AST	Archivio di Stato di Torino		GRIRC	Getty Research Institute, Research Collections, Brentwood, Los Angeles
AVR	Archivio del Vicariato di Roma, San Giovanni in Laterano, Rome		GE	Galleria Estense, Modena
BA	Biblioteca Ambrosiana, Milan		GNDS	Gabinetto Nazionale di Disegni e Stampe, Rome
BA	Biblioteca Angelica, Rome		GSD	Gabinetto Stampe e Disegni, Museo di Capo di Monte, Naples
BAL	British Architectural Library, Royal Institute of British Architects, London		IMSF	Istituto e Museo della Scienza di Firenze, Florence
BAV	Biblioteca Apostolica Vaticana, Vatican		KB	Kunstbibliothek, Berlin
BBV	Biblioteca Bertoliana di Vicenza		KKSK	Kupferstich-Kabinett, Staatlichen Kunstsammlungen, Dresden
BC	Biblioteca Communale, Siena		LB	Landesbibliothek, Dresden
BCA	Biblioteca Civica, Arezzo		LCD	Louvre, Cabinet des Dessins, Paris
BE	Biblioteca Estense, Modena		MA	Musée Atget, Montpellier
BCA	Biblioteca Communale Ariostea, Ferrara		MC	Museo Civico, Vicenza
BIASA	Biblioteca del Istituto di Archeologia e Storia dell'Arte, Rome		MC	Musée Condé, Chantilly
BL	Beinecke Library, Yale University, New Haven		MM	Metropolitan Museum, New York
BK	Bibliothek des Kunstgewerbemuseums, Berlin		MW	Musée Wicar, Lille
BL	British Library, London		NL	National Library, Budapest
BM	British Museum, London		NL	National Library, Prague
BM	Biblioteca Marucelliana, Florence		NL	National Library, Vienna
BML	Florence, Biblioteca Medicea Laurenziana		PC	Private collection, Paris
BNM	Biblioteca Nacional, Madrid		PML	Pierpont Morgan Library, New York
BMRE	Biblioteca Municipale di Reggio Emilia		RIBA	Royal Institute of British Architects, London
BMV	Biblioteca Nazionale Marciana, Venice		RKP	Rijskprentenkabinet, Amsterdam
BN	Biblioteca Nacional, Madrid		RL	Royal Library, Stockholm
BN	Biblioteca Nazionale, Naples		RL	Royal Library, Windsor
BN	Bibiothèque Nationale, Paris		ROM	Royal Ontario Museum, Toronto
BNCF	Biblioteca Nazionale Centrale di Firenze		RUCB	Ghent
BP	Biblioteca Passionei, Fossombrone		SC	Santini Collection, Urbino
BP	Biblioteca Palatina, Parma		SJSM	Sir John Soane's Museum, London
BR	Biblioteca Reale, Turin		SK	Staatliche Kunstsammlungen, Kassel
BU	Biblioteca Universitaria, Padua		SK	Städelschen Kunstinstitut, Frankfurt am Main
CB	Casa Buonarotti, Florence		SKK	Staatlichen Kupferstichkabinett zu Berlin
CCA	Canadian Centre for Architecture, Montreal		SPK	Staatsbibliothek Preussischer Kulturbesitz
CE	Cabinet des Estampes, now Département des Estampes et de la Photographie, Bibliothèque Nationale, Paris		UB	Universitätsbibliothek, Salzburg
			V & A	Victoria & Albert Museum, London
CIL	*Corpus Inscriptionum Latinarum*; see Bibliography under *Corpus*		VC	Veste [Schloss] Coburg

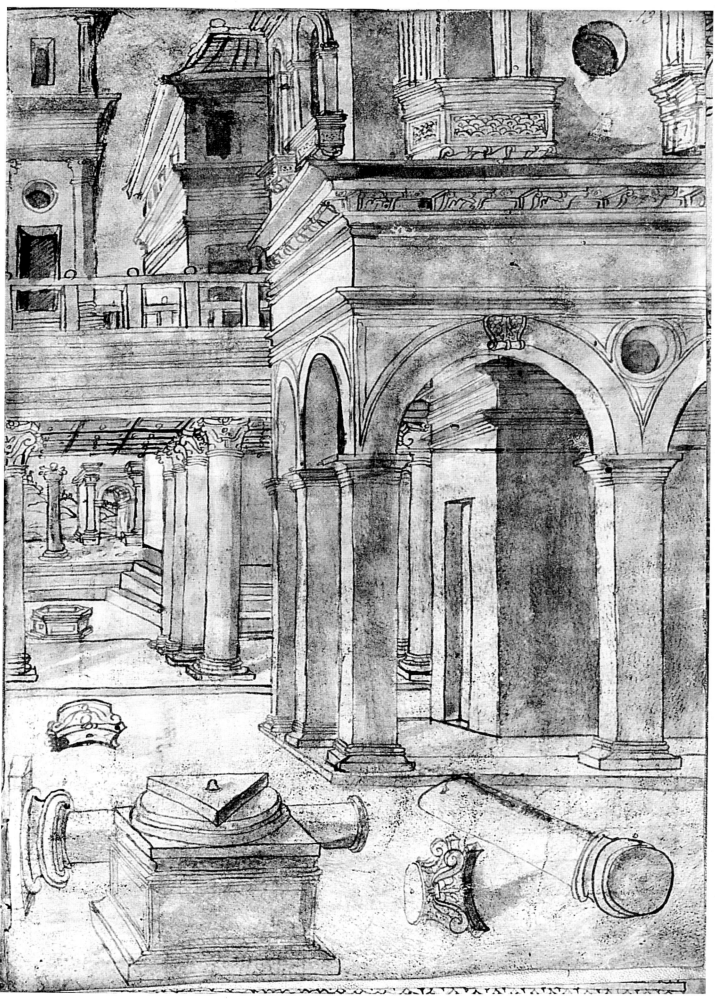

12

The North Italian album
Designs for ornament by a Lombard artisan
c.1500

On 14 February 1891 Baron von Geymüller wrote a letter to the President of the Royal Institute of British Architects, for publication in its *Journal* on 19 February, asking him to add an appendix to his paper on Bramante. He related how 'Mr J.W. Wild, the curator of Sir John Soane's Museum, drew my attention to a volume of sixty-eight drawings on vellum in the Museum which he thought to be interesting; and in fact this they are in a very high degree, for after close examination I have been able to recognize them with entire certainty as authentic sketches of Bramante. But at the same time I felt much perplexity as to their significance, and sure that this affirmation would be met, at first at least, by an incredulity easily understood.'[1]

Geymüller suggested that the drawings, which betray in turn naivity and sophistication, were a kind of architectural joke, like a hieroglyphic riddle, which were intended as a gift from Bramante to an *intarsiatore*.

Marcel Röthlisberger, following Geymüller, characterized the album as 'patterns for intarsia craftsmen'.[2] He identified some of the buildings represented in the volume: the Colosseum, the arch of Constantine and the Torre delle Milizie in Rome, the Florentine baptistery, the Tempio Malatestiano in Rimini, and the Porta Palatina in Turin. He recognized the baluster-spoke wheel (cat.50) as a quotation from Prevedari's engraving, which was designed by Bramante, and he attributed the album to a Lombard-Veneto draughtsman active around 1500. Opinion on the attribution and dating of these drawings, which have never been systematically studied, has since diversified.

Meg Licht attributed the album to Nicoletto da Modena, whose supposed signature, *Nicholeto da Modena Ferrara*, in the Domus Aurea, Rome, located his activity in Modena and Ferrara.[3] She compared the putto caryatids on the design for a throne on a graffito insignia with an enthroned *Virgin and Child* signed NICHOLET and with similar putti on pp.24–5 (cat.23 and 24) of the album, and noted the use of *repoussoir* architectural elements in Nicoletto's work, which are also frequently found in the album. In 1973 she attributed some of the drawings on vellum in a dismembered album in the Rothschild cabinet in the Louvre, Paris (inv. nos 841DR-860DRV), to the same hand.[4] She related another album of drawings on paper in the Rothschild cabinet (inv. nos 1367DR–1479DR), which she attributed to the young Baldassare Peruzzi, to the first group of drawings on vellum and characterized both as drawings for festivities or stage sets influenced by Filarete's treatises on architecture.

Licht's attribution and definition of the function of the drawings were generally accepted until Graziano Manni, also convinced of the Ferrarese origin of the album, attributed it to Gherardo Costa and dated it c.1470–80.[5] This attribution is difficult to sustain, because Costa, who was in Ferrara from 1454 to 1481, is known only through documents, which record his activity mainly as a decorator, and no graphic work by

him survives to compare with the drawings.

Götz Pochat tentatively identified one of the drawings in Paris, inv. no.860DRr, as the setting for *Menechino* by Plautus, which was performed in Ferrara in 1486 and described by Guarino. He rejected the attribution to Nicoletto da Modena on the grounds of the low quality of the London and Paris drawings. Because of the predilection for rich ornament, he prudently returned the attribution to an anonymous Lombard artist, and dated the album to the end of the 15th century. He described the drawings as 'sketches, not for use in the theatre, but which are to some extent influenced by contemporary theatrical performances'.[6]

In the catalogue of the Poldi Pezzoli exhibition Marzia Faietti wisely followed the anonymous attribution but she changed the date significantly.[7] She drew attention to the similarity of the drawing of the Colosseum on p.43 (cat.42) to Cesare Cesariano's illustration of it in his translation of Vitruvius, published in Como in 1521. She also reported the opinion of Tafuri and Burns on the striking image of the serliana façade on p.22 (cat.21), which they described as a 'serliana spaziale' (spatial serliana), an invention that they dated after 1540, the publication date of Serlio's *Architettura et prospettiva*.[8]

Examination of the drawings confirms Licht's suggestion that the North Italian album and some of the drawings in the Louvre album (inv. nos 841DR–860DRV) are by the same hand. The quality of the drawing varies considerably, but the style within each type of subject is unified, and the consistency of the contents points to a single hand. Variations can be explained by subject matter and materials and by the fact that the drawings were probably made over a long period of time. The mediums of the underdrawing and the wash techniques vary a little. The tabernacle on p.27 (cat.26) is drawn in a thicker wash in a different technique, suggesting that it was added later, and Louvre inv. no.855DRV was drawn after a thick blue-green wash, like that on p.28 (cat.27), was applied to the vellum to cover an earlier drawing of a panel of ornament below it.

The early history of the drawings is obscure; the Soane album was acquired in London from John Britton in 1834. The drawings are collated in an 18th-century Venetian marbled paper binding, and the title page bears a watermark, a crossbow close to Briquet 1968, no.738, that was found in both Udine and the Veneto at the beginning of the 18th century.[8] No evidence survives of an earlier binding. The sheets of vellum are of different sizes; some have rounded corners as though they once belonged to or were prepared for a volume, while others are square. It is probable that the sets of loose gatherings of folded vellum folios, usually of two sheets, were bound together in the 18th century in Venice, not far from the place of origin of the drawings.

The drawings on vellum in the Rothschild cabinet in the Louvre (inv.

1. Geymüller 1891a, pp.93 ff.
2. Röthlisberger 1957.
3. Licht 1970.
4. Licht 1973.
5. Manni 1986, pp.70 ff.
6. Pochat 1980, pp.269 and 272–3.
7. Milan 1991, p.238
8. op.cit.
9. op.cit.
10. *Catalogue of the Sunderland Collection of Drawings by Old Masters*, Christie's, London, 15 June 1883, lots 67 ff; Paris 1972, p.9, cat.2.

nos 841DR–860DRV) were also part of an album, now dismembered. It came from the Sunderland collection (formerly in the Bonfiglio collection in Bologna), which was sold at Christie's on 15 June 1883.[10] The album contains drawings by several hands, which Pochat divided into three groups.[11] He identified four hands in the first group, which is dateable to the first half of the 15th century. These drawings are executed in pen and brown ink over metalpoint on a blue, green or white ground, and they are often washed with a pale rose. Annegrit Schmitt attributed one of them, inv. no.848DRV, to a North Italian artist of the early 15th century after Altichiero.[12] Another drawing by the same hand, inv. no.843DRr and v, is close to a drawing of soldiers in the Lugt Collection.[13] These figures recall Pisanello's work, and they probably derive from one of his historical fresco cycles, such as those in the ducal palace in Mantua and in the Doges's palace in Venice.[14]

A second group is by an artist identified by Faietti as the Master of the Flagellation, whose figures and landscapes are associated with North Italian painting of the end of the 15th century.[15] The *Flagellation* drawn on Louvre inv. no.859DRV demonstrates that the artist studied Pollaiuolo's work. The drawing of *St George and the Dragon* on inv. no.856DRV is based on the same source as a painting dated 1494 by Lucchino da Milano from Palazzo S. Giorgio in Genoa, which may have been derived from Gentile da Fabriano's fresco in the Broletto in Brescia.[16] The third group is by the anonymous master of the North Italian album; a drawing of a tower and a frieze by him on two folios with drawings by the early hand, inv. nos 841DRV and 847DRr, confirms that they belong to a single group of drawings. A fourth artist drew the animals, birds and fruit on many of the Louvre folios by all of the different hands, as well as similar subjects and the sculpture in the Soane album. He used the same materials as the Master of the North Italian Album, which suggests that they were contemporaries and belonged to the same workshop.

A thorough study of the album has enabled more buildings and works of art to be identified; all are Lombard-Veneto, and the buildings are either medieval or date from the last quarter of the 15th century. There are allusions to Castello Sforzesco in Vigevano, Castello Sforzesco in Milan – with a reference to Leonardo da Vinci's project for domed corner towers – Filarete's project for the Sforza monument, the abbey of Chiaravalle and the medieval town hall in Piacenza; there are also numerous quotations from Amadeo's design for the Colleoni chapel in Bergamo, of the 1470s, the Certosa of Pavia, of the 1480s, and the model and building of Pavia Cathedral, of the 1490s, which was a major source for the drawings in the album.

The sculptures recorded in the Soane album include a *Putto Standing on a Tortoise* in the Abbott Guggenheim Collection, attributed to Michelozzo, Antico da Bonacolsi's Gonzaga vase in the Galleria Estense, Modena (p.55, cat.54), and Riccio's *Tobias* and Donatello's *Atys-Amorino* in the Museo Nazionale del Bargello, Florence (p.56, cat.55). There are references to Mantegna (p.15, cat.14) and explicit quotations from the drawings in Marcanova's Modena manuscript, *Quaedam antiquitatum fragmenta* (p.12, cat.11), and from Filarete: the Marciana manuscript of his treatise on pp.10–11 (cat.10) and from the silver plaquette of *Christ Healing a Possessed Man* in the Louvre, traditionally attributed to Brunelleschi but given by Isabelle Hyman to Filarete (p.51, cat.50).[17]

Artists' repertories or model books, which often show different examples of similar kinds of objects together on a page, can range from the extremely refined sketchbook in the Kunstbibliothek in Berlin, Oz.111, by the Master of the Mantegna Sketchbook, which also relates to this album

on pp.32 and 65 (cat.31 and 64), to the much cruder, engraved model book of Heinrich Vogtherr's *Ein Freinbds und wunderbars Kunstbuechlin*, published in Strasbourg in 1538, which also shows repetitive objects and gestures. In the North Italian album objects and motifs are often combined together to form a single composition, which can be interpreted in many ways, to supply ideas to different kinds of craftsmen. The design on p.1 (cat.1), for example, could be used as an architectural setting for figures in an engraving or for the brass case of a clock. For this reason it is not always possible to identify the object depicted. A wide range of subjects, almost exclusively architectural, are covered in the album: the drawings show tabernacles, polyptych frames, city views, buildings, conical stacks of steps, perspective views, frames or portals, a fireplace and a scene with a satyr and centaur as well as repertory pages with columns and helmets, vases, chariots and consoles, entablatures, candelabra, thrones, capitals and bases, and Paduan bronzes. The ornamental language is consistent, and offers a wide range of Classical moulding patterns: coin, braided laurel, cable, guilloche, egg and dart, bead and reel, leaf and tongue, acanthus ogee, anthemion, flutes and dentil mouldings. Single items from a limited range of Classical motifs – satyr masks, lion's heads, bucranes, sirens, Medusa masks, breastplates, rosettes, helmets, *tabula ansata*, profile busts and eagles – are set into recessed panels to decorate surfaces or form plaquettes, which are accumulated into the design of piers. Almost all of these motifs are found frequently in classicizing Lombard ornament after 1470. Only the breastplate and *tabula ansata* panels are unusual, but they conform to Richard Schofield's analysis of Amadeo's ornamental language.[18]

Ornament, deriving from specific sources quoted in the drawings, is recombined for repetition in other drawings. For example, the panel of ornament with a breastplate, which derives from the source on p.15 (cat.14), recurs throughout the album; on Louvre inv. no.857DRV it is recombined with the palm motif, and both motifs are used to decorate the pilaster relief on p.4 (cat.4); the relief in the frieze above both piers on p.15 is reversed and joined together as a frieze on p.26 (cat.25). Buildings are repeated in different compositions. In one case a building reappears three times in a single drawing, with changing geometric sequences of plan shapes.

Alessandro Rovetta identified two strands of influence from the Antique operating in Milanese art in the 1470s, both of which informed the design of the stained-glass cycle of *St John the Evangelist* by Cristoforo de Mottis in Milan Cathedral as well as Sforza manuscript illumination. The same influences are at work in this group of drawings.

The first source was Marcanova's manuscript, which provided the model (fol.38r) for the image of the temple in Jerusalem in de Mottis's window of the *Test of the Poison*.[19] Cristoforo de Predis used this source for the temple in a book of hours made for Gian Galeazzo Sforza in 1476,[20] and the draughtsman of the North Italian album adopted it for the architecture on p.12 (cat.11).

Dedicated to Malatesta Novello in 1465, Giovanni Marcanova's manuscript contained the inscriptions collected by Marcanova between 1457 and 1460. It was transcribed and illustrated by Felice Feliciano. It gives a romantic vision of ancient Rome and the scenographic reconstructions provide decorative settings for the collection of Roman inscriptions. It contains allusions to *Hypnerotomachia Polifili* and to Filarete.[21] Huelsen identified Cyriacus of Ancona as the source for much of the information in the manuscript.[22] The ornament with machicolations and the rich mouldings found in the North Italian album derive from Marcanova's manuscript and from the Florentine

11. Pochat 1980, pp.269, 272–3.
12. Schmitt 1974, p.182, fig.15.
13. Paris 1996, p.10, cat.13, pl.7; the soldier pulling up his stocking is particularly close to the Lugt drawing.
14. Woods Marsden 1988, fig.8.
15. Milan 1991, pp.236–7.
16. Milan 1988, pp.136–7, cat.23.
17. Hyman 1981.
18. Schofield 1992 and 1993.
19. Rome 1988b, cat.1, fol.38r; Rovetta 1993, p.410, figs 4 and 7.
20. Turin, BR, Codex Varia 124; Turin 1987, fol.119v.
21. Bruschi 1967, p.43.
22. Huelsen 1907; Rome 1988b, pp.38ff., cat.1.

chronicle, which is traditionally attributed to Maso Finiguerra.[23]

The second strand of influence was Filarete's architecture, especially the building on the reverse of Sperandio's medal (*c*.1466), which Giordano interpreted as Filarete's project for the mausoleum of Francesco Sforza.[24] It was used as the model for the representation of the Holy Sepulchre in Cristoforo de Predis's miniature in the book of hours in Turin,[25] and it influenced a building drawn by the anonymous artist of the North Italian album on one of the drawings in the Louvre, inv. no.858DRbis v. Another image representing the Holy Sepulchre in de Mottis's stained-glass cycle has a source in common with drawings by the anonymous master of the North Italian album. In the background of the *Story of the Dead Man* a dome rises above a wall with oculi on either side of a door below a tall entablature. It is close to the architectural setting of Louvre inv. no.858DRr, which is copied from the beautiful silver plaquette of *Christ Healing a Possessed Man*, which Hyman attributed to Filarete. She recognized the Florentine sources for the architecture and suggested that the piece was intended as a Medici gift, and that the subject was elaborated by Filarete after he left Florence.[26] The composition on Louvre inv. no.858DRr is re-worked on p.51 (cat.50) of the North Italian album.

Some of the pages reflect the modern and contemporary architectural theories of Leon Battista Alberti, Francesco di Giorgio and Bramante. On p.2 (cat.2) arched bays are juxtaposed with trabeated bays, and the artist shows the two ways for an arch to meet a trabeated block demonstrated in Brunelleschi's buildings and illustrated in Francesco di Giorgio's treatise. The range of columns shown with circular, hexagonal, square and triangular or rhombus forms, also derives from Francesco di Giorgio, although he designs them with abstract rather than figural capitals. On p.56 (cat.55) columns with different plans are shown in an image of a bridge that seems to quote from Marcanova's manuscript, Filarete and Francesco di Giorgio simultaneously.

Square columns with abstract capitals, which are usually associated with Francesco di Giorgio and which are found in Bramante's *Street Scene* of *c*.1500 and in the attic of the sacristies on the wooden model of Bramante's project for Pavia Cathedral, are repeated many times in the album.[27] The *all'antica* cornice with acanthus consoles, which was used by Bramante at S. Maria presso S. Satiro in Milan, and the superimposition of pilasters or half-columns above two pilasters, a motif typical of Bramante, are used repeatedly in the album. A mausoleum, based on that of Hadrian in Rome, is reproduced obsessively, with the geometry of the plans changing as they rise from a square to a cylinder and a rhombus (cat.40).

Numerous perspective views demonstrate the artist's interest in perspective, but although references to perspectival theory show that he was well-informed, he was unskilled in the construction of the drawings: as Pochat observed, the perspectives are empirical and incoherent, and the vanishing point is often outside the scene.[28] The drawings of wells and stacked steps derive from the study of Piero della Francesca's *mazzocchio* in *De prospectiva pingendi*. The explicit quotation of Bramante's scenographic engraving *Street Scene* on p.13 (cat.12) declares an acquaintance with Bramante's study of perspective, which was influenced in his formative years by Mantegna and Piero della Francesca and applied in the Milanese projects. The repetition of squares, circles and triangles in the foreground of so many drawings, where they function as part of the subject of the image rather than as an attribute of geometry, is evocative of the frontispiece of the *Prospectivo Melanese*, a poem about the antiquities of Rome written in 1496–8 and attributed to Bramantino.[29]

The artist employed high quality materials: the use of vellum is rare in Italy at this date, when paper was more commonly used for drawings, although its greater durability would make it an appropriate support for a workshop manual. The use of pigments is considered even though the way in which they are mixed in the mediums sometimes results in crude effects. The quality of the drawings suggests that the artist may have been a professional craftsman who was also an amateur of painting and architecture, with access to a prestigious professional workshop. The frequent references to the model of Pavia Cathedral suggest that he was in the workshop of Cristoforo Rocchi who made the first edition of the model.[30] The presence of copies of privileged humanist material in the workshop is demonstrated by the fact that Rocchi's project of 1487 for the rebuilding of Pavia Cathedral was a small-scale reproduction of St Sophia in Constantinople, which must have been based on Cyriacus of Ancona's drawing of it.[31] Bramante's association with the workshop, began in 1488 when he was invited to advise on the construction of the Cathedral.[32] In the 1490s Francesco di Giorgio and Leonardo, the other important influences on the draughtsman of the album, were consultants with Bramante on the Cathedral.

The birds, fruit and animals, possibly copied from a model book that was used to decorate manuscripts or ducal diplomas, are by a second and more proficient artist, who could have been an illuminator. The use of discarded vellum from a manuscript or diploma workshop may help to explain the choice of material and the irregular sizes and shapes of the folios. It may also explain the artist's interest in the work of the Putti Master and the London Pliny Master, who collaborated together in Venice and Padua in the decoration of printed books. They were leaders in the establishment of the *all'antica* style in the Veneto after Donatello and Mantegna. They used the same repertory of Antique motifs for ornament as Amadeo, although Schofield, who analyzed this material, acknowledged the difficulty of connecting Amadeo with the book illuminators, because he remained in Milan throughout his career.[33]

The late 15th-century artist of the Paris album, called by Faietti the Master of the Flagellation, also had interests in common with the Putti Master. He seems to have based the composition of the *Flagellation* in the Louvre (inv. no.859DRv) on a lost composition by Pollaiuolo; the Putti Master reworked the print of Pollaiuolo's *Battling Nudes* by the Mantegna school early in 1469.[34] The story of Hercules, the only myth explicitly evoked in the North Italian album, was also explored at an early date by the Putti Master and his collaborator, the London Pliny Master, and features of their iconography are probably found in the drawings of *Hercules* by the anonymous Master of the North Italian album.[35] Nessus and Deianeira on p.68 (cat.67) are probably quoted from a miniature by the London Pliny Master.

The presence of two late 15th-century hands in the whole collection of material that records Lombard-Veneto painting could explain the division of interests in the London and Paris drawings. Painterly interest turned towards Padua and Venice: works by Altichiero and Pisanello are recorded by the early 15th-century hand; works by Donatello and Riccio are recorded by the anonymous illuminator who was the contemporary of the master of the North Italian album. Works by the Putti Master and the London Pliny Master are drawn both by the Master of the Flagellation and the master of the North Italian album, who shows a consistent interest in Milanese court artists. His doggedly uniform hand, combined with the commitment of a *dilettante*, moves over the surface of the vellum with a line that recalls the chiselled line of a woodcarver. He could have trained with his contemporary, the illuminator, in the workshop of the Putti

23. Colvin 1898.
24. Hill & Pollard 1967, p.26, cat.115; Giordano 1988, pp.124–6.
25. Turin 1987, fol.120v.
26. Hyman 1981, p.114.
27. Venice 1994, pp.462–4, cat.54.
28. Pochat 1990, pp.270–71.
29. Robertson 1993, pp.377ff.; for allegories of geometry, see Winner 1986, pp.37–8, tav.XVII–XIX.
30. Venice 1994, pp.462–4, cat.54.
31. Bruschi 1967, p.44.
32. Malaguzzi Valeri 1915, p.83.
33. Burnett & Schofield 1998.
34. Armstrong Anderson 1968,
pp.156–7.
35. Armstrong 1981, pp.59ff., figs 42–7 and 73–85.

Master and the London Pliny Master, who in addition to illuminating books also produced woodcut plates for the friezes that decorated the margins and the plates of printed books produced in the 1470s in their workshop in Venice.[36] The drawings made by the early 15th-century hands and by the Master of the Flagellation in Lombardy, Padua or Venice could have been inherited there and taken to Pavia to Cristoforo Rocchi's workshop, where the model for the Cathedral of Pavia was engaging the most innovative architects of the day.

LITERATURE Geymüller 1891, pp.93ff.; Röthlisberger 1957, p.95–100; Licht 1970; Licht 1973; Manni 1986, pp.70ff.; Pochat 1990; Milan 1991, p.234, cat.63; Thurley 1993.

CATALOGUE

The boards and spine with four raised bands are covered by a Venetian marbled paper, coloured ochre, pink, blue and green and probably dating from the 18th century; no.26 is written in ink at the top centre of the board and 33 in ink on the left. The volume measures 328 × 227 mm, open 464 mm.

It is inscribed *1490* in ink on the spine, *Fogl.34-66 dessins origineuuse/du –15 me –siecle* in ink inside the front board, and *on 68 pages* in a second hand. The volume has one endpaper and a paper frontispiece of white laid writing paper with a ruled border of two narrow lines enclosing a wide line framing the title, DISEGNI/DI ARCHITETTURA DEL 1400. The watermarks are listed at nos 5,6 and 40 in the catalogue of watermarks in vol.II.; the folios measure 322 × 221 mm.

PROVENANCE The volume was acquired from the bookseller John Britton and included in a bill dated January 1834, *Architectural drawings – by an Italian Master £3. 3. 0* (the same price as he charged Soane for Fontana's 'Drawings of Amphitheatres' on 13 July 1830; Sir John Soane's Museum, Archive, Private Correspondence, III.B.1.107). It is catalogued by Richardson as *Designs in the 15th Century folio/very curious and interesting/Fifteenth century Original designs/made in that epoch*; in the margin the entry is inscribed *Disegni di Architettura del '400* in red ink. The volume was located in case 10 on the east wall of the library/dining-room, to the right of the fireplace in the dining-room.[37]

The materials used in the album were analyzed by UCL Painting Analysis. The following is extracted from their report.

The parchment was first prepared with lime (calcium oxide). The drawings are all on vellum in quill and two qualities of ink. They were both based on the same material, probably iron gall; one was very dilute, the other thicker and more crystalline. The variation in the constituency of the inks is probably explained by the relative thickness of the two inks. Where the material is protected from the atmosphere by a thick gummy medium, the ink is darker, because the oxidization process has been arrested; where it is thinly spread on the page it is paler because it has converted to the oxidized form. The medium has not been identified but it is likely to be a gum.

The palette consisted of vermilion, organic red lake, red earth, orange clay, organic yellow lake, yellow ochre, lead white, natural chalk and a very small amount of carbon black.

The colours are occasionally used on their own – for example, the red tiles on p.8 (cat.8) are pure vermilion, and the dense white on p.5 (cat.5) is a thick layer of lead carbonate white – but generally they have been mixed, and the mixtures seem to have been selected to achieve maximum transparency without losing brightness. Yellow ochre is mixed with yellow lake and with red lake; red lake is mixed with black and orange clay; vermilion with natural chalk; vermilion and iron oxide red

are mixed together. The same kind of colour wash on traditional illuminated manuscripts would usually be carried out using organic pigments, which are initially very brilliant but fade rapidly on exposure to light. By mixing organic pigment with lakes the painter has retained the transparency and avoided the problem of fading.

NOTES ON THE COLOURS

Carbon black is found only on p.5 (cat.5), mixed with red lake; blacks, dark browns and greys have all been achieved with the iron-gall (?) ink. The bright blue on many pages is azurite, it is used in a number of ways, usually unmixed with white; it is coarsely ground to preserve the intensity of the colour. The bulky nature of the paint in an aqueous medium has led to apparently crude results. The second blue pigment is indigo; on p.34 (cat.33) it is mixed with lead white, and on p.28 (cat.27) it is mixed with lead white and green earth.

The only green is malachite; it is mixed with black for the tail of the chimera on p.50 (cat.49). The pigment is more finely ground than the azurite. The bright red, such as the roof tiles on p.8 (cat.8), is pure vermilion; sometimes it is mixed with natural chalk, and with iron oxide red. The colouring principle of the red lake was not identified but it is probably based on the *kermes* or cochineal beetle. Pink is a mixture of vermilion, chalk and iron oxide red.

The bright yellow of the frieze on p.16 (cat.15) is a high quality ochre; another yellow on the same page is mixed with yellow lake. It is likely that the yellows in the album, which are always bright, are mixed with yellow lake: the brilliant effect is more difficult to achieve with ochre alone, even with ochre of the best quality. The third yellow, lead-tin yellow, is found only on the bird's wing on p.9 (cat.9) and as highlights on the dome on p.28 (cat.27).

Orange is used in two ways: as a transparent wash as a mixture of yellow lake, red lake and yellow ochre and as an opaque colour. The extensive use of lead white is surprising; that so much has survived is probably due to the excessive amounts of mediums used to mix the paints.

The pigments are of good quality: the azurite has few impurities, the yellow ochre is bright and the lakes strongly coloured. Most of the pigments were in common use. The virtual absence of carbon black, and the total absence of any green pigments, except on the chimera's wing, added by a second hand, is very surprising.

Barytes (barium sulphate) is probably the substrate of the lakes. This is an unusual choice: the substance is readily available, but contemporary references to lake-making suggest that aluminium hydroxide or various forms of calcium carbonate were the bases normally used.

CATALOGUE NOTE

All of the drawings are on vellum, in quill with one or two dispersions of iron-gall? ink. Most of the drawings are on a light creamy ground; when the yellow colour of the parchment is exploited, it is recorded in the entry. The colours used and the size of the rectos are given in the entries, but the number of the dispersions of ink is visible in the illustrations and is not listed in every case. When underdrawings are visible they are recorded first, followed by hatching. For details of how the colours are achieved the reader should refer to this section. The pigments are mixed as watercolours but blacks, browns and beiges are achieved with different dispersions of the ink.

The drawings in the Rothschild cabinet in the Louvre, Paris (inv. nos 841DR–860DR), that are in the same hand as this album are: inv. no.841DRV (tower), 846DRr (frieze with satyrs), 847DRr (frieze), 848DRr (ornament only), 850DRV, 852DRV, 854DRV, 855DRV, 857DRr andv, 857DRbis r and v, 858DRr and v, 858DRbis r and v, and 860DRr and v.

36. Armstrong 1981, pp.26–9.
37. Richardson 1830, p.35.

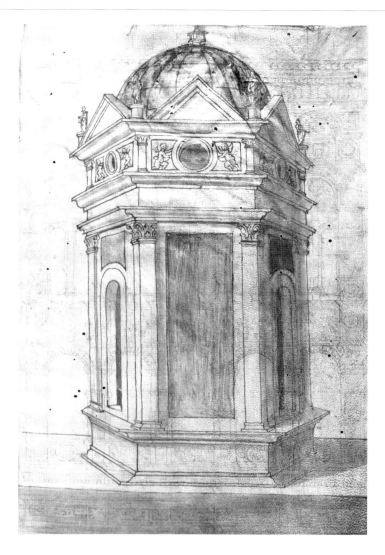

1

Hexagonal building
Coloured pale brown, blue, red pink
and yellow; 313 × 215 mm
SJSM, vol.122, p.1

A domed hexagonal building, on a low
basement, with alternating recessed
rectangular and semicircular arched
niches, the latter surmounted by
recessed panels in the spandrels. The
bays are framed by bent 'Corinthian'
pilasters supporting an entablature
and a shallow drum with tympana in
front of the dome.

The building, with tympana on top
of an attic in front of a ribbed dome
with a lantern, derives from the sac-
risties on the model of Pavia Cathedral;
oculi within rectangular panels in
the attic appear in panels below the
buttresses on the model (Malaguzzi
Valeri 1915, fig.99; Venice 1994, p.67).
Putti upholding roundels in the attic
ultimately derive from antique *clipeus*
sarcophaghi. A drawing in the British
Museum, London, attributed to an early
16th-century Lombard artist close
to Bramante, shows a similar building,
which is developed in plan and eleva-
tion to include a peristyle portico sup-
ported on piers with straight trabeations
below the arches inside the portico
(Popham & Pouncey 1950, cat.294).

There is an almost identical building
in the background of a Florentine
engraving of the *Descent of the Holy Spirit*
(c.1470–90; Hind 1938, III, pl.185, cat.I,
p.126, BI, cat.13; there is a coloured
version of the print in the Rothschild
Cabinet in the Louvre). In the engraving
the attic has been opened as a balcony
with figures on it. A French brass
astrolabic table clock dated 1545 in the
British Museum (reg.no.1888, 12-1, 123)
is based on a variant of this design.
Two hexagonal clocks are also of the
same type. Each of the faces of the
clock dated 1535 has four flutes, like
the fluting on p.23 (cat.22); the other
clock has herms in the attic and a brass
acanthus leaf on a lion's foot at each
angle, as on Verrocchio's porphyry
sarcophagus of Piero and Giovanni
de' Medici in S. Lorenzo, Florence, of
1469–72 (Tardy 1981, p.95; Dubois 1858,
pp.87–8, pl.4).

REPRODUCED Faietti 1992, p.35.

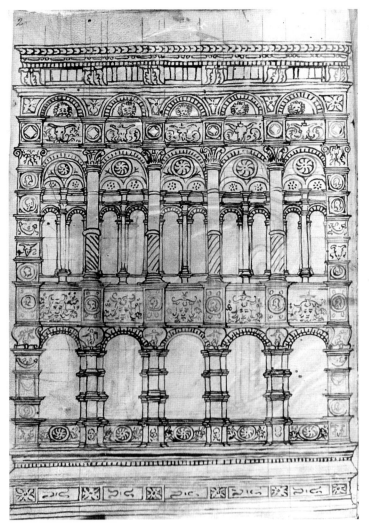

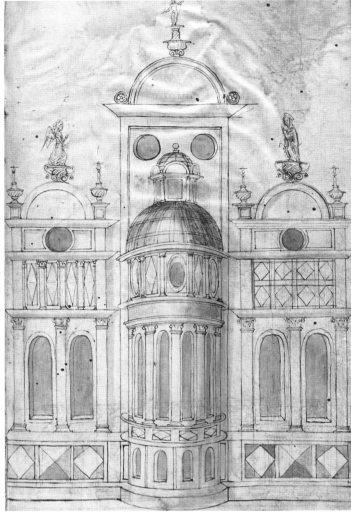

2
Frame
Red chalk construction lines are visible at the top
SJSM, vol.122, p.2

A two-storey frame of five equal bays stands on a projecting basement decorated with panels containing rosettes and ribbon ornament. The lower order comprises a ringed pier with a half-column; in the upper storey a 'Corinthian' order frames biforate arched windows with a small order supporting a trabeation below two relieving arches in the wide arch of the bay. At each side of the frame is an accumulated order of plaquettes and medals with disconnected Classical motifs, which is defined by Schofield (1992) as the principal characteristic of Amadeo's system. Composite or Corinthian columns with spiral flutes and plain shafts separated by decorated rings, on tall decorated pedestals, occur in a slightly different form in the architecture of Pietro Lombardo, for example, the monument to Doge Nicolò Marcello in SS Giovanni e Paolo, Venice, of *c*.1481–5 (McAndrew 1980, p.127, pl.9.9).

Certain features recur frequently in the album: the ornamental panels between the orders decorated with a single motif – grotesque masks, bucranes and lion's

heads; the main entablature with consoles decorated with acanthus leaves; and the cornice moulding with dentil, bead-and-reel and guilloche ornament. The draughtsman experiments with arch and trabeation: he shows two solutions for the meeting of the archivolt with the trabeation block, both deriving from Brunelleschi and recorded in Francesco di Giorgio's treatise on architecture (fol.18v, cat.96). For the consoles, see p.48 (cat.47).

REPRODUCED Faietti 1992, p.36.

3
Elevation of the east end of a church
Red chalk in the basement, coloured pale brown, blue, red, pink and yellow; 313 × 215 mm
SJSM, vol.122, p.3

A semicircular apse with a basement, dome and lantern abuts a narrow wall, undecorated except for recessed panels and oculi. A segmental pediment, which is more than semicircular and framed by bolsters, rises behind the cornice on the same plane as the wall, as in Lombard Gothic, rather than Classical, prototypes. Above the pediments are statues of the *Redeemer* in the centre and the *Virgin* and the *Annunciate Angel* on either side.

Façades with lunette pediments are typically Venetian; they appear, for instance, at S. Giorgio Maggiore, on the dormitory wing known as La Manica Lunga, which has a three-pedimented façade. The example closest to the façade in the drawing is Bartolomeo Bon's church of S. Rocco, of the 1490s, which has three narrow bays with a central triangular pediment and belfries on top of lunettes (McAndrew 1980, pp.497 and 507, pls 31.7 and 32.2). Other details relate the design to Lombard architecture: the basement with arched windows lighting a crypt recalls the apse crypt of Pavia Cathedral, which was built with round-headed windows

by 1490. Some details have parallels on the model of the Cathedral: the lunette pediments; the design of the attic with rectangular panels containing oculi; the juxtaposition of the ribbed dome and lantern against plain walls with oculi, which recalls the way in which the sacristies abut the body of the church; and the fluted urns crowning the pediments, which are similar to the pedestal above the façade. The *Redeemer* recalls the figure on the arch in Bramante's *Street Scene* (*c*.1500; Malaguzzi Valeri 1915, figs 362 and 98; Hind 1948, VI, pl.635; Venice 1994, pp.62 and 66–7). Vases enlivening the roof-line are also shown in a drawing of the façade of the Certosa of Pavia in *Raccolta Bianconi* (vol.VI, fol.36r; Bruschi 1969, fig.15). The diamond-shaped revetment, which has a Roman source in the interior of the church of SS Cosma and Damiano, was used by Leon Battista Alberti for the portal of the Tempio Malatestiano in Rimini, drawn on p.19 (cat.18). The detail of S. Ambrogio that appears in the fresco by Bernardino Zenale and Bernardino Butinone in the Grifi chapel in S. Pietro in Gessate, Milan, is based on the same sources (Rovetta 1986, p.85, fig.8). Similar ornamental forms were used by Alessandro Scala da Filighera at the Bramantesque church of the Madonna del Tirana (*c*.1515; Malaguzzi Valeri 1915, fig.409).

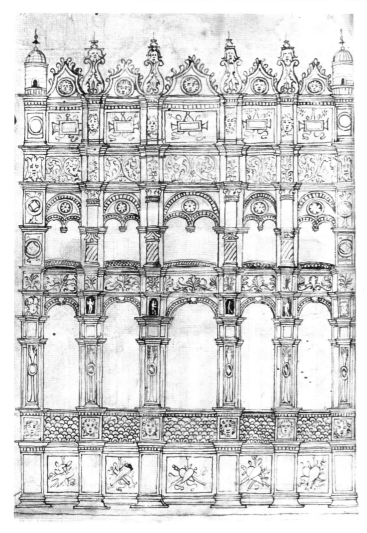

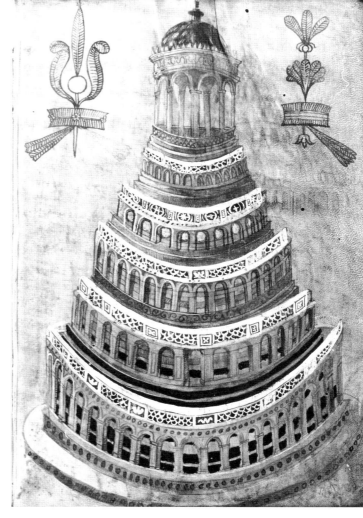

4
Polyptych frame

Grey chalk construction lines visible at the top, coloured brown and white
SJSM, vol.122, p.4

The two-storey frame, with a wider central bay, is supported on superimposed orders of pilasters, below an attic on pedestals. The pilasters of the bottom storey bear reliefs of palm trees (see p.15, cat.14). The lower shafts of the 'Composite' columns are spiral-fluted, the upper plain; they frame very shallow niches, similar to those at S. Maria delle Grazie, Milan. Rectangular panels with single items of *all'antica* ornament such as trophies fill the spaces between the bays. The frame is crowned by cusped gables and acanthus balusters and satyr masks, with conical domed buildings, similar to those on the top of commemorative columns, at either end.

The foliage decoration on the cusping, similar to that at Casa Olzignano, Padua, is typically Venetian (Paoletti di Osvaldo 1893, I, p.187, fig.75; Wolters 1976, figs 661–4). The foliage balusters between the gables resemble those on the pedestals on the apses of S. Maria delle Grazie (Malaguzzi Valeri 1915, fig.223), which Schofield suggested may derive from Francesco di Giorgio's drawing of a similar baluster in S. Salvatore, Spoleto (Turin, BR, MS T, fol.93r;

Schofield 1986, p.50; for the antique prototype, see Salmi 1951, tav.XIX).

Biforate windows supported on corbels and enclosed within a second arch are found all over Lombardy, as for example at the Palazzo Stanga in Cremona. Leonardo da Vinci's *Benois Madonna* of 1478–80 in the Hermitage, St Petersburg, has a similar window in the background (Malaguzzi Valeri 1904, p.323; Clark 1988, fig.14). Scale decoration was used traditionally in Milan: the walls of the cloister of the church at Canepanova are covered with graffito scale ornament, 'in the 15th-century transitional manner' (Malaguzzi Valeri 1915, pp.117–26, fig.136; see also p.5, cat.5). The grilles between the pedestals recall those in the sacristy of S. Maria presso S. Satiro in Milan. A faded drawing, copied from Codex Atlanticus, shows Leonardo experimenting with lattice grilles for the cupboards of the treasury in Castello Sforzesco, Milan (Malaguzzi Valeri 1913, p.350).

5
Metà Romuli

On yellow vellum, underdrawn in a pale ink visible on the left, diagonal hatch, coloured brown, beige, blue, pink, red, orange, black and white; 320 × 220 mm
SJSM, vol.122, p.5

[1] A conical mausoleum of five tiers, with arcades supported on piers at each level and an open domed tempietto on top. The tempietto is supported on eight arches on columns or piers below an entablature with a scroll frieze, a saw-tooth pattern above the cornice and a semicircular dome with a lantern.

The conical building is reminiscent of the Metà Romuli as it is described in the *Prospectivo Melanesi* of 1496–8, which Charles Robertson (1993, pp.379ff.) has attributed to Bramantino. The description of the Metà covered with precious stones is followed by an account of the Pigna, the pine-cone from the fountain in the courtyard of Old St Peter's, which was covered by a vault on eight porphyry columns: *Afrontallui era dequallalteze/ vna gran meta di pietra murata/di gemme fine et di gran gentileza/Nel mezallun allaltrera piantata vna pigna de octon coperta doro* (Govi 1876, p.15, stanzas 53–4; translated in Fienga 1980, p.46: 'in front of it [Castel S. Angelo] there was of equal height a great pyramid made of stone and inlaid with fine gems. Not far

from these was located a pine-cone of gilt bronze girded by a structure'). The artist probably merged the monuments. It was shown by Schedel (1493, fols LVIIV –LVIIIr) as the conical nucleus of a building. The pyramid in Filarete's relief of the *Martyrdom of St Peter* on the bronze doors of St Peter's is probably a four-storey reconstruction of the monument (Lazzaroni & Muñoz 1908, tav.III).

The scale decoration on the balconies is the most common of two types of scale ornament in the album; the other is on p.4 (cat.4). It derives from the bronze grilles above the door of the Pantheon in Rome (cat.294), and is also found in the oculus of Amadeo's Colleoni chapel in Bergamo, of the 1470s (Bernstein 1992, fig.2). The *barco* in S. Michele in Isola, Venice, attributed to Mauro Codussi and dated after 1480, has a marble parapet with fish-scale grilles (McAndrew 1980, pp.257–9, fig.17.14).

The azurite is used in three ways: applied thickly over white it gives an intense blue on the balconies; ground finely and brushed thinly over the yellow parchment it gives a green effect less at the base of the tower; and used as a glaze over dark brown for shadow in the arcades. [2, 3] The feather tournament pennants do not seem to have heraldic significance.

REPRODUCED Faietti 1992, p.37.

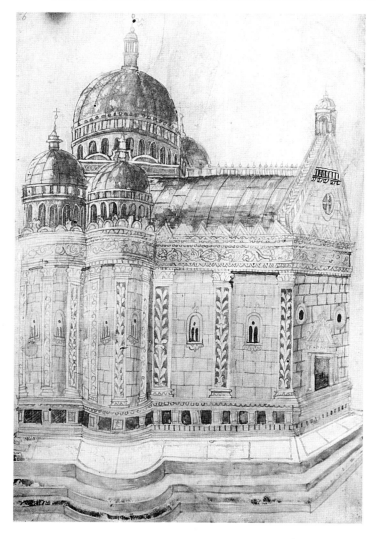

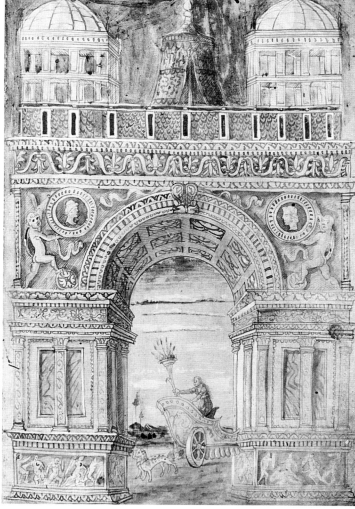

6

A five-domed basilica

Coloured brown, blue, red, pink,
orange and white
SJSM, vol.122, p.6

A perspective of a basilica with five
domes, showing it set on a podium
with three steps and a basement with
recessed coloured rectangular panels
alternating with panels bearing figural
reliefs. Pilasters with foliage ornament
reliefs, against the drafted masonry
walls of the nave, support an entabla-
ture with a deep frieze decorated
with rinceaux and small gables below
a copper roof. The façade, with a door
above the basement flanked by an
oculus on either side, has a gable with
an oculus below a balcony, galleries
running up the sides and a domed
baldacchino on top. The four small
domes are subordinated to a larger
central dome with a lantern.

A drawing in the Rothschild Cabinet
in the Louvre (inv. no.857DRbis v)
shows a similar building with six domes,
which recalls Paduan prototypes, such
as S. Antonio or S. Giustina. The lead-
plate roofing, shown on the drawing
and on many folios in the North Italian
album, is typical of buildings in Venice
and Padua. Quinquux central plans are
generally associated with Filarete, and
in a basilical form with Francesco di

Giorgio's treatise (fols 17v and 18r,
cat.94–95). They influenced drawings of
fantasy buildings in the Uffizi, Florence,
traditionally attributed to Cronaca
(Bartoli 1914–22, I, tav.XVII–XIX)
but more recently given to Baldassare
Peruzzi (Frommel 1991–2, pp.137ff.).
The merlons running up the gable
recall those on the Palazzo della
Ragione and the Palazzo del Capitano
in Mantua (Paccagnini 1960, figs 90
and 112); the stair up the gable recalls
Siena Cathedral. A building with
merlons shown on Louvre inv.
no.860DRr is particularly close to the
Mantuan buildings; the building in
the background recalls the arched
bays on piers under the lofty trabeated
bays below the dome at Amadeo's
Colleoni chapel in Bergamo, of the
1470s (Schofield 1992, p.29, fig.1).

For Filarete and the quinquux
plan, see Spencer 1958; for Francesco
di Giorgio's and Bramante's use of it,
see Morresi 1991, pp.138ff.

REPRODUCED Milan 1991, p.237, fig.196
as 3v; Faietti 1992, p.38.

7

Triumphal arch

Diagonal cross-hatching, coloured
brown, blue, red, yellow and white;
320 × 220 mm
SJSM, vol.122, p.7

The barrel vault of a triumphal arch
frames a view of a figure holding a
cornucopia full of wheat on a cart pulled
by leopards, against a distant mountain-
ous landscape with trees. The figure
perhaps represents Ceres. The orders
framing panels of coloured stone are
reminiscent of Florentine painting, but
the bipartite division created by placing
the central pilaster in front of a recessed
panel is unusual and suggests that the
source may have been misunderstood.
A drawing of an arch attributed to a
North Italian artist (Paris, Louvre,
inv. no.1420DR) shows a similar feature.
The open *logge* above the arch recall
the towers at Castel Nuovo, Ferrara
(Zevi 1960, p.495, fig.596); a drawing
of a church or mausoleum attributed
to Bramantino shows a superstructure
with five arched bays and a pavilion
roof (Pinacoteca Ambrosiana, vol.F.251,
fol.145r; Malaguzzi Valeri 1915, fig.40).

The use of profile portraits in roundels,
deriving from Roman numismatic
obverse portraits, occurs frequently in
the album without iconographic signi-
ficance. Upheld by putti and ultimately

deriving from Roman *clipeus* sarco-
phaghi, they are found early in
Lombardy, in the frieze of the Colleoni
tomb in Bergamo, of the 1470s (Schofield
1992, p.36, figs 13 and 5). A design for an
arch attributed to the circle of Pisanello,
in the Boijmans Van Beuningen
Museum, Rotterdam, has similar putti
with fluttering ribbons stepping up to
hold the roundel (Fossi Todorow 1966,
p.120, cat.165). The Rotterdam drawing
is usually associated with the arch at
Castel Nuovo in Naples, although
Hersey suggested that it was for the
festival of 1447 at Castel Capuano. The
rearing horse of the equestrian monu-
ment on the arch predates Filarete's
horse in the monument on top of a
tower in Codex Magliabecchiano (II.I,
140, fol.172r; Hersey 1973, pp.24–6,
fig.16). Filarete's tower is entered
through a wide arch surmounted by a
roundel and framed by wide pilasters,
as in the Rotterdam drawing. The
similarity between the hand in this
album and that in the Rotterdam
drawing is striking.

REPRODUCED Faietti 1992, p.39; Golzio
& Zander 1968, tav.V.

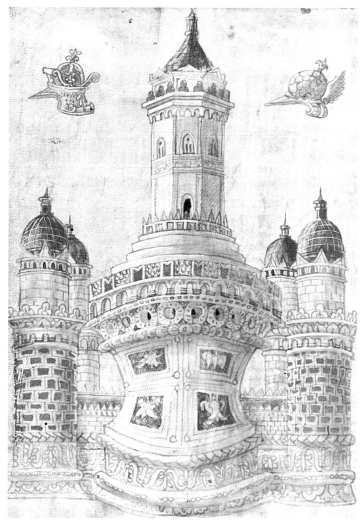

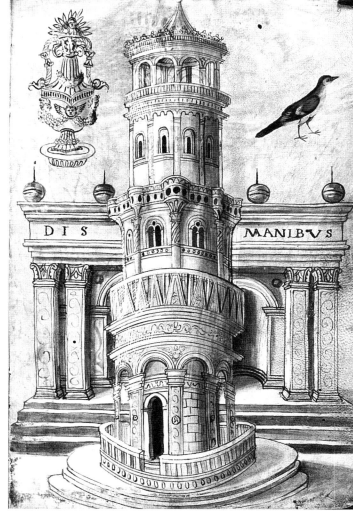

8
A castle and helmets
Diagonal hatched, coloured brown,
blue, red, pink, orange and white
SJSM, vol.122, p.8

[1] A castle with a grand central gate
surmounted by a tower has low walls
with merlons connecting four circular
towers with domed tops. The building
is set on a basement decorated with
rich mouldings: a cavetto with acanthus-
ogee decoration, a bead-and-reel
astragal, anthemion frieze and cable
moulding. The central tower, panelled
on the ground floor, each panel deco-
rated with trophies, has an entablature
with a guilloche moulding, a frieze
with oculi below machicolations and
merlons, and a central octagonal tower
on a conical stack of four steps.

The design is based on Castello
Sforzesco, Milan, as rebuilt to Francesco
Sforza's specifications after 1450, with
three round rusticated corner towers
and low walls with merlons running
between them, and a central two-storey
entrance tower. The drawing alludes
to Leonardo's project of the 1490s to
beautify the corner towers; he planned
to close the merlons to make arched
windows and to build domed pavilions
on the gun platforms (Windsor, RL, inv.
no.12.552r; Marani 1984, p.180, cat.47).
The central tower does not depend on

Filarete's gate, which was based on the
reconstruction of the mausoleum of
Hadrian that Ciriaco d'Ancona pro-
vided for the bronze doors of St Peter's.
The two-storey octagonal tower derives
from the abbey of Chiaravalle near
Milan, which also has biforate windows,
machicolated decoration and an ogival
open gallery around the spire (Malaguzzi
Valeri 1915, fig.220). A design for a
candelabrum in the form of a square
castle with projecting corner towers
and a central keep suggests a use for the
design (Malaguzzi Valeri 1913, p.147).
[2, 3] The dress helmets, [2] decorated
with strapwork scrolls and [3] with
scale decoration, are similar to helmets
drawn by Francesco di Giorgio in MS L
(Florence, BML, fol.96v; Maltese 1967,
I, tav.178).

REPRODUCED Licht 1973, fig.3; Faietti
1992, p.40.

9
A tower, a vase and a goldfinch
Inscribed DIS MANIBVS
Over grey chalk, coloured with brown,
pink and white, the bird with black,
blue, red, pink, yellow and white;
316 × 215 mm
SJSM, vol.122, p.9

[1] A four-storey tower, on a podium of
three steps, is enclosed in a balustrade
on a step with scoop ornament. The
ground floor has a central drum enclosed
in a circular arcade supported on thin
piers bearing roundels and rinceaux and
with winged figures in the spandrels,
below an entablature and a balustrade
with pinnacles separated by colonnettes.
The first floor is articulated by 'Compo-
site' columns with plain and spiral-fluted
shafts framing double-arched windows
on a dado, the second floor by plain
pilasters rising two storeys to an entab-
lature above machicolations; the entab-
lature supports a balustrade around a
circular loggia with ten open arches and
a conical tent roof. The tower stands in
front of a building with either a segmen-
tal arched niche or two round-headed
niches between paired pilasters at the
corners. The pilasters, decorated with
rinceaux, support an entablature and
frieze with the sepulchral inscription.

A similar arch frames a *Creation* illu-
minated by the Putti Master in the *Biblia*

italica published in Venice in 1471
(Armstrong 1981, cat.11, ill.18). The
balconies or *echauguettes* derive from
medieval military architecture, where
they usually rest on top of machicola-
tions, as at the Belfry in Bruges and
Manzanares El Real in Spain. They
appear at the Château les Contes de
Flandres in Ghent above an order. The
window type, usually associated with
Michelozzo's design for Palazzo Medici
Riccardi, Florence (Venice 1994, p.207),
and in Milan with Filarete's Ospedale
Maggiore (Welch 1995, fig.80), are
closer to Amadeo's windows in the
tower of Palazzo Bottigello, Pavia, now
Doghani, which also have two pitched
arches enclosed in a semicircular arch
(Malaguzzi Valeri 1915, fig.314).
[2] The vase, decorated with cherubim
and garlands, is similar to the restored
graffito vase of flowers from the demol-
ished house of the Missaglia family
in Milan (Patetta 1987, pp.260ff.).
[3] The goldfinch is in a second hand
using the same materials. It was proba-
bly copied from a model book for use as
an attribute to evoke Christ, or as a child's
favourite pet; a portrait of *Francesco
Sforza* as a baby shows him clutching a
terrified little goldfinch (Coll. W. Beattie,
Glasgow; Malaguzzi Valeri 1913, p.441).

REPRODUCED Faietti 1992, p.41.

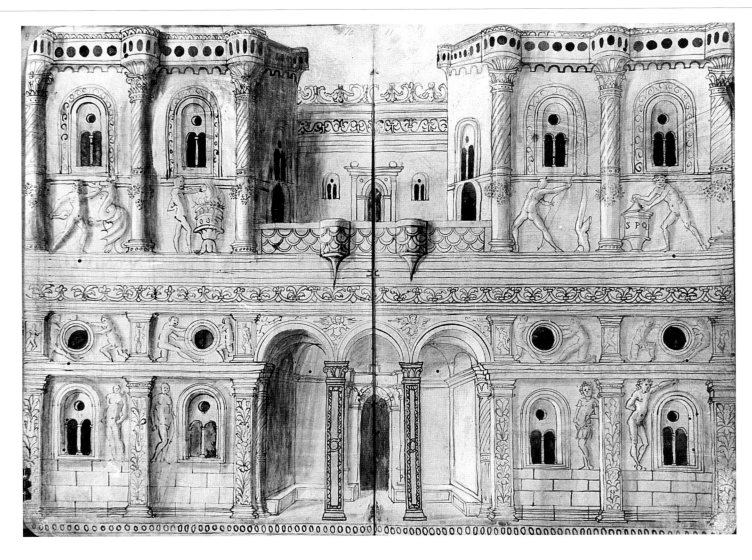

10

Venetian palace façade
Inscribed s p q
Coloured brown, beige, red, pink
and white; 316 × 430 mm
SJSM, vol.122, pp.10–11

The blocks flanking the ground-floor
loggia are articulated by pilasters with
foliage and by reliefs of male nudes
standing on a dado of drafted masonry.
The design of the attic derives from that
on p.1 (cat.1). The piano nobile is articu-
lated by half-columns with plain lower
shafts and spiral-fluted upper shafts with
crowns at the hypertrachelion. Scenes
from Classical mythology are depicted
on the dado, and appear to include
*Hercules Killing the Hydra, Mutius
Scaevola Holding His Hand in the Flames*
and *Hercules and the Stymphalian Birds.*

The biforate arched windows inside
a pitched arch are the reverse of the
windows on p.9 (cat.9). Resting on a
stone dado, they are framed by wide
bands with terracotta reliefs and
surmounted by *échauguettes,* machi-
colations and a parapet with oculi.

A similar scheme appears at the town
hall at Piacenza, begun in 1281 (Pérouse
de Montclos 1972, II/XVII, 56). The win-
dow type derives from early medieval
examples, such as those at S. Simpliciano,
Milan (Krautheimer 1965, p.113). A bal-
cony above an order occurs on a church

façade in Jacopo Bellini's album in the
British Museum (fol.91r; Eisler 1988,
pl.128).

The overall scheme, with a central
void and solid blocks on either side,
follows the tradition of Venetian
palaces. The introduction of a fully
articulated mezzanine on the ground
floor is found in Filarete's Venetian
palace in the manuscript made in
Milan for Mattius Corvinus between
1484 and 1489 (Venice, BMV, MS 2796,
fol.157r; Finoli & Grassi 1972, I, pp.CXII ff.).
The fenestration, with the windows
off-centre on both the ground floor and
the attic, could suggest that the drawing
depicts architecture for a festive event.
The decorative use of arched machico-
lations below the entablature features
prominently in early pattern books
such as the Florentine Chronicle in the
British Museum (Colvin 1898, fols 18r
and 19r), and Marcanova's manuscript
in Modena (BE, MS lat.992; fols 27r and
29r; Rome 1988b, cat.1). Alberti and
Francesco di Giorgio used the motif
respectively at Palazzo degli Anziani,
Ancona, and Palazzo della Signoria,
Jesi. The doors on both storeys with an
arch enclosed in a trabeated order recall
the portal of the Medici bank in Milan
(Visioli 1989, p.107; Maltese 1967, II,
tav.239). Classically-inspired reliefs,
of the *Life of Bacchus,* are used in a

comparable way on a façade in the
Birth of the Virgin by the Master of the
Barberini triptych (*c.*1467; Metropolitan
Museum of Art, New York; Bober &
Rubinstein 1986, p.106, fig.69b).

REPRODUCED Faietti 1992, p.37.

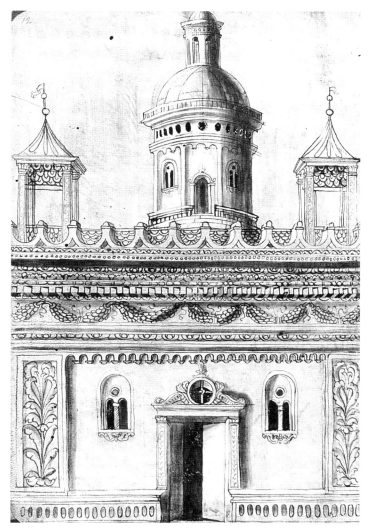

11
Façade
Coloured dark brown, beige, pink
and white
SJSM, vol.122, p.12

The central door is flanked by biforate
windows and surmounted by a round
window containing an iron grille with
a central knot, enclosed in scrolls.
The wall is framed by wide pilasters
with symmetrical foliage springing
from acanthus leaves and crowned
by an accumulation of rich decorative
mouldings – machicolation, egg and
dart, a garland frieze, dentils, bead and
reel and many foliate mouldings – and
by a balustrade formed of upturned
arches filled with scale grilles. Above,
at each end of the wall, is a square open
pavilion on piers and with a tent roof.
In the centre a domed tower rises from
a rusticated masonry drum.

The scheme derives from a building
in Marcanova's manuscript (Modena,
BE, MS lat.992; fol.38r), which Rovetta
has associated with the background
of the *Test of the Poison*, a stained-glass
window by Cristoforo de Mottis in
Milan Cathedral, intended to convey
the temple in Jerusalem (Rome 1988b,
cat.1, fol.38r; Rovetta 1993, p.398, figs
4–7; Pirina 1986, p.150). A similar set-
ting for the temple is shown in a book of
hours made in 1476 for Galeazzo Maria

Sforza in the workshop of Cristoforo
de Predis (Turin 1987, II, fol.119v).
There is a loose relationship with
Alberti's Holy Sepulchre in the Rucellai
chapel in Florence, which has a rectan-
gular door in a high basement, a crown
of openwork ornament and a domed
superstructure (Venice 1994, p.135).
The trabeated pavilions on square
piers above an order recall the pavilions
on the façade of the Colleoni chapel in
Bergamo, of the 1470s (Schofield 1992,
p.29, fig.1). The decoration on the wide
pilasters is repeated throughout the
album (see p.61, cat.60).

A more refined variant of the compo-
sition, quoted by de Mottis in the
stained-glass cycle in Milan Cathedral,
also appears on a drawing in the Louvre
(inv. no.858DRr; see fol.51, cat.50). A
similar scheme has been adapted for
the background of the *Miracle of the Man
Wounded by a Pike* by the workshop of
1493, one of the *Miracles of S. Bernardino*
in the Galleria Nazionale dell'Umbria,
Perugia (Venice 1994, p.447).

REPRODUCED Faietti 1992, p.42.

12
Cityscape
Coloured brown, beige, blue, pink and
white; 300 × 212 mm
SJSM, vol.122, p.13

The perspective is asymmetrical and
imprecisely constructed. In the fore-
ground on the right is the corner of a
palace with a two-bay arcuated portico
with an oculus in the spandrel, the
arches joined by iron ties, and an
entablature on the inner wall of the
portico. The palace stands in front of
a trabeated loggia, four columns deep,
with a coffered ceiling and a balustrade
on top. It offers a view to a hexagonal
well enclosed by steps and to a land-
scape with a column and triumphal
arch beyond.

The architectural fragments in the
foreground function as *repoussoir* ele-
ments for the perspective, one of the
devices associated with Nicoletto da
Modena, which led Licht to attribute
the album to him. The corner perspec-
tive of the portico on square columns
derives from Bramante's scenographic
engraving *Street Scene* of *c*.1500, where
it is reversed (Hind 1948, V, pp.104–5,
cat.2; VI, pl.635). In Bramante's design
the square arcuated order is contrasted
with a taller Corinthian trabeated order,
three columns deep, which is shown
here behind the portico. The fluting, as

on a column, seen below the dome in
the *Street Scene* could be a reference to
the fluted buildings in Marcanova's
manuscript. The palace is repeated on
a drawing in the Rothschild Cabinet
in the Louvre (inv. no.854DRV). Uffizi
242A-560A, a study for a perspective of
a scenery wing attributed to Raphael
and Giulio Romano, also based on
Bramante's stage set, is close to this
drawing; the vault rests on imposts in
the Uffizi version, on an entablature
above pilasters in Bramante's version
(Venice 1994, pp.530–31, cat.163 and
165). The perspective of the hexagonal
well inside a theatrical arrangement of
steps belongs to a group of images that
Daly Davis (1980, p.191) has associated
with Piero della Francesca's *De prospec-
tiva pingendi*, tav.XIV. The exaggerated
light effects that characterize many of
the drawings are evident in the shadow
of the balcony.

LITERATURE Röthlisberger 1957, p.99,
fig.4; Licht 1970, pl.16; Faietti 1992, p.43.

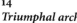
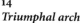

13

Cityscape

Diagonal hatch, coloured brown, beige, blue, red, pink and white
SJSM, vol.122, p.14

The asymmetrical perspective of a noble city street shows a palace, a tower and a triumphal arch, and two columns – one of which is broken, the statue lying foreshortened head-first on a squared pavement – in front of a distant cityscape and red skyline. On the right is the corner of a palace with a ground-floor loggia on piers, a piano nobile with half-columns and an attic decorated with a roundel and a profile bust.

The diamond rustication seen on the palace on the left is found in many cities: it appears on the basement of the house in Venice designed by Bartolomeo Bon and acquired by Francesco Sforza from Marco Corner, which Filarete went to Venice to draw (Beltrami 1900, pp.17 and 58; Bulgarelli & Ceriana 1996, pp.108–10, n.22); it embellishes the round towers of Castello Sforzesco, Milan; Antonio Rizzo used it at the Palazzo Ducale in Venice in the 1480s; and in Ferrara it was used to decorate a whole façade (Zevi 1960, pp.26 ff.). It is drawn in Francesco di Giorgio's treatise in MS T (Turin, BR, fol.20v; Maltese 1967, I, tav.36). It is also found on the basement of a square corner tower at Palazzo

Santacroce in Rome (Tomei 1942, fig.168). The balustrade with square balusters and the architecture of the mezzanine above the entablature of the palace on the left are simplified variants of the building on the left of Mantegna's *Baptism of Hermogenes* in the Ovetari chapel, Padua. The figures in the clouds are quoted from Mantegna (Lightbown 1986, p.12, pl.43, cat.10 and p.90; London 1992, pl.60). The sky, a saturated blue fading to pink and white on the horizon, and the cloud formation are close to Bramantino's *Nativity and Saints* of 1495, and to his *Philemon and Banci* of 1485–90 (Mulazzani 1978, tav.XVII and VI). The foreshortened figure derives from *virtuoso* perspectival demonstrations like those of Leonardo in his lost treatise on painting known through MS Huygens in the Pierpont Morgan Library (Maltese 1980, p.423, fig.8).

A broken tower like the Torre delle Milizie in Rome, had been used to evoke the city of Rome from the time of Cimabue's view in the vault of the upper church of S. Francesco, Assisi (Frutaz 1962, I, p.113; II, tav.142, pp.154–5).

REPRODUCED Licht 1970, pl.17; Manni 1986, p.52, tav.19; Milan 1991, p.237, fig.197 as fol.7v.

14

Triumphal arch

Coloured beige, blue, red, yellow and white; 302 × 222 mm
SJSM, vol.122, p.15

The three-bay façade, covered with blocks of coloured marbles, has deeply projecting piers at either end and a central door on the ground floor framed by 'Composite' columns. The pilasters at the bottom of the piers bear a diamond within a circle and a relief, on the right a palm tree with a sacrificial jug, an *urceus* and a rudder at its base; the pilasters above are each decorated with a breast-plate, and the panels above them with Roman numismatic portraits, below a deep concave cornice. On the right the cornice is decorated with a relief of a *Victory* in a chariot.

The pier and cornice are quoted from Mantegna's fresco of *St James Led to Execution* in the Ovetari chapel, Padua, where the positions of the relief of the palm tree and trophy are reversed. The Vitruvian inscription in the roundel, quoted by Mantegna from the arch of the Gavi, which is not the architectural source for his arch, is omitted here. The siren frieze in the lower entablature is quoted from Mantegna's *Martyrdom of St Christopher* in the Ovetari chapel. Lightbown (1986, p.398, pl.26) identified the frieze from the temple of Hadrian

at Ephesus, citing Foss (1979, pp.72–4), who refers to a figural frieze, and *Vogue* (January 1985, p.124). If the Ephesian frieze is the source, Mantegna's knowledge of it would have derived from Ciriaco d'Ancona. The arched windows on colonnettes with flutes below spiral flutes above the entablature are drawn from the Porta dei Borsari in Verona (Zorzi 1958, tav.21). Trophy reliefs in recessed panels, which are repeated throughout the volume, derive from Mantegna's fresco or his source and are shown combined with a palm tree in a drawing in the Louvre (inv. no.857DRV). They are rarely found in Lombard *all'antica* decoration, but the London Pliny Master and Bartolomeo Sanvito both used them in their illuminated books and manuscripts (Armstrong 1981, fig.108; Schroter 1987–8, Abb.30–31). Two reliefs in the attic of Nero's palace in Filarete's *Martyrdom of St Peter* on the bronze doors of St Peter's show a scene of sacrifice on the left and a figure in a chariot pulled by satyrs on the right (Lazzaroni & Muñoz 1908, tav.III). The *Victory* in her chariot copied directly from Mantegna or his source relates to Filarete's relief; it is reunited here with a sacrificial relief on the left, not shown by Mantegna.

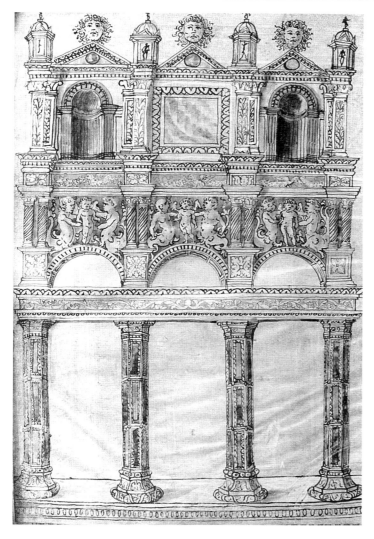

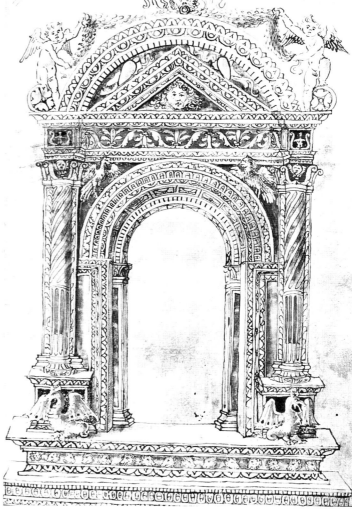

15

A triple-arched screen or frame

Diagonal hatch, coloured blue, red, pink, yellow and white
SJSM, vol.122, p.16

The screen or frame on four hexagonal panelled piers rests on a podium decorated with scoop ornament. The straight entablature has a frieze with rinceaux and three relieving arches above it. Pairs of spiral-fluted colonnettes on pedestals between the arches frame scenes showing families of Tritons. The entablature with an eagle-and-garland frieze breaks forward over the order and supports an attic with shell niches on either side of a marbled panel, the whole crowned by pediments with Medusa masks and small tabernacles, as on p.1 (cat.1).

Hexagonal or octagonal columns, also shown on p.31 (cat.30), date from the period of Sixtus IV; they were used in Rome in the portico of SS Apostoli, c.1473, the cloister at S. Cosimato, c.1480, and in the loggia of the Palazzina of Innocent VIII, c.1484 (Tomei 1942, figs 103, 107 and 140); they were used for the last time in Rome at Palazzo Penitenzieri, begun in 1480, in the side porticos of the courtyard attributed to Baccio Pontelli (communication Pia Kehle). Relieving arches above the trabeation are an unusual ornamental feature, but they appear on an early 16th-century drawing in the British Museum by an anonymous Lombard artist, which shows a fantasy building that also relates to cat.1 (Popham & Pouncey 1950, cat.294r). Triton families recall Mantegna. The coffering rosette, on the pedestals below the colonnettes, is found on the front of a lavabo attributed to Amadeo in the first chapel of the Certosa in Pavia (Malaguzzi Valeri 1904, p.221). The fluted socle is also found on the portal of the Colleoni chapel in Bergamo, of the 1470s (op.cit, p.44). For the frieze with eagles and garlands, probably also deriving from the Certosa in Pavia, see p.65 (cat.64).

16

Frame

Diagonal hatch, coloured brown, blue, red, pink, yellow and white; 303 × 217 mm
SJSM, vol.122, p.17

A perspective of an arched frame, which has winged dragons in front of pedestals supporting 'Composite' half-columns, a straight entablature with an anthemion frieze and a triangular pediment within a lunette pediment. The frame rests on a podium with leaf-and-tongue mouldings, a boar's-head frieze, dentils and scoop mouldings. The fluted and spiral-fluted half-columns are applied to pilasters with recessed panels, which stand in front of the half-pilasters framing the opening. Putti stepping on bolsters, as on p.7 (cat.7), on either side of the pediment hold garlands suspended from a ring in the mouth of a lion mask.

Large bolsters enclosing rosettes above an order, deriving from Donatello's Cavalcanti *Annunciation* of c.1435 in S. Croce, Florence, are frequently found in Lombard goldsmiths' work, especially in *pace* and tabernacle frames, where they are also combined with an abundance of rich mouldings (Malaguzzi Valeri 1917, figs 380–84, tav.XII). They also feature prominently in the model of Pavia Cathedral (Venice 1994, p.67). Rich mouldings, such as dentils, egg-and-dart and flutes, usually applied to horizontal mouldings, were applied by Amadeo to the oculus on the façade of the Colleoni chapel in Bergamo, of the 1470s. The portal is of the same type as Alberti's door at S. Maria Novella, Florence (Borsi 1975, p.85). The superimposition of a half-order on two pilasters, drawn by Francesco di Giorgio on the mausoleum of the Plautii (Turin, BR, MS T, fol.93v; Maltese 1967, I, tav.174), was used by Bramante in the upper storey of the Belvedere, Rome, and by Bramantino in the *Argos* fresco in Castello Sforzesco, Milan (Schofield 1982, p.127). Rich figural capitals appear early in Lombardy; the cherubim capitals, which ultimately derive from antique examples, such as the one in the Capitoline Museum, Rome (inv. no.781), were common (Mercklin 1962, p.141, cat.372c, Abb.697–8). The eagle is probably a reference to Amadeo's eagle above the window at the Certosa in Pavia (see p.65, cat.64). Like the Medusa mask, panels of ornament with sirens, found in the work of the London Pliny Master (Armstrong 1981, p.89), were also common in Lombardy (see p.31, cat.30). The half-pilaster inside the pier of the arched frame is similar to the side entrance at S. Maria delle Grazie, Milan (Malaguzzi Valeri 1915, fig.202).

REPRODUCED Manni 1986, p.53, tav.20.

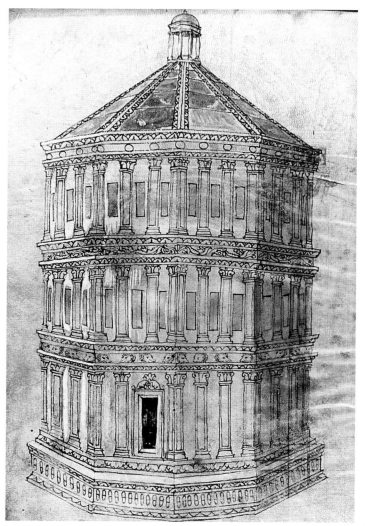

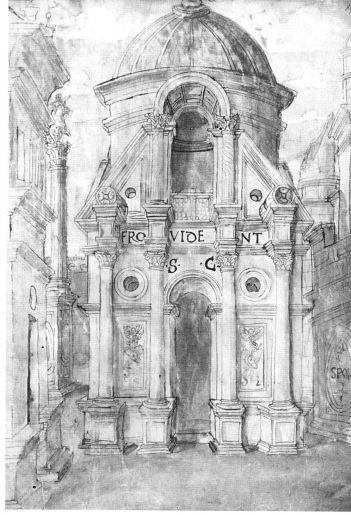

17
Baptistery
Red chalk construction lines and squaring added at bottom right, coloured brown, beige, blue, pink and white
SJSM, vol.122, p.18

A perspective of a three-storey octagonal building on a podium with leaf-and-tongue and scoop mouldings. The door on the ground floor rests on top of the basement. The façades are articulated by four 'Composite' pilasters with recessed panels supporting entablatures with a boar's-head frieze, a siren frieze and a frieze with oculi. The ribbed roof has a domed lantern on colonnettes.

The building, identified by Röthlisberger as the Florentine baptistery, most recalls Lombard baptisteries, and a similar structure with open *logge* is shown in a drawing attributed to Bramantino in the Pinacoteca Ambrosiana, Milan (vol.F.251, fol.58r). The open lantern with a dome resting on a deep entablature above columns resembles Bramante's lanterns above the dome of the sacristy of S. Maria presso S. Satiro, Milan, and above the domes of the sacristies on the model of Pavia Cathedral (Malaguzzi Valeri 1915, fig.99; Venice 1994, p.67).

REPRODUCED Röthlisberger 1957, p.95; Milan 1991, p.235, fig.192 as 9v.

18
Cityscape with the Tempio Malatestiano
Inscribed FRO/VIDE/NT –·S··C·– SPQR
Coloured brown, beige, blue, orange and white; 316 × 214 mm
SJSM, vol.122, p.19

A roughly constructed perspective with a central building breaking the recession into the distance. The façade of the domed building, based on the arch of Constantine in Rome, recalls the Tempio Malatestiano in Rimini. Röthlisberger identified the view as based on the medal of *Sigismondo Malatesta* attributed to Matteo di Pasti (Hill & Pollard 1967, cat.66). In the medal the building is shown with a broken segmental frontispiece and a wide dome. Here the building has steep gables with oculi, profiles of gables are shown at the sides of the building above the crossing, and the dome has different proportions. These features are shown in Raffaello Adimiri's *Sito Riminese* of 1616, and the drawing confirms Hope's suggestion that graphic material existed as the source for his view. Hope (1992, pp.133 and 148, pl.23b) reconstructed the east end of the church as cruciform, with a dome the full width of the church, and suggested that it was the prototype for S. Maria delle Grazie in Milan. The arch framing a niche in front of the drum and dome is based on the Porta dei Borsari in Verona; the niche is not shown clearly in Adimiri's view, where the order rests on a drafted masonry basement rather than pedestals. Röthlisberger interpreted the inscription as a misreading of PROVIDENT. S.C from an inscription on a coin of Augustus.

The building on the right with a square basement is a variant on the mausoleum of Hadrian (see p.41, cat.40); the palace on the left is an unrusticated version of the palace on p.14 (cat.13) with a concave cornice like the one on p.15 (cat.14), which derives from Roman churches, such as S. Maria in Aracoeli (Golzio & Zander 1963, fig.42), and they are found on Lombard palace façades, such as those of Palazzo Raimondi of c.1496 and Palazzo Stanga in Cremona (Malaguzzi Valeri 1915, figs 389 and 392). Bramantino painted a concave cornice in *Filomone and Banci* (Mulazzani 1978, tav.VI). The equestrian statue of the Gattemalata type on a column recalls Ercole de' Roberti's project for the monument to *Ercole d'Este*, which was on two columns and a double basement (begun in 1499 and abandoned by 1502; Manca 1992, cat.28, doc.28, fig.28; Kehle 1992–3, pp.186–7, figs 13–14).

LITERATURE Röthlisberger 1957, pp.96 and 98, n.8, fig.2.
REPRODUCED Milan 1991, p.235, fig.193 as 10r.

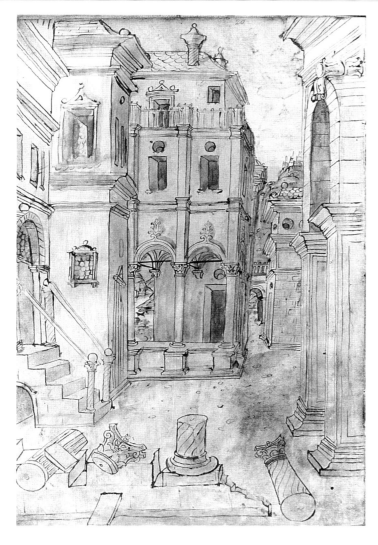

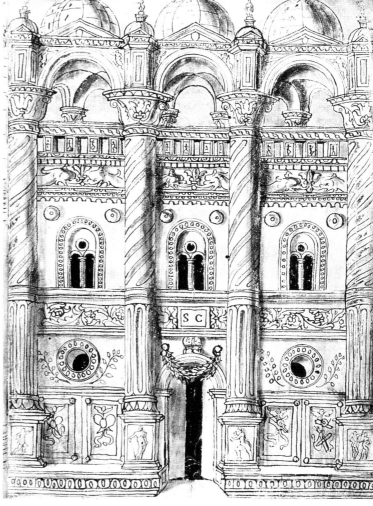

19
Cityscape
Coloured brown, beige, blue, red, pink, yellow and white
sjsm, vol.122, p.20

A perspective of a city street, with a triumphal arch on the right, based on the Arch of Gallienus in Rome, and on the left a sequence of two palaces in front of two bays of an arcuated loggia on 'Composite' columns with pedestals. Deep square pilasters rise from the capitals between the arches to the top of the piano nobile. Cornices and string courses run across the pilasters to form abstract capitals, below a balustrade in front of a recessed attic with a central pedimented door. The portico opens at the back to a distant landscape. The square pilasters recall a similar order in the attic of the sacristies on the model for Pavia Cathedral (Venice 1994, p.67). The window type, with rectangular openings surmounted by oculi above an arcade, is also found in the fragment of a Bramantesque building formerly in Via B. Porrone in Milan and now in Castello Sforzesco, dated by Arslan (1956, VII, pp.682–3) to 1485–95.

Details such as the cusps above the arched windows, the spiral-fluted chimney stacks and the stairs supported on an arch are all characteristic of Venetian architecture. The central building

recalls the public *logge* built in the Veneto in the late 15th and 16th centuries. It is very similar to the left-hand building on a drawing in the Louvre (inv. no.854DRV), which is like the building on the left of a drawing of *St Christopher in Lycia* in the British Museum, of 1466 from the workshop of Squarcione for the Lazara chapel in S. Antonio, Padua (Popham & Pouncey 1950, p.156, cat.253). The asymmetry and the sequence of building types – public buildings, towers and columns rather than palaces – are also found in the British Museum drawing. The arch on the right shown in recession, made from large blocks of stone, is probably quoted from the masonry arch in the background of Marcanova's manuscript (Rome 1988b, p.43, cat.1, fol.40v); a keystone with a characteristic large bolster has been added to it. The side of the bolster is treated like the side of an Ionic capital, as in the consoles in the oculus of the Colleoni chapel, Bergamo. Donatello's relief of the *Miracle of the Miser's Heart* on the altar of S. Antonio, Padua (Janson 1957, pl.309) has a serliana similar to the arch in this drawing

REPRODUCED Licht 1970, pl.18.

20
Temple of Solomon
Inscribed s c
Coloured brown, beige, pink and white; 313 × 214 mm
sjsm, vol.122, p.21

A structure with three cross-vaults below domes is supported on eight 'Composite' columns on pedestals bearing athlete reliefs and crowned by small hexagonal tabernacles, as on p.1 (cat.1). The columns are fluted to a ring and then spirally fluted. The arched door in the centre has a garland hanging down from rosettes in the spandrels. The side bays are decorated with rectangular trophy panels. The double-arched windows, like those on pp.10–11 (cat.10), rest on a frieze with the inscription in rinceaux. The crowning entablature on machicolations has a dolphin frieze and a balustrade with square balusters decorated with pin-men reliefs and a guilloche rail below the capitals.

The similarity of this design to the drawing of *c.*1510 in the Louvre (inv. no.1431DR), attributed to a Lombard artist, was noticed by Licht, who associated it with Filarete's illustration in book XII of the Codex Magliabecchiano (fol.87v) of the stage of an ancient Roman theatre, shown like a palace façade, with a vaulted colonnade above it to improve the acoustics inside.

Bernstein (1992, p.48, figs 2 and 3) suggested that the scheme was the source for the organization of the façade of the Colleoni chapel in Bergamo, of the 1470s. Another theatrical image can be associated with this drawing: the woodcut for the frontispiece of a Terence (Hind 1935, II, p.609, fig.358), which shows giant fluted ringed columns supporting a vault and a stage and auditorium between the columns. The woodcut, published by Johann Treschel in Lyon and by a German or Netherlandish designer, was reprinted many times in the 16th century.

The capitals are standard Lombard s-scroll types, which are found on the *pace* given by Francesco Sforza to Vigevano Cathedral and at S. Maria presso S. Satiro, Milan (Malaguzzi Valeri 1917, tav.XIII; Malaguzzi Valeri 1915, p.59). The oculi framed by inset roundels are Venetian motifs; they are found on the façades of S. Maria dei Miracoli and Palazzo Dario (McAndrew 1980, figs 12.17 and 15.7). The design of the basement, with rectangular framed panels between projecting pedestals on a socle, is similar to that of the Certosa in Pavia (Malaguzzi Valeri 1904, p.155). For the dolphin frieze, see p.29 (cat.28).

LITERATURE Licht 1973, p.98, figs 19–21.
REPRODUCED Faietti 1992, p.44.

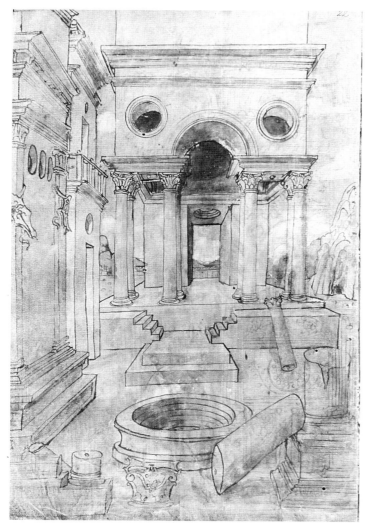

21

Cityscape
Yellow vellum, coloured brown, blue, beige, pink and white
SJSM, vol.122, p.22

A stage-set with a serliana façade in front of a landscape. On the left, in front of a palace façade, is a temple with corner pilasters bearing shields with a *caduceus* hanging from them and three oculi high on the wall. The *caduceus*, the personal *impresa* of Beatrice d'Este, wife of Lodovico Sforza, is so marginalized in this image that it is difficult to accept it as a specific allusion to her (Welch 1995, pp.228ff.; Borsi 1989, p.171).

Crum traced serliana façades to Diocletian's palace in Split. There are three 16th-century examples, in places for public appearance: Raphael's painted loggia in the *Fire in the Borgo* in the Vatican, where Leo IV appears to the Romans; Giulio Romano's nymphaeum in the Sala di Costantino; and Vasari's built loggia at the Uffizi, Florence, where Cosimo de' Medici appeared to the Florentines (Crum 1989, pp.242–5).

Serlianas on four-column piers on the garden façade of Giulio Romano's Palazzo del Te in Mantua, of the 1530s, support the late date proposed for the drawing by Tafuri and Burns, who defined the façade as a spatial serliana datable no earlier than 1540 (Faietti

1992, p.37). Given the early date of the other sources for the images in the album, however, it is difficult to accept this date. Serlianas are found before the 16th century: one stands above the choir at the Certosa of Pavia, and it was used for the elevation of the bays at S. Maurizio in Milan, of *c*.1503 (Fiorio 1985, p.86). The Pazzi chapel in Florence could provide a precedent for a free-standing serliana façade. The piers stand on a basement in front of a deep, tall portico. The height of the interior of the portico recalls Alberti's S. Sebastiano in Mantua; the towering aspect of the façade, Bramantino's Trivulzio chapel in Milan. Bramante's window in the Sala Reggia in the Vatican has a serliana on four columns, not eight as here. In combination with the low basement, the serliana echoes Bramante's or Raphael's designs for the nymphaeum at Genazzano. The double flight of temporary wooden steps, set off-centre against the basement, serves to emphasize the theatrical associations. The effect of the spatial serliana could derive from the artist's habit of layering the orders. (For full columns in front of columns, see p.44; cat.43). A similar rock formation is found in in Bramantino's *Christ at the Column* (Mulazzani 1978, tav.I–II).

LITERATURE Licht 1970, pl.19.

22

Triumphal arch
Inscribed S P Q R
Diagonal cross-hatch, coloured brown, beige, blue, red and pink; 319 × 214 mm
SJSM, vol.122, p.23

A perspective of a triumphal arch with fluted piers supporting an entablature and attic with corner pilasters and standing figures in the side bays. The pilaster type, with four flutes filled at the bottom, is found in the Marche at Ascoli Piceno and Jesi, where antique prototypes may have justified this preference. The type is found in Ansuino da Forlì's fresco of the *Prayer of St Christopher* in the Ovetari chapel in Padua (Lucco 1989–90, II, p.492, fig.586). The figures of *Adam* and *Eve* in the attic above the pilasters are similar to the figures on the portal of Palazzo Stanga, Cremona, now in the Louvre, and to the figures of the *Cardinal Virtues* in rectangular niches on Pietro Lombardo's tomb of *Doge Nicolò Marcello* in SS Giovanni e Paolo, Venice (*c*.1481–5; Signorini 1881, pp.13–15; Schofield 1992, p.44, n.66; McAndrew 1980, fig.9.7).

The central arch is framed by a spiral-fluted order with a highly decorated lower shaft set in front of a richly carved foliate pilaster and a half-pilaster with recessed panels framing the opening. The door with a full column on a

pedestal is of the same type as Palazzo del Maino in Pavia (Malaguzzi Valeri 1915, p.261, fig.300; Visioli 1989, p.108; for spiral-fluted columns, see Bulgarelli & Ceriana 1996, pp.154, 183 and 186, n.243). The layering of decorated orders is found on the portal of S. Maria dei Miracoli in Brescia, which also has an attic and deep entablature (Hill 1978, fig.2/8/2). Putti holding cornucopia and blowing trumpets fill the spandrels of the arch, the keystone of which bears a half-figure with two dolphins as a tail; this could be a variant of the headless torso with dolphins in the sacristy of S. Satiro, Milan (op.cit, fig.59). Pilasters without capitals are found in Mantegna's Ovetari chapel in Padua; they are characteristic of Vincenzo Foppa's work (Lightbown 1986, figs 14 and 15; Mazzini 1965, tav.175–6).

REPRODUCED Licht 1970, pl.12; Faietti 1992, p.45.

23
Palace façade
Coloured brown, blue, red and pink
SJSM, vol.122, p.24

The façade of a Venetian palace set on a squared pavement has a recessed central block and two projecting blocks on *logge* with arcades resting on stepped podia. An order of 'Corinthian' columns on pedestals, with fluted lower shafts and garlands hanging from a ring below the spiral-fluted upper shafts, frames two arches on columns with an oculus in the spandrel and supports an entablature with three arched windows separated by colonnettes and framed by putto telamons supporting the balustrade of a balcony. Behind the balustrade is a recessed rusticated façade, with a central door with a pediment and machicolations below an entablature, with a second balcony and a recessed rusticated block articulated by spiral-fluted columns and crowned by cusped gables. Domed square pavilions decorated with garlands and surmounted by orbs are set at right angles to the upper storey. The palace in the background of Jacopo Bellini's *Departure for the Hunt* in album 46 in the Louvre follows the same scheme; the balconies on the projecting wings are similar to the balcony on the recessed bay here (Eisler 1988, pl.89).

One of the drawings in the Louvre (inv. no.845DRV) by the early hand is the Gothic model for this drawing. The cresting on the top of the building is found on the Porta della Carta at the Palazzo Ducale, Venice, of *c*.1438 (Wolters 1976, pl.845, cat.240); it is also found in Tuscany at Pisa Cathedral and Baptistery.

REPRODUCED Licht 1970, pl.13; Licht 1973, fig.2; Milan 1991, p.237, fig.198 as 12v; Faietti 1992, p.46.

24
Baldacchino over a well
Grey chalk underdrawing in the impost on the left and the putti, diagonal hatch, coloured beige, blue and pink;
320 × 216 mm
SJSM, vol.122, p.25

A perspective of a domed baldacchino on square pilasters, above a circular well surrounded by a square balustrade. The piers with recessed foliage panels, on pedestals bearing reliefs of eagles, have capitals with volutes threaded through the eye sockets of a bucrane. The main cornice is supported by putti telamons in the spandrels of the arch. The putti hold ribbons and festoons, a putto hanging on each. Above the cornice, further putti holding cornucopia recline against flaming orbs, on either side of a central standing figure with a staff, in front of the drum and dome.

The rectangular frame crowned by a drum and dome recalls the small wooden altar with the *Nativity* attributed to the school of Amadeo in the Pinacoteca Comunale, Milan (Malaguzzi Valeri 1917, p.231, fig.256). The simultaneous viewing of the exterior and the interior of the dome is a characteristic feature of Lombard wood-carving; a drawing of *c*.1509 by Giovanni Angelo del Maino for the altar of the Carmine in Pavia shows it in a

different form with a similar ornamental language, putti and cornucopia (Accademia, Venice, inv. no.194; Milan 1982, p.123). Cristoforo de Mottis's window of 1477 in the Sala del Lavabo at the Certosa of Pavia shows a richly moulded arch below an octagonal drum with a view into it, and oculi in the spandrels like the ones in this drawing (Malaguzzi Valeri 1923, tav.XI). Fra Antonio da Monza's *Pentecost* in the Albertina, Vienna, which depends on Prevedari's engraving (1481; Hind 1948, V, pp.102–3; VI, pl.633) for its architectural setting, shows a similar crossing on square piers with an apse and shell niche: the Virgin's crown, suspended from the shell, is treated in a similar manner to the reliquary hanging from the centre of the dome (Malaguzzi Valeri 1917, pp.152–6). Putti or baby satyrs as telamons are found in both Venetian and Paduan art: they hold up the basement of Pietro Lombardo's tomb of *Doge Nicolò Marcello* of *c*.1481–5 in SS Giovanni e Paolo, Venice, and support the vases on the arms of the throne in Andrea Bellunello's *Virgin and Child* of *c*.1478 in Oderzo Cathedral (Lucco 1989–90, II, p.568, fig.669). A maiolica disk in the Museo Civico, Padua, which was originally sunk into the façade of a ceramic workshop, bears the motif on the throne of the *Virgin and*

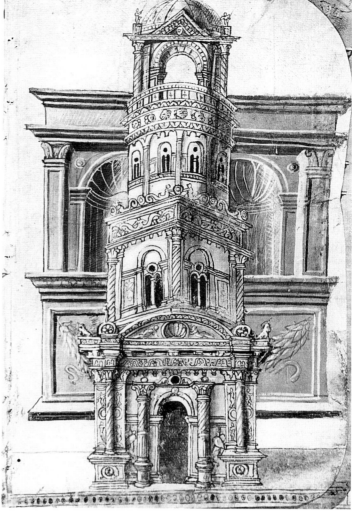

Child. The disk is attributed to Nicoletto da Modena on the basis of the inscription on the cornice, NICOLETTI; it must have been made during his documented visit to Padua in 1506, and relates to an engraving of an enthroned *Virgin and Child* of *c*.1506 (Bartsch 1980–4, vol.25.2, pp.177–9), copied from a Ferrarese artist. The thrones in the two Paduan works are similar to the thrones on p.38 (cat.37).

Reliefs of putti hanging from ribbons with upside-down festoons were carved by a Venetian sculptor on the lower order of the façade of S. Zaccaria in Venice, built by Antonio Gambello before 1481 (Malaguzzi Valeri 1904, p.77). Bartolommeo Sanvito used the motif in a manuscript for Cardinal Francesco Gonzaga (Rome, BAV, MS GR.1626, fol.2r; Schroter 1987–8, p.90, Abb.30).

REPRODUCED Licht 1970, pl.14; Manni 1986, p.56, tav.2; Faietti 1992, p.47.

25
Portal or frame
Diagonal hatch, coloured brown, beige, red, pink and orange
SJSM, vol.122, p.26

A rectangular opening is framed by wide 'Corinthian' piers, decorated with panels of foliage behind half-columns made of three superimposed panels with arched niches. The piers rest on pedestals bearing reliefs or paintings of eagles and athletes. The entablature breaks forward over the columns and carries a frieze that derives from the reliefs on the cornices of the piers of p.15 (cat.14), united into one relief. A lunette pediment with rich mouldings – dentil, egg and dart, leaf and tongue – frames a steep gable with an oculus in the centre and putti lying on the sides. The frame is crowned with a mask in foliage, tritons holding vases and putti on pedestals above the piers. The trabeated door frame is uncommon in domestic architecture, with only one example in Lombardy, the Corso Magenta portal in the museum in Castello Sforzesco, Milan. Deriving from the Arco degli Argentieri in Rome, it is found in churches, such as S. Maria delle Grazie, Milan (Visioli 1989, p.104; illustrated in Malaguzzi Valeri 1913, p.78).

REPRODUCED Milan 1991, p.237, fig.199.

26
A tower in front of a double niche
Coloured brown, beige and white;
311 × 204 mm
SJSM, vol.122, p.27

A perspective of a tower with changing geometrical plans – square on the ground, rhombus then cylindrical – is inspired by Filarete and by reconstructions of Roman tombs, below an open domed pavilion. The drawing exhibits the familiar ornamental language of spiral-fluted columns, biforate windows with an oculus in the diaphragm of the arch, machicolations, siren frieze, balustrade on square balusters and steep gables in front of the dome. To the right and left of the tower are two half-elevations of niches, drawn differently with a brush in watercolour; they could have been added later by the same hand. They rest on a high basement with a garland and are framed by 'Composite' pilasters with recessed panels, which support an entablature with a plain frieze.

The winged putto-head frieze is found on the façade of the Colleoni chapel in Bergamo and on the tomb of *Medea Colleoni* (Burnett & Schofield 1998). Röthlisberger suggested that the towers illustrate Vitruvius' and Alberti's descriptions of towers or tombs with changing geometrical plans (Rykwert

1988, pp.31–48). It is not clear whether the niche in the background is a wide segmental arch or two round-headed niches. A tabernacle with a segmental arch on a basement frames a miniature by the Putti Master in the *Biblia Italica* of *c*.1471 in the Pierpont Morgan Library, New York (vol.1, fol.1r, Mariani Canova 1969, p.26, pl.8).

LITERATURE Röthlisberger 1957, p.98; Faietti 1992, p.48.

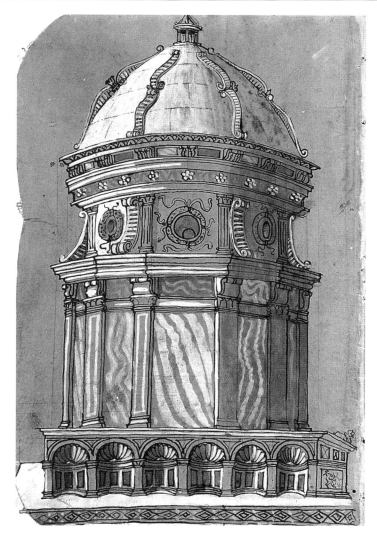

27
Tabernacle
On a blue-green ground, incised and
with grey chalk underdrawing, coloured
blue, green, red, yellow and white
sjsm, vol.122, p.28

A perspective of a domed tabernacle
with inlaid marble decoration. The
decagonal building, resting on a rectan-
gular basement with six shell niches,
each with three panels, has five panels of
marble framed by pilasters carrying an
entablature below an octagonal drum
with oculi framed by laurel wreaths and
ribbons. Composite colonnettes and
long scrolled volutes in the attic support
a deep entablature with rosettes in the
frieze and foliage consoles in the cor-
nice below a dome, which has double-
volute ribs and a lantern on colonnettes.
 The superimposition of the octagon
over the decagon and rectangle is
very uncertain. The cornice of the
lower entablature bends at the corners,
but not the frieze or the pilasters. The
position of the volutes in the drum is
left unclear.
 The overall design recalls
Brunelleschi's cupola in Florence
with its tall drum, oculi, steeply pitched
dome and lantern; the niches are
reminiscent of the exedrae at the
base of the drum, a feature shown
in Michelino's *Dante and the Three*

Kingdoms in Florence Cathedral (1465;
Venice 1994, p.204). A similar drum
is shown in a drawing in the Louvre
(inv. no.1453DR), which is close to the
Florentine painting, the wings project-
ing below the volutes. The double
strapwork scrolls, deriving from the
roof of the temple of Venus in *Hypn-
erotomachia Poliphili*, on fol.72r,
are references to the model of the apse
of Pavia Cathedral (Colonna 1964,
p.199; Bruschi 1977, fig.48). The base-
ment with niches is found on a drawing
attributed to Cronaca, and recently to
Peruzzi (Bartoli 1914–22, I, tav.XVIII,
fig.38; Frommel 1991–2), which was fre-
quently copied, for example, in Codex
Zichy in Budapest, on fol.51v. It also
appears in the painted architecture in
Matteo di Giovanni's *Vision of St
Augustine* in the Art Institute of Chicago
(Scaglia 1970, p.17ff., fig.18). The cornice
with acanthus consoles and cyma with
leaf-and-tongue ornament, consistently
drawn in the album, is similar to the
cornice of S. Maria presso S. Satiro,
Milan (Malaguzzi Valeri 1915, p.15).
 The blue-green background has
been achieved by mixing indigo with
lead white and green earth. The yellow
highlights are lead-tin yellow.

28
*A screen, choir-stall or a case of
drawers*
Diagonal hatch, coloured brown, beige,
blue, red, pink, orange-yellow and
white; 312 × 218 mm
sjsm, vol.122, p.29

A *spalliera* composed of six panels of
false porphyry and serpentine and
divided by deep square piers, each con-
sisting of three superimposed niches,
and by wide entablatures decorated
with lion's masks above the projecting
order and with foliage with sirens, vases
or rosettes in the recessed bays, sits on
a basement with two horizontal battle
reliefs, marble panels and ornamental
colonnettes. On top, dolphins rise up to
putti, their tails curling upwards and
joined by a ring below the pedestal of a
vase; they are similar to the dolphins
with a pedestal on the lavabo of *c*.1489
at the Certosa (Malaguzzi Valeri 1904,
pp.106 and 114–15). Dolphins ride on the
pediment in the drawing for the façade
of the Certosa in Pavia in *Raccolta
Bianconi* (vol.VI, fol.36r; Bruschi 1969,
fig.15), which also has piers composed of
superimposed double niches, contain-
ing figures. The dolphins probably
derive from the Roman relief of the
Throne of Neptune in S. Vitale, Ravenna
(for the relief, see Bober & Rubinstein
1986, no.52A; for the Lombard artist's

use of it, see Schofield 1993, pp.127–8;
Burnett & Schofield 1997). The frieze on
p.21 (cat.20) is probably also based on
this source. The design could be for a
screen, a choir-stall or a case of drawers
with inlaid and carved panels; the rec-
tangles of richly veined veneers may
represent drawer fronts, as Peter
Thornton has suggested.

REPRODUCED Licht 1970, pl.24; Manni
1986, p.59, tav.23; Milan 1991, p.238,
fig.200 as 15r.
LITERATURE Thornton & Dorey 1992,
p.107, fig.113.

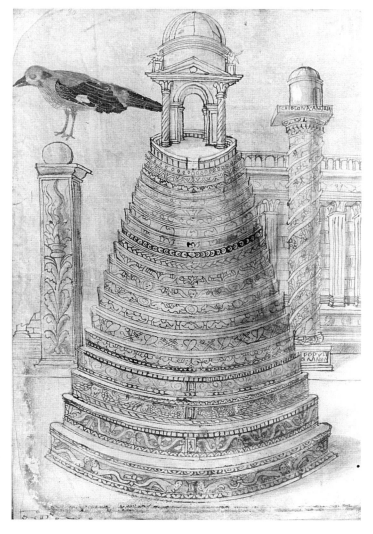

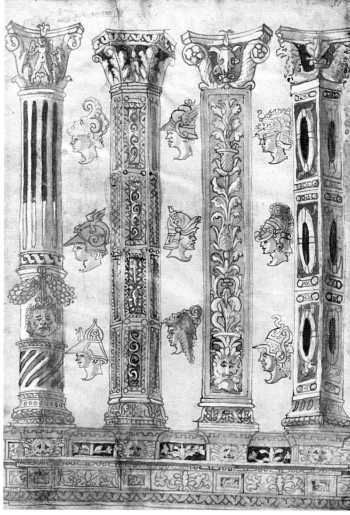

29

Mausoleum, two columns and a bird

Inscribed CHOLONA ANDRIA
POPVLV/OMANVS
Diagonal hatch, coloured brown, red,
pink, orange and white
SJSM, vol.122, p.30

[1] A conical stack of 21 steps, each with
a different frieze, below an open domed
building could be a repertory of orna-
mental mouldings. From the bottom
confronting harpies, anthemion,
bucranes and garlands, waves, sirens,
trophies, bell-flowers, dolphins, putto
heads and cornucopia, anthemion and
cornucopia friezes, cable, guilloche,
waves, acanthus-ogee and chevron
mouldings can be identified. The taber-
nacle on top of the steps is a variant of
the design on p.25 (cat.24).

The pyramidal arrangement of steps
decorated with mouldings recalls the
basement of the columns in Piazza
Maggiore, Ravenna, by Pietro
Lombardo (1483; Paoletti di Osvaldo
1893, pp.213–14, figs 136–7). Margaret
Daly Davis (1980, pp.191–3, fig.20)
described how Piero della Francesco
developed his drawing of the *mazzocchio*
in *De prospectiva pingenda* to a stacked
platform that could be used as a setting
for figures. She illustrated an intarsia
from the *grotta* of Isabella d'Este in the
ducal palace, Mantua, with a circular

stack of ten steps, which can be com-
pared with this drawing. Tintoretto's
Presentation of the Virgin of *c*.1552 in
S. Maria del Orto, Venice, has a set of
circular steps similar to this one, each
step decorated with a different pattern
(Tietze 1948, p.370, figs 98–100).
[2] The square column on the left with a
recessed panel decorated with sym-
metrical foliage and a *flambeau* has a
ball or orb on top.
[3] The column on the right with a
low pedestal and a spiral relief, with a
domed structure above it, represents
Trajan's column, which was sometimes
identified as Hadrian's column; an
anonymous view of Rome in a minia-
ture of 1447 is inscribed *colonna adriana*
(Frutaz 1962, I, pp.129–30; II, tav.153).
The building in the background with
square piers in front of a drafted
masonry wall is probably a reference
to Trajan's forum.
[4] The bird, which could be a jay, was
probably copied from a model book
for use as an attribute; it is drawn
entirely in watercolour.

30

'Composite' columns and helmets

Coloured beige, blue, red, orange,
yellow and white; 321 × 220 mm
SJSM, vol.122, p.31

Four 'Composite' columns with circu-
lar, hexagonal, square and triangular
plans are displayed on a basement with
a leaf-and-tongue moulding and panels
of foliage and lion's-mask ornament.
[1] The circular column has a spiral-
fluted lower shaft and a fluted upper
shaft, the flutes half-filled; the two sec-
tions are separated by a wide ring with
garlands and a Medusa mask hanging
from a ribbon. Medusa masks are often
found on Lombard tombs; one hangs
from a garland on the candelabrum in
Prevedari's engraving (Bruschi 1969,
fig.93; for the motif, see Bulgarelli &
Ceriana 1996, pp.161 and 189, n.267;
Burnett & Schofield 1998). The capital,
with a putto standing on foliage, ulti-
mately deriving from antique prece-
dents (Mercklin 1962, p.458a), was also
common in Lombardy.
[2] Each face of the octagonal column is
divided into panels of recessed foliage
ornament; it has an acanthus capital.
[3] The square column is decorated with
a relief panel of foliage and vases spring-
ing from a grotesque mask. Its capital,
with a bucrane and cornucopia, is a
Milanese type; cornucopias as volutes

are found in the Colleoni chapel,
Bergamo (communication Richard
Schofield).
[4] Each face of the triangular or rhom-
boid column is divided into three rec-
tangular panels and decorated with
circular wreaths. Eagles support the
volutes of the capital. A similar capital,
deriving from an antique example,
is drawn in Codex Escurialensis
(fol.20v; Mercklin 1962, fig.571a; Egger
1905–6, p.82).

Francesco di Giorgio developed this
repertory of column plans and used the
square column in his buildings. On
fol.50r of his manuscript (cat.147) he
shows them with abstract rather than
conventional capitals, and with mould-
ings and cornices as on the square
orders on pp.13 and 20 of the North
Italian album (cat.12 and 19). Square
columns with capitals are found in
Donatello's relief of the *Miracle of the
Miser's Heart* on the altar of S. Antonio in
Padua, and in Piero di Cosimo's archi-
tectural allegory of the *Building of a
Double Palace* in the John and Mable
Ringling Museum of Art, Sarasota
(Venice 1994, pp.84, 86–7 and 479,
cat.86).

A repertory of nine parade helmets is
shown between the columns. They are
decorated as follows: [5] with a
grotesque faun-mask as the visor; [6] as

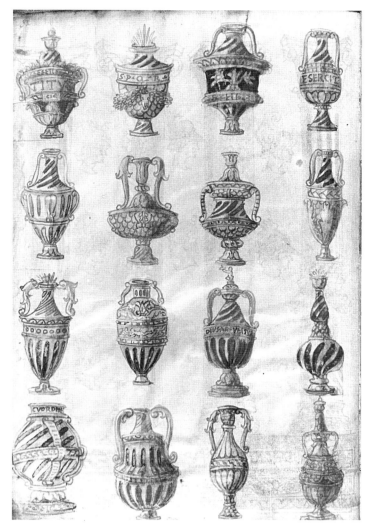

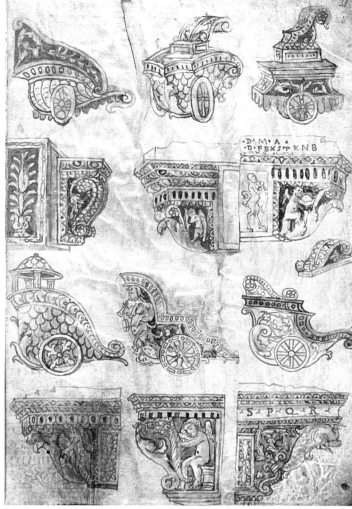

spiral snail's shell with wings at the side; [7] with a lion's-mask visor; [8] with a winged dragon on top of the helmet; [9] with a cherubim; [10] with scale ornament on the helmet and a crest terminating in a volute; [11] with a snail emerging from an ogival shell; [12] with double satyr-masks; and [13] with a satyr mask and scrolls. Francesco di Giorgio shows similar helmets in MS T: the helmets with a winged dragon and a spiral snail shell are identical (Turin, BR, MS T, fol.96v; Maltese 1967, I, tav.178). A helmet with a dragon on the crown is in the Florentine Chronicle (Colvin 1898, fol.26r). The models survived in repertories such as these and were repeated in Filippo Orsoni's album in the Victoria and Albert Museum, London, which illustrates similar helmets designed by Caramolo Modrone, who worked in Mantua until his death in 1543 (Ward-Jackson 1979, pp.101–7, cat.212). The helmet with a brim is close to a surviving helmet in the style of Modrone (c.1550; Kunsthistorisches Museum, Vienna; Vienna 1990, cat.A1398, Abb.78, pp.143ff.; for Modrone and Orsoni, see Hayward 1982; Blair 1983).

REPRODUCED Manni 1986, p.57, tav.22; Thurley 1993, fig.124.

31
Vases

Inscribed [1] TITVS [2] SPQR [4] ESERCIT [11] DIVS· ARFVM SVS [13] CVORDIN
Coloured blue, red, orange and yellow
SJSM, vol.122, p.32

A repertory page of 16 modern vases decorated with ancient ornament. [1] has a gadrooned lower bowl with a band of acanthus leaf below a cable astragal, an inscription and a spiral-fluted cover with a vase-shaped handle; [2] has scale decoration and garlands hanging from a bucrane below the inscription and a spiral-fluted neck; [3] has a central flat relief with an acanthus cluster below a leaf-and-tongue cyma and a spiral-fluted neck; [4] has a gadrooned lower bowl below the inscription and spiral-fluted neck; [5] is decorated with a double tier of flutes with scroll volutes on the upper tier and a spiral-fluted neck; [6] has a bowl decorated with scale ornament and a neck shaped like a waisted acanthus-leaf baluster with foliate dolphin handles; [7] has a scrolled lower bowl below a concave spiral-fluted upper bowl with a laurel-wreath ovolo below a baluster-shaped acanthus cover; [8] has a long lower bowl decorated with scales and four long acanthus leaves below a band of plaited decoration

and a spiral-fluted neck; [9] has a gadrooned lower bowl with a band of ornament below a leaf-and-tongue cyma and a spiral-fluted neck with dolphin handles; [10] has a gadrooned bowl below a band of decoration with wrestling putti, a foliate shoulder and a fluted neck; [11] has a gadrooned lower bowl below a band with the inscription and a spiral-fluted shoulder; [12] is baluster-shaped with a spiral-fluted lower bowl, scaled waist and a spiral-fluted neck; [13] has a gadrooned bowl with a horizontal band of coin ornament and vertical strips of strapwork below the inscription at the neck; [14] has a gadrooned bowl with a central beaded astragal and an egg-and-dart moulding at the shoulder below the spiral-fluted neck; [15] has a gadrooned bowl with a central band of guilloche decoration; [16] has a gadrooned lower bowl and a band of acanthus ogee below a baluster-shaped neck with acanthus and scales.

The vases resemble those on the carts in Mantegna's *Triumphs of Caesar*, and others in the Master of the Mantegna sketchbook (Martindale 1979, p.32; Leoncini 1993, pp.104–7, fols 31r–35r).

REPRODUCED Licht 1970, pl.23; Manni 1986, p.61, tav.24.

32
Chariots and consoles

Inscribed [6]·D· M· A· / · D·FBXSTKNB [12]· S· P· Q· R·
Coloured beige, blue, red, orange and yellow; 316 × 217 mm
SJSM, vol.122, p.33

A repertory sheet with six triumphal chariots alternating with six consoles shown in profile and in perspective.

The chariots are decorated with [1] gadroon, scoop and foliage ornament; [2] scales, acanthus leaves and scoop ornament; [3] scales and scoop ornament on the throne and a rinceau in a cavetto on the pedestal; [7] scales, coin mouldings and a domed baldacchino; [8] foliage scrolls and a half-figure holding a tambourine and blowing a trumpet; [9] scrolls and rinceaux.

The consoles are decorated with [4] a foliage relief panel at the side and foliage scrolls; [5] a plain recessed panel at the side and a satyr climbing on an acanthus leaf in the volute; [6] a satyr relief panel at the side, a putto climbing on to an acanthus scroll on the volute and an unintelligible inscription; [10] a scrolled volute and a putto holding a cornucopia, and a panel of foliage ornament; [11] a putto sitting on a pedestal holding a cornucopia and a rinceau; and [12] a dolphin and rinceaux.

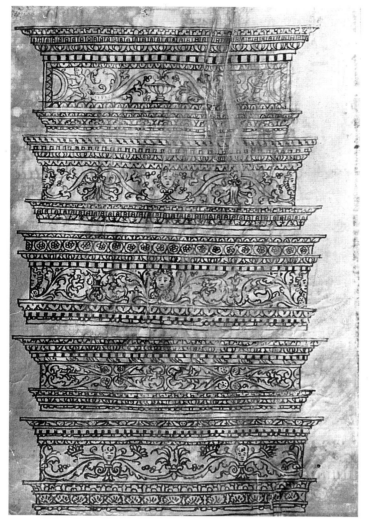

33

Five ornamental entablatures
On a thick blue watercolour ground
SJSM, vol.122, p.34

All of the cornices are represented
as symmetrical panels, as on cassoni
and sarcophagus reliefs.
[1] The architrave has bead-and-reel,
acanthus-ogee and egg-and-dart
mouldings below a frieze decorated
with Triton half-figures holding
roundels, their tails springing from a
central vase. The cornice has dentils,
egg-and-dart, scoop and palmette
mouldings.
[2] The architrave with palmette,
scoop and egg-and-dart mouldings is
surmounted by a frieze with a central
putto head alternating with anthemion
in scrolls. The cornice has palmette,
egg-and-dart, dentil and guilloche
mouldings.
[3] The architrave has bead-and-reel,
dentil and palmette mouldings below a
frieze with rinceaux and a central mask.
[4] The architrave has a bead-and-reel,
an egg-and-dart and a decorated
moulding below a frieze with
moresques. The cornice has a bead-
and-reel fillet below dentils, egg-and-
dart and foliage mouldings.
 Similar friezes are shown on fol.16r
of the model book by the Master of
the Mantegna Sketchbook in the

Kunstbibliothek, Berlin (1470s; Leoncini
1993, pp.96 and 153). It is close to the
pattern of the 15th-century frieze of
graffito decoration in the basement
of the chapter house at Chiaravalle
(Reggiori 1970, fig.95).
[5] The architrave has bead-and-reel,
shell and palmette mouldings, a frieze
with putto masks between cornucopia
alternating with anthemion, and a cor-
nice with leaf-and-tongue, bead-and-
reel, dentil and putto-head mouldings.
 The blue pigment is indigo; it is only
used on the blue tinted pages and on
Louvre inv. no.855DRV.

REPRODUCED Manni 1986, p.63, tav.25.

34

Wall tomb
Diagonal hatch, coloured beige, blue,
red and pink; 311 × 217 mm
SJSM, vol.122, p.35

A tomb supported on four deep con-
soles, above a basement with reliefs
of trophies separated by pilasters, is
framed by piers composed of three
superimposed niches. The piers support
a cornice and frame a projecting arch on
consoles containing a representation of
the *Holy Family with St Sebastian*. The
deceased lies on the lid of the sarcopha-
gus, which has four musical angels
standing in front of it and a coved cover
with reliefs of athletes and a standing
warrior; the last is similar to the figure
in front of the keystone of the arch of
Trajan in Rome.
 The basic scheme, with the trabeated
piers with niches flanking a central arch,
was common in Venice and used for a
variety of objects of different sizes.
The tabernacle in the Cappella del
Sacramento in S. Pantaleon, Venice,
dated 1380, is an early example (Wolters
1976, p.205, cat.119, fig.370). The silver
tabernacle with the *Crucifixion* in the
Louvre, from Lombardy, is a small-scale
example (Malaguzzi Valeri 1917,
tav.XII). Pietro Lombardo's tomb of
Doge Nicolò Marcello in SS Giovanni e
Paolo, Venice, also has a sarcophagus

supported on consoles with the
deceased on the cover; the Virgin and
Child and saints are represented in the
arch above, which breaks forward in
front of piers with niches (McAndrew
1980, p.127, pl.9.9; for the most recent
summary of the history of the tomb,
see Bulgarelli & Ceriana 1996, pp.182–3,
n.226).

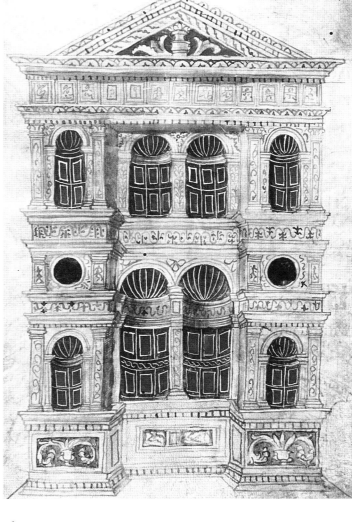

35
Three candelabra
On yellow vellum, coloured pink, with
diagonal hatching in white
, vol.122, p.36

[1] A diamond-shaped or triangular
base, with concave faces decorated with
acanthus, rests on Triton half-figures. It
supports a gadrooned and scaled vase, a
spiral-fluted pedestal, a pair of diving
dolphins with their tails joined below a
grotesque mask and a pedestal support-
ing a standing nude putto holding two
flaming cornucopias below a flambeau.
[2] An octagonal base supported on
half-figures has concave sides decorated
with athletes alternating with foliage
reliefs. It supports a spur-shaped socle
below a concave fluted pedestal, serpen-
tine forms coiled around a palmette
below a gadrooned vase, a double cor-
nucopia with a baluster and two fluted
pedestals.
[3] A hexagonal base with panels of
scoop decoration below figural reliefs
rests on dolphin feet. It supports a vase
with scales and gadrooning below a
double vase with spiral flutes, double
foliage scrolls joined by a ring below a
vase with an anthemion and garlands, a
vase with double handles and an upper
vase with a gadrooned base and bowl.

The designs for candelabra could also
be used for reliefs on pilasters or for

border designs in tapestries, manuscript
illuminations, paintings and prints.
Candelabra with superimposed orna-
mental objects, such as vases alternating
with figures and animals, rather than
foliage are characteristic of the ornament
of the Certosa of Pavia, and may be a
specifically Lombard form. The cande-
labra by the Master of the Mantegna
Sketchbook are close to these designs,
and his technique of a cross-hatched
ground is shared with some of the
drawings in the Soane album. The bor-
der on the frontispiece of Bartolomeo
Sanvito's Pliny manuscript (London, BL,
MS 23,777) shows a candelabrum with
similar objects, in the same sequence and
with a similarly limited amount of foliage
ornament; it has concave pedestals as in
[1] and [2], and a gadrooned, fan-shaped
vase and double dolphins as in [1]. One
of the piers from the Monte di Pietà in
Cremona is decorated with a similar
relief (Malaguzzi Valeri 1923, p.321).
Candelabra similar to these also appear
in the border of a miniature by
Francesco dai Libri, executed in Verona
in 1503 (Padua 1976, pp.160–62, cat.135).
The white-hatch technique is often
found on Lombard drawings.

REPRODUCED Manni 1986, p.63, tav.26.

36
Cabinet
Coloured blue, red, pink, orange and
white; 310 × 215 mm
SJSM, vol.122, p.37

A four-bay façade on a basement with
vase and rinceaux reliefs has projecting
bays on either side of two central niches.
In each side bay pilasters with rinceaux
frame a panelled shell niche and sup-
port an entablature with an anthemion
frieze, below an attic with a roundel in a
rectangular panel framed by pilasters;
above is a second entablature below a
panelled shell niche framed by pilasters,
which support an entablature with relief
panels and a cornice with a triangular
pediment.

The vase with a double rinceau is sim-
ilar to a stone relief built into a fountain
with fragments of Sforza heraldry in the
courtyard of the Castello Sforzesco,
Milan (Welch 1995, p.171, fig.99). The
attic with the motif of pilasters and
roundel is based on the model for Pavia
Cathedral, and is also found on pp.1, 3,
10–11 and 28 (cat.1, 3, 10 and 27). The
building in front of the tower on a
drawing in the Louvre (inv. no.857DRV)
is a variation on this design.

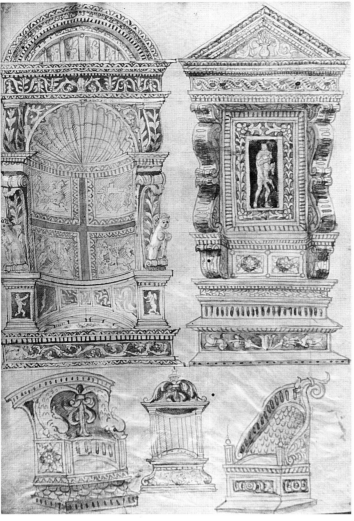
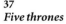
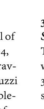
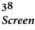

37
Five thrones

Diagonal hatch, coloured beige, blue, red and pink
sjsm, vol.122, p.38

A repertory page with the elevations of five thrones.
[1] A shell niche with panels of coloured marble below four recessed panels bearing battle reliefs. The shell canopy is supported on convex foliage volutes with little sphinxes sitting on bolsters above the pedestals, which are decorated with reliefs of winged putti. The entablature, with an anthemion frieze on foliate consoles, supports a lunette pediment with rosettes. The way in which the bolster scrolls forward at the top of the throne recalls Justus of Ghent's thrones for the *Liberal Arts* from Federigo da Montefeltro's studiolo in Urbino, which are similar to the consoles on the *Argos* fresco in Castello Sforzesco, Milan (Bruschi 1969, figs 43–4 and 65).
[2] A rectangular throne with a *spalliera* decorated with a relief or painting of *Hercules and Antaeus* has double-scroll supports with brackets carrying the entablature with a guilloche frieze and a triangular pediment with a vase. Hercules and Antaeus are front-to-front with Antaeus' legs around Hercules as in the Medici *Lotatori*. The

composition was copied in a school of Mantegna woodcut (Bartsch 1980–4, vol.25, p.50, 16(237)) and in an engraving by Giovanni da Brescia (Malaguzzi Valeri 1917, p.332, fig.411). The double-scroll arms are similar to the arms of a throne in Filarete's Marciana manuscript (fol.1r).
[3] A throne without a canopy, on a socle with scoop ornament and a cavetto with scales, has a semicircular seat framed by dolphins, their heads resting on the sides of the throne, their tails joined by a foliage scroll at the back.
[4] A panelled niche on a pulvinated basement with foliage scrolls on a moulded socle is crowned by an acanthus canopy and lantern.
[5] A throne with a niche bearing scale decoration rests on a square base with a recessed panel of guilloche ornament. The arms of the throne comprise small square pedestals with orbs on top; the frame has scoop ornament rising to a dolphin with a scroll tail.

REPRODUCED Licht 1970, pl.15; Manni 1986, p.63, tav.27; Milan 1991, p.238, fig.201 as 19v.

38
Screen

Traces of grey chalk, the circles drawn with a compass; coloured beige; 312.5 × 218.5 mm
sjsm, vol.122, p.39

The three-storey screen, rendered in perspective, has four narrow fields with relief panels separated by projecting piers. The piers, which rest on pedestals with warrior reliefs, are decorated with reliefs of fleshy foliage growing from an acanthus plant. In the lower and top tiers are four reliefs of pairs of standing warriors. In the second tier roundels with the *Labours of Hercules* are framed by putto heads in the spandrels above and by pedestals with foliage scrolls enclosing numismatic profile busts below. Hercules is shown with his lion's skin only in the first two scenes; from the left he is shown slaying the Numean lion; killing the Lernaean hydra; with Cacus; and with the Cretan bull. The bays are surmounted by foliage scroll gables enclosing roundels with reliefs; warriors stand between them on top of the projecting entablature over the piers. A drawing in the Louvre (inv. no.857DRr) has identical gables; another (Louvre, inv. no.857 DRbis r) is close to this drawing, but the paired figures are replaced by single warriors. Series of illustrious men were often used to illustrate d'Este

family history. The drawings by Ligorio in the British Museum demonstrate the longevity of this tradition (Pouncey & Gere 1983, cat.209, pp.119–20, pl.198).

The roundels of Hercules with the Cretan bull and the Lernaean hydra recall roundels dated 1511 in the Kunsthalle, Bremen (inv. nos L771 and L766). Panofsky (1943, II, p.94, cat.916) rejected their attribution to Dürer. Hercules killing the Numean lion is close to the obverse of Pisanello's medal of *Alfonso of Aragon*, which shows a nude killing a wild boar (Milan 1988, cat.78).

The Hercules legend is the only myth explicitly cited in the album. Filarete executed a *Hercules* cycle on the bronze doors of St Peter's in the 1430s, but the most influential example was Pollaiuolo's lost cycle made for the Medici in the 1460s. This could have influenced the Putti Master's work; he reworked the Mantegna School print of Pollaiuolo's *Battling Nudes* (Armstrong 1981, p.62). Similar thin figures of Hercules astride the bull and the lion are found in the work of the London Pliny Master (op. cit., p.59, figs 78–87).

REPRODUCED Manni 1986, p.63, tav.28; Milan 1991, p.238, fig.202 as 20r.

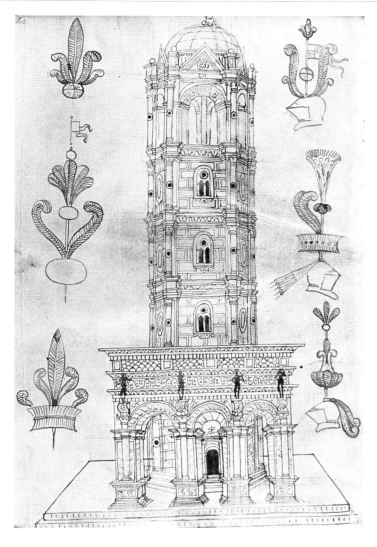

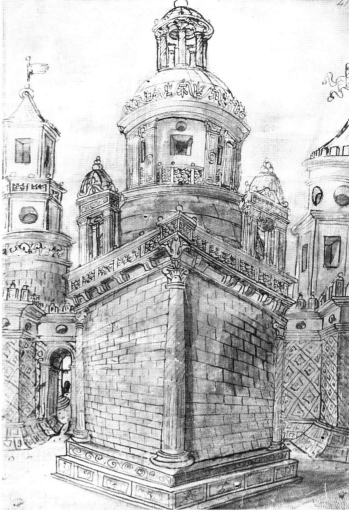

39
A loggia below a polygonal tower
Grey chalk construction lines, coloured brown
SJSM, vol.122, p.40

[1] The three-bay arcuated loggia has half- or full-columns on pedestals in front of wide square piers bearing recessed panels of foliage ornament; string courses and cornices form abstract capitals. The columns support consoles with statues standing on top of them in front of an attic made from an accumulation of ornamental mouldings: dentils, leaf and tongue, and anthemion and scale friezes. A five-storey tower rises four storeys above the loggia, which gives access to it. The middle three storeys have corner half-columns in front of piers, and drafted masonry walls with central biforate windows with a roundel enclosed in an arch alternating with blind bays with round panels. The entablatures break forward over the orders at the corners. The building is crowned by an open domed lantern on arches, with pediments in front of the drum of the dome and pedestals with orbs above the orders.

Licht suggested that towers were a common feature of festive decor. The unusual combination of a polygonal tower and a tripartite loggia may depend on Filarete's drawing of the

great tower of a castle (Lazzaroni & Muñoz 1908, tav.10.1). The polygonal plans of the three storeys and the circular, domed lantern are identical to this drawing.

On the left of the tower are three plumed pennants [2–4], and on the right three plumes with helmets [5–7], of the type that is found in Uccello's *Rout of San Romano*.

Plumes are consistently drawn on the same folios as towers – they appear on p.5 (cat.5) – possibly in reference to tournaments, but they do not seem to have any heraldic significance. A drawing in the Louvre (inv. no.857DRV) shows a similar design that also relates to pp.37 and 15 (cat.36 and 14), which have piers bearing similar palm and trophy *all'antica* reliefs. A very similar domed tabernacle is found on p.49 (cat.48).

LITERATURE Licht 1970, pl.21; Licht 1973, p.102, figs.25 and 26.

40
Cityscape with a mausoleum
Coloured brown, beige, blue and pink;
311 × 210.5 mm
SJSM, vol.122, p.41

A view showing a mausoleum three times, the geometry of its plan changing on each floor as it rises. The building is based on a Roman tomb type, such as the mausoleum of Hadrian as reconstructed by Filarete (Lazzaroni & Muñoz 1908, tav.III).

In the centre a drafted masonry basement with a rhombus or triangular plan and columns at the corners supports a cornice with consoles below a scale balustrade and two open domed pavilions with a square plan and piers. These features are close to Marcanova's reconstruction of a mausoleum (Rovetta 1993, p.411, fig.7). Similar pavilions above an order are found on p.12 (cat.11) and on the façade of the Colleoni chapel in Bergamo. Two cylindrical drums rise above the basement, the first with drafted masonry, the second with an applied order, below an entablature with anthemion cresting around a dome and a domed lantern on trabeated spiral columns. On the right an octagonal drum rises from a square base of drafted diamond masonry and turns into a cylinder below a conical spire. On the left a cylindrical drum of

drafted diamond masonry is surmounted by octagonal and square drums below a spire.

The stacking of different geometrical forms is typical of Filarete, who superimposed squares, octagons and circles (Lazzaroni & Muñoz 1908, tav.2.2 and 3); the introduction of the rhombus or triangular plan into the repertory recalls Francesco di Giorgio.

REPRODUCED Licht 1973, fig 4; Faietti 1992, p.49.

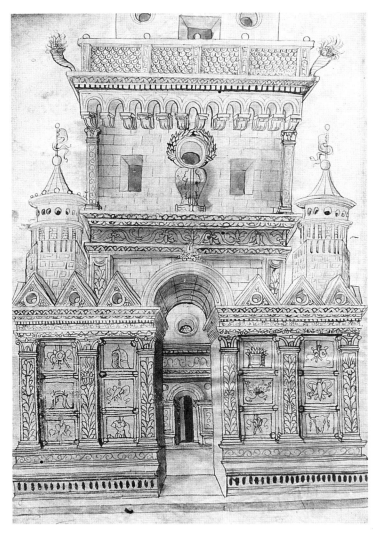

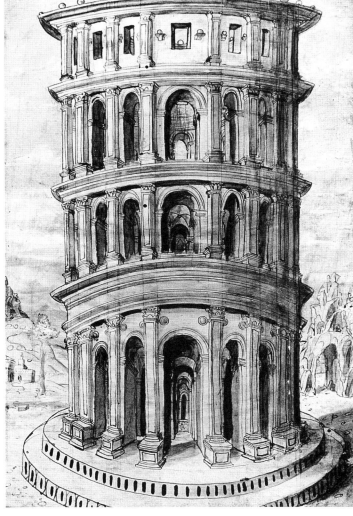

41

A square building with a courtyard
Coloured brown, beige, pink and
orange
sjsm, vol.122, p.42

A five-bay façade is entered through a
narrow barrel-vaulted corridor in the
central bay. The side bays are decorated
with recessed panels of a single item
of *all'antica* ornament, separated by
pilasters with foliage reliefs, and crowned
by three gables. The two-storey tower
recalls the tower of Castello Sforzesco
at Vigevano; it has an entablature with
an anthemion frieze above the arch, an
oculus surrounded by a garland on a
console, and machicolations support-
ing a balcony with a scale balustrade
(Malaguzzi Valeri 1913, I, p.662). On
either side are hexagonal towers with
circular drums and conical roofs.

The gables recall the tympana by the
Dalle Masegne brothers on the façade
and exterior of the nave chapels of
Mantua Cathedral, recorded in Morone's
Route of the Bonaccolsi in the ducal palace
in Mantua (London 1981, cat.2, p.103);
the placing of three tympana over two
bays is careless. The superimposition of
square panels containing reliefs is very
close to a drawing of *c*.1510 in the Louvre
(inv. no.1456DR) by an anonymous
Lombard artist. The presentation of a
single item of ornament in a panel is

close to Amadeo and Bramante, who
used a similar repertory: trophies,
armour, bucranes and, not shown in this
drawing, sirens, dolphins, cherubim
and cornucopias. The same repertory is
found in the miniatures of the London
Pliny Master in a slightly different form
(Armstrong 1981, pls 89–90). The helmet
on the relief at top left derives from
Mantegna's fresco of the *Trial of St James*
in the Ovetari chapel, Padua, and the
helmet on the middle panel on the left is
similar to one in Montorfano's fresco of
the *Crucifixion* in the refectory of S. Maria
delle Grazie, Milan (Lightbown 1986,
pl.13; Mazzini 1965, tav.271). The bracket
like an upturned baluster with foliage
ornament at the side and the garland are
similar to the decoration on the pedestals
on the upper storey of the apse of S. Maria
delle Grazie (Malaguzzi Valeri 1915,
fig.224; see p.4, cat.4). Brackets ending
in Ionic bolsters are found on the
oculus of Amadeo's Colleoni chapel in
Bergamo. The three tiers of square pan-
els of ornament recall Gambello's base-
ment of the façade of S. Zaccaria, Venice,
built before 1481 (McAndrew 1980,
fig.19.7). Jacopo da Martugnana's trip-
tych with the *Annunciation* of 1495 also
has a central arch and side bays crowned
by tympana (Padua 1976, cat.18).

REPRODUCED Faietti 1992, p.50.

42

ROME: *Colosseum*
Underdrawn in grey chalk, coloured
brown, beige, pink, orange and yellow;
305 × 212 mm
sjsm, vol.122, p.43

In the centre, in front of a rocky land-
scape, a perspective shows five arched
bays of the four superimposed storeys
of the Colosseum on a podium of two
steps. 'Composite' pilasters on
pedestals frame the arches on each
storey, with roundels in the spandrels of
the ground-floor bays. In the top storey
the pilasters frame rectangular win-
dows, which are flanked by corbels to
support the *velarium*. The corbels here
and on top of the entablature are shown
with orbs or balls on top.

Röthlisberger associated the image
of the Colosseum, which is shown here
in the form of a tower, with Giuliano
da Sangallo's Barberini Codex (Rome,
BAV, MS Barb. lat. 4424; Huelsen 1910,
fol.12v), and the engraving of *c*.1500
that Hind (1948, p.295, no.11, pl.890)
compared with Bramante's *Street Scene*
engraving. Faietti more convincingly
associated the image with the engraving
of the Colosseum published in Cesare
Cesariano's edition of Vitruvius of 1521
(book v, fol.LXXXV), which shows it as a
tower on a podium with five arches and
a half arch on either side, as it is here.

Cesariano's image, however, is much
more sophisticated architecturally. It
has Doric and Ionic half-columns on
the two lower storeys and 'Composite'
pilasters on the third storey. Poles
resting on the window sills in the third
storey break through the entablature
above to form the elevation of the fourth
storey, to support the domed *velarium*.
The fourth storey is entirely different in
this drawing. It is difficult to believe that
Cesariano is really the source for this
image; only the number of bays and the
view through the building are common
to both. The perspective showing the
lowest entablature with the greatest
curvature in opposition to the laws of
perspective, not found in Cesariano's
engraving, must derive from another
source. Both images could derive from a
common Lombard source. The colour-
ing of the sky fading to pink, yellow and
white recalls Bramantino's *Nativity and
Saints* (Milan, Pinacoteca Ambrosiana;
Mulazzani 1978, tav.XVII).

LITERATURE Röthlisberger 1957, p.98, fig
195, fig 1; Faietti 1992, p.51.

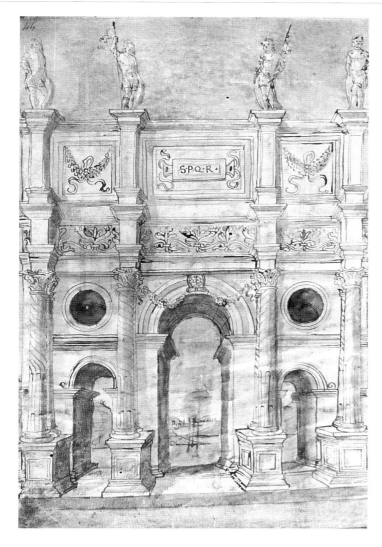

43
A triumphal arch
Inscribed s·p·q·r·
The roundels are drawn with a compass, coloured brown, beige, blue and yellow
sjsm, vol.122, p.44

An arch, based on the arch of Constantine in Rome, is shown in perspective at the centre of the composition in front of a distant landscape with a river and trees. The tall central arch is flanked by wide piers with lower arches surmounted by an oculus. The arches are framed by full columns with standard Lombard capitals in front of pilasters; both orders stand on a pedestal and have fluted lower shafts and spiral-fluted upper shafts. They support an entablature with a plain frieze that breaks forward over the columns and a recessed frieze decorated with anthemion and cornucopias above the arches. Statues of warriors stand on top of tall pedestals in the attic, which is decorated with panels containing garlands and a *tabula ansata* for the inscription.

Röthlisberger associated the figures on the attic with those drawn by Giuliano da Sangallo on the attic of the arch in the Barberini Codex (fol.21r; Huelsen 1910, tav.23v). The pedestals in the attic below them recall the order on the piano nobile of p.20 (cat.19) and the order in the attic of the sacristies on the

model of Pavia Cathedral. Similar cornucopia and anthemion frieze were drawn in the Master of the Mantegna Sketchbook in Berlin, on fol.28r, and in the Codex Zichy in Budapest, on fol.74r (Leoncini 1993, p.102, fig.165a).

When a design based on the arch of Constantine is used as the frame for a manuscript page, one of the roundels is usually suppressed. The arch is shown modified in this way in drawings in the Louvre (inv. nos 1410DR and 1417DR; Pochat 1980, p.270, fig.6).

LITERATURE Röthlisberger 1957, p.98.
REPRODUCED Golzio & Zander 1968, tav.v.

44
Screen or polyptych
Diagonal hatch, coloured brown;
313 × 218 mm
sjsm, vol.122, p.45

Three narrow arches on square piers support three storeys of sculptural decoration. The piers on pedestals are composed of plaquette panels divided by mouldings and foliage friezes. The arches below the first entablature are framed by four tall rectangular panels with standing figures of *Hercules*, his lion's skin shown behind him, and there are figures on the bolsters of the keystone consoles. Above, paired shell-niches containing warrior statues are framed by projecting piers with a single statue in a niche. In the second storey the projecting piers bear rectangular panels with warriors, framing roundels with combat scenes. The third storey mirrors the first. The *Coronation of the Virgin* fills the segmental lunette above the three central bays; the pedestals on either side of it contain a relief of the *Annunciate Angel* below a statue of *St Peter* on the left, and a relief of the *Virgin* on the right below a statue of *St Paul*. Christ climbs out of Limbo on to a pedestal on top of the pediment, flanked by three standing putti on pedestals to his left and right.

The superimposition of figures in

niches and the more-than-semicircular lunette framed by free-standing figures representing an *Annunciation* is close to Antonio Rizzo's monument to *Doge Nicolò Tron* in the Frari, Venice (1473–9; McAndrew 1980, fig.6.3). Piers made of three plaquettes surmounted by a suite of niches, the proliferation of mouldings and the projecting piers all recall the lower storey of the façade of S. Zaccaria in Venice, built by Gambello before 1481 (op. cit., fig.3.8), where the panels frame precious marbles rather than reliefs.

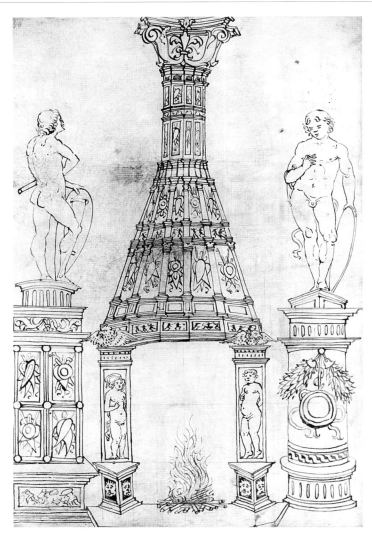

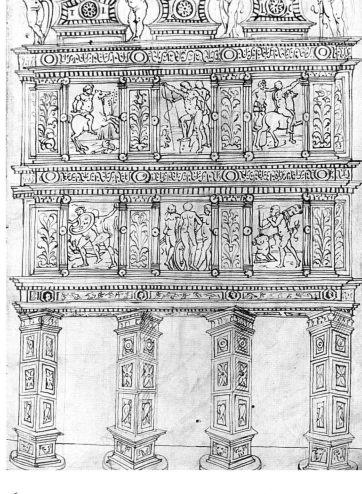

45
Fireplace and two statues on pedestals
Grey chalk construction lines
SJSM, vol.122, p.46

A fireplace framed by pilasters bearing reliefs of standing nude figures rests on triangular pedestals with lion's masks. The cornice with scoop and dentil mouldings supports winged eagle half-figures, which uphold the half-decagonal canopy of the chimney. The canopy is divided by colonnettes into ten rectangular fields with trophy reliefs, below a chimney with ten trophy reliefs and a 'Composite' capital with acanthus and volutes. On the right and left of the fireplace nude male figures with shields stand on pedestals. The figure on the left stands in profile on a cylindrical fluted base above a square pedestal decorated with four recessed panels with trophy reliefs. The figure on the right stands frontally on top of a triangular base superimposed on a cylindrical pedestal decorated with bands of scoop and guilloche ornament and a round shield with fluttering ribbons hanging from garlands. The tail emerging behind the figure on the right suggests that he represents Hercules.

The chimney is similar to one of Francesco di Giorgio's fireplaces in his treatise (fol.40r; cat.132). The pedestals below the statues show an accumulation of geometrical forms, which recalls Donatello's *Judith* in Florence, with its triangular pedestal above a baluster with a circular plan (Janson 1957, p.350). There is a similar pedestal in a miniature of a Bacchic procession in a manuscript of Livy's *Historiae Romanae decades* attributed to the London Pliny Master (1470; Vienna, Nationalbibliothek, MS Inc.5.c.9; Armstrong 1981, p.102, cat.3, fig.3).

In a drawing in the Louvre (inv. no. 860DRV) Mercury stands on a pedestal made from fragments of a pedestal and a spiral-fluted column, and another statue stands above a pedimented entrance to a chapel. The figures clearly derive from Marcanova's manuscript, where one figure is shown on top of the gable of a building and another on a square pedestal (Rome 1988b, p.40, cat.1, fol.27r). A tower, similar to the one on p.9 (cat.9), stands between the statues.

REPRODUCED Manni 1986, p.67, fig 30.

46
Screen
Grey chalk construction lines and underdrawing, diagonal hatch;
315 × 217 mm
SJSM, vol.122, p.47

Three trabeated bays are framed by triangular or rhombus piers on pedestals with bucrane reliefs. Each pier is divided into three square recessed panels with reliefs of trophies alternating with rosettes; they support an entablature with a figural frieze broken by four hexagonal frames enclosing profile busts. The two upper storeys contain six *all'antica* warrior relief panels separated by wide pilasters with foliage ornament. They are crowned by three cusped gables flanked by standing putti holding attributes, from the left a shield and pennant, a trumpet, a shield, and a sword.

Square coffers with rosettes, usually associated with ceilings, are regularly shown as surface decoration in the album. They appear in the terracotta ornament on the lavabo of *c*.1386 in the north sacristy of Milan Cathedral, which was revealed when the marble revetment was removed (Welch 1995, p.75, fig.54). They are used in a similar way to decorate a missal stand from S. Agostino in Cremona attributed to G.M. Platina, who was active in Mantua between 1455 and 1500, and the same decorative motif appears on the intarsia of the sacristy cupboard, dated 1477 (Cremona 1976, p.103, fig.540). It is found in the ornamental language of the school of Amadeo, on the lavabo in the first chapel at the Certosa of Pavia (Malaguzzi Valeri 1904, p.221).

A drawing in the Louvre (inv. no.857 DRT; Paris 1972, p.10, cat.4) is closely related to this design. Pia Kehle suggested that the Louvre drawing could be connected loosely with the Appartamento Segreto in Ferrara, which had a tripartite arched entrance with an apartment above it decorated with Classical reliefs.

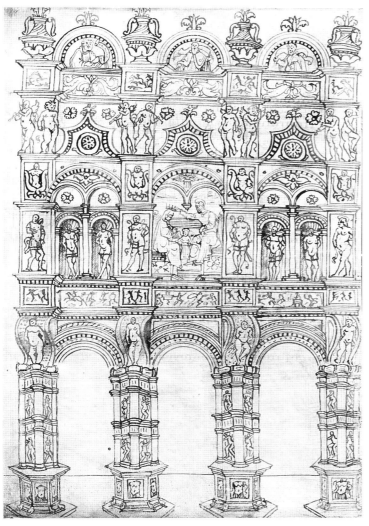

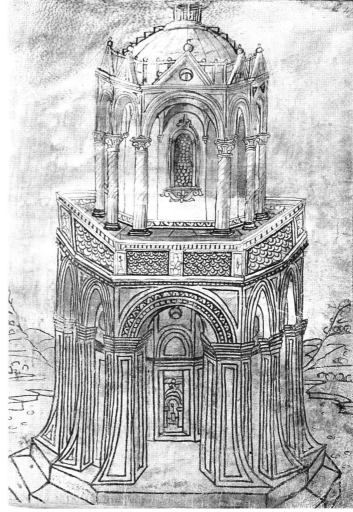

47
Screen
On yellow vellum, coloured brown
SJSM, vol.122, p.48

Three arches on triangular or diamond-shaped piers with colonnettes at the corners stand on hexagonal pedestals with trophy reliefs. The piers, composed of plaquettes with athlete reliefs separated by friezes, support large consoles with boys standing in front of them on bolsters. The consoles support the basement of the upper storey, which has paired shell niches containing statues of warriors framing a central bay with a *Coronation of the Virgin*. The bays are framed by reliefs of *Hercules*, the tail of the lion's skin behind him, with siren reliefs above. They are surmounted by musical putti alternating with cusped gables. Lunette pediments and vases rest on top of the entablature with panels of foliage alternating with battle reliefs in the frieze.

Figures on keystones, ultimately deriving from the arch of Trajan in Rome, were turned into putti by Donatello in S. Antonio, Padua, in the relief of the *Ass of Rimini Kneeling Before the Host*, of 1446–50 (Janson 1957, pp.102ff., pl.296), and by Mantegna in his frescos in the Ovetari chapel, Padua; they occur frequently in this album (for Amadeo's regular use of the motif, see Burnett &

Schofield 1998). The figures on the consoles on this drawing and on p.2 (cat.2) most resemble the musical putti carved by Biagio di Vairone in the Canonica of S. Ambrogio in Milan; they are described as 'cartozi 6 fati a figure' in payments for them in February and March 1494 (Malaguzzi Valeri 1915, tav.IV; Baroni 1940, p.44). They were probably designed by Bramantino (communication Charles Robertson). Dentils in arches and in the architrave are also found in the tabernacles and in the oculus on the façade of the Colleoni chapel in Bergamo (Burnett & Schofield 1998). This drawing and the design on p.45 (cat.44), both with a Marian theme combined with an elaborate sculptural programme, could reflect the influence of designs for several churches in Lombardy dedicated to miraculous Virgins, such as S. Maria dei Miracoli in Lonigo and in Brescia, all of which had complex sculptural schemes on their façades (communication Charles Robertson).

48
RAVENNA: Mausoleum of Theodoric
Dark yellow vellum, overdrawn in dark brown ink at the bottom, coloured beige, blue, pink and white;
303 × 212 mm
SJSM, vol.122, p.49

An octagonal building on a podium of two steps stands in front of a landscape. It has an exterior arcaded portico supported on ungainly, tapering concave piers with moulded recessed panels below a balcony decorated with scale panels. A rectangular opening inside the portico on the ground floor gives access to the central space. Above, an octagonal portico with arches on 'Corinthian' columns, with fluted lower shafts and spiral-fluted upper shafts, surrounds an octagonal cella, which is lit by an arched window. The arches are crowned by pedimented gables enclosing oculi and supporting an orb in front of a balustrade. The building is covered by a dome and lantern on colonnettes below a domical feature, cut at the top.

Röthlisberger identified the building as loosely based on the mausoleum of Theodoric in Ravenna, with the basement treated in a heavy and fantastical manner and the peristyle on the upper storey in the Venetian Gothic style.

LITERATURE Röthlisberger 1957, p.98.

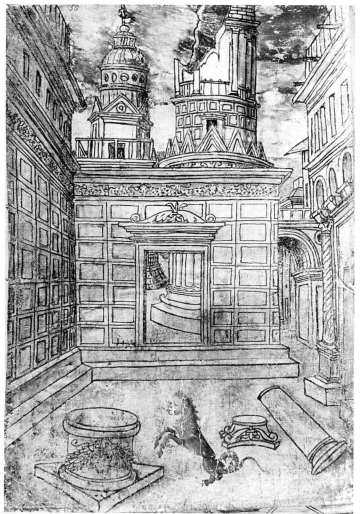

49
Cityscape with a chimera
Coloured beige, grey, blue, green, red,
yellow and white
SJSM, vol.122, p.50

In the foreground, close to a circular
well on a triangular socle, a chimera –
part cloven-hoofed animal, dragon and
lion – stands on its hind legs in front of
an upturned capital and a column-shaft,
which points diagonally into the per-
spective. A drafted masonry wall with a
garland and bucrane frieze closes the
perspective in the middle ground. The
central opening gives a view of the bases
of two towers, which rise above the wall
in the centre. The central tower has a
column base on a socle below a fluted
column; the entablature above the wall
has a crown of triangular gables in front
of a shallow drafted masonry drum with
a central opening. The broken cylindri-
cal drum above has an order and a
balustrade, below a fourth drafted
drum. The second tower, slightly to the
left of the first, has a square scarped
base, an octagonal first storey with a
pediment above each façade and a
central door, and two cylindrical drums
and a dome with a domed lantern sur-
mounted by a statue. The palace on
the right has a spiral-fluted column at
the corner of the façade below a row
of machicolations below the upper

storey. It stands in front of an arch with
a view through to a city street beyond.

 The fluted tower reminiscent of a
giant column glimpsed through an
open door recalls the tower on the left
of Ponte S. Angelo in Marcanova's
manuscript (Rome 1988b, p.42, cat.1,
fol.37r); the sloping basement of the
tower on the left with a diamond pattern
is very similar to the basement in the
background of the view. The same folio
in Marcanova's manuscript is quoted
on p.56 (cat.55). The bucrane frieze,
deriving from the tomb of Cecilia
Metella in Rome, was reconstructed by
Filarete in his relief of the Mausoleum
of Hadrian, on the bronze doors of
St Peter's (Lazzaroni & Muñoz 1908,
tav.III).

REPRODUCED Licht 1970, pl.20.

50
Cityscape
Underdrawn in pale ink, coloured
beige, blue, pink and white;
302 × 214 mm
SJSM, vol.122, p.51

A cityscape showing a piazza lined with
noble palaces has a central loggia on a
podium of three steps. On the top step
of the podium is a horizontal oculus
with a wheel-like grille of four baluster
spokes. The loggia is three bays wide
and deep, and has five domes with
domed lanterns crowned by statues and
a projecting central bay with pilasters.
Röthlisberger related the baluster-
spoked wheel grille in the pavement to
Prevedari's engraving, and the central
building with the five domes to
Sperandio's medal of *Francesco I Sforza*
(1466; Hill & Pollard 1967, cat.115 rev),
which has been identified as Filarete's
project for the mausoleum of Francesco
Sforza, who died in 1466 (Giordano
1988, p.126). The building shown on
Sperandio's medal was used to repre-
sent the Holy Sepulchre in the manu-
script illuminated by Cristoforo de
Predis for Gian Galeazzo Sforza (1476;
Turin, BR, Codex Varia 124; fol.120r). A
drawing in the Louvre (inv. no.858DRbis
v), which shows the mausoleum after
the medal, can be compared with the
Soane drawing, which transforms it by

opening the three bays as a loggia in
front of the domes. Another drawing
in the Louvre (inv. no.858DRr) shows
an identical five-domed building
behind a closed three-bay façade with a
deep entablature and frieze. Licht (1973,
p.95, fig.12 as p.37 of the Soane album)
associated this drawing with a Filaretian
five-dome scheme above a wall, which
was widely diffused in Lombardy. The
drawing in Paris has a precise precedent
in a silver relief in the Louvre showing
Christ Healing a Possessed Man tradition-
ally attributed to Brunelleschi; the
façade articulated by the orders, the
domes and the frieze with wide putto
heads are identical. Isabelle Hyman
(1981, pp.105ff.), who recognized the
Florentine sources of the architecture
on the relief and attributed it to Filarete,
suggested that it was made as a Medici
gift, which Filarete further elaborated
in Milan after leaving Florence. A
composition based on the silver
relief appears in the background of
Cristoforo de Mottis's stained-glass
window *St John Curing the Sick* in Milan
Cathedral (Rovetta 1993, pp.409–10,
figs 2–5; Pirina 1986, p.127). A similar
configuration appears in Cima da
Conigliano's *St Mark Healing Amian*
(Berlin, Preussischer Kulturbesitz
Gemäldegalerie; Lucco 1989–90,
I, p.332).

The hole in the pavement in front of the mausoleum could be a reference to a burial place in a crypt, probably deriving from Florentine examples; a stone in the pavement in front of the chapel of SS Cosma e Damiano marks the tombstone of Cosimo de' Medici, and there are grilles above the crypt containing the tomb of Lorenzo and Piero de' Medici (Florence 1992a, pp.117–18). There are also crypts in Pavia Cathedral and at the Trivulzio tomb, Milan.

For the putto and garland frieze, which was popular in Florence and with Filarete, see Burnett & Schofield 1998.

LITERATURE Röthlisberger 1957, p.97, fig.3; Licht 1973, p.95, fig.12.

51
Frame
Grey chalk, coloured brown, thick blue watercolour at the top and lower right side, and a strip of pink on the right
SJSM, vol.122, p.52

The three-bay frame has a wide rectangular opening in the centre above a basement bearing two relief panels with lion's masks, and arched entrances on either side supported on piers with nude *Hercules* reliefs on triangular pedestals. Above the imposts the piers are composed of panels with roundels enclosing profile busts, tablets framed by bolsters, seated sphinxes and recessed moulded hexagons. The piers frame panels above the side bays decorated with grotesque masks in foliage, nudes holding gadrooned vases and almost frontal centaurs holding long shields. Statues on pedestals stand on either side of the wide pediment framing the pediment above the central bay.

The centaurs are close to the confronting centaurs on the frontispiece of the *Sallust* of *c*.1474 by the London Pliny Master (John Rylands University Library; Armstrong 1981, cat.37, fig.89), which are almost fully frontal, their horse-bodies in profile. Centaurs upholding roundels facing alternately inwards and outwards appear on the entablature in the background of

Prevedari's engraving. Amadeo used centaurs as a decorative element on the tomb of *Giacomo Stefano Brivio* in S. Eustorgio, Milan (*c*.1484; Schofield 1992, p.41).

The thick blue watercolour at the top and lower right side is also found on p.28 (cat.27).

52
Frame
Coloured brown, beige and pink; 312 × 220.5 mm
SJSM, vol.122, p.53

The three-bay frame has a basement with three recessed marbled panels with moulded frames separated by marbled pilasters with roundels enclosing diamond panels; the entablature has bead-and-reel and cable mouldings, an anthemion frieze, and dentil and palmette mouldings in the cornice. Above the basement four columns with cornucopia capitals stand on low pedestals in front of square piers with coffered arches; they support an entablature that breaks forward over the columns, with a lion's mask in the frieze, and dolphins and putti above the arches. Putti stand above and baby Tritons advance towards vases over the bays.

The putto holding the large cornucopia is like a relief in the Colleoni chapel, Bergamo (Malaguzzi Valeri 1904, p.74); cornucopia and dolphins decorate the façade of the model of Pavia Cathedral (Venice 1994, p.63). The cornucopia capital is also found in the Colleoni chapel (for examples in Lombardy, see Burnett & Schofield 1998).

REPRODUCED Manni 1986, p.65, tav.29; Milan 1991, p.239, fig.203 as fol.27r.

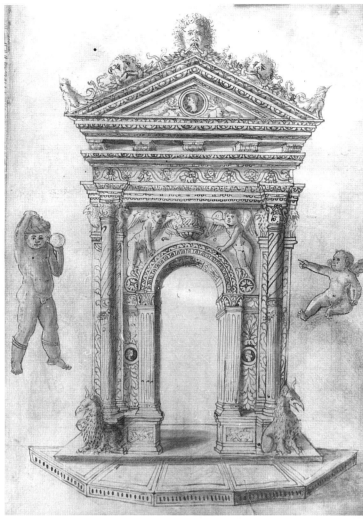

53
Palace façade
Grey chalk construction lines and
underdrawing, coloured brown, beige
and pink
sjsm, vol.122, p.54

A perspective of a palace façade, based
on the Porta Palatina in Turin, with a
recessed loggia and half-elevations of
projecting wings with convex exedrae
on the ground floor. The exedrae have
central arched entrances in a drafted
masonry wall and machicolations below
a balustrade with anthemion decoration
pierced by oculi and crested with
upturned arches supporting balls. The
three-bay arcuated loggia on square
piers has pedestals with recessed panels
that run around the walls of the loggia as
a bench; the rear wall is decorated with
trophy reliefs. In the central bays, the
first storey is articulated by foliage
pilasters framing rectangular windows
with pediments and roundels, and the
second storey with recessed panelled
pilasters framing arched openings.
Above is an anthemion frieze and a crest
with dolphins, joined at their tails by a
ring, meeting anthemions, similar to
those on p.29 (cat.28). The side bays are
crowned by domed structures.

REPRODUCED Faietti 1992, p.52.

54
Frame and two putti
Grey chalk construction lines, parallel
hatch, coloured beige, pink and yellow;
311.5 × 219.5 mm
sjsm, vol.122, p.55

[1] The standing bronze putto holding
an orb on the left derives from the *Putto
Standing on a Tortoise* in the Abbott
Guggenheim Collection, traditionally
attributed to a Venetian artist. Laura
Camins (1988, cat.1, pp.14–16) has
attributed it to the circle of Michelozzo,
c.1440. The bronze derives from an
erotes on an erotes sarcophagus in the
Campo Santo in Pisa, which was known
in Florence in the 15th century and
drawn in the Codex Escurialensis
(fol.34r; Egger 1905–6, p.99) and in the
Barberini Codex (fol.12r; Rumpf 1939,
pp.23, Taf.43.6; Huelsen 1910, p.22). The
putto's hair is braided as in this draw-
ing; it may have also been the prototype
for the putto in the ceiling fresco of the
Banquet of the Gods in the Sala di Psiche
in the Farnesina in Rome, which has a
similar braided golden hairstyle, but
does not wear the high sandals, *pyterges*,
worn by the bronze and by the putto
here. The ball or orb in the putto's left
hand could show an attribute that has
been lost from the original. The tortoise
below the foot of the bronze is not shown

here; a putto on p.56 (cat.55) treads
on a tortoise. [2] Tall 'Composite' full
or half-columns with fluted lower shafts
and spiral-fluted upper shafts stand on
pedestals in front of piers with foliage
reliefs and eagle capitals. The eagles are
similar to those in the attic on
Marcanova's manuscript (Rome 1988b,
cat.1, p.41, fol.33r). The columns frame a
central arch with fluted pilasters sup-
porting a barrel vault; winged putti in
the spandrels hold up a vase. The entab-
lature has a frieze of putto masks and
anthemion and consoles in the cornice,
which supports a pediment with deco-
rated mouldings and putti holding up a
medallion with a profile bust. Garlands
fall from the mouth of a satyr mask at
the apex of the pediment, and sphinx
half-figures sit on either side.

The griffins in front of the pedestals
recall the open-beaked griffins on top of
the basement on the frontispiece of the
Bodleian breviary by the London Pliny
Master, of 1475–6 (Armstrong 1981,
cat.39, pl.91). Licht noted the diffusion
of richly moulded pediments deriving
from book xi of Filarete's treatise. There
is a similar pediment in the background
of one of Cristoforo de Mottis's windows
in Milan Cathedral (Pirina 1986, p.123).
The satyr mask on top of the pediment
is a direct quotation from the Gonzaga

vase of c.1483 by Antico da Bonacolsi, in
the Galleria Estense, Modena (London
1981, p.133, cat.51).
[3] The pose of the seated winged putto
on the right depends on the child in
Donatello's oval marble relief of the
Virgin and Child in the Victoria and
Albert Museum, which Joannides (1987,
pp.12–13, figs 15a, 18a, 19a and 19b) has
shown to be the source for Masaccio's
Virgin and Child with Four Angels in the
National Gallery, London. The putto on
the parapet in Schiavone's *Virgin and
Child* in the Galleria Sabauda, Turin, is
probably a winged relative of this baby.
The subject, a putto with a book, is rare;
a putto by Bartolommeo Bellano sits
holding a book on the architrave of the
sacristy of S. Antonio in Padua, and
three of the reliefs on Riccio's tomb of
Girolamo and Marc'Antonio dalla Torre,
formerly in S. Fermo, Verona, and now
in the Louvre, show standing winged
putti with books (Planiscig 1926, pp.30,
Abb.20, pp.394-5, Abb.488, 491–2).

LITERATURE Licht 1973, p.24, fig 22.

55
Bridge and two putti
Grey chalk underdrawing, coloured
brown, beige, pink, yellow and white
SJSM, vol.122, p.56

[1] The putto on the left in a tunic, his
right hand pointing down and his left
holding an object, perhaps a bird, close
to his neck, derives from Riccio's
bronze *Tobias* with a fish in the Bargello,
Florence (Planiscig 1926, p.197,
Abb.224).
[2] On the right a putto with wings on
his shoulders and heels holds snakes
in both hands and treads on a tortoise –
the attribute of the erotes attributed to
Michelozzo lost from the drawing on
p.55 (cat.54). It is reproduced by
Buddenseig, who showed that it derives
from Donatello's *Atys-Amorino* of *c*.1440
in the Bargello. He used the drawing to
document the lost attributes: two snakes
held in his hand and a tortoise beneath
his left foot. He interpreted the *Atys-
Amorino* as a natural divinity of peasant
origin with attributes expressing oppos-
ing forces of nature. Rosenauer (1993,
pp.191–2, cat.42) summarizes the
various interpretations of the bronze.
[3] A bridge, two bays deep, with four
arches on fifteen piers, is rendered in
bird's-eye perspective. The piers are
triangular in plan in the front row, cir-
cular in the second row and square in

the third; both faces of the piers are
divided by egg-and-dart mouldings into
four recessed panels. A putto riding a
dolphin sits on top of the blade of the
bridge. An entablature with decorated
mouldings and a foliage frieze carries a
balustrade and a central corbel support-
ing a gabled, domed, hexagonal lantern
on four colonnettes. At either end of the
bridge are domed square buildings.
 The bridge is based on the represen-
tation of Ponte S. Angelo, Rome, in
Marcanova's manuscript (fol.39r; Rome
1988b, p.43, cat.1); p.50 (cat.49) quotes
from the same folio. The buildings at
either end are close to the bridge in
Filarete's Marciana treatise copied
by an anonymous Lombard artist in
Louvre 1448DR, of *c*.1510, one of a group
of drawings attributed to Peruzzi (Licht
1973, figs 16 and 17). The triangular spurs
are shown in Marcanova's manuscript,
but the explicit reference to the blades
of a bridge and the demonstration of
triangular, circular and square columns
are explicit references to Francesco di
Giorgio's treatise, fols 13r and 50r
(cat.88, 147).

REPRODUCED Licht 1973, fig.18.
LITERATURE Faietti 1992, p.53;
Buddenseig 1986, pp.43–9, Taf.VII,
Abb.28. and Taf.XI–XII).

56
An arch for a door or frame
Diagonal hatch; 313 × 216 mm
SJSM, vol.122, p.57

The arch rests on a podium of one step
with plait ornament and is supported on
piers formed by superimposed frag-
ments of decorated pedestals and cor-
nices. The lower pedestal has a base with
decorated mouldings and a rectangular
panel containing a roundel with an
eagle in a laurel wreath below a frag-
ment of fluting. Above is a cornice with
a Medusa mask framed by acanthus
consoles, a pedestal with a plain
recessed panel, a cornice with decorated
mouldings, and a frieze similar to the
one shown on p.66 (cat.65), with two
shell niches containing statues of stand-
ing warriors separated by pilasters with
foliage panels, and spandrels filled with
rosettes, similar to those on the portal
of Palazzo Schifanoia, Ferrara (Bruschi
1969, fig.6). The cornice below the
arch with acanthus consoles framing a
square panel containing a flower is the
standard cornice type in the album.
The arch mouldings are decorated
with waves, sirens with foliage tails
and vases, dentil, bead-and-reel, egg-
and-dart and acanthus mouldings
and enclosed rosettes.

REPRODUCED Manni 1986, p.67, tav.31.

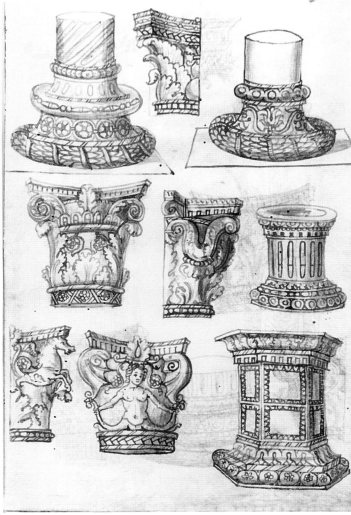

57
A theatrical cart, chariot and helmets
Coloured brown and beige
SJSM, vol.122, p.58

[1] A two-wheeled chariot with bell-flower spokes and a frame with guilloche ornament crowned by a dome on colonnettes is pulled by a pair of serpents.

There is an antique precedent for a chariot being drawn by a pair of serpents on the lid of a Medea sarcophagus, which was in Palazzo Lancilotti in the 16th century and is now in the Casina of Pius IV in the Vatican garden; it is drawn in Codex Coburgensis (fol.78r; Matz 1871, no.217).
[2–4] Three helmets are shown decorated with wings, a Pegasus and with scrolls and *fleur de lis*. Further helmets are drawn on pp.16 and 31 (cat. 15 and 30).
[5] A chassis on four wheels with bell-flower spokes is covered by a canopy with a frieze of putto heads and garlands and a cornice with dentil and leaf-and-tongue pattern. A conical stack of seven steps has draped female figures arranged on them below a domed tempietto; this has an arched opening within spiral-fluted columns supporting a pediment and framing a figure. The subject, with four figures at the corners of the wagon, six others sitting on the stacked steps and a seventh standing

in the arch of the tempietto on the top, has been identified by Fabianski, who related it to a miniature accompanying the text of the description of the wedding of Costanzo Sforza to Camilla of Aragon in May 1475. He related the iconography to ideal *Musaea*. Two other drawings, in the Victoria and Albert Museum, for triumphal cars carrying architectural models of the Pantheon and the Colosseum have been attributed to the school of Peruzzi (Ward-Jackson 1979, p.123, cat.247–8).

REPRODUCED Licht 1970, pl.22; Licht 1973, fig.1; Fabianski 1990, pp.110–111, n.2.
LITERATURE Fabianski 1990, pp.110–111, n.2; Milan 1991, p.239, fig.204 as 29v.

58
Bases, capitals and pedestals
Coloured pale brown; 316 × 216 mm
SJSM, vol.122, p.59

[1] A base with a lower torus decorated with laurel wreath, a cable fillet, a scotia with rosettes and a bead-and-reel astragal below a cable fillet, scotia with scoops and an upper astragal with coin ornament.
[2] A half-elevation of a 'Corinthian' capital with bead and cable-moulded fillets at the hypertrachelion and three tiers of half-acanthus leaves below an abacus decorated with plait, bead-and-reel and cable mouldings.
[3] An elevation drawn in bird's-eye perspective of a base with a lower torus decorated with braided laurel wreath ornament, a cable fillet below a scotia with anthemion, a cable fillet and an astragal with coin ornament.
[4] A 'Composite' capital with a ring of rosettes in basketwork at the hypertrachelion of the column and a ring of acanthus – leaves alternating with half-leaves with rosettes – below a cable astragal and an egg-and-dart echinus; the volutes spring from the echinus and an acanthus leaf rises to the top of the abacus.
[5] A half-elevation of a 'Corinthian' capital with a bead moulding enclosed in cable mouldings at the hypertrachelion has a ring of alternating half- and

full-acanthus leaves, which rise up to support the double caulicula below the abacus.
[6] A round fluted pedestal on a base with coin, bead and acanthus-ogee mouldings has a cornice with dentil, bead and egg-and-dart mouldings.
[7] A half-elevation of a 'Composite' capital with a ring of acanthus half-leaves above bead and cable fillets and a Pegasus half-figure supporting the abacus.

The capital, ultimately deriving from the temple of Mars Ultor, Rome (Mercklin 1962, pp.252–3, cat.610, Abb.1179–80), was found early in Lombardy in the Dalla Torre tomb in S. Maria delle Grazie and in the north transept of S. Maria presso S. Satiro, Milan (Schofield 1992, p.29).
[8] An elevation of a 'Composite' capital with plait and cable mouldings at the hypotrachelion and a siren rising to the fleuron between reverse volutes.
[9] A hexagonal pedestal, with a base moulding decorated with rosette, cable and leaf-and-tongue mouldings, has two square recessed panels with egg-and-dart mouldings on each face of the hexagon and a cornice with dentil, cable and acanthus-leaf mouldings.

REPRODUCED Manni 1986, p.67, fig.32, detail p.91, fig.53; Milan 1991, p.239, fig.205 as 30r.

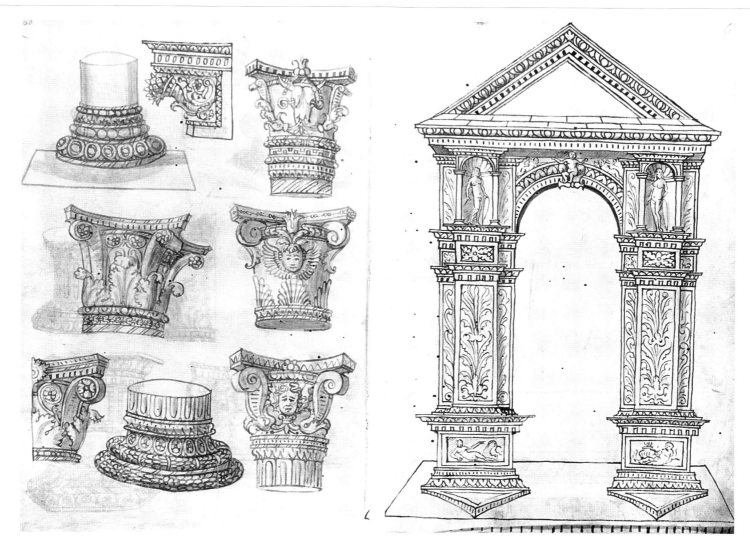

59
Bases, capitals and a console
Coloured pale brown
SJSM, vol.122, p.60

[1] A base with a cable astragal, lower torus with coin ornament, cable fillet, bead-and-reel astragal, acanthus-ogee cyma and bead-and-reel astragal.
[2] An elevation of the profile of an impost with a cornucopia full of fruit, below leaf-and-tongue, scoop and egg-and-dart mouldings.
[3] An elevation of a capital with many decorated mouldings – leaf and tongue, scoop, egg and dart, Greek key, braided laurel, cable – in the frieze of a spiral-fluted column. Strapwork scrolls flank a bucrane with a snake or a ribbon threaded through its eye sockets and garlands hanging from its nostrils. A similar bucrane capital is found on the tomb of *Bishop de Dominicis* (d.1478) in the Duomo Vecchio in Brescia; and a capital in the sacristy of S. Maria presso S. Satiro, Milan (Malaguzzi Valeri 1915, p.74, fig.85), has scrolls of strapwork passing through the eye sockets of a bucrane to form volutes.
[4] An elevation of a capital with a ring of bell-flowers and an egg-and-dart moulding at the hypertrachelion, and a ring of alternating half- and full-acanthus leaves with curving lobes support-ing strapwork volutes that scroll around

rosettes below the corners of the abacus, which has dentil and cable mouldings. A standard Lombard capital type, this example is close to one drawn by the Master of the Mantegna Sketchbook (fol.12r; Leoncini 1993, pp.93 and 149, cat.12), but the crane, vase and fleuron are omitted here.
[5] A capital with a ring of palmettes and a central cherubim head between strap-work volutes below a fleuron that springs from an echinus with a coin moulding.
[6] A half-elevation of a capital with a ring of acanthus leaves below a strap-work-scrolled volute enclosing a rosette, below the corner of the abacus with dentil and cable mouldings and a central fleuron.
[7] A base with two braided laurel toruses separated by a cable astragal below a scotia with enclosed rosettes and a cyma reversa with leaf-and-tongue decoration below a fillet.
[8] An elevation of a capital with a Medusa mask between scrolled strap-work volutes below the abacus, which has a central fleuron resting on an egg-and-dart echinus. The neck of the fluted column is decorated with leaf-and-tongue, bead and cable mouldings. There are antique examples of this capital, and the Medusa head often occurs in Lombard ornament (Mercklin 1962, cat.571n; Burnett & Schofield 1998).

60
A portal or frame
Grey chalk construction lines and underdrawing at top left, diagonal hatch, coloured beige; 314.5 × 217.5 mm
SJSM, vol.122, p.61

Wide piers with foliage ornament on pedestals with triangular spurs in front of them are set on a podium of one step. The pedestals bear reliefs of *Leda and the Swan* on the left and of the *Infant Hercules*? on the right. Pilasters without capitals and decorated with foliage pan-els stand in front of wide piers with similar foliage ornament, and support an entablature that breaks forward over the pilasters, below a figure standing in a niche on either side of the arch with a putto riding on the keystone. The cornice with dentil and egg-and-dart mouldings projects in front of the triangular pediment, which has the same mouldings.

The view from above on to spur-shaped platforms, in this case a pedestal to balance the frame, is also found on pp.46 and 54 (cat.45 and 53); the plat-forms are typical of Marco Zoppo's work, and they also occur in that of Nicoletto da Modena (Hind 1948, V, p.121, cat.35, VI, pl.659). Pedestals such as these are found in a miniature by Ser Ricciardo di Nanni in a book of hours (fol.165v; Garzelli 1985, II, p.143, fig.210).

The decoration on the wide pilasters, of symmetrical leaves rising from a cluster of acanthus leaves, is found on an altar frontal of the mid-15th century at the Madonna del Carmine in Brescia (Hill 1978, part 8, 2/8/45). There are similar pilasters in a fresco of a *Soldier Between Two Pilasters*, copied after a fresco of 1481 by Angelo Zoppo in the chapter house at the Scuola di SS Sebastiano e Marco at Padua Cathedral (Padua 1976, p.22, fig.4b).

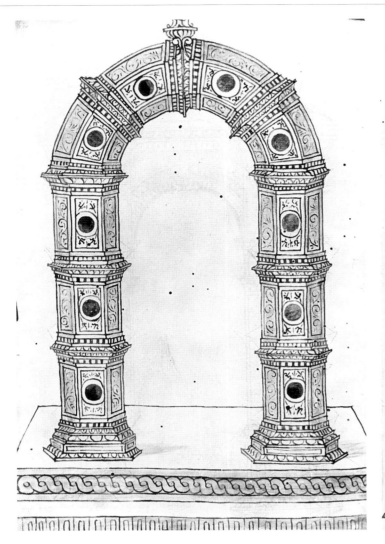

61

Arch

Grey chalk underdrawing and penti-
menti in the profiles, coloured dark
brown and beige
SJSM vol.120, p.62

An arch, on a podium of two steps
with scoop and guilloche mouldings,
is composed of a series of hexagonal
pedestals with decorated base mould-
ings; the panels of the hexagonal drums
have foliage scroll ornament alternating
with a central roundel with flowers
in the spandrels. They are joined by
cornices with decorated mouldings
to form an arched frame.

The design could be for a ceramic
arch. An arch made of twisted glass
joined by golden rings is shown as a
frame for a miniature by the Maestro
delle Sette Virtù, in the *Decretalis* of
1471 for Innocent IV (Gotha, Lands-
bibliotek, fol.106r; Mariani Canova
1969, p.64, pl.27).

62

A portal or frame

Grey chalk construction lines, diagonal
hatch, coloured beige; 319 × 216 mm
SJSM, vol.122, p.63

The portal is set on a podium of one
step, with scoop ornament. It is framed
by rectangular piers composed of three
superimposed plaquettes, resting on
round pedestals with spiral flutes and
decorated base mouldings. The plaque-
ttes are all framed by pilasters with
recessed panels and the entablatures
above them have guilloche friezes. The
first has a relief of a centaur, the second
a diamond framing a profile bust,
the third a warrior relief. Composite
capitals support an entablature with
a frieze bearing confronting dolphins
with long foliage tails. A putto sits on
top of a central console in the triangular
pediment, which has dentil and egg-
and-dart mouldings.

The dentil moulding in the architrave
that runs above the capitals and across
the opening is often drawn in the album,
and is also found on Amadeo's tomb of
Medea Colleoni in Bergamo (Malaguzzi
Valeri 1904, pp.59 and 60).

63

*Capitals and entablatures
and a cornice*

Diagonal hatch, coloured beige
SJSM, vol.122, p.64

[1] A half-elevation of a 'Corinthian'
capital with three tiers of acanthus
leaves, the full upper leaf scrolling into a
volute below the abacus, which has a
dentil moulding and a central palmette.
[2] A half-elevation of a 'Corinthian'
capital with a leaf-and-tongue mould-
ing at the hypotrachelion, a ring of half-
acanthus leaves and a full acanthus
below the abacus and the caulicula in
the centre, with rosettes between them.
[3] An elevation of a standard Lombard
s-scroll capital with a scale ovolo and
two leaf-and-tongue mouldings at the
hypotrachelion and three tiers of
stylized acanthus leaves below volutes
with s-scrolls, which are joined in the
centre by a palmette rising to the abacus.

Capitals on the portal of Palazzo
Schifanoia in Ferrara, attributed to
Francesco del Cossa or Biagio Rossetti
(Zevi 1960, fig.29), and on the apse of
Pavia Cathedral resemble this example
(Malaguzzi Valeri 1915, fig.126; for this
type, see Burnett & Schofield 1998).
[4] An elevation of a 'Composite' capi-
tal with a braided laurel-wreath ovolo
moulding at the hypotrachelion and full

acanthus leaves at the sides of a strap-
work scroll that rises from a palmette at
the base of the capital to a scrolled bol-
ster formed by an s-scroll, which meets
in a ring below the palmette in front of
the abacus.

[3] and [4] are close to Mantegna's
capitals on the half-columns framing
the S. Zeno altar in Verona (Lightbown
1986, pl.36). The s-scroll capital, which
was popular in Lombardy, derives from
Alberti's use of it (see Morolli 1996,
pp.330ff.).
[5] An elevation of a 'Composite' capital
with a laurel-wreath ovolo at the hyper-
trachelion. Two strapwork scrolls join
below an acanthus flower, below cable
and egg-and-dart mouldings as an echi-
nus, with four acanthus leaves falling
down over them and volutes above
framing a cherubim in the channel
below the abacus.
[6] A half-elevation of a capital with
plait and acanthus mouldings below
two half-sea horses, their tails joined by
a rosette below the square abacus with
plaited decoration. The capital is similar
to one with winged sea horses at Abbiate-
grasso, of c.1497 (Borsi 1989, p.99).
[7] A profile elevation of an entablature
with an architrave with two plain fasciae
separated by bead and reel and acanthus
ogee, a garland frieze, and a cornice

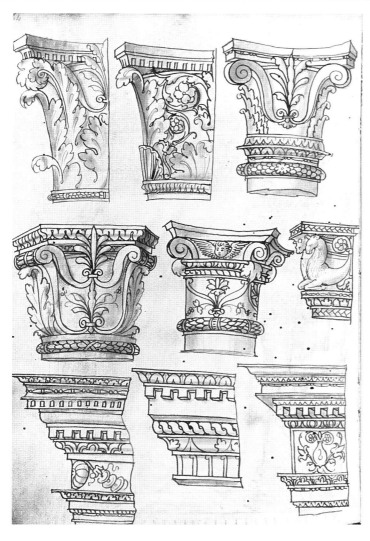

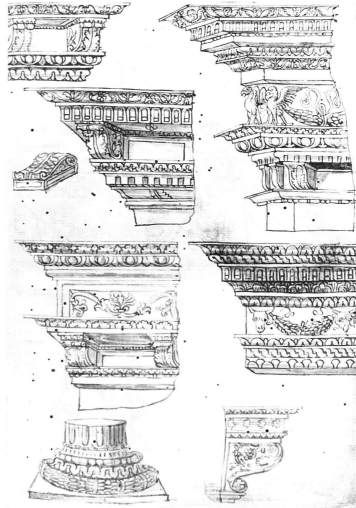

with an acanthus-ogee cyma reversa, dentil moulding, plain ovolo, a corona with scoop moulding, a bead-and-reel fillet and an acanthus-ogee cyma recta.
[8] A profile elevation of a cornice with a dentil moulding, egg and dart with an acanthus cyma recta, a guilloche ovolo, a plain corona, dentil moulding and leaf-and-tongue cyma recta.
[9] A profile elevation of an entablature with an architrave of one fascia with leaf-and-tongue mouldings below it and a bead-and-reel moulding with an acanthus-ogee cyma recta above; the frieze bears moresques and the cornice has an egg-and-dart ovolo, dentils below a plain corona with bead-and-reel and leaf-and-tongue mouldings below a plain cyma recta.

64
Cornices, entablatures, a console and a base

Coloured brown and beige;
312 × 217 mm
SJSM, vol.122, p.65

[1] A cornice with a leaf-and-tongue cyma reversa below an egg-and-dart ovolo has a corona with acanthus consoles and an anthemion cyma recta.
[2] A cornice with plain fillets and cyma recta below a dentil moulding and an acanthus-ogee cyma reversa below an acanthus modillion supporting a corona with scoop ornament and an anthemion cyma recta.

The cornice to the dentil mouldings is drawn in the Master of the Mantegna Sketchbook (Leoncini 1993, p.89, fol.6b), and in Codex Zichy in Budapest, on fol.157r. The cornice at S. Maria presso S. Satiro, Milan, is a simplified variant.
[3] The profile of the corner of an entablature with a bead-and-reel fillet below a plain cyma recta supporting acanthus consoles below a dentil moulding, egg-and-dart ovolo and oak-and-acorn cyma recta moulding below the frieze, which has winged eagles at the corner supporting garlands. The cornice has a plain slab with an anthemion cyma recta, a leaf-and-tongue cyma reversa, a plain slab, a bead-and-reel fillet, a

corona with scoop ornament and a cyma recta with cherubim.

This is probably the source for the friezes on pp.16 and 17 (cat.15 and 16). The frieze derives from Filarete's use of the motif in the basement of Nero's palace on the bronze doors of St Peter's (Lazzaroni & Muñoz 1908, fig.6). The Trajanic eagle at SS Apostoli, Rome, Filarete's source, was used by Amadeo (Schofield 1992, p.32).
[4] A profile elevation of an entablature with a bead-and-reel fillet and acanthus-ogee cyma reversa below acanthus consoles with a plain fillet and an acanthus cyma recta above, below the frieze with anthemions. The cornice has a plain cyma reversa below an egg-and-dart ovolo and an acanthus cyma recta.
[5] A profile elevation of an entablature, which has an architrave with scale, guilloche and leaf-and-tongue mouldings below a frieze bearing bucranes with garlands hanging from the horns and a cornice with a leaf-and-tongue cyma recta, acanthus-ogee cavetto, a corona with scoop decoration, a guilloche ovolo and a leaf-and-tongue cyma recta.

Bucrane and garland friezes are associated with Filarete, who planned to ornament Castello Sforzesco in Milan with one based on the reconstruction of the mauso leum of Hadrian on the bronze

doors of St Peter's (Welch 1995, pp.185–8).
[6] A base with a braided laurel lower torus, a scotia with leaf and tongue and a bead-and-reel astragal and an upper scotia with scoop decoration and a cable fillet.
[7] The profile of a console with double foliage scrolls, and a rosette below a cornice with a frieze of bell-flowers.

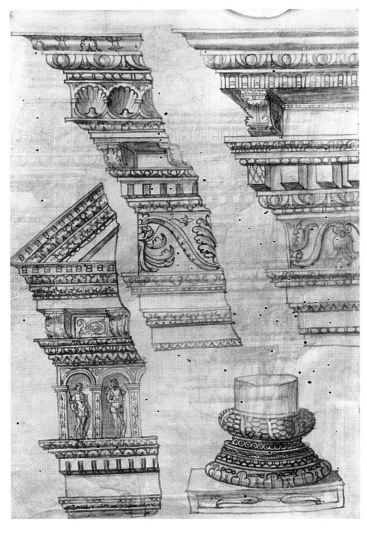

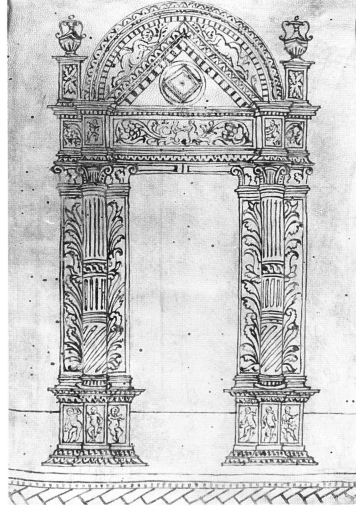

65
Entablatures and a base
Coloured beige
SJSM, vol.122, p.66

[1] A profile elevation of an entablature with an architrave with two plain fasciae separated by a bead fillet and an acanthus-leaf cyma reversa and crowned by a bead fillet and an acanthus cyma reversa below a frieze with anthemion relief. The cornice has an acanthus cyma reversa, a dentil moulding and an egg-and-dart ovolo below acanthus consoles that support a slab, and an acanthus cyma recta below a corona with shells, a bead-and-reel fillet, egg-and-dart ovolo and plain cyma recta.
[2] A profile elevation of an entablature with an architrave with three fasciae separated by bead and leaf-and-tongue mouldings is crowned by a bead fillet and a cyma recta below a frieze with bell-flowers. The cornice has a bead fillet, an egg-and-dart ovolo below dentils, then a bead fillet and cyma reversa below acanthus consoles supporting a corona with scoop decoration, an egg-and-dart ovolo and a plain cyma recta.
[3] A profile elevation of an entablature below a pediment. The entablature comprises a bead-and-reel moulding below the plain fascia of the architrave, which is crowned by dentil, leaf-and-tongue and acanthus mouldings below

the frieze with standing warriors in niches. Above the frieze are a leaf-and-tongue cyma reversa, an egg-and-dart ovolo and an acanthus cyma recta below acanthus consoles; the last have vine tendrils between them and support a plain fascia, bead fillet, acanthus cyma reversa and cyma recta below a cyma recta decorated with scoop ornament.
[4] A base with a lower scotia decorated with acanthus, an ovolo with scales and a bead astragal below a scotia with coin ornament. The upper torus is decorated with braided laurel.

REPRODUCED Manni 1986, p.67, tav.33.

66
Portal or frame
Pen and two pale and dark brown washes; 312 × 212 mm
SJSM, vol.122, p.67

The frame, on a podium of one step with plait decoration, has a rectangular opening framed by piers and columns on pedestals with putti reliefs. The piers bear foliage panels, and the column shafts, divided into three by rings, have spiral flutes and two different straight flutes separated by a ring of guilloche ornament. The piers and columns support an entablature that projects above the columns with a frieze decorated with single putto figures; the central recessed frieze bears confronted half-figures with long foliate scrolled tails.

These figures are close to the figures in the frieze in the refectory at S. Maria della Pace, Rome, of the first decade of the 16th century, inspired by Bramante (Malaguzzi Valeri 1915, fig.244). A triangular gable, with putti lying on top of it, is enclosed in a segmental lunette, with pedestals and vases on either side.

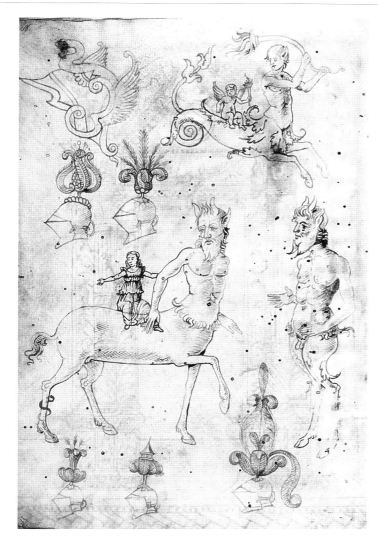

67

A centaur, satyrs and helmets
Blue-green stain
SJSM, vol.122, p.68

The youthful satyr half-figure with a putto on his back, both figures holding cornucopia, seems to have provoked a misunderstanding of the story of *Hercules and Deianeira* shown below. A faun advances towards the centaur Nessus, who abducted Deianeira from Hercules. He turns to touch the foot of the draped, acquiescent nymph on his back. The scale of the tiny figure is closer to the *amor* usually depicted riding a centaur.

A similar thin elderly centaur is found in a Sallust published in Venice in 1474 and illuminated by the London Pliny Master. The centaur approaches a faun satyr and embraces him as he stretches his arm across the body of a nymph on his back, in a protective gesture resembling the one on this drawing (Armstrong 1981, fig.89, cat.37). The Triton with a cornucopia and putto on its back is similar to two figures in the Attavante, from the circle of Mattia Corvino (*c.*1487-90; Vienna, Österreichische Nationalbibliothek, Cod.656; Garzelli 1985, p.484, fig.812).

One of the three helmets above is decorated with a serpent and two wings while the others have plumes; the three helmets at the bottom of the sheet also have elaborate plumes.

The helmets with plumes and a round disk attached to the visor with leather straps are called *armettes*; they are similar to the helmets in Uccello's *Rout of S. Romano*. A helmet of this kind in the Kunsthaus, Zürich, is illustrated by Malaguzzi Valeri (1923, fig.38). The helmet with the winged dragon recalls the surviving parade helmets of *c.*1560 by Giovanni Seraglio of Milan (Vienna 1990, cat.A.802, Abb.116, pp.188ff.).

Havendo la città rasgion misura e forma del corpo
humano hora delle circonferentie loro et partitioni
prexisamente scrivere :~

In prima è da sapere esteso in terra il corpo humano
posto un filo alinbelliso alla estremità di esso tirano
circular forma sara similmente quadrata et angulata
designation si trovera :~

Adonq e da considerare come il corpo ha tutte le par-
tition et membri con perfetta misura et circonferen-
tie el medimo nella città et altri edefici osservar
si debbe, et quando in essa città rocha da far non
fusse in loco di essa in la cathedral chiesia s'attribu-
ischi con la sua mirigola piazza dove il pallazzo
signorile habbi correspondentia et dell' opposita par
et rotondità dell'ombilico la principal piazza : le pal-
me e gioldi ad altri tempi e piazze constituire sono
et cosi come gliocchi, orecchie, naso, e bocha le
vene, intestina, et altre interiore che dentro et in
torno al corpo si trova alla necessità et bisogno
di esso cosi nella città osservar si debbe si come
partimente alcune forme mediterrane :~

Hora de siti de esse città et castella in che modo de
constituir sono e in poggio, piano, appresso, a fiumi
over marina fosse ciascuna di queste iuxta diverse
compositione si come in adietro seguendo esporro:
Adonq se la città sara in loco montenoso in prima
è da vedere il parer sia sirvito e suggitimuto delli habi-
tanti : sia li intorno, et appresso fiumi per lo maci-
nare, et altri edificij necessarij, orseri, fonti, e
pozi d'acqua viva, et se non grande copia di ciro-
no sia in tal modo composta, che le vie piazze e
strade, no sieno arte vigorentini e strenui ma an-
dunie, circulari overo aguisa de lumecha per le di-
pendentia et obliquità del monte, et cosi l'una via et
l'altra conferente, et in graduati sieno li habitanti
per la facilità dell'andare no li par mille molto et anco
e da fare la piazza di tal grandezza che corrispondesse
ad esse città sia rivendo le publiche e maistre strade
a più dirita linea che si può, ornate, et cirno di fonde-
chi, et altre iura marcantili, et tutte le chiesie vicine
alle coi strade in tal modo componere che li habitanti

Francesco di Giorgio
A copy of his manuscript treatise on architecture
*c.*1570

Francesco di Giorgio's treatise on architecture, copied in this manuscript, was the first attempt at an illustrated treatise on the subject since antiquity; it represented a renewal of Vitruvius' *Ten Books on Architecture*. A comprehensive work, probably written around 1478–81, it covered the same ground as Vitruvius but addressed the needs of modern architecture. The treatise was never published, but the large number of manuscript copies of its two editions gave it great influence. Fra Giovanni Giocondo, Leonardo da Vinci, Bramante and Baldassare Peruzzi all knew Francesco, and Sebastiano Serlio, Daniele Barbaro, Palladio and Vincenzo Scamozzi had read his manuscripts.

The original manuscripts of the treatise are lost. The text and illustrations in the Soane manuscript are almost identical to Codex Ashburnham 361 in the Biblioteca Medicea Laurenziana, Florence, which was owned and annotated by Leonardo da Vinci;[1] in the literature, this is referred to as MS L. The Soane manuscript contains in addition a chapter on the military arts, which was copied from a fragment of a manuscript in Reggio Emilia, henceforth MS R, which Mussini recognized as a lost fragment of MS L.[2]

Mussini also demonstrated convincingly that MS L was the first draft of the treatise, and that MS Saluzziano 148 in the Biblioteca Reale, Turin, henceforth MS T, which contains more chapters than MS L, was the revised version; until then, since the pioneering work of Promis,[3] MS T had generally been accepted as the first draft of the text. MS T contains Francesco's autograph annotations and a chapter on metals added between the chapters on raising and conducting water, as well as sections on convents, bells, belfries and gardens and an appendix with a series of archaeological drawings of Antique buildings, which are not reproduced in MS L or in any of its derivatives. There are 13 chapters in MS T; only 11 survive in MS L.

An improved edition of the treatise, developed from the two early drafts, survives in the Biblioteca Nazionale in Florence: the Codex Magliabecchianus MS II.I.141, henceforth MS M, which is bound with a new translation of Vitruvius by Francesco. Maltese suggested that the publication of Alberti's *De re aedificatoria* in 1485 – and the appearance in 1486 of the first printed edition of Vitruvius, unillustrated, with Frontinus' book on aqueducts – probably prompted Francesco di Giorgio to improve the first drafts of his treatise, which reveal no sign of his having read Alberti.[4] The new edition was probably also stimulated by other contemporary efforts to illustrate Vitruvius. In the early 1490s Giorgio Valla wrote to Jacopo Antiquario about a Vitruvius he had illustrated.[5]

The first illustrated edition of Vitruvius' Latin text was published in 1511 with a commentary by Fra Giocondo. This was primarily concerned with the scrupulous analysis, restitution and integration of Vitruvius' text. Francesco di Giorgio and Fra Giocondo must have known each other. Fra Giocondo had worked for Alfonso II of Aragon, Duke of Naples and Calabria, during the time that Francesco was in his employment there, in the early 1490s. A connection between the two architects is also suggested by the fact that Fra Giocondo was paid for 126 drawings for two Francesco di Giorgio manuscripts on architecture, on 30 June 1511.[6] Fra Giocondo's surviving drawings indicate that he was copying from a different archetype to the Soane manuscript, which is closer to MS M but not identical to it. Fontana suggested that Fra Giocondo may have collaborated with Francesco on the translation of Vitruvius, and that Francesco's improved text in MS M was probably helped by the new autograph translation of Vitruvius, which is bound in with it.[7]

Francesco di Giorgio's treatise, which was written in Italian, was not a workshop manual but a compilation of theory and practice made to enhance his reputation and professional status and to promote the fame of his ingenuity;[8] in this, he followed his fellow Sienese Mariano Taccola (1381–1458), whose *De ingeneis* was written in Latin a generation earlier. Michelini Tocci noticed that Taccola's manuscript of *De ingeneis* (books I–II), now in Munich, contains drawings by Francesco di Giorgio, a fact that suggests that the manuscript was once in his office.[9] The earliest autograph drawings and notes for the treatise survive in the *Codicetto*, Francesco's pocket notebook on vellum now in the Vatican, which was compiled over many years from *c.*1465. It contains hundreds of tiny sketches and notes, paraphrasing or commenting on Taccola, as well as his own inventions and designs for military machines that date from the period after 1477, when he moved to Urbino to work for Federigo da Montefeltro.

Although Taccola's book expands on Vitruvius' book X, it is a compilation; in contrast, Francesco, who was inspired by Vitruvius, presents his material analytically in logical progression. Several examples of single types such as cisterns and chimneys, or plans, are given, and the examples are categorized, presented and illustrated in sequence.[10] The density of the illustrations distinguishes his treatise from those of his predecessors: Vitruvius' had some diagrams, but Alberti's treatise was not illustrated; Filarete also used marginal illustrations, though far fewer of them.

Taccola's book supplied the precedents for many of the illustrations: the drawings on hydraulic engineering and surveying, and many of the mechanical and military illustrations. There are no precedents in Taccola for the architectural drawings, although some of the drawings on building practice, such as those of chimneys and reinforced beams, derive from him. Francesco drew on his own practice to present a large range of commodious houses and palaces for nobles; in the second edition these are systematized into house types according to the social status of the inhabitants.

The illustrations of a wide range of church plans are particularly interesting; Francesco describes three types of temples, longitudinal, central and composite, without defining the types or expressing preference. In MS L they are captioned with Vitruvian terms, and in MS T with abbreviated descriptions of the plan type. Of all Renaissance theorists, Francesco alone

1. Maltese 1967, I, p.xx.
2. Mussini 1991.
3. Promis 1841, I, pp.90–94.
4. Maltese 1967, I, pp.xlvi–xlvii.
5. Bulgarelli & Ceriana 1996, pp.114, especially p.177, n.93.
6. Brenzoni 1960, p.21.
7. Fontana 1988, pp.32–3.
8. Siena 1991, p.111.
9. Michelini Tocci 1962, p.203.
10. Florence 1996 b, p.37.

presents longitudinal plans as ideal for churches, although in the second version of the treatise, MS M, he recognized the round temple as the most perfect form, like Alberti.[11] He offered a range of models drawn from buildings of different periods: Roman tombs (fol.19v, cat.98), early Christian buildings, S. Costanza (fol.20r, cat.99), and contemporary buildings such as S. Pietro in Montorio in Rome (fol.16v, cat.92) and the Certosa and Cathedral of Pavia (fol.18r, cat.95). He is documented at Pavia Cathedral in consultation with Bramante and Amadeo in 1490, a fact that provides intriguing problems for the chronology of the treatises.[12]

Taccola's illustrations are very pictorial and highly coloured single images that fill the vellum pages, accompanied by short Latin texts. In contrast, Francesco di Giorgio's drawings are numerous, small, diagrammatic and neutral except for blue to express water, and red alternating with green or blue to express either walls or columns in the plans. The illustrations fill the margins of the double-column pages of MSS L and T close to the text that describes them. The conventions for architectural drawing used in the first version of the treatise follow contemporary practice: for the churches and palaces plans only are given; they are drawn with double lines showing wall thicknesses, with breaks for doors. In the second edition the drawings are more diagrammatic and show more clearly the variety of room shapes, their sequence and the *enfilade* of the doors and windows; walls are indicated with single lines, with breaks for doors and windows. Colour is eliminated entirely in the Soane manuscript and in MS M.

The surveying diagrams follow medieval conventions, but they are improved by the addition of lettering, also found in Arabic copies of Greek manuscripts that were transmitted to the West, appearing in the drawings of Villard de Honnecourt in the 13th century. The introduction of an eye as the originator of the perspective in one of Francesco's diagrams could be an innovation. While Taccola's views of surveyors at work relate to his specialities – military or hydraulic surveying – Francesco demonstrates the full range of the architectural applications of measuring.

The drawings of machinery are the most inventive in the treatise. On fol.64r (cat.173) Francesco stresses the speculative nature of machines and the difficulty of describing them. He regarded them as fantasies in which imaginative and variable arrangements of components produced different outcomes. Leonardo later classified and defined the properties of the single components.[13] Francesco gave detailed information on mechanical principles and on the dimensions and proportions of components, and in some of the experiments he recorded technical developments. For example, he illustrated flywheels in combination with cranks and coupling rods at an early date, and his description of the bucket pump and the use of hemp packing for syringes anticipated later developments.

In Taccola's *De machinis* and *De ingeneis* the machines are set in frames and always shown perspectively in landscape (occasionally they are set in boxes, as in *De ingeneis*, book II, fol.96v).[14] Francesco developed the frame into the perspectival boxes that is the characteristic feature of his illustrations of machinery.[15] The components are set in chambers of different sizes within the perspective boxes so that their positions, the proportions of the parts and the scale of the whole can be clearly read while showing a view of the machine in operation – characteristic of Renaissance and modern mechanical presentation drawings, usually called views. Through perspective, he was thus able to combine the clarity of ancient diagrams with a view of the machine working, which he could show to patrons. The standardization of the settings for the machines and the use of roughly constructed perspective probably also helped to guarantee the workshop production of large numbers of copies with uniform images. The means of representing machines is continued in MS M but the number of examples is reduced.

In MS M, the second version of the treatise, the text is presented in a single column and the drawings are larger and more important; occasionally, they replace the text. Illustration here is the distinguishing feature of Francesco's treatise. In his writing he stressed the importance of drawing and in the second edition he listed for the first time arithmetic, geometry and design (*disegno*) as the pre-eminent skills for the architect.[16] He wrote: 'although in our day it [*disegno*] is held unworthy and inferior to many other mechanical arts, none the less anyone who reflects on how useful and necessary it is for every human activity, whether for the process of invention or for the exposition of ideas, whether for working purposes or for art and whoever considers how closely related it is to geometry, arithmetic and optics [perspective] will easily judge, and with good reason, that drawing is a necessary means in every theoretical and practical aspect of the arts'. Onians traced the emphasis on the priority of drawings to the influence of Piero della Francesca in Urbino.[17]

The change from pages with two columns and marginal illustrations in MSS L and T to a single column in MS M could have been stimulated by the example of antiquity; while Vitruvius had used only a few diagrams to illustrate his ideas, ancient technical literature was full of illustrations. The type of layout, with scattered images in the appropriate place in columns of text, is the most striking characteristic of the Greek manuscripts that were copied in the Renaissance and which Francesco certainly knew. Philo's *Pneumatica* was cited by him, and it was translated in its entirety by an anonymous Sienese architect from his workshop in a manuscript in the British Library (MS add.34113).[18] The same format is also found in one of the treatises of the *agrimensores*, or Roman land surveyors, attributed to Hygimus, which shows octagonal colonial cities drawn in perspective and scattered in a single-column format.[19]

The surviving manuscripts of Francesco's treatise, mainly copied from lost originals without title, date, name of author or intended dedicatee, were collected and catalogued by Gustina Scaglia in 1992. The complexities of the chronology of the many versions of the manuscripts were outlined by Mussini in the catalogue of the exhibition in Siena.[20] Both scholars have established that more than one hand was at work on the text and the illustrations, but the contribution of the different hands has not been definitively analyzed. The circumstances in which the manuscripts were copied in the workshop and the way in which the consistency of the technical illustrations was maintained are still open questions.

The Soane manuscript, on paper, is arranged in a single column, as in MS M. This probably reflects the taste of the second half of the 16th century. The drawings are recorded accurately; they are carefully underdrawn in chalk then filled in ink. Details in the architecture and clothing, which suggest that the draughtsman was Venetian or Ferrarese, led Scaglia to date the manuscript c.1540.[21] The text has been transcribed faithfully from MS L in an elegant chancellery hand by a copyist, which I prefer to date to the second half of the 16th century. He read the text with sympathy, his intelligence engaged: on fol.16r (cat.91) he departed from the text to contribute his appreciation of Francesco's critical view of Vitruvius' text; in a few instances he noticed discrepancies between the text and the illustration and corrected mistakes made by the copyist of MS L; occasionally he made spelling mistakes and words are modernized. Francesco di Giorgio gave dimensions for only one plan in the text on fol.30r[1] (cat.115), and these are inserted inaccurately into the illustration. Room dimensions are added to the plans as in Palladio's treatise, where architectural elements are used to fix the dimensions of rooms according to Veneto conventions. Palladio organized his plans by the repetition of rooms of fixed dimensions as though he thought of rooms as components.[22] Codex 491 in the Beinecke Library at Yale University, New Haven, which was also probably executed in the Veneto, has dimensions, though fewer of them, on some of the plans.

11. Betts 1981, p.108.
12. Siena 1993a, p.359.
13. Florence 1996b, p.192ff.
14. Prager & Scaglia 1972, p.47, fig.19.
15. Siena 1991, p.108.
16. Maltese 1967, I, p.37.
17. Maltese 1967, II, pp.293–4; translated in Onians 1988, pp.172–4. For the attribution see Onians 1988, p.173.
18. Siena 1991, p.174.
19. Weitzmann 1959, pp.6–7, pl.II, fig.3.
20. Siena 1993a, pp.358–9.
21. Scaglia 1992b, p.170.
22. London 1975, p.227.

The interesting modification made to the illustrations of MSS L and T, by changing the coupling rods to connection rods (fol.63r bis, 73r; cat.183), may help to date the manuscript.

LITERATURE Scaglia 1992b, pp.169–73, cat.69.

CATALOGUE

The manuscript is bound in paper-covered boards of speckled brown and beige with brown leather corners and a gold-tooled spine with red leather and gold title; the volume measures 387 × 260 mm. It is inscribed DISEGNI/DI/MATHEM/ARCHIT/ET FORTIF on the spine, and on the free end-paper in graphite: *Treatise on fortification, Architecture/Mechanics in Italian with numerous drawings, very neatly executed with the pen*, with 1.1.0 at top left and 554 at top right; the inscription in graphite on the verso reads: *Esisteva questo Codice nella insigne/Biblioteca Soranzo di Venezia/ab Celotti di Venezia.*

The support is a white laid writing paper with a consistent watermark and countermark throughout the volume (the watermarks are listed at nos 29 and 30 in the catalogue of watermarks in vol.II). The drawings are executed in pen and pale brown iron-gall ink over grey and red chalk with ruled margin lines of red chalk; the folios measure 357 × 246 mm.

PROVENANCE In the 19th century the manuscript was in Abbot Celotti's library in Venice; previously, probably in the 18th century, it was in the Biblioteca Soranza, Venice. Celotti's library was sold at Sotheby's in 1821 and 1825 but none of the volumes catalogued corresponds with this volume.[23]

The entry in Richardson's catalogue of Sir John Soane's Library is inscribed: *Fortification. treatise on* [*fortification* deleted], *Architecture, Mechanics etc. in Italian, folio various drawings neatly executed in pen. It was located in case 100 in the recess in the museum with a miscellany of books.*[24]

The folios are numbered 1–71 then 62–82 followed by 72–82, making a total of 92 folios. A second series of folios is numbered 62–71; they are catalogued as bis numbers, 62r bis, 72r and so on.

In the entries, the footnote heading 'Other manuscripts' refers to the two drafts of the first edition of the treatise on architecture, MSS L and T. MS T is listed before MS L so that the reader may follow the text in Maltese 1967 (vol.I) more easily. The folios copied from the fragment of MS L that survives in the Biblioteca Municipale in Reggio Emilia and which are called MS R; the fragmentary folios of a manuscript by Giambattista Venturi in the same library in Reggio copied from a manuscript in the Biblioteca Estense, Modena, are referred to here as Venturi copy of MS E. These manuscripts were used by Mussini to reconstruct the prototype manuscript for the first edition of the treatise. Notes from an early draft of the treatise in Codex Zichy in the National Library in Budapest are listed next. All of the above manuscripts are variants of the archetypes for the first edition of the treatise. The 16th-century copies of the first edition of the manuscript, Codex 491 in the Beinecke Library at Yale University, New Haven (listed as New Haven, BL, MS B), and MS cod.IT.IV, 3–4 (5541), which are similar to the Soane manuscript but with the illustrations traced and glued on to the folios, are cited next. When an image from the treatise is repeated in the second edition, MS M, the fact is recorded. Finally, Francesco's autograph drawings in *Codicetto* (Rome, BAV, MS Urb.Lat.1757) or *Opusculum* (London, BM, reg.no. 197.b.21), which are related but not preparatory drawings for the illustrations, are listed last. There are captions in the Soane manuscript only on the folios with the palace and house plans. Where captions are given in MS L they are recorded; otherwise they are transcribed from MS T.

'Other representations' refers to 16th-century Italian copies of the illus-trations of drawings from the first edition of the treatise only; when no artist's name is given the artist is anonymous.

The commentary on the illustrations and text is a guide to the text. Cross-references to Francesco's buildings are intended to introduce the reader to his beautiful architecture and its bibliography. Bibliographic references, which cannot be comprehensive, are designed to give entry into the general bibliography of the many buildings and subjects raised in the treatise. Only the illustrated pages are reproduced.

The texts of MS L, MS T and the Soane manuscript are compared and the changes recorded in a three-column manuscript analysis separate from the commentary on the illustrations, so that other texts can be compared against them easily (see pp.146–75 below). The page references are given to the published editions of the text. Maltese 1967, I, refers to MS T, Marani 1979 to MS L, and Mussini 1991 to MS R. To enable the reader to follow the text more easily, MS T, the second version of the treatise, is placed in the first column because the edition of the text in Maltese 1967 has both page and line references. For legibility Maltese's modernizations of the spelling have been followed, although accents are not transcribed.

For Francesco di Giorgio's biography the reader is referred to Weller's monograph of 1943, and for his work as an engineer to the introductory essay by Paolo Galluzzi to the catalogue of the exhibition held in Florence in 1996.[25]

23. Scaglia 1992b, pp.169–70.
24. Richardson 1830, p.507.
25. Florence 1996b.

Fortifications
sjsm, vol.120, fol.1r
No illustration

68
Anthropomorphic design of a city
sjsm, vol.120, fol.1v

A standing nude male figure, his legs slightly apart, holds up with both hands a fortress-like helmet to protect his head. In the centre of his chest is a temple with an apse, standing above a circular piazza with his navel at its centre. The figure's elbows and feet are surrounded by towers; the walls of the city correspond to his arms and legs, and walls run between the towers at his feet, with a ravelin in front of the entrance between them. Walls are shown between the feet and the arms explicitly in ms t; they are not shown here or in ms l.

The illustration and text refer to the anecdote told in Vitruvius' preamble to books ii and vi about the architect Dinocrates, who showed Alexander his project for a city on Mount Athos. This was remodelled in human form and

realized in the form of a colossus who holds a vessel to collect water in a lake from mountain streams and in his left hand the walls of the new city. Francesco illustrated the anecdote literally in ms m (fol.27v; Maltese 1967, ii, tav.210). For mss l and t he created an image of the Vitruvian theory of the human body as the model of perfection to justify the design of a city in the shape of a pentagon.

For the Dinocrates legend, see Lotz 1940 and Oechslin 1982.

OTHER MANUSCRIPTS Turin, br, ms t, fol.3r (Maltese 1967, i, p.4, line 7–p.5, line 16; p.253, tav.1); bml, ms l, fol.1r, inscribed *Rocha–tor[r]one–piaz[z]a–chorpo dela citta–tor[r]one–rivellino* (Marani 1979, ii, cap.iii–v, p.111); Reggio, bmre, Venturi copy of ms e, fol.12r (Mussini 1991, fig.13); New Haven, bl, ms b, fol.1r; Venice, bmv, fol.1v.
OTHER REPRESENTATIONS Pietro Cataneo, Uffizi 3317a.

Fortifications
sjsm, vol.120, fol.2r
No illustration

69
Geometrical shapes and fortified structures
sjsm, vol.120, fol.2v

[1] The illustration shows the range of geometrical forms – polygonal, square, triangular, rhombus and rhomboid – that could be used for fortress plans; the choice would depend on the site. Round towers are drawn at the corners. Francesco noted the lack of surviving ancient fortifications and quoted Vegetius in recommending angular forms, which provide improved defence against battering-rams – and in Francesco's day cannon – and cover the curtain walls more efficiently. According to Francesco, modern fortifications should be compact, so that they can be guarded and defended easily. The circle is rejected as a fortress shape; the rhombus and rhomboids are considered almost perfect forms, followed by triangles and polygons.
[2] The elevation of a modern circular scarped tower, with merlons and machicolations, shows the profile of the scarp, which inclines towards the exterior 1 *piedi* for every 4–5 *piedi* and rises two-thirds the height of the tower. The walls are solid except for small openings that allow smoke from the bombards to escape. The tower stands on a walled platform with merlons; the entrance is protected by a ravelin in the form of a vaulted corridor with gun embrasures.

[3] The low polygonal building, shown as an alternative to the round tower, is very advanced for its date: it is crowned by machicolations – the arched gallery below the merlons – with holes above the arches for dropping heavy projectiles, and a casemate or pill-box with gun embrasures stands on top of the gun platform. Francesco built a ravelin following this plan at Costacciaro (see fol.5r, cat.74).

The term *Anprigonio* in the caption to ms l means a triangle with an obtuse angle at the top; it was called an ambly-gonium in Euclid's *Elementa* (Venice, 1482; see Maltese 1967, i, p.253).

OTHER MANUSCRIPTS Turin, br, ms t, fol.4r (Maltese 1967, i, p.6, line 21–p.7, line 27; p.253, tav.3); Florence, bml, ms l, fol.2r and v, inscribed [1] *pentaghono –Quadrilate/ro–equilatero–equichruro–ronbo–ronboido–ho[r]taghonio–hexaghonio–Anprighonio*; [2] *calicie–rivellino choverto*; [3] *cap[p]annata hovero testudo* (Marani 1979, ii, cap.vi, p.111); Reggio, bmre, Venturi copy of ms e, fol.12r (Mussini 1991, fig.13); New Haven, bl, ms b, fol.2r; Venice, bmv, fols 4v, 5r and 7r.
OTHER REPRESENTATIONS Vicenza, bbv, [3] fol.107r, no.2, [1–9] fol.83v; Pietro Cataneo, Uffizi 3317a.

70
Fortifications
sjsm, vol.120, fol.3r

With the development of artillery in the 15th century, when cannon could break walls from a distance, medieval fortresses with straight walls and round corner towers grew progressively more vulnerable to attack. Fortress plans had to provide for movement of the defenders' cannon, and walls were lowered and thickened at the base to form a scarp to resist bombards.
[1] The drawing shows a round machicolated tower, with a pill-box on the gun gallery, standing on a scarped platform.
[2] The elevation of a square tower and section of a ditch, described as 100 *piedi* wide at the top, 40 *piedi* half-way down and 50 *piedi* high. According to Francesco, the ditch was the most important member of the defensive structure on a flat site. It was defended by an inclined bank or *ciglio* 20 *piedi* wide and high enough to protect the soldiers' heads. In ms m the width of the *ciglio* is narrowed to 8–10 *piedi*. The ditch could be filled with water if there was a spring; otherwise, the water would become stagnant in heat. Opinions varied as to whether or not the ditch should be filled (see Alberti, *De re aedificatoria*, 1485, book v, cap.xi). The machicolations had holes above the arches in the gun platform so that

heavy projectiles could be dropped on to enemy troops on the platform below. They are consistently referred to as important defensive superstructures.
[3] A plan and a bird's-eye view of a square fortification with two firing levels, a square central keep and corner towers surmounted by casemates or pill-boxes. The circuit is clear so that cannon can be moved around the walls easily. In elevation, the gun gallery with its pill-boxes is linked to the keep by an elevated machicolated bridge.

OTHER MANUSCRIPTS Turin, br, ms t, fol.4r (Maltese 1967, i, p.7, line 27–p.9, line 4; p.253, tav.3); Florence, bml, ms l, fol.2r, inscribed [1] *Piramide–tor[r]o*; [2] *fosso la[r]go pie/ciento ala sup[er]fficia i[n] fo/ndo la[r]gho p/ie quara[n]ta–ciglio– Alto pie 50*; [3] *Fondo di roccha ho cittadella/cho[n] quatro divixionj in p/del chastellano–Mastio–ciglio–fosso–ciglio* (Marani 1979, ii, cap.x–xi, p.111); Reggio, bmre, Venturi copy of ms e, fols 12r and 13r (Mussini 1991, figs 13 and 15); New Haven, bl, ms b, fol.2r; Venice, bmv, fol.7r and v.
OTHER REPRESENTATIONS Pietro Cataneo, Uffizi 3317a.

68

69

70

71

Fortifications
SJSM, vol.120, fol.3v

[1] A bird's-eye view and half-elevation of a polygonal fortification with double walls, semicircular towers and a polygonal central keep. Pepper and Adams (1986, pp.18–20, fig.10) reconstructed the three-tier system showing the relationship of the keep and the three levels of ditch with an elaborate system of casemates inside them; heavy guns were fired from the lower tiers and lighter guns from the gallery at the top of the tower. The keep dominates the structure so that the keeper can control the circuit and the casemates in the ditch, which were built so that they could be demolished easily from the tower. For casemates, see fol.5r (cat.74).
[2, 3] Two plans of a keep showing the concealed entrances to the towers. The plan is divided so that there is a room in the centre of the tower for the keeper and smaller rooms for trusted officers; doors in these rooms give access to narrow stairs leading to the terrace and

the machicolations. Marani (1984, p.198, cat.118) suggested that this fortress could be the source for Leonardo's fortress in Codex Atlanticus (Milan, BA, fol.132r).
[4] A bird's-eye elevation of a fort in its ditch, showing the arcaded routes, allowing cover, between the scarped keep and the towers on the scarped circuit. A gate in the middle of the passage between the tower and the keep enables the keeper to close the passage.

OTHER MANUSCRIPTS Turin, BR, MS T, fol.4v, inscribed *ciglio–Mastio–fosso–fosso–fondo di roccha ho cittadella/cho[n] quatro divixionj in p. del chastellano* (Maltese 1967, I, p.9, line 5–p.10, line 8; p.253, tav.4); Florence, BML, MS L, fol.2v (Marani 1979, II, cap.XI–XIII, p.111); Reggio, BMRE, Venturi copy of MS E, fols 2v and 13r (Mussini 1991, figs 18 and 15); New Haven, BL, MS B, fol.2v; Venice, BMV, fols 7v, 8r and v.
OTHER REPRESENTATIONS Vicenza, BBV, fol.113r, [1] no.7, [2] nos 8 and 9, [3] no.11; Pietro Cataneo, [3] Uffizi 3318A.

72

Fortifications
SJSM, vol.120, fol.4r

A plan of a polygonal moated fortification with a subterranean passage below the moat. The diagram shows how supplies were stored in the fortress. There is a well in the central keep, and rooms of different sizes for the storage of wood and wine on the ground floor, and grain, meat, vinegar, flour, oil, salt, etc., on the upper floor. Arms, balisters, blowpipes, bows, muskets and gunpowder were stored on the top floor, as far away as possible in case of accident.

OTHER MANUSCRIPTS Turin, BR, MS T, fol.4v, inscribed *Fondo di cittadella* (Maltese 1967, I, p.10, line 8–p.11, line 10; p.253, tav.4); Florence, BML, MS L, fol.2v (Marani 1979, II, cap.XIII–XV, p.111); Reggio, BMRE, Venturi copy of MS E, fol.13r (Mussini 1991, fig.15); New Haven, BL, MS B, fol.2v; Venice, BMV, fol.9r.

OTHER REPRESENTATIONS Vicenza, BBV, fol.99v, no.10; Pietro Cataneo, Uffizi 3326A.

73

Fortifications
SJSM, vol.120, fol.4v

Polygonal fortifications show bridges across the ditches for the defending soldiers to enter and the system of courtyards inside the fort.
[1] An arcaded gallery facing the keep in the inner wall of the ditch outside the moat runs around the circuit; it reinforces the wall and provides shelter for the troops guarding the fortress, unseen by soldiers outside. Defending soldiers enter the fort across bridges. The interior courtyards, which are used to accommodate cavalry or infantry according to the keeper's wishes, are surrounded by double walls.
[2] A fortress with two connected keeps, with the entrance organized so that there is only one entrance bridge and a second door for each keep. The fortress is subdivided and the bridges are arranged for the use of each keep, so that no-one can enter without common agreement. The entrances to the towers are above the scarp and entered by drawbridge. The four courtyards are shown full of water, not mentioned in the text. Two of the courts are filled with water in MS L; this detail is not clearly specified in MS T.

OTHER MANUSCRIPTS Turin, BR, MS T, fol.5r, inscribed *Divisioni di cittadelle fosse pi/azza rivellini scharpe ba[r]ba/chani e tori* (Maltese 1967, I,

p.11, line 10–p.12, line 14; p.253, tav.5); Florence, BML, MS L, fol.3r (Marani 1979, II, cap.XV–XVI, p.111); New Haven, BL, MS B, fol.3r; Venice, BMV, fols 11r and 13v; Reggio, BMRE, Venturi copy of MS E, fol.14r (Mussini 1991, p.146, fig.20).
OTHER REPRESENTATIONS Vicenza, BBV, [1] fol.99r, no.16, [2] fol.99v, no.15; Pietro Cataneo, [2] Uffizi 3317A.

74

Fortifications and casemates
SJSM, vol.120, fol.5r

[1, 2] A triangular fortified plan, one angle turned towards the offensive and several returns made in the wall behind it and behind the other two angles, which have the entrance and the keep between them; it is secure without building more towers. The fortress has walls 25–30 *piedi* thick. In the second plan, Francesco shows how to secure a circular circuit of walls and defend its flanks without building towers: '[draw] a circle the size of the place to be fortified and a larger circle 15 *piedi* outside it and draw straight lines from the centre to both circumferences and connect the lines of intersection of the two circles with the walls'.

Both plans are developed in MS M (Maltese 1967, II, p.451, tav.260). Leonardo sketched them in Codex Atlanticus (Milan, BA, fol.132r; Marani 1984, pp.198–9, cat.118), and both plans are shown on Antonio da Sangallo's sketches for the Fortezza da Basso, Florence (Uffizi 758A; Frommel & Adams 1993, pp.125–6).
[3] A polygonal fortress with ravelins, traditional protective structures built at the entrances in a variety of shapes. A ravelin designed by Francesco, following the shape of the polygonal tower on fol.2v (cat.69), survives in plan at Costacciaro in the Marche, built in 1477 (Siena 1993a, pp.208–10).
[4] A casemate – a low, bomb-proof

shelter with gun embrasures on the sides – was placed at the angles of the fortress walls to give the defenders a field of horizontal fire at the foot of the main fortification (Pepper & Adams 1986, p.18, n.37). Built quickly and joined to the wall by a passage, they were manned by a few men with light arms. They could be demolished easily from the keep.
[5] Details of casemates of different plans and sections.
[6] Metal rings, corresponding to the circumference of a cannon-ball, with cross-struts were inserted in the holes made by cannon to reinforce the wall.

OTHER MANUSCRIPTS Turin, BR, MS T, fols 4v–5v (Maltese 1967, I, p.12, line 14–p.13, line 21; p.253, tav.4–6); Florence, BML, MS L, fol.3r, inscribed [1] *fo[r]ma ad a[n]golj*; [2] *fo[r]ma ci[r]chulare a[n]golata*; fol.3v, inscribed [4] *pirami/dale–da fare i[n]fondo de fossj*; [5] *chanpanata–Achuta–Capan[n]ata hove[r] testudo*; [6] *croce di fe/ro p(er) le bonbar/diere* (Marani 1979, II, cap.XVI–XVIII, p.111); Reggio, BMRE, Venturi copy of MS E, fols 13r and 14r (Mussini 1991, figs 15, 17 and 20); New Haven, BL, MS B, fol.3r and v; Venice, BMV, fols 11v–14r, 15r.
OTHER REPRESENTATIONS Vicenza, BBV, [1] fol.99r, no.12, [2] fol.99r, no.13, [3] fol.83v, no.14, [4] fol.83r, no.17, [5] fol.83r, no.18; Pietro Cataneo, [1] Uffizi 3323A; [2] Uffizi 3328A.

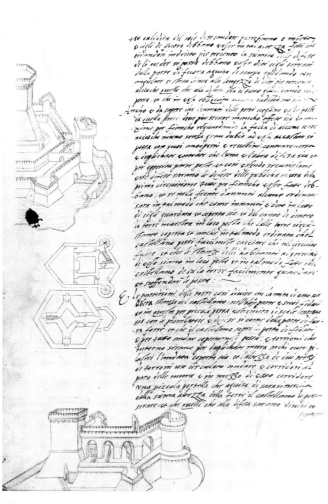

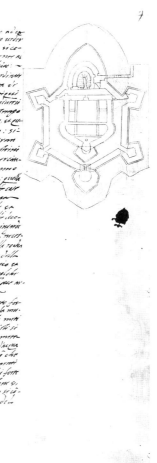

71

72

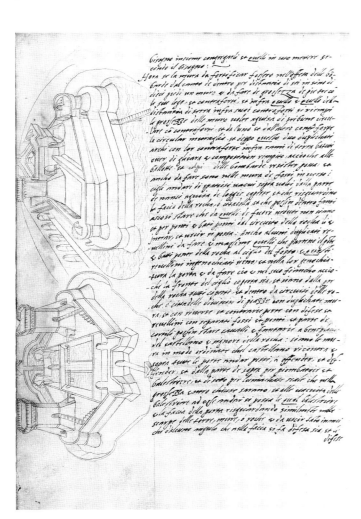

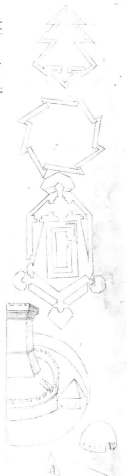

73

74

75

Fortifications

SJSM, vol.120, fol.5v

[1] A section showing the construction of a scarped tower with concentric walls built of drafted tufa, stone blocks or brick and filled with finely ground rubble and mortar. The concentric walls are linked by wooden beams and the total width of the wall is two-thirds the diameter of the tower. The rusticated tower recalls the circular towers of the Castello Sforzesco in Milan, of c.1450.

[2] A fortress with a drawbridge suspended on two beams acting as a counterweight.

[3] A bird's-eye view of an octagonal fortress showing an elaborate ditch, in which casemates or pill-boxes are used as protected passageways as well as the means of delivering flanking fire (Pepper & Adams 1986, p.19). The bridge is protected by a range of traps: spikes to lame horses, holes in the ground covered with branches, barricades with spikes and ravelins built of wattle. Such traps were used in both ancient and modern military practice.

They are shown more clearly in *Opusculum* (London, BM, fol.41v).

OTHER MANUSCRIPTS Turin, BR, MS T, fol.5v (Maltese 1967, I, p.13, line 21–p.15, line 4; p.254, tav.6); Florence, BML, MS L, fol.3v, inscribed [1] *vano–ghiara–pietre tufignie* (Marani 1979, II, cap.XVIII–XX, p.111); New Haven, BL, MS B, fol.3v; Venice, BMV, fol.14r; Rome, BAV, *Codicetto*, [3] fol.45v.

OTHER REPRESENTATIONS Vicenza, BBV, [1] fol.83r, no.19, [2] fol.41r, no.21, [3] fol.41r, no 20; Pietro Cataneo, [4] Uffizi 3317A; Oreste Vannocci Biringucci, Siena, BC, fol.99v.

76

Drawbridges and a corridor bridge

SJSM, vol.120, fol.6r

[1] A drawbridge, its length corresponding to the height of the tower, is suspended from double chains with a counterweight and lowered over pulleys. The counterweights shown in MSS T and L are not represented here.

[2] A drawbridge suspended from two chains joined by a ring is raised and lowered by a beam acting as a balanced lever, with a chain attached to raise and lower it.

[3] A corridor bridge on two wheels working in channels on either side of a narrow gate is extended by a winch on the bank, which is attached by rope to bronze pulleys at the entrance to the gate and to the end of the bridge. Similar bridges with technical improvements are drawn in MS M (fols 55v–56r); the corridors are strengthened to support cannon. The text to fol.7v on fortified bridges in chapter II is based on Francesco's practice. The drawing on fol.97v of Leonardo's Madrid Codex (BN, II, no.8936) is copied from the version of these bridges in MS M

(Reti 1974, II, fol.97v, V, p.196; Mussini 1991, p.166, n.18).

Drawbridges were also built for peaceful purposes. At the end of the 15th century the Rialto bridge in Venice was rebuilt in timber with a central section that could be raised and lowered (Parsons 1968, pp.507–8).

OTHER MANUSCRIPTS Turin, BR, MS T, fol.5v, inscribed [1] *ponte co[n] chatene/e charuchole dalle/vare*; [2] *ponte levatoio*; [3] *ponte choridoio* (Maltese 1967, I, p.15, line 4–p.16, line 25; p.254, tav.6–7); Florence, BML, MS L, fols 3v–4r (Marani 1979, II, cap.XX–XXII, p.111); New Haven, BL, MS B, fol.4r; Venice, BMV, fols 15v and 16v; Florence, BNCF, MS M, fols 55v–56r (Maltese 1967, I, tav.250–51).

OTHER REPRESENTATIONS Vicenza, BBV, [1] fol.87r, no.22, [2] fol.87r, no.24, [3] fol.59v, no.23.

77

Corridor bridges

SJSM, vol.120, fol.6v

[1] A similar bridge to that on fol.6r[3] (cat.76) can be operated without a winch on the opposite bank by inserting a straight beam with a set square on it below the corridor in the centre, and adding square panels of wood to increase the length of the bridge. The set square will keep the corridor level and reinforce it.

[2] A corridor bridge that is wound out by means of a worm-screw and gear.

[3] A bridge that is wound out by a worm-screw and gear has a flat, smooth, angled box attached to it. The box is well joined so that water cannot get in; it will float and support the bridge on water, and will also provide added weight and solidity.

OTHER MANUSCRIPTS Turin, BR, MS T, fol.6r, inscribed [1] *ponte chor[r]/idoio scho[m]/messo i[n] due/pezzi*; [2] *ponte sop[r]a/rulli p[er] chana/le della vita ch/acciato*; [3] *ponte cho[r]rido/io che sop[r]al/aqua el pondo regia[r] possa* (Maltese 1967, I, p.16, line 26–p.17, line 26; p.254, tav.7); Florence, BML, MS L, fol.4r (Marani 1979, II, cap.XXII–XXIII,

p.111); New Haven, BL, MS B, fol.4r; Venice, BMV, fol.16v.

OTHER REPRESENTATIONS Vicenza, BBV, [1] fol.83r, no.25.

78

Fortification

SJSM, vol.120, fol.7r

The illustration shows a bird's-eye view of the fortified arrangement for elevated or flat sites, which Francesco considered most secure from cannon and other war machines: 'The master tower or keep is in the shape of a rhombus with its angle turned toward the offensive. The interior of the tower will be more or less 40 *piedi* wide according to the site, the walls 18–20 *piedi* thick; it will be scarped to two-thirds of its height, with defensive structures or machicolations above and below it. A vaulted ravelin [like the one shown on fol.2v, cat.69] follows the line of the rhombus at the base. Around the ravelin is a ditch 30 *piedi* wide at the top and 25 at the bottom, and 30 *piedi* from the ditch is a second wall in the shape of the rhombus and that wall is at least 20 *piedi* thick, scarped to two-thirds of its height, with a round tower 40 *piedi* wide at each angle with smaller towers above them following their lines 30 *piedi* wide and 40 high so that there is a passage above the large towers around the whole defensive structure, which should be machicolated. The towers

should be connected to the keep by an arcaded passage fitted with Saracen gates so that the keeper can close areas of the fort and maintain troops on the gangways below the smaller towers; if he wants to put troops on the elevated passages he can place 40 men, 10 to a passage, and close off the gates. The fort is defended by a ditch 50 *piedi* wide and 40 high with a bank (*ciglio*) so high that only the machicolations can be seen from outside.'

Leonardo's fortress plan in the Madrid Codex is probably based on this plan (fol.79r; Marani 1984, pp.229–30, cat.142).

OTHER MANUSCRIPTS Turin, BR, MS T, fol.6v, inscribed *Roccha quadrijpartita –fosso* (Maltese 1967, I, p.17, line 27–p.18, line 26; p.254, tav.8); Florence, BML, MS L, fol.4v (Marani 1979, II, cap.XXIII, p.111); Reggio, BMRE, Venturi copy of MS E, fol.15v (Mussini 1991, fig.25); New Haven, BL, MS B, fol.4v; Venice, BMV, fol.18v.

OTHER REPRESENTATIONS Vicenza, BBV, fol.59r, no.28.

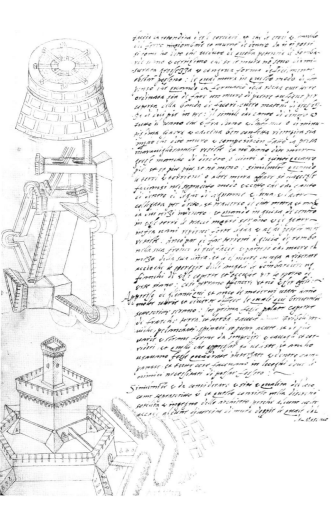

75

76

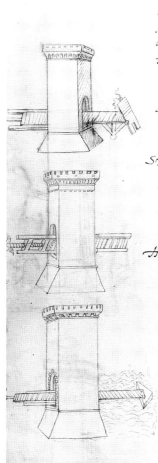

77

78

Fortifications
SJSM, vol.120, fol.7v
No illustration

79
City plans
SJSM, vol.120, fol.8r

[1] A diagram showing a male figure, his legs together and his arms out-stretched, circumscribed within a circle and a square, as described by Vitruvius in book I. Francesco di Giorgio uses Vitruvius' idea of symmetry in temple design in book III as a justification for using the circle and the square as the basis for city plans. He gives two categories of city, fortified and unfortified. The *homo ad circulum* is considered a microcosm and the ideal model for the concentric city. The cathedral corresponds to the umbilicus; other temples and points of the city are likened to the eyes, ears, nose and mouth, which are embodied in the diagram as the head, hands and feet touching the circumference of the circle.
[2–7] Francesco departed from Vitruvius by extracting an octagon from the figure, and the first and fourth plans illustrated are octagonal with central octagonal piazzas and radial streets with squares half-way along them; one has ravelins in front of the entrances. Octagonal city planning, probably based on ancient sources, survived in Italy at Castel del Monte (Ledoux 1984, pp.19–25). Rather than follow Vitruvian planning based on a rectangular piazza and blocks, Francesco adapted the shape of the central piazza to the radial street system and the city's circumference (De la Croix 1960, pp.270–72, figs 11 and 12). The text reads: 'Hill-top towns should be in a fertile site near a river to power the mills and other machines and to supply cisterns and fountains. The streets should be organized so that they are not too steep, and follow the con-tours of the hill in a circular or spiral plan like a snail's shell. Major public streets with the most important mer-cantile buildings and piazze on them are on axis with the piazza and connect it to the gates. The most important public buidings, the fortress or cathe-dral, are on the piazza. Churches on piazze will be directly connected with the major streets.'
 For the human analogy and the city, see Lowic 1983, pp.360–70; for Leonardo's diagram of the human analogy, see Mussini 1991, pp.183ff. and p.211, n.114, figs 48 and 49. See also fols 26v, 36v and 37r (cat.110, 125, 126).

OTHER MANUSCRIPTS Turin, BR, MS T, fols 6v–7r (Maltese 1967, I, p.20, line 6–p.21, line 7, tav.8–9); Florence, BML, MS L, fol.5r, inscribed [1] *fo[r]mation di citta a faccia/e angolj*; [2, 5] *Tera chone strade/graduate*; [3] *Ter[r]a chone strade/hubliquate a ghiu/xa di se[r]pe*; [6] *Ter[r]a a chuixa e fo/rma di lomache i[n] nelle ho[r]denate str/ade*; [7] *Ter[r]a a chiuxa e fo[r]ma di due cho[n]trarie lomache/hop[p]oxite luna/a laltra i[n]n/elle stra/de sue* (Marani 1979, II, cap.XXV–XXVI, p.111); New Haven, BL, MS B, fol.5r; Venice, BMV, fols 19v, 20v–21v.
OTHER REPRESENTATIONS Vicenza, BBV, [1] fol.59v, no.34, [5] fol.59v, nos 29–32.

80
Angular city plans
SJSM, vol.120, fol.8v

Francesco recommended that city cir-cuits should be planned with reversed angles, like hooks, or with obtuse angles, which are easy to guard. Cir-cular towers are built on the projecting angles.
[1] A half-plan of a city in the shape of a rhombus with a square central piazza, a straight grid of streets and two parish churches to the left and right of the main square
[2] An octagonal plan with a circular central piazza and radial streets that widen into piazze half-way along on the axes with the entrance gates. The piazze are connected by concentric streets. A town was constructed according to this plan in the late 16th century at Palmanova (De la Croix 1960, p.271).
[3] A quarter-plan of a city with right-angles in the outline of the city walls, corner towers, a central square piazza and a grid of streets.
[4] A half-plan of a city with right-angles in the outline of the city walls, corner towers, a central square piazza and a grid of streets.
[5] A half-plan of a city with right-angles in the outline of the walls, two square piazze in the centre and a grid of streets.
 The plans are repeated in MS M.

OTHER MANUSCRIPTS Turin, BR, MS T, fol.7v (Maltese 1967, I, p.21, line 7–p.22, line 9; pp.254–5, tav.10); Florence, BML, MS L, fol.5v, inscribed [1] *formatione di ter/ra a guixa di/ronbo a[n]golare*; [2] *Ter[r]a a fo[r]ma e guixa di lom/acha sichome nellaltra faccia/si denota*; [3] *terra e forma di retti angholi–gholi–modi* (Marani 1979, II, cap.XXVI–XXVIII, p.111); New Haven, BL, MS B, fol.5v; Venice, BMV, fols 22v–23r; Florence, BNCF, MS M, fols 28v–29v (Maltese 1967, II, tav.213).
OTHER REPRESENTATIONS Vicenza, BBV, fol.109v.

81
City plans and the siting of public buildings
SJSM, vol.120, fol.9r

[1] A polygonal plan of a city with two piazze and a rectangular grid of streets. The cathedral is close to the main square at the top of the plan. Francesco comments: 'the town hall should be on the square as well as a spacious loggia for the merchants. The second piazza is reserved for the market. The parish churches are on small piazze on the cross-axes; for visibility their entrances should be on axis with the streets. The city council, prison, custom-house and salt store should be close to the market square, the taverns as remote from view as possible from both piazze.'
[2] A half-plan of a city situated on a river that passes through the centre of the city. The text reads: 'The entrance and exit of the river to the city should be clear and weirs or dams should be made so that the impetus of water dur-ing flooding cannot damage the city. Inside the city walls the level of the water should be controlled by locks, which will protect the bridges from the fury of the water. The city is defended by rhombus-shaped fortifications where the river enters and leaves the city; mills can be constructed near them to use the level variations and velocity of the current generated by the river and the locks. Set up spiked barricades [such as those on fols 79r, 89r, cat.207] so that the entrance to the city can be secure from attack should the locks fail. Inside the city build a scarp and high walls along the river as extra protection from flood water. Spacious straight streets should be laid with buildings with porticos in square blocks as high as they are wide, and cross streets perpendicular to them; at the crossing of the grid a piazza can be sited.'

OTHER MANUSCRIPTS Turin, BR, MS T, fol.7v (Maltese 1967, I, p.22, line 7–p.23, line 8; p.255, tav.10); Florence, BML, MS L, fol.5v, inscribed [1] *formatione e partime[n]tj dan/prissima citta–chiexa chatedrale–piaza–strade–chasame/ti-principal piaza*; [2] *fo[r]matione e partime/ntj della citta che sop[r]al fiume hedificata sera–cittadella–fiumara–cittadella–Ricietto/navi* (Marani 1979, II, cap.XXVIII– XXX, p.111); New Haven, BL, MS B, fol.5v; Venice, BMV, fols 23r and 24v.
OTHER REPRESENTATIONS Vicenza, BBV, fol.109r; Pietro Cataneo, Uffizi 3292A; Oreste Vannocci Biringucci, Siena, BC, fol.90v.

79

80

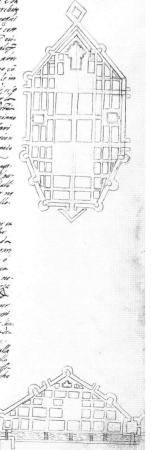

81

City planning
sjsm, vol.120, fol.9v
No illustration

82
Cities near harbours
sjsm, vol.120, fol.10r

The text reads: 'When a city is built near a harbour, the city must follow the nature of the site. If the city is fortified, the fortress must be above the city and harbour so that it can function both offensively and defensively. The port should be organized so that vessels can easily enter and leave the port. Warehouses, storerooms and reservoirs for water should be arranged inside the harbour.'
[1] The first plan shows a polygonal city with two rectangular piazze in the centre and a rectangular grid of streets leading to the gates, which have polygonal perimeter walls. A fortress

defends the entrance to a natural u-shaped harbour with a curving jetty and warehouses behind it.
[2] A polygonal walled city with a square central piazza and a square grid of streets has a polygonal fortress at the mouth of a river. Francesco comments: 'A harbour at the mouth of a river can become blocked by sand and rubble driven in by the waves and winds. To prevent this lay on the seabed semicircular iron grilles, made with iron bars arranged like a fan, so that the angle of their incline opposes the motion of the waves and prevents the sand and stones being drawn into the port.'
[3] A polygonal city with rectangular piazze and a square grid of streets is situated on a site without a natural port. The text reads: 'Two tall, wide towers 100 piedi apart are constructed in the water with walls connecting them to the city; a wall is built between them with an acute angle, like a ravelin,

which can resist the force of the water. The ships can enter and leave the port through the passages between the towers and the sea wall. The warehouses are inside the port, along the sea wall in front of the city.'

OTHER MANUSCRIPTS Turin, BR, MS T, fol.8r (Maltese 1967, I, p.24, line 11–p.25, line 14; p.255, tav.11); Florence, BML, MS L, fol.6r, inscribed [1] maghaxeni–molo–marina–marina–roccha; [2] marina–fiumana–rocha; [3] marina–entrata–molo–entrata–magaxeni–marina–ter[r]a–ter[r]a (Marani 1979, II, cap. XXXI–XXXII, p.111); New Haven, BL, MS B, fol.6r; Venice, BMV, fol.26r and v.
OTHER REPRESENTATIONS Vicenza, BBV, fol.111v; Pietro Cataneo, Uffizi 3292AV.

83
Dykes, weirs, bed of a lock
sjsm, vol.120, fol.10v

[1] A perspective of a sea wall, to prevent the erosion of the shoreline close to a city. A dyke of triangular section is constructed of parallel beams joined together by beams at right angles to them; it is filled with earth and rubble and covered by panels of wood. Francesco comments: 'To make them particularly strong, when they are almost full of lime and rubble place large square stones on top before covering them with panels of wood.'
[2] A perspective showing the bed of a lock, of semicircular section, reinforced with wooden beams laid parallel and perpendicular to each other; the square sections are filled with lime and rubble and covered by panels of wood, well joined and nailed down.
[3–5] Weirs buttressed by wooden beams. Weak banks can be reinforced by a wall of beams laid against vertical beams driven into the river bed and carried by diagonal beams to piles in the river bed behind them. A weir, made from a double curved barricade filled with rubble and connected by diagonal beams to piles driven into the river bed, provides extra strength.

The chapter on hydraulics, to fol.14v, derives from Francesco's practice and from Taccola's De machinis (Siena 1991, p.64).

OTHER MANUSCRIPTS Turin, BR, MS T, fol.8r and v (Maltese 1967, I, p.25, line 15–p.27, line 4; p.225, tav.11–12); Florence, BML, MS L, fol.6v, inscribed [1] chiusa e chal/icie dove la/marina molto/frangiesse; [2] [chiu]sa a semi/[cir]chulo; [3] Riparo chon dup[r]ichatj stegli/di creta pieno–creta; [4] d'asse ettravj–di[n]traversale travj edj…etti e cholleghatj stellj e i[n]fra/[qua]drj loro di ghiara et chalcie rie[n]pite (Marani 1979, II, cap.XXXII–XXXIV, p.111); New Haven, BL, MS B, fol.6v; Venice, BMV, fols 26v and 27v; Rome, BAV, [4] Codicetto, fol.111v.
OTHER REPRESENTATIONS Vicenza, BBV, [1, 2] fol.93r, [3–5] fol.109v; Pietro Cataneo, Uffizi 3292Ar and v; Oreste Vannocci Biringucci, Siena, BC, fols 99v and 100v.

84
Lock
sjsm, vol.120, fol.11r

The elevation and section of a lock constructed from timber beams with a sluice-gate for the downflow of water (Siena 1991, p.323).
[1] The bed of the lock is reinforced with a grid of wooden beams, the spaces between them filled with concrete.
[2] The elevation of the lock shows the reinforced bed and the Saracen gate in the lock.
[3] A section of the wooden reinforcement of the Saracen gate.

OTHER MANUSCRIPTS Turin, BR, MS T, fol.8v (Maltese 1967, I, p.27, line 4–p.28, line 8; p.255, tav.12); Florence, BML, MS L, fol.6v, inscribed [1] Chiusa chol[l]egata di riquadra/te travi e stellj di chompoxitio/ne i[n]fra suo quadrj riepita; [2] Chiusa cholle sue portelle dove/laccqua aven[n]do lexedo edoppo/la sua hedifichatione p[er]/le se/rate; [3] Modo di chiusa a chiuxa/da[r]mate travj (Marani 1979, II, cap.XXXIV, p.111); New Haven, BL, MS B, fol.6v; Venice, BMV, fol.30v.
OTHER REPRESENTATIONS Vicenza, BBV, [1, 3] fol.111r, [2] fol.87v; Pietro Cataneo, Uffizi 3293Ar and v.

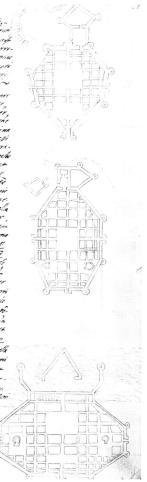

82

83

84

85

Dams and breakwaters

SJSM, vol.120, fol.11v

[1] A double, straight barricade, supported on beams driven into the river bed and connected by diagonal beams to piles driven into the river bed behind them, is covered by square panels of wood (for pile drivers, see fol.65bis r, 75r, cat.187).

[2] Wedge-shaped cases, 12–13 *piedi* long and 3–5 *piedi* wide, are filled with pebbles and arranged at the edge of a stream so that the wide ends lie against the narrow ends of the cases. They deflect the flow of the stream and prevent erosion of the banks.

[3] Jetties, made by driving stakes into the sea-bed and connecting them with wattle, are filled with lime and rubble to protect the city walls from erosion. Taccola suggests that barrels filled with stones should be sunk into the river bed as a breakwater to divert the flow of the river (*De machinis*, fol.14v; Scaglia 1971, I, p.82, II, fol.14v).

OTHER MANUSCRIPTS Turin, BR, MS T, fols 8v–9r (Maltese 1967, I, p.28, line 9–p.29, line 10; p.255, tav.12–13); Florence BML, MS L, fol.7r, inscribed [1] *riparo didirittj stegli enchollegate/travj e*

asse e i[n]fral vano suo dicreta/rienpire–Chiusa sotto el detto riparo; [2] *Rostatoio di ghiara e ccalce/forme d'a[n]golate chasse*; [3] *Rostatoie di tessuti lengnj pulanghe/e steglj di ghiara e gravedine fra/suoi vani ripieni* (Marani 1979, II, cap.XXXIV, p.111); New Haven, BL, MS B, fol.7r; Venice, BMV, fol.31r; Rome, BAV, *Codicetto*, [2] fol.15r.
OTHER REPRESENTATIONS Vicenza, BBV, [1, 2, 5] fol.93r, [3] fol.111r; Pietro Cataneo, Uffizi 3295A.

86

Dams and an artificial lake

SJSM, vol.120, fol.12r

Dams were built to divert water from streams either temporarily or for specific, long-term purposes, to control rivers or to raise the level of the water above the surrounding area.
[1] Francesco writes: 'Dams to divert streams temporarily can be made quickly with twigs of willow and elder covered with earth, or with stakes and wattle filled with rubble and earth.'
[2] He advises: 'Before creating an artificial lake, first check that the site is suitable and will provide a firm bed and strong banks to receive the water from the mountains that will supply the lake; that the water will not carry stones and rocks down from the mountains; that the site will supply a range of depths to support a variety of fish. There should be large stones where the fish can lay eggs and long grasses for the fish to graze in. All trees and their roots must be pulled out or burned, otherwise fish will not live there. A fish pond [*peschiera*] and cave must be created where the fish can be released … Locks on the lake should be high enough for the downflow of water to find an exit, otherwise the water must pass through

the channel in the lock itself, which reduces the downflow of water.' The illustration shows the innovative use of a winched Saracen gate for controlling rivers. In 1468 the Sienese republic wanted to create a fishing reserve by damming the River Bruna to supply the state with fish, which had to be imported from Lake Trasimeno. In the early 1490s Francesco was invited to advise on the project, which was not completed (Siena 1991, pp.319ff.; for the dam on the River Bruna, see Adams 1984). For the design and construction of dams, see Smith 1971; Hill 1984, pp.47ff.

OTHER MANUSCRIPTS Turin, BR, MS T, fols 8v–9r (Maltese, 1967, I, p.29, line 10–p.30, line 14; p.255, tav.12–13); Florence, BML, MS L, fol.7r, inscribed [1] *Chiusa di viminj e gioc[c]chi e/riettj fatta–Chiusa inpertichatj e palang/di ghiara piena aforma gra[d]uata*; [2] *Lagho chol suo sboch/atoio* (Marani 1979, II, cap.XXXIV–XXXV, p.111); New Haven, BL, MS B, fol.7r; Venice, BMV, fols 31r and 32r; Rome, BAV, *Codicetto*, fols 68r and 92r.
OTHER REPRESENTATIONS Vicenza, BBV, [1] fol.41r; Pietro Cataneo, Uffizi 3295A.

87

Foundations for bridges

SJSM, vol.120, fol.12v

[1–3] The illustrations show foundations for bridges. The text reads: 'If the river bed is not firm a foundation can be made by driving very thick piles in the river bed in a rhombus shape. Alternatively thick panels of wood, which have been pierced, are laid where the piers of the bridge will be built, and tightly fitting stakes are driven through the holes. The spaces below the panels of wood are filled and the pier of the bridge is built on top of it.' [3] shows boxes in the form of long, acute pyramids placed upside down in a frame of thick beams and filled with cement.
[4] Diagrams of the wooden frameworks that are filled with cement and attached to the piers of a bridge to join the piers together.
[5] A wooden, structural frame of triangular section of the blade of a bridge.
[6] A perspective half-elevation of a bridge showing the oval vaulted foundations used on a subsiding site. The

foundations drawn in MS M (fol.52r; Maltese 1967, II, pp.432–3), suitable for a soft, subsiding site and which Francesco had seen at the temple of Minerva in Rome, have oval, arched reinforcements as in these foundations, made by two upturned arches, each one raised by a quarter of its radius. They are also drawn in MS T, on fol.85v.

OTHER MANUSCRIPTS Turin, BR, MS T, fol.9r and v (Maltese 1967, I, p.30, line 14–p.31, line 15; p.255, tav.13–14); Florence, BML, MS L, fol.7v, inscribed [1] *fo[n]do palifi/chato a chiuxa di/ronbo*; [2] *fo[n]do pali/fichato ch/[on] forrati… celli*; [3] *Chasse piramidalj di chal/cie e ghiara piene*; [4] *aghuisa/atetro–di chollegate travj/e stellj* (Marani 1979, II, cap.XXXV–XXXVI, p.111); New Haven, BL, MS B, fol.7v; Venice, BMV, fols 33v, 34r and 35v.
OTHER REPRESENTATIONS Vicenza, BBV, [1, 3, 4] fol.91r, [2, 6] fol.87r; Pietro Cataneo, Uffizi 3292Ar and Uffizi 3295Ar; Oreste Vannocci Biringucci, Siena, BC, fols 80r and 88v.

88

Bridge

SJSM, vol.120, fol.13r

A triple-arch bridge on triangular piers with a tower at one end. In his text Francesco notes that the piers should be in the shape of a rhombus with the angle of the blades above the water, and that the arch of the vault should be raised by a quarter of the radius, to increase the strength of the piers and the shoulders of the arch. The river bed should be firm and the shoulders of the bridge well built to resist sudden flooding; the arches need to be high enough to receive the water and to allow floodwater to escape.

The shape of the bridge recalls Ponte Fabricio in Rome as drawn by Fra Giocondo in Codex Destailleur (St Petersburg, Hermitage, fol.55r; Fontana 1988, fig.29).

OTHER MANUSCRIPTS Turin, BR, MS T, fol.10r (Maltese 1967, I, p.31, line 15–p.32, line 14; p.255, tav.14); Florence, BML, MS L, fol.7v, inscribed *Formatione de pontj/che sop[r]a aglianghola/rj pilastrj*

da hedifich/are (Marani 1979, II, cap.XXXVI, p.111); New Haven, BL, MS B, fol.7v; Venice, BMV, fol.34v.
OTHER REPRESENTATIONS Vicenza, BBV, fol.87v; Pietro Cataneo, Uffizi 3292Ar; Oreste Vannocci Biringucci, Siena, BC, fol.100r.

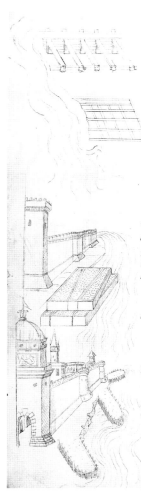

85

86

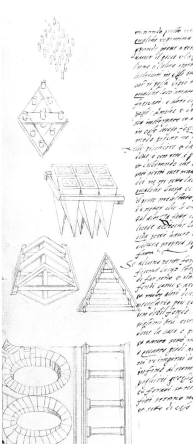

87

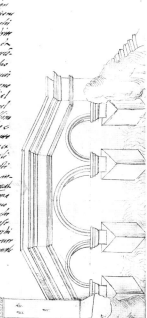

88

89
Foundations for a marshy site
SJSM, vol.120, fol.13v

Francesco writes: 'To lay foundations in a marshy site make two parallel walls, 3 or 4 *piedi* apart, any shape you like, with square beams joined with dovetail joints along their length. fill the spaces between the walls with clay. Either clear the space in the middle or fill them with piles so that you can build. If you are working on a site that cannot be approached by boat or on foot, you begin at the shore and build a path with two lines of piles filled as described until you reach the place where you want to build.'

OTHER MANUSCRIPTS Turin, BR, MS T, fol.10r (Maltese 1967, I, p.32, line 15–p.33, line 16; p.255, tav.15); Florence, BML, MS L, fol.8r, inscribed *di duprichatj tigillj che lu[n] laltro cho/mette i[n]fral suo vano di creta pieno–palude* (Marani 1979, II, cap.XXXVI–XXXVIII, p.111); New Haven, BL, MS B, fol.13v; Venice, BMV, fol.35r; Florence, BNCF, MS M, fol.89r (Maltese 1967, II, p.490, tav.315). OTHER REPRESENTATIONS Pietro Cataneo, Uffizi 3316A.

90
Cofferdam method for draining a site
SJSM, vol.120, fol.14r

[1] The text reads: 'To build a tower at sea measure the depth and make two circles of small piles to that height. In the first circle the piles will have ⅛ of a module between them, and a bottom with well-joined piles that is filled with rocks and stones and sunk to the sea-bed. The second circle, inside the first, has no spaces between the piles, and no bottom; it is filled with clay well-battered down so that the space between the circle and the reef is filled before excavating the foundations in the normal way.' Francesco does not mention whether the site is drained or not. The concrete must be made with fresh water. The cofferdam method of clearing a site of water before building is explained, not entirely clearly, by Vitruvius (book V, cap.XII; Granger 1931, p.314). The method is clearly illustrated in Taccola's *De ingeneis* (book III, fol.46r; his description, book III, fol.42r and v, is translated in Prager & Scaglia 1972, pp.100–01, figs 48–9). Francesco paraphrased Taccola's description, which is the clearest, and Leonardo transcribed the passage in Codex Atlanticus (Leonardo 1975–80, fol.774v; Marani 1979, cap.XXVII, p.17; Marani 1984, cat.179), but neither Francesco nor Leonardo make clear that the method was used to clear a site of water rather than as part of the foundation system of the building. Taccola shows the cofferdam as the foundation of the tower above it. This illustration, identical to MS L, shows the base of a square masonry tower constructed within a circular barrier holding the water out. The Romans built a cofferdam of wood on shore or on a boat, with a double wall of planks, the space between the walls filled with clay. The cofferdam was floated out to sea, sunk and weighed down in position and water was pumped out with a tympanum or Archimedes screw; the foundations for the building were then excavated (Hill 1984, p.13).
[2] Four boats are lashed together by wooden beams so that a square space is left in the centre between them. Canvases, attached by ropes to winches, hang from the sides and a web of thick ropes forms the bottom of a box-shaped net in the space between the ships. This is filled with building materials that are gradually lowered to the sea-bed by their own weight and by the winches. Francesco notes that the material should be allowed to settle for 30 to 40 days before building on it. The method is repeated in MS M, fol.89r, where he writes that the foundation should be left for at least a year to settle.

OTHER MANUSCRIPTS Turin, BR, MS T, fol.10r (Maltese 1967, I, p.33, line 17–p.34, line 19; p.255, tav.15); Florence, BML, MS L, fol.8r, inscribed [1] *Creta–fo[n]do di torre–circhulari chomessi e duprichatj tr..*; [2] *E quatro navilj cho/cholla ir[r]etita ch[assa]/gli a[r]ghani ghia/re sop[r]al man…dallacqua as…[ede]fichare si po [tra]l* (Marani 1979, II, cap.XXXVIII, p.111); New Haven, BL, MS B, fol.13v; Venice, BMV, fol.36r and v; Florence, BNCF, MS M, fol.89r (Maltese 1967, II, pp.490–91, tav.315); Rome, BAV, *Codicetto*, [1] fol.48r, [2] fol.64r.
OTHER REPRESENTATIONS Vicenza, BBV [1] fol.91r, [2] fol.93r; Pietro Cataneo, Uffizi 3316A; Oreste Vannocci Biringucci, Siena, BC, fol.111v.

91
Amphibious carts and bridges; the box or caisson method of laying foundations at sea
SJSM, vol.120, fol.14v

The folio shows [1] a rowing boat mounted on four empty barrels that act as wheels on dry land and float on water; [2] a boat mounted on wheels; [3] a flat cart without sides and with solid wheels; [4] a bridge on empty wooden chests that float; [5] a bridge on empty wooden barrels; and [6] the *caisson* method of laying foundations at sea.
Taccola shows a bridge of barrels in *De ingeneis* (book II, fol.108r). He describes the *caisson* method of laying foundations at sea: 'Join four ships together on shore and on the four ships build a square box of well-joined oak or pine and fill the box with concrete made from stones, lime and sand mixed with fresh water. Float the structure out to sea on four boats to an underwater ledge. Holes that have been drilled in each boat are unplugged; they fill with water and sink to the bottom, anchoring the half-built tower to the floor of the sea. The construction of the tower is then finished' (*De ingeneis*, book II, fol.43r and v; Prager, Scaglia & Montag 1984, p.217; Prager & Scaglia 1972, pp.102–3, figs 50–51). Neither Taccola nor Francesco tells us whether the foundation was drained or how the building was continued.

OTHER MANUSCRIPTS Turin, BR, MS T, fol.10r (Maltese 1967, I, p.34, line 19–p.35, line 15; p.255, tav.15); Florence, BML, MS L, fol.8v, inscribed [1–5] *[car]rj da[n]dare p[er] lochj paludosj–ponti sopra'acqua*; [6] *Marina–da hedifichare sop[r]a lo schoglio marino/chole chonesse echollegate barche* (Marani 1979, II, cap.XXVIII, p.111); New Haven, BL, MS B, fol.8v; Venice, BMV, fols 37r and 38r; Rome, BAV, *Codicetto*, [2] fol.133r, [5] fol.89r, [6] fols 40r and 49r.
OTHER REPRESENTATIONS Vicenza, BBV, fol.15r; Pietro Cataneo, Uffizi 3316A.

Of temples, qualities of the architect
SJSM, vol.120, fol.15r
No illustration

Of temples, architect's education
SJSM, vol.120, fol.15v
No illustration

[manuscript text — left column, page 89]

[manuscript text — right column, page 90]

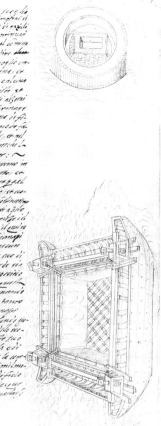

89

90

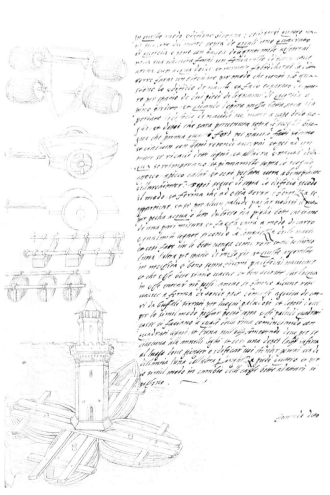

[manuscript text — page 91]

91

Architect's education

SJSM, vol.120, fol.16r

No illustration

92
Plans of temples

SJSM, vol.120, fol.16v

Francesco paraphrased Vitruvius, book III, cap.II, and defined six kinds of temples, categorized according to the number of columns and their relationship with the chamber walls of the temples: [1] temples in antis, temples with pilasters; [2] prostyle with columns in front; [3] pseudo-dipteros with columns all round set at a distance from the temple walls; [4] amphriprostyle with columns on both fronts; [5] peripteros with columns all round; and [6] hypaetral with the interior open to the sky (Granger 1934, I, pp.167–8). In Codex Zichy he illustrates the disposition of the columns in the interior of temples described by Vitruvius, whereas in MSS L and T ancient temple types are associated with church plans (Kolb 1988, p.150, fig.10). Campbell (1984, pp.155ff.) gives a good analysis of Francesco's understanding of the Vitruvian meaning of

these terms. [5] is not illustrated and [6] is illustrated on fol.17r[2] (cat.92). In his illustrations Francesco does not attempt to analyze Vitruvius' meaning, although he uses the terms to caption some of the plans in MS L. In MS T he reverts to descriptive captions. He offers two types of plans for the design of churches: the longitudinal basilica based on the human body, and central plans based on simple geometric forms (Lowic 1982, p.152). Both are found in Antique and Early Christian architecture. [1] A rectangular church with a single projecting apse and four niches contained within the walls on either side of the nave, as in the plan of S. Pietro in Montorio, Rome, begun in 1472 (Siena 1993a, p.359).
[2] A Latin-cross plan deriving from S. Spirito, Florence, with a nave with four niche chapels on either side, a single apse and projecting transepts with a screen of columns at their entrances and apses emerging on the exterior. The plan is close to Francesco's design for S. Maria delle Grazie al Calcinaio, Cortona (for the church, see Siena 1993a, pp.244–52).
[3] A circular plan with nine radiating apses and a central drum that is

supported on paired columns.
[4] An octagonal plan, based on a Roman tomb, with seven radiating apses and an ambulatory around an octagonal drum on paired columns. Montano drew a similar plan (vol.II, fol.70r, cat.1149).

OTHER MANUSCRIPTS Turin, BR, MS T, fol.11r (Maltese 1967, I, p.39, line 20–p.41, line 14; p.255, tav.17); Florence, BML, MS L, fol.9v, inscribed [1] *Tenpio senza navj/e crocj–ciella–In antis*; [2] *Tempio crociato e senza navj–prostilios*; [3] *tenpio tondo–Anfri prostilos*; [4] *tenpio affaccie–pixeulo ditteros* (Marani 1979, II, cap.XXXIX–XL, p.112); New Haven, BL, MS B, fol.9v; Venice, BMV, fol.42r and v.
OTHER REPRESENTATIONS Pietro Cataneo, Uffizi 3299A; Giorgio Vasari il Giovane, [1] Uffizi 4723A; [2] Uffizi 4717A.

93
Longitudinal plans of churches

SJSM, vol.120, fol.17r

[1] A Latin-cross plan with an apse, shallow projecting transepts with apsidal terminations and a single-cell nave, which has three shallow apses on each side. The square crossing has columns at the entrances to the transepts, apse and nave. The plan is close to cruciform, tricorn martyria, which probably inspired S. Bernardino in Urbino, the mausoleum for Federigo da Montefeltro (Siena 1993a, p.60; Burns 1974, pp.298ff.). The plan was widely influential, for the Corner chapel in SS Apostoli, Venice, and for the plan of S. Maria delle Grazie, Milan (Bulgarelli & Ceriana 1996, p.116; Bruschi 1977, figs 93 and 130; for Girolamo Genga's church of S. Giovanni Battista in Pesaro, see Pinelli & Rossi 1971, p.166; Siena 1993a, p.61).
[2] A Latin-cross plan with a small apse and projecting transepts with apsidal terminations has three aisles in the crossing and a three-bay nave with niches as chapels flanked by freestanding paired columns. Francesco identified this plan as 'pedros'. The

motif of paired columns was taken up by his pupil Baldassare Peruzzi, who used them in his project to convert the baths of Agrippa into Palazzo Orsini (Wurm 1984, p.147), and on the façade of Palazzo Massimi alle Colonne, Rome (Siena 1993a, p.61).
[3] An anthropomorphic representation of a Latin-cross plan showing how the parts of the plan conform to the human body. The apse corresponds to the head, the domed crossing to the chest, the transepts to the arms, and the nave to the thorax and legs. The plan of the crossing probably reflects Nicholas V's project for Old St Peter's (Magnuson 1958, p.171, fig.20). The exaggeratedly long and thin plan and deep crossing arms recall Peruzzi's projects for S. Domenico in Siena (Wurm 1984, tav.219–38).

There was a long tradition for the association of the human form with the parts of a church (Lowic 1983, pp.360–65; Mussini 1991, p.211, n.114).

OTHER MANUSCRIPTS Turin, BR, MS T, fol.11r (Maltese 1967, I, p.41, line 15–p.43, line 11; p.256, tav.17–18); Florence, BML, MS L, fol.10r, inscribed

[1] *Tenpio cho[n] crocie et/navi–Ipedros* (Marani 1979, II, cap.XL–XLI, p.112); New Haven, BL, MS B, fol.10v; Venice, BMV, fols 42v and 46r; Budapest, NL, Codex Zichy, fol.138r; Rome, BAV, *Codicetto*, fol.134v.
OTHER REPRESENTATIONS Pietro Cataneo, [2, 3] Uffizi 3298A.

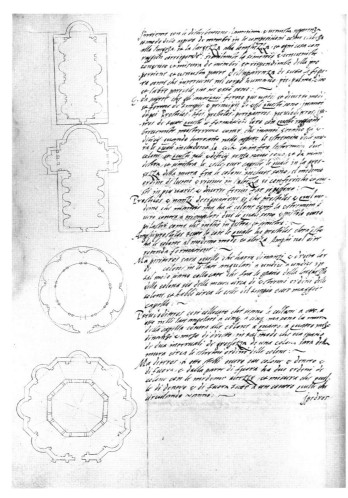

92

93

94

Longitudinal plans of churches
SJSM, vol.120, fol.17v

[1] The diagram illustrates the rule that the body of the temple should be divided into seven: one part is given to the presbytery, two to the crossing and four to the nave. If the church is to have aisles, half a module should be given to them. The domed Latin-cross church has projecting transepts, three apses emerging on the exterior.

[2] A plan of a Latin-cross church with three aisles in the nave and transepts, a dome supported on columns, three projecting semicircular apses and three deep rectangular chapels on either side of the presbytery. The columnar nave, transepts and crossing relate to Brunelleschi's churches of S. Lorenzo and S. Spirito in Florence.

[3] A four-domed, Latin-cross plan with three aisles in the nave and transepts, and two domes the full width of the nave and aisles supported on a ring of columns. The organization of the trilobe transepts depends on the Certosa of Pavia; the shallow transepts with domes on columns in a cube recall S. Saturno, Cagliari, a Romanesque

example (Lacoste 1963, p.172, fig.1); Siena Cathedral, where the dome covers the full width of the building, is another medieval prototype (Salmi 1961, p.22, fig.40). The plan as a whole anticipates Francesco's project for S. Sebastiano in Vallepiatta (Siena 1993a, pp.302ff.).

[4] A Latin-cross plan with a crossing dome supported on a ring of columns. The nave has six niches on each side with alternating paired and single columns at their entrances. The plan is close to S. Agostino in Rome, of 1479–83 (Siena 1993a, p.359).

Francesco di Giorgio is documented in Milan in 1490, and gave his opinions along with Amadeo and Bramante on the projects for Pavia Cathedral. The state of the design is unclear in 1490. The surviving 16th-century model, with emerging apses, sacristies and an octagonal cupola on a ring of isolated piers, reflects Bramante's ideas; the dome in the early projects for St Peter's, Rome (Florence, Uffizi 20A and Uffizi 7945A), is also similar (Siena 1993, pp.60; for the model, see Venice 1994, pp.462ff.). Metternich and Thoenes (1987, pp.99–100) noted the

influence on St Peter's of S. Lorenzo in Milan, a building that influenced other drawings by Francesco, which have survived in drawings by other artists (see Montano, vol.II, fol.69r, cat.1148).

OTHER MANUSCRIPTS Turin, BR, MS T, fol.11v, inscribed [1] *Tenpio a cr/ociera e se[n]/za navi–chup[p]ola hove[r] / trebuna*; [2] *tempio a crocera a navj/cholla hel/evata e circhula[r] trebuna*; fol.12v, inscribed [3] *Altra fo[r]matione di tempio co[n] tre chupole ove[r] trebune*; fol.12r, inscribed [4] *tenpio anavj* (Maltese 1967, I, p.43, line 11–p.44, line 22; p.256, tav.18–20); Florence, BML, MS L, fols 10v and 11r (Marani 1979, II, cap.XLI, p.112); New Haven, BL, MS B, fols 10v and 11r; Venice, BMV, fols 47r, 48v–49r; Budapest, NL, Codex Zichy, fols 138r and 139r.
OTHER REPRESENTATIONS Pietro Cataneo, [1, 3, 4] Uffizi 3298A; [2] Uffizi 3299A; Giorgio Vasari il Giovane, [2] Uffizi 4724A; [3] Uffizi 4721A; [4] Uffizi 4729A.

95

Longitudinal plans of churches
SJSM, vol.120, fol.18r

[1] A Latin-cross plan with a dome supported on columns and five apses as chapels in each of the nave walls, separated by free-standing paired columns. At the end of each projecting transept is a circular chapel with an ambulatory, five radiating apses and a dome supported on a ring of columns.

[2] A Latin-cross church with a three-bay aisled nave supported on square piers alternating with two columns, a central dome and a projecting transept with columns at two entrances and a semicircular apse on each arm.

[3] A Latin-cross church with a nave of one-and-a-half bays with aisles supported on piers with two columns between them, a central dome on four columns and a shallow projecting crossing with projecting apses. At the entrances to the transepts are free-standing columns.

The alternation of piers and columns relates to Early Christian buildings. Francesco would have seen examples at S. Maria in Cosmedin and S. Prassede in Rome (Siena 1993a, p.25).

OTHER MANUSCRIPTS Turin, BR, MS T, fols 12v and 13r, fol.12v inscribed [1] *Crociato ten/pio co[n] vari/ate forme di/trebune* (Maltese 1967, I, p.44, line 22–p.45, line 28; p.256, tav.20–21); Florence, BML, MS L, fol.11r and v (Marani 1979, II, cap.XLI–XLIII, p.112); [3] fol.11v; New Haven, BL, MS B, fol.11r; Venice, BMV, fols 48v and 50v; Budapest, NL, Codex Zichy, fol.139r.
OTHER REPRESENTATIONS Giorgio Vasari il Giovane, [1] Uffizi 4722A; [3] Uffizi 4716A.

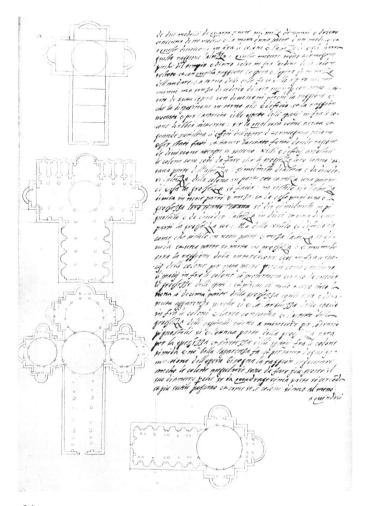

94

95

96
Crossing piers, plans of presbyteries
SJSM, vol.120, fol.18v

[1–4] Four elevations of the orders of [1] square piers and [2] columns showing pedestals, bases, capitals and imposts for trabeated and arcaded orders. The ways in which the arches meet the impost blocks are quoted from Brunelleschi (Siena 1993a, p.25). In the first example [3] the whole of the archivolt of the arch meets the impost, the solution at S. Spirito, Florence; in the second example [4] the outer arches merge above the impost, as in the arches at S. Lorenzo, Florence. In the text to fol.25r (cat.108) Francesco records that the fluting on a square pier should comprise 6 flutes on each side, making a total of 24, a practice consistently followed by Brunelleschi.
[5–7] Three plans of presbytery chapels showing their proportional relationship to the human head. The illustrations in this manuscript and in MS L are not drawn accurately; they show the first chapel as of two squares rather than one-and-a-half as prescribed in MS T, and the second chapel, which is described as of one square, is shown as

of one-and-a-third squares.
In the elevations of the orders *cimase* is the term used to describe the impost or entablature.

OTHER MANUSCRIPTS Turin, BR, MS T, fol.12r and v (Maltese 1967, I, p.45, line 29–p.49, line 2; p.256, tav.19–20); Florence, BML, MS L, fol.11r, inscribed [1] *pilastrj cho[n] cimaxi*; [4] *cimaxocholonna*; [5] *chapella di quad/ro e mezo*; [6] *chapella du[n] quatro e terzo*; [7] *chapella a emicicro* (Marani 1979, II, cap.XLIII–XLIV, p.112); New Haven, BL, MS B, fol.11; Venice, BMV, fols 48r, 49v–50r; Budapest, NL, Codex Zichy, fol.139r.
OTHER REPRESENTATIONS Vicenza, BBV, [5–7] fol.117v; Pietro Cataneo, [5–7] Uffizi 3298A.

97
Longitudinal plans of churches
SJSM, vol.120, fol.19r

The plan has a single-cell nave of three bays with six apses on each side and a projecting semicircular chapel with three apses.

OTHER MANUSCRIPTS Turin, BR, MS T, fol.12r (Maltese 1967, I, p.47, line 2–p.48, line 7; p.256, tav.19); Florence, BML, MS L, fol.11r, inscribed *Tenpio de quatro quadri uno nella chapella/et tre i[n] nel cho[r]po* (Marani 1979, II, cap.XLIV–XLVI, p.112); New Haven, BL, MS B, fol.11r; Venice, BMV, fol.47v.
OTHER REPRESENTATIONS Pietro Cataneo, Uffizi 3299A; Giorgio Vasari il Giovane, Uffizi 4719A.

98
Central plans for churches
SJSM, vol.120, fol.19v

Francesco offers a range of examples for the design of centralized churches, based on simple geometric figures: the circle, pentagon, hexagon and octagon. The plan shaped like a rhombus is a misunderstanding of the illustration in MS T, which shows a pentagonal plan.
[1] An octagonal building, entered through a tripartite portico supported on four columns, has an ambulatory corresponding to a quarter of the diameter of the building, with seven shallow radiating apses and six triangular chapels projecting between them, around a central octagonal ring of eight columns.
[2] A dodecagonal building, with 12 projecting semicircular apses with buttresses between them and a hexagonal tribune supported on columns, is entered through a tripartite portico with a double row of columns.
[3] A decagonal plan with nine projecting apses with buttresses between them.
All of the plans are based on the tomb of the Calventi, Via Appia, Rome, which has a hexagonal plan with six emerging apses with buttresses between them. Tafuri drew attention to

Peruzzi's drawings of the tomb (Uffizi 1651Ar and Uffizi 426Ar), which are followed by geometrical variations on the same plan (Siena 1993a, p.49; Wurm 1984, Taf.431, 368, 344–6).
[4] A plan shaped like a rhombus, with three projecting semicircular apses at the angles and projecting rectangular apses on the four straight sides, entered through a portico supported on two rows of columns. The plan is a pentagonal variant of a tomb drawn by Montano (vol.II, fol.70r, cat.1149; there is a pentagonal plan of a tomb on fol.80r, cat.1163).
For the magical and religious associations of the pentagon, from Villard de Honnecourt to Kepler, see Marconi 1973, pp.76ff.

OTHER MANUSCRIPTS Turin, BR, MS T, fol.13r (Maltese 1967, I, p.48, line 7–p.49, line 9, tav.21); Florence, BML, MS L, fol.11v (Marani 1979, II, cap.XLVI–XLVII, p.112); New Haven, BL, MS B, fol.11v; Venice, BMV, fols 52v–53r; Budapest, NL, Codex Zichy, fol.139r.
OTHER REPRESENTATIONS Pietro Cataneo, [1–4] Uffizi 3296A; [4] 3299A; Giorgio Vasari il Giovane, [2] Uffizi 4724A; [3] Uffizi 4726A; [3] Uffizi 4727A.

99
Central plans
SJSM, vol.120, fol.20r

[1] A circular plan with an ambulatory with seven alternating rectangular and semicircular niches emerging on the exterior and a dome supported on a ring of paired columns is entered through a tripartite portico with two rows of columns. The columns screening the entrances to the niches recall the Pantheon. The semicircular niches emerging on the exterior framed by emerging rectangular niches are close to a building drawn by Giuliano da Sangallo in the Barberini Codex (Rome, BAV, MS Vat. Lat. 4424, fol.8r), and identified as the grotto of the Cumean Sibyl on Lake Averna. It was drawn more faithfully by Francesco in his drawing of the baths on Lake Averna (Siena 1993a, p.342, cat.XX.21). [4] and [5] are both variants of the same plan. Peruzzi also made studies based on this building (see Montano, vol.II, fol.73r, cat.1154).
[2] A circular plan with a portico of paired columns around the chamber, an ambulatory with seven semicircular niches and a central ring of paired columns.
[3] A central plan with a circular portico with paired columns alternating

with groups of four columns around an ambulatory, and a central ring of columns supporting the dome. The ring of paired columns, grouped in four, has wide intercolumniations in the cross-axes as at S. Costanza, Rome.
[6] A circular plan with a single semicircular apse on the axis and eight buttresses.

OTHER MANUSCRIPTS Turin, BR, MS T, fol.13v, inscribed [1] *Nave–Trebuna–porticho*; [2] *Log[g]ie ci[r]cholare, nave chi[r]chulare–chuppola*; [3] *log[g]ie–Nave–tribuna*; [4] *porticho* (Maltese 1967, I, p.49, line 9–p.50, line 9; p.256, tav.22); Florence, BML, MS L, fol.12r (Marani 1979, II, cap.XLVII, p.112); New Haven, BL, MS B, fol.12r; Venice, BMV, fols 54v–55r; Budapest, NL, Codex Zichy, fol.140r.
OTHER REPRESENTATIONS Pietro Cataneo, [2–6] Uffizi 3296A; Giorgio Vasari il Giovane, [1] Uffizi 4719A; [4] Uffizi 4716A; [6] Uffizi 4718A.

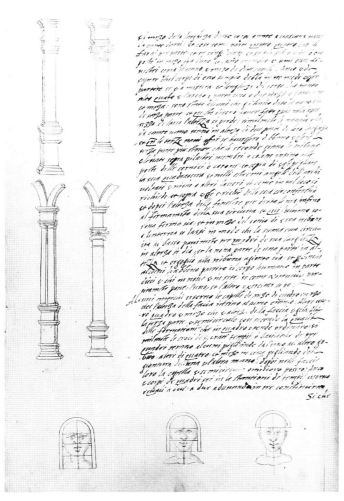

96

97

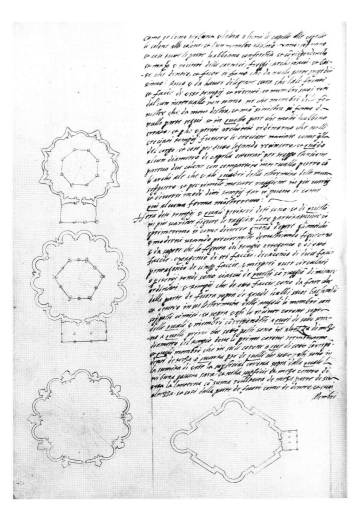

98

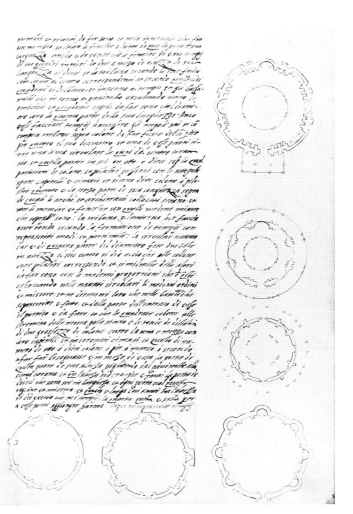

99

100

Central plans

SJSM, vol.120, fol.20v

[1] A triangular plan with a central dome inscribed in a square with three radiating circular chapels, each with five semicircular niches, is entered through a hexastyle portico with three rows of columns.

[2] A circular chamber with four circular chambers of the same size projecting on the cross axes and porticos carried on piers and columns between them. The central chamber is entered through the portico, and the radiating rooms from the chamber.

[3] A domed chamber inscribed in a square has four projecting circular domed rooms with seven niches on the cross axes. A portico with two rows of two columns marks the entrance. S. Maria della Croce at Crema, contracted to Giovanni Battagio on 15 July 1490, has a similar plan (for the church, see Giordano 1990).

[4] A plan with an ambulatory around a dome supported on a ring of columns. Four entrances on the diagonal axes give access to four radiating decagonal spaces with five deep apses

and triangular spurs between them. Tafuri noted the similarity between this plan and a building in the background of the *Nativity* of 1485–90, formerly in S.Domenico, Siena (Siena 1993a, pp.46 and 58).

The aggregate plans with radiating, minor spaces had great influence, over a long period of time. They probably inspired the drawings with radiating circular chapels on Uffizi 1698Ar, attributed to Fra Giocondo (Fontana 1988, p.21). Both architects worked for Alfonso II of Aragon, Duke of Naples and Calabria, and Fra Giocondo was paid for 126 drawings for two Francesco di Giorgio manuscripts on architecture and artillery (Brenzoni 1960, p.21).

Leonardo owned MS L and his radial plans probably depend on Francesco's designs (Mussini 1991, pp.187ff., and p.214, n.123), as do Peruzzi's projects of 1518–19 for S. Giovanni dei Fiorentini, Rome (Uffizi 510Ar and v, 505Ar and v; Wurm 1984, Taf.9 and 11). The trilobe plan, which probably influenced Philibert de l'Orme's project in the British Museum for the chapel of Villers Cotteret (Siena 1993a, pp.57 and 61; Blunt 1958, pp.74–5, fig.48), was an

important source for Montano: his plans in vol.II, fols 84r–87r (cat.1169–73) are triangular, while his radial aggregate plan on fol.88r (cat.1175) also reflects Francesco di Giorgio's influence.

OTHER MANUSCRIPTS Turin, BR, MS T, fols 13v–14r (Maltese 1967, I, p.50, line 9–p.51, line 8; p.256, tav.22–3); Florence, BML, MS L, fol.12r (Marani 1979, II, cap.XLVII–XLVIII, p.112); New Haven, BL, MS B, fol.12r and v; Venice, BMV, fols 55r and 56r; Budapest, NL, Codex Zichy, fol.140r.
OTHER REPRESENTATIONS Vicenza, BBV, [4] fol.89v; Pietro Cataneo, [1, 2] Uffizi 3299A; [3] Uffizi 3296A (both drawings show an octagonal central space); Giorgio Vasari il Giovane, [2] Uffizi 4721A and 4727A (with a hexagonal central chamber).

On temples

SJSM, vol.120, fol.21r
No illustration

101

Church façades

SJSM, vol.120, fol.21v

[1] A circular temple with applied pilasters on the ground floor below a drum, articulated by pilasters and pedimented windows, which supports a dome and lantern with a cone on top. The Mannerist cartouche with winged putto heads and ribbons, drawn above the central door with reclining figures resting on it, does not appear in MS T or MS L; it betrays the mid-16th-century taste of the draughtsman of this manuscript.

[2] A church with a cruciform plan has wide pilasters at the corners of the façade with continuous string courses running over them to give two orders of pilasters, framing central windows with segmental and steep triangular pediments. A continuous entablature breaks forward above the pilasters below the steep triangular pediments over the central and side bays. A dome with a lantern supported on a drum with oculi covers the crossing. The drum in MSS T and L, and the abstract order of pilaster, with continuous string courses crossing it and forming

the capital, is close to S. Bernardino in Urbino (for the church, see Siena 1993a, pp.230–43). Tessari (1995, pp.40–43) noted the relationship between this drawing and Peruzzi's façade at S. Maria di Castello, called the Sagra, at Carpi, which has a similar abstract order and steep pediment.

OTHER MANUSCRIPTS Turin, BR, MS T, fol.14r (Maltese 1967, I, p.52, line 17–p.53, line 15; pp.256–7, tav.23); Florence, BML, MS L, fol.12v (Marani 1979, II, cap.XLIX, p.112); New Haven, BL, MS B, fol.12v; Venice, BMV, fol.57r.
OTHER REPRESENTATIONS Vicenza, BBV, fol.89v; Giorgio Vasari il Giovane, [1] Uffizi 4728A.

102

Acoustics in theatres

SJSM, vol.120, fol.22r

[1] A schematic elevation of the façade of a Roman theatre with three orders of pilasters diminishing in height as they rise, probably in reference to the three harmonic modulations described by Vitruvius (book V, cap.IV; Granger 1934, I, pp.271ff.).

[2] Vitruvius' text reads: 'In Roman theatres built of stone and rubble, bronze vases, made with mathematical ratios corresponding with the theatre, are made so that when they are touched they make a sound from one to the other of the 4th–5th–2nd octave. Compartments are made in the seating and the vases so placed that they do not touch the wall and with a space around them.' Terracotta vases for this purpose have been found in Roman theatres: pots were not necessary in wooden theatres because the wooden floors resound (op.cit., pp.277–81).

[3] A bird's-eye view of a Roman theatre showing the three-sided machine that turned for scene changes described by Vitruvius (book V, cap.VI, 8), and which corresponds to the three

Roman stage sets, tragic, comic and satyric (Granger 1934, I, p.289).
[4] The plan of a Roman theatre showing the circular arcaded *logge* below the stepped seats.

OTHER MANUSCRIPTS Turin, BR, MS T, fol.14r (Maltese 1967, I, p.53, line 15–p.55, line 4; p.257, tav.23); Florence, BML, MS L, fol.13r, inscribed [2] *Vaxi cho[n] chap/allamento/giendo lun/alatro–Gradi dove e vaxi benej/[fi]tulj posti i[n] nequalj la voce/dandosi agliorentj degli a[uditori]/p[er] veniva–Canale dela v/ocie ronpendo/corre–grado–capella/mento de/l vaxo–vaxo;* [3] *teatro–vaxi i[n] negradi–ho[r]chestra–teatro;* [4] *fondo del teatro* (Marani 1979, II, cap.XLIX–LI, p.112); New Haven, BL, MS B, fol.13r; Venice, BMV, fol.58r and v.
OTHER REPRESENTATIONS Vicenza, BBV, [1, 3] fol.91v, [4] fol.91r, [2] fol.89r; Oreste Vannocci Biringucci, Siena, BC, fol.51r.

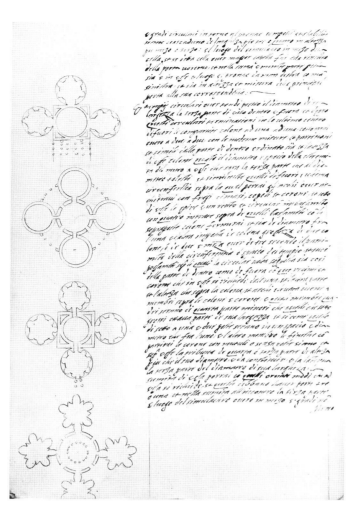

100

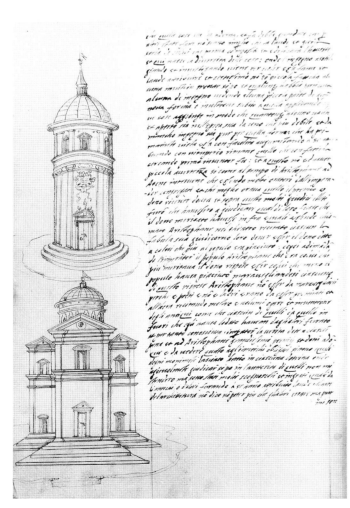

101

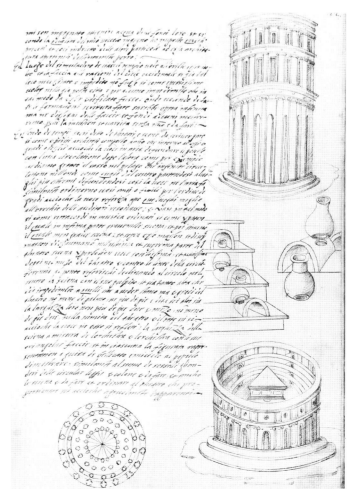

102

103

The three orders: Doric, Ionic and Corinthian

SJSM, vol.120, fol.22v

The chapter on the orders begins by giving Vitruvius' account of their origins in emulation of human types: [3] the first, Doric, is based on the male; [2] the second, Ionic, on the female; and [1] the Corinthian on a slender, graceful maiden. The diagram at the top shows the taller Corinthian column with the same nine-module proportion as the Ionic column to the right of it; the latter is lower because its capital is one-third of a module while the Corinthian capital is two-thirds of a module tall. The parts of the columns, like those of temples and churches, follow the human body: the feet correspond to the base, the neck to the hypertrachelion, and the head to the capital.

Francesco relied on proportion to identify the orders: 1:7 for the Doric, 1:8 for the Ionic and 1:9 for the Corinthian. A system of proportion is also applied to the details of the orders – capitals and bases: the Doric base is ⅓, the Ionic ⅔ and the Corinthian ½ modules tall.

The projection of the base is obtained by dividing the diameter of the base into five and giving one-fifth to the projection on either side, the projection of the capital by dividing the neck of the column into four and giving two modules on each side to the projection. [4] The column with a ring one-third of the way up the shaft is a graphic interpretation of entasis. On the right of it at [5] is the rule for entasis, the swelling of the column under the pressure of its weight. The diminution of the column is incorrectly drawn: the rule in the text states that the diameter of the column at the base is divided into five parts and reduced to four at the top. [6] Francesco retells Vitruvius' anecdote that the flutes on columns imitate the folds of matronly robes and that their number, 24, is a reference to man's ribs. He shows [7] columns with ribbon decoration as in ancient *stola*, and [8] a spiral-fluted column, which he would have known from S. Agnese in Rome. There are antique examples of [9] columns with sawn-off branches (Daremberg & Saglio 1887, col.1345); Francesco's interest in them, which probably derived from Vitruvius, was

shared by Bramante, who used them in the portico at S. Ambrogio in Milan (see Marani 1982, pp.104–20). The proportion of the abacus [10, 11] is found by dividing the width of the column into four; one part is given to the height of the abacus and two to the projection. Vincenzo Danti's discussion of the proportion of the orders is also anthropomorphically derived. Egnazio Danti collected Francesco's drawings (Daly Davis 1982, pp.72ff.).

OTHER MANUSCRIPTS Turin, BR, MS T, fol.14v (Maltese 1967, I, p.55, line 4–p.57, line 13; p.257, tav.24); Florence, BML, MS L, fol.13v, inscribed [3] *cholon[n]a pulvinata havero go[n]fiata*; [4] *Antas*; [6] *Cholona ascanelli hovero chanalj*; [7] *cholonna a stola*; [8] *cholonna striata*; [9] *cholona a tro[n]chonj*; [10] *Inudi dela chan/pana–Tronchilo sup[er]ficiale* (Marani 1979, II, cap.LI–LII, p.112); New Haven, BL, MS B, fol.13v; Venice, BMV, fol.62v; Budapest, NL, Codex Zichy, fols 121v–122r. OTHER REPRESENTATIONS Vicenza, BBV, [1–6] fol.117v, [8–10] fol.103v, [11] fol.103r; Oreste Vannocci Biringucci, Siena, BC, fol.152r.

104

Columns

SJSM, vol.120, fol.23r

[1] The elevation of a column showing the height as nine modules and the plan of the capital and base.
[2] The elevation of a Corinthian column with a plan of the capital and base, showing their projection.
[3, 4] Columns in the shape of candelabra and balusters are Renaissance decorative features, which have precedents in Roman art although they are not described by Vitruvius. They were used in Milan, especially by Amadeo: the baluster pilasters shown by Francesco on the exterior of the dome of a tempietto in MS T (fol.85r; Maltese 1967, I, tav.155) recall Amadeo's use of them at the Colleoni chapel in Bergamo, of the 1470s. Bramante used them ornamentally at S. Maria delle Grazie, Milan, in the painted architecture at Vigevano, and for the pillar in the centre of Prevedari's *Ruined Temple* (illustrated in Malaguzzi Valeri 1904, pp.38–9; Bruschi 1977, figs 21, 59 and 67–9). The baluster column was treated almost as a member of the Classical canon and presented in two forms by

Diego da Sagredo in *Medidas del Romano* of 1526, which was probably influenced by Francesco's text (Llewellyn 1977, pp.294ff. and n.11). In the edition of 1511 Fra Giocondo misunderstood Vitruvius' text to give authority to the baluster column (book III, cap.III, 5; Vitruvius 1521, fol.55v; Bury 1976, p.215, n.56; balusters are comprehensively treated in Davies & Hemsoll 1983, pp.1–23, especially pp.8ff.).
[5] A man's head drawn inside the profile of a capital shows the relationship of the leaves with the proportions of the human face. The elevation is shown on fol.26r (cat.109).
[6] The profile of a base on a socle with a torus, scotia and fillets and upper torus.
[7] A plan of the volutes, echinus and abacus of a capital .

OTHER MANUSCRIPTS Turin, BR, MS T, fol.15r (Maltese 1967, I, p.57, line 4–p.59, line 3; p.257, tav.25); Florence, BML, MS L, fols 13v–14r, inscribed [3] *cholo[n]na a chandeliere*; [4] *cholonna a balagustj*; [6] *basa dopia*; [7] *chu[r]vatura dellabaco–Taula dellabaco*

(Marani 1979, II, cap.LII, p.112); New Haven, BL, MS B, fol.14r; Venice, BMV, fol.63v; Budapest, NL, Codex Zichy, fols 122r and 123r; Rome, BAV, *Codicetto*, fol.33v. OTHER REPRESENTATIONS Vicenza, BBV, [1, 3] fol.103r, [3, 4] fol.117r, [5, 6] fol.105r, [7] fol.103v; Pietro Cataneo, [7] Uffizi 3289A.

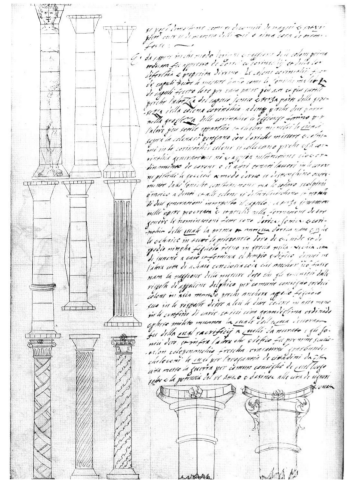

103

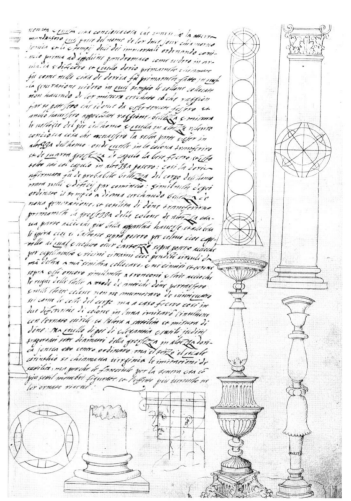

104

105

Corinthian Order, capitals, and entablature

SJSM, vol 120, fol.23v

[1] The drawing illustrates the story of the burial of a Corinthian maid and the origin of the Corinthian capital as told by Vitruvius (book IV, cap.I; Granger 1931, I, p.209): 'A nubile maiden, a native of Corinth, was attacked by disease and died. After her funeral the goblets that had delighted her when living were put together in a basket by her nurse, carried to the monument and placed on the top. She covered the basket with a tile. By chance the basket was placed over an acanthus root that put forth leaves and shoots. The shoots grew up the sides of the basket and, being pressed down at the angles by the force of the weight of the tile, were compelled to form the curves of volutes at the extreme parts. Callimachus, renowned as a marble carver, passed by. He was delighted by the novelty of the grouping, and made columns for the Corinthians on this model and fixed their proportions.' As retold by Francesco in MSS T and L, the corpse of the maid was placed in a conical basket

full of earth and brought by her nurse to an orchard that she had loved in life, where she was buried feet first, her head covered by the tiles. By chance the basket rested on an acanthus root that grew up through the basket and burst out at the corner of the tile. The anecdote is told correctly in MS M (Maltese 1967, I, p.59, n.1; II, pp.379–80).
[2] An entablature with two fasciae above the capital; here the capital has scoop ornament below an egg-and-dart echinus and volutes containing rosettes with an acanthus leaf tumbling over the volute.

Francesco used fluted capitals, with only an abacus, at the Palazzo Pubblico in Iesi, and a capital like this one at S. Bernardino in Urbino. The type derives from Alberti (Bulgarelli & Ceriana 1996, p.135 and especially p.186, n.194).
[3] The 'Composite' capital has a ring of lily leaves below a pair of cornucopia, with grapes below the abacus, supporting the entablature. The base has a lower torus, a scotia, two astragals, an upper scotia and torus.
[4] A base with a lower torus, scotia, fillets and upper torus.

[5] The diagram to measure the diminution at the top of a column from the entasis is completed on fol.25r (cat.108).

The capitals and trabeations on this folio are modern and close to impost capitals in the Victoria and Albert Museum, London, and in Birmingham Museum and Art Gallery (Siena 1993a, pp.303–6).

OTHER MANUSCRIPTS Turin, BR, MS T, fol.14v (Maltese 1967, I, p.59, line 4–p.60, line 10; p.257, tav.24–6); Florence, BML, MS L, fol.13v, inscribed [1] *Chalimacco/da chori[n]tio–ciesto della supulta fa[n]ciulla posta sop[r]a alla radice dela/[canto]*; fol.14r, inscribed [4] *baxa dopia*; [5] *bastone–Ghola–Spira hove[r] bastone–Modello della baxa*; fol.14v, inscribed [2] *cimaxi*; [3] *fregio/cimaxi qu/adratj–strigia–Mixure e diminutionj dela sop[r]a posta colon[n]a* (Marani 1979, II, cap.LII, p.112); New Haven, BL, MS B, fol.13v; Venice, BMV, fols 62v and 65v; Budapest, NL, Codex Zichy, fol.119v.
OTHER REPRESENTATIONS Vicenza, BBV, [1] fol.103r, [2, 3] fol.99r, [4, 5] fol.103v.

106

Capitals and a vase

SJSM, vol.120, fol.24r

[1] A capital with a tall neck decorated with a ring of acanthus leaves has an echinus with an egg-and-dart moulding and foliate volutes; the entablature has a plain architrave and a pulvinated frieze with a cushion literally bursting open under the pressure of the weight of the cornice. Francesco shows volutes on Doric capitals. The bases in the choir of S. Maria dei Miracoli in Venice are decorated with cushions, also expressing the weight born by the order.
[2] A capital with a tall neck is decorated with scoop ornament below an oak wreath with acanthus leaves falling from the abacus the full height of the capital. The entablature has a plain architrave, a pulvinated frieze squashed into a pointed profile decorated with guilloche ornament and a cornice.
[3] The elevation of a vase standing on a base with volutes. The bowl is supported on acanthus scrolls with dolphin heads. The shoulder of the bowl and the rim are gadrooned and the neck is decorated with acanthus leaf.

OTHER MANUSCRIPTS Turin, BR, MS T, fols 15v–16r (Maltese 1967, I, p.60, line 10–p.61, line 21; pp.257–8, tav.26–7); Florence, BML, MS L, [1] fol.14v, inscribed *chorona hove[r] cornice–pulvino*; [3] fol.15r, inscribed *cimaxi a uxo di vaxj* (Marani 1979, II, cap.LII–LIII, p.112); New Haven, BL, MS B, fols 14v–15r; Venice, BMV, fol.67r.
OTHER REPRESENTATIONS Vicenza, BBV, [1, 2] fol.9r, [3] fol.81v.

[manuscript page with column drawing]

[manuscript page]

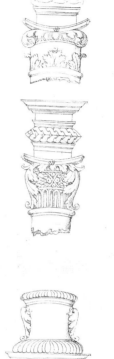

105

106

107
Vases
SJSM, vol.120, fol.24v

[1] A square vase with lion's feet and acanthus leaves rising from them at the angles is used above a capital to increase the height of a vault. It derives from an antique prototype from the interior of S. Salvatore in Spoleto, drawn by Francesco in MS T (fol.93r; Maltese 1967, I, tav.173).
[2] A baluster-shaped vase, the base supported by winged putti, is decorated with bands of scoop, egg-and-dart and gadrooned decoration.
[3] A vase on a round base and supported by two winged sphinxes has a gadrooned shoulder and a neck with scoop decoration below a wide rim. The drawing shows vases that can be used to decorate a wall above a capital. Francesco showed similar forms in his painted architecture in the *Abduction of*

Helen in the Berenson Collection at Villa i Tatti, Florence (Siena 1993b, p.43, fig.39). Bramante's pedestals below the baluster pilasters on the attic of S. Maria delle Grazie, Milan, recall the baluster shown at [1] (Malaguzzi Valeri 1915, figs 223–4).

OTHER MANUSCRIPTS Turin, BR, MS T, fol.16r (Maltese 1967, I, p.61, line 21–p.63, line 2; tav.27); Florence, BML, MS L, fol.15r, inscribed [1] *cimaxi quadran/golatj* (Marani 1979, II, cap.LIII, p.112); New Haven, BL, MS B, fol.15r; Venice, BMV, fol.68r.
OTHER REPRESENTATIONS Vicenza, BBV, [1] fol.99r, [2, 3] fol.81v.

108
Entasis
SJSM, vol.120, fol.25r

An incomplete diagram showing the diminution of the column following the plan shown on fol.23v (cat.105); the diagram is fully drawn in MS M on fol.34v. Serlio (book IV, 1619, p.128) shows an analogous method. The rule states that the diameter at the base should be divided into eight modules and a scale drawn at the top of the shaft; the two scales are then connected vertically. The width of the shaft at the top will be reduced from eight to six modules by one module on each side. The shaft is divided into seven horizontal blocks from a point one-third of the height of the column, and the horizontal lines are extended to the parallel lines connecting the two scales. The diminution can be measured in the shaded area at every stage as the

column rises. Its dimension can be plotted on the plan drawn on fol.23v.

OTHER MANUSCRIPTS Turin, BR, MS T, fol.15v, inscribed *Diminuitione della cholonna sichondo el p[er]dimento dele linie del tondo* (Maltese & Maltese Degrassi 1967, I, p.63, line 2–p.64, line 2; tav.26); Florence, BML, MS L, fol.14v (Marani 1979, II, cap.LIII, p.112); New Haven, BL, MS B, fol.14v; Venice, BMV, fol.65r; Florence, BNCF, MS M, fol.34v (Maltese & Maltese Degrassi 1967, II, tav.222, p.379); Budapest, NL, Codex Zichy, fol.119v.
OTHER REPRESENTATIONS Vicenza, BBV, fols 81v and 99v.

The orders
SJSM, vol.120, fol.25v
No illustration

109
Projection of the capital and base, proportions of the capital
SJSM, vol.120, fol.26r

[1] An elevation of a column showing the projection of the base and capital, the proportions of the parts and the plan of the capital. The same diagram is drawn in MS M, on fol.34r.
[2] An elevation of a capital with a human head drawn to show the relationship of the height of the leaves to the features of the face. The lower tier rises to below the nose, the second tier to the eyes, the volutes occupy the brow and the abacus the crown of the head. The profile of this diagram is drawn on fol.23r (cat.104). Fra Giocondo's drawings of the Corinthian order (Uffizi 1690AV) for the 1511 edition of Vitruvius, showing the plan and

elevation of the capital and the diminution of the column, derive from his drawings after Francesco (Fontana 1988, p.33, tav.16).

OTHER MANUSCRIPTS Turin, BR, MS T, fol.16r (Maltese 1967, I, p.65, line 8–p.66, line 8; pp.257–8, tav.25–6); Florence, BML, MS L, fol.15r, inscribed [1] *Mixure e p[r]opo[r]tione della [form]matione del chapitello* (Marani 1979, II, cap.LIII–LIV, p.112); New Haven, BL, MS B, fol.15r; Venice, BMV, fol.68r and v; Florence, BNCF, MS M, fol.34r (Maltese 1967, II, tav.221); Budapest, NL, Codex Zichy, fol.123r.
OTHER REPRESENTATIONS Vicenza, BBV, fol.105v.

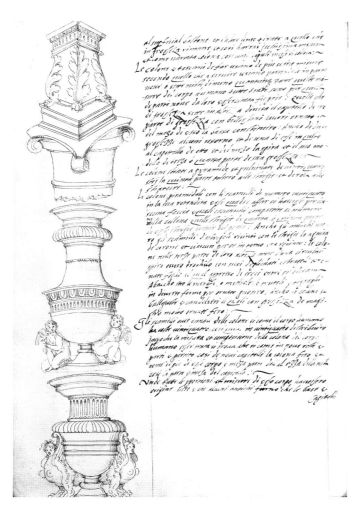

107

108

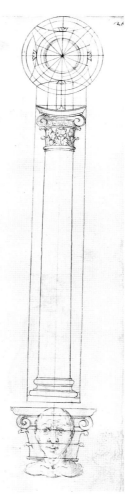

109

110

Units of measurement

SJSM, vol.120, fol.26v

A man stands within a modular grid, nine modules in height; one module is equal to the distance from the figure's eyes to his collarbone.

Vitruvius explained the origin of measurement in anthropomorphical units – finger, thumb, hand, foot, cubit and fathom. The units were systematized in different number systems: decimals based on 10 probably from 10 fingers, binary with a base of 2, and sexagesimal based on 60 for chronology and trigonometry. All these systems were used in Antiquity and it is in this connection that Vitruvius (book III, cap.I, 2; Granger 1931, I, p.159) discusses the perfect numbers, 10 and 6, and the most perfect, 16, the number of *once* in the foot.

Francesco interpreted the rule for a foot: 'the length of an arm minus [the width of] two hands equals the length of the foot [or the width] of four hands. But [the width of] a hand is equal to four fingers so that one gets a foot [equal to] thirteen fingers.' In MS T the calculation was corrected to 16. In this illustration from MS L Francesco expresses his confusion on the point. He made three drawings with 24, 16 and 13 units, here given as 23, 16 and 15 (Kolb 1988, p.154). The first foot is divided into 23, the second into 16 and the third into 15 *once*.

Thiem (1976b, pp.127–34) has shown that Classical buildings were planned using the dimensions of the Vitruvian norm, the circle and the square, and Lorenzen calculated the diameter of the circle circumscribed around Vitruvian man as 214,6625cm. The practice survived in the Middle Ages. For ancient metrology, see Lorenzen 1966 and Lorenzen 1970; for the survival of the Vitruvian circle and square as a planning instrument in the Middle Ages, see Thiem 1976b.

OTHER MANUSCRIPTS Turin, BR, MS T, fol.16v, inscribed *misura e partime[n]to del pie* (only one foot is drawn; Maltese 1967, I, p.66, line 9–p.68, line 3; p.258, tav.28); Florence, BML, MS L, fol.15v (Marani 1979, II, cap.LIV–LV, p.112); New Haven, BL, MS B, fol.15v (three feet are drawn, with 24, 16 and 13 *dite*); Venice, BMV, fol.68v.

Units of measurement

SJSM, vol.120, fol.27r
No illustration

Units of measurement

SJSM, vol.120, fol.27v
No illustration

111

Royal palaces

Inscribed from left to right:
capella–peschiera–giardino–giardino–andati coperti–fonte–piaza–logia–salla–cortile–salla–piazza–logia–cortile–logia–logia–cortile–cortile–logie–salotto–salla–sallotti–entrade–piazza
SJSM, vol.120, fol.28r

Francesco drew on his experience to define the qualities and needs of modern buildings. He wrote: 'royal palaces should have a great piazza in front of them and the façade should be elevated on a podium of two steps with one or three doors in the façade. There should be clear wide streets around it and buildings nearby should not overlook it. It should have a large courtyard with *logge* opposite the entrance 40 *piedi* long by 20 wide. The pavement of the *logge* should be raised 2 *piedi* above the ground so that the water falling from the eaves does not flood them. The floor of the courtyard should slope towards an underground channel to carry away rain water. The rooms should be symmetrically arranged, so that they lead into each other on either side of the courtyard, and there should be stairs on both sides of the courtyard, giving access to the *logge* on the upper floors. The rooms on the upper floors should have doors and windows that correspond with those on the lower floors and they should be arranged in *enfilade*. There should be a second courtyard, on the same axis as the entrance to the palace, but in this courtyard the stairs should be private and out of sight in the corners. This courtyard should open into a spacious loggia overlooking a garden with statues and a fountain, trees of many sorts, plants, domestic and wild fruits, with places to keep animals and birds. At the end of the garden there should be a concealed place that can be used for dining and drawing during the summer as well as a chapel for prayer and the celebration of the Mass.'

OTHER MANUSCRIPTS Turin, BR, MS T, fol.17r (Maltese 1967, I, p.69, line 25–p.71, line 2; tav.29); Florence, BML, MS L, fol.16r (Marani 1979, II, cap. LVII–LVIII, p.112); New Haven, BL, MS B, fol.16r; Venice, BMV, fol.72v.
OTHER REPRESENTATIONS Pietro Cataneo, Uffizi 3300A; Giorgio Vasari il Giovane, Uffizi 4758A.

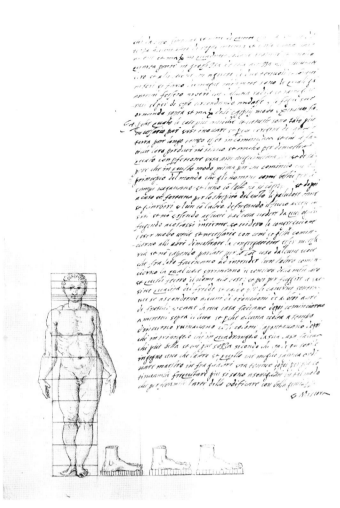

110

111

112

Palaces for princes and nobles

Inscribed [1] *sallotto–salla*; [2] *piaza–logia–salotto–salla–sallotto*; [3] *sallotto–salla dala/fro[n]te di nan/zi–loggia–cortille–loggia–piaza–salla–piaza–sallotto–cortile–salla–logia–giardino*; [4] *salla–loggia–sallotto – logie e porticho* SJSM, vol.120, fol.28v

Francesco's palace plans have a long axis, lateral symmetry and geometrical variety in the plans of the central rooms or courtyards, which are circular, square, rectangular and octagonal. Façades are differentiated, flat towards the street, with garden *logge* at the rear; rooms are arranged in suites of apartments; and stairs are accommodated in the plan in both public and concealed positions.
[1] A symmetrical palace plan entered through a long central room, with a smaller room behind it, has two small rooms on either side of the sala, stairs leading from the sala and large rectangular rooms behind the stairs. The central room at the rear of the building is flanked by suites of one square and two rectangular rooms. The U-shaped plan

is close to that of Palazzo della Signoria in Jesi, unique in town-hall planning of the period for its bilateral symmetry (Siena 1993a, pp.93–4).
[2] A symmetrical plan with a large circular room at the entrance and suites of five smaller rooms grouped around a rectangular room on either side. A double flight of stairs behind the central room is flanked by suites of two small rooms and courtyards with *logge* on either side; the private, spiral stairs are concealed, like the stairs of the Pantheon, in the spaces behind the circular room.
[3] A symmetrical palace plan with two courtyards has a large room at the entrance with a rectangular room and a suite of three smaller rooms on either side. Double staircases lead to the upper storey and behind them, on either side of the central courtyard, are small rooms and open courts with *logge*. A large square room gives access to a second courtyard with smaller rooms on either side. A rectangular room with suites of rooms on each side opens on to the garden through a projecting loggia.

[4] A symmetrical palace plan with a recessed entrance loggia with stairs on either side, parallel to the façade, has a central rectangular room flanked by two smaller rooms. There are sequences of four small rooms on either side of the sitting-rooms with *logge* behind them. The *logge* in the rear wing on either side of the six rectangular rooms, or possibly stables, are shown in MS L as recessed, colonnaded *logge* on either side of a projecting block.

OTHER MANUSCRIPTS Turin, BR, MS T, fol.17v (Maltese 1967, I, p.71, line 2–p.72, line 4; tav.30); Florence, BML, MS L, fol.16v (Marani 1979, II, cap.LVIII, p.112); New Haven, BL, MS B, fol.16v; Venice, BMV, fols 75v–76r; Budapest, NL, Codex Zichy, fol.144r.
OTHER REPRESENTATIONS Pietro Cataneo, Uffizi 3300A; Giorgio Vasari il Giovane, [2] Uffizi 4758A; [3] Uffizi 4757A.

113

Palace plans

Inscribed [1] *sallotto 20x30–sallotto–salla 40x30–piazze–sala in fondo/atrio 30x40–prima entrata–sallotto–sallotto*; [2] *sallotto 30x15–piaza–salla–logia–cortille–salotto 24x15–sallotto– sala in fondo–atrio 30x30*; [3] *sallotto– logie–Cortile–sallotto–loggie–Cortile–principal salle–logia–Cortile–entrata– salotto–logia–Cortile–salotto*; [4] *salla–logie–Cortile–sallotto–salla* SJSM, vol.120, fol.29r

Francesco writes that palaces for nobles 'should be sited on spacious squares near to the cathedral and public places like the city offices and other mercantile buildings in the city. They should be in an elevated position, not overlooked, with abundant running water or cisterns, with large delightful gardens and sometimes with more than one entrance. In the basement the rooms and the walls must correspond with those on the upper floors, and cellars, larders, woodstore and many other service rooms should be accommodated in the basement. On the floor above the cellars on the level of the

entrance there will be the large and smaller sitting-rooms, chambers, antechambers, larders, studies, rooms for secretaries and accountants and bathrooms, all interconnecting and arranged symmetrically on both sides of the courtyard. On the next floor, the rooms of the nobleman and his *logge* are covered by vaults or richly decorated ceilings supported on columns that carry arches or architraves' (Maltese 1967, I, pp.74–5).
[1] A plan entered through a large square room has a circular courtyard with a portico. On either side of the entrance are suites of four rooms of different sizes. At the side of the courtyard are double flights of stairs with suites of five rooms grouped around them; the spiral stairs are concealed behind the central court. The plan of the rear wing is identical. The dimensions given on the plan are described in the text; they are not shown in MS L or MS T. Plans with circular courtyards are very rare; Mantegna's house in Mantua and Raphael's Villa Madama for Leo X in Rome both have circular courtyards.
[2] A plan with a central square entrance and suites of four rectangular

rooms on either side, which are linked by a rectangular courtyard with *logge* to a rear wing with the same plan. On either side of the central courtyard are rectangular rooms with suites of smaller rooms linked to them.
[3] A plan with a large square central room and four courtyards with porticos on each side has symmetrical suites of six rooms in the four corners of the plan.
[4] A plan with a large rectangular central room on either side of a colonnaded courtyard, with small square and rectangular rooms around them. Except for [1], the dimensions on the plans are not given in the text, and they are not shown in MS L or MS T.

OTHER MANUSCRIPTS Turin, BR, MS T, fols 17v–18r (Maltese 1967, I, p.72, line 5–p.73, line 3; p.258, tav.30–31); Florence, BML, MS L, fols 16v–17r (Marani 1979, II, cap.LIX, p.112); New Haven, BL, MS B, fols 16v–17r; Venice, BMV, fol.76r and v; Budapest, NL, Codex Zichy, fol.144r.
OTHER REPRESENTATIONS Pietro Cataneo, [3, 4] Uffizi 3300A; Giorgio Vasari il Giovane, [1] Uffizi 4746A.

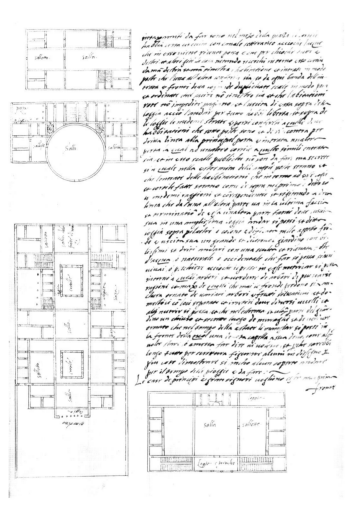

112

113

114

Palace plans

Inscribed [1] *salla–sallotta–loggia–piazza*; [2] *piaza*; [5] *salotto 25x45–salle 30x50– salotto 45x25–sallotto 30x30– loggie– Cortile–sallotto 30x30*; [6]*loggia–piaza–sallotto 20x30–sallotto [30]x20*
SJSM, vol.120, fol.29v

[1] A plan with a square central room and suites of three rooms of different sizes on either side of it opens on to a portico and courtyard. A double flight of stairs rises from the portico on the right of the plan, and there is a suite of four rooms and six rooms on the left.
[2] An octagonal plan with a central octagonal courtyard with a portico, large rectangular rooms in the cross axes and suites of four rectangular rooms in the diagonal axes with circular rooms in the spaces between the suites of rooms. Plans by Fra Giocondo (Uffizi 1698Ar) and a drawing of villas by Giulio Romano in Codex Chlumczansky (Prague, Library of the National Museum, fol.1v) depend on this plan (Siena 1993a, pp.385–8). The same plans are drawn in Marten van Heemskerck's Mantuan sketchbook

(Mantua 1989, p.41).
[3] is a hexagonal variant of [2].
[4] An almost-square plan with a rectangular room and suites of three rooms on either side in front of a courtyard with porticos on three sides and a wall with a gate on the fourth. The courtyard has a double-flight staircase on the left and symmetrical suites of three rooms.
[5] A square plan with a square central room with suites of three rooms of different sizes on either side, in front of a T-shaped courtyard with two porticos and suites of four rooms and double stairs.
[6] A rectangular plan with a central courtyard with a single loggia is entered through a shallow rectangular vestibule flanked by double-ramp staircases parallel to the façade. On either side of the courtyard there are long rooms with three smaller rooms, and two rectangular sitting-rooms in the corners with suites of four smaller rooms at the rear.

OTHER MANUSCRIPTS Turin, BR, MS T, fols 17v–18v, [2] fol.18r, [3] fol.17v,

[4–6] fol.18v (Maltese 1967, I, p.73, line3–p.74, line 6, tav.30–32); Florence, BML, MS L, [1–3] fol.17r, [4, 5] fol.17v, [6] fol.17v (Marani 1979, II, cap.LIX, p.112); New Haven, BL, MS B, fol.17r and v; Venice, BMV, fol.77r and 78r.
OTHER REPRESENTATIONS Pietro Cataneo, [2, 3] Uffizi 3303AV; [4] Uffizi 3300AV; Giorgio Vasari il Giovane, [2] Uffizi 4746A.

115

House plans for private citizens

Inscribed [1] *sallotti 20x45–sala 80x40–logia–Cortile*; [2] *salla–piaza–Cortile*; [3] *cortile*; [4] *sallotto 30x20–salla 40x24*
SJSM, vol.120, fol.30r

Francesco writes: 'on either side of great rooms there should be smaller rooms, *salotti*, with ornamental fireplaces, which give access to a smaller room, *camera*, which in turn opens into two *anticamere* for services. The arrangement should be symmetrical on all sides of the building. Services can be provided in the storey above this floor and the stairs connecting them should be spiral or concealed in the thickness of the wall.'
[1] A plan with two square courtyards and a great room between them is entered through a square atrium. At the head of each courtyard is a long room with three rooms leading from it; at the side of each courtyard is a suite of six identical small rooms with a long room and two smaller square rooms in the corners of the plan.
[2] An octagonal plan with a central square courtyard and concentric walls

forming two large rectangular rooms and suites of three or five rooms on one axis, and four or five rooms grouped around a small central rectangular room and staircase on the other. Little courtyards with diagonal *logge* fill the spaces between.
[3] An octagonal plan with a courtyard and concentric walls arranged so that behind each façade there is a rectangular room with a smaller room behind it. Latrines are shown in the triangular spaces between the rooms.
[4] A rectangular plan with a sala parallel to the façade, symmetrical suites of three rooms and a central rectangular courtyard, which has rectangular rooms on either side with three rooms next to them, and a suite of three rooms on either side of the stair on the long axis.

Like Alberti, Francesco categorized types of houses according to different classes of people ranging from kings to private citizens. In MS M house types for private citizens are divided into further categories – for artists, merchants, students and nobles – and an even greater range of housing is offered (Maltese 1967, II, fols 16r–21r, tav.192–3,

196–202). The hierarchy of the room arrangements, especially when grouped in three, and the accommodation of stairs and services recall Palladio (London 1975, pp.224–5).

OTHER MANUSCRIPTS Turin, BR, MS T, fols 18v–19r (Maltese 1967, I, p.74, line 6–p.75, line 9; tav.32–3); Florence, BML, MS L, fols 17v–18r (Marani 1979, II, cap.LIX, p.112); New Haven, BL, MS B, fols 17v–18r; Venice, BMV, fols 78r, 80v and 81r; Budapest, NL, Codex Zichy, fol.144r.
OTHER REPRESENTATIONS Pietro Cataneo, [1, 2] Uffizi 3303A; Giorgio Vasari il Giovane, [3] Uffizi 4756A.

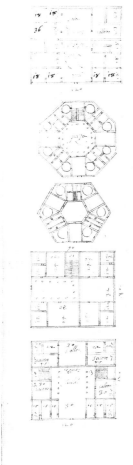

114

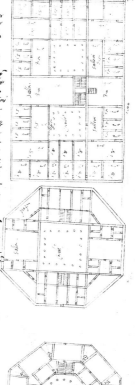

115

116

Plans of houses

Inscribed [1] *salla–loggia–cortile*; [2] *salla 36 x 38–sallotto[30] x 18–cortile– loggia*; [3] *loggia–salla–loggia piaza 50 x[50]–salla 40 x 50*; [4] *sallotto 35 x 20–Atrio e lume sop[ra]/la circulari abita/tione–salotto 35 x [20]*

SJSM, vol.120, fol.30v

[1] A plan with a central rectangular room that opens on to a rectangular colonnaded courtyard has suites of three rooms of different sizes, double staircases and suites of three rooms on either side of the courtyard. The rear wing is symmetrical.
[2] A plan with a central square courtyard with porticos on two sides and two rectangular rooms of different sizes behind each loggia. A suite of nine identical rooms occupies one side of the plan; the other has a central double-ramp stair flanked by symmetrical suites of six rooms.
[3] A plan with a rectangular room and suites of two small square rooms on either side of it in front of a courtyard with symmetrical, double-ramp stair-cases and suites of three rooms behind them. Behind the courtyard is a rectangular room that opens into a smaller room with light wells on either side of it, which act as vestibules to a third large rectangular room, flanked by suites of smaller rooms.
[4] A square plan with a square central

room entered through narrow corridors, with two rectangular rooms parallel to the façade on one side, symmetrical suites of four identical, smaller rooms on two sides and a smaller room and a staircase flanking the corridor on the fourth side. The suites of rooms flanking the courtyard are for the habitation of women on one side and for the use of visitors on the other; staircases lead down from the kitchen above them to both sets of apartments. Francesco never identified the Vitruvian term *atrium* correctly as courtyard as Alberti had done (Pagliara 1986, p.26); the term is nearly always used to denote an intermediate space between the entrance and the courtyard. In the caption he uses the term to identify the circular central room, which is usually lit from above (see fol.37v, cat.127). The reference to top lighting is characteristic of the captions in MS M (Maltese 1967, II, tav.199–201; Siena 1993a, p.394).

OTHER MANUSCRIPTS Turin, BR, MS T, fols 18v–19r (Maltese 1967, I, p.75, line 9–p.76, line 7; pp.258–9, tav.32–3); Florence, BML, MS L, fols 17v–18r (Marani 1979, II, cap.LIX–LXI, p.112); New Haven, BL, MS B, fol.18r; Venice, BMV, fol.77v.
OTHER REPRESENTATIONS Oreste Vannocci Biringucci, Siena, BC, fol.101r.

117

Plans of houses

Inscribed [1] *salla 36 x 48–loggia– cortile–sallotto quadro 36 x 36–salotto 36 x 22*; [2] *andare d'loggie–salla 32 x 28–sallotto 36 x 26–cortile– lumacha*; [3] *sallotto–loggie–cortile– salla 40 x 80*

SJSM, vol.120, fol.31r

[1] A plan with a central courtyard has a central double stair with square sitting-rooms on either side of it on one side, and a rectangular room with a smaller room on either side in the opposite wing. The two wings are linked at the side by a double row of identical small rectangular rooms, ten rooms in the outer row and four in the inner row. The large number of identical small rooms is suggestive of a convent or collegiate building.
[2] A central courtyard with four rectangular rooms on the cross axes and four smaller rooms in the corners between them. Three spiral stairs in towers project from the walls.
[3] A rectangular plan with a central courtyard has suites of three identical rectangular rooms on two opposite sides. On the right are central stairs with square rooms on either side of them and a large room occupying the full depth of the building. On the left a rectangular room and three smaller rooms have suites of four smaller rooms grouped around them.

OTHER MANUSCRIPTS Turin, BR, MS T, fol.19v (Maltese 1967, I, p.76, line 8–p.77, line 10; p.259, tav.34); Florence, BML, MS L, fol.18v (Marani 1979, II, cap.LXI–LXII, p.112); New Haven, BL, MS B, fol.18v; Venice, BMV, fols 78r, 81v–82r; Budapest, NL, Codex Zichy, fols 147r and 149r.
OTHER REPRESENTATIONS Pietro Cataneo, [1] Uffizi 3303A; Giorgio Vasari il Giovane, [2] Uffizi 4745A.

118

Plans of houses

Inscribed [1] *sallotto–portico [?] x 10– salla e atrio*; [2] *piaza 32 x 20–salla 68 x 30–cortile[50] x 24–sallotto 40 x 30– sallotto 40 x 20–piaza 30 x 20*

SJSM, vol.120, fol.31v

[1] A central rectangular room with two smaller rooms on either side is entered through a portico flanked by two square rooms. In the opposite wing two smaller corner rooms are connected by three small rooms. The wings are joined by suites of six identical rectangular rooms.
[2] A plan with a central rectangular room, parallel to the façade, flanked by rectangular rooms and suites of four rooms. The central room opens on to an exedral loggia and courtyard with stairs on each side. On both sides of the courtyard, a rectangular room gives access to a piazza and two suites of four and three rooms.

OTHER MANUSCRIPTS Turin, BR, MS T, fol.19r and v (Maltese 1967, I, p.77, lines 9–10–p.78, line 13; p.259, tav.33–4); Florence, BML, MS L, fol.18v (Marani 1979, II, cap.LXII, p.112); New Haven, BL, MS B, fol.18v; Venice, BMV, fol.81v.
OTHER REPRESENTATIONS Pietro Cataneo, [2] Uffizi 3303AV; Giorgio Vasari il Giovane, [2] Uffizi 4752A.

119

Plans of houses

Inscribed *sallotto 34 x 24–sallotto 28 x 32–atrio*

SJSM, vol.120, fol.32r

A rectangular plan with a central rectangular courtyard has sitting-rooms on three sides of the atrium and two rectangular rooms and a staircase on the fourth side. In the corners are four suites of four rooms, each with two medium and two small rooms, one with a latrine.

Francesco writes: 'they require windows, light and entrances in the most salubrious positions. The ancients had porticos at the entrances with a vestibule and passage into a courtyard with the staircase placed in the centre of the side of the courtyard. Others used atria and a stair on the left of it to the upper floors. On each side of the courtyard are entrances into the apartments. The first leads to the *sala* and

from this to the *anticamere* and *camera* which were at the service of the *sala*. From the courtyard there is an entrance to a *salotto*, sitting-room, for daily use and similarly a breakfast room, larders and smaller rooms to serve the *salotto*. The arrangements of the apartments must be symmetrical on both sides of the courtyard' (Maltese 1967, I, pp.78–9).

OTHER MANUSCRIPTS Turin, BR, MS T, fol.19v (Maltese 1967, I, p.78, line 14–p.79, line 17; p.259, tav.34); Florence, BML, MS L, fol.18v (Marani 1979, II, cap.LXIII, p.112); New Haven, BL, MS B, fol.18v.

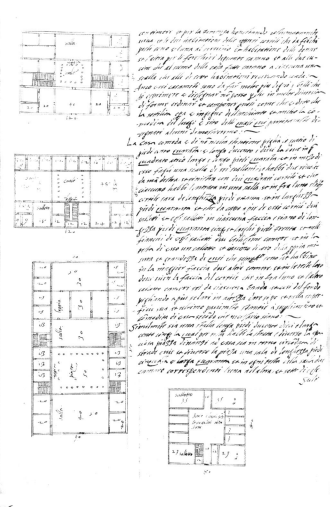

116

117

118

119

120

Circular plans of houses

Inscribed [1] *salla–Cortile–salla–36*; [2]
salla–il diametro 96/cortile 40–salla
SJSM, vol.120, fol.32v

[1] A circular plan with a central circu-
lar courtyard with a wedge-shaped
room on either side, a double stair
and a concentric outer room and two
concentric rooms on the cross axes,
and four suites of concentric rooms
with an inner room and four small
radiating, rectangular rooms on the
diagonal axes.
[2] A circular plan with a central circu-
lar courtyard has four wedge-shaped
apartments with a single rectangular
concentric inner room and three radi-
ating smaller outer rooms on the diag-
onal axes, and three apartments with

one concentric outer room and three
small inner rooms on the cross axes;
the fourth is occupied by a double stair
and a concentric outer room.
[3] A circular plan with a circular
portico, a ring of equal size, small
rooms, an ambulatory and a circular
colonnaded courtyard.

OTHER MANUSCRIPTS Turin, BR, MS T,
fol.19r and v (Maltese 1967, I, p.79, line
17–p.80, line 19; p.259, tav.34);
Florence, BML, MS L, fol.18r and v
(Marani 1979, II, cap.LXIII–LXVI, p.112);
New Haven, BL, MS B, fol.18r; Venice,
BMV, fol.81r; Budapest, NL, Codex
Zichy, fols 144r and 148r.
OTHER REPRESENTATIONS Giorgio
Vasari il Giovane, [1] Uffizi 4749A;
[2] Uffizi 4753A; [3] Uffizi 4750A.

Of palaces

SJSM vol. 120 fol.33r
No illustration

Of palaces

SJSM, vol.120, fol.33v
No illustration

Of palaces

SJSM, vol.120, fol.34r
No illustration

121

Courtyards and shapes of rooms
SJSM, vol.120, fol.34v

Francesco wrote that the ancients had
square courtyards and rectangular
courtyards of one-and-a-third squares,
of one-and-a-half squares, and of two
squares, as well as round or oval court-
yards (Maltese 1967, I, p.79). He illus-
trated an oval courtyard with a portico
and drew the outline of an octagonal
courtyard.

OTHER MANUSCRIPTS Turin, BR, MS T,
fol.20r (Maltese 1967, I, p.84, line
20–p.86, line 2; p.259, tav.35); Florence,
BML, MS L, [1] fol.19v; [2] fol.19r
(Marani 1979, II, cap.LXX, p.112);
New Haven, BL, MS B, fol.19v; Venice,
BMV, fol.88r.
OTHER REPRESENTATIONS Pietro
Cataneo, Uffizi 3303AV.

122

Courtyards and shapes of rooms

Inscribed [5] *salla de dui qua/dri e terzo*;
[6] *sala o ver sallotto/e tuti una me/dema
misura /contengono–sala de dui quadri*
SJSM, vol.120, fol.35r

[1–4] Courtyards based on a double
square; on one-and-a-half squares;
one-and-a-third squares; and on a
whole square. All of the courtyards
have corner piers and porticos on
columns. The height of the upper *logge*
should be a quarter, fifth or sixth part
of the *logge* below, and rules for the
intercolumniation are given as 1, 2 and
2½ modules. In MS M the loggia rule
says that the *logge* above can be open
with parapets and columns or closed
with windows (Maltese 1967, II, p.346).
Francesco writes: 'The shape of the
courtyard should be chosen according
to site and the same forms are suitable
for piazzas or for courtyards in castles.'
[5, 6] Room shapes based on two
squares and on two-and-one-third
squares.

OTHER MANUSCRIPTS Turin, BR, MS T,
fol.20r (Maltese 1967, I, p.86, line
3–p.87, line 6; p.259, tav.35); Florence,
BML, MS L, fol.19v (Marani 1979, II,
cap.LXXI–LXXII, pp.112–13); New
Haven, BL, MS B, fol.19v; Venice, BMV,
fol.88r; Budapest, NL, Codex Zichy,
fol.149r.
OTHER REPRESENTATIONS Pietro
Cataneo, Uffizi 3303AV.

120

121

122

123

Rooms and façades

Inscribed [2] *Camera d'un inti/ero quadro–Camera de quadro/e mezo–Camere de quadrro et/terzo*
SJSM, vol.120, fol.35v

[1–4] A triclinium, dining-room, based on a square with one open side; the same rule is given in MS M (Maltese 1967, II, p.347). According to Vitruvius (book VI, cap.III, 8), the length of a triclinium is twice its width. Plans of rooms based on a square, one-and-a-half squares and one-and-a-third squares are given. Francesco writes: 'the rule for the height of all these rooms will be the height of the square. If the rooms are circular or polygonal they will follow the same rule, also antechambers, and if these rooms are vaulted they can be decorated with sculpture.' In MS M (fol.17v) the height of all of the rooms is given as the diagonal of the square.
[5, 6] Elevations of houses with a central door and three windows in the upper storey; a half-elevation with a central door on the ground floor and three windows on the piano nobile. The drawing shows the proportions of the divisions of the façade; the floors diminish in height as they rise. The ground floor is six modules high, the piano nobile four; the door is four modules and the windows are three modules high.
[7] The unfinished elevation of a three-bay façade. The inscription in MS T refers to rustication on the ground floor and scale decoration on the upper floors, which are not shown in this drawing.
[8] A three-bay façade with corner pilasters and an arched central door. The MS T caption refers to diamond-shaped rustication. The storeys diminish in height at Francesco di Giorgio's Palazzo della Signoria in Jesi in the ratios 5:4:3; the only precedents in Renaissance architecture are found in palaces with superimposed orders, Palazzo Rucellai in Florence and Palazzo Piccolomini in Pienza (Siena 1993a, p.108). In MS M Francesco describes a proportional method using diagonals, which gives similar proportions.

OTHER MANUSCRIPTS Turin, BR, MS T, fol.20r and v (Maltese 1967, I, p.87, line 6–p.88, line 8; p.259, tav.35–6); Florence, BML, MS L, fol.19v, inscribed [1] *Tridinia dove tre/tavole da tre fa/ccie amensa por puo*; [2] *Chamara dun/o i[n]tero quadro*; [3] *Chamara di q[u]adro e mexo*; [4] *Chamara di q[u]adro e tterzo*; fol.20r, inscribed [5] *dalluno all altro pavimento/parti tre–vano della fi/nestra parti una e meza–la porta alta parte qu/arta el vano de due quadri*; [6] *finestra pa[r]ti tre nesuoi vanj*; [8] *Legamenti di recinto fanno in piu varj edive[r]si modj come nel di/segnio si manifesta* (Marani 1979, II, cap.LXXII–LXXIV, p.113); New Haven, BL, MS B, fols 19v–20r; Venice, BMV, fol.90r and v; Budapest, NL, Codex Zichy, fol.151r; Florence, BNCF, MS M, fol.17v (Maltese 1967, II, p.346, tav.194).
OTHER REPRESENTATIONS Pietro Cataneo, Uffizi 3291A; [1, 2] Uffizi 3303A.

124

Palace façades

SJSM, vol.120, fol.36r

[1] A three-bay, three-storey façade showing the proportions of the vertical divisions. The ground floor is six modules high, the piano nobile five, and the attic four-and-a-half modules high.
[2] A five-bay façade with corner pilasters and two Ionic pilasters on either side of a central door supporting an entablature. In the piano nobile Ionic pilasters support an entablature and frame rectangular windows.
[3] A three-bay façade with paired pilasters at the corners on the ground floor and a central door with a triangular pediment. On the upper floor paired pilasters frame niches at the corners of the façade, and the impost moulding of the niches is continued over the architraves of the three central windows resting on the entablature of the ground floor. The pilasters support a deep entablature.

The continuous string courses forming capitals over the pilasters on the ground floor and the continuous moulding linking the windows and niches are features of Francesco di Giorgio's architectural style.

OTHER MANUSCRIPTS Turin, BR, MS T, fols 20v–21r (Maltese 1967, I, p.88, line 8–p.89, line 12; p.113, tav.36–7); Florence, BML, MS L, [1] fol.20r, inscribed *Dividisi all uno elaltro pavimento i[n] parti cinque–lapo[r]ta pa[r]ti quarta nel sio vano–partj sei dalluno all al/tro pavime[n]to–ilsichondo pavime[n]to parte quinta alterzo pavimen/to parti qua[r]ta* (Marani 1979, II, cap.LXXIV–LXXVI, p.113); New Haven, BL, MS B, fol.20r and v; Venice, BMV, fol.90r and v; Budapest, NL, Codex Zichy, fol.152r.
OTHER REPRESENTATIONS [1–3] Pietro Cataneo, Uffizi 3291A; Vicenza, BBV, fol.115r.

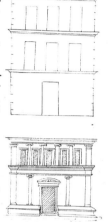

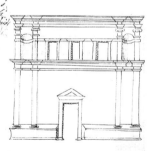

123

124

125

Façade of a theatre; diagram of an entablature

SJSM, vol.120, fol.36v

[1] The façade of a theatre with super-imposed orders diminishing in height as they rise.

[2] The profile of a male head and torso is shown in an entablature to illustrate the relationship of the parts of the entablature to human forms: 'The head is the cornice, the neck the frieze and the shoulders, which bear loads, the architrave. The head is divided into four fasciae: the first, the cranium, is the upper cyma and fillet; the second, the brow, is the corona; the third, the nose, is the ovolo; and the fourth is divided into two, the upper lip and chin, which are given to the dentil moulding and lower cyma. The chin to the forking of the breast is the frieze. The shoulder and breast correspond to the architrave; as the comb of the breast has four serried ribs, so the divisions of the fillets and astragals of the architrave will be constituted' (Betts 1977, p.12). The projection of the cornice equals its height, and the pro-jection of the corona is based on one side of an equilateral triangle drawn from the top of the brow or corona and the chin or lower cyma, to the ear. The same diagram is drawn in MS M, fol.37r. In *Medidas del Romano* (1526) Diego da Sagredo illustrated a pair of images

showing the relationship of the face and the cornice based on Francesco's diagram. He shows the face turned towards the cornice (Biir) and looking out of it, so that the face is the profile (Biiv). Bernini also made a critical series of sketches that integrated these drawings (Llewellyn 1977, pp.292–3, pl.91).

[3] Doors with trabeated openings and triangular and segmental pediments.

OTHER MANUSCRIPTS Turin, BR, MS T, fol.21r (Maltese 1967, I, p.89, line 8–p.90, line 16; pp.259–60, tav.37); Florence, BML, MS L, fol.20v, inscribed [2] *Ghola=Cranio–Ghocciolatoio= fro[n]te–huovolo=naso–Dentello=sotto naso–Sottoghola reve[r]sa=sotto naso– Fregio=vano e pien del mento–Ghola reversa dell/architrave–Regholi delle sotto poste strigie–Architrave*; [3] *frontespitio– astraghalo–porte di due i[n]tere quadri–di portione di cierchio–chorona–fregio– Architrave–Intavolatu[r]a* (Marani 1979, II, cap.LXXVI–LXXVIII, p.113); New Haven, BL, MS B, fol.20v; Venice, BMV, fol.93r and v; Florence, BNCF, MS M, fol.37r (Maltese 1967, II, tav.227). OTHER REPRESENTATIONS Vicenza, BBV, [2] fol.105r; [3] fol.115v; Pietro Cataneo, [2] Uffizi 3288A.

126

Façades of temples

SJSM, vol.120, fol.37r

Just as the male figure defined the proportions of the Doric order, here a nude male figure with his arms out-stretched defines the proportions of the façade of a temple or basilica with a tall central nave and side aisles. The figure is divided into nine modules.

Francesco understood the Vitruvian circle and square as basic units of mea-surement; in MS M he developed a the-ory in which they gave the proportions and modules of a building (Maltese 1967, II, tav.233–5) In MS M the human figure is no longer the primary means of determining the design of all the parts of architecture, on a declining scale for cities, sacred buildings and the orders, as it is here. The diagrams are generated from geometric figures in grids based on simple relationships of squares and circles, from which Francesco could design any church type (Lowic 1982, p.155 and n.27; see also Millon 1958).

OTHER MANUSCRIPTS Turin, BR, MS T, fol.21v (Maltese 1967, I, p.90, line 16–p.91, line 13; p.260, tav.38); Florence, BML, MS L, fol.21r, inscribed *chonpartimento de/le faccie di ciasch/u[n] tenpio a mixu/ra e ffo[r]ma del cho[r]/po humano* (Marani 1979, II, cap.LXXVIII– LXXIX, p.113); New Haven, BL, MS B,

fol.21r; Venice, BMV, fol.95r; Budapest, NL, Codex Zichy, fol.126r. OTHER REPRESENTATIONS Vicenza, BBV, fol.105r; Oreste Vannocci Biringucci, Siena, BC, fol.55v (he records the dia-grams from both MS L and MS M and compares them side by side).

127

Façades of temples and vaults

SJSM, vol.120, fol.37v

[1] An unfinished diagram to show the proportions of the façade of a circular building. The drawing is also incom-plete in MSS T and L.

[2] A view of a flattened dome with a central oculus and a parapet above it. The dome is similar to those in the side chapels of S. Andrea, Mantua (illus-trated in Lightbown 1986, pp.452–3), and to Rosenthal's reconstruction of a central domed room in Mantegna's house in Mantua, begun in 1476; in MS M Francesco shows the plan of a house that is very similar to Mantegna's. The covered rotundas or octagons in the group of small houses for the upper classes drawn in MS M, usually called *atria*, are usually lit from above by an oculus in the vault or by clerestory win-dows below the vault (Rosenthal 1962, pp.332 and 344, fig.18; Maltese 1967, II,

p.558, tav.198). Mantegna's *trompe-l'oeil* vault in the Camera degli Sposi, Mantua, also has an oculus and parapet cut into a vault on lunettes (illustrated in Lightbown 1986, cat.54).

[3] Perspectival section of a barrel vault with square coffers.

OTHER MANUSCRIPTS Turin, BR, MS T, fol.21r (Maltese 1967, I, p.91, line 13–p.92, lines 11–12; p.260, tav.38); Florence, BML, MS L, fol.21r, inscribed [1] *faccia e chompartimento du[n] ritondo difitio delli/vani ellumj*; [2] *volta e huovolo ottonde ch/oj riquadratj*; [3] *volta a botte chon suoi riquadr/hovero a semicirchulo* (Marani 1979, II, cap.LXXIX–LXXXI, p.113); New Haven, BL, MS B, fol.21r; Venice, BMV, fols 93v and 95v; Budapest, NL, Codex Zichy, fol.130r. OTHER REPRESENTATIONS Vicenza, BBV, [1] fol.119r; [2, 3], fol.105r; Pietro Cataneo, Uffizi 3291A, with the same inscription as MS T.

128

Vaults

SJSM, vol.120, fol.38r

Diagrams of vaults found in ancient buildings – [1, 2] two views of a flattened dome with an oculus; [3] a melon dome with ribs rising from imposts or *peducci*; [4] a flattened dome on shell niches with an oculus as in the Camera degli Sposi, Mantua; [5] a vault on shell niches; and [6] details of the shell niches with dolphins riding them – are given before two examples of modern vaults, [7] a vault on lunettes and [8] a sail vault. Giulio Romano's vault in the Sala degli Aquile in Palazzo del Te, Mantua, is on shell niches (Hartt 1958, fig.217).

OTHER MANUSCRIPTS Turin, BR, MS T, fols 21v–22r (Maltese 1967, I, p.92, line 12–p.93, line 18; p.260, tav.38–9); Florence BML, MS L, fol.21r, inscribed [1] *volta a choncha*; [2] *volta a choncha*

gradua/ta; fol.22v, inscribed [3] *Volta a peduccj*; [4] *volta a nichj i[n] modo delle lunette e i[n] mezo la churvata concha– choncha*; [5] *Volta a nichj i[n] loco delle lunette*; [6] *Infra nicchi li hornati peducci*; [8] *Volta a vela*; [7] *Volta a lunette* (Marani 1979, II, cap.LXXXI–LXXXII, p.113); New Haven, BL, MS B, fol.21v; Venice, BMV, fol.97r; Budapest, NL, Codex Zichy, fols 130r–131r OTHER REPRESENTATIONS Vicenza BBV, [1, 2], fol.115v; [5], fol.119r; Pietro Cataneo, Uffizi 3291A (with the same inscription as MS T and an additional drawing inscribed *Volta di tomboli o camoni di terra*, which is drawn in MS L without an inscription).

125

126

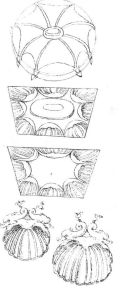

127

128

129
Bricks, triglyphs
SJSM, vol.120, fol.38v

The bricks and consoles used by ancient builders: [1] a brick with a T-shaped section to support the end of a beam in a roof structure; [2] a round, hollow vessel and [3] a section showing the hollow vessels *in situ* in a spandrel to lighten the structure of a vault; [4] a console supported on a little winged dragon; [5] a perspectival elevation and profile of a console with three scrolls; and [6] a bracket to receive the wooden beam of a roof structure made from bricks with a T-shaped section.

Amphora are shown lightening the vaults of a building based on the aula in Trajan's market in Giulio Romano's altarpiece of the *Stoning of St Stephen* in S. Stefano, Genoa (Hartt 1958, fig.95). The little animal on the console [4] is captioned *tigra* in MS L. In MS T the word is erased and replaced by *trigrafo*. This suggests that the term for triglyph was

misunderstood. Francesco explains that they are so-called because the ancients divided them into three parts, at first carving their faces in the guise and form of a tiger (Betts 1977, p.6). The anecdote disappears completely in MS M (Maltese 1967, II, p.94, n.10).

OTHER MANUSCRIPTS Turin, BR, MS T, fol.22r (Maltese 1967, I, p.93, line 19–p.95, line 1; p.260, tav.38); Florence, BML, MS L, fol.22v, inscribed [1] *mattonj p[er] fiano a cchiavicela*; [2] *vaxo*; [3] *fiancho di vachui vaxj pieno–fia[n]cho*; [4] *Tigrafo*; [5] *Tigrafo–Tigrafo*; [6] *Molle hove[r] chonsoleio da solarj achiaviciella* (Marani 1979, II, cap.LXXXII, p.113); New Haven, BL, MS B, fol.21v; Venice, BMV, fols 98v–99r; Budapest, NL, Codex Zichy, fols 106r, 119r, 131r and 145r.
OTHER REPRESENTATIONS Vicenza, BBV, fol.119r; Pietro Cataneo, Uffizi 3288A and Uffizi 3997A; Oreste Vannocci Biringucci, Siena, BC, fol.50v.

130
Consoles and beams
SJSM, vol.120, fol.39r

[1–6] Perspectival views and profiles of consoles with acanthus leaf, ram's head and guilloche ornament.
[7, 8] A false beam made from several pieces of wood, which can support great weights; a reinforced beam.
[9] Sections of beams showing the different kinds of joints that can be used to make strong, straight beams from several pieces of wood.

Taccola also shows different kinds of joints for roof beams in *De ingeneis* (book I, fol.37r; Prager, Scaglia & Montag 1984, p.73).

OTHER MANUSCRIPTS Turin, BR, MS T, fol.22r and v (Maltese 1967, I, p.95, line 1–p.96, line 11; p.260, tav.39–40; [1] and [6] are not drawn in MS T); Florence BML, MS L, fol.22r, inscribed [1] *[m]utolo*; [2] *montone*; [3] *mutolo hover molo–[m]utolo*; [4] *Metofa–Metofa altrime(n)ti/*

mensole; [6] *bordone–monacho–chavallo*; [8] *di piu pexi* (Marani 1979, II, cap.LXXXIII–LXXXIV, p.113); New Haven, BL, MS B, fol.22r; Venice, BMV, fols 98v, 99v and 100r; Rome, BAV, [7–9] *Codicetto*, fols 53v–56v.
OTHER REPRESENTATIONS Vicenza, BBV, fol.101r; Pietro Cataneo, Uffizi 3297AV; Oreste Vannocci Biringucci, Siena, BC, fols 101v, 119r and 145r.

131
Beams, roof structures and chimneys
SJSM, vol.120, fol.39v

[1] A section of two beams showing the joints used to make a strong beam from several pieces of wood.
[2, 3] Reinforced roof structures made from several pieces of wood without a main beam.
[4] A chimney-pot with a square plan and two flues, so that if the wind blows down one flue the smoke can escape through the other. The cone or pyramid on top prevents rain coming down the chimney. The eight smoke exits on the sides are protected by four projecting screens, which prevent the smoke returning down the chimney in winds.
[5] A chimney-pot with a round plan and a conical top has openings all round screened by a circular gallery with openings for the smoke to escape.
[6] A circular chimney-pot has three flues, a conical cap and three curved funnels to allow the smoke to escape; the funnels narrow to prevent the smoke returning into the chimney.

Francesco developed expertise in fireplace and chimney design. Federigo Gonzaga asked him to come to Mantua to advise him on smoking chimneys; he replied from Urbino enclosing designs for chimneys that used to smoke but which he had succeeded in ventilating (Siena 1993a, pp.356–7).

OTHER MANUSCRIPTS Turin, BR, MS T, fols 22v–23r (Maltese 1967, I, p.96, line 11–p.97, line 12; p.260, tav.40–41); Florence, BML, MS L, fol.22v, inscribed [2] *a fongho*; [4] *fumante–mantelletto–Ghola pa[r]tita*; [5] *Cimaxa delfu[m]ante–ma[n]tel–Ghola e chamino piramidale–Entrata dell/[aca?]ppa piram/dale*; fol.23r, inscribed [6] *Chapello del cimaxo–chamino trepa[r]tito con tre cho[r]ni/a chiascuno partime[n]to el suo* (Marani 1979, II, cap.LXXXIV–LXXXV, p.113); New Haven, BL, MS B, fol.22r and v; Venice, BMV, fols 100r and 103v; Budapest, NL, Codex Zichy, fol.153r; Rome, BAV, *Codicetto*, fol.55v.
OTHER REPRESENTATIONS Vicenza, BBV, [6] fol.73r; [5] fol.101r; Antonio da Sangallo, Uffizi 4053AV; Pietro Cataneo, Uffizi 3308A.

132
Fireplaces
SJSM, vol.120, fol.40r

Francesco describes three types of fireplaces and chimneys.
[1] A fireplace with balusters and consoles supporting a trabeated pyramidal canopy and flue that bends on itself as it rises to a chimney-pot with arched openings to let out the smoke and a cone on top to stop the rain entering the chimney. Francesco describes it as a perfect chimney (Maltese 1967, I, p.99, n.2).
[2] A fireplace with pilasters supporting an entablature that breaks forward above them has a canopy decorated with dolphins whose tails curl upwards as consoles to support a straight wide flue with a pyramid on top.

Vitruvius does not mention fireplaces, which certainly existed in Antiquity, probably with different chimneys. In a drawing of the baths at Cassino, Francesco recorded a fireplace on the south side of the octagonal room; in MS M (fol.13r and v) he listed ancient fireplaces he had seen without including the one at Cassino (Siena 1993a, p.337; Maltese 1967, II, pp.331–3, tav.188). Francesco da Carrara is credited with building the first fireplaces in Rome, in 1369. For their evolution in Italy, see Schiaparelli 1983, I, pp.88–113; Thornton 1991, pp.20–27.

The fireplaces in the dressing-room next to the bath and in the Sala del Trono in the Palazzo Ducale, Urbino, are similar to the fireplace with pilasters [2]; one is built to a larger scale following the advice that they should be large in rooms, *sala*, and smaller in chambers, *camere*. A drawing by Francesco in the Uffizi shows a fireplace with a free-standing column (Uffizi 320A; Siena 1993a, pp.171 and 334–5).

OTHER MANUSCRIPTS Turin, BR, MS T, fol.23r (Maltese 1967, I, p.97, line 13–p.98, line 8; p.261, tav.41); Florence, BML, MS L, fol.22v, inscribed [1] *Chamino to[r]tuoso hovero an/gholato aguixa dangue–E questi to[r]tuosi chaminj ap[r]esso de greci zetj detti son[n]o p[er]che affor[r]ma du[n] /zeta dichano essere fattj*; [2] *Ghola del chamino tutta huguale* (Marani 1979, II, cap.LXXXV, p.113); New Haven, BL, MS B, fol.22v; Venice, BMV, fol.103r; Budapest, NL, Codex Zichy, fols 108r and 152r; Florence, BNCF, MS M, fol.13r (Maltese 1967, II, pp.331–2, tav.189).
OTHER REPRESENTATIONS Vicenza, BBV, [2] fol.119v; Pietro Cataneo, Uffizi 3308A.

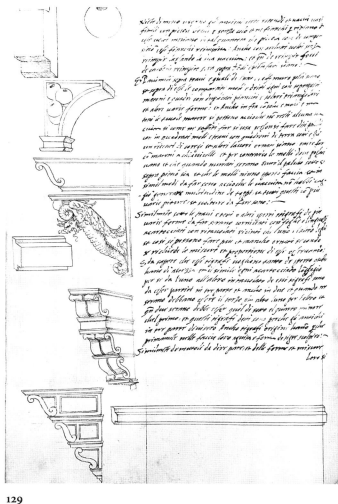

129

130

131

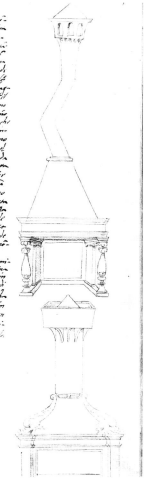

132

133
Chimneys
SJSM, vol.120, fol.40v

[1] A chimney-pot with a half cover protecting the smoke exits, which is turned by a metal pennant that follows the direction of the wind.
[2] A fireplace with an architrave supported on piers and with a wide, bell-shaped canopy. Francesco recommends that the embrasure should be 2 piedi high by 2–3 piedi maximum in chambers, camere, and 2–4 piedi wide in rooms, sale.
[3] A chimney-pot with two inverted cones, so that when the smoke has exited through the narrow hole, the wind cannot blow it back down the chimney. Rain water collects in the bottom of the upper cone.
[4] A profile showing the top of the embrasure and the position and projection of the flue behind the hood and inside the chimney-stack.

Chimneys in the modern sense have been constructed since the Middle Ages. Taccola wrote about chimneys in De ingeneis (book I, fols 32v–35r), and Francesco copied his drawings (Siena 1991, p.337; Scaglia 1984, I, p.65). Daniele Barbaro (Vitruvius 1556, book VI, cap.10) noted that Vitruvius did not mention them, and he referred to Francesco's designs for fireplaces;

Scamozzi (1615, book III, cap.21) also cited his designs.
For early chimneys, see Promis 1841, pp.42–4, n.3.

OTHER MANUSCRIPTS Turin, BR, MS T, fol.23r (Maltese 1967, I, p.98, line 9–p.99, line 9; p.261, tav.41); Florence, BML, MS L, fol.22v, inscribed [1] penello hove[r] ba/ndaruola dira/me ho fer[r]o-bilicho sop[r]a cimaxa/della banderola et/ma/ntelletto–mantelletto di rame; [2] Chap[p]a a fo[r]ma di vaxo; [3] Cimaxo quadrj pa[r]tito–Bocha dela ristre/tta piramida; [4] Cho[r]no dentro/el chamino–Bocha del corno fuore del muro (Marani 1979, II, cap.LXXXV, p.113); New Haven, BL, MS B, fol.22v; Venice, BMV, fol.103r and v; Budapest, NL, Codex Zichy, fols 152r and 153r.
OTHER REPRESENTATIONS Vicenza, BBV, [2, 3], fol.119v; Pietro Cataneo, Uffizi 3306A; Oreste Vannocci Biringucci, Siena, BC, fol.68r.

134
Baths
SJSM, vol. 120, fol.41r

Francesco borrowed Vitruvius' text (book V, cap.X, 4-5) to introduce baths.
[1] A perspective section of the circular domed sudarium of a bath with a continuous bench around the walls. After Vitruvius, the height of the room below the semicircular dome with oculus corresponds to its width. On the right a stove heats the water for the warm baths above.
[2] A plan of the underfloor heating system below a sudarium. It shows the low piers supporting the floor of the sudarium and a triangular stove in front. The stove is narrow at the front opening and wide at the back to create a draft so that wood or charcoal can burn on iron grates and generate great heat; the hot ash can also be raked into the basement below the sudarium to heat it. The width of the room is two-thirds the length, as prescribed by Vitruvius.
[3] A bath house with a room on the left with the tubs for warm baths, a frigidarium in the centre, and on the right a sudarium with a cavity wall and a continuous bench, a shelf for bottles and glasses and a towel rail. A wood-burning stove below it heats the underfloor heating system and the cavity wall.

In Roman baths the cavity walls were created by covering the walls with earthenware tiles with a nipple on each corner, tegulae mammatae, which left a cavity through which the heat could rise. The furnace, hypercaust, was usually outside the caldarium; the heat from it was conducted below the copper water-tank to heat the water, then under the floor of the caldarium and upwards via the wall cavities. The fuel used to heat the furnace was probably charcoal, because wood smoke would have been deposited as soot behind the tiles, where it could not be swept (Sandkleff & Selling 1976).

OTHER MANUSCRIPTS Turin, BR, MS T, fol.23v (Maltese 1967, I, p.99, line 9–p.100, line 18; p.261, tav.42); Florence, BML, MS L, fol.23r, inscribed [1] Bagnio–frigidario–profurnio; [2] fondo della stufa–vachuita fralluno ellaltro muro dovel chalore chorendo rischalda-p[r]ofu[r]nio; [3] frigidario–stufa-p[r]ofu[r]nio della stufa–p[r]ofu[r]nio delle chaldaie (Marani 1979, II, cap.LXXXV–LXXXVI, p.113); New Haven, BL, MS B, fol.23r; Venice, BMV, fol.106r and v; Budapest, NL, Codex Zichy, fols 152r and 164r.
OTHER REPRESENTATIONS Vicenza, BBV, [1] fol.67v; [2, 3] fol.73r; Pietro Cataneo, Uffizi 3308AV.

135
Baths
SJSM, vol.120, fol.41v

A circular sudarium with underfloor heating and a cavity wall, a chimney in the centre rising the full height of the room and a continuous bench around the walls. Inside the chimney a dome-shaped snuffer attached by a rope to a winch could be raised or lowered to draw the flames into the chimney and heat the room. On the right a door leads to the warm baths with a stove below to heat the water supply.

Francesco's bathroom in the Palazzo Ducale at Urbino is the earliest surviving example in a palace of a bath inspired by ancient examples. The bath was square in plan and it had steps for heating channels. It was located immediately below the studiolo on the piano nobile. Francesco describes this arrangement for baths in palaces in MS M (Maltese 1967, II, pp.351–2; Siena 1993a, pp.168ff., especially p.171). Access to the baths was from the stair

in the tower next to the apartments and from the courtyard of the palace. Alberti also designed a baths complex for the Gonzaga (Burns 1979, pp.45–56), and Giulio Romano built a bathroom for Federigo Gonzaga close to the tennis court at Palazzo del Te in Mantua.

OTHER MANUSCRIPTS Turin, BR, MS T, fol.23v (Maltese 1967, I, p.100, line 18–p.101, line 22; p.261, tav.42); Florence, BML, MS L, fol.23r, inscribed intufa sicho[n]do/li antichi–chamino del fuocho p[er] la quale la stufa ri/scalda Capello di bro[n]zo–Tenpera[n]za–p[r]ofurnio delle chalderie–p[r]ofu[r]nio della stufa (Marani 1979, II, cap.LXXXV–LXXXVI, p.113); New Haven, BL, MS B, fol.23r; Venice, BMV, fol.106r; Budapest, NL, Codex Zichy, fol.154r.
OTHER REPRESENTATIONS Vicenza, BBV, fol.67v; Pietro Cataneo, Uffizi 3308AV; Oreste Vannocci Biringucci, Siena, BC, fol.103v.

136
Rustic building
SJSM, vol.120, fol.42r

Two narrow rectangular buildings with two superimposed logge on piers supporting overhanging roofs, which give shelter from sun and rain, occupy two sides of a courtyard, which is entered by gates in a low wall connecting the two buildings. The courtyard is divided in two by a low wall; supplies are kept in the first courtyard and the second is used for habitation.

The division of the courtyards to serve domestic and agricultural functions is traditional. Piero de' Crescenzi's late 14th-century treatise on agriculture, first printed in Venice in 1486, described similar divisions, and the frontispiece of the edition of 1495 shows the same functions divided and organized differently. For Fra Giocondo's interest in the book, see Brenzoni 1960, p.97.

OTHER MANUSCRIPTS Turin, BR, MS T, fol.24r (Maltese 1967, I, p.101, line 22–p.102, line 18; p.261, tav.43); Florence, BML, MS L, fol.23v, inscribed Cholonbara–Chasa rusticha–cortile della chasa abita/bile–Co[r]ti/le p[er] li animalj–Entrata del rusticho–Entrata esta[n]za p[er] li animalj (Marani 1979, II, cap.LXXXVI–LXXXVII, p.113); New Haven, BL, MS B, fol.23v; Venice, BMV, fol.107r.
OTHER REPRESENTATIONS Vicenza, BBV, fol.73v; Pietro Cataneo, Uffizi 3294A; Oreste Vannocci Biringucci, Siena, BC, fol.51r.

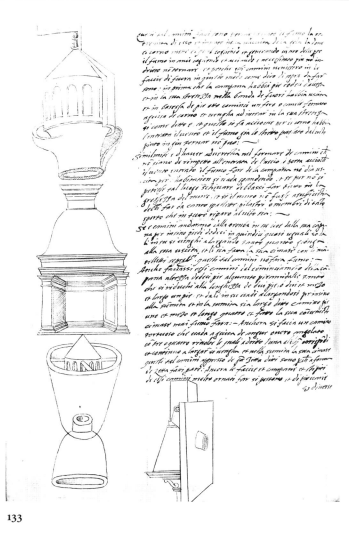

133

134

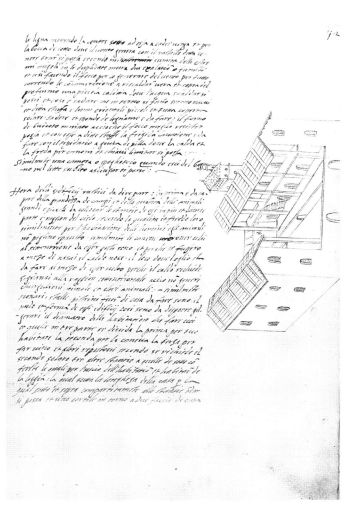

135

136

Tuscan buildings and houses of the Greeks
SJSM, vol.120, fol.42v
No illustration

Gymnasia
SJSM, vol.120, fol.43r
No illustration

Nature of materials, lime, bricks and stone
SJSM, vol.120, fol.43v
No illustration

Stone and wood
SJSM, vol.120, fol.44r
No illustration

137
Villa and hunting park
SJSM, vol.120, fol.44v

The villa is situated in an eminent position in the centre of the park. It is approached by spiral paths up the hill and surrounded by a moat, which can also function as a fish pond. The cultivated land lies in front, and porticos for storing grain and hay are built against the enclosure walls on either side of the villa. Densely forested areas of deciduous and evergreen trees provide shelter for wild animals, and fruit trees are planted in fenced orchards. On the left of the park is a rectangular enclosure for rabbits, and on the right is a semicircular one for wild boar.

The villa, in an elevated position, with a loggia on the ground floor and an attic loggia, and with the services separated from the house, provides a precedent for the Palladian villa.

OTHER MANUSCRIPTS Turin, BR, MS T, fol.25r (Maltese 1967, I, p.106, line 9–p.107, line 10; p.261, tav.45); Florence, BML, MS L, fol.25r, inscribed *barchetto/p[er] chonilj–barcho–barchetto p[er] cinghialj* (Marani 1979, II, cap.XCI, p.113); New Haven, BL, MS B, fol.25r; Venice, BMV, fol.110v.
OTHER REPRESENTATIONS Vicenza, BBV, fol.73v; Pietro Cataneo, Uffizi 3311A.

138
Shelters at the mouths of rivers
SJSM, vol.120, fol.45r

The illustrations show how the mouths of rivers can be protected from the force of the wind driving in deposits, which block the entrances so that ships can neither enter nor leave. Wing-shaped, reinforced promontories to slow the flow of water are constructed from stakes and wattle filled with rubble and earth. A rhombus is constructed in the centre of the river with two curved wings, shaped like an anchor, projecting into the sea and sheltering the promontories.

Francesco said that there was a shelter such as this at Fallari in Sicily. There was a similar promontory at Phalacrium in northern Sicily, now Capo Rasocolmo, but no trace of a river that could be identified as Fallari survives (Maltese 1967, I, p.109, n.6).

OTHER MANUSCRIPTS Turin, BR, MS T, fol.25v (Maltese 1967, I, p.108, line 21–p.109, line 22; p.261, tav.46); Florence, BML, MS L, fol.25r, inscribed *fiume–Ronbo–mare–Traversia* (Marani 1979, II, cap.XCI–XCII, p.113); New Haven, BL, MS B, fol.25r; Venice, BMV, fol.111v.
OTHER REPRESENTATIONS Vicenza, BBV, fol.67r; Pietro Cataneo, Uffizi 3294AV; Oreste Vannocci Biringucci, Siena, BC, fol.100r.

139
Harbours at the mouths of rivers
SJSM, vol.120, fol.45v

[1] Winglike promontories, built from stakes and wattle, are built out from the mouth of the river towards the sea; a barrier, shaped like a bow, screens the entrance. The city view in the drawing in MS L is not shown here.
[2] Francesco writes: 'The ancients built an arrangement on Crete with two tortuous winged promontories, one curving back on itself, the other projecting forward and turning back at an angle.'
[3] Two wings forming a rhombus-shaped basin with a central sluice-gate in front of a concave semicircular barrier, 200 *piedi* behind it, with a central sluice-gate at the mouth of the river. The gates can be opened to control the level of water in the harbour basin and to evacuate the river when necessary. There was a similar arrangement at Talamone, near Grosseto, Tuscany. Ladder bridges connect the two barriers to the shore.
[4] A horseshoe-shaped harbour is constructed at the mouth of the river.

OTHER MANUSCRIPTS Turin, BR, MS T, fol.25v (Maltese 1967, I, p.109, line 22–p.110, line 27; p.261, tav.46); Florence, BML, MS L, fol.25v, inscribed [1] *fiume–Mare–Traversia–Traversia*; [2] *fiume–Traversia–Mare–fiume*; [3] *portella–ponte–Angolo a ro[m]bo–Traversia–Mare–portello [traver]sia*; [4] *fiume [tra]ve[r]sia–Mare* (Marani 1979, II, cap.XCII–XCIV, p.113); New Haven, BL, MS B, fol.25v; Venice, BMV, fol.112r and v.
OTHER REPRESENTATIONS Vicenza, BBV, [1–3] fol.43v; [4] fol.57v; Pietro Cataneo, Uffizi 3294AV.

140
Foundations, cisterns, filters and conduits
SJSM, vol.120, fol.46r

[1] The text reads: 'To lay foundations for a building on a marshy site construct two wooden boxes, the inner one smaller than the outer one by the desired thickness of the walls, then reinforce them with large wooden beams; take them to the site and fill the spaces between the boxes.' This is a clear description of the cofferdam method shown on fol.14r (cat.90). Water filtered by gravity is delivered to fountains on city squares.

The text on cisterns prescribes: 'the larger they are the better they will maintain water. It should be 20 *piedi* wide and 50 deep. If it is built on a marshy site it should be reinforced and it should have double walls 1 *piede* apart filled with pebbles and lime. The wall should be covered with concrete. The bottom of the cistern is covered with a layer of broken pebbles mixed with broken terracotta pots, then a second layer of crushed pebbles covered by a layer of concrete, which is rubbed down with oil or lard. The water that collects on the roof will pass through an upper filter and enter a hollow pier 4 *piedi* wide filled with small, well-washed pebbles that will filter the water and purify it of impurities picked up while it was accumulating on the roof. Before entering the cistern, the water passes into another filter 16 *piedi* wide and 18 *piedi* high full of pebbles.'
[2] The drawing has been misunderstood, because it shows the cistern with a chimney and the cistern on marshy ground merged together as one.
[3] A detail of the way in which cisterns can be reinforced is also slightly misunderstood.
[4] The drawing shows the reinforcement of a cistern. The cisterns at the bottom of the folio are not like those in MS T and MS L; they are identical to those drawn in MS B on fol.25v (illustrated in Siena 1991, p.281).

OTHER MANUSCRIPTS Turin, BR, MS T, fol.26r (Maltese 1967, I, p.110, line 27–p.111, line 34; p.262, tav.47); Florence, BML, MS L, fol.25v, inscribed [1] *chassa*; [2] *Inbochatoio/del cho[n]p[r]uvio–Ghola–chola–Ciste[r]none–Ciste[r]na*; [3] *Modo da[r]madura in/nella cisterna*; [4] *Ciste[r]na–ciste[r]none* (Marani 1979, II, cap.XCIV, p.113); New Haven, BL, MS B, fol.25v; Venice, BMV, fols 113r and 115v.
OTHER REPRESENTATIONS Vicenza, BBV, [1–3] fol.57v; [4] fol.43r; Pietro Cataneo, [2, 3] Uffizi 3307A.

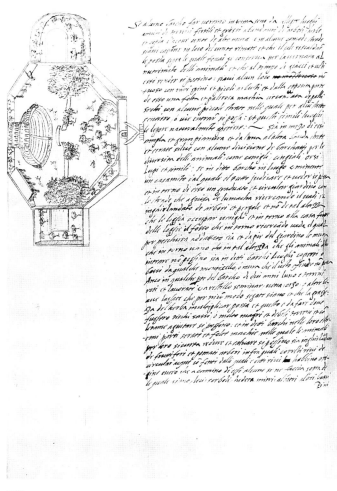

137

138

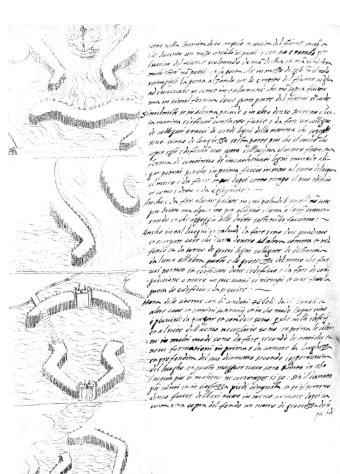

139

140

141
Cisterns
SJSM, vol.120, fol.46v

[1] Francesco writes: 'A cistern with a spiral filter is about 10 *piedi* wide by 20 *piedi* high; the channel that spirals around the cistern is 3 *piedi* wide at the top and 2 *piedi* wide at the bottom. The channel is filled with pebbles, and if the ground is inclined towards its mouth the water from the piazza will flow through the filter and enter the cistern.'
[2] Two superimposed inverted pyramidal filters.

OTHER MANUSCRIPTS Turin, BR, MS T, fol.26r (Maltese 1967, I, p.112, line 1–p.112, line 31; p.262, tav.47); Florence, BML, MS L, fol.26r, inscribed [1] *Chisterna chonchola/toio a lomacha*; [2] *cholatoio a uxo/di piramide de dup[r]ichato* (Marani 1979, II, cap.XCV–XCVI, p.113); New Haven, BL, MS B, fol.26r; Venice, BMV, fol.115v; Rome, BAV, *Codicetto*, [2] fol.9v.
OTHER REPRESENTATIONS Vicenza, BBV, [1] fol.87v; [2] fol.67r; Pietro Cataneo, Uffizi 3307A.

142
A cistern, inverted siphons bringing water to a fountain in a city, the construction of water conduits
SJSM, vol.120, fol.47r

[1] Inverted siphons were used by the Romans to cross deep valleys, where a bridge would be very high and expensive to construct. A pipe runs from a head tank to a crossing in the valley then up to a receiving tank on the other side. For the siphon to work the difference in level between the start and finish must be large enough to give the water velocity. The water supply at Lyon is a well-known example of the technique (Smith 1975, p.91). Vitruvius (book VIII, cap.VI) described inverted siphons without understanding how they worked; he said that air-valves were needed to relieve the pressure, and these are shown in Francesco's drawing.
[2] A well sunk into a cistern filled with pebbles to filter the water. Arched openings at the bottom of the well to let in water, shown in MSS T and L, have not been drawn in this illustration.
[3–5] The details show the beams reinforcing an underground water conduit, the wall of an underground water conduit and hydraulic junctions.

OTHER MANUSCRIPTS Turin, BR, MS T, fols 26r–27r (Maltese 1967, I, p.112, line 31–p.113, line 31; p.262, tav.47–9); Florence, BML, MS L, fol.26r, inscribed [1] *Nascime[n]to dellaq[ua]–sfiatolo–Ghalaza–Sfiatatoj–Aquidotto*; [2] *ciste[r]na–ghiara–ghiara–pietra*; fol.26v, inscribed [3] *Modo darmadura di/chava sotteranea*; [4] *muro di chava/sotteranea*; [5] *Tonboli* (Marani 1979, II, cap.XCVI– XCVII, p.113); New Haven, BL, MS B, fol.26r and v; Venice, BMV, fols 117r and 118v; Rome, BAV, *Codicetto*, [1] fol.9r.
OTHER REPRESENTATIONS Vicenza, BBV, [1, 2] fol.43r; [3–5], fol.43v; Pietro Cataneo, Uffizi 3307A; Oreste Vannocci Biringucci, Siena, BC, fol.88v.

143
Excavation of tunnels for water conduits
SJSM, vol.120, fol.47v

According to Vitruvius (book VIII, cap.VI), tunnels were cut through hills between a fountain-head and a city. They were unlined if the formation was stone or tufa; otherwise floors and walls were lined with masonry and the tunnels vaulted, with vertical shafts sunk at intervals of 120 *piedi*. The sections show straight and zigzag tunnels for conduits underground. Rope stretched between plumb-lines, suspended down the shafts, are used to check that the level of the tunnel is constant, so that the water can flow by gravity. The shafts are used as air shafts and to clear away waste material. The section [1] shows the level of the bore controlled by a surveyor's set square with a plumb line suspended from it to ensure a level, straight tunnel. The plumb line in [2] also controls the surveyors' set squares, which are set at angles to each other to direct the path of the bore and to ensure the even width of a level, zigzag tunnel. The zigzagging is probably to slow the flow of the water.
There is an analogous drawing in *Opusculum* (fol.18v). Taccola shows the same tunnelling process in *De ingeneis*, and refers to the use of the magnetic compass (Prager & Scaglia 1972, pp.134–5, figs 79–80).

Between 1469 and 1472 Francesco worked on the underground aqueduct in Siena called *bottini* (Siena 1991, pp.274–9), probably mainly on maintenance and cleaning, although he is documented as making a new branch of 80 *braccia* (Weller 1943, doc.V–VI; Siena 1993a, p.143; for the *bottini*, see Balestracci 1984).

OTHER MANUSCRIPTS Turin, BR, MS T, fol.27r (Maltese 1967, I, p.113, line 31–p.114, line 30; p.262, tav.49); Florence, BML, MS L, fol.26v, inscribed [1] *puteo–a riga–pionbo–piombo–intrate della chava/sotteranea*; [2] *puteo–sqadra–chamino sotter[r]aneo tortuoso* (Marani 1979, II, cap.XCVII–XCVIII, p.113); New Haven, BL, MS B, fol.26v; Venice, BMV, fol.118r.
OTHER REPRESENTATIONS Vicenza, BBV, fol.57r.

144
Water filters
SJSM, vol.120, fol.48r

Water is filtered through a series of three compartments to purify it. The first compartment is full of pebbles; the second is empty, and the water enters it through a small hole in the bottom of the dividing wall; the water then flows through a ridge in the top of the dividing wall into the third box, shown in the Laurenziana drawing, which is full of the smallest pebbles; finally, it falls into the reservoir and flows by tube to the fountain.
The chambers of the filter are all shown full of pebbles in the Soane and MS B drawings (Siena 1991, p.280). The second chamber is not shown empty in any of the manuscripts.

OTHER MANUSCRIPTS Turin, BR, MS T, fol.27r, inscribed *modo di ghalazze e cchole di ghiara piene che ll'una in nell' altra/circulando vada* (Maltese 1967, I, p.114, line 31–p.115, line 30; p.262, tav.49); Florence, BML, MS L, fol.27r (Marani 1979, II, cap.XCVII–C, p.113); New Haven, BL, MS B, fol.27r; Venice, BMV, fol.120v.
OTHER REPRESENTATIONS Vicenza, BBV, fol.12r.

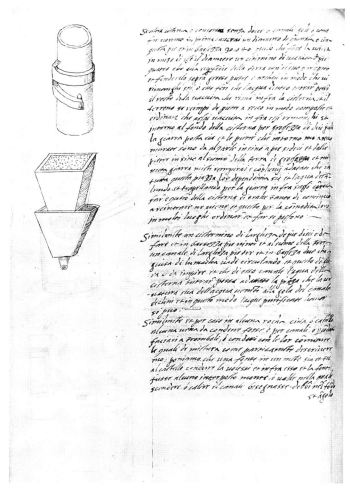

47

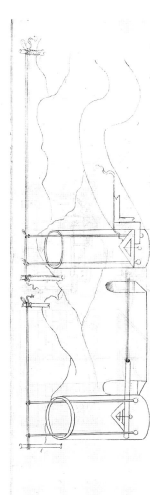

141

142

48

143

144

Glazes or stuccoes

SJSM, vol.120, fol.48v

No illustration

145

Geometry, ways of measuring distances, height and depths; basic geometrical forms

SJSM, vol.120, fol.49r

The illustrations show [1, 2] a straight line between two points; [3] a curving line; [4] a right angle; [5] two right angles created by a cathetus drawn on the baseline; [6] an obtuse angle, which is larger than a right angle; [7] an acute angle, which is smaller than a right angle; [8] a circle; [9] the centre of a circle where the lines from the centre of the circle to its circumference are of equal length; [10] the diameter of a circle, the line that divides the circle in half; [11] half a circle determined by the diameter and the circumference; and [12] part of a circle determined by any straight line across a circle and the cir-

circumference greater or less than a half circle.

MS L bears an annotation by Leonardo about the difference between the point in nature, which is divisible, and the mathematical point, which is indivisible (Mussini 1991, pp.166 and 198, n.20–21). The points are shown in MSS T and L, but they are not shown here.

The section on practical geometry is based on Leonardo fibonacci's *La pratica di geometria*, written in the 14th century (Arrighi 1970, p.2; for Fibonacci, see Boncompagni 1862; Arrighi 1966). A drawing in Leonardo's Madrid Codex (II, no.8936, fols 139v–140r; Reti 1974, II, fols 139v–140r; V, pp.294–5) recalls Francesco's illustration.

OTHER MANUSCRIPTS Turin, BR, MS T, fols 27v–28r, inscribed [1, 2] *linea rec/tta*; [3] *curva*; [4] *Angholo re/ctto*; [5] *catetto–baxa*; [6] *Angholo hottuxo*; [7] *Angholo acuto*; [8] *circhulo*; [9] *acentro*; [10] *diametro*; [11] *Mezzo ci[r]chulo*; [12]

po[r]tione di ce[r]chio (Maltese 1967, I, p.117, line 9–p.118, line 22; p.262, tav.50–51); Florence, BML, MS L, fol.27v (Marani 1979, II, cap.CII, p.113); New Haven, BL, MS B, fol.27v; Venice, BMV, fols 122v–123r.

146

Basic geometrical forms

SJSM, vol.120, fol.49v

Francesco describes the geometrical forms, as [1] a segment of a circle determined by straight lines from the centre of the circle that cut the circumference; [2] a three-sided figure, a triangle; [3] a four-sided figure, a square; [4] many-sided figures, a polygon; [5] a pentagon with five sides; [6] a hexagon with six sides; [7] a decagon with ten sides. There are four kinds of triangles: isosceles with two equal sides; [8] a right-angled triangle where two sides form a right angle and the longest side is the hypotenuse; [9] an equilateral triangle with three equal sides; and [12] a scalene triangle with three sides of different lengths. A rhombus [11] is a figure without right angles, with all the sides of equal length; a rhomboid [10] has different angles and sides of different lengths.

OTHER MANUSCRIPTS Turin, BR, MS T, fol.28r, inscribed *Po[r]tione del ce[r]chio–Tri latere–Quadrilatere–dechagonj–pentaghonj–hesaghonj–Mont a[n]ghonj o/vero molti la/tere–hortogonio–diversi latere–ronboidos–Ronbo–Isop[r]euro–yxocchiles* (Maltese 1967, I, p.118, line 21–p.119, line 26;

p.262, tav.51); Florence, BML, MS L, fol.27v (Marani 1979, II, cap.CII, p.113); New Haven, BL, MS B, fol.27v; Venice, BMV, fol.123r and v; Budapest, NL, Codex Zichy, fol.90v.

OTHER REPRESENTATIONS Vicenza, BBV, [1, 2] fol.10v, [3] fol.11r.

147

Geometrical solids, columns, an obelisk and a quadrant

SJSM, vol.120, fol.50r

[1] Columns are characterized as geometrical solids with opposing sides equidistant from each other; they can be triangular, square or circular in plan. Square columns with a moulding and cornice as the capital are used as the order for the ground-floor loggia in the courtyard of the Palazzo della Signoria in Jesi.

[2] The other solids listed are the sphere, shown in MS L but not in MS T, and the pyramid, one module high, not drawn, and in its acute form as an obelisk.

[3] The quadrant, an instrument to measure height, is a frame in the shape of a quarter of a circle with sight holes on one side and a plumb line that falls from the vertex to the arc, which is graduated from 1 to 90 degrees. It has a rectilinear scale perpendicular to the sight line, which is divided into a scale of 12 on the bisecting line of the quadrant at 0.

Francesco gives the following instructions for measuring heights: 'Align the sights of the quadrant with the top of the object you want to measure and set the quadrant at 45 degrees.

Then measure the distance from your feet to the base of the object you are measuring and add your height to get the height of the object.' The rule for measuring heights using the rectilinear scale on the quadrant is given on fol.51v (cat.150). The quadrant is drawn in the same way by Fra Giocondo in the Laurenziana manuscript in a miscellany of scientific material (Florence, BML, Plut.29, Cod.43; Fontana 1988, p.48, fig.38).

For Francesco di Giorgio's use of the square order in built and painted architecture, see Agostinelli & Mariano 1986, pp.104ff. See also the North Italian album, p.31 (cat.30).

OTHER MANUSCRIPTS Turin, BR, MS T, fol.28r, inscribed [1] *Cholonon[n] a/tria[n]gholare–Cholon[n]a qu/adra [n]gholar[e]–cholon[n]a ci[r]/culare*; [2] *Cholon[n]a pi/ramidale*; [3] *schala–quadra[n]te* (Maltese 1967, I, p.120, line 1–p.121, line 6; pp.269–70, tav.51); Florence, BML, MS L, fol.28r (Marani 1979, II, cap.CII–CIV, p.113); New Haven, BL, MS B, fol.28r; Venice, BMV, fols 124v–125v; Budapest, NL, Codex Zichy, fol.91r.

OTHER REPRESENTATIONS Vicenza, BBV, [1, 2] fol.10v, [3] fol.11r; Pietro Cataneo, Uffizi 3859A.

145

146

147

148
Measuring heights
SJSM, vol.120, fol.50v

Surveying heights from a distance was an important skill for military engineers, who would often have to assess the height of towers to build scaling ladders (for aiming cannon, see fols 75v, 85v, cat.200).
[1] Francesco writes: 'To measure the height of a tower the surveyor must first establish through the quadrant that the sun is at 45 degrees, when the height of the tower will be the same as the length of the shadow.' Like other Renaissance authors (Bartoli 1564, book I, cap.IX, pp.16-17), Francesco noted that the sun is at 45 degrees only once a day, at midday; in reality it will give the reading only twice a year (Maltese 1967, I, p.121, n.4).

On the rare occasions that it can be employed, this method will give an accurate result, but only if the face being measured is perfectly vertical. Villard de Honnecourt shows the same method (Hahnloser 1935, pp.119-21, Taf.40, Abb.88-9), as does Cosimo Bartoli in *Del modo di misurare …* (1564), using an astrolabe.

[2] The detail of the quadrant shows the sight holes incorrectly, on the face of the quadrant, where they could not be aligned with the object; they are drawn correctly in MSS T and L. The rectilinear scale of 12 units is also shown clearly in MS L, and the scales are captioned, *anversa* for the horizontal scale and *retta* for the vertical.
[3] Measuring a tower that cannot be approached, because it is on top of a mountain, using poles to generate similar triangles. The rule is given on fol.51v (cat.150).

OTHER MANUSCRIPTS Turin, BR, MS T, fols 28v-29r (Maltese 1967, I, p.121, line 7-p.122, line 15; p.270, tav.52-3); Florence, BML, MS L, fols 28r-29r, fol.28v inscribed [2] *honbra aversa-honbra retta* (Marani 1979, II, cap.CV-CVIII, p.113); New Haven, BL, MS B, fol.28r; Venice, BMV, fols 126r, 130r and v.
OTHER REPRESENTATIONS Vicenza, BBV [1] fol.10v, [2] fol.18v.

149
Surveying with a quadrant
SJSM, vol.120, fol.51r

The drawing shows the quadrant in use. The shadow square of a quadrant or astrolabe, consisting of straight scales at right angles to each other, could be used as a much more precise substitute for measuring rods. Alberti used an astrolabe to measure the angular disposition of the landmarks of Rome in *Descriptio urbis Romae* (1968, pp.60-63; Kemp 1990, p.168). In his text Francesco refers to measuring the height of the north star with a quadrant using the maximum terrestrial circle of 20,400 miles and the degree of 56 ⅔ miles, the data used by Columbus to plan his voyage (Maltese 1967, I, p.123, n.6).

Francesco gives the rule for measuring an object that cannot be approached with the rectilinear scales of a quadrant: 'fix the summit of the tower through the sights and note the position of the plumb line on the vertical scale; hold the number of points in your mind and mark the place where you are standing. Move further away and fix the summit of the tower

again, mark the place where you stand and remember the position of the plumb on the horizontal [*anversa*] scale. Subtract the smaller number of points on the scale from the greater and multiply the result by 12. Divide the result by the difference between your first and second position on the ground and add your height from your eye to your feet to the result to get the height of the tower.'
Taccola also shows this method with a similar diagram in *De ingeneis* (book IV; Prager & Scaglia 1972, pp.132-3).

OTHER MANUSCRIPTS Turin, BR, MS T, fol.28v (Maltese 1967, I, p.122, line 15-p.123, line 20; tav.52); Florence, BML, MS L, fol.28r (Marani 1979, II, cap.CVIII-CXI, p.113); New Haven BL, MS B, fol.28r; Venice, BMV, fol.127r.
OTHER REPRESENTATIONS Vicenza, BBV, fol.11r.

150
Measuring the heights of towers
SJSM, vol.120, fol.51v

The drawings show the method of measuring the heights of towers from a distance using a measuring rod; the procedure is based on the ratios of similar triangles.

In most cases, the description and diagrams do not match exactly. But if the letter s at the base of the tower [1] is lettered I and if a G is inserted on the horizontal line at the pole between A and B, then the formula for measuring the height of the tower can be given as $FI = \frac{GA \times HC}{GD + CD}$. The fact that Francesco gives two illustrations and a third on fol.50v (cat.148) suggests that the procedure can be followed using different ratios.

OTHER MANUSCRIPTS Turin, BR, MS T, fol.29r (Maltese 1967, I, p.123, line 20-p.124, line 30; p.270, tav.53); Florence, BML, MS L, fols 28v-29r (Marani 1979, II, cap.CXII-CXIV, p.173); New Haven, BL, MS B, fols 28v-29r; Venice, BMV, fols 129r and 130r.
OTHER REPRESENTATIONS Vicenza, BBV, fol.18v.

151
Measuring the heights of towers using mirrors
SJSM, vol.120, fol.52r

A development of the rod technique using small mirrors on the ground or hanging on vertical measuring rods (Siena 1991, p.299). The aim in both cases was to establish optically similar triangles, one small, one large, so that the proportional calculation of an unknown dimension could be completed. The medieval method of calculating measurement was still being described in the late 16th century, by Bartoli in *Del modo di misurare* (1564, book I, cap.XII, fols 25v-26v; Kemp 1990, p.168, fig.322).
[1] A mirror is placed on the ground near to a tower; the surveyor finds a position from which he can see the top of the tower in the centre of the mirror. The distances from the centre of the mirror to the feet of the surveyor BC and the height of the surveyor to his sight line CD are both given dimensions, which have proportional relationships to BE and AE, which can be calculated following Euclid. In the case of two similar triangles for which the

lengths of two sides of the one and one side of the other are known, the unknown length of the corresponding side in the second triangle can be calculated. The drawing [2] shows the same procedure using two mirrors.

The formula for this procedure is incorrectly expressed in the manuscript as $EA = \frac{BZ \times CD}{CZ - BC}$ (Maltese 1967, I, p.126, n.1). For the procedure to work well, the surveyor would need to check that the ground was perfectly flat with a spirit level. Francesco suggested that he could use a bowl of water. The accuracy of this operation would be greatly increased by drawing wires or etching diagonal lines on the mirror.

OTHER MANUSCRIPTS Turin, BR, MS T, fol.29v, inscribed *spechulo–Spechulo e spechulo* (Maltese 1967, I, p.124, line 30-p.126, line 1; p.263, tav.54); Florence BML, MS L, fol.29r (Marani 1979, II, cap.CXIV-CXVI, p.113); New Haven, BL, MS B, fol.29r; Venice, BMV, fols 131r and 132r.
OTHER REPRESENTATIONS Vicenza, BBV, fol.10v.

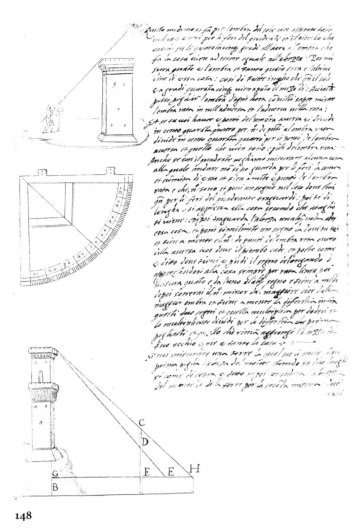

148

149

150

151

152

Measuring the heights, depths and widths of towers, wells, ditches and fields without entering them
SJSM, vol.120, fol.52v

[1] The diagram shows how to plot the width of a field. The text describes how a man at point C makes a line at right angles 10 *braccia* long to a point on his left at B. He moves forward 7 *braccia* from C to point O and draws a second perpendicular line on his left. All the points are outside the field to be measured. The man will return to point B and set up his sight line from point B to point A at the other side of the field; point P will be marked by an assistant on OP where the sight line intersects the line, which can then be measured. If OP measures 9 the surveyor knows that he has lost a *braccia* over 7 *piedi*. He will therefore have 19 more units of *braccia* to lose; 19 × 7=133, which will be the width of the field.
[2] The second diagram shows a similar procedure, which generates similar triangles by drawing lines below line DA, from D to C and F to E. Points B G C E are set following the procedure described above and according to the

diagram. If BC is 44 (in the Soane drawing this measurement is given as 24+24=48; in MSS T and L it is shown as 24+20=44) and the surveyor advanced 12 *braccia* to GE, which is 42⅔, then 1⅓ *braccia* is lost over 12 *braccia*. Francesco multiplies 44 by 12=528 and divides by 1⅓ to get 396, which will be the length of AD. The width of the field FA is 396–12=384.

The diagram shows the width of the field as 140; the calculation in the text describes AC as the multiplication of 20 braccia units; 7 × 20=140 minus the measurable distance outside the field, which gives the correct result of 133. This scheme can also work vertically for measuring the height of towers or the depth of wells.

OTHER MANUSCRIPTS Turin, BR, MS T, [1] fol.29v, [2] fol.30r (Maltese 1967, I, p.126, line 1–p.127, line 3; p.270, tav.54–5); Florence, BML, MS L, fol.29v (Marani 1979, II, cap.CXVI–CXVII, p.113); New Haven, BL, MS B, fol.29v; Venice, BMV, fols 133v and 135r.
OTHER REPRESENTATIONS Vicenza, BBV, fol.12v.

Measuring heights and distances
SJSM, vol.120, fol.53r
No illustration

153

Calculating the area of a triangular and a rectangular field
SJSM, vol.120, fol.53v

[1] The triangle has not been lettered ABC with B at the apex and numbered AC 30 BA 40 BC 50 as in MS T and MS L. The text reads: 'Suppose you have a triangular field and you know that the length of AC is 30 and BC is 50; to calculate the length of BA square 50=2,500 and square 30=900 and subtract 900 from 2,500=1,600. The square root of 1,600, 40 *braccia* is the length of BA and the area of the triangle is 600 *braccia*.'
[2] The area of the rectangular field is calculated by multiplying the width by the length, 40 × 50=200 square *braccia*.

OTHER MANUSCRIPTS Turin, BR, MS T, fol.30r (Maltese 1967, I, p.128, line 1–p.129, line 4; p.263, tav.55); Florence, BML, MS L, fol.30r (Marani 1979, II, cap.CXVIII–CXX, p.113); New Haven, BL, MS B, fol.30r; Venice, BMV, fol.135v.
OTHER REPRESENTATIONS Vicenza, BBV, fol.12v.

154

Drawing a square and measuring the height of a tower
SJSM, vol.120, fol.54r

Three methods for drawing a perfect square are given.
[1] The text reads: 'To draw a perfect square, draw a circle with a compass and divide the circumference at four points and draw a line through the middle of the circle to them. Draw four lines between these points.'

Francesco's procedure assumes that the intersecting lines through the middle of the circle are at right angles.
[2] The second diagram shows two overlaid diagrams: the horizontal and vertical lines of a right angle obtained by the point of intersection of arcs made by a compass. Lines are drawn between the points where the arcs meet.
[3] The third diagram shows how a true horizontal can be obtained off a plumb line by intersecting arcs.
[4] The illustration shows how to measure the height of a tower by comparing the length of its shadow with the length of the surveyor's pole and its shadow. If the length of the pole is 4 *braccia* and its

shadow 5⅓ and the shadow of the tower is 200, Francesco multiplies 200 × 4=800 and divides 800 by 5⅓=150, which will be the height of the tower.

OTHER MANUSCRIPTS Turin, BR, MS T, fol.30v, inscribed [1] *Pa[r]timento della sqadra*; [2] *Altro modo da pa[r]tire la squadra*; [3] *Modo senza a[r]chipe[n]dolo tirare una diri/ta linea* (Maltese 1967, I, p.129, line 6–p.130, line 7; p.263, tav.56); Florence, BML, MS L, fol.30r (Marani 1979, II, cap.CXX–CXXII, p.113); New Haven, BL, MS B, fol.30r; Venice, BMV, fols 136v and 137v.
OTHER REPRESENTATIONS Vicenza, BBV, fol.12v.

152

153

154

155

Measuring the height of a tower and the depth of a well using an instrument with an inclining viewfinder

SJSM, vol.120, fol.54v

[1] The diagram shows the procedure for measuring a tower without approaching its base. The text reads: 'Take a pole 3 *braccia* long and place it at right angles to the ground as far away from the tower as you like, then place another pole 4 *braccia* long between it and the tower so that the sight line crosses them at the top. Measure the distance between the poles, P–Q, 10 *braccia*, which gains 1 *braccia* in height if the distance to the base of the tower is 300 *braccia* there will be 290 braccia more, giving a height of 30 *braccia*+3 *braccia* for the height of the pole.'

The height is calculated incorrectly in MS T as 303 *braccia*; it is correct in MS L (Maltese 1967, I, p.130, n.4).
[2] The diagram shows an instrument to measure depth set on a well-head; it is not absolutely clear how it works. Presumably the arm DB rests on the well-head and the surveyor looks down the sight holes at O and B; the movable arm F would be inclined towards A or to the side of the well at the bottom, establishing the triangle to be measured. Two holes are shown on the instrument at point B to measure the depth of a well; only one hole is shown in MSS T and L. In MS L the movable arm F is aligned to the eye at C; in MS T it is aligned to A. An extra diagram appears in both MS T and MS L that shows a section of the device mounted on the well

with the movable arm pointing down the well to point F at the bottom. Similar triangles are established, DCB and BCF, which enable the depth to be calculated. Silvio Belli (1570, *Parte terza*, pp.103–5), using a piece of wood placed across a well-head to balance a set square, shows the same means of measuring depth.

OTHER MANUSCRIPTS Turin, BR, MS T, [1] fol.30v, [2] fol.31r (Maltese 1967, I, p.130, line 7–p.131, line 5; p.263, tav.56–7); Florence, BML, MS L, fol.30v (Marani 1979, II, cap.CXXII–CXXIII, p.113); Venice, BMV, fols 138v and 140r.
OTHER REPRESENTATIONS Pietro Cataneo, [1] Uffizi 3288A.

Measuring the depth of a well

SJSM, vol.120, fol.55r
No illustration

156

Measuring with a geometrical square, measuring the widths of stretches of water

SJSM, vol.120, fol.55v

[1] Francesco's procedure states: 'if you want to measure the length or width of a plain you should make a geometrical square of wood or brass like A B C D. Insert pieces of wood of equal length in each angle at A, B, C and D; make a groove in the side of the square between A and B and insert a piece of wood like the ones in each corner to form a movable cursor on the groove E; divide BA on the square into as many parts as you like. Then look through CB to the point you want to measure at F and read the point through which the line DF passes to generate similar triangles; you know the lengths of AE and AD of the small triangle, and DC of the large triangle, therefore the length can be calculated following the usual procedures.'

The line F–D is not fully drawn as it is in MSS L and T; as well as the scale on BC, a scale is shown on AB with a peg of wood projecting from it to mark the point of intersection.
[2] A surveyor's tee square with sliding horizontal arms set at the water's edge can generate similar triangles to measure the width of a stretch of water. The arm is raised or lowered to align with the line of sight to point E on the far side, and the proportional ratios of the triangles are established. Fra Giocóndo also draws the geometrical square (Fontana 1988, p.48, fig.37). The

geometrical square, a simplified version of a device used by Alberti in *Ludi geometrici*, was developed by Francesco and drawn by Leonardo in Codex Atlanticus (fol.148v), probably in the 1490s when the architects were together in Pavia. Tartaglia, Rivius and Bartoli made later versions of it (Veltman 1986, pp.91–3).

The numbering of the diagrams – 9, 10, 11 – copied from MS L first occurs on this folio. It is dropped on fol.56r and reinstated on fol.56v, with 17.

OTHER MANUSCRIPTS Turin, BR, MS T, fol.31r and v (Maltese 1967, I, p.132, line 10–p.133, line 12; p.263, tav.57–8); Florence, BML, MS L, fol.31r, inscribed [1] *peduccio sop[r]a delquale posa el quadro* (Marani 1979, II, cap.CXXV–CXXVII, p.113); Venice, BMV, fol.141r and v.
OTHER REPRESENTATIONS Vicenza, BBV, fol.9r.

157

Diagram of an astrolabe, measuring the radius of an arch and squaring a circle

SJSM, vol.120, fol.56r

[1] The diagram of the astrolabe is similar to the drawing in MS L except that the Soane drawing does not show the two sight holes in the horizontal bar. Many of Bartoli's procedures for measuring heights use an astrolabe (1564, book I, cap.XV; for Bartoli's manuscript of *Del modo di misurare* of 1550, see Mancini 1918, pp.84–135, especially pp.116–18; for a description of an astrolabe and its use as a measuring instrument, see London 1975, p.93, cat.175; Hill 1984, pp.120ff.).
[2] The text reads: 'When you have an arch 1 *piede* wide and you want to calculate the radius, you draw intersecting arcs in the archivolt and draw lines through the points where they intersect until they meet at a point, which will give you the radius of the arch.'
[3] Squaring a circle to calculate its area is achieved by dividing the circle into 25 or 30 triangles and making a strip by laying them alternately top to bottom to form rectangles; the areas of the rectangles can be calculated by width times height, then the areas multiplied by the number of rectangles to give the area of the circle. The more triangles the circle can be divided into, the greater the accuracy of the calculation. The length of the strip is the equivalent of a single rotation of the circle along the ground.

The diagram is drawn inaccurately;

the height of the strip should be equal to the radius of the circle, as shown in MS L. The means of squaring a circle was adapted by Leonardo (Windsor, RL, inv. no.12280; Kemp 1982, p.81). For Francesco di Giorgio's and Alberti's interest in squaring a circle, see Lowic 1982, pp.157–9.

OTHER MANUSCRIPTS Turin, BR, MS T, fols 31v–32r (Maltese 1967, I, p.133, line 12–p.134, line 14; p.263, tav.58–9); Florence, BML, MS L, fol.31v, inscribed [2] *da trovare el centro della[r]cho/ chaduto*; [3] *quadratura dal to[n]do* (Marani 1979, II, cap.CXXXVII–CXXIX, p.113); New Haven, BL, MS B, fol.30v; Venice, BMV, fols 142r–143r.
OTHER REPRESENTATIONS Vicenza, BBV, [1–3] fol.17r; Pietro Cataneo, [2] Uffizi 3289A.

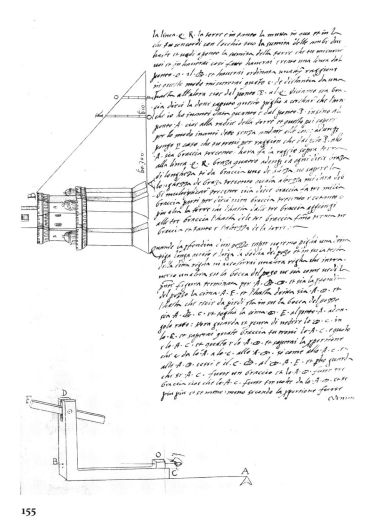

155

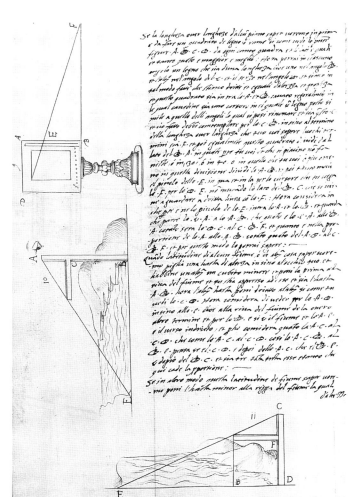

156

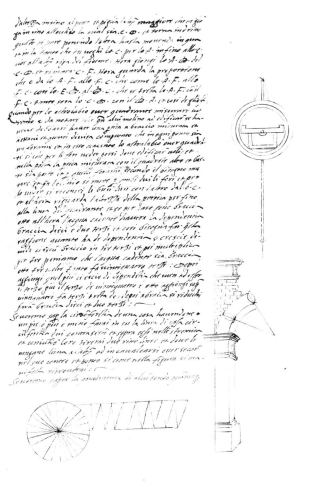

157

158

*Calculating the diameters
and circumferences of circles*
SJSM, vol.120, fol.56v

The diagram shows how to calculate
the diameter and circumference of a
circle. The text reads: 'If you know
that the circumference of a circle is
22 *braccia* you will estabish the diame-
ter of the circle by dividing it by $3\frac{1}{7}$
to give 7; if you want to calculate the
circumference of a circle and you
know that the diameter is 7, you
multiply it by $3\frac{1}{7}=22$.'

OTHER MANUSCRIPTS Turin, BR, MS T,
fol.32r (Maltese 1967, p.134, line
15–p.135, line 25; p.263, tav.59);
Florence, BML, MS L, fol.31v (Marani
1979, II, cap.CXXX–CXXXII); New
Haven, BL, MS B, fol.30v; Venice, BMV,
fol.144v.

159

*Calculating the circumference and
area of a circle*
SJSM, vol.120, fol.57r

[1] Another circle with a given diame-
ter of 25 *braccia* is multiplied by
$3\frac{1}{7}=78\frac{4}{7}$ will be the circumference
multiplied by the diameter $25=1,189\frac{2}{7}$;
divide the result by $4=472\frac{9}{28}$, which is
the area of the circle.
[2] The diagram shows how to calculate
the circumference of the largest circle
that can be constructed within a square
with sides of 56 *piedi*. The circumfer-
ence of the circle will touch all four
sides of the square so that its diameter
is the same as a face of the square; to
calculate the circumference, 56 should
be multiplied by $3\frac{1}{7}$, giving 176. To cal-
culate the area of the square, the cir-
cumference should be multiplied by
the diameter and the sum divided by 4.

The numbering of the diagrams,
copied from MS L, where it is followed
consistently, is resumed here.

OTHER MANUSCRIPTS Turin, BR, MS T,
fol.32v (Maltese 1967, I, p.135, line
25–p.137, line 2; p.263, tav.60);

Florence, BML, MS L, fol.32r (Marani
1979, II, cap.CXXXII–CXXXIV, p.113);
New Haven, BL, MS B, fol.32r; Venice,
BMV, fol.145r.

160

*A square inscribed in a circle and a
circle inscribed in a triangle*
SJSM, vol.120, fol.57v

[1] The text reads: 'To inscribe a square in
a circle and to calculate the length of the
sides of the square given that the circle
has a circumference the square root of
$493 + \frac{43}{49}$ you divide the circumference
by $3\frac{1}{7}$ to give the diameter, 50. Divide
the square root of 50 by root 2=root 25.
The square root of 25=5, which is the
length of the sides.'
[2] Francesco writes: 'To inscribe a cir-
cle in a triangle with sides of different
lengths and to calculate the diameter of
the circle, let us suppose that the trian-
gle has one side 9 *braccia*, another 8,
and another 7. The length of the sides
added together is 24, divide this in
half=12, multiply by 5=60. For the sec-
ond side take 8 from 12=4, which is
multiplied by 60=240. For the third
side subtract 9 from 12=3, then multi-
ply 3 by 240=720 and the square root of
720 will be the area of the triangle. Now
we shall see why the three sides are not
equal. Add 7, 8 and 9=24, divide by
3=8, now you will have an equilateral
triangle with sides 8 *braccia* long. To

calculate the diameter of the circle,
square one of the faces, $8 \times 8=64$
divided by $\frac{1}{3} = 21\frac{1}{3}$, which is the diame-
ter of the circle in the triangle. Now to
calculate the area of the equilateral tri-
angle and to obtain the area of the other
triangle, add all the sides together
$8+8+8=24$, divide in half=12, subtract
$8 = 4$, and multiply by $12=48$. Now for
the other side 8 *braccia* subtracted from
$12=4$ multiplied by $48=192$. Now for the
other 8 subtracted from $12=4$ multiplied
by $192=768$, therefore the area of the
equilateral triangle is the square root of
768 and a circle has a diameter of $21\frac{1}{3}$.
To find the diameter of the circle that
can be inscribed in a circle with an area
of 720 multiply 720 by $21\frac{1}{3}=1536$ [in
reality 15,360; Maltese 1967, I, p.138, n.9]
which you divide by $768=20$. The root
of 20 will be the diameter of the circle.'
This calculation follows the formula
given by Hero (op. cit, n.10).

OTHER MANUSCRIPTS Turin, BR, MS T,
fol.32v (Maltese 1967, I, p.137, line
2–p.138, line 9; p.263, tav.60); Florence,
BML, MS L, fol.32r (Marani 1979, II,
cap.CXXXIV–CXXXVI, p.113); New Haven,
BL, MS B, fol.32r; Venice, BMV, fol.146r.

161

Measuring the area of a pentagon
SJSM, vol.120, fol.58r

Francesco describes the method: 'To
measure the area of a five-sided figure,
convert the figure to rectangles and
right-angle triangles, then work out the
area of each and add them together.'

OTHER MANUSCRIPTS Turin, BR, MS T,
fol.33r (Maltese 1967, I, p.138, line
9–p.139, line 16; p.263, tav.61);
Florence, BML, MS L, fol.32v (Marani
1979, II, cap.CXXXVI–CXXXVII, p.113);
New Haven, BL, MS B, fol.32v; Venice,
BMV, fol.148r.

158

159

160

161

162
Perspective
SJSM, vol.120, fol.58v

[1] The drawing shows a perspective construction using a vanishing point and a distance point, or the point placed at a fixed distance from the central point which defines the distance from which the image is to be observed. [2] The systematic measurement of foreshortening with a piece of string is shown. A pole is used to fix the position of the eye; a string is extended from it and the points of intersection are marked in succession on the pavement. MS T shows a develpment of [2]. The terrain is divided into *piedi*; 2 *piedi*=1 *braccia*. A man 2 *braccia* tall stands 1 *braccia* away from an interposed plane and observes the diminutions of objects both parallel and at right angles to the interposed rods (Veltmann 1986, p.91 and p.50, figs 43–7; for an explanation of the perspective systems, see Maltese 1962, pp.303–14 and op. cit., p.140, n.1; Siena 1991, pp.105–12). The section on perspective comes at the end of a chapter on measurement. This suggests that for Francesco perspective derived from practical, geometric surveying (for this aspect of perspective, see Veltmann 1979; Veltmann 1986; Kuhn 1990).

OTHER MANUSCRIPTS Turin, BR, MS T, fol.33r, inscribed [1] *Cientro–cho[n]tra centro*; [2] *Perdimento di linie sichondo p[r]ospecttiva* (Maltese 1967, I, p.139, line 16–p.141, line 20; p.263, tav.61); Florence, BML, MS L, fol.32v (Marani 1979, II, cap.CXXXVIII–CXXXIX, p.113); New Haven, BL, MS B, fol.32v; Venice, BMV, fol.149r.

163
Lifting weights and an elevation of a half-wheel
SJSM, vol.120, fol.59r

Francesco gives the rule for calculating the power of a wheel based on the dimensions of half its diameter: 'Divide the diameter of the axle and wheel in half, the number of times half the diameter of the wheel can be divided by half the diameter of the axle will give the power of the wheel. If half the diameter of the axle is ½ *braccia* and half the diameter of the wheel is 5, then 5 divided by =10. Therefore for every pound of weight on the circumference 10 *libre* can be lifted on the axle.' He illustrates a half-wheel.

Although Vitruvius (book X, cap.5; Granger 1934, II, pp.305–6) described how to build an undershot waterwheel, it is not clear how frequently or when they were first used in ancient Rome. Animal mills were common in the 4th century, and the average bakery in Rome had its own animal mill. The Tiber was not suitable for ordinary undershot mills because the variation of the water-level could leave mills idle or expose them to damage through flooding. Undershot mills were probably most useful in the countryside where brooks or streams could be harnessed and protected from flooding in spring by dams or weirs. For towns on large rivers or cities not sited on rivers, the water had to be brought by aqueduct. The mills on the Janiculum were powered by an aqueduct from the 4th century until AD 537, when they were cut off by the Goths. A watermill using an alternative power source was constructed at the baths of Caracalla, where the outflow of water from the baths powered the mill (Wikander 1979, pp.14–16).

Francesco, like Taccola, acknowledged that mills were often difficult to build because of lack of water, and described a range of alternative power sources.

OTHER MANUSCRIPTS Turin, BR, MS T, fol.33v (Maltese 1967, I, p.141, line 20–p.142, line 22; pp.263–4, tav.62); Florence, BML, MS L, fol.33r, inscribed *Lieva una lira leva dieci nella circhunferentia* (Marani 1979, II, cap.CXXXIX–CXL, p.113); New Haven, BL, MS B, fol.33r; Venice, BMV, fol.150r.

164
Mills
SJSM, vol.120, fol.59v

A. A mill operated by a vertical treadmill showing two gearing arrangements. On the left a vertical crown-wheel on the axle of the wheel engages a lantern-pinion on the stone spindle. On the right a lantern-pinion on the axle of the wheel engages the large spur-cogs of a spur and crown-wheel; a second lantern-pinion on the stone spindle engages the smaller crown-cogs. The mill on the left will run faster if the man or animal on the treadmill can provide enough power; less power will be lost because of the one-toothed arrangement of the wheel. The same kind of mill is drawn by Taccola (Munich MS of *De machinis*, fol.45v; Scaglia 1971, fig.72, cat.114–15).
B. A hand-mill with a horizontal lantern-pinion on a crank-shaft is connected to a spur and crown-gear and a second, vertical, lantern-pinion on the stone spindle. The arrangement of the crown and spur-wheel seems to change the direction of motion rather than increase the velocity of the gearing shown on mill A on the right.
C. A conventional, edge-runner mill powered by an overshot waterwheel, which is turned by the mass of water in the buckets. A lantern-pinion on the axle of the wheel engages a crown-gear on the upright shaft to drive the edge-runner stone on a spindle.

For sources of the overshot wheel, see Hill 1984, pp.159ff.

OTHER MANUSCRIPTS Turin, BR, MS T, [A] fol.33v, [B, C] fol.34r (Maltese 1967, I, p.142, line 23–p.144, line 6; p.264, tav.62–3); Florence, BML, MS L, fol.33r, inscribed [A] *pistrino didue varj modj da fare*; fol.33v, inscribed [B]*pistrino in ognj luocho potes[s]j/hexe[r]citare*; [C] *Mulino che'aguado ho holio ha gra[n]de e facilissima lieva* (Marani 1979, II, cap.CXLI–CXLV, pp.113–14); New Haven, BL, MS B, fols 33r and 34r; Venice, BMV, fols 151v–152r; Florence, BNCF, [A, B] MS M, fol.96r (Maltese 1967, II, p.501, tav.326); London, BM, *Opusculum*, fol.4v.
OTHER REPRESENTATIONS Vicenza, BBV, fol.19r.

165
Mills driven by water
SJSM, vol.120, fol.60r

P. Water pours down a tapering funnel on to the concavities of the blades of a horizontal waterwheel in the lower chamber. After the percussion of the impetus, the water falls through the wheels and runs away. The rim of the wheel rests in shallow water and moves easily on its axis, which drives a lantern-pinion that connects with a horizontal spur-gear in the second chamber, on the upright shaft driving the edge-runner. The same mill is shown in *Meccanica* (fol.12r, cat.225). The tapering funnel serves to increase the impetus of the water.
D. On a site where water is abundant but the land is flat, or where there is an incline and little water, water is delivered as a counterweight. An undershot waterwheel moves a horizontal lantern-pinion on its axle and engages a double crown-gear connecting with a second, vertical lantern-pinion on the stone shaft. The intermediate wheel is idle and the ensemble seems to have been made purely to divert the motion. According to Francesco, the doubling of the toothed wheel with large teeth increases the thrust of the waterwheel; on the opposite side the small teeth on the wheel engage the lantern-pinion on the axle of the wheel and make it move more quickly. The use of an idle wheel to divert the motion is unusual.
E. Francesco writes : 'It can be built where there is an incline and little water because the wheel is large and free. The waterwheel is 16 *piedi* high and the lantern-pinion on the axle of the wheel 2 *piedi* in diameter. The double crown-gear has large crown-teeth that engage with a pinion with a larger circumference on the axle of the waterwheel, and small spur-teeth that engage the pinion on the axle of the stone, where the frequency of the small teeth on the smaller circumference makes the mill move more quickly.'

On the sources of horizontal wheels, see Hill 1984, pp.160, 162.

OTHER MANUSCRIPTS Turin, BR, MS T, fol.34r (Maltese 1967, I, p.144, line 6–p.145, line 13; p.264, tav.63); Florence, BML, MS L, fol.33v, inscribed [P] *Mulino co[n] retrecine ter[r]ang/niola da holio ho guado*; [D] *Mulino che a assai lieve esotto la ruota hell a[c]qua delchanale nele pale p[er]cote*; [E] *Mulino dagrano che a grande e facili/ssima leva [mabasta?]* (Marani 1979, II, cap.CXLV– CXLVII, p.114); New Haven, BL, MS B, fol.33v; Venice, BMV, fols 153r and v, 158r; Florence, BNCF, MS M, fol.95r (Maltese 1967, II, p.500, tav.325); Rome, BAV, *Codicetto*, [P] fol.163v, [D] fol.162r, [C] fol.136r; London, BM, *Opusculum*, fol.36r.
OTHER REPRESENTATIONS Vicenza, BBV, [P] fol.19r, [D, E] fol.1r.

162

163

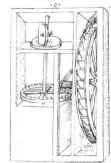

164

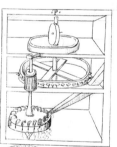

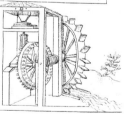

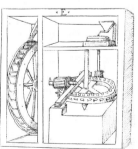

165

166

Mills driven by water

SJSM, vol.120, fol.60v

F. A mill that works on the same principle as E, with a smaller wheel to reduce its weight. Water pouring down a tapering funnel on to a horizontal waterwheel in the lower chamber turns a lantern-pinion on the axle of the wheel, which engages a double spur-gear and a second lantern-pinion on the axle of the millstone in the upper chamber. There seems to be little point in the double gearing unless it was to drive more than one stone

G. A horizontal waterwheel in the lower chamber turns a vertical lantern-pinion and a double crown-gear with large and small teeth; the large teeth at the bottom engage the pinion on the wheel and the ring of small teeth at the top engages the vertical lantern-pinion on the axle of the mill-stone.

H. A horizontal waterwheel turns a vertical lantern-pinion on its axle, which engages the spur-teeth of a horizontal spur and crown-gear. The crown-teeth engage a second lantern-pinion on the same axle as the crown-gear and a further lantern-pinion on the stone spindle. Francesco comments: 'The multiplication of the wheels and pinions relieves the burden and it can be easily made.'

I. The runner stone of the mill is driven directly from the waterwheel. On the right there is a screw tentering arrangement through a sector and lantern-pinion to adjust the relationship of the bed and milling stones, which are driven by capstan bars from the chamber above. The radial part of the sector passes through the capstan-head of a screw forming a foot-step bearing; this can be clearly seen in the MS L drawing.

K. The diagram shows a similar arrangement driven through a lantern-pinion and spur-gear. On the right a similar tentering arrangement as I is shown, but the sector has not been drawn. The head of the sector shown in MS L is interpreted here as a cord. Some speed reduction is shown in the step-up gearing.

L. A horizontal waterwheel in the lower chamber moves a spur-gear on its axle in the second chamber, which engages a lantern-pinion on the stone shaft. A flywheel has been introduced on to the stone spindle below the stone floor. This is an early illustration of a flywheel.

M. A hand-powered mill worked by alternate pushing and pulling of a rod connected to a return-crank on the upright shaft, which carries a flywheel and spur-gear. The mill is driven through a step-up gear of a spur-wheel and lantern-pinion.

OTHER MANUSCRIPTS Turin, BR, MS T, fols 34v–35r (Maltese 1967, I, p.145, line 14–p.146, line 17; p.264, tav.64–5); Florence, BML, MS L, fol.34r, inscribed [F] *Retrecino di mu/lino ter[r]ag[nolo]*

co[n] rochetti e rota di dup[r]ichati de[n]ti; [G] *Mulino ter[r]ang[ol]o cho[n] rocchetto e rota*; [H] *Mulino a r[r]etrecine terragniolo che p[er] la facilita de le rote ronchetto e ribecchj cho[n] pocha/acqua legreme[n]te va*; [I] *Mulino a rretrecine ter[r]agniole*; [K] *Mulino ter[r]agnolo co[n] roccheta e ribeccho*; [L] *ter[r]ang[iolo] cho[n] rochetto e ribecchi e ruote vachue*; [M] *pistrino a fruchatoio* (Marani 1979, II, cap.CXLVIII–CLIX, p.114); New Haven, BL, MS B, fol.34r; Venice, BMV, fols 155r–157r; Rome, BAV, *Codicetto*, [F] fol.140r, [G, H] fol.163r, [K, L, M] fol.163v; London, BM, *Opusculum*, [M] fol.77r.

OTHER REPRESENTATIONS Vicenza, BBV, [F, G, H] fol.19v, [H, L, M] fol.63v; Bernardo Puccini, Florence, BNCF, MS Palatino 1077, [K] fols 90r–91v (Lamberini 1990b, p.57, fig.18; Siena 1991, p.270).

167

Mills driven by water

SJSM, vol.120, fol.61r

N. The water acts as a counterweight to move the mill, which is similar to E on fol.60r (cat.165). A horizontal lantern-wheel drives a cogged pinion; E shows longer wheels and cogs. The outcome is the same and as drawn the intermediate wheel is idle. An unusual feature of this pairing is the fact that the lantern is the large component and the cogged-wheel the small.

O. Water funnelled on to an overshot waterwheel in a narrow chamber turns a crown-gear on the axle, and drives a lantern-pinion on a shaft with a spur-gear engaging a second lantern-pinion on the axle of the mill stone. The central gearing is idle.

P. The same arrangement as F on fol.60v (cat.166), which has a double row of cog teeth. Francesco comments: 'The cross bars in the spur-gear reduce the weight of the gear at the circumference.'

Q. A horizontal waterwheel in the lower chamber turns a crown-gear on the same axle, which engages a horizontal crown and spur-gear on a second, vertical axle and a vertical lantern-pinion on the stone spindle. More than one stone could be driven by this arrangement, which shows a compound gear. The use of crown-gears between parallel shafts is very unusual. In MS L (fol.34v) the illustration of the crown-gear on the second shaft could be intended as roller teeth.

R. An overshot vertical waterwheel turns a crown-gear on its axle, which engages a driven wheel with roller teeth. A detail of the driven wheel is shown at z on fol.61v (cat.168). This ensemble is similar to O.

OTHER MANUSCRIPTS Turin, BR, MS T, fol.35r (Maltese 1967, I, p.146, line 17–p.147, line 20; p.264, tav.65); Florence, BML, MS L, fol.34v, inscribed [N] *Mulino cho[n] rota a chasse cho[n] rochetto e/ribeccchj e cho[n] pocha acqua lieva fa*; [O] *Mulino cho[n] rota a chasse cho[n] ribecchj e rullatj/rocchettj*; [P] *Mulino aretrecine terang[olo] co[n]/rota e rocchettj*; [Q] *Mulino cho[n] ritreccine terang[olo] co[n] ribeccho rullato/e denta ta rota co[n] suo rocchetto*; [R] *Chulu[n] baria rota/conribeccho rullato/edentata rota co[n]/sue ribeccho* (Marani 1979, II,

cap.CLIX–CLX, p.114); New Haven, BL, MS B, fol.34v; Venice, BMV, fol.159r; London, BL, *Opusculum*, [N] fol.76r, [P] fol.75v, [Q] fol.76v; Rome, BAV, *Codicetto*, [N, P] fol.164r, [R] fol.164v.

OTHER REPRESENTATIONS Vicenza, BBV, [Q] fol.27r.

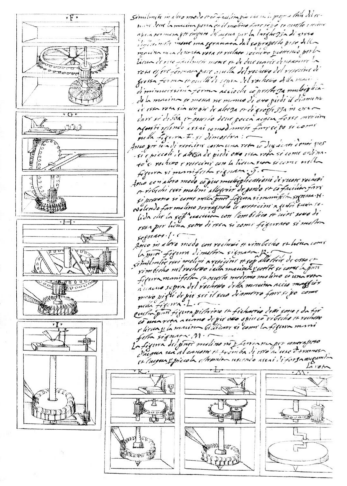

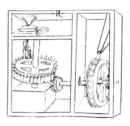

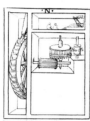

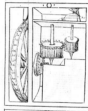

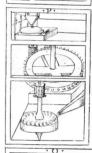

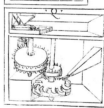

168

Mills driven by water, with automatic water supplies and a horse-driven mill

SJSM, vol.120, fol.61v

s. A horizontal waterwheel with a spur-gear on its axle turns a driven wheel with roller teeth on a second axle, which engages a lantern-pinion on the stone shaft. The diameter of the wheel must be no less than 15 *piedi*.

T. The text reads: 'When you are prevented topographically from setting up a mill by a river and cannot excavate, an undershot waterwheel is powered by siphoned water carried by terracotta pipes over a hill to a tail-race lower than the source of the water.' The waterwheel turns a crown-gear on its axle and connects with a lantern-pinion on the stone shaft. Taccola also illustrated siphoning as well as a pump of this kind in *De ingeneis* (Siena 1991, pp.314–15).

v. A mill with still water acting as a counterweight. An overshot waterwheel has a lantern-gear on its axle, which engages with crown-teeth on a vertical shaft. Spur-teeth on the same wheel engage a lantern-pinion on the spindle of the mill. A lantern on the vertical shaft engages a crown-wheel driving a baling device composed of a chain of pots, which raises water from the tail-race to the head-race of the

mill. The ensemble is a study in perpetual motion and physically impossible.

z. A horse turns a capstan-bar and moves a horizontal crown-gear that connects with a horizontal wheel with roller-teeth and drives a lantern on the stone shaft. A plan of the wheel with roller-teeth is shown on the right in the bottom margin. Francesco writes: 'This mill can be made in any castle or city; it is fairly useful, easy to build and set in motion, since it is light and an animal can move it easily.'

OTHER MANUSCRIPTS Turin, BR, MS T, fol.35v (Maltese 1967, I, p.147, line 20–p.149, line 1; p.265, tav.66); Florence, BML, MS L, fol.34v, inscribed [s] *Retrecine ter[r]ag[nolo] co[n]/ribeccho rullato e de[n]/tata rota co[n] suo rochetto*; [T] *Mulino dove lacqua/sop[r]al pog[g]io monta[n]/do/ellacqua attraendo el/mulino a macina[r] ve/ra*; [v] *Mulino in acqua mo[r]ta*; [z] *pistrino a chavallo ho b[b]o* (Marani 1979, II, cap.CLX–CLXIII, p.114); New Haven, BL, MS B, fols 34v–35r; Venice, BMV, fols 160r and v, 162v; Rome, BAV, *Codicetto*, [s, T] fol.148r, [v] fols 158r and 163v.

OTHER REPRESENTATIONS Vicenza, BBV, [s] fol.27r, [T] fol.33v, [v] fol.77r, [z] fol.64v.

169

Mills driven by still water and by hand

SJSM, vol.120, fol.62r

Francesco writes: 'Since stones worked by hand do not grind as well as stones worked by watermills, I shall demonstrate other means of working stones by water.'

x. A baling device is operated by capstan bars, which turn a lantern-pinion and crown-gear and rotate a vertical wheel with a chain of brass vessels. The vessels descend into a reservoir and collect water, which, at the top, is conducted by a funnel on to an overshot waterwheel. The wheel turns a lantern-pinion on its axle, and a combination of a crown and spur-gear and a second lantern-pinion on the stone shaft. As a straightforward conversion of energy the mill does not make sense unless the energy is to be stored by keeping water in the upper reservoir, not mentioned in the text.

Y. Two suction lift-pumps raise water from below, to a race above a waterwheel. The lantern-pinion on the axle of the waterwheel engages the crown-teeth of a crown and spur-gear on a vertical shaft. The spur-teeth drive the mill. The shaft also carries the lantern-pinion engaging the crown-wheel on the double crank driving the pumps. The ensemble is a study in perpetual

motion and physically impossible.

I. Capstan bars in a lower chamber turn a lantern-pinion on the axle in the second chamber, and drive an idle spur-gear on a second axle and a slightly smaller lantern on the stone shaft. The lantern-pinion is 5 *piedi* and the spur-wheel 18–20 *piedi* in diameter.

II. Capstan bars, moved by animals, turn a lantern-pinion and move a ring-gear with external and internal teeth and a second lantern-pinion on the stone shaft. There is a differential in the gear because there are more teeth on the external ring and fewer on the internal ring; the lantern-pinions of equal size allow a small step-up ratio.

OTHER MANUSCRIPTS Turin, BR, MS T, fols 35v–36r (Maltese 1967, I, p.149, line 27–p.149, line 34; p.265, tav.66–7); Florence, BML, MS L, fol.35r, inscribed [x] *mulino in acqua mo[r]/ta*; [Y] *Mulino in acqua mo[r]ta*; fol.35v, inscribed [I] *Pistrino dove lanimale voltando va*; (Marani 1979, II, cap.CLXIV–CLXVII, p.114); New Haven, BL, MS B, fol.35r; Venice, BMV, fols 161v–162r, 163r–164r; Rome, BAV, *Codicetto*, [Y, I] fol.141r; Florence, BNCF, MS M, [I] fol.96v (Maltese 1967, II, p.502, tav.328).

OTHER REPRESENTATIONS Vicenza, BBV, [x] fol.77r, [I, II] fol.113v ; Oreste Vannocci Biringucci, Siena, BC, fol.107v.

170

An animal-powered mill and floating mills

SJSM, vol.120, fol.62v

III. An internal, vertical treadmill, 4 *piedi* wide, 25–30 *piedi* in diameter, operated by an ox, moves a vertical crown-gear on its axle and a horizontal spur-gear with roller teeth that engage a second set of cogs and a lantern-pinion on the stone shaft.

IIII. Two boats moored in a river have a current-wheel with scoops suspended between them; the current of the water turns the wheel and moves a lantern-pinion on its axle. This engages a horizontal crown and spur-gear that drives the lantern-pinion on the stone shaft.

v. A horizontal waterwheel is suspended from a platform on two boats and partially immersed in a river. The current turns the wheel and moves a lantern-pinion on its axle, which engages a spur-gear and a second lantern-pinion on the stone shaft. It is unlikely that the horizontal current-wheel would work.

vI. A current-wheel constructed as a simple undershot wheel is suspended between two boats. It turns a lantern-

pinion on its axle and engages a crown and spur-gear, which drives a vertical lantern-pinion on the stone shaft.

Taccola draws floating mills in *De ingeneis* (book IV, fol.66r; Prager & Scaglia 1972, fig.91). Floating mills, described by Procopius, were developed in Rome after the spring of AD537, when the Goths cut off the aqueducts, stopping the watermills, and the shortage of fodder made the use of animal-powered mills impractical. They were still in use in Rome in the 19th century: Acquaroni's engraving of Ponte Cassio, of c.1820, shows a floating mill below it (Wikander 1979, p.30).

OTHER MANUSCRIPTS Turin, BR, MS T, fol.36r and v (Maltese 1967, I, p.150, line 1–p.151, line 2; p.265, tav.67–8); Florence, BML, MS L, fol.35v, inscribed [v] *Mulinj sop[r]a a fiumara/e ba[r]che*; [vI] *Mulino sop[r]a a fium/e eba[r]che* (Marani 1979, II, cap.CLXVIII–CLXXII, p.114); New Haven, BL, MS B, fol.35v; Venice, BMV, fols 164r–165v; Rome, BAV, *Codicetto*, [v, vI] fol.139v, [v] fol.150v.

OTHER REPRESENTATIONS Vicenza, BBV, [III, IIII] fol.113v, [v, vI] fol.107v.

171

Windmills, still-water mills

SJSM, vol.120, fol.63r

vII. A chain-of-pots baling device is activated by a horizontal windmill that engages a lantern-pinion and crown-gear and turns a wheel with the chain of vessels attached to it. The pots descend into a reservoir and collect water, which is conducted into a channel at the top. The water is funnelled on to an overshot waterwheel, which drives a lantern-pinion on its axle, a crown and spur-gear and a second lantern-pinion on the stone shaft. The shaft is adjustable on a screwed footstep and two lantern-pinions so that either may be engaged to change the direction of the windmill. Veins hinged to bend in only one direction, specified in the text, are essential for this mill (Maltese 1967, I, p.151, n.1).

vIII. A horizontal windmill, mounted on a tower, turns a lantern-pinion and a spur-gear below it on the same axle; it engages a smaller lantern-pinion on the stone shaft.

vIIII. Water falls in stages to drive two overshot waterwheels. A chain of pots is suspended from a wheel into a well; on the axle of the wheel is a lantern-

pinion that moves a crown-gear. Below this a second crown-gear engages a lantern-pinion on the axle of an overshot waterwheel, which turns continuously because of the water delivered from the baling device. The water falls to the lower reservoir and runs through the hole below the wheel to be funnelled over the lower wheel, with a lantern-pinion that engages the crown-teeth of a horizontal crown and spur-gear. The spur-teeth engage the lantern on the stone spindle and the water runs back to the well through the hole below the mill. On the sources for windmills, see Hill 1984, p.172.

OTHER MANUSCRIPTS Turin, BR, MS T, fols 36v–37r (Maltese 1967, I, p.151, line 3–p.152, line 9; p.265, tav.68–9); Florence, BML, MS L, fol.35v, inscribed [vII] *Mulino ha acqua eve[n]to*; fol.36r, inscribed [vIII] *Mulino a ve(n)to*; [vIIII] *Mulino inacqua/morta* (Marani 1979, II, cap.CLXXIII–CLXXV, p.114); New Haven, BL, MS B, fols 35v–36r; Venice, BMV, fols 166r and v, 167v; Rome, BAV, *Codicetto*, [vII] fol.149v, [vIII] fol.154r.

OTHER REPRESENTATIONS Vicenza, BBV, [vII] fol.113r, [vIII, vIIII] fol.5v.

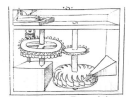

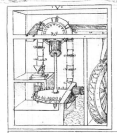

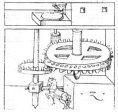

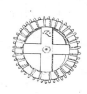

168

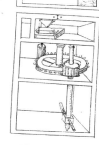

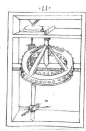

169

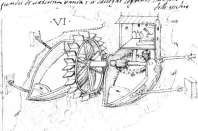

170

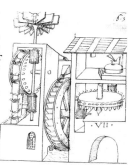

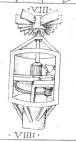

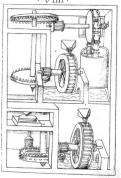

171

172
Watermills powered by automatic water supply
SJSM, vol.120, fol.63v

x. Francesco writes: 'When there is very little water to power a mill, you must first build two wheels; the first carries on its axle a closed, sealed wheel with pointed, sealed buckets on its circumference, so that the vacuum inside will force the wheel to rise with great force when it enters the water.' A lantern-pinion on the axle connects with the crown-teeth of the crown and spur-wheel, and the spur teeth drive the lantern-pinion on the stone spindle. A sluice, worked by rocking beams, controls the flow of water to the waterwheel.

xi. Water is pumped by a pair of lift pumps on balanced levers attached by connecting rods to a double crank on the axle of a waterwheel. The water

delivered by the pumps drives the waterwheel and turns a small crown-gear on its axle, which connects with a horizontal spur-gear with roller and spur-teeth and a lantern-pinion on the same axle as the stone shaft. The function of the foot-step bearing below the spur-gear is unclear.

xii. A single beam, operated by a double crank-handle linked by connecting rods to the pistons, works two pumps on either side of its fulcrum behind the mill. They pump water up from a lower reservoir to overshoot a vertical waterwheel. The wheel turns a lantern-pinion on its axle, which connects with a crown and spur-gear and a second lantern-pinion on the same axle as the mill-wheel.

xiii. A device for use in places where water is abundant but the incline is slight. Siphoned water is carried over an arch to a sloping funnel on to a

simple waterwheel, which drives the millstone on the same shaft. The drawing implies that the water runs back to its source.

OTHER MANUSCRIPTS Turin, BR, MS T, fol.37r and v (Maltese 1967, I, p.152, line 9–p.153, line 13; pp.265–6, tav.69–70); Florence, BML, MS L, fol.36r, inscribed [x] *Mulino pa[r]te acqua viva e pa[r]te morta*; [xi] *Mulino inacqua mo[r]ta*; fol.36v, inscribed [xii] *mulino in acqua mo[r]ta*; [xiii] *[M]ulino dalzare lacqua p[er] la chan[n]a sop[r]a/degli archj dove pendente lacqua ma/[ci]na[n]te si da* (Marani 1979, II, cap.CLXXV–CLXXVIII, p.114); New Haven, BL, MS B, fols 36r and 37r; Venice, BMV, fols 168r–169v; Rome, BAV, *Codicetto*, [x] fol.149r, [xi] fol.151r, [xii] fol.150r, [xiii] fol.148r. OTHER REPRESENTATIONS Vicenza, BBV, [x, xi] fol.5v, [xiii] fol.27v.

173
Mills powered by animals
SJSM, vol.120, fol.64r

xiiii. A horse tethered to a wall, his front legs on the floor, eats from a manger while his rear legs move an inclined horizontal hollow treadmill. A roller lantern-pinion on the axle of the treadmill engages a double spur-gear; the upper spur-teeth connect with a lantern-pinion at the back of the chamber on the stone shaft. The same mill is drawn in *Meccanica*, fol.57r (cat.270).

xv. A horse-engine turns an axle and wheel with roller teeth, which connect with a crown and spur-gear and engage a lantern-pinion, not shown, on the same axle as the mill stone in the upper chamber, which has a tiled roof. A crown-wheel with roller-teeth and the lantern-pinion are specifically shown in MS L. The foot-step bearing below

the shaft allows for the wheel to be raised and lowered. The lantern pinion on the axle is 4 *piedi*; the large wheel is 20 *piedi* and the lantern on the pinion 8 *piedi* in diameter.

xvi. A driving weight, suspended from a cord, turns a drum on a horizontal axle. A lantern-pinion on the shaft engages a spur wheel on a second shaft. A lantern-pinion on this shaft engages the crown-teeth of a crown and spur-wheel on a vertical shaft. The spur-teeth engage the lantern-pinion on the stone spindle. The footstep under the intermediate wheel is shown as adjustable with a screw. This may be a way of disengaging the second lantern-pinion from the crown-teeth for the weight to be rewound. The proportions of the wheels are the same as the others.

xvii. In an upper chamber a horse tethered to a wall, eating from a manger,

turns with its hind legs an external vertical treadmill in the chamber below. A vertical crown-gear attached to the shaft of the wheel connects with a horizontal spur-gear with roller teeth and engages a lantern-pinion on the stone shaft. The mill, described by Francesco as useful in any location, has appeared in many books on mechanical inventions, from Strada in 1617–18 to Leupold in 1724. Beck (1899, pp.535 and 537) found an identical mill still in use in Holland c.1870. Strada misunderstood Francesco's roller teeth and replaced them by a round-tooth angle-wheel, to which he applied the semicircular, cut-out cogs of the driving wheel (Reti 1963, p.294).

OTHER MANUSCRIPTS Turin BR, MS T, fols 37v–38r (Maltese 1967, I, p.153, line 13–p.154, line 14; p.266, tav.70–71);

Florence, BML, MS L, fol.36v, inscribed [xiiii] *pistrino dove lanimale g/uida elq[u]ale a macina[r] va*; [xv] *pistrino da guida[r]si p[er] asino ho chavallo*; [xvi] *pistrino acho[n]/tra pesj*; [xvii] *pistrino dov/e el chavallo ho mulo sop[r]a la ruota chor/re drieto di ch/ontinovo m/oto da* (Marani 1979, II, cap.CLXXIX–CLXXXII, p.114); Venice, BMV, fols 170v–171r, 172r; London, BM, *Opusculum*, fol.74v; Rome, BAV, *Codicetto*, [xiiii, xvii] fol.138v; [xv, xvi] fol.139r; Florence, BNCF, MS M, fol.97r (Maltese 1967, II, p.503, tav.329) OTHER REPRESENTATIONS Vicenza, BBV, [xiiii, xvii] fol.5r.

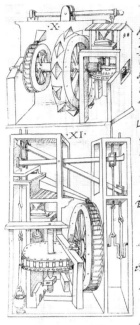

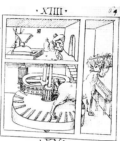

174

Windmills and a mill driven by a man

SJSM, vol.120, fol.64v

XVIII. A vertical windmill with cloth sails rests on roller bearings so that it can be turned to the wind in any direction. The sail turns a lantern-pinion on its axle, which connects with a crown-gear and lantern-pinion, a spur-gear and third lantern-pinion on the stone shaft.

XVIIII. A man raises and lowers a lever attached by a chain to a return crank, which turns a flywheel on the left and a lantern-pinion on the right. The lantern-pinion engages a crown and spur-gear and drives a second lantern-pinion on the stone shaft. In MS L a man operates the crank.

XX. A horizontal windmill drives a lantern-pinion, which connects with a crown-gear and turns the axle of a scoop-wheel. Water, carried in the buckets of the wheel, is deposited at the top and funnelled down over an overshot waterwheel. A lantern-pinion on the axle of the wheel turns a crown and spur-gear and a second lantern-pinion on the axle of the stone.

OTHER MANUSCRIPTS Turin, BR, MS T, fol.38r and v (Maltese 1967, I, p.154, line 14–p.155, line 14; p.266, tav.71–2); Florence, BML, MS L, fol.37r, inscribed [XVIII] *mulino a ve[n]to*; [XVIIII] *pistrino a fruch/atoio*; [XX] *Mulino ad acqua mo[r]ta/evento* (Marani 1979, II, cap.CLXXXIII–CLXXXV, p.114); New Haven, BL, MS B, fol.37r; Venice, BMV, fols 172v–173v; Florence, BNCF, MS M, [XVIII] fol.95v (Maltese 1967, II, p.501, tav.326); Rome, BAV, *Codicetto*, [XVIII, XVIIII] fol.137r, [XX] fol.140v.
OTHER REPRESENTATIONS Vicenza, BBV, [XVIII] fol.37v, [XX] fol.27v; Pietro Cataneo, [XVIII] Uffizi 3371A.

175

Undershot watermills and an overshot waterwheel

SJSM, vol.120, fol.65r

XXI. A vertical waterwheel is suspended over a stream between two boats chained to the banks. As it turns it powers a lantern-pinion on its axle, which engages a crown and spur-gear with a lantern-pinion on the stone shaft. The first upright shaft carries a flywheel at the top.

XXII. Water carried from a lower reservoir by a chain pump with circular palettes is funnelled on to an overshot waterwheel. The waterwheel moves a lantern-pinion on its axle, engaging a horizontal crown and spur-gear and a second lantern pinion on the stone shaft. A crown-wheel on the upright engages a pinion on the shaft that carries the driving drum of the chain pump. A new kind of lantern-pinion is shown at the top with openings in the drum to engage the teeth. This is another study in perpetual motion and physically impossible.

XXIII. An undershot waterwheel with buckets turns an axle with a four-leafed pinion, which connects with a recessed face gear on the same axle as the millstone.

OTHER MANUSCRIPTS Turin, BR, MS T, fol.38v (Maltese 1967, I, p.155, line 15–p.156, line 17; p.266, tav.72); Florence, BML, MS L, fol.37r, inscribed [XXI] *Mulino sop[r]a fiume e ba[r]che*; [XXII] *Mulino in acqua morta*; fol.37v, inscribed [XXIII] *Mulino adacqua dovel chanal sotto la ruota da* (Marani 1979, II, cap.CLXXXVI–CLXXXIX, p.114); Venice, BMV, fol.175r and v; Rome, BAV, *Codicetto*, [XXI] fol.139v, [XXII] fol.147r, [XXIII] fol.144r.

176

Still watermills and a float-wheel mill

SJSM, vol.120, fol.65v

XXIIII. Hand- or animal-power is used to turn capstan-bars on an axle below a lantern-pinion that connects with a crown-gear and lantern-pinion, which engage the teeth on the face of a scoop-wheel. The water carried in the buckets is deposited at the top and funnelled on to an overshot waterwheel. This turns a lantern-pinion and a crown and spur-gear, which engages a second lantern-pinion on the stone shaft.

XXV. A horse-yoke turns a capstan that is connected to a lantern-pinion and crown-gear, which turn double cranks with a flywheel. Connecting rods from the cranks work a pair of balanced beams that drive four lifts to power a conventional mill, which Vitruvius would recognize.

XXVI. An undershot waterwheel, for a site with an incline of 2–3 *piedi*. The float wheel, 20 *piedi* in diameter, is closed and well joined to prevent water entering; it has sealed buckets that cause the wheel to turn because a vacuum cannot remain below the surface of the water. The wheel turns a lantern-pinion on its axle, which engages a crown- and spur-gear and connects with the lantern-pinion on the stone shaft.

OTHER MANUSCRIPTS Turin, BR, MS T, fol.39r and v (Maltese 1967, I, p.156, line 17–p.157, line 18; pp.266–7, tav.73–4); Florence, BML, MS L, fol.37v, inscribed [XXIIII] *Mulino dove la bestia guida[n]do ellacqua sop[r]a delle ruote he/levandosi inele galaz[z]a sop[r]a/la ruota del mulin chade[n]do m/acina[r] lo fa*; [XXV] *Mulino in acqua mo[r]ta*; [XXVI] *Mulino in acqua/morta* (Marani 1979, II, cap.CLXXXIX–CXCI, p.114); New Haven, BL, MS B, fol.37v; Venice, BMV, fols 175v, 176v–177r; Rome, BAV, *Codicetto*, [XXV] fol.145v.

177

Float-wheel mill and an animal-powered mill

SJSM, vol.120, fol.66r

XXVII. A float wheel with pyramidal sealed boxes drives a mill that works on the same principle as XXVI. The hollow wheel, 30 *piedi* in diameter and 1⅔ *piedi* wide, has hollow saw-tooth boxes attached to the rim inside, each box containing 25 *libre* of gravel. The wheel is closed and sealed and acute pyramidal boxes with one straight face are arranged on its outside rim. The wheel rises from the water by the vacuum and is drawn down again by the transferred weight of the gravel inside the boxes. The wheel operates a lantern-pinion on the spur-teeth of a spur and crown-gear. The crown-teeth engage a pinion on a stone shaft. A man with a sack of grain enters the mill; part of the stair to the stone chamber is shown on the left. These details are not shown in MS L.

XXVIII. A treadmill operated by a man turning a large wheel with very large roller-teeth, which engage a rectangular frame with a roller on the axle of the treadmill that moves the large wheel. The lantern-pinion on the axle of the wheel engages the crown-teeth of a spur and crown-gear, which move the vertical lantern-pinion on the stone spindle.

OTHER MANUSCRIPTS Turin, BR, MS T, fol.39v (Maltese 1967, I, p.157, line 19–p.158, line 18; pp.266–7, tav.74); Florence, BML, MS L, fol.37v, inscribed [XXVII] *Mulino in acqua morta*; fol.38r, inscribed [XXVIII] *pistrino dove la bestia i[n] nella ro/ta chami[n]do macina[r] la fa* (Marani 1979, II, cap.CXCI–CXCIII, p.114); New Haven, BL, MS B, fols 37v–38r; Venice, BMV, fol.178r and v; Rome, BAV, *Codicetto*, [XXVII] fol.147v, [XXVIII] fol.156r.
OTHER REPRESENTATIONS Vicenza, BBV, fol.33r.

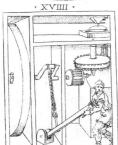

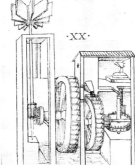

174

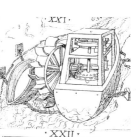

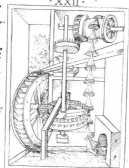

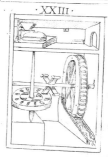

175

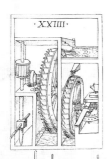

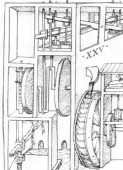

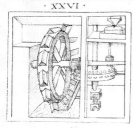

176

177

178

*Float-wheel mills, a siphon powering
a mill and a horse-powered mill*

SJSM, vol.120, fol.66v

XXIX. A float-wheel with pyramidal
empty boxes attached to the circumfer-
ence will move because of the buoyancy
of the empty boxes when under water.
A treadmill on the same axle activates
a lantern-pinion, a crown-and-spur-
gear mechanism and a second lantern-
pinion on the axle of the wheel.
XXX. An overshot wheel with hinged
buckets driving a crown-wheel on its
axle and a lantern-pinion on the stone
shaft.
XXXI. A diagram showing how
siphoned water brought over moun-
tains can be channelled into winding
mountain streams to increase the force
of the water when it reaches the mill.
Taccola shows siphoned water power-
ing a mill in *De ingeneis* (book II, fols
56v–57r and fol.66v; see the siphons
on fol.71r, cat.179).
XXXII. A horse yoked to a capstan bar
turns it and moves a lantern-pinion
that engages a crown-gear and drives a
pump with jointed buckets, which
empty at the top over a vertical water

wheel. The water moves the wheel and
sets the lantern-pinion on the axle of
the wheel and the crown-gear on the
stone shaft in motion.

OTHER MANUSCRIPTS Turin, BR, MS T,
fol.40r (Maltese 1967, I, p.158, line
19–p.159, line 18; p.267, tav.75);
Florence, BML, MS L, fol.38r, inscribed
[XXIX] *mulino in acqua mo[r]ta*; [XXX]
mulino in acqua/mo[r]ta; [XXXI] *Mulino
da alzaresi lacqua/p[er]le chan[n]e
sop[r]a del mo[n]te/e ponte*; [XXXII]
Mulino in acqua mo[r]ta (Marani 1979,
II, cap.CXCIV–CXVII); New Haven, BL,
MS B, [XXX, XXXII] fol.38r; Venice, BMV,
fols 179r–180v; Rome, BAV, *Codicetto*,
[XXIX] fol.141v, [XXX] fol.103r, [XXXI]
fol.70v, [XXXII] fol.164r.
OTHER REPRESENTATIONS Vicenza, BBV,
[XXX, XXXI] fol.33r; Pietro Cataneo,
[XXX] Uffizi 3370A.

*Springs and ways of raising and con-
ducting water*

SJSM, vol.120, fol.67r
No illustration

Underground water supplies

SJSM, vol.120, fol.67v
No illustration

Underground water supplies

SJSM, vol.120, fol.68r
No illustration

Underground water supplies

SJSM, vol.120, fol.68v
No illustration

Underground water supplies

SJSM, vol.120, fol.69r
No illustration

Natural hot and cold springs

SJSM, vol.120, fol.69v
No illustration

Geology and water characteristics

SJSM, vol.120, fol.70r
No illustration

Natural hot and cold springs

SJSM, vol.120, fol.70v
No illustration

179

Siphons

SJSM, vol.120, fol.71r

The illustration shows a siphon as a
means of conducting water over
mountainous ground. Francesco di
Giorgio's use of siphons depends on
Taccola's account, which in turn
derives from Hero's *Pneumatica* of the
2nd century BC (parts I–IV; translated
in Hero of Alexandria 1851). Taccola
shows siphons in various forms, started
by suction (*De ingeneis*, book I, fol.68r);
with a range of controls at the intake
and outlet valves (book I, fol.73v); and
started mechanically (book I, fols 60r,
62v–63r). He also shows siphons cross-
ing over mountains and transporting
water from the source to the point of

use (Prager & Scaglia 1972, pp.53–4,
pls 12 and 31). Taccola described a mill
driven by siphoned water: 'by use of
its valve system water always rises and
descends by inherent motion. In the
first place let the descent be greater
than the ascent by one fourth. Let the
water-carrying pipes be of terracotta,
and let clay be walled up around
them…when you want the water to
ascend, fill the entire pipe having first
closed the mouthpiece, then let the
apertures be unsealed both at the same
time. Let it be as you have it in the
drawing. Water is drawn from the
pond or the lake in the plain, and then
it pours from the other and downwardly
sloping part' (op. cit., pp.122–3).
Francesco's diagram shows the ropes

attached to plugs that can be pulled out
when the siphon has been filled from
the top; water will flow continuously
and draw in more water because of
gravity. He shows the down-pipe one
fourth longer than the intake; it is also
thicker and wider.

OTHER MANUSCRIPTS Turin, BR, MS T,
fol.42v (Maltese 1967, I, p.169, line
5–p.178, line 11; p.267, tav.78); BML, MS
L, fol.40v, inscribed *Chanale da passare
l'acqua sop[r]a dela/monta[n]gnia dal-
luno ellaltra val[l]e* (Marani 1979, II,
cap.CCXVI, p.114); New Haven, BL, MS B,
fol.40v; Venice, BMV, fol.191r; Rome,
BAV, *Codicetto*, fols 7v and 12v.

XXX

XXXI

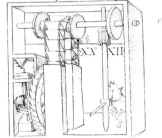

178

179

180
Aqueducts
SJSM, vol.120, fol.71v

Water is transported over a bridge by sinking a large tubular well into a river or stream; the well has a hole that can be plugged in the side at the bottom. A long straight open-ended pipe is lowered to the bottom and carried over the arch before descending to a cistern below the level of the inlet. When the hole is unplugged, the cistern fills with water and the tube fills continuously as the water is carried over the arch and delivered by the downflow to the cistern. To work, the down-pipe must always be inclined 4, 6, 8 or 10 *piedi* below the inlet pipe that takes in the water. The hole in the bottom of the cistern is plugged to stop the flow.

OTHER MANUSCRIPTS Turin, BR, MS T, fol.45r (Maltese 1967, I, p.178, line 11–p.179, line 10; p.267, tav.81); Florence, BML, MS L, fol.41r, inscribed *puteo–Attrar[r]e lacqua di marine/lago ho fiume sop[r]a al/chunj montj hoschogli ho/ inaltrj luogi cho[n]dur/si puo* (Marani 1979, II, cap. CCXVII–CCXVIII, p.114); New Haven, BL, MS B, fol.41r; Venice, BMV, fol.192r; Rome, BAV, *Codicetto*, fols 11v, 70v, 128v and 154v.
OTHER REPRESENTATIONS Vicenza, BBV, fol.77v.

181
Fountain and a navigable canal with locks
SJSM, vol.120, fol.62r bis, 72r

[1] The illustration shows a fountain in the shape of a vase with a jet of water rising in the centre of the upper basin. The fountain has two pools of water, in the base and in the upper basin, connected by narrow vertical tubes of different lengths. When water is poured into the basin it falls into the lower reservoir, then the air expelled from the lower reservoir enters the upper chamber and pushes the water upwards to form a jet. The fountain is called *a termine* because it is started by water being poured into the basin, and it stops when the water falls into the lower reservoir (Siena 1991, p.306).
[2] Francesco describes a method of bringing ships from the sea or a river to a city on a shallow river or to one on an elevated site: 'first check the incline and see that the banks are firm. If the first part of the river has an incline of 30 *piedi*, make a high Saracen gate with a sluice gate or cataract, so that by opening it with winches or windlasses the water level rises. Divide the whole length of the river so that as the boat enters the lock and the gate closes because of the water entering the lock, which will cause the boat to rise, then the second lock can be entered and as the gate closes the boat rises and so on along the canal to the city. On the return journey the water level will fall in each lock.'

OTHER MANUSCRIPTS Turin, BR, MS T, fol.45r (Maltese 1967, I, p.179, line 10–p.180, line 14; p.277, tav.81); Florence, BML, MS L, fol.41r, inscribed [1] *fonte a tte[r]mine*; [2] *Fiume cho[n] po[n]tj e chataratte dove he navilj ina[n]xi/endrieto andare possono* (Marani 1979, II, cap.CCXVIII–CCXIX, p.114); New Haven, BL, MS B, fol.41r; Venice, BMV, fols 192v and 193v; Rome, BAV, *Codicetto*, [1] fols 18r and 33v; London, BM, *Opusculum*, fols 62r and 66v.
OTHER REPRESENTATIONS Vicenza, BBV, [1] fol.77v, [2] fol.69r.

182
Pumps
SJSM, vol.120, fol.62v bis, 72v

All four machines are for drawing water from a shallow well or cistern.
I, II. Lift and plunger pumps are described in *Meccanica* (fol.11r, cat.224).
III. The plunger pump is also described in *Meccanica* (fol.71r, cat.284).
IIII. The swape is described in *Meccanica* (fol.43r, cat.256).

The machines are not numbered in MSS L and T. In *De ingeneis* Taccola also draws piston pumps (fol.42r and v) and a pump operated by a crank-shaft (fol.82v; Prager, Scaglia & Montag 1984, pp.83–4, 164).

OTHER MANUSCRIPTS Turin, BR, MS T, fol.45v (Maltese 1967, I, p.180, line 14–p.181, line 19; p.268, tav.82); Florence, BML, MS L, fol.41v; New Haven, BL, MS B, fol.41v; Venice, BMV, fols 194v–195r; Rome, BAV, *Codicetto*, [I, II] fol.157r.
OTHER REPRESENTATIONS Vicenza, BBV, [I, IV] fol.71v, [II] fol.69r, [III] fol.79r, [IV] fol.71v.

183
Suction pumps
SJSM, vol.120, fol.63r bis, 73r

V. A double lift-pump worked on tappets with non-return valves in the feet of the barrels and in the bottom of the tubes, which are paired on a frame with rollers to reduce friction. The rollers are clearly shown in MS L. An animal turns the capstan-bars on an axle below a crown-gear engaging a rung-gear or trundle on the same axle as the tappets. Water is thrown out at the top of the tubes. In *De ingeneis* Taccola shows a pump powering a mill with long tubes worked by tappets in short barrels (book III, fols 44v–45r; Prager & Scaglia 1972, p.106, fig.53). This drawing is closer to a conventional lift-pump because of the long barrels and tubes.
VI. A baling device with wooden or brass buckets fitted with a valve at the bottom and at the side. The buckets dip below water, fill up and discharge at the side with a mechanism that is hinted at in the drawing. They are suspended from toothed-frames, clearly drawn in MS L, which work through half-wheel gears. The capstan-bars are turned so that the lantern-pinion on the axle moves a crown-wheel in continuous engagement on the axle of the pinions; when the bucket at the front rises to the summit on the teeth of the mutilated pinion, the bucket at the back, no longer engaged on the pinion, falls by gravity back into the reservoir.
VII. Paired lift-pumps, with valves in the bottom of the buckets, are clearly shown in MS L. The water enters the moving part and is delivered through the top of it. In MS L the water is shown clearly spilling out; here it seems to be delivered through a spout. The weighted rocking-lever is moved by a roller crank-shaft attached to a coupling rod with an elongated loop in MS L and a ring in this drawing. This detail suggests that the draughtsman of this copy of the manuscript thought of the device as a connection rather than a coupling rod. In MS L the elongated loop that transfers reciprocating or oscillating motion is consistently drawn. The connecting rods converting the rotation of the wheel have a ring. The weight, shown as a horn-shaped element, has been misread from MS L.
VIII. This device is also more clearly drawn in MS L. A cylinder is constructed above a pier and an axle is threaded through a diaphragm at the top and bottom with two valves in each one; the lower diaphragm does not move. The pump is worked by two levers, a weighted lever at the bottom of the axle and a second lever attached by cord to an L-shaped rod that works the roller-crank in a loop as a coupling rod connecting two oscillating elements, which are worked like tappets. The cord is eliminated in MS T, probably because it is superfluous. The outlet at the top of the cylinder, in MS L and here, is shown half-way down the cylinder in MS T (Maltese 1967, I, p.182, n.4). Zonca (1607; Reti 1963, fig.10a) engraved this pump.

OTHER MANUSCRIPTS Turin, BR, MS T, fols 45v–46r (Maltese 1967, I, p.181, line 19–p.182, line 28; p.268, tav.82–3); Florence, BML, MS L, fols 41v–42r (Marani 1979, II, cap.CCXXV–CCXXVII, p.114); New Haven, BL, MS B, fol.42r; Venice, BMV, fols 195v–197r; Rome, BAV, *Codicetto*, [V] fol.130r, [VIII] fols 127v and 142r.
OTHER REPRESENTATIONS Vicenza, BBV, [V] fol.71v, [VI, VII, VIII] fol.61v; Zonca 1607, [VIII] pl.109.

180

181

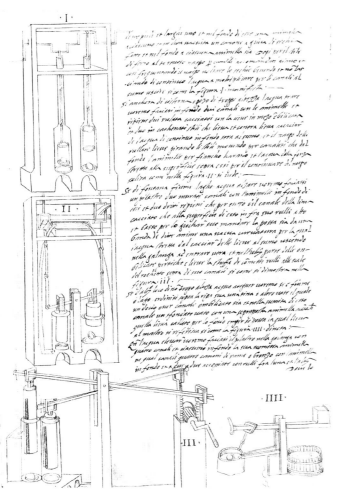

182

183

184

Machines for raising water

SJSM, vol.120, fol.63v bis, 73v

VIIII. A conventional force-pump with a tube shaped like a trumpet fitted with a foot valve and a delivery-valve in the tube next to it. The plunger works at considerable height above the valve chamber to work air into the barrel, drive water into the delivery valve and deliver it through a spout on the right at the top. The handle will rise on its own because of the weight, then it is worked by the men raising and lowering the handles in the roller frame. The rollers are not shown. For the sources of the force pump, see Hill 1984, pp.142–3.

X. A kind of suction pump called a bellows pump, which is made of wood without leather. Water is delivered to the bellows through a trumpet-shaped suction limb with a valve at the top. The water does not rise above the middle board, which rises to the middle as the water fills; the counterweight causes it to fall to expel the water through the nozzle. The pump is operated through a roller-crank working through an elongated loop, drawn here as vertical and correctly as horizontal in MS L. The flywheel illustrated is not mentioned in the description. This pump will operate to a maximum height of c.25–30 piedi.

XI. The cocleae ratio shown at XIII is drawn with a short helix; for the device to work it must rise to the top. Francesco specifies in the text that the helix must be constructed with two spirals of sheet iron. Water is raised using a windlass on the bank (see XIII on fol.64r bis, 74r, cat.185).

OTHER MANUSCRIPTS Turin, BR, MS T, fol.46r and v (Maltese 1967, I, p.182, line 28–p.184, line 3; p.268, tav.83–4); Florence, BML, MS L, fol.42r and v (Marani 1979,II, tav.CCXXVIII–CCXXX, p.114); New Haven, BL, MS B, fol.42r and v; Venice, BMV, fols 197v–198v; Florence, BNCF, MS M, fol.94v (Maltese 1967, II, p.500, tav.324); Rome, BAV, Codicetto, [VIIII] fol.144v, [X, XI] fol.146r.

OTHER REPRESENTATIONS Vicenza, BBV, [VIIII, X] fol.79r, [XI] fol.71r.

185

Pumps

SJSM, vol.120, fol.64r bis, 74r

XII. A trumpet suction-limb with a foot-valve and a valve at the top works in a barrel 4 piedi high and 1 piedi wide. Francesco specifies that the piston in the barrel works like a syringe with hemp packing. The pump is started by an animal turning the crank-shaft on an axle, then a lantern-pinion engages the crown-gear on the axle of a roller-crank in an elongated loop to provide the reciprocating motion. The pump is engraved by Zonca (1607; Reti 1963, pl.103).

XIII. The cocleae ratio described in Vitruvius (book X, cap.VI, 1) and attributed to Ctesebius was used in Egypt long before Archimedes introduced it to Europe, where it has since been known as Archimedes' screw. It consists of a cylinder enclosing several spirals. The lower part of the cylinder is placed in water and inclined, the screw turned and the water rises up the spirals. It was used principally in agriculture for irrigation and drainage; it was also used in ports and mines (Vitruvius 1986, p.153). The screw is worked in the shaft by a worm-screw and pinion. The worm-screw is a variation on the Archimedian screw principle. The machine is represented in the terracotta

relief of machines once set above the bench on the façade of the Palazzo Ducale in Urbino and now inside the building, (Rotondi 1970, p.89).

XIIII. A lift-pump set at an incline; the loop-and-frame coupling rod on the crank-handle makes the rod and frame vibrate to move the roller-frame on the pump.

XV. A pair of plunger-pumps, worked by a wheel, turns reciprocating motion to rotation and back again to reciprocating motion. The pumps deliver water to a valve chest with delivery valves, and the delivery pipe that runs through the centre of the view spurts water out at the top above the frame. As the lower crank is turned, the rod with two loops rises and falls, rocking the upper crank-shaft, which through the roller-crank and loop system gives motion to the vertical crank and pump-rods.

OTHER MANUSCRIPTS Turin, BR, MS T, fol.46r and v (Maltese 1967, I, p.184, line 3–p.185, line 6; p.268, tav.84–5); Florence, BML, MS L, fol.42v; Marani 1979, II, cap.CCXXXI–CCXXXIV, p.114; New Haven, BL, MS B, fol.42v; Venice, BMV, fols 199r–200v; Rome, BAV, Codicetto, [XII, XIII] fol.146v, [XIIII, XV] fol.143r.

OTHER REPRESENTATIONS Vicenza, BBV, [XII, XIII, XV] fol.71v.

186

Machines for raising water

SJSM, vol.120, fol.64v bis, 74v

XVI. A paired lift-pump worked through a rocking-beam, the typical connecting system through rollers, is operated by a pendulum rod with a loop engaging a roller-crank worked by a winch. A flywheel is attached to the crank-shaft. The bob weights do not seem to serve any particular purpose; their combination with the flywheel may demonstrate concern for the comfortable operation of the pump.

XVII. The baling device, a variant of VI, is operated by a return-crank; as the buckets are lifted they deliver sideways through spouts into a waterchest.

XVIII. A double-suction pump is worked by a treadmill pump, as drawn by Agricola, where the looped coupling rods are replaced by connecting rods. Zonca (1607; Reti 1963, fig.11a) engraved this pump .

XVIIII. Piston pumps with a groove in the side of the pistons are worked by a rocking beam. A similar pump is drawn in Meccanica (fol.71r, cat.284).

XX. The swape, which is lowered into water and filled, is operated by a rocking beam worked by two men pulling on a connection rod. A swape is drawn in Meccanica (fol.43, cat.256). It was engraved by Zonca (1607; Reti 1968, fig.12a).

MSS T and L are unnumbered.

OTHER MANUSCRIPTS Turin, BR, MS T, fol.47r and v (Maltese 1967, I, p.185, line 6–p.186, line 8; p.268, tav.85–6); Florence, BML, MS L, fol.43r (Marani 1979, II, cap.CCXXXV–CCXXXIX, p.114); New Haven, BL, MS B, fol.43r; Venice, BMV, fols 201r–202v; Rome, BAV, Codicetto, [XVI] fol.155v with variations, [XVII] fol.152r, [XVIII, XX] fol.151v, [XVI-III] fol.152v.

OTHER REPRESENTATIONS Vicenza, BBV, [XVII] fol.69v.

187

Pile-drivers, cranes and machines for lifting heavy weights

SJSM, vol.120, fol.65r bis, 75r

Vitruvius (book III, cap.IV; 1931, p.181) says that pile-drivers were driven by machines; he is otherwise unspecific .

XXXI. A heavy weight, suspended from a rope, which has been winched up by capstan bars through ropes and pulleys, is dropped inside the tall wooden frame on to a pile. Leonardo made a note in MS L about the resistance of rope in this machine and a second note about gravity, which Mussini has connected with a sketch illustrating gravity in the Madrid Codex that is close to this image (Reti 1974, II, fol.102r; Mussini 1991, pp.166 and 199, n.22–3).

XXXII. A pile-driver driven by a vertical treadmill is suspended on a tall wooden scaffold. The toothed ring of the treadmill engages a lantern-pinion that drives a rack with a weight attached to it up and down to sink the pile into the ground. The efficiency of the machine is based on its ability to deliver repeated blows rather than on the weight of the

mallet, which would split the piles. The pile-driver is featured on the terracotta relief in Urbino (Rotondi 1970, p.90).

For other pile-drivers based on Francesco's prototype, see Venice 1994, p.488, cat.102.

XXXIII. A pole, which can be rotated by capstan bars set in a wooden frame, embraces a balanced beam. The beam is raised and lowered by pulling a chain attached to one end. Taccola shows a similar lever in De machinis (fol.27v; Scaglia 1971, p. 98).

OTHER MANUSCRIPTS Turin, BR, MS T, fols 48v–49r (Maltese 1967, I, p.188, line 13–p.189, line 19; p.269, tav.88–9); Florence, BML, MS L, fol.44r (Marani 1979, II, cap.CCL–CCLIII, p.114); New Haven, BL, MS B, fol.44r; Venice, BMV, fols 206v–207v; Rome, BAV, Codicetto, [XXXI] fol.131r and v, [XXXII] fol.125v, [XXXIII] fol.25v; London, BM, Opusculum, [XXXIII] fol.72r.

OTHER REPRESENTATIONS Vicenza, BBV, [XXXIII] fols 7v and 53v, [XXXII] fol.13r; Meccanica, fol.49r (cat.262).

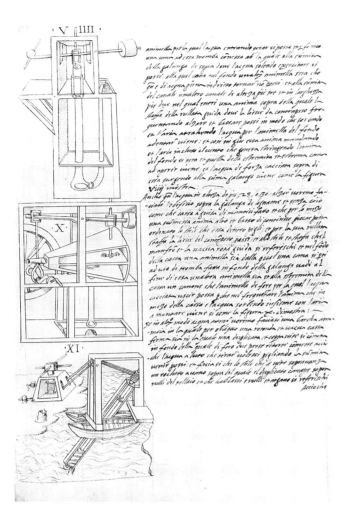

184

185

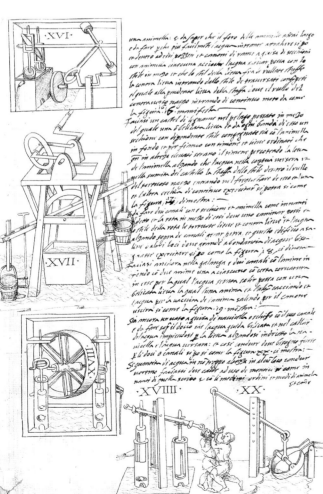

186

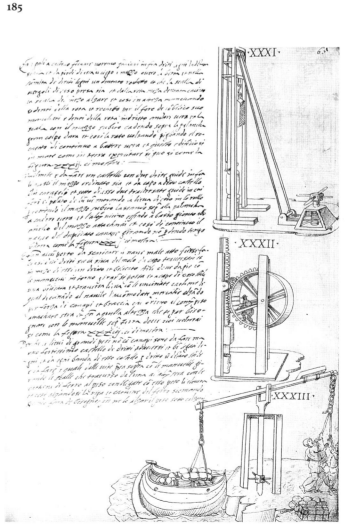

187

188

Machines for hoisting columns into place

SJSM, vol.120, fol.65v bis, 75v

XXXIIII. Two handles each turn a worm-screw that engages the teeth of a vertical rack and moves a horizontal bar attached by a chain to the column up and down. Planks inserted beneath the column support it as it rises.

XXXV. Two handles turn vertical screws, which raise a platform with a column suspended from it by chains. Blocks of wood inserted below the column support it as it rises.

XXXVI. Two screws pass through nuts to be turned by capstan bars; they are suspended from a frame and connected by a horizontal yoke with a column hanging from it. The screws are gently cranked up and the column slowly rises. The device is shown in greater detail in *Meccanica* (fol.10, cat.223). The series of machines to move columns were stimulated by the projects during the pontificates of Nicholas V (1447–55) and Paul II (1464–71) to move the obelisks of Rome, not realized until the time of Sixtus V (1585–90)(see Montano, vol. III, fol.41, cat.1263).

OTHER MANUSCRIPTS Turin, BR, MS T, fol.49r and v (Maltese 1967, I, p.189, line 19–p.190, line 11; p.269, tav.89–90); Florence, BML, MS L, fol.44r and v (Marani 1979, II, cap.CCLIV–CCLV, p.114); New Haven, BL, MS B, fol.44r and v; Venice, BMV, fols 208r–209r; Rome, BAV, *Codicetto*, [XXXIIII–XXXVI] fol.165r. OTHER REPRESENTATIONS Vicenza, BBV, [XXXIIII] fol.7v, [XXXV] fol.13r, [XXXVI] fol.13v.

189

Winches

SJSM, vol.120, fol.66r bis, 76r

II. A handle, outside the casing at the side, turns a horizontal worm-screw and worm-gear and winds the rope vertically around the axle of the gear. The rope arrives at the side of the casing diagonally and enters the casing horizontally, over pulleys.

III. A capstan, on top of the casing, turns a vertical worm-screw and worm-gear and winds the rope horizontally on to the axle of the gear.

IIII. A vertical lantern and crown-gear turns a winch horizontally on the axle of the gear in the second chamber. A rectangular slot cut in the side and top of the casing allows the rope to be winched in diagonally.

V. Brunelleschi's three-speed hoist had a capstan at the bottom of the chamber turning a vertical lantern-pinion and crown-gear. A second horizontal lantern on the axle of the gears engages a vertical spur-gear that winds in the rope, diagonally from the front, on to the horizontal winch on the same axle.

VI. A capstan turns a vertical worm-screw and worm-gear that has a horizontal winch attached to the same axle in a second chamber; the rope is winched in through a slot in the casing.

VII. A capstan on top of the casing turns a lantern and crown-gear with a winch on the same axle in the second chamber and winds in the rope.

OTHER MANUSCRIPTS Turin BR, MS T, fols 49v–50r (Maltese 1967, I, p.190, line 12–p.191, line 20; p.269, tav.90–91); Florence, BML, MS L, fols 44v–45r (Marani 1979, II, cap.CCLVI–CCLXI, p.14; New Haven, BL, MS B, fols 44v–45r; Venice, BMV, fols 209v–211r; Rome, BAV, *Codicetto*, [II], fol.165r, [III] fol.127r, [V, VI, VII] fol.166r; London, BM, *Opusculum*, fols 5r and 18r. OTHER REPRESENTATIONS Vicenza, BBV, [II, III, IIII], fol.13v, [V] fol.21r.

190

Winches, machines for moving heavy weights along the ground

SJSM, vol.120, fol.66v bis, 76v

VIII. A capstan on top of the casing turns a vertical lantern and crown-gear with a horizontal lantern on the same axle, which engages a horizontal crown-gear and winds a winch on the same axle. The rope enters the casing diagonally over pulleys at the side and is winched in horizontally.

X. A vertical treadmill powered by a man turns a horizontal worm-screw and vertical worm-gear with a winch on the same axle and winds the rope in diagonally through a slot in the top and side of the casing.

VIIII. A capstan turns a worm-screw and worm-gear with a screw attached to it, which pushes a trolley with a column on top along the ground.

XI. A capstan turns a vertical worm-screw and worm-gear with a horizontal worm-screw on the same axle, which moves a horizontal rack that is attached to a trolley with an obelisk standing on it.

XII. A capstan turns a vertical worm-screw and double worm-gears with horizontal worm-screws on the same axles, which are supported on two vertical frames. They move a straight rack attached to a trolley with an obelisk on top along the ground.

There is a break in the manuscript at this point; the chapter on metals is omitted from the Soane manuscript and its prototype, MS L. The text resumes in MS T, (Maltese 1967, I, p.197, line 12; fol.51r, tav.93–fol.53r, tav.97). XXXI–XXXIII are copied in the margin of the Soane manuscript from MS L, but the text on fols 45v–47r has not been copied.

OTHER MANUSCRIPTS Turin, BR, MS T, fol.50r and v (Maltese 1967, I, p.191, line 21–p.192, line 26; p.269, tav.91–2); Florence, BML, MS L, fol.45r (Marani 1979, II, cap.CCLXII–CCLXVI, p.114); New Haven, BL, MS B, fol.45r; Venice, BMV, fols 211v–213r; Rome, BAV, *Codicetto*, [VIII] fol.166r, [X] fol.168r, [XI] fol.167v, [XII] fol.167r; London, BM, *Opusculum*, [VIII] fol.17v, [XI] fol.10v. OTHER REPRESENTATIONS Vicenza, BBV, [X, VIIII, XI] fol.21r, [XII] fol.39v.

191

Winch, amphibean transport and vehicles

SJSM, vol.120, fol.67r bis, 77r

F. A capstan bar turns an axle with a lantern-pinion, which engages a toothed wheel with a crown–wheel on its axle; this engages a roller lantern-pinion on the winding drum of the winch. A mistake in the drawing shows one diagonal strand of rope entering the box at the back and a second from the front.

H. A cannon carriage with low wheels at the back and large wheels at the front has a hinged, tilting platform that can be raised and supported on a leg for firing or dropped to move the cannon.

J. Two amphibian cars made by mounting boats on four-wheeled chassis.

XXXI. The vehicle, driven by two pairs of wheels, is driven from a capstan-head with a pinion on its axle, which engages a crown-gear with a worm-screw on its axle and a pinion that drives a pair of wheels. The vehicle is steered by two steering columns, one on each side, with lantern-pinions engaging lateral sector racks attached by T-shaped frames to the axles of the wheels.

XXXII. A four-wheeled vehicle, each wheel propelled independently by a worm-screw and lantern-pinion. The wheels are attached to a T-shaped frame that is linked to the central beam of the chassis. It is steered by two central columns, one for the front and one for the rear wheels, with a lantern-pinion on the axle of the capstan engaging a toothed sector linked to the T-frames of the wheels. The device does not seem to be fully worked out. The vehicle is also drawn in *Meccanica* (fol.3r, cat.216).

XXXIII. Four wheels are attached to a rectangular frame with cross bars reinforcing the chassis. The vehicle is moved by two wheels powered by worm-screws and worm-gears and steered by a lantern engaging a straight horizontal rack on the left, and a lantern and spur-gear moving a spur-gear with a straight recessed, face-gear in the chassis on the right.

G. A capstan in the upper chamber turns a vertical lantern and crown-gear with a lantern on the same axle, which engages a horizontal crown-gear with a winch on its axle. The winch winds in the rope horizontally from the side.

Amphibian carts pulled by oxen or buffalo are illustrated by Taccola in *De machinis* (fols 87v–88r; Scaglia 1971, I, p.152).

OTHER MANUSCRIPTS Turin, BR, MS T, fols 52v–53r (Maltese 1967, I, p.197, line 12–p.197, line 25; pp.197 and 270, tav.96–7); Florence, BML, MS L, fols 46v–47r (Marani 1979, II, p.95, CCLXXXIX–CCXCI, p.114); New Haven, BL, MS B, fols 46v–47r; Venice, BMV, fols 219r–222r; Rome, BAV, *Codicetto*, [J] fols 130v and 133r, [XXXI] fol.119v, [XXXII] fol.117r, [XXXIII] fol.117v; London, BL, *Opusculum*, [XXXI] fol.31r, [XXXIII] fol.26v, [G] fol.153r. OTHER REPRESENTATIONS Vicenza, BBV, [H, J, XXXI and G] fol.47r.

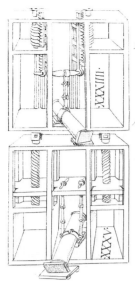

188

189

190

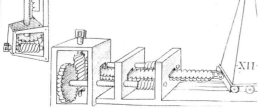

191

Military arts, qualities of a leader
SJSM, vol.120, fol.67v bis, 77v
No illustration

192
*Responsibilities of a leader
and provisions for war*
SJSM, vol.120, fol.68r bis, 78r

The text next to the drawing of the tower recalls an anecdote from Taccola's *De machinis* (Paris, BN, MS lat.7239, fol.77r). When the custodian of a tower needs to leave his post without the enemy realizing it, he should tether a dog to a bell and place food and water at the correct distance away, so that when the animal tries to reach them he rings the bell (Knobloch 1984, p.371; Siena 1991, p.355).

OTHER MANUSCRIPTS Turin, BR, MS T, fol.53v, inscribed *Torre de due guardianj* (Maltese 1967, I, p.199, line 11–p.200, line 12; p.270, tav.98); Florence, BML, MS L, fol.48r (Marani 1979, II, cap.CCX-CIX–CCCIII, p.114); New Haven, BL, MS B, fol.48r; Venice, BMV, fol.224r.
OTHER REPRESENTATIONS Vicenza, BBV, fol.35v.

Responsibilities of a leader
SJSM, vol.120, fol.68v bis, 78v
No illustration

Tricks to fool the enemy
SJSM, vol.120, fol.69r bis, 79r
No illustration

Tricks to fool the enemy
SJSM, vol.120, fol.69v bis, 79v
No illustration

Naval warfare
SJSM, vol.120, fol.70r bis, 80r
No illustration

Explosives
SJSM, vol.120, fol.70v bis, 80v
No illustration

Explosives
SJSM, vol.120, fol.71r bis, 81r
No illustration

193
*Blowing up a tower and interrupting
the water supply of a city*
SJSM, vol.120, fol.71v bis, 81v

[1] In *De machinis* Taccola quoted Vegetius, who recommended bringing down buildings by tunnelling under them and filling the tunnel with combustibles (Scaglia 1971, I, pp.116–18; Siena 1991, p.364).

A tunnel leads to a cave below a tower; barrels of gunpowder are used to blow it up. A rope soaked in sulphur is laid into a barrel and a thick wall of lone, sand and lime is built at the doorway before the rope is lit. In the text on this page Francesco mentions as an example the mining of the Palazzo dei Signori in Ragusa, in 1459. He first used this method when he laid a mine for the Aragonese to regain possession of Castelnuovo, occupied by the French (Weller 1943, pp.35–6, doc.CXXIV; Siena 1991, p.365). By the early 16th century mining was carried out defensively as well as offensively. For early mines, see Bury 1982; for mining and countermining techniques, see Pepper 1982.

[2] Francesco writes: 'To stop the supply of water from an underground spring to a city's fountains and mills, make a tunnel to the well delivering water to the city and block the sluice gates that control the flow of water in and out of the well with rubble and lime, so that the water remains in its bed and does not enter the well.'

OTHER MANUSCRIPTS Turin, BR, MS T, fols 55v–56r (Maltese 1967, I, p.208, line 7–p.209, line 15; p.271, tav.102–3); Florence, BML, MS L, fol.50r, inscribed [1] *Charatellj di polvare–intrata/della chava*; [2] *poz[z]o hovero/smiraglio-po[r]tella–portella–Chamino sotterraneo dove lacqua nella/ter[r]a va* (Marani 1979, II, cap.CCCXXVI–CCCXXX, p.114); New Haven, BL, MS B, fol.50r; Venice, BMV, fols 231v and 232v; Rome, BAV, *Codicetto*, [1] fol.86v; London, BM, *Opusculum*, fol.35r; Reggio, BMRE, Venturi copy of MS E, fol.23r (Mussini 1991, p.39, n.25).
OTHER REPRESENTATIONS Vicenza, BBV, fol.26v.

194
*Diverting a river from the centre
of a city*
SJSM, vol.120, fol.72r bis, 82r

If there is a slope to a valley or plain, a river passing through the centre of a town can be diverted by making a ditch or tunnel underground and building a dam in the river, with piles and planks driven obliquely and quickly into the river bed and filled with earth, so that the water flows into the ditch.

OTHER MANUSCRIPTS Turin, BR, MS T, fol.55v (Maltese 1967, I, p.209, line 15–p.210, line 16; p.271, tav.102); Florence, BML, MS L, fol.50r, inscribed *fiume–chiusa–formola dove el fiume volle* (Marani 1979, II, cap.CCCXXX–CCCXXXIII, pp.101 and 114); New Haven, BL, MS B, fol.50r; Venice, BMV, fol.232r.
OTHER REPRESENTATIONS Vicenza, BBV, fol.35r.

[handwritten manuscript text]

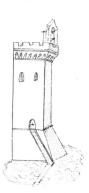

192

[handwritten manuscript text in two columns]

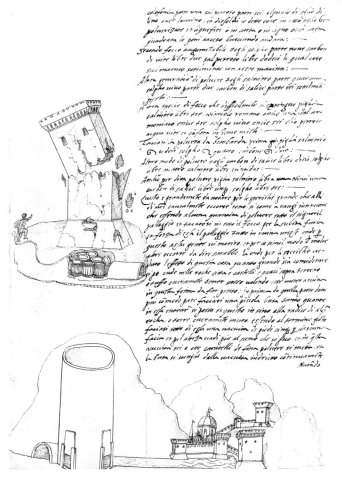

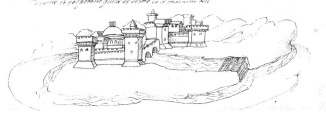

193

194

195
Trenches and gabions
SJSM, vol.120, fol.72v bis, 82v

[1] The drawing shows winding, curving and zigzag trenches in front of a citadel on top of a hill. The zigzag trenches prevented cannon fired from the citadel from travelling far along the trench. Developed for cannon, this was an unusual feature of military planning in the 15th century, but it became a little more common in the 16th century and was widely used in the 17th century.
[2] The winding trench has gabions placed along it.
[3] The details of the gabions show their wattle construction and rectangular, triangular and circular plans, which can be filled with earth. They were used alone without trenches to stop cannon balls.

OTHER MANUSCRIPTS Turin, BR, MS T, fol.56r and v (Maltese 1967, I, p.210, line 16–p.211, line 19; p.271, tav.103–4); Florence, BML, MS L, fol.50v (Marani 1979, cap.CCCXXXIV– CCCXXXV, p.114); New Haven, BL, MS B, fol.50v; Venice, BMV, fols 233v–234r; Rome, BAV, Codicetto, [1] fol.86v; Reggio, BMRE, Venturi copy of MS E, fol.17v (Mussini 1991, p.151, fig.29).
OTHER REPRESENTATIONS Oreste Vannocci Biringucci, Siena, BC, fol.88r.

Shelters
SJSM, vol.120, fol.73v, 83v
No illustration

197
Cannon shelters
SJSM, vol.120, fol.74r, 84r

[1] A cannon shelter made from four concrete blocks filled with earth and bolted together and a wooden v-shaped shelter that can be pivoted up to protect the gunner while he loads or down when he is ready to fire. The device is shown on a relief in the Palazzo Ducale, Urbino (Rotondi 1970, no.69).
[2] A concrete block filled with earth can be winched aside from the central opening between two wattle gabions.

196
Shelters
SJSM, vol.120, fol.73r bis, 83r

[1] A shelter made by bolting together two rectangular weighted blocks and an arrow-headed block to form a bastion-shape, which can stop cannon and absorb the shock.
[2] A boarded mobile shelter or penthouse on a four-wheeled chassis, with a triangular section that is open on one side to allow sappers to undermine a fortress.
[3] The frame of a triangular shelter made from wood, which can be covered with boards and filled with earth and used to stop cannon.
[4] A cannon on a gun-carriage and two wattle gabions on either side of a boarded shelter balanced on a frame like a see-saw to protect the gunner while he loads the cannon. The shelter is pulled up by a rope for firing.

Mobile penthouses, which enabled soldiers and their equipment to approach walls of fortifications in safety, were widely used in the medieval period. They are drawn in the Greek manuscripts (see Meccanica, fol.27r, cat.240) and by Taccola in De ingeneis; Valturio shows them in his manuscript (Bassignana no date, tav.XXXV) as well as in De re militari (1532, p.244).

OTHER MANUSCRIPTS Turin, BR, MS T, fols 56v–57r (Maltese 1967, I, p.211, line 19–p.212, line 21; p.271, tav.104–5); Florence, BML, MS L, fol.51r (Marani 1979, II, p.103, cap.CCCXXXVI-CCCXXXVII); New Haven, BL, MS B, fol.51r; Venice, BMV, fols 234v–236r; Reggio, BMRE, Venturi copy of MS E, fol.17r and v (Mussini 1991, pp.151 and 153, figs 29 and 32).
OTHER REPRESENTATIONS Vicenza, BBV, [1, 2] fol.53v; [3] fol.35r; Pietro Cataneo, [2, 3] Uffizi 3309A.

OTHER MANUSCRIPTS Turin, BR, MS T, fol.57r and v (Maltese 1967, I, p.213, line 28–p.214, line 31; p.271, tav.105–6); Florence, BML, MS L, fol.51v, [2] inscribed fosso (Marani 1979, II, p.104, cap.CCCXXXVIII, p.114); New Haven, BL, MS B, fol.51v; Venice, BMV, fol.238r and v; Rome, BAV, Codicetto, [1] fol.160r; Reggio, BMRE, Venturi copy of MS E, fol.18r (Mussini 1991, p.153, fig.31).
OTHER REPRESENTATIONS Vicenza, BBV, [1, 2] fol.31r.

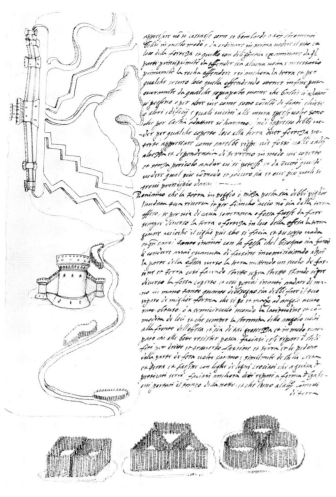

195

196

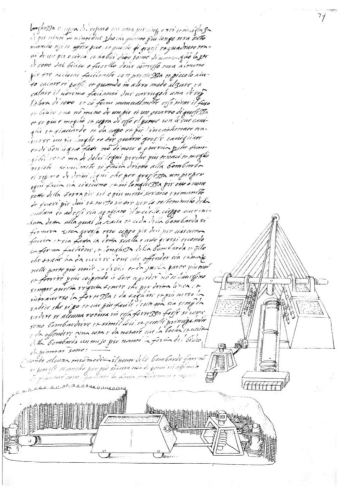

197

198
Shelter
SJSM, vol.120, fol.74v, 84v

A cannon shelter made from four weighted blocks bolted together with a v-shaped wooden shelter in front. The shelter can be folded and collapsed by means of chains, operated by ropes.

OTHER MANUSCRIPTS Turin, BR, MS T, fol.57v (Maltese 1967, I, p.214, line 31–p.215, line 31; p.271, tav.106); Florence, BML, MS L, fol.51v (Marani 1979, II, p.104, cap.CCCXXXIX–CCCXL, p.114); New Haven, BL, MS B, fol.51v; Venice, BMV, fol.237v; Rome, BAV, *Codicetto*, fol.160r.
OTHER REPRESENTATIONS Vicenza, BBV, fol.49v; Pietro Cataneo, Uffizi 3309A.

199
Shelters
SJSM, vol.120, fol.75r, 85r

[1] A cannon aims its fire at a tower; the gunner is protected from returned fire by a line of concrete shelters filled with earth with a central opening. A concrete block on wheels can be winched backwards and forwards behind the opening when the gunner is ready to fire.
[2] Wooden shelters on wheels with winches.

OTHER MANUSCRIPTS Turin, BR, MS T, fol.57v (Maltese 1967, I, p.215, line 31–p.216, line 34; p.271, tav.106); Florence, BML, MS L, fol.52r, inscribed [1] *strada dentro alla citta–Riparo di chasse piene di gravedine*; [2] *Ghatto a huxo di po[n]te–sub ter[r]a* (Marani 1979, II, p.105, cap.CCCXLII–CCCXLIII, p.114); New Haven, BL, MS B, fol.52r; Venice, BMV, fols 239r–240r.
OTHER REPRESENTATIONS Vicenza, BBV, [1, 2] fol.49v.

200
Aiming a cannon, cannon mounted on boats
SJSM, vol.120, fol.75v, 85v

[1] A cannon mounted on a flat timber bed has a straight piece of wood lying along its whole length to establish the angle of fire. Francesco writes: 'Check with the compasses that the two bores of the cannon are aligned at the same angle and mark the thickness of the metal of the bores on the sight at the top of the cannon and fix the sights, checking with a plumb line that they are level.' The details below the cannon illustrate the sight at the top of the barrel, with the holes showing the thickness of the metal of the bores and the sight-holes. The sight that the gunner looks through has a pierced panel that moves up and down to fix the sight-holes at the top of the barrel of the cannon and to aim it (see also fol.77r, 87r; cat.203).
[2] A gun-carriage on a boat, with a collapsible shelter fitted to it, is moved into the firing position by throwing overboard a barrel, attached to the carriage by ropes.
[3] A cannon on a gun-carriage on a boat. The shelter is raised when the carriage is moved back for loading, and lowered again when it is rolled forward for firing.

OTHER MANUSCRIPTS Turin, BR, MS T, fol.58r (Maltese 1967, I, p.217, lines 1–30; p.271, tav.107); Florence, BML, MS L, fol.52v, inscribed [1] *Mire da trar[r]e bo[n]ba[r]de–Archipe[n]dolo ho mira da trar[r]e di gio[r]no e di notte*; [2] *Mantelletto* (Marani 1979, pp.105–6, II, cap.CCCXLIV–CCCXLV, p.114); Rome, BAV, *Codicetto*, [1] fol.86r and v; New Haven, BL, MS B, fol.52v; Venice, BMV, fols 241r and 242r.
OTHER REPRESENTATIONS Vicenza, BBV, [1, 2] fol.31v, [3] fol.51v, [4] fol.27v; Pietro Cataneo, [4] Uffizi 3309A; Oreste Vannocci Biringucci, Siena, BC, fol.68r.

201
Cannon mounted on boats
SJSM, vol.120, fol.76r, 86r

[1, 2] Cannon are mounted on wooden *chèvres* of triangular section and suspended from ropes ready for transport; a pulley system is shown for lowering the cannon.
[3] A cannon on a boat is set in a flat rectangular frame that encloses the boat and has hollow boxes at either end, which give buoyancy to the heavily laden boat.
The wooden *chèvres* are shown in Valturio's manuscript (fol.90v; Bassignana, no date, tav.XXXIV).

OTHER MANUSCRIPTS Turin, BR, MS T, fol.58v (Maltese 1967, I, p.218, line 1–p.219, line 2; p.271, tav.108); Florence, BML, MS L, fols 52v–53r, inscribed [3] *chasse allenten[n]e/chon[n]esse* (Marani 1979, II, pp.106–7, cap.CCCXLVI–CCCIL, p.114); New Haven, BL, MS B, fol.53r; Venice, BMV, fols 242v–243v.
OTHER REPRESENTATIONS Vicenza, BBV, [1] fol.31v, [2] fol.51r, [3] fol.29r; Pietro Cataneo, [1] Uffizi 3309A.

198

199

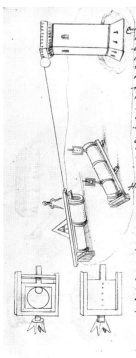

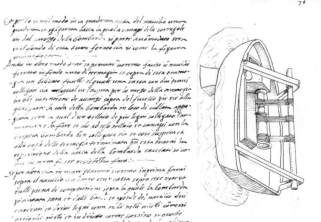

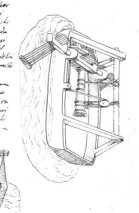

200

201

202

Cannon mounted on boats

SJSM, vol.120, fol.76v, 86v

[1] A cannon hanging by ropes from a *chèvre* with inverted v-shaped supports.
[2] A cannon on a gun-carriage that is moved forward by an axle with two paddles in the water. Boards suspended from both ends of the boat ensure that it remains still; after the cannon has been fired, the boards can be pulled up by ropes to enable the boat to move forward. Taccola shows cannon on a boat in *De ingeneis* (fol.51r; Prager, Scaglia & Montag 1984, p.101).

OTHER MANUSCRIPTS Turin, BR, MS T, fols 58v–59r (Maltese 1967, I, p.219, line 2–p.220, line 7; p.272, tav.108–9); Florence, BML, MS L, fol.53r, inscribed [1] *Sospesa la bo[m]barda sop[r]a*
dup[r]ichatj canapi; [2] *Retrecine q[ua]adrate pale* (Marani 1979, II, p.108, cap.CCCIL–CCCLI, p.114); New Haven, BL, MS B, fol.53r; Venice, BMV, fol.244r and v; Rome, BAV, *Codicetto*, [1] fols 18v, 19v and 24r, [2] fol.61r.
OTHER REPRESENTATIONS Vicenza, BBV, fol.51r.

203

Section of a cannon showing the bores

SJSM, vol.120, fol.77r, 87r

The section of a cannon, cast in two parts so that it can be moved more easily, shows the reduced bore of the powder chamber. A scale of six modules reduces to four for the barrel, which narrows to two modules at the entrance of the powder chamber; this narrows by a quarter of a module on either side at the back of the powder chamber. The thickness of the walls of the bores are marked on the sight at the top of the cannon when the gunner calculates the firing line (see fol.75v, 85v, cat.200).

Muzzle-loaded cannon of bronze were made from the middle of the 15th century using bell-foundry technology. The breech walls were thicker than the barrel walls by a combination of exterior mouldings and the narrow bore; they were made in several sections and assembled on flat wooden beds for firing (Pepper & Adams 1986, pp.8–9, fig.5). Francesco wrote a chapter on bell founding in the appendix to MS T (Maltese 1967, I, pp.244ff., tav.126).

For cannon casting, see Hall 1952, pp.9–14; for cannon and their calibration, see Promis 1841, pp.130–60; Hall 1952.

OTHER MANUSCRIPTS Turin, BR, MS T, fol.59r (Maltese 1967, I, p.220, line 7, p.221, line 5; p.272, tav.109); Florence, BML, MS L, fol.53v, inscribed *Mixura di bonba[r]de* (Marani 1979, II, p.108, cap.CCCLII, p.114); New Haven, BL, MS B, fol.53v; Venice, BMV, fol.246r; Rome, BAV, *Codicetto*, fols 18v, 19v and 24r.
OTHER REPRESENTATIONS Vicenza, Bᴿᵛ, fol.75r.

204

Cannon on fortress carriages and on a gun-carriage, a tripod and a ship equipped with rakes

SJSM, vol.120, fol.77v, 87v

[1] A frame in the shape of a segment of a circle has two wheels at the apex and a curving, vertical post through the chassis, which supports the tiller below the cannon. The cannon can be lowered by raising the opposite end of the beam between curved upright posts with pin holes, and moved horizontally by means of the pin holes in the segmental frame.
[2] A horizontal carriage is supported at one end by inverted v-shaped legs. A post on the chassis supports a wooden tiller below the cannon; at the other end the tiller is held between two uprights with holes for pins. Only horizontal firing lines are possible with this carriage. Francesco di Giorgio's terracotta relief in Urbino shows this machine (Rotondi 1970, p.97).
[3] A triangular, segmental chassis is mounted at the apex on two wheels; the cannon carriage is supported on a rectangular block at the back and a post at the front. Uprights on either side of the carriage allow it to be raised and lowered, and the cannon is supported on a tiller, which can be tilted and lowered into a box-shaped flat bed to prevent movement during transportation.
[4] The illustration, marked III, shows a ship equipped with rakes for dredging.

One of the two earliest representations of cannon appears in *De secretis secretorum* (London, BL, MS 47680, fols 44v–45r), a treatise on the education of princes made for Edward III in 1326-7;
the other is in the companion to the manuscript, *De nobilitatibus* (Oxford, Christ Church, MS 92). The cannon fired feather darts or quarrels; improvements in size and efficiency led to the use of heavier and more damaging projectiles of lead or stone. The earliest cannon were either fired directly from the ground, supported on tillers, or lashed down to a fixed wooden stand; they were awkward to move. As the cannon's efficiency as a weapon increased, engineers focused on improving their mobility. Elevating gun carriages pulled by oxen started to make their appearance in 1400. Valturio shows gun carriages of a similar kind in his manuscript (fols 88v, 91v, 92r and v; Bassignana, no date, tav.XXXVI–XXXVIII). Taccola shows gun carriages with aiming mechanisms in *De machinis* (fol.19r and v) and in *De ingeneis* (fol.50r; Scaglia 1971, I, pp.87–8; Prager, Scaglia & Montag 1984, I, p.75).

OTHER MANUSCRIPTS Turin, BR, MS T, fols 59r–60r (Maltese 1967, p.221, line 5–p.222, line 12; p.272, tav.109–11); Florence, BML, MS L, fol.53v, inscribed *Chavalettj da spi[n]ga[r]de/ecce[r]bottane* (Marani 1979, II, p.108, cap.CCCLIII–CCCLV, p.115); New Haven, BL, MS B, fols 53v–54r; Venice, BMV, fols 247r and 248v; Reggio, BMRE, Venturi copy of MS E, fol.19v (Mussini 1991, p.154, fig.33); Rome, BAV, *Codicetto*, [1, 2] fol.62r, [3] fol.60v, [4] fol.19r; London, BM, *Opusculum*, [1, 2] fol.15v, [3] fol.16v.
OTHER REPRESENTATIONS Vicenza, BBV, [1] fol.75v, [2–4] fol.65r.

205

Armed ship, siege tower, trebuchets, battering-rams

SJSM, vol.120, fol.78r, 88r

I. A ship armed with a crow's beak that can be winched up and down to make holes in enemy ships.
II. A wooden machicolated tower is pushed along by oxen inside a square four-wheeled chassis below. It has an extendable bridge for crossing moats. There are small triangular arrow-loops in the front wall of the tower and in the gate at the end of the bridge, which can be lowered on to the target.
IIII. Two trebuchets balanced on the cross-bar of a vertical frame have a single and double counterweight at one end and a burning projectile in a sling at the other. They are launched by releasing the heavy counterweights to produce a swivel action on the arm carrying the projectile, which releases it at the apex.
V. Battering-rams.
VI. A battering-ram suspended from a cage with four wheels.
VII. A cage for archers, which is suspended from a beam and balanced on a frame so that it can be lowered to the ground to enable the soldiers to climb in and then raised by a pulley. Valturio also draws this engine (fol.82v; Bassignana no date, tav.X).

The folio shows both ancient and medieval weapons. The ship with the crow's beak, the siege towers and battering-rams are Roman devices. Taccola drew them mounted on carriages in *De machinis* (fols 69r and 70v; Scaglia 1971, pp.138 and 140). Trebuchets are medieval weapons.
They are illustrated by Vegetius and there are many drawings of them in Taccola's *De ingeneis* (fols 40v and 39v; Prager, Scaglia & Montag 1984, pp.70 and 68; Siena 1991, pp.341 and 344). Earlier and less powerful catapults inherited from the Romans are drawn in *Meccanica* (fol.15r, cat.).

For trebuchets, see King 1982, pp.457–69.

OTHER MANUSCRIPTS Turin, BR, MS T, fols 59v–60r (Maltese 1967, I, p.222, line 12–p.223, line 17; tav.110–11); Reggio, MS, fol.1r, inscribed *chorbo–chastello di le[n]gn/iame cho[n] ponte e/mantelletto aguixa di bastia–Trabocco–Bricchola–Anchudinato–testudo–Aries–Sa[n]bucha* (Mussini 1991, p.49, fig.1, pp.237–8 and 247; Siena 1991, p.82, fig.2); New Haven, BL, MS B, fol.54r; Venice, BMV, fols 248r–250r; Reggio, BMRE, Venturi copy of MS E, fol.20r (Mussini 1991, p.154, fig.34); Rome, BAV, *Codicetto*, [I] fol.19v, [IIII] fols 76r and 77r; London, BM, *Opusculum*, [I] fol.50r, [IIII] fol.32v.
OTHER REPRESENTATIONS Vicenza, BBV, [I] fol.29r, [II, IIII, V and VII] fol.49r, [IIII] fol.51v.

202

203

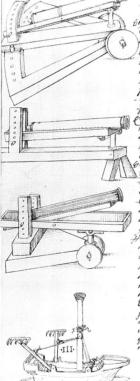

204

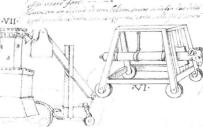

205

206

A machine for launching projectiles, armed ships, a naval siege tower, battering-rams and a pontoon bridge

SJSM, vol.120, fol.78v, 88v

VIII. A machine to launch projectiles is operated by winching back a plank attached to a beam; when it is released it hits an iron bar, which discharges the missile.

VIIII. A ship with a wooden tower on it. Ships such as this are shown by Valturio (fols 75r and 103v) and by Taccola in *De ingeneis* (fol.92v; Bassignana no date, tav.v and LIII; Prager, Scaglia & Montag 1984, p.184). The Greeks armed ships in the same way (see *Meccanica*, fol.21r, cat.234).

X. A ship with a battering-ram on an L-shaped arm dropped down through the prow and operated by rope.

XI. Augurs suspended on either side of a boat are operated by capstan-bars inserted in a capstan-head. They turn a worm-screw engaging long pinion-heads, which drive the augurs. Warships with battering-rams and drills were built for modern warfare in the medieval period; Taccola drew them in *De machinis* (fol.56r) and *De ingeneis* (fol.11r; Scaglia 1971, p.126; Prager, Scaglia & Montag 1984, p.21; Siena 1991, p.358).

XII. Boats with a shelter in the form of a roof, which has bales of wool suspended from a framework of triangular section. Weapons can be fired through spaces made between the bales.

XIII. A bridge of boats, with the bridges raised and lowered to the prows by means of ropes attached to beams balanced on vertical frames.

OTHER MANUSCRIPTS Turin, BR, MS T, fol.60r and v (Maltese 1967, I, p.223, line 18–p.224, line 26; tav.111–12); Reggio, BMRE, MS.R, fol.1r, inscribed *Balista–Chastello de le/ngniame sop[r]a/navilj*; fol.1v, inscribed *da frangiare le nimiche navi/sotto all'acqua–da forare le navj sotto/lacqua–Riparo di balle di lana–po[n]te sop[r]a ba[r]che* (Mussini 1991, pp.49–50, figs 2–3, pp.238–9; Siena 1991, pp.82–3, figs 2–3); New Haven, BL, MS B, fol.54r; Venice, BMV, fols 250r–251v; Reggio, BMRE, Venturi copy of MS E, fol.20r, (Mussini 1991, p.154, fig.34); Rome, BAV, *Codicetto*, [VIIII] fol.25r, [X] fol.125r, [XIII], fol.19v; London, BM, *Opusculum*, fol.45r.

OTHER REPRESENTATIONS Antonio da Sangallo, [X] Uffizi 1114A; Vicenza, BBV, [VIII, VIIII] fol.51v, [X, XI] fol.65r, [XII, XIII] fol.75v.

207

Bridges and underwater devices for sinking ships

SJSM, vol.120, fol.79r, 89r

XIIII. A bridge on three barrels that float in the water. The drawings in *Opusculum* and *Meccanica*, and relief no.46 in Urbino, are identical. Valturio drew the same bridge on fol.109v (Basignana no date, tav.LVII). In *De machinis* Taccola suggests floating bundles of cane as a bridge (fol.77v; Scaglia 1971, p.146).

XV. A bridge on inflated wine skins; a detail showing the bellows that inflate the wine skins is also shown on the folio in MS R. The idea of making a bridge from inflated wine skins existed in Antiquity, and it is illustrated in the anonymous *De re bellicis* (Florence, BNCF, MS lat.9662, fol.61v; Siena 1991, p.17). Valturio shows a bridge made with inflated animal corpses following descriptions in ancient texts (fol.112r; Bassignana no date, tav.LXII). A horse and rider float down river on an inflated goat skin in Taccola's *De machinis* (fol.78r; Scaglia 1971, p.147).

XVI. A sunken barrier at the entrance of a port has pointed, weighted posts suspended from a crossbar; the pressure on the weights caused by the ship entering the port makes the posts rise up at an angle, leaving the ship captive. Taccola shows the same spiking device in *De ingeneis* (fol.3v; Prager, Scaglia & Montag 1984, p.6). Francesco recommends them as extra security for a city on a river (fol.9r[2], cat.81).

OTHER MANUSCRIPTS Turin, BR, MS T, fol.61r (Maltese 1967, I, p.224, line 26–p.226, line 2; tav.113); Reggio, BMRE, MS.R, fols 1v–2r, fol.2r inscribed *ponte sop[r]a botte a. ponte sop[r]a hotrj e ret[t]–Accio che lenimiche navj possa[n] passare lo hedefitio i[n]clina[n]dosi/da lacqua naschoso le navilj passa[n]do subito dal peso le ponte levate e navilj passatj prigio[n] faranno–Chasse piene di gr/avedine* (Mussini 1991, p.51, fig.4, pp.239–40 and 247; Siena 1991, p.83, figs 3–4); New Haven, BL, MS B, fols 54v–55r; Venice, BMV, fols 252r and v, 253v–254r; Rome, BAV, *Codicetto*, [XIIII] fols 6v and 33v, [VIIII] fols 126v, 157v–158v.

OTHER REPRESENTATIONS Vicenza, BBV, [VIII, X] fol.55v, [VIIII] fol.66v, [X] fol.55v, [XI] fol.45r.

208

Devices for blocking rivers, a tension-bow

SJSM, vol.120, fol.79v, 89v

XVII. A river is blocked by bolting wooden chests together and suspending them from chains over a river.

XVIII. Spikes suspended from chains between the banks of a river are attached to triangular weights filled with gravel on the river bed.

XIX. An arrow is fired from a tension-bow in a triangular frame. The trigger is released by a capstan-bar turning a screw, which flexes the arms of the bow marked F and releases the slider, marked P, with the arrow on it. The arrow launcher is represented on a relief at Urbino.

OTHER MANUSCRIPTS Turin, BR, MS T, fol.61v (Maltese 1967, I, p.226, line 3–p.227, line 7; tav.114); Reggio, BMRE, MS R, fol.2r, inscribed *Serame del porto–Serame del porto*; fol.2v, inscribed *difitio pote[n]tissimo da tra[r]re dardj e pietre* (Mussini 1991, pp.51–2, figs 4–5, pp.241–2 and 247; Siena 1991, pp.83–4, figs 4–5); Venice BMV, fols 253v, 254r and 255r; Rome, BAV, *Codicetto*, [XVII] fol.101v; London, BM, *Opusculum*, [XVII, XVIII], fol.52r with variations.

OTHER REPRESENTATIONS Vicenza, BBV, [XVII] fol.37r, [XVIII] fol.45r, [XIX] fol.65v.

209

Trebuchets, a ladder bridge

SJSM, vol.120, fol.80r, 90r

The trebuchet, a weapon for hurling missiles at an enemy stronghold, was fired by releasing a heavy counterweight to produce a swivel action in the arm carrying the projectile.

It was the only siege machine developed in the Middle Ages, from ancient catapults. A book of hours executed in Maastricht *c*.1300 (London, BL, Stowe MS 17, fols 243v–244r) shows a carefully drawn trebuchet, ready for action and about to be fired by an ass. Another manuscript (BL, MS Royal 16 G, VI, fols 387v–388r) of the late 14th century shows the enormous size of them.

XX. Two arrows attached to a forked arm are pulled up and hurled by the counterweight in the chest at the opposite end of the arm. Francesco writes: 'To fire, first lower the chest to fill it with gravel, raise the weight and arm the trebuchet before firing it by dropping the weight.'

XXI. A trebuchet with a cup to hold a burning missile at one end and a square chest that can be filled with gravel as a counterweight at the other end is launched by a winch operated by capstan bars. Trebuchets with cups were much less efficient than trebuchets with loose slings, which guaranteed maximum efficiency.

XXII. A trebuchet with a sling.

[A] Two sliding, interconnecting ladders are balanced on a vertical beam on a trolley with four wheels. The ladder is weighted. Ladder bridges were developed by medieval military engineers; they are drawn by Taccola.

OTHER MANUSCRIPTS Turin, BR, MS T, fols 61v–62r (Maltese 1967, I, p.227, line 7–p.228, lines 9–10; tav.114–15); Reggio, BMRE, MS R, fol.2v, inscribed *da trar[r]e dardi–da trar[r]e focho a/huxo di traboccho–trabocco*; fol.3r, inscribed *schala duprichata– Chassa pi/ena di gra/vedine* (Mussini 1991, pp.52–3, figs 5–6, pp.241–2 and 247–8; Siena 1991, p.84, figs 5–6); New Haven, BL, MS B, fols 55v–56r; Venice, BMV, fols 255v, 256v–257r; Rome, BAV, *Codicetto*, [XXI] fol.160v, [XXII] fol.159v, [A] fol.161r; London, BM, *Opusculum*, [XXII] fol.79r, [A] fol.81r.

OTHER REPRESENTATIONS Vicenza, BBV, [XX, A] fol.23v, [XXI, XXII] fol.45v.

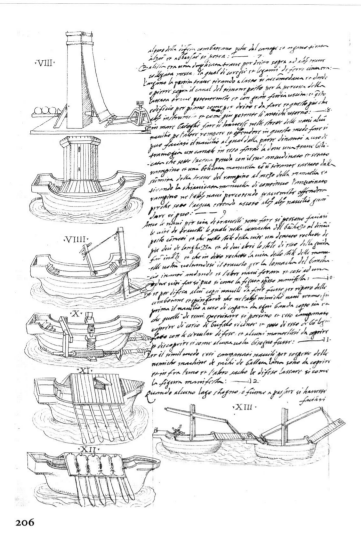

206

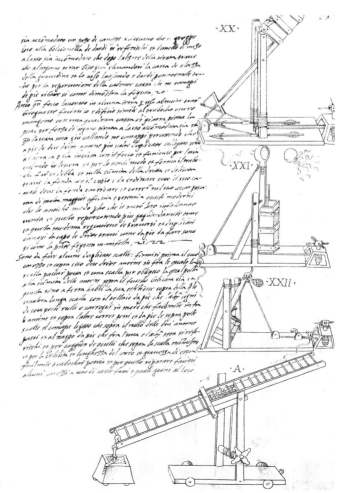

207

208

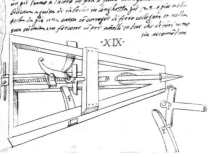

209

210

Articulated siege ladders

SJSM, vol.120, fol.80v, 90v

B. A ladder on a platform with four wheels rests on the cross-bar of a vertical support at the front of the cart. The ladder can be rolled up a diagonal frame below it between the back of the cart and the vertical upright frame at the front.

C. A ladder balanced on the tall upright frame of an armoured cart can be winched up by rope. A rope-ladder on pulleys connects the bottom of the ladder with the ground.

D. A ladder attached to a forked platform, which is balanced on a vertical frame and controlled by ropes and pulleys. The platform is supported from below by a diagonal beam that can be raised on the upright frame by holes and pegs as the platform is winched out by ropes and pulleys over the moat. The movement of the beam can be arrested by pins.

E. A rope-ladder on a cart is operated by a beam balanced on a vertical frame.

The beam is winched by a capstan and pulls up the rope-ladder attached to the forked end of the beam.

Taccola shows ladder combinations on carriages in De machinis (fols 25v–26r; Scaglia 1971, cat.96–7).

OTHER MANUSCRIPTS Turin, BR, MS T, fol.62r and v (Maltese 1967, I, p.228, line 10–p.229, line 12; tav.115–16); Reggio, BMRE, MS R, fol.3r, inscribed schala dupricata–schala da mo[n]/tare sop[ra] le/mura–schala da lassa[r]la/ andare sop[r]a le m/ura–schala difuni (Mussini 1991, p.53, fig.6, pp.242–3; Siena 1991, p.84, fig.6); New Haven, BL, MS B, fol.56r; Venice, BMV, fols 257v–259r; Rome, BAV, Codicetto, [B, E] fol.161r, [E] fol.161v; London, BM, Opusculum, [C] fol.79r, [D] fol.81r, [E] fol.81r.

OTHER REPRESENTATIONS Vicenza, BBV, [B, D] fol.55r, [C, E] fol.75r.

211

Articulated mobile siege ladders

SJSM, vol.120, fol.81r, 91r

The siege ladders were developed to span the ditches surrounding fortifications.

F. A rope-ladder on a trolley can be raised and lowered by winching a fork-ended balanced beam on two vertical supports.

G. A ladder is balanced between tall vertical supports on a trolley with an arrow-shaped platform for soldiers, mantelleto, above it. The ladder is weighted at the bottom and is winched in and out by ropes attached to it.

I. A carriage with an acute angle at the front has two straight beams of the ladder acting as a support for an L-shaped balanced lever at the top with a pointed mantelleto suspended from a pair of beams. The soldiers climb the ladder under cover of the boarded angle and jump on to the platform.

H. A carriage with tall vertical supports and a balanced L-shaped beam embracing a second beam with a pointed

mantelleto with firing embrasures. A rope-ladder operated by crank-handles is pulled out as the balanced beam supporting the platform is raised and lowered by a winch. The soldiers on the rope-ladder get on to the platform through the hole in it.

Taccola illustrated winch-operated ladders mounted on carriages in De machinis (fol.22v; Scaglia 1971, p.95).

OTHER MANUSCRIPTS Turin, BR, MS T, fols 62v–63r (Maltese 1967, I, p.229, line 12–p.230, line 14; tav.116–17); Reggio, BMRE, MS R, fol.3v, inscribed schala di funi–schala e bastia–bastia e scha/[la]– bastia a[n]da sop[r]a/le mura (Mussini 1991, pp.54–5, fig.7, p.243–4; Siena 1991, p.84, fig.7); New Haven, BL, MS B, fol.56v; Venice, BMV, fols 259v–261r; Rome, BAV, Codicetto, [F, G], fol.159r, [I, H], fol.161v; London, BM, Opusculum, [F], fol.67r, [I], fol.80r, [H], fols 79v and 34v.

OTHER REPRESENTATIONS Vicenza, BBV, [G] fol.85, [I], fol.95v.

212

Mobile siege lifts and a ladder bridge

SJSM, vol.120, fol.81v, 91v

K. Soldiers on a pointed platform, suspended from paired beams balanced on hinged supports in a vertical frame, can be raised and lowered by a screw turned by a capstan bar at the bottom, which moves a shelf on the screw; it can be stopped by inserting pins into the holes. The device, set on a trolley with four wheels, can be tilted by ropes attached to a winch and pulley at the back of the trolley.

L. An armoured ladder on four wheels has a perpendicular ladder defended by a pointed shelter at the front. The soldier climbs the ladder to get on to the platform, which can be raised by turning a capstan with a worm-screw on its axle; this engages a toothed wheel that connects with the ladder and raises it to a very limited height.

M. A lift is operated by capstan bars turning a worm-screw, which engages a toothed wheel and worm-screws on its axle. They drive two pinions with long screws on their axles to raise and lower the platform. A similar lift was drawn in 1400 by Conrad Keysser (1967,

fol.33). Valturio also shows this machine in his manuscript (fol.78r; Bassignana no date., tav.x), and Taccola illustrated similar devices in De machinis (fols 25v-26r; Scaglia 1971, pp.96–7).

N. A double ladder supported on an L-shaped frame on a trolley. A winch at the bottom of the ladder attached by rope to the ladder at the top turns it through 180 degrees over the vertical bar at the top to rest on the walls of the target. Reliefs nos 48 and 58 in Urbino show K, L, and N.

OTHER MANUSCRIPTS Turin, BR, MS T, fol.63r and v (Maltese 1967, I, p.230, line 14–p.231, line 14; tav.117–18); Reggio, BMRE, MS R, fol.4r, inscribed bastia da hele/varsj–[b]astia da he/[le]va[r]si in assai/[al]tez[z]a–bastia da heleva[r]sj/cho[n] grave peso–Schala dup[r]ichata (Mussini 1991, p.55, fig.8, pp.244–6; Siena 1991, p.84, fig.8); New Haven, BL, MS B, fol.57r; Venice, BMV, fols 261v–263r; Rome, BAV, Codicetto, [K] fol.161r; London, BM, Opusculum, [L] fol.78v, [M] fol.81v, [N] fol.10v.

OTHER REPRESENTATIONS Vicenza, BBV, [K] fol.95v, [L, M] fol.95r, [N] fol.85v.

213

Mobile corridor bridge and mobile shelters

SJSM, vol.120, fol.82r, 92r

O. A five-wheeled cart, armoured at the front, has two pairs of uprights, the taller one at the front. They support a plank bridge fixed by horizontal bars. The front of the bridge is made of collapsible panels joined together by chains, which can be opened by a rope attached to a winch on a worm-screw at the back. In operation the bridge is weighted at the back.

Q. The illustrations show a shelter made from bales of wool attached to a wooden frame on a chassis with two wheels; a shelter made from two solid pieces of wood, with arrow-loops, set at an acute angle on a chassis; and a shelter made from a flat piece of wood with arrow-loops on a chassis.

P. An armoured cart in the shape of a half cone. A handle turns two worm-screws on the axle, which engage pinions on the axles of the wheels.

During an assault, cross-bowmen, given cover by archers and slingers, were protected by wooden mantlets, large shields set on wheels. Mantlets

were also used to cover the entrance to a penthouse or to protect a siege engine. Taccola shows mantlets on wheels in De machina (fol.20v), and draws a shelter like P in De ingeneis (fol.37v; Scaglia 1971, p.90; Prager, Scaglia & Montag 1984, p.74). A drawing by Leonardo shows the shields in offensive and defensive use (Malaguzzi Valeri 1915, II, fig.428).

OTHER MANUSCRIPTS Turin, BR, MS T, fols 63v–64r (Maltese 1967, I, p.231, line 15–p.232, line 17; tav.118–19); Reggio, MS, fol.4r, inscribed ponte schom[m]esso dandare alemura sop[r]al fosso; fol.4v, inscribed chiocciola da[n]dare/chontra le mura–ma[n]telletto achuto–ballette di lana–char[r]ettj cho[n]riparj (Mussini 1991, pp.55–6, figs 8–9, p.246; Siena 1991, p.84, figs 8–9); New Haven, BL, MS B, [Q] fol.57r and v; Venice, BMV, fols 263v–264v; Rome, BAV, Codicetto, [Q] fol.76r and v, [P] fols 85r and 75r; London, BM, Opusculum, [Q] fols 33r, 35r and 46r.

OTHER REPRESENTATIONS Vicenza, BBV, [O] fol.37r, [Q, P] fol.37v.

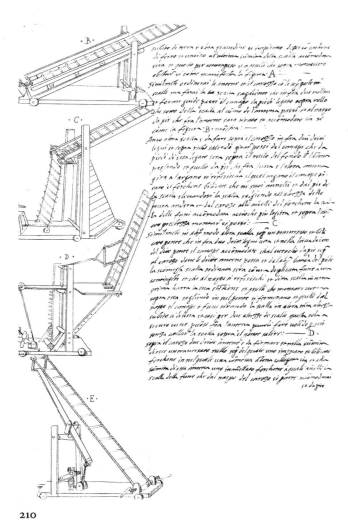

210

211

212

213

Francesco di Giorgio

SALUZZIANO **LAURENZIANA** **SOANE**

FOL.1r Fortifications
(Maltese 1967, I, p.3, line 6–p.4, line 9)
p.3

	SALUZZIANO	LAURENZIANA	SOANE
line 9	in [Maltese 1967, I, n.1]	*et* [correction]	*et*
line 12	*vetruvio*	*Vetruvio*	*vitruvio*
line 17	*e massime*	*et maxime*	*et maxime*
line 18	*el capo*	*el corpo*	*corpo*
line 20	*di* [*a* deleted, n.3]	*dia*	*die*
line 21	*aluogo* [eminente added by Francesco di Giorgio, n.4]	*in luocho*	*in loco*
line 25	*signoreggiata*	*signoreggiata*	*signorezata*
line 26	*dia essere*	*dia essere*	*deve esser*
line 29	*E siccome vediamo*	*E si come noi vediamo*	*Et si come noi veggiamo*

p.4

line 1	*foture*	*foture*	*future*
line 3	*aiuto; fisico*	*aiuto; fisico*	*aguto; physico*
line 4	*curata*	*currata*	*currata*
line 6	*el governatore e rettore della citta*	as MS T	*rettore* omitted
lines 6–7	*citta continua* [n.2]	*citta con continua*	*citta con continua*
line 8	*riparar debba*	*riparar*	*riparar*

FOL.1v Anthropomorphic design of a city
(Maltese 1967, I, p.4, line 7–p.5, line 16) — (Marani 1979, II, pp.3–4, cap.III–v)
p.4

line 11	*appricate membra*	*rispondenti menbro*	*respondenti mimba*
line 12	*braccia; aggiunte*	*le braccia; apricate*	*brazza* [*belleza* deleted]; *applicate*
lines 13–14	*le quali circulando partitamente leghi el resto di tutto el corpo, amprissima citta*	*le quali circondando essa recinghi il resto di tutto il corpo amplissima citta*	*le quali circondando essa recinghi il resto di tutto il corpo amplissima citta*
line 25	*le mura basse* [*sieno* erased, n.8]	*mure basse sieno*	*le mure basse*
line 27	*machine* [n.10]	*nemiche macchine*	*inemiche macchine*

p.5

line 1	*attitudine* [n.1]	*attitudine* [*dela fortezza* almost illegible]	*attitudine*
line 4	*ubriquati*	*ubriquati*	*obliquante*
line 16	*offendere*	*offendere*	*diffendere*

FOL.2r Fortifications
(Maltese 1967, I, p.5, line 16–p.6, line 21) — (Marani 1979, II, p.4, cap.v–vi)
p.5

line 19	*potesse*	*potesse*	*potessino*
line 21	*adattate*	*adattate*	*adaptate*
line 23	*torri*	*torri*	*jtocari*
line 25	*esporro*	*spero*	*spero*

p.6

line 3	*riparar potessi divino ingegno piu che humano dire aver potersi*	*riparar puosse*	*dir haver potriasi*
line 4	*catapulte, sanbuche; stormenti*	*catapulte; sambuche; strumenti*	*catapulat; sabuche; strome[n]ti*
line 5	*trovar*	*trovar*	*provar*
line 6	*vagillando*	*vagillando*	*vacilando*
line 9	*trovarebbe*	*trovarebbe*	*traterebbe*
line 11	*polvare quasi simile*	*polvare quasi simile*	*polvere simile*

SALUZZIANO	LAURENZIANA	SOANE
FOL.2v Geometrical shapes and fortified structures (Maltese 1967, I, p.6, line 21–p.7, line 27)	FOL.2v Geometrical shapes and fortified structures (Marani 1979, II, pp.4–5, cap.VI–X)	FOL.2v Geometrical shapes and fortified structures

p.6

SALUZZIANO		LAURENZIANA	SOANE
line 22	*briccole*	*usorno briccole*	*usorno bricole*
line 23	*promutar*	*promutar*	*co[m]mutar*
line 24	*tralassati*	*tralassati*	*relassati*
lines 28–9	*perche quanto*	*perche quanto*	*p[er]hoche queste*

p.7

line 3	*perche*	*che*	*che*
line 5	*perche*	*il che*	*il che*
line 18	*bertesche*	*bertesche*	*Bertrasche*
line 25	*trovato*	*trovato*	*retrovato*

SALUZZIANO	LAURENZIANA	SOANE
FOL.3r Fortifications (Maltese 1967, I, p.7, line 27–p.9, line 4)	FOL.3r Fortifications (Marani 1979, II, p.5, cap.X–XI)	FOL.3r Fortifications

p.8

line 5	*E presso*	*E per esso*	*E per esso*
line 6	*o 5* [added in a different hand, n.3]	omitted	omitted
line 7	*avere* [n.4]	*haver debba*	*haver debba*
line 8	*E colle*	*e colle*	*et in quelle*
line 10	*fumanti*	*fumanti*	*strume[n]ti*
line 15	*movarai una acuta, vacua*	*minerai una acuta varca*	*menerai una acuta varca*
line 17	*incrinata* [n.9]	*incrinata sia*	*inclinata sia*
line 21	*ubriquita*	*ubriquita*	*obliquita*
lines 21–2	*sua essere offesa non puo*	*sua essere offesa non puo*	*offese esser non po*
line 23	*son da fare* [word erased after *fare*, n.12]	*fare sono*	*da far sono*

SALUZZIANO	LAURENZIANA	SOANE
FOL.3v Fortifications (Maltese 1967, I, p.9, line 5–p.10, line 8)	FOL.3v Fortifications (Marani 1979, II, pp.5–6, cap.XI–XIII)	FOL.3v Fortifications

p.9

line 6	*diseccando esse putrefanno e'l luogo infetto*	*diseccando esse putrefano e lluogo infetto sia*	*disecandose putrefanno o infetta*
line 11	*ubriquita*	*ubriquita*	*obliquita*
lines 11–12	*et in fra' l fosso…piei 20* [the phrase was added later, n.4]	omitted (the phrase was added later)	*et in fra 'fosse…piei*
line 17	*con tre reverse*	*con tre reverse*	*contraroversa*
line 23	*sia coperta*	*sia* omitted	*sia*
line 28	*torri sieno* [n.9]	*sieno* omitted	*sieno* omitted
line 30	*dia* [correction by Francesco di Giorgio, n.10]	*sia*	*sia*

p.10

line 4	*cuperto* [n.2]	*cuperto sia*	*cuperto sia*

SALUZZIANO	LAURENZIANA	SOANE
FOL.4r Fortifications (Maltese 1967, I, p.10, line 8–p.11, line 10)	FOL.4r Fortifications (Marani 1979, II, pp.6–7, cap.XIII–XV)	FOL.4r Fortifications

p.10

lines 11–12	*sia* [n.8]	*sia* omitted	*sia* omitted
lines 13–14	*ordenate* [*fatta?* deleted] *alla custodia e guardia* [n.9]	*ordinate sono alla custodia*	*ordinate sono alla custodia, della guardia*
line 17	*I quali*	*I quali*	*et quasi*
line 23	*adattata* [n.10]	*adattata sia*	*adattata sia*
line 27	*in suprema parte*	*in prima parte*	*in prima parte*

p.11

lines 4–5	*spingarda* [n.2]	*spingarda metterai*	*spingarda metterai*
line 5	*silinga*	*silunga*	*silinga*
line 9	*ed anco per* [n.4]	*ed* [*anco* omitted]	*anco* omitted

SALUZZIANO	LAURENZIANA	SOANE
FOL.4v Fortifications (Maltese 1967, I, p.11, line 10–p.12, line 14)	FOL.4v Fortifications (Marani 1979, II, p.7, cap.XV–XVI)	FOL.4v Fortifications

p.11

line 11	*secondo ch'il bisogno fusse* [n.5]	*secondo il bisogno*	as MS L
line 19	*riempito sera* [n.11]	*sera* omitted	*sera* omitted
line 20	*alle botte e al colpire*	*alle botte e al colpire*	*alle ballotte et* [*colpi* in a different hand]
line 22	*logge uperti* [there is a deletion and the word is illegible; the text is restored from MS L, n.12]	*loggie huperti*	*loggie coperti*

SALUZZIANO	LAURENZIANA	SOANE
FOL.5r Fortifications and casemates (Maltese 1967, I, p.12, line 14–p.13, line 21)	FOL.5r Fortifications and casemates (Marani 1979, II, pp.7–8, cap.XVI–XVIII)	FOL.5r Fortifications and casemates
p.12		
line 15 *coverte son da fare*	*coverte son da fare*	*coperte de fuori*
line 20 *sicura* [n.9]	*sicura sia*	*sicura sia*
line 25 *da ordenar*	*da ordenar*	*hormai*
line 29 *composte* [n.12]	*composte siano*	*composte siano*
p.13		
line 5 *considerare*	*considerare*	*desiderare*
line 19 *grossime* [in error for *grossissime*, n.5]	*grossissime*	*grossissime*
FOL.5v Fortifications (Maltese 1967, I, p.13, line 21–p.15, line 4)	FOL.5v Fortifications (Marani 1979, II, p.8, cap.XVIII–XX)	FOL.5v Fortifications
p.13		
lines 22–3 *murare di drento da esse* [*bombardiere* is added in a later hand above *si possi*? n.8]	*murare di drento di essi*	*de dentro di si si possi* [*bonbardiere* added later]
p.14		
line 1 *riempita* [n.2]	*riempita sia*	*riempita sia*
line 17 *tavole acutate*	*tavole agutate*	*tavole* space [*achritte* added in another hand]
FOL.6r Drawbridges and a corridor bridge (Maltese 1967, I, p.15, line 4–p.16, line 25)	FOL.6r Drawbridges and a corridor bridge (Marani 1979, II, pp.8–9, cap.XX–XXII)	FOL.6r Drawbridges and a corridor bridge
p.15		
line 6 *utili essare paiano*	*utili essare paiano*	*utili et se ariparano*
line 9 *Adunque de'vedere*	*E pero die vedere*	*p[er] ho debbe vedere*
p.16		
line 8 *corridoi*	*corridoi*	*corridoi* omitted
line 22 *e* in error for *che* [n.4]	*che*	*che*
FOL.6v Corridor bridges (Maltese 1967, I, p.16, line 26–p.17, line 26)	FOL.6v Corridor bridges (Marani 1979, II, p.9, cap.XXII–XXIII)	FOL.6v Corridor bridges
p.17		
line 2 *alzar* [n.3]	*usar*	*usar*
line 8 *o di tre*	*o di tre*	*di tre* omitted
line 11 *troppa*	*troppa*	*pocha*
line 12 *piana* [n.7]	*piana sia*	*piana sia*
line 25 *sicondo* [n.9]	*sicondando*	*circondando*
FOL.7r Fortification (Maltese 1967, I, p.17, line 27–p.18, line 26)	FOL.7r Fortification (Marani 1979, II, pp.9–10, cap.XXIII)	FOL.7r Fortification
p.18		
line 15 *fatto sia*	*e da fare*	*e da fare*
line 22 *sopra* [n.7]	*sopra a*	*sopra*
FOL.7v Fortifications (Maltese 1967, I, p.18, line 26–p.19, line 23)	FOL.7v Fortifications (Marani 1979, II, p.10, cap.XXIII–XXIV)	FOL.7v Fortifications
p.18		
line 28 *a tetto*	*a tetto*	*a tutto*
p.19		
line 7 *ponte intrando*	*ponte intrando*	*ponte intrante*
line 13 *E perche*	*perche*	*Et perche*
line 14 *faccenda infinita*	*faccenda infinita*	*negocio infinito*
line 21 *forme* [n.5]	*forme mostrare*	*forme dimostrare*
line 22 *massimi de*	*massime de*	*massime che*
FOL.8r City plans (Maltese 1967, I, p.20, line 6–p.21, line 7)	FOL.8r City plans (Marani 1979, II, p.11, cap.XXV–XXVI)	FOL.8r City plans
p.20		
line 7 *descrivero*	*descrivero*	*scrivero*
line 10 *disegnazione sira*	*disegnazione sira*	*disignation si trovera*
line 19 *organizzati* [added in the hand of Francesco di Giorgio, n.3]	*organizzati si trova*	*si trova*
line 25 *supperimento*	*suprimento*	*supplimento*
line 26 *Abbi fonti*	*Abbi fonti*	*arbori fonti*

SALUZZIANO	LAURENZIANA	SOANE
FOL.8v Angular city plans	FOL.8v Angular city plans	FOL.8v Angular city plans
(Maltese 1967, I, p.21, line 7–p.22, line 9	(Marani 1979, II, pp.11–12, cap.XXVI–XXVIII)	
p.21		
line 19 *piazza* [n.6]	*piazza sia*	*piaza sia*
line 24 *che l'uno membro all'altro*	*che l'uno membro all'altro*	*che l'uno e l'altro*
line 25 *l'un braccio all'altro*	*l'un braccio all'altro*	*bracio cun braccio laltro*
line 32 *ordenamenti* [n.8]	*ordinati*	*ordinati*
line 33 *porre*	*porre*	*farre*
p.22		
line 3 *levato* [n.1]	*levato e intorno spedito*	*levato e intorno spedito*
FOL.9r City plans and the siting of public buildings	FOL.9r City plans and the siting of public buildings	FOL.9r City plans and the siting of public buildings
(Maltese 1967, I, p.22, line 7–p.23, line 8)	(Marani 1979, II, p.12, cap.XXVIII–XXX)	
p.22		
line 15 *e fronte d'esso edifizio e piazza* [n.5]	*d'esso e simile delle piazze*	*d'esso e simile delle piazze*
line 23 *distante*	*remote*	*remote*
lines 26–7 *il fiume in tal modo* [n.9]	*il fiume adattaremo*	*il fiume adatteremo*
line 27 *offesa* [n.10]	*offesa e in tal modo*	*offesa et in tal modo*
p.23		
line 5 *abundanzia* [n.2]	*fecundia*	*de faculta*
FOL.9v City planning	FOL.9v City planning	FOL.9v City planning
(Maltese 1967, I, p.23, line 8–p.24, line 11)	(Marani 1979, pp.12–13, cap.XXX–XXXI)	
p.23		
line 15 *stia, che* [n.6]	*stia et che*	*stia et che*
FOL.10r Cities near harbours	FOL.10r Cities near harbours	FOL.10r Cities near harbours
(Maltese 1967, I, p.24, line 11–p.25, line 14)	(Marani 1979, II, p.13, cap.XXXI–XXXII)	
p.24		
line 16 *men offese sieno; circunferenzie*	*me difese sieno; circunferenzie*	*meglio difesa siano; correspondentie*
line 17 *forme*	*modi*	*modi*
line 19 *che edificate*	*che edificate*	*che sono edificate*
line 21 *cosi essere figurata*	*cosi essere figurata*	*cosi esser cusi figurata*
line 24 *fondo* [n.8]	*fondo e*	*fondo e*
line 27 *entrata*	*entrata*	*entrata entrata*
p.25		
line 1 *Anco quando; rostatoie*	*Anco quando; rostatoie*	*Quando anco; restatogio*
line 4 *steccata*	*steccata*	*secheta*
line 7 *per spazio* [n.4]	*per he spacio*	*per il spacio*
line 8 *in terra ferma*	*in terra ferma*	*et in terra*
FOL.10v Dykes, weirs, bed of a lock	FOL.10v Dykes, weirs, bed of a lock	FOL.10v Dykes, weirs, bed of a lock
(Maltese 1967, I, p.25, line 15–p.27, line 4)	(Marani 1979, II, pp.13–14, cap.XXXII–XXXIV)	
p.26		
line 8 *generazione de sasso* [n.3]	*generazione de sasso sono*	*generatione de sasso*
FOL.11r Lock	FOL.11r Lock	FOL.11r Lock
(Maltese 1967, I, p.27, line 4–p.28, line 8)	(Marani 1979, II, p.14, cap.XXXIV)	
p.27		
line 4 *l'acqua truova o fa*	*l'acqua trova o fa*	*l'acqua o sta per*
line 5 *corosso*	*caossa*	*caso*
line 6 *opportunita*	*importunita*	*importunita*
line 11 *berta, manzo overo*	*berta, manzo overo*	*bertamaco overo*
line 12 *partirai* [n.4]	*cosi partirai*	*cosi partirai*
line 16 *riferischi*	*riferischi*	*rinfreschi*
line 19 *altitudine. E dalla parti in sotto* [n.7]	*altitudine cosi dalla*	*altitudine cosi in la parte di sopra*
line 28 *riempito* [n.12]	*riempito sia*	*riempito sia*
p.28		
line 3 *arrampate*	*arrampate*	space, *trara[n]porte* added later
line 5 *sopra scritte*	*soprascritte*	*sopradette*
line 7 *quarta*	*quarta*	*terza*

SALUZZIANO	LAURENZIANA	SOANE
FOL.11v Dams and breakwaters (Maltese 1967, I, p.28, line 9–p.29, line 10)	FOL.11v Dams and breakwaters (Marani 1979, II, pp.14–15, cap.XXXIV)	FOL.11v Dams and breakwaters
p.28		
line 11 *siccome e detto* [n.6]	*siccome detto*	*siccome e detto*
line 14 *mista*	*misto*	*misto* omitted
line 30 *detto*	*tutto*	*tutto*
p.29		
line 4 *fatta* [n.1]	*fatta sia*	*fatta sia*
FOL.12r Dams and an artificial lake (Maltese 1967, I, p.29, line 10–30, line 14)	FOL.12r Dams and an artificial lake (Marani 1979, II, p.15, cap.XXXIV–XXXV)	FOL.12r Dams and an artificial lake
p.29		
line 21 *da riempire* [n.8]	*riempire e simile e cestoni sono da fare*	*riempire e simile e cestoni sono da fare*
line 30 *ponno*	*possano*	*possino*
FOL.12v Foundations for bridges (Maltese 1967, I, p.30, line 14–p.31, line 15)	FOL.12v Foundations for bridges (Marani 1979, II, pp.15–16, cap.XXXV–XXXVI)	FOL.12v Foundations for bridges
p.30		
line 18 *ghiara*	*ghiara* omitted	*ghiara* omitted
line 25 *stretto luogho*	*stretto luogho*	*luogho serato*
line 27 *d'intraversati correnti*	*d'intraversati correnti*	*doi traver/sati ariete overo travi*
p.31		
line 3 *edificare*	*edificare*	*edifichare*
line 6 *bitumine* [n.3]	*bitume e*	*bitume, e*
line 8 *stelli*	*stelli*	*teli*
line 9 *la coscia*	*la coscia*	*la casa*
FOL.13r Bridge (Maltese 1967, I, p.31, line 15–p.32, line 14)	FOL.13r Bridge (Marani 1979, II, pp.16–17, cap.XXXVI)	FOL.13r Bridge
p.31		
line 28 *riempite* [n.9]	*riempite serano*	*riempite sarano*
p.32		
line 9 *essi ponti*	*ditti ponti*	*ditti ponti*
FOL.13v Foundations for a marshy site (Maltese 1967, I, p.32, line 15–p.33, line 16)	FOL.13v Foundations for a marshy site (Marani 1979, II, p.17, cap.XXXVI–XXXVIII)	FOL.13v Foundations for a marshy site
p.32		
lines 15–16 *galazzando*	*galazzando*	*calzando*
line 25 *volto* [n.5]	*volto sia*	*volto sia*
p.33		
line 4 *sopra esso* [n.1]	*sopra a esso*	*sopra esso*
line 16 *da uno a l'altro* [n.4]	*da uno rastro al altro*	*da uno vastro al altro*
FOL.14r The cofferdam method for draining a site (Maltese 1967, I, p.33, line 17–p.34, line 19)	FOL.14r The cofferdam method for draining a site (Marani 1979, II, pp.17–18, cap.XXXVIII)	FOL.14r The cofferdam method for draining a site
p.33		
line 25 *lassando* [n.8]	*lassandola*	*lasciandola*
p.34		
line 12 *rilassati* [n.4]	*rilassati e*	*rilasciati e*
FOL.14v Amphibious carts and bridges; the box or caisson method of laying foundations (Maltese 1967, I, p.34, line 19–p.35, line 15)	FOL.14v Amphibious carts and bridges; the box or caisson method of laying foundations (Marani 1979, II, p.18, cap.XXXVIII)	FOL.14v Amphibious carts and bridges; the box or caisson method of laying foundations
p.34		
line 21 *assettato. In nella*	*asseterai nella*	*asseterai nella*
line 29 *dipoi a un tempo*	*et poi ad un trato*	*et poi ad un trato*
p.35		
line 1 *e fa l'opra*	*e fa l'opra*	*e fa essa opera*
FOL.15r Of temples, qualities of the architect (Maltese 1967, I, p.36, line 8–p.37, line 11)	FOL.15r Of temples, qualities of the architect (Marani 1979, II, p.19, cap.XXXIX)	FOL.15r Of temples, qualities of the architect
p.36		
line 9 *pare*	*pare*	*parmi*
lines 22–3 *memorioso*	*memorioso*	*ingenioso*
line 25 *lingnia* [n.3]	*lingua* correctly	*lingua*
line 27 *siccome seguira descrivero* [n.5]	*brevemente spero*	*brevemente spero*
line 29 *raciocinazio. La fabrica*	*ratiotinio di fabriche*	*ratiotinio di fabriche*

SALUZZIANO	LAURENZIANA	SOANE
p.37		
line 4 — *senza ingegno* [n.1]	*senza lo ingegno*	*senza l'ingegno*
line 6 — *disegnatori*	*disegnio torj*	*disegni torre*
FOL.15v Of temples; architect's education	FOL.15v Of temples; architect's education	FOL.15v Of temples; architect's education
(Maltese 1967, I, p.37, line 11–p.38, line 17)	(Marani 1979, II, pp.19–20, cap.XXXIX)	
p.37		
line 12 — *congiunzione*	*congiunzione*	*cognitione*
line 24 — *e le cose a esse appartenenti* [n.4]	*necessario e,*	*necessaria*
line 25 — *tutte* [n.5]	*tutte le cose* correctly	*tutte le cose*
line 26 — *pietre da conci*	*pietre*	*pietre*
line 29 — *sicondo el bisogno disponendo*	*chonoscia bixongnia*	*cognoscer bisogna*
p.38		
lines 7–8 — *E. Pertanto…in tale arte si ricerca* [correction in another hand, Francesco di Giorgio?, n.3]	*necessarij sono*	*necessarij sono*
FOL.16r Architect's education	FOL.16r Architect's education	FOL.16r Architect's education
(Maltese 1967, I, p.38, line 17–p.39, line 20)	(Marani 1979, II, p.20, cap.XXXIX)	
p.38		
line 17 — *si puo*	omitted	*puossi*
line 30 — *fizio* for Pytheos [n.10]	*phitio*	*Plinio*
line 31 — *piu potere*	*piu potere*	*piu sapere*
p.39		
line 2 — *appartenendo si rechiede*	*necessarie sono*	*necessarie sono*
line 12 — *uso del cercino*	*ciercino*	*exercino*
line 13 — *spazi de' piani*	*spazi de' piani*	*spacij di piu piani*
line 14 — *e diritta*	*e diritta*	*e detta diritte*
line 19 — *volonta*	*volonta.*	*volonta: la inventione e una esplicatione et raggione delle oscure questioni trovata con nobil vigore della cosa nova, et terminatione della dispositione hora…*
FOL.16v Plans of temples	FOL.16v Plans of temples	FOL.16v Plans of temples
(Maltese 1967, I, p.39, line 20–p.41, line 14)	(Marani 1979, II, pp.20–21, cap.XXXIX–XL)	
p.40		
line 1 — *pixeulo ditteros* [n.6]	*peseulo ditteros*	*pseuliditeros*
p.41		
line 6 — *Pixeulo* [n.4]	*Pseudo diteros* correctly	*Pseudo diteros*
line 12 — *sotto l'architravi* [n.5]	*overo pilastri*	*overo pilastri*
FOL.17r Longitudinal plans of churches	FOL.17r Longitudinal plans of churches	FOL.17r Longitudinal plans of churches
(Maltese 1967, I, p.41, line 15–p.43, line 11)	(Marani 1979, II, p.21, cap.XL–XLI)	
p.41		
line 15 — *stili*	*stili*	*pilij*
p.42		
line 2 — *perignostilos* [n.2]	*perignostilos*	*perignotiro*
p.43		
lines 5–7 — *ordenate sera divisa in parti dieci e mezzo sfuore delle stensione delle base. Se sera di dieci colonne in parte diecennove*	*ordenate sera divisa in parti dieci e mezzo sfuore delle stensione delle base*	*hordenati sera divisa se tetrastilo sera da fare undeci sia in parti dieci e mezo a fuori de l'estensione delle base, et sera di sie colone in parti disdotto.*
line 7 — *parti vinti due*	*parti vinti due*	*parti vintiquatro e meze*
FOL.17v Longitudinal plans of churches	FOL.17v Longitudinal plans of churches	FOL.17v Longitudinal plans of churches
(Maltese 1967, I, p.43, line 11–p.44, line 22)	(Marani 1979, II, pp.21–2, cap.XLI)	
p.43		
line 16 — *cella* [n.6]	*cella fe*	*cella fe*
line 21 — *con* [n.10]	*con e*	*come*
FOL.18r Longitudinal plans of churches	FOL.18r Longitudinal plans of churches	FOL.18r Longitudinal plans of churches
(Maltese 1967, I, p.44, line 22–p.45, line 28)	(Marani 1979, II, p.22, cap.XLI–XLIII)	
p.45		
lines 2–3 — *per errata parte s'ordini*	lines 2–3 — *per errata parte s'ordine*	lines 2–3 — *per rata parte si divida*

SALUZZIANO	LAURENZIANA	SOANE
FOL.18v Crossing piers, plans of presbyteries (Maltese 1967, I, p.45, line 29–p.49, line 2)	FOL.18v Crossing piers, plans of presbyteries (Marani 1979, II, pp.22–3, cap.XLIII–XLIV)	FOL.18v Crossing piers, plans of presbyteries
p.46		
line 20 *aggionto* [n.5]	*aggionto sia*	*agionto sia*
line 30 *quadro* [n.10]	*quatro*	*quatro*
FOL.19r Longitudinal plans of churches (Maltese 1967, I, p.47, line 2–p.48, line 7)	FOL.19r Longitudinal plans of churches (Marani 1979, II, p.23, cap.XLIV–XLVI)	FOL.19r Longitudinal plans of churches
p.47		
line 11 *posta* [n.4]	*posto sia*	*posta sia*
line 15 *costituireno* [n.7]	*costituiremo*	*constitueremo*
FOL.19v Central plans for churches (Maltese 1967, I, p.48, line 7–p.49, line 9)	FOL.19v Central plans for churches (Marani 1979, II, pp.23–4, cap.XLVI–XLVII)	FOL.19v Central plans for chur ches
p.48		
line 7 *all'altra, i luma a'lumi*	*all'altra, e lumi a'lumi*	*e laltra a lumi*
line 23 [*periteri* cancelled] *anfriprostilos* written by Francesco di Giorgio, also on line 29 [n.2]	*periteri*	*periteri* [also line 29]
lines 29–30 *misure composte e ordenati*	*misure composte e ordenati*	*misure ordenati*
p.49		
line 2 *I quali* correctly [n.1]	*A queli*	*a quelli*
line 5 *posti. E* [n.2]	*posti sia*	*posti sono*
FOL.20r Central plans (Maltese 1967, I, p.49, line 9–p.50, line 9)	FOL.20r Central plans (Marani 1979, II, pp.24–5, cap.XLVII)	FOL.20r Central plans
p.49		
line 9 *da fare*	*da fare sono*	*far sono*
line 12 *si dia*	*si dia*	*si diece*
line 13 *colle linie*	*colle linie*	*con lumi*
line 21 *capuli*	*capuli*	*capitelli*
line 26 *sopra scritti* [n.7]	*soprascritte sono*	*soprascritte sono*
line 29 *da fare* [n.9]	*da fare sono*	*da fare sono*
p.50		
line 7 *sua* [n.1]	[*sua* omitted] *si dia*	*si die*
FOL.20v Central plans (Maltese 1967, I, p.50, line 9–p.51, line 8)	FOL.20v Central plans (Marani 1979, II, p.25, cap.XLVII–XLVIII)	FOL.20v Central plans
p.51		
line 8 *non piu* [n.4–5]	*non men di tre ne piu di cinque*	*no[n] meno*
FOL.21r On temples (Maltese 1967, I, p.51, line 8–p.52, line 17)	FOL.21r On temples (Marani 1979, II, pp.25–6, cap.XLVIII–XLIX)	FOL.21r On temples
p.51		
line 8 *piu di tre ne piu fare*	*ne piu di cinque fare*	*ne piu di cinque fare*
line 9 *offerire e sacrificare vanno* [n.6]	*offerire vanno*	*offerire vanno*
line 11 *altri lavori*	*altri lavori*	*altri colori*
line 21 *tenpi recinti*	*tenpi recinti*	*tenpij vene*
FOL.21v Church façades (Maltese 1967, I, p.52, line 17–p.53, line 15)	FOL.21v Church façades Marani 1979, II, p.26, cap.XLIX)	FOL.21v Church façades
p.52		
line 26 *ingegno* [n.4]	*ingegno sia*	*ingegno sia*
line 34 *infra'poeti*	*infra'poeti*	*infra'poeti* omitted
p.53		
line 9 *e Aristofare* [n.1]	*et a Aristofare* correctly	*et ad Aristofare*
FOL.22r Acoustics in theatres (Maltese 1967, I, p.53, line 15–p.55, line 4)	FOL.22r Acoustics in theatres (Marani 1979, II, pp.26–7, cap.XLIX–LI)	FOL.22r Acoustics in theatres
p.53		
line 22 *accade*	*accade*	*accade* omitted
p.54		
line 15 *meson*	*meson*	*masson*
line 23 *la longhezza*	*la longhezza*	*la larghezza*
line 24 *la figurata rappresentazione*	*la figurata rappresentazione* [repeated twice]	

SALUZZIANO	LAURENZIANA	SOANE
p.55		
line 1 *de detta orchestra* [correction, n.6]	*de detta orchestra* omitted	*de detta orchestra* omitted
line 3 *ordenare*	*ordenare*	*fare et ordenare*
line 4 *facilmente*	*agevolmente*	*agevolmente*
FOL.22v The three orders: Doric, Ionic and Corinthian	FOL.22v The three orders: Doric, Ionic and Corinthian	FOL.22v The three orders: Doric, Ionic and Corinthian
(Maltese 1967, I, p.55, line 4–p.57, line 13)	(Marani 1979, II, p.27, cap.LI–LII)	
p.57		
line 6 *essere. E lui*	*essere. Et lui*	*disse a lui*
line 10 *Meloconi*	*choloconi*	*choloconi*
FOL.23r Columns	FOL.23r Columns	FOL.23r Columns
(Maltese 1967, I, p.57, line 4–p.59, line 3)	(Marani 1979, II, p.28, cap.LII)	
p.57		
line 14 *Canis e Lela* [incorrect rendering of *avando espulsi i Cari e i Legegi*, n.8]	*chanisella*	*canesellae*
FOL.23v Corinthian order capitals and entablature	FOL.23v Corinthian order capitals and entablature	FOL.23v Corinthian order capitals and entablature
(Maltese 1967, I, p.59, line 4–p.60, line 10)	(Marani 1979, II, p.28, cap.LII)	
p.59		
lines 22–5 *L'altezza…angoli dell'abaco* [the translation of this sentence is confused, n.3].	*L'altezza…dell'abaco* [Maltese 1967, I, p.59, n.3, notes the confusion of the translation of this sentence in both MS T and MS L]	*la larghezza dell'abacco sara qua[n]ta e l'altezza duppla dentro*
p.60		
lines 3–4 *in parte tre, le quali a le foglie si dia mezza latitudine. Tenghi in negli angoli quelle de'voluti che una all'altra precorre*	*in parte tre,…precorre*	*in parte, et delle quali una al basso foglio si dia il secondo foglio habbia meza altitudine a cauliciuli Q[ue]sta istessa altezza darai dalli quali nascono le fogli che tolgono su l'abacco et corrono alli estremi ne gli angoli quelli devo/lute che luna all'altra per correre*
line 5 *della*	*la*	*la*
FOL.24r Capitals and a vase	FOL.24r Capitals and a vase	FOL.24r Capitals and a vase
(Maltese 1967, I, p.60, line 10–p.61, line 21)	(Marani 1979, II, pp.29-30, cap.LII–LIII)	
FOL.24v Vases	FOL.24v Vases	FOL.24v Vases
(Maltese 1967, I, p.61, line 21–p.63, line 2)	(Marani 1979, II, pp.29–30, cap.LIII)	
p.61		
line 25 *Le stilobate* [n.5]	*Le colone* correctly	*Le colone*
line 27 *umano* [n.6]	*humano tutto*	*humano tutto*
line 28 *fu*	*fu*	*fu p[ro]prie*
line 32 *dero*	*dero*	*de otto*
p.62		
line 11 *antas* [meaning entasis, n.3]	*antas* [meaning entasis]	*entri*
line 12 *Anco*	*Anco*	*Abaccho*
FOL.25r Entasis	FOL.25r Entasis	FOL.25r Entasis
(Maltese 1967, I, p.63, line 2–p.64, line 2)	(Marani 1979, II, p.30, cap.LIII)	
p.63		
line 19 *divisa* [n.4]	*divisa sia*	*divisa sia*
line 21 *grossezza* [n.5]	*grossezza sia*	*la grosseza sia*
line 23 *E cosi* [n.7]	*e cosi* omitted	*e cosi* omitted
p.64		
line 4 *un terzo* [n.2]	*due terzi*	*due terzi*
FOL.25v The orders	FOL.25v The orders	FOL.25v The orders
(Maltese 1967, I, p.64, line 6–p.65, line 7)	(Marani 1979, II, pp.30–31, cap.LIII)	
p.64		
line 7 *decrinando*	*decrinare*	*declinando*
line 15 *overo* [n.4]	*e*	*e*
line 17 *rilassi* [n.6]	*e lassi*	*si lassi*
line 23 *di colonna* [n.8]	*di colonna* omitted	*di colonna* omitted
p.65		
line 1 *prime lengue*	*prime lenghue* [meaning *foglie*]	*prima linea*
line 2 *lengue*	*lenghue*	*linie*

SALUZZIANO	LAURENZIANA	SOANE
FOL.26r Projection of the capital and base, proportions of the capital (Maltese 1967, I, p.65, line 8–p.66, line 8)	FOL.26r Projection of the capital and base, proportions of the capital (Marani 1979, II, p.31, cap.LIII–LIV)	FOL.26r Projection of the capital and base, proportions of the capital
p.65		
line 30 *mostruosi animali* [n.1]	*mostruosi animali*	*mostruosi*
p.66		
line 2 *e terza*	*e terzo*	*e mezzo*
line 3 *fero*	*faro* incorrectly	*ero*
line 7 *data* [n.4]	*data fu*	*data fu*
FOL.26v Units of measurement (Maltese 1967, I, p.66, line 9–p.68, line 3)	FOL.26v Units of measurement (Marani 1979, II, pp.31–2, cap.LIV–LV)	FOL.26v Units of measurement
p.66		
line 10 *uguale*	*uguale*	*regale*
p.67		
line 12 *innovare* [n.2]	*innovare e p[er]che*	*inovare e p[er]che*
line 13 *perche* [n.3]	*che*	*che*
p.68		
line 3 *belta e gentilezza*	*belta gentilezza*	*bella gentilleza*
FOL.27r Units of measurement (Maltese 1967, I, p.68, line 3–p.69, line 7)	FOL.27r Units of measurement (Marani 1979, II, pp.32–3, cap.LVI)	FOL.27r Units of measurement
p.68		
line 15 *pie* defined as *petto* [n.3]	*pie* (defined as *petto*) *petto*	*petto*
lines 19–20 *perfetto distribuito* [n.4]	*perfetto hanno distribuito*	*perfetto hanno distribuito*
p.69		
line 4 *pititos*	*pititos*	*pantor*
FOL.27v Units of measurement (Maltese 1967, I, p.69, line 7–p.69, line 24)	FOL.27v Units of measurement (Marani 1979, II, p.22, cap.LVI)	FOL.27v Units of measurement
p.69		
line 12 *dicalca e tricalca*	*sicalca e tricalca*	*a tricalcha*
line 14 *coie dieci*	*coie dieci*	omitted in Soane
line 20 *Ma el palmo; tredici* [n.2]	*Ma el palmo; sedici* correctly	*che il palmo; sedici*
FOL.28r Royal palaces (Maltese 1967, I, p.69, line 25–p.71, line 2)	FOL.28r Royal palaces (Marani 1979, II, p.33, cap.LVII–LVIII)	FOL.28r Royal palaces
p.69		
line 26 *e vedere* [n.3]	*e vedere sono*	*e vedere sono*
p.70		
line 7 *stati* [n.3]	*stati sono*	*stati sono*
FOL.28v Palaces for princes and nobles (Maltese 1967, I, p.71, line 2–p.72, line 4)	FOL.28v Palaces for princes and nobles (Marani 1979, II, p.34, cap.LVIII)	FOL.28v Palaces for princes and nobles
p.71		
line 3 *da fare* [n.1]	*da fare sono*	*da far sono*
line 12 *abitazione sotto poste* [n.5]	*habbitationi che sotto poste sono*	*habbitationi che sotto posto sono*
line 14 *l'entrata* [n.6]	*entrata sia*	*l'entrata sia*
line 21 *aspetto e fronte* [n.8]	*aspetto fronte*	*aspetto fronte*
line 29 *nutrir* [n.10]	*nutrir si possa*	*nutrir si possa*
line 31 *cenar e disinar*	*cienar e diximare si possa*	*mangiar si possi*
p.72		
line 3 *demostrar* [*formaremo* is a later addition, n.1]	*dimostrare si ancho alcun coperte andare per il tempo delle piogge e da fare*	*dimostrare si ancho alcun coperte andare per il tempo delle piogge e da fare*
FOL.29r Palace plans (Maltese 1967, I, p.72, line 5–p.73, line 3)	FOL.29r Palace plans (Marani 1979, II, p.34, cap.LIX)	FOL.29r Palace plans
p.72		
line 6 *e luoghi* [n.2]	*e altri luoghi*	*altri luochi*
line 16 *d'esse* [n.3]	*d'esse case*	*d'esse case*
line 20 *occulti* [n.5]	*occulti sieno*	*occulti siano*

SALUZZIANO	LAURENZIANA	SOANE
FOL.29v Palace plans	FOL.29v Palace plans	FOL.29v Palace plans
(Maltese 1967, I, p.73, line 3–p.74, line 6)	(Marani 1979, II, pp.34–5, cap.LIX)	
p.73		
line 5 *d'esso, tutti; conferenti* [n.2]	*d'esso e che tutti; conferenti sieno*	*di esso e che tutti; conferenti sieno*
line 15 *pilastri* [n.5]	*pistili*	*pistili*
line 16 *mensole, gocciole* [n.6]	*mutoli, metafi*	*mutali, metafi*
line 30 *concovi e*	*cu[n]duo*	*cu[n]duo*
FOL.30r Houseplans for private citizens	FOL.30r Houseplans for private citizens	FOL.30r Houseplans for private citizens
(Maltese 1967, I, p.74, line 6–p.75, line 9)	(Marani 1979, II, p.35, cap.LIX)	
p.74		
line 9 *tegole* [n.3]	*tegole serano*	*tegole serano*
line 14 *rivolta a testa*	*testa*	*testa*
line 19 *dato sera* [n.5]	*dato sia*	*dato sia*
line 21 *formate* [n.6]	*formate seranno*	*formate serano*
line 26 *andata sera* [variant in MS T by Francesco di Giorgio, n.8]	*andare si possa*	*andar[e] si porsi*
line 30 *in esso composte* [n.9]	*composte seranno*	*co[m]poste sarano*
FOL.30v Plans of houses	FOL.30v Plans of houses	FOL.30v Plans of houses
(Maltese 1967, I, p.75, line 9–p.76, line 7)	(Marani 1979, II, p.36, cap.LIX–LXI)	
p.75		
line 13 *sono* [correction by Francesco di Giorgio, n.2]	*seranno*	*sarano*
line 15 *ne posso* [n.3]	*ne so*	*no[n] posso*
line 26 *da capo e da pie* [n.7]	*e essi salotti*	*etessi salotti*
line 32 *banda* [n.8]	*banda sera*	*banda*
p.76		
lines 1-2 *siccome la figura segnata* A [added by Francesco di Giorgio, n.1]	omitted	omitted
line 3 *casa*	*casa*	*stalla*
line 5 *essa* [n.2]	*essa sia*	*essa sia*
FOL.31r Plans of houses	FOL.31r Plans of houses	FOL.31r Plans of houses
(Maltese 1967, I, p.76, line 8–p.77, line 10)	(Marani 1979, II, pp.36–7, cap.LXI–LXII)	
p.76		
line 8 *pubrico* [n.3]	*pubrico sia*	*publico sia*
line 11 *sala* [n.4]	*sala sia*	*sala sia*
line 15 *lato* [n.5]	*lato sera*	*lato sera*
line 18 *sinistra* [n.7]	*sinistra fatta sera*	*sinistra fatta sera*
p.77		
line 3 *E in* [n.1]	*e perche in*	*e perche in*
line 5 *et a ogni* [n.3]	*che a ciaschedun*	*che a ciascu[n]*
line 6 *l'andata sera*	*andar si possa*	*andar si possa*
line 7 *la figura formato* B [n.4]	omitted	omitted
FOL.31v Plans of houses	FOL.31v Plans of houses	FOL.31v Plans of houses
(Maltese 1967, I, p.77, lines 9–10–p.78, line 13)	(Marani 1979, II, p.37, cap.LXII)	
p.77		
line 11 *sopra* [n.5]	*sopra a*	*sopra*
p.78		
line 13 *tali inconvenienti cessando fuggire*	*tali inconvenienti cessando fuggire*	*inco[n]veniente fuggire e seguire la salute*
FOL.32r Plans of houses	FOL.32r Plans of houses	FOL.32r Plans of houses
(Maltese 1967, I, p.78, line 14–p.79, line 17)	(Marani 1979, II, pp.37–8, cap.LXIII)	
p.78		
line 14 *e particulari*	*e particulari*	omitted
line 21 *a l'aire temparato e da voltare* [n.4]	*a l'aire temperate da voltare sono*	*o l'aer temperato da voltar sono*
line 24 *portico e* [*vestibolo* added by Francesco di Giorgio, n.5]	correctly *portico*	*portico*
page.79		
line 3 *entrava* [correction by Francesco di Giorgio, n.1]; *camare*	*andar si possi; camare*	*andar si possa; camare;* omitted
line 13 *della casa*	*della casa date saranno*	*della casa date saranno*
line 14 *esalatoi*	*esalatoi*	*palatoi*

SALUZZIANO	LAURENZIANA	SOANE

FOL.32V Circular plans of houses
(Maltese 1967, I, p.79, line 17–p.80, line 19)
p.79

FOL.32V Circular plans of houses
(Marani 1979, II, p.38, cap.LXIII–LXVI)

FOL.32V Circular plans of houses

line 22	*sono da fare* [correction by Francesco di Giorgio, n.7]; *a essa*	*da far sono; et atrio*	*da far sono; et atrio*
lines 29–30	*e cosi l'abitazion che nel quadrato serà* [n.11]	*e simile alcun quadrato a facce o tondo attrio, e quali alzati lumi sopra abitazioni da dare sono*	*E simile alcun quadrato a faccie o tondo atrio eguali aligati lumi sopra habitatione da dar sono*

p.80

line 6	*seranno* [correction by Francesco di Giorgio, n.3]	*farai*	*ferai*
line 9	*e*	*e che*	*e che*
line 10	*pare* [correction by Francesco di Giorgio, n.5]	*e sono*	*e sono*
line 17	*attribuire porremo* [correction by Francesco di Giorgio, n.7]	*attribuito sia*	*attribuito sia*

FOL.33r Of palaces
(Maltese 1967, I, p.80, line 19–p.82, line 3)

FOL.33r Of palaces
(Marani 1979, II, pp.38–9, cap.LXVI–LXIX)

FOL.33r Of palaces

p.80

line 23	*fermare un cintro*	*fermare un cintro*	*fermare u[n] circino*

p.81

line 3	*si dia* [correction by Francesco di Giorgio, n.1]	*si puosse*	*si po*
line 4	*porremo* [correction by Francesco di Giorgio, n.2]	*puossi*	*puosi*
line 5	*alcuni* [n.3]	*alcuni qui nella carta de nanci*	*alcuni qui nella carta de nanci*
line 7	*faccisi* [n.5]	*faccinsi*	*far[r]asi*
line 9	*casa un andare*	*casa un andare*	*casa vi ha ad andare*
line 10	*sfinestrato* [n.7]	*sfinestrato sia*	*finestrato sia*
line 11	*sia* [n.9]	*sara*	*sera*
lines 11–12	*dove la ritonda mancati*	*dove la roto[n]dita mancasti*	*dove la roto[n]dita mancha*
line 14	*colle* [*sue* has been erased, n.10]; *conferenti* [n.11]	*con le sue; conferenzie*	*con le sue; conferentie*
line 18	*dove* [n.13]	*due*	*dove*

FOL.33V Of palaces
(Maltese 1967, I, p.82, line 3–p.83, line 15)
p.82

FOL.33V Of palaces
(Marani 1979, II, p.39, cap.LXIX)

FOL.33V Of palaces

line 13	*travi*	*travi*	*scalle*
lines 18–19	*quaranta* [in error for *sessanta*, n.7]	*quaranta*	*quaranta*
line 20	*alari, overo parete di muro*	omitted	

p.83

line 4	*trabini*	*trabini*	*tre lumi*
line 6	*trenta a quaranta*	*trenta a quaranta*	*a quaranta*
line 7	*trabino*	*trabino*	*traburo*
line 8	*trabino*	*trabino*	*traburo*
line 14	*espetto*	*espetto*	*aspetto*

FOL.34r Of palaces
(Maltese 1967, I, p.83, line 15–p.84, line 20)
p.83

FOL.34r Of palaces
(Marani 1979, II, pp.39–40, cap.LXIX–LXX)

FOL.34r Of palaces

line 16	*a lui*	*a lui*	*altri*
line 17	*larghezza*	*larghezza*	*longheza*
line 18	*inmargine*	*inmargine*	*imagine*
line 19	*dell'ale*	*dell'ale*	*delle*
line 20	*come che*	*come che*	*come se*
line 25	*abbin* [n.9]; *modo dorico*	*abbin di modo dorico*	*habbia; modo di archo*
line 26	*architrave* correctly by Francesco di Giorgio [n.10]	*pilastro* incorrectly	*pilastro*

p.84

line 3	*seranno* [correction by Francesco di Giorgio, n.1]	*sono*	*sono*
line 4	*si dia* [n.2]	*si dia due volte longhezza sia die*	*due volte la longhezza si debbi*
line 12	*Hoeti ahetete* [this may be a	*Hoeti ahetete*	*athe a otheti*

	SALUZZIANO	LAURENZIANA	SOANE
	corruption of *Oeci Corinthii*, n.5]		
line 14	*misure di quattro equali fare* [n.7]	*misure che sopra scritte sono*	*misure che sopra scritte sono*
line 18	*adalbavano*	*adalbavano*	*albavano*

FOL.34v Courtyards and shapes of rooms (Maltese 1967, I, p.84, line 20–p.86, line 2) — Laurenziana: FOL.34v Courtyards and shapes of rooms (Marani 1979, II, p.40, cap.LXX) — Soane: FOL.34v Courtyards and shapes of rooms

	SALUZZIANO	LAURENZIANA	SOANE
p.85			
line 6	*collocoro*	*collocoro*	*con lo corno*
lines 7–8	*collocati in circuizione di tridinia over tre parti*	as MS T	*collocati da due over tre parte*
line 14	*agevol volte* [n.10]	*agevolmente*	*agevolmente*
line 23	*collocare* [n.12]	*collocare ne*	*collocare ad*
line 24	*dinde*	*dinde*	*dal di*

FOL.35r Courtyards and shapes of rooms (Maltese 1967, I, p.86, line 3–p.87, line 6) — Laurenziana: FOL.35r Courtyards and shapes of rooms (Marani 1979, II, pp.40–41, cap.LXXI–LXXII) — Soane: FOL.35r Courtyards and shapes of rooms

	SALUZZIANO	LAURENZIANA	SOANE
p.86			
line 3	*atri* [correction by Francesco di Giorgio, n.2]	*cortili*	*cortile*
line 6	*sprimera* [n.4]	*spremero*	*esprimero*
line 8	*terzo* [n.5]	*terzo e da fare*	*terzo da fare*
line 14	*s'e muro*	*s'e muro*	omitted
line 24	*siccome…tetrastili* in another hand [n.7]	*siccome…tetrastile* omitted	omitted
p.87			
line 2	*e necessita*	*e necessita*	*e misura*
line 3	*darai*	*darai*	omitted
line 5	*darle volessi* [n.1]	*dar[e] si volessi da far sono*	*dar[e] si volessi da far sono*

FOL.35v Rooms and façades (Maltese 1967, I, p.87, line 6–p.88, line 8) — Laurenziana: FOL.35v Rooms and façades (Marani 1979, II, p.41, cap.LXXII–LXXIV) — Soane: FOL.35v Rooms and façades

	SALUZZIANO	LAURENZIANA	SOANE
p.87			
line 10	*tigrini* [n.3]	*trabini*	*tribini*
line 16	*pare*	*sono*	*sono*
line 22	*d'essi casamenti…e come con* changed by Francesco di Giorgio? [n.5]	*d'essi casamenti da descrivare pare e come con ragione*	*d'essi casamenti da descrivere pare e come con ragione*
p.88			
line 4	[a word has been erased, and the space left empty]	*richiede*	*richiede*

FOL.36r Palace façades (Maltese 1967, I, p.88, line 8–p.89, line 12) — Laurenziana: FOL.36r Palace façades (Marani 1979, II, pp.41–2, cap.LXXIV–LXXVI) — Soane: FOL.36r Palace façades

	SALUZZIANO	LAURENZIANA	SOANE
p.88			
line 14	*fare saranno*	*fare sono*	*fare sono*
line 20	*l'aire infette* [n.5–6]	*arie infetto*	*aere infeti*
line 26	*per qualche; certi*	*per qualche; certi*	omitted; *alcuni*
line 27	*assai*	*assai* omitted	*assai* omitted
line 28	*ricolcolta* [n.7]	*riconcolta*	*rico[n]nolta*
p.89			
line 6	*si debbono ordenar* [n.1]	*cosi sono da fare*	*cosi sono da fare*
line 12	*richiede* [*sono da fare* deleted; the space has been left empty, n.2]	*richiede sono da fare*	*richiede sono da fare*

FOL.36v Façade of a theatre; diagram of an entablature (Maltese 1967, I, p.89, line 8–p.90, line 16) — Laurenziana: FOL.36v Façade of a theatre; diagram of an entablature (Marani 1979, II, p.42, cap.LXXVI–LXXVIII) — Soane: FOL.36v Façade of a theatre; diagram of an entablature

	SALUZZIANO	LAURENZIANA	SOANE
p.89			
line 14	*seghi*	*seghi*	*seghi* omitted
line 18	*mensole* [correction by Francesco di Giorgio, n.3]	*metofe*	*matofe*
line 20	*calcielli* [n.5]	*cancielli* [exact word]	*caliceti*
p.90			
line 2	*si lassi* [correction by Francesco di Giorgio, n.1]	*si dia*	*si dia*

SALUZZIANO	LAURENZIANA	SOANE
FOL.37r Façades of temples	FOL.37r Façades of temples	FOL.37r Façades of temples
(Maltese 1967, I, p.90, line 16–p.91, line 13)	(Marani 1979, II, p.43, cap.LXXVIII–LXXIX)	
p.90		
line 30 *descrivaro* [correction by Francesco di Giorgio, n.4]	*da dire pare*	*da dire parte*
FOL.37v Façades of temples and vaults	FOL.37v Façades of temples and vaults	FOL.37v Façades of temples and vaults
(Maltese 1967, I, p.91, line 13–p.92, lines 11–12)	(Marani 1979, II, p.43, cap.LXXIX–LXXXI)	
p.91		
line 13 *altezza* [n.2]	*altezza sia*	*altezza sia*
line 30 *membro* [n.5]	*membro e da fare*	*membro ha da fare*
p.92		
line 11 *offendare*	*o fondare*	*offender*
FOL.38r Vaults	FOL.38r Vaults	FOL.38r Vaults
(Maltese 1967, I, p.92, line 12–p.93, line 18)	(Marani 1979, II, p.44, cap.LXXXI–LXXXII)	
p.92		
line 19 *scende era la*	*scende cosi era costituita*	*scende cosi la*
lines 20–21 *a tomboli…costituiro* added by [copyist, n.7]	*e a tomboli; costituiro* omitted	omitted
p.93		
line 1 *i pali* [correction by Francesco di Giorgio, n.1]	*da esse*	*da esse*
line 11 *volta* [n.7]	*volta sia*	*volta sia*
line 14 *serrate* [n.8]; *darle* [correction by copyist, n.9]	*serato sieno; dare a esse*	*serato siano; dare ad esso*
line 15 *trave catene*	*trave catene*	*trave co[n] cathene*
line 17 *accio* [n.10]	omitted	*accio* omitted
FOL.38v Bricks, triglyphs	FOL.38v Bricks, triglyphs	FOL.38v Bricks, triglyphs
(Maltese 1967, I, p.93, line 19–p.95, line 1)	(Marani 1979, II, p.44, cap.LXXXII)	
p.93		
line 22 *riempia*	*riempia*	*riempica*
line 24 *si riempia* [n.14]	*riempito sara*	*riempito sara*
line 25 *pianciti; E anco da pomice* [addition by Francesco di Giorgio, n.15]	*pianciti; E anco da pomice* omitted	*pianta; E anco da pomice* omitted
p.94		
line 9 *piano* [n.4]	*piano sia*	*pieno sia*
line 10 *e da fare* [correction by Francesco di Giorgio, n.5]	*da fare sono*	*da fare sarrano*
line 14 *da fare* [n.6]	*da fare saranno*	*da far serano*
line 24 [*tigra* has been erased, but the word is still legible, n.10]	*tigra*	*tigre*
FOL.39r Consoles and beams	FOL.39r Consoles and beams	FOL.39r Consoles and beams
(Maltese 1967, I, p.95, line 1–p.96, line 11)	(Marani 1979, II, p.45, cap.LXXXIII–LXXXIV)	
p.95		
line 7 *sira* [correction by Francesco di Giorgio, n.1]	*sia*	*sia*
line 9 *e volte* [added by Francesco di Giorgio, n.2]; *E rincontra*	omitted; *et anco rinchonta*	*e volte* omitted; *et ancho inco[n]tra*
line 13 *del franbo* [for *fabro*, n.6]	unclear	*del fabro* [correction]
line 16 *si dice* [correction, n.7]	*dette sono*	*ditte sono*
line 17 *mezzi tretanti* [the Vitruvian term is *medi tetrantes*, n.8]	*mezzi tretanti*	*mezi tratati*
line 24 *Tarchesio*	*Arkesios*	*Terchepio*
p.96		
line 1 *trovar*	*trovar*	*ritrovar*
FOL.39v Beams, roof structures and chimneys	FOL.39v Beams, roof structures and chimneys	FOL.39v Beams, roof structures and chimneys
(Maltese 1967, I, p.96, line 11–p.97, line 12)	(Marani 1979, II, p.45, cap.LXXXIV–LXXXV)	
p.96		
line 12 *ventosi o* [n.3]	*ventosi*	*ventosi*
line 16 *aperta*	*aperta*	*cop[er]ta*

SALUZZIANO	LAURENZIANA	SOANE
line 17 — *e luogo*	*e luogo*	*del luogo*
line 26 — *stensione*	*stensione*	*stantione*
line 27 — *cappa*	*cappa*	*campana*
line 28 — *piramida* [n.6]	*piramida sia*	*piramide sia*
line 30 — *sera* [n.7]	*sia*	*sia*
p.97		
line 2 — *larghezza con uno capello elevato*	*sia* added after *larghezza*	*largheza sia come levato*
FOL.40r Fireplaces	FOL.40r Fireplaces	FOL.40r Fireplaces
(Maltese 1967, I, p.97, line 13–p.98, line 8)	(Marani 1979, II, p.46, cap.LXXXV)	
p.97		
line 26 — *giovan*	*giovare* correctly	*giovare*
line 29 — *cappa*	*cappa*	*campana*
line 32 — *cappa*	*cappa*	*campana*
FOL.40v Chimneys	FOL.40v Chimneys	FOL.40v Chimneys
(Maltese 1967, I, p.98, line 9–p.99, line 9)	(Marani 1979, II, pp.46-7, cap.LXXXV)	
p.98		
line 11 — *le parti di fuori el fumo*	as MS T	*delle p[a]rte il fumo*
line 14 — *saranno* [correction by Francesco di Giorgio, n.2]	*sono*	*sono*
line 15 — *in nella sua*	*in nella sua*	*in la sua*
line 17 — *formata*	*formato* correctly	*formato* [correction]
p.99		
line 2 — *pie quattro*	*quatro*	*quatro*
line 7 — *Questi tali camini perfetti sono* added in a later hand, omitted in MS L	*appresso de' Greci zeti detti sono che a forma di zeta essare fatti pare*	*camini appresso de G[reci]a zeti ditti sono p[er]ch[e] a forma de zetta fatti pare*
FOL.41r Baths	FOL.41r Baths	FOL.41r Baths
(Maltese 1967, I, p.99, line 9–p.100, line 18)	(Marani 1979, II, p.47, cap.LXXXV–LXXXVI)	
p.99		
line 14 — *i bagni*	*bagni*	*bagni*
line 22 — *sera* [correction by Francesco di Giorgio, n.7]	*sia*	*sia*
line 26 — *da se uno*	*da se uno*	*da esse uno*
p.100		
lines 1–2 — *anbasamenti* [n.1]	*abassamanti* [correction]	*abassamenti* [correction]
line 5 — *fussero* [correction by Francesco di Giorgio, n.2]	*sieno*	*siano*
lines 16–17 — *in nel vano* [n.4]	*in nel vano* omitted; *esso muro* substituted	*in nel vano* omitted, *esso muro* substituted
FOL.41v Baths	FOL.41v Baths	FOL.41v Baths
(Maltese 1967, I, p.100, line 18–p.101, line 22)	(Marani 1979, II, pp.47-8, cap.LXXXV–LXXXVI)	
p.100		
line 19 — *esedo*	*esedo*	*exito*
line 20 — *condotto; forno*	*condotto sia; fuocho*	*co[n]doto sia; fuocho* deleted to *forno*
line 28 — *ordinato* [n.8]	*ordinato sia*	*ordinato sia*
p.101		
line 6 — *circulare* [n.1]	*circulare esse*	*circulare ad esse*
line 7 — *gomentare*	*achomentare*	*augome[n]tare*
line 10 — *riscaldi, e'l fumo per*	*riscaldi, e'l fumo per*	*riscaldi il forno per*
line 15 — *d'altezza*	*d'altezza*	*dal terzo*
line 20 — *drento alquanto*	*drento alquanto*	*alquanto*
FOL.42r Rustic building	FOL.42r Rustic building	FOL.42r Rustic building
(Maltese 1967, I, p.101, line 22–p.102, line 18)	(Marani 1979, II, p.48, cap.LXXXVI–LXXXVII)	
p.101		
line 23 — *cor rastrello*	*cor rastrello*	*con il rastrello*
line 24 — *sommita*	*estremita*	*estremita* deleted, *sumita* added
line 30 — *buono loto*	*buono loto*	*buo(n) coto*
line 33 — *li mettar*	*li mettar*	*limitar*
p.102		
line 8 — *da voltare* [n.3]	*essar volto*	*esser volto*
line 10 — *fienari; far penso*	*fienari; a fare sono*	*sionari; a fare sono*

SALUZZIANO	LAURENZIANA	SOANE

FOL.42V Tuscan buildings and houses of the Greeks (Maltese 1967, I, p.102, line 18–p.103, line 18)

FOL.42V Tuscan buildings and houses of the Greeks (Marani 1979, II, pp.48–9, cap.LXXXVII–LXXXIX)

FOL.42V Tuscan buildings and houses of the Greeks

	SALUZZIANO	LAURENZIANA	SOANE
p.102			
line 25	*in es[s]e* [correction by Francesco di Giorgio, n.11]	*a esse*	*ad esse*
line 27	*colombaro*	*colombaro*	*colo[m]bagio*
p.103			
line 12	*In nelle*	*In nelle*	*in* added later
line 13	*architrave* [correction by Francesco di Giorgio, n.2]	*pilastri*	*pilastri*

FOL.43r Gymnasia (Maltese 1967, I, p.103, line 19–p.105, line 5)

FOL.43r Gymnasia (Marani 1979, II, p.49, cap.LXXXIX–XC)

FOL.43r Gymnasia

	SALUZZIANO	LAURENZIANA	SOANE
p.103			
lines 19–20	*che larga sia*	*che larga sia*	*che di larghezza sia*
p.104			
line 8	*perfettamente*	*perfettamente*	*perfettamente* omitted
line 9	*cento pie* [n.2]	*cento*	*venti*
line 16	*d'uopera*	*duopera*	*nepita*
line 17	*procrei andamenti* [n.7]	*prodrei andamenti*	*podrei andamenti*

FOL.43v Nature of materials, lime, bricks and stone (Maltese 1967, I, p.105, line 5–p.106, line 9)

FOL.43v Nature of materials, lime, bricks and stone (Marani 1979, II, p.49, cap.XC)

FOL.43v Nature of materials, lime, bricks and stone

	SALUZZIANO	LAURENZIANA	SOANE
p.105			
line 16	*feva*	*feva*	*faceva*
line 23	*denso*	*denso*	*di esso*
line 25	*perche riarde e triste presa fa. Et…*	*perche riarde e triste presa fa. Et…*	*perche riarde et pocca pre fa et trista. Et…*
p.106			
line 2	*terra* [n.2]	*terra fa* incorrectly	*terra fa*

FOL.44r Stone and wood (Maltese 1967, I, p.106, line 9–p.107, line 10)

FOL.44r Stone and wood (Marani 1979, II, p.50, cap.XC)

FOL.44r Stone and wood

	SALUZZIANO	LAURENZIANA	SOANE
p.106			
line 11	*peperino*	*peperino*	*peregrini*
line 17	*in fondi* [n.7]	*ne'fondi*	*in fondo*
line 18	*regge*	*regge*	*raggione*
line 22	*oppio* [n.9]	*poppio* possibly for *pioppo*	*populo*
line 24	*setim* [n.10]	*setim*	*satino*
p.107			
line 3	*oppressi da la* [n.2]	*veduto la*	*vedutola*
line 6	*natura*	*natura*	*materia*

FOL.44v Villa and hunting park (Maltese 1967, I, p.106, line 9–p.107, line 10)

FOL.44v Villa and hunting park (Maltese 1967, I, p.106, line 9–p.107, line 10)

FOL.44v Villa and hunting park

	SALUZZIANO	LAURENZIANA	SOANE
p.107			
line 13	*entrate*	*entrate*	*strade*
line 19	*perticate stecchi; entrate*	*perticate stecchi; entrate*	*palli secchi; strade*
line 22	*esterte e serene*	*esterte e serene*	*strette e serate*
p.108			
line 4	*ingrillandato*	*ingrillandato*	*inghirlandato*
line 11	*giena*	*giena*	*vena*
line 14	*bretti* [n.7]	*bretti*	*bretti* omitted
line 17	*possino; ingrillandato*	*possi; ingrillandato*	*si possino; inghirla[n]data*
line 20	*letrelle; albari*	*letrelle; albatri* [correction]	*letrelle* omitted; *albatri*

FOL.45r Shelters at the mouths of rivers (Maltese 1967, I, p.108, line 21–p.109, line 22)

FOL.45r Shelters at the mouths of rivers (Marani 1979, II, p.51, cap.XCI–XCII)

FOL.45r Shelters at the mouths of rivers

	SALUZZIANO	LAURENZIANA	SOANE
p.108			
line 30	*sarmia*	*sarmia*	*santia*
line 31	*leprina*	*leprina*	*leprina* omitted
p.109			
line 1	*essi*	*essi*	*sassi*
line 4	*sopra foce* [n.2]	*sopr'al golfo*	*sopra il colpho*
line 6	*in questo modo* [n.5]	*in questo*	*in questo*
line 22	*E* [n.7]	*Anche*	*Ancho*

SALUZZIANO	LAURENZIANA	SOANE

FOL.45v Harbours at the mouths of rivers

	SALUZZIANO	LAURENZIANA	SOANE
	(Maltese 1967, I, p.109, line 22–p.110, line 27) p.110	(Maltese 1967, I, p.109, line 22–p.110, line 27)	
line 5	*ferma*	*ferma*	*forma*
line 6	*alzar*	*alzar*	*aligar*
line 11	*da far* [n.6]	*da far sono*	*da fare sono*
line 17	*cole*	*cole*	*con le*
line 18	*prugare*	*prugare*	*purgar* [correction]
line 20	*necessarie. In* [n.10]	*necessarie sono*	*necessarie sono et*

FOL.46r Foundations, cisterns, filters and conduits

	SALUZZIANO	LAURENZIANA	SOANE
	(Maltese 1967, I, p.110, line 27–p.111, line 34) p.111	(Marani 1979, II, pp.52–3, cap.XCIV)	
line 11	*loro*	*sue*	*sue*
line 25	*galazza*	*galazza*	*galanga*
lines 29–30	*intorno. Di; in nel vacuo* [n.7]	*intorno farai; in vacuo*	*intorno farai; in vacuo*

FOL.46v Cisterns

	SALUZZIANO	LAURENZIANA	SOANE
	(Maltese 1967, I, p.112, line 1–p.112, line 31) p.112	(Marani 1979, II, p.53, cap.XCV–XCVI)	
line 14	*dependenzia* [n.2]	*dependenzia sia*	*dependenzia sia*

FOL.47r A cistern, inverted siphons, bringing water to a fountain in a city, the construction of water conduits

	SALUZZIANO	LAURENZIANA	SOANE
	(Maltese 1967, I, p.112, line 31–p.113, line 31; Marani 1979, II, pp.53–4, cap.XCVI–XCVII) p.112	(Marani 1979, II, pp.53–4, cap.XCVI–XCVII)	
line 32	*galazza*	*chalo[n]ga*	*chalo[n]ga*
p.113			
line 3	*galazza*	*chalangetta*	*galangata*
line 7	*intervallo d'alcun fosso fusse*	*intervallo d'alcun fosso fusse*	*alcu[n] fosso intervalo fosse*
line 20	*cenare di cerro* [n.2]	*cenere*	*cenere*
line 23	*a*	*a*	*et*
line 24	*anvestire* [n.5]	*anvestire sono tirata sia*	*investire sono*

FOL.47v Excavation of tunnels for water conduits

	SALUZZIANO	LAURENZIANA	SOANE
	(Maltese 1967, I, p.113, line 31–p.114, line 30) p.113	(Marani 1979, II, p.54, cap.XCVII–XCVIII)	
line 33	*tirata* [n.6]	*tirata sia*	*tirata sia*
line 34	*che a quella medesima dirittura che la corda tirarai* [p.114]	*che a quella medesima dirittura che la corda tirar ai*	omitted
p.114			
line 2	*pozzo* [n.2]	*pozzo va*	*pozzo va*

FOL.48r Water filters

	SALUZZIANO	LAURENZIANA	SOANE
	(Maltese 1967, I, p.114, line 31–p.115, line 30) p.115	(Marani 1979, II, p.54, cap.XCVIII–C)	
line 1	*terreni*	*terreni*	*caminir*
line 2	*lamano*	*lamano*	*cavano*
line 13	*inanti*	*inanti*	*inanti* omitted
line 17	*galazze*	*galanga*	*galanga*
line 19	*galazze*	*galanga*	*galanga*
line 20	*acqua* [n.3]	*acqua sia*	*acqua sia*
line 22	*galazza*	*galanga*	*galanga*
line 30	*escira*	*escira*	*sera*

FOL.48v Glazes or stuccoes

	SALUZZIANO	LAURENZIANA	SOANE
	(Maltese 1967, I, p.115, line 31–p.116, line 21) p.116	(Marani 1979, II, p.55, cap.CI)	
line 1	*di quindici*	*di quindici*	*quindici giorni*
line 11	*che*	*che*	*p[er]che*
line 17	*litargilio*	*litargilio*	*litargirio* [correction]

SALUZZIANO	LAURENZIANA	SOANE

FOL.49r Geometry, measuring distances, height and depths; basic geometrical forms
(Maltese 1967, I, p.117, line 9–p.118, line 22)
p.118
line 4 *linie*

FOL.49r Geometry, measuring distances, height and depths; basic geometrical forms
(Marani 1979, II, p.56, cap.CII)

linie prodotte dalla intersezione di altre piani

FOL.49r Geometry, measuring distances, height and depths; basic geometrical forms

linie

FOL.49v Basic geometrical forms
(Maltese 1967, I, p.118, line 21–p.119, line 26)
p.118
line 33 *ypoleos*
p.119
line 4 *tre lati* [n.2]
line 7 *letoroni miches* [n.3]
line 8 *contrari* [n.5]
line 14 *paratelle*

FOL.49v Basic geometrical forms
(Marani 1979, II, pp.56–7, cap.CII) (100)

ysoleon

tre e lati [*e* meaning *i*]
letoroni miche
contari
paratelle

FOL.49v Basic geometrical forms

ysalon

tre li lati
Ateronimiches
copiali
parallela [correction]

FOL.50r Geometrical solids, columns, an obelisk and a quadrant
(Maltese 1967, I, p.120, line 1–p.121, line 6)
p.121
line 1 *li* [n.1]

FOL.50r Geometrical solids, columns, an obelisk and a quadrant
(Marani 1979, II, p.57, cap.CII–CIV)

li e

FOL.50r Geometrical solids, columns, an obelisk and a quadrant

et di

FOL.50v Measuring heights
(Maltese 1967, I, p.121, line 7–p.122, line 15)
p.122
line 10 *Pero*
line 11 *essa*
lines 13–14 *guardare*
lines 16–18 *divide in cento quara[n]ta quattro*
line 23 *ombra*

FOL.50v Measuring heights
(Marani 1979, II, pp.57–8, cap.CV–CVIII)

P[er]o
essa
mirare
divide in cento quara[n]ta quattro as MS T
ombra retta

FOL.50v Measuring heights

Poi
esse omitted
mirare
repeated twice
ombra rata

FOL.51r Surveying with a quadrant
(Maltese 1967, I, p.122, line 15–p.123, line 20)
p.122
line 28 *montiprica*

FOL.51r Surveying with a quadrant
(Marani 1979, II, p.58, cap.CVIII–CXI)

montiprica

FOL.51r Surveying with a quadrant

moltiplica

FOL.51v Measuring the heights of towers
(Maltese 1967, I, p.123, line 20–p.124, line 30)
p.123
line 20 *tanto e. E questo*
p.124
line 1 *torre saper*
line 2 *dinanzi da te diverso*
line 4 CD
line 12 *gobiti*

FOL.51v Measuring the heights of towers
(Marani 1979, II, pp.58–9, cap.CXII–CXIV)

tanto e. E questo

torre saper
dinanci da te diverso
CD
gobiti

FOL.51v Measuring the heights of towers

tanto questo

torre separata sapere
dinanti diverso
A.C.D
cubiti

FOL.52r Measuring the heights of towers using mirrors
(Maltese 1967, I, p.124, line 30–p.126, line 1)
p.125
line 3 EG *del* HG [n.2]
line 25 PCD
line 29 *resta*

FOL.52r Measuring the heights of towers using mirrors
(Marani 1979, II, pp.59–60, cap.CXIV–CXVI)

eg dal KG
POCD
rimane

FOL.52r Measuring the heights of towers using mirrors

eg dal KG
POCD
rimane

FOL.52v Measuring the heights, depths and widths of towers, wells, ditches and fields without entering them
(Maltese 1967, I, p.126, line 1–p.127, line 3)
p.126
line 13 *bene numinate intero*
p.127
line 1 *perdare* [n.1]

FOL.52v Measuring the heights, depths and widths of towers, wells, ditches and fields without entering them
(Marani 1979, II, p.60, cap.CXVI–CXVII)

bene numinate intero

perdare tutta

FOL.52v Measuring the heights, depths and widths of towers, wells, ditches and fields without entering them

bene [blank space] *in terra*

perdere

SALUZZIANO

FOL.53r Measuring heights and distances
(Maltese 1967, I, p.127, line 3–p.128, line 1)

FOL.53v Calculating the area of a triangular
and a rectangular field
(Maltese 1967, I, p.128, line 1–p.129, line 4)
p.128
line 13 BC
line 14 AB

FOL.54r Drawing a square and measuring the
height of a tower
(Maltese 1967, I, p.129, line 6–p.130, line 7)
p.129
lines 5–6 *Or di cosi*
line 9 *dipoi* [n.2]
line 11 *linie* [n.3]
line 33 *che ne viene* [n.4]
p.130
line 4 *di terra*

FOL.54v Measuring the height of a tower and the
depth of a well using an instrument with an inclin-
ing viewfinder
(Maltese 1967, I, p.130, line 7–p.131, line 5)
p.130
line 10 Q [n.3]
line 23 *trecento tre* [n.4]

FOL.55r Measuring the depth of a well
(Maltese 1967, I, p.131, line 5–p.132, line 9)
p.131
line 26 *al ponte* D

FOL.55v Measuring with a geometrical square,
measuring the widths of stretches of water
(Maltese 1967, I, p.132, line 10–p.133, line 12)
p.132
line 19 *si possa muovare e sia questo* E
lines 20–21 *quella cosa*

FOL.56r Diagram of an astrolabe, measuring the
radius of an arch and squaring a circle
(Maltese 1967, I, p.133, line 12–p.134, line 14)
p.134
lines 6–7 *che saran* [n.1]

FOL.56v Calculating the diameters and circumfer-
ences of circles
(Maltese 1967, I, p.134, line 15–p.135, line 25)
p.134
line 16 *quello che ti*
line 19 *in a altro* [n.6]
line 23 *in nella*
p.135
lines 18–19 *Anco…orato* [n.5]

FOL.57r Calculating the circumference and
area of a circle
(Maltese 1967, I, p.135, line 25–p.137, line 2)
p.136
line 32 *tutte e quattro*

LAURENZIANA

FOL.53r Measuring heights and distances
(Marani 1979, II, p.60, cap.CXVII–CXVIII)

FOL.53v Calculating the area of a triangular
and a rectangular field
(Marani 1979, II, p.61, cap.CVIII–CXX)

BC
AB

FOL.54r Drawing a square and measuring the
height of a tower
(Marani 1979, II, pp.61–2, cap.CXX–CXXII)

Or di cosi
dipoi lo
linie e cosi
viene

in terra [correction]

FOL.54v Measuring the height of a tower and the
depth of a well using an instrument with an inclin-
ing viewfinder
(Marani 1979, II, p.62, cap.CXXII–CXXIII)

0 [correction]
tre trentatre

FOL.55r Measuring the depth of a well
(Marani 1979, II, pp.62–3, cap.CCXXIII–CCXXIV)

al ponte D

FOL.55v Measuring with a geometrical square,
measuring the widths
(Marani 1979, II, p.63, cap.CXXV–CXXVII)

si possa muovare e sia questo E
lines 20–21 *quella cosa*

FOL.56r Diagram of an astrolabe, measuring the
radius of an arch and squaring a circle
(Marani 1979, II, pp.63–4, cap.CXXVII–CXXIX)

saran

FOL.56v Calculating the diameters and circumfer-
ences of circles
(Marani 1979, II, p.64, cap.CXXX–CXXXII)

quello che ti
nel'altro correctly
in nella

lines 18–19 omitted

FOL.57r Calculating the circumference and
area of a circle
(Marani 1979, II, p.65, cap.CXXXII–CXXXIV)

tutte e quattro

SOANE

FOL.53r Measuring heights and distances

FOL.53v Calculating the area of a triangular
and a rectangular field

AB
BC

FOL.54r Drawing a square and measuring the
height of a tower

dico cosi
dipoi
le linee et cosi
viene

in terra

FOL.54v Measuring the height of a tower and the
depth of a well using an instrument with an inclin-
ing viewfinder

trenta tre

FOL.55r Measuring the depth of a well

al ponte B [correction] (Maltese 1967, I, n.5)

FOL.55v Measuring with a geometrical square,
measuring the widths

si possi rinonare
lines 20–21 *quella cosa* omitted

FOL.56r Diagram of an astrolabe, measuring the
radius of an arch and squaring a circle

saran

FOL.56v Calculating the diameters and circumfer-
ences of circles

quel ti
nel'altro correction
nella

lines 18–19 *Anco…forato* omitted

FOL.57r Calculating the circumference and
area of a circle

tutte quatro

SALUZZIANO	**LAURENZIANA**	**SOANE**
FOL.57V A square inscribed in a circle and a circle inscribed in a triangle	FOL.57V A square inscribed in a circle and a circle inscribed in a triangle	FOL.57V A square inscribed in a circle and a circle inscribed in a triangle
(Maltese 1967, I, p.137, line 2–p.138, line 9)	(Marani 1979, II, p.65, cap.CXXXIV–CXXXVI)	
p.138		
line 1 *meta che e dodici*	*meta che e dodici*	*meta che e radice*
line 8 *Ora a*	*Ora a*	*Hora e*
FOL.58R Measuring the area of a pentagon	FOL.58R Measuring the area of a pentagon	FOL.58R Measuring the area of a pentagon
(Maltese 1967, I, p.138, line 9–p.139, line 16)	(Marani 1979, II, p.66, cap.CXXXVI–CXXXVII)	
p.138		
line 13 *Aggiungi* [n.4]	*Hora aggiungi*	*Hora aggiungi*
line 15 *dodici e quatro*	*otto a dodicie quatro*	*otto e dodici gli e quatro*
line 16 *insino* [n.5]	*a*	*fino*
FOL.58V Perspective	FOL.58V Perspective	FOL.58V Perspective
(Maltese 1967, I, p.139, line 16–p.141, line 20)	(Marani 1979, II, pp.66–7, cap.CXXXVIII–CXXXIX)	
p.139		
lines 19–20 *Et a volere trovare… da fare* [n.6]	omitted	omitted
p.141		
line 13 *bracchia* 2 [n.4]	*braccia*	*braza doe*
lines 17–19 *E se sera braccia sedici… per libra*	*E se sera braccia sedici…per libra*	omitted
FOL.59R Lifting weights and an elevation of a half-wheel	FOL.59R Lifting weights and an elevation of a half-wheel	FOL.59R Lifting weights and an elevation of a half-wheel
(Maltese 1967, I, p.141, line 20–p.142, line 22)	(Marani 1979, II, p.67, cap.CXXXIX–CXL)	
p.142		
line 15 *spriemar non si puo* [*non* was added later, n.1]	*spriemar si puo*	*esprimer si po*
line 25 *po*[*ssano* erased, n.2]	*possano*	*possano*
FOL.59V Mills	FOL.59V Mills	FOL.59V Mills
(Maltese 1967, I, p.142, line 23–p.144, line 6)	(Marani 1979, II, pp.67–8, cap.CXLI–CXLV)	
p.143		
line 2 *piei diciotto, in nella quale*	*piei diciotto in nella quale*	*poi di sotto in la qual*
line 3 *el* [n.1]	*sia el*	*sia il*
line 5 *el rocchetto* [n.2]	*sia e rocchetto*	*sia e rochetto*
line 17 *e da fare* [n.8]	*far si puo*	*far si puo*
p.144		
line 1 *gusci*	*gusci*	*posti*
line 2 *guscio* [n.3]	*guscio sia*	*chiuso sia*
line 3 *gusci*	*gusci*	*ghusti*
FOL.60R Mills driven by water	FOL.60R Mills driven by water	FOL.60R Mills driven by water
(Maltese 1967, I, p.144, line 6–p.145, line 13)	(Marani 1979, II, pp.68–9, cap.CXLV–CXLVII)	
p.144		
line 6 *la ruota*	*la ruota*	*lavorata*
line 9 *al diritto*	*al diritto*	*al ditto*
line 11 *fare* [n.8] .	*fare si puo*	*fare si puo*
line 14 *con croci*	*con croci*	*corroci*
line 29 *e da fare* [n.11]	*far si puo*	*fare si puo*
p.145		
line 6 *dentro* [n.1]	*dentro sia*	*dentro sia*
line 8 *dove i denti sono, veloce*	*dove i denti sono, veloce*	*dove velocemente*
line 13 *la figura* E *dimostra*	*la figura* E *dimostra*	*la figura dimostra signata* E
FOL.60V Mills driven by water	FOL.60V Mills driven by water	FOL.60V Mills driven by water
(Maltese 1967, I, p.145, line 14–p.146, line 17)	(Marani 1979, II, pp.69–70, cap.CXLVIII–CLIX)	
p.145		
line 15 *e da fare* [n.2]	*fare si puo*	*fare si po*
line 16 *dell'acqua* [n.3]	*d'acqua*	*del'acqua*
line 17 *move ma*	*muove*	*muove*
line 19 *va* [correction n.4]	*muove*	*move*
lines 28–9 *segnata* G *si manifesta*	*segnata* G	*si manifesta*
p.146		

SALUZZIANO	LAURENZIANA	SOANE
line 2 *sotto sia* [n.1]	*sotto d'essa*	*sotto di essa*
line 3 *figura segnata* I *dimostra* [n.2]	*sicomme figurato si dimostra segnato* I	*figurato si mostra segnato* I
lines 4–5 *figura segnata* K [n.3]	K *manifesta*	*figura dimostra signata* K

FOL.61r Mills driven by water — (Maltese 1967, I, p.146, line 17–p.147, line 20) / (Marani 1979, II, p.70, cap.CLIX–CLX)

p.146
| line 29 *interposta* [n.7] | *interposta sera* | *interposta sera* |
| line 30 *segnato* O [n.8] | *segnato* O *si manifesta* | *segnato* O *manifesta* |

p.147
line 3 *circunferenzia* [n.1]	*circunferenzia sia*	*circunferenzia sia*
line 7 P [n.2]	P *manifesta*	P *manifesta*
line 9 *dentato* [*che* correction by the copyist above *el quale*; n.3]	*dentato el quale*	*dentato el quale*
line 12 *lieva* [n.4]; Q *dimostra* [n.5]	*lieva d'essa*; Q *dinotando*	*lieva d'essa*; Q *dinotando*
line 18 *figura* [n.7]	*figura manifesta*	*figura mostra*

FOL.61v Mills driven by water, with automatic water supplies and a horse-driven mill — (Maltese 1967, I, p.147, line 20–p.149, line 1) / (Marani 1979, II, pp.70-71, cap.CLX–CLXIII)

p.147
| line 24 *scoglio* | *scoglio* | omitted |

p.148
lines 5–17 the text describes mill x	the text describes mill v, which has been moved to after mill x, beginning on p.148, line 24 *operare si come la figura* x *dimostra.*	The text describes mill v, which has been moved to after mill x. Mill x is drawn on fol. 62. *operare si come la figura* x *dimostra et*
line 14 *ad operare* [n.6]	*Et questi in ogni loco fare si possano* omitted	*q[ue]sti in ogni loco fare si possino* omitted
lines 16–17 *E questi.emostra* inserted in MS L, after *operare* [n.6]		

FOL.62r Mills driven by stillwater and by hand — (Maltese 1967, I, p.149, line 1–p.149, line 34) / (Marani 1979, II, pp.71-2, cap.CLXIV–CLXVII)

p.149
line 6 *acquaia*	*acquaia*	*agiata*
line 21 z *si manifesta* [n.3]	z	z *si dimostra*
line 32 *guida*	*chiuda*	*chiuda*

FOL.62v An animal-powered mill and floating mills — (Maltese 1967, I, p.150, line 1–p.151, line 2) / (Marani 1979, II, p.72, cap.CLXVIII–CLXXII)

p.150
line 5 *pie 12* [added later, n.1]	*quindeci*	*quindeci*
line 12 IIII [n.2]	IIII *dimostra*	IIII *dinota*
line 19 *un pie* [n.4]	*pie*	*pie*
line 21 *siccome* v (n.5)	v *manifesta*	v *manifesta*

FOL.63r Windmills, still-water mills — (Maltese 1967, I, p.151, line 3–p.152, line 9) / (Marani 1979, II, p.73, cap.CLXXIII–CLXXV)

p.151
line 7 *lo stile*	*esso stile*	*esso stile*
lines 9–13 example missing from MS L [n.4]	entirely omitted	omitted
line 17 *manifesta*	*manifesta*	*mostra*
lines 20–21 *quaranta piei sopra terra sia*	as MS T	*sopra terra quaranta piedi sia*
line 29 *volvendo*	*volvendo*	*voltando*

p.152
| lines 7–8 *percote in diamitro per venticinque* [n.1] | *percote in diametro pie diciotto et la seconda rota in diamitro pie vinticinque* correctly | *percote in diametro pie deciotto et la seconda rotta in diametro pie vinticinque* |

FOL.63v Watermills powered by automatic water supply — (Maltese 1967, I, p.152, line 9–p.153, line 13) / (Marani 1979, II, pp.73-4, cap.CLXXV–CLXXVIII)

p.152
line 14 *pelago*	*pelago*	*sotto*
line 17 *ruota*	*ruota sia*	*ruota sia*
line 18 x *dimostra* [n.4]	x *ci dimostra*	x *si dimostra*

p.153
line 2 *cho* [n.1]	*che* correctly	*che*
line 3 *ci* [n.2]	*ci* omitted	*ci* omitted
line 7 *tomboli*	*toboli*	*triboli*

SALUZZIANO	LAURENZIANA	SOANE
FOL.64r Mills powered by animals (Maltese 1967, I, p.153, line 13–p.154, line 14)	FOL.64r Mills powered by animals (Marani 1979, II, pp.74–5, cap.CLXXIX–CLXXXII)	FOL.64r Mills powered by animals
p.153		
line 23 *e da dare* [n.6]	*he da[n]dare* incorrectly	*a da dare*
line 25 *dimostra* [n.7]	*mostra*	*mostra*
p.154		
line 6 *dimostra*	*dimostra*	*mostra*
FOL.64v Windmills and a mill driven by a man (Maltese 1967, I, p.154, line 14–p.155, line 14)	FOL.64v Windmills and a mill driven by a man (Marani 1979, II, p.75, cap.CLXXXIII–CLXXXV)	FOL.64v Windmills and a mill driven by a man
p.154		
line 16 XVII *ci demostra*	*prexente ci dimostra*	*17 demostra*
line 24 *aguisa*	*aguisa*	*aguisa* omitted
line 26 *segnata*	*manifesta*	*dimostra*
p.155		
line 6 *rebecco* corrected [n.3]	*rocco*	*rocho*
FOL.65r Undershot watermills and an overshot waterwheel (Maltese 1967, I, p.155, line 15–p.156, line 1)	FOL.65r Undershot watermills and an overshot waterwheel (Marani 1979, II, pp.75–6, cap.CLXXXVI–CLXXXIX)	FOL.65r Undershot watermills and an overshot waterwheel
p.155		
line 21 *mostra* [n.4]	*ci dimostra*	*dimostra*
p.156		
line 2 *demostra* [n.1]	*mostra*	*dimostra*
line 3 *Quando per acqua mulino*	*Quando per acqua mulino*	*Qu[an]do molino p[er] acqua*
line 8 *piana*	*piana*	*prima*
line 12 *mulin* [n.3]	*mulin sia*	*molino sia*
FOL.65v Still watermills and a float-wheel mill (Maltese 1967, I, p.156, line 17–p.157, line 18)	FOL.65v Still watermills and a float-wheel mill (Marani 1979, II, p.76, cap.CLXXXIX–CXCI)	FOL.65v Still watermills and a float-wheel mill
p.156		
line 17 *ch'e*	*che*	*d'*
line 20 *girando* [n.4]	omitted	*girando* omitted
line 24 *siccome* [n.6]	*come*	*come*
p.157		
line 4 *in mezzo*	*in mezzo*	*insieme*
FOL.66r Float-wheel mill and an animal-powered mill (Maltese 1967, I, p.157, line 19–p.158, line 18	FOL.66r Float-wheel mill and an animal-powered mill (Marani 1979, II, pp.76–7, cap.CXCI–CXCIII)	FOL.66r Float-wheel mill and an animal-powered mill
p.157		
line 20 *dieci* [n.3]	*dieci sera*	*dieci sara*
line 21 *manifesta*	*manifesta*	*dimostra*
line 31 *pie* [2 added above the line; n.4]	*pie*	*pie*
p.158		
line 4 *agomenta*	*agomenta*	*augumentare*
line 7 *verra* [n.1]	*vera siccome la figura* XXVII *demostra*	*vera si come la figura 27 dimostra*
line 10 *siccome la figura* XXVII *dimostra* [n.1]	*si come dimostra* omitted	as MSL
line 11 *utilissimo*	*utilissimo*	*utilissimo* omitted
line 13 *croscie*	*croce* [correction]	*croce*
FOL.66v Float-wheel mills, a siphon powering a mill and a horse-powered mill (Maltese 1967, I, p.158, line 19–p.159, line 18)	FOL.66v Float-wheel mills, a siphon powering a mill and a horse-powered mill (Marani 1979, II, p.66, cap.CXCIV–CXCVII)	FOL.66v Float-wheel mills, a siphon powering a mill and a horse-powered mill
line 31 *dare*	*dare si puo*	*dare si puo*
p.159		
line 1 *aiuto*	*aiuto*	*aciuto*
line 7 *da fare* [n.1]	*da fare si come la figura* XXX *si dimostra*	*da fare si come la figura* XXX *si dimostra* [this phrase is on line 8 of MS T]
line 10 *comoda*	*comodita*	*comodita*
line 18 *mostra*	*mostra*	*manifesta*

SALUZZIANO	LAURENZIANA	SOANE

FOL.67r Springs and ways of raising and conducting water
(Maltese 1967, I, p.160, line 6–p.161, line 5)
p.160

FOL.67r Springs and ways of raising and conducting water
(Marani 1979, II, p.78, cap.CXCVIII–CXCIX)

FOL.67r Springs and ways of raising and conducting water

line 10 *sporro*	*sporro*	*spero*
line 23 *Si anco*	*si anco*	*anco*
lines 24–5 *e necessitato di riempirsi*	*necessitato di riempirsi*	*e necessario riempirla*
line 27 *putto*	*putto*	*ponto*

FOL.67v Underground water supplies
(Maltese 1967, I, p.161, line 5–p.162, line 5)
p.161

FOL.67v Underground water supplies
(Marani 1979, II, p.78, cap.CXCIX–CCII) (136)

FOL.67v Underground water supplies

line 13 *meno*	*meno*	*mancho*
line 18 *gretone* [=cretone]	*grato*	*grato*
line 26 *terreno nero*	*terreno nero*	*terreno magro*
line 27 *e sono lattate*	*e sono lattate*	*escono l'estate*
line 30 *enbio, ronbicie, calda equina* [n.5]	*ebio, robicie, cauda equina*	*ebio, rumice, cauda equina*
p.162		
line 1 *Anco*	*Anco*	*Ancora*

FOL.68r Underground water supplies
(Maltese 1967, I, p.162, line 5–p.163, line 13)
p.162

FOL.68r Underground water supplies
(Marani 1979, II, p.79, cap.CCIII–CCVIII)

FOL.68r Underground water supplies

line 13 *drento sereni*	*drento sereni*	*drento sereni* omitted
line 14 *giemitii*	*giemitii*	*giomitij*
line 15 *gretone*	*gretone*	*grattone*
line 16 *embrio*	*ebio*	*ebio*
line 25 *focaie*	*fochaie*	*faccie*
p.163		
line 1 *gretone*	*gretone*	*grattone*
line 10 *calda*	*calda*	*cauda acquina*

FOL.68v Underground water supplies
(Maltese 1967, I, p.163, line 13–p.164, line 26)
p.163

FOL.68v Underground water supplies
(Marani 1979, II, pp.79–80, cap.CCVIII–CCXI)

FOL.68v Underground water supplies

lines 19-20 *faggi overo ontani*	*faggi overo ontani*	*fa[n]gi over pa[n]tani*
p.164		
line 26 *fossa* [n.5]	*fossa esso*	*fossa esso*

FOL.69r Underground water supplies
(Maltese 1967, I, p.164, line 27–p.165, line 29)
p.164

FOL.69r Underground water supplies
(Marani 1979, II, p.80, cap.CCXI–CCXIII)

FOL.69r Underground water supplies

line 27 *cinta, e la fossa di tavole e terra dia essere cupirta*	*cinto sia dipoi di tavole la fossa da coprire*	as MS L
line 29 *estare*	*estare*	*stare*
line 31 *cento vinti, e s'e cresciuto*	*cento vinti, e s'e cresciuto*	*cento* [*e 20* added in a second hand]
p.165		
line 2 *tre; sessanta*	*tre; sessanta*	*due* [in a second hand]; *ottanta* [in a second hand]
line 17 *inoristana* [n.3]	*incristana* [correction for the Sienese word *inguistare*, a carafe]	*inghistera*
line 27 *tenghisi*	*tenghisi*	*toglisi*
line 29 *razzara* [n.5=*raggiare*]	*ragira*	*ragnira*

FOL.69v Natural hot and cold springs
(Maltese 1967, I, p.165, line 30–p.167, line 2)
p.166

FOL.69v Natural hot and cold springs
(Marani 1979, II, pp.80–81, cap.CCXIII–CCXIV)

FOL.69v Natural hot and cold springs

line 9 *ora di*	*hor fa*	*hor fa*
line 10 *trattaro*	*trattaro*	*tentero*
line 18 *seccaginosa*	*seccaginosa*	*sanguinosa*
lines 19–20 *et anco verdi* [n.3]	*et anco verdi* omitted	omitted
line 21 *sassi*	*sassi*	*fossi*
line 22 *volte*	*volte*	*voli*
line 28 *Quest'e*	*Quest'e*	omitted

SALUZZIANO	LAURENZIANA	SOANE
FOL.70r Geology and water characteristics (Maltese 1967, I, p.167, line 2–p.168, line 5) p.167	FOL.70r Geology and water characteristics (Marani 1979, II, pp.81–2, cap.CCXIV–CCXV)	FOL.70r Geology and water characteristics
line 3 *scendendo scemera*	*scendendo scemera*	*scende*
line 32 *inciesi*	*incieso*	*inasi*
FOL.70v Natural hot and cold springs (Maltese 1967, I, p.168, line 6–p.169, line 4) p.168	FOL.70v Natural hot and cold springs (Marani 1979, II, p.82, cap.CCXV)	FOL.70v Natural hot and cold springs
line 24 *del sasso*	*del sasso*	*del* [*essa* deleted] *sasso*
FOL.71r Siphons (Maltese 1967, I, p.169, line 5–p.178, line 11) p.169	FOL.71r Siphons (Marani 1979, II, p.82, cap.CCXVI)	FOL.71r Siphons
line 5 *sono; da*	*sono; da*	*havemo; di* [correction]
line 9 *cierco*	*ciercha*	*chercho*
line 12 *Alchindus, Hermes*	*Alchindus ermes*	*cindus, Pemes*
lines 13–14 *cosa di verita invenire l'ho possuto, salvo*	as MS T	*alcuno per esperie[n]tia ho p[ro]*
line 23 *acqua; tura*	*heccietto*	*vato et esp[er]ime[n]tato ne alcuna excetto*
line 31 *che quella* [a later addition by Francesco di Giorgio, n.9]	*acqua sia; tura* omitted	*acqua sia; tutta* omitted
p.170		
line 2 *el filosofo non datur vacuo* [n.2]	*el philoxofo non dictum vachuo dice*	*il che dice che no[n] dit[um] vacuu[m]*
line 3 *la figura segna* [n.3] MS T continues with a chapter on metals	The chapter on metals, beginning on p.171, is omitted; the chapter on raising water begins here	The chapter on metals is omitted and the chapter on raising water begins at the bottom of fol. 71r.
FOL.71v Aqueducts (Maltese 1967, I, p.178, line 11–179, line 10) p.178	FOL.71v Aqueducts (Marani 1979, II, p.83, cap.CCXVII–CCXVIII)	FOL.71v Aqueducts
line 10 *Anco l'acqua attrare* [n.1]	*anco per altro modo; l'acqua attrare* omitted	*Anco per altro modo; l'acqua attrare* omitted
line 12 *congionta*	*congionta sia*	*congionta sia*
line 22 *stura*	*estura*	*ottura*
p.179		
line 6 *segnati 2* [n.2]	omitted	omitted
FOL.62r bis, 72r Fountain and a navigable canal with locks (Maltese 1967, I, p.179, line 10–p.180, line 14) p.179	FOL.62r bis, 72r Fountain and a navigable canal with locks (Marani 1979, II, pp.83–4, cap.CCXVIII–CCXIX)	FOL.62r bis, 72r Fountain and a navigable canal with locks
line 11 *d'essa* [n.4]	*essa sia*	*essa sia*
line 19 *pieno* [n.5]	*pieno sia*	*pieno sia*
line 25 *segnata 3* [n.6]	omitted	omitted
line 29 *sopperire*	*sopperire*	*aperire*
line 30 *che detto*	*che detto*	*il ditto*
p.180		
line 1 *chiavica*	*chiavica*	*chiavica* omitted
line 12 *siccome…manifesta* [n.3]	omitted	*siccome…manifesta* omitted
line 13 *canali* [n.4]	*canali o*	*canali o*
FOL.62v bis, 72v Pumps (Maltese 1967, I, p.180, line 14–p.181, line 19) p.180	FOL.62v bis, 72v Pumps (Marani 1979, II, p.84, cap.CCXX–CCXXIII)	FOL.62v bis, 72v Pumps
line 15 *nel fondo d'esse un'animella a ciascuno. E in detta*	as MS T; *E in detta*	*nel fondo a ciascuna animella sia*
line 17 *animella sia*	*animella sia*	omitted
line 24 *fara*	*fara*	*sera*
p.181		
line 4 *quelli*	*quelli*	*esso*
line 9 III *ci manifesta* [n.3]	*si mostra la figura* III *e da o[r]denare*	*si dimostra nella figura .*III.
line 14 *manfro*	*manfro*	*mastro*
line 15 *demostra*	*demostra*	*dinota*

SALUZZIANO	LAURENZIANA	SOANE

FOL.63r bis, 73r Suction pumps

SALUZZIANO	LAURENZIANA	SOANE
(Maltese 1967, I, p.181, line 19–p.182, line 28)	(Marani 1979, II, p.85, cap.CCXXV–CCXXVII)	
p.181		
line 27 v *manifesta*	v *manifesta*	v *mostra*
p.182		
line 3 *timon*	*timo[n]*	*termino*
line 6 *si puo, sicomme la figura*	*si puo* [*siccome* is omitted]	*si po come nella figura* VI
VI *manifesta* [n.1]		
line 13 *ceppi*; VII *manifesta*	*ciepj*; VII *ci manifesta*	*venghi*; VII *manifesta*
line 18 *abbi*	*abbi*	*ambi*

FOL.63v bis, 73v Machines for raising water

SALUZZIANO	LAURENZIANA	SOANE
(Maltese 1967, I, p.182, line 28–p.184, line 3)	(Marani 1979, II, pp.85–6, cap.CCXXVIII–CCXXX)	
p.183		
line 17 *alta e bassa* [n.2]	*alto e basso* [correction]	*alto e basso* [correction]
line 22 *animella* [n.3]	*animella sia*	*animella sia*
lines 24–5 x *dimostra* [n.4]	x *ci dimostra*	x *dimostra*
line 29 *coverta*	*coverta*	*coperta*

FOL.64r bis, 74r Pumps

SALUZZIANO	LAURENZIANA	SOANE
(Maltese 1967, I, p.184, line 3–p.185, line 6)	(Marani 1979, II, p.86, cap.CCXXXI–CCXXXIV)	
p.184		
line 7 *sopra* [n.3]	*sopra a*	*sopra*
lines 9–10 *E a la sommita*	as MS T	*e nella*
line 15 *ch'e*	*ch'e*	[*ch'e* omitted]
line 18 *ci manifesta*	*ci dimostra*	*dimostra*
line 23 *mostra* [n.6]	*dimostra*	*denota*
line 26 *animella* [n.7]	*animella sia*	*animella sia*
line 31 *ci dimostra*	*ci dimostra*	*mostra*
p.185		
line 4 *ci dimostra*	*ci dimostra*	*si manifesta*

FOL.64v bis, 74v Machines for raising water

SALUZZIANO	LAURENZIANA	SOANE
(Maltese 1967, I, p.185, line 6–p.186, line 8)	(Marani 1979, II, p.87, cap.CCXXXV–CCXXXIX)	
p.185		
line 15 *Anco* [n.2]	*Anco* omitted	*Anco* omitted
line 28 *bisognasse* [n.3]	*bisognasse exercitare si po*	as MS L
line 30 *cioe una per ciascuna* [n.4]	*con due anime una a ciascuna*	*cioe* omitted, *con due anime una a ciascuna*
p.186		
line 7 *mantaci*	*mantaci*	*mentici*
The text continues with examples XXI–XXXI	The text breaks here	The text for machines XXI–XXXI, after *siccom'e*– is missing

FOL.65r bis, 75r Pile-drivers, cranes and machines for lifting heavy weights

SALUZZIANO	LAURENZIANA	SOANE
(Maltese 1967, I, p.188, line 13–p.189, line 19)	(Marani 1979, II, p.89, cap.CCL–CCLIII)	
p.188		
line 19 *manzo*	*mazzo*	*mazzo*
line 21 *venendo* [n.8]	*verra* [correction]	*vera* [correction]
line 23 *ci manifesta*	*ci manifesta*	*ci mostra*
line 25 *manzo*	*ma[n]zo*	*mazzo*
line 26 *ne'*	*ne'*	[*ne'* omitted]
line 27 *manzo*	*ma[n]zo*	*mazzo*
p.189		
line 1 *battendo* [n.1]	*battera* [correction]	*battera*
line 2 *mostra* [n.2]	*dimostra*	*ci dimostra*
line 17 *le rampe delle scommesse catene* [n.5]	*le rappe e catene*	*la ripa et cathene*
line 19 *calzari* [n.6]	*calzerai*	*calzerai*

FOL.65v bis, 75v Machines for hoisting columns into place

SALUZZIANO	LAURENZIANA	SOANE
(Maltese 1967, I, p.189, line 19–p.190, line 11)	(Marani 1979, II, pp.89–90, cap.CCLIV–CCLV)	
p.189		
line 20 *demostra*	*manifesta*	*manifesta*
p.190		
line 1 *tor*	*tor*	*tuore*

SALUZZIANO

FOL.66r bis, 76r Winches
(Maltese 1967, I, p.190, line 12–p.191, line 20)
p.190
line 13 *vite* [n.2]
line 16 *figura* I *manifesta*
line 20 *demostra* [n.5]
line 22 *curba* [n.6]
line 24 *ci manifesta* [n.7]
p.191
line 3 *ci manifesta* [n.1]
line 7 *guidando* [n.2]
line 10 *due* [n.3]
lines 10–11 *Si anco* [n.4]
line 13 *sicomme la figura* v *manifesta*
lines 19–20 *demostra*

FOL.66v bis, 76v Winches, machines for moving heavy weights along the ground
(Maltese 1967, I, p.191, line 21–p.192, line 26)
p.191
line 27 *ci manifesta*
line 28 *Sia fatto*
p.192
line 6 *bronzo*
line 7 *demostra*
line 11 *Anco si* [n.2]
line 18 *demostra* [n.3]
line 25 *demostra* [n.4]
The text continues from the beginning of IIII to example XXXIII G and the beginning of F.

FOL.67r bis, 77r Winch, amphibean transport and vehicles
(Maltese 1967, I, p.197, line 12–p.197, line 25)
p.197
line 17 *manifesta* [n.5]
line 22 *h demostra* [n.6]
line 25 *siccome la figura* J *dimostra* [n.7]

FOL.67v bis, 77v Military arts, qualities of a leader
(Maltese 1967, I, p.198, line 11–p.199, line 11)
p.198
line 12 *de'essa.*
line 14 *auldacie*
line 15 *nelle*
line 34 *si metterano in rotta*
p.199
line 6 *nemici* [n.1]
line 7 *sonniferate*
line 8 *fingendo*

FOL.68r bis, 78r Responsibilities of a leader and provisions for war
(Maltese 1967, I, p.199, line 11–p.200, line 12)
p.199
line 16 *da la lunga*
line 23 *gimbe*; from the Latin *cymba* or *cumba* [Maltese 1967, I, n.5]
line 26 *veggie*
lines 26–7 *argomenti*
p.200
line 11 *cuociare*

LAURENZIANA

FOL.66r bis, 76r Winches
(Marani 1979, II, pp.90–91, cap.CCLVI–CCLXI)

vite che [correction]
qui la figura I
demostra omitted
curva
ci manifesta omitted

ci manifesta omitted
guidando va
due sicome la figura v *manifesta*
si anco omitted
omitted
si manifesta

FOL.66v bis, 76v Winches, machines for moving heavy weights along the ground
(Marani 1979, II, p.91, cap.CCLXII–CCLXVI)

ci manifesta
Faccisi in nella

bronzo
manifesta
Anco si omitted
demostra omitted
demostra omitted
The break in the Laurenziana text occurs after the second line of chapter CCLXVII (Marani 1979, II, p.92)

FOL.67r bis, 77r Winch, amphibean transport and vehicles
(Marani 1979, II, p.95, cap.CCLXXXIX–CCXCI)

manifesta omitted
siccome la figura h demostra omitted
omitted

FOL.67v bis, 77v Military arts, qualities of a leader
(Marani 1979, II, p.96, cap.CCXCII–CCXCVIII)

de'essa.
auldacie
deto
vitoria aran[n]o

nemici acquistare
sonniferate
fingendo

FOL.68r bis, 78r Responsibilities of a leader and provisions for war
(Marani 1979, II, pp.96–7, cap.CCXCIX–CCCIII)

da la lunga
gimbe

veggie
argomenti

cuociare

SOANE

FOL.66r bis, 76r Winches

vite che
qui alla figura
dimostra
curva
ci mostra

ci manifesta
guidando va
dove sicome la figura quinta manifesta
si anco omitted
sicomme la figura V *manifesta* omitted
si manifesta

FOL.66v bis, 76v Winches, machines for moving heavy weights along the ground

mostra
Faciati nella

bra[n]zo
manifesta
Anco si omitted
manifesta
mostra
Break in the text; missing examples IIII–XXX, G and the beginning of F. The break in the MS L text occurs after the second line of chapter CCLXVII (Marani 1979, II, p.92).

FOL.67r bis, 77r Winch, amphibean transport and vehicles

dimostra
H *demostra*
sicome la figura J *manifesta*

FOL.67v bis, 77v Military arts, qualities of a leader

de'essa da tratare
audace
nelle
vittoria harai

nemici
sonniferate omitted
fugendo

FOL.68r bis, 78r Responsibilities of a leader and provisions for war

da longi
cibe

vazze et botte [correction]
instromenti

cacciare

SALUZZIANO	LAURENZIANA	SOANE

FOL.68v bis, 78v Responsibilities of a leader
(Maltese 1967, I, p.200, line 13–p.201, line 12)

p.200

line 17	*e steccatarsi*	*e steccarsi*	*e steccarsi* omitted
line 20	*stregnare*	*stregnare*	*stringer*
line 21	*all'altro*	*l'altro*	*l'altro*
line 27	*osseguire*	*osseguire*	*exeguire*
line 31	*una*	*una*	*haver*

p.201

line 6	*asa fetita*	*asa fetita*	*essa fetida*

FOL.68v bis, 78v Responsibilities of a leader
(Marani 1979, II, p.97, cap.CCCIV–CCCVI)

FOL.68v bis, 78v Responsibilities of a leader

FOL.69r bis, 79r Tricks to fool the enemy
(Maltese 1967, I, p.201, line 13–p.202, line 24)

p.201

line 21	*facidia*	*facidia*	*fal/ lacia*

p.202

line 1	*debbiti*	*debbiti*	*si debbi*
line 3	*e delle salmarie*	*e delle salmarie*	omitted
line 7	*e cosi la vittoria ottener porrai*	*ottene[n]do la vittoria*	*ottene[n]do la vittoria*
line 11	*veggie*	*veggie*	*botte*
line 14	*tebano; libra* [n.3]	*tebano; lira*	*thebacco; Libra*
line 15	*dentro* [n.4]	*dentro* omitted	*dentro* omitted

FOL.69r bis, 79r Tricks to fool the enemy
(Marani 1979, II, pp.97–8, cap.CCCVII–CCCVIII)

FOL.69r bis, 79r Tricks to fool the enemy

FOL.69v bis, 79v Tricks to fool the enemy
(Maltese 1967, I, p.202, line 25–p.204, line 7)

p.202

line 25	*oviosa*	*oviosa*	*odiosa*
line 27	*lo struzzo* [n.8]	*lo sturzo*	*lo struzzo*
line 28	*patisce; galloloro* for *galloria* [n.9].	*patisce; callo loro*	*digerisce; callo loro*

p.203

line 5	*Anco debba* [n.1]	*debba il capitano*	*debbi il capitano*
lines 10–12	*Quando per cammino…figura* added later [n.3]	omitted; the illustration is also omitted	omitted

FOL.69v bis, 79v Tricks to fool the enemy
(Marani 1979, II, p.98, cap.CCCIX–CCCXIII)

FOL.69v bis, 79v Tricks to fool the enemy

FOL.70r bis, 80r Naval Warfare
(Maltese 1967, I, p.204, line 7–p.205, line 13)

p.204

line 7	*E* [n.5]	*Dipoi*	*dopoi*
line 8	*operarla vorremo* [n.6]	*gittar si volesse*	*gettare si volesse*
line 12	*falcioni*	*falcioni*	*falzoni*
line 20	*cotto*	*cotto*	*cotto* omitted
line 22	*usar*	*attribuir*	*attribuir*

p.205

line 12	*ragia; ammoniaco* [n.3]	*ragia; armoniaco*	*resa; a moniaco*

FOL.70r bis, 80r Naval Warfare
(Marani 1979, II, p.99, cap.CCCXIV–CCCXVII)

FOL.70r bis, 80r Naval Warfare

FOL.70v bis, 80v Explosives
(Maltese 1967, I, p.205, line 14–p.206, line 22)

p.205

line 16	*solimato*	*solimato*	*sublimato* [correction]

p.206

line 4	*e oprelo*	*chop[r]elo*	*cop[er]to*
line 15	*fisso*	*fuso*	*fisso*
lines 17–18	*E fatto questo darali*	*di poi si lidia*	*di poi si lidia*
line 21	*fiso*	*fuso*	*fuso*

FOL.70v bis, 80v Explosives
(Marani 1979, II, pp.99–100, cap.CCCXVIII–CCCXXX)

FOL.70v bis, 80v Explosives

FOL.71r bis, 81r Explosives
(Maltese 1967, I, p.206, line 22–p.208, line 7)

p.206

lines 23–4	*da fuoco si levi*	*levalo da focco*	*levalo da focco*

p.207

line 1	*Fatto questo cavalo*	*popoi la cava*	*popoi la cava*
line 3	*vivo; sercocolla*	*vivo* omitted; *comino* added; *sechocholla*	*vivo* omitted; *comino* added; *secco con la*
line 7	*hliv galbarun* [n.4]	*hliv galbaru[m]* [n.4]	*olio galbano* [correction]
line 10	*lo tura*	*lo tura*	*lo ottura*
line 15	*e* [n.7]	omitted	omitted

FOL.71r bis, 81r Explosives
(Marani 1979, II, p.100, cap.CCCXX–CCCXXVI)

FOL.71r bis, 81r Explosives
No drawings

SALUZZIANO	LAURENZIANA	SOANE
line 16　　*strade e* [n.8]	*strada* omitted	*strada* omitted
p.208		
line 1　　*olio di lino* [n.1]	*grasso d[i] porco*	*grasso d[i] porco*
FOL.71v bis, 81v　Blowing up a tower and interrupting the water supply of a city (Maltese 1967, I, p.208, line 7–p.209, line 15)	FOL.71v bis, 81v　Blowing up a tower and interrupting the water supply of a city (Marani 1979, II, pp.100–01, cap.CCCXXVI–CCCXXX)	FOL.71v bis, 81v　Blowing up a tower and interrupting the water supply of a city
p.208		
line 13　　*peste* [n.6]	*con aceto macina*	*con aceto macina*
line 15　　*dieci* [n.7]	*due*	*due*
p.209		
line 12　　*e* [n.3]	omitted	omitted
FOL.72r bis, 82r　Diverting a river from the centre of a city (Maltese 1967, I, p.209, line 15–p.210, line 16)	FOL.72r bis, 82r　Diverting a river from the centre of a city (Marani 1979, II, p.101, cap.CCCXXX–CCCXXXIII)	FOL.72r bis, 82r　Diverting a river from the centre of a city
p.209		
line 17　　*stremita* [n.6]	*stremita* omitted	*sumita*
line 23　　*insieme*	*insieme*	*insieme al fuoco*
line 24　　*inistinguibile; Tolle*	*inistinguibile; Tolle*	*extinguibile; piglia*
p.210		
line 13　　*nel suo letto restando* [n.4]	omitted	omitted
FOL.72v bis, 82v　Trenches and gabions (Maltese 1967, I, p.210, line 16–p.211, line 19)	FOL.72v bis, 82v　Trenches and gabions (Marani 1979, II, p.102, cap.CCCXXXIV–CCCXXXV)	FOL.72v bis, 82v　Trenches and gabions
p.210		
line 18　　*pare*	*pare*	*pare* omitted
line 21　　*si anco*	*si anchora*	*si anchora*
p.211		
line 1　　*piaggia*	*piaggia*	*piaza*
line 3　　*offesa* [n.1]	*o fossa*	*o fosa*
FOL.73r, 83r　Shelters (Maltese 1967, I, p.211, line 19–p.212, line 21)	FOL.73r, 83r　Shelters (Marani 1979, II, pp.102–3, cap.CCCXXXVI– CCCXXXVII)	FOL.73r, 83r　Shelters
p.211		
line 21　　*angholi reti e ottusi*	*angholi retti e ottusi*	*angholi e piramidale retti e obtusi*
line 24　　*fosso*	*fosso*	*offesa*
p.212		
lines 2–3　　*E dove recoprire* [n.1]	omitted	omitted
line 19　　*fermarai; legni fatto*	*fermarai; legni fatto*	*formerai; legni*
FOL.73v, 83v　Shelters (Maltese 1967, I, p.212, line 21–p.213, line 28)	FOL.73v, 83v　Shelters (Marani 1979, II, p.103, cap.CCCXXXVII–CCCXXXVIII)	FOL.73v, 83v　Shelters
p.213		
line 10　　*riparo investito fusse. Anco di grate*	as MS T	*riparo anco fosse investito di creta*
lines 19–20　*richieggano*	*richierchano*	*ricerchano*
line 21　　*tromba*	*tromba*	*tomba*
line 22　　*traggi; uperta*	*traggi; uperta*	*tria; coperta*
line 24　　*d'uperta; per errata* for *per rata* [n.6]	*d'uperta; per errata*	*racup[er]ta; per rata* [correction]
line 26　　*forcine*	*forcine*	[*formatione* deleted] *forcine*
FOL.74r, 84r　Cannon Shelters (Maltese 1967, I, p.213, line 28–p.214, line 31)	FOL.74r, 84r　Cannon Shelters (Marani 1979, II, p.104, cap.CCCXXXVIII)	FOL.74r, 84r　Cannon Shelters
p.214		
line 6　　*se piu* [n.2]	*se piu e*	as MS L
line 9　　*e* [n.3]	*e* omitted	as MS L
line 28　　*manifesta* [n.7]	*manifesta* omitted	as MS L
line 31　　*uperte*	*uperto*	*coperte*
FOL.74v, 84v　Shelter (Maltese 1967, I, p.214, line 31–p.215, line 31)	FOL.74v, 84v　Shelter (Marani 1979, II, p.104, cap.CCCXXXIX–CCCXLI)	FOL.74v, 84v　Shelter
p.215		
line 1　　*in nella fossa…d'rulli*	*in nella…de' rulli* as MS T	*coperte* *in nella fossa …sopra de'rulli* omitted
line 2　　*larga pie dieci e larga pie sette* [n.1]	*larga pie sei e larga pie sette*	*et larga pie sei o sette* as MS L

SALUZZIANO	LAURENZIANA	SOANE

FOL.75r, 85r Shelter
(Maltese 1967, I, p.215, line 31–p.216, line 34)
p.216
line 5	*dirietro*	
line 26	*Riempisi* [n.4]	
line 27	*suvi* [n.5]	

FOL.75r, 85r Shelter
(Marani 1979, II, p.105, cap.CCCXLII–CCCXLIII)

dirietro
riempisi dipoi
suvvi

FOL.75r, 85r Shelter

dritto
riempisi dopoi
su

FOL.75v, 85v Aiming a cannon, cannon mounted on boats
(Maltese 1967, I, p.217, lines 1–30)
p.217
line 23	*bombarda*	
line 30	*fermato* [n.6]	

FOL.75v, 85v Aiming a cannon, cannon mounted on boats
(Marani 1979, II, pp.105–6, cap.CCCXLIV–CCCXLV)

bombarda sia
fermato sera

FOL.75v, 85v Aiming a cannon, cannon mounted on boats

bombarda sia
fermato sera

FOL.76r, 86r Cannon mounted on boats
(Maltese 1967, I, p.218, line 1–p.219, line 2)
p.218
line 7	*collegata. La qual* [n.2]	
line 8	*stensione*	
line 17	*della quale*	
line 27	*non entronando*	
line 28	N *dimostra* [n.7]	

FOL.76r, 86r Cannon mounted on boats
(Marani 1979, II, pp.106–7, cap.CCCXLVI–CCCIL)

collegata sia; laquale
stensione
della quale
non entronando
la figura N

FOL.76r, 86r Cannon mounted on boats

collegata sia [*nel* deleted] *laqual*
intentione
la quale
no[n] *ne trova*[n]*do*
H *ci mostra*

FOL.76v, 86v Cannon mounted on boats
(Maltese 1967, I, p.219, line 2–p.220, line 7)
p.219
line 4	*sia* [n.2]	
line 10	*siccome la figura* T *manifesta* [n.4]	
line 12	*paratella* [n.5]	
line 22	*siccome...manifesta* [n.7]	
line 23	*le bombarde*	
line 28	*giuste*	
p.220		
line 1	*paretelle* [n.1]	
line 6	*passavolanti...in circa* [n.2]	

FOL.76v, 86v Cannon mounted on boats
(Marani 1979, II, p.108, cap.CCCIL–CCCLI)

in
omitted
paratella sia
omitted
le bombarde
giuste

paratelle
omitted

FOL.76v, 86v Cannon mounted on boats

in
omitted
paratella sia
omitted
le bombarde omitted
viste

parattelle
omitted

FOL.77r, 87r Section of a cannon showing the bores
(Maltese 1967, I, p.220, line 7–p.221, line 5)
p.220
line 9	*essare*	
line 13	*tiglio*	
line 17	*lire*	
line 19	*due*	
line 19	*lire*	
line 20	*lire*	
line 23	*lire*	

FOL.77r, 87r Section of a cannon showing the bores
(Marani 1979, II, p.108, cap.CCCLII)

essare o
tiglio
lire
due;
lire
lire
lire

FOL.77r, 87r Section of a cannon showing the bores

essare o
omitted
libre [correction]
tredici
libre
libre
libre

FOL.77v, 87v Cannon on fortress carriages and on a gun carriage, a tripod and a ship equipped with rakes
(Maltese 1967, I, p.221, line 5–p.222, line 12)
p.221
line 10	*vinti*	
line 11	*pietra lira*	
line 13	*poppi, ontani*	
line 17	*Se la*	
lines 28–30	*Et per lo simil poranno 123* [the numbers are unjustified]	
p.222		
line 6	*E detti stormenti poi che*	
[MS R, FOL.1r, begins on p.222, line 1]

FOL.77v, 87v Cannon on fortress carriages and on a gun carriage, a tripod and a ship equipped with rakes
(Marani 1979, II, p.108, cap.CCCLIII–CCCLV)

vinti–in vinti
in deleted before *lire*
poppi–opi; ontani–onari
Se la–Q[ua]n[do]
Et per lo simil poranno 123 [the numbers refer to drawings at the bottom of the page.]

E quali poi che'lle
MS L ends here
MS R begins Maltese 1967, I, MS T, p.222, line 6

FOL.77v, 87v Cannon on fortress carriages and on a gun carriage, a tripod and a ship equipped with rakes

in vinti
in deleted before *lire*
opi; onari
Q[ua]n[do]
omitted; the drawings are grouped in the same order as MS L on the left margin; MS L ends here.

e quali dopoi che'lle (MS R, FOL.1r)

SALUZZIANO	LAURENZIANA	SOANE
FOL.78r, 88r Armed ship, siege tower, trebuchets, battering-rams (Maltese 1967, I, p.222, line 12–p.223, line 17)	FOL.78r, 88r Armed ship, siege tower, trebuchets, battering-rams (Mussini 1991, pp.237–8, FOL.1r, cap. 1-8)	FOL.78r, 88r Armed ship, siege tower, trebuchets, battering-rams
p.222		
line 13 *si mostra*	*si manifesta*	*si manifesta*
lines 19–20 *siccome…manifesta*	omitted	omitted
p.223		
line 1 *appiccato*	*attaccato*	*attachato*
lines 3–4 *a terra tirato, mettendo el lasso* [Mussini 1991, pp.238 and 297, n.23]	*tirato l'ara*	*tirrata l'hara* as MS R
line 12 *le tustudinati* [originally *Hetustudinati*]	*E tustudinati*	
line 13 *innanzi detto*	*innanzi e detto* [Mussini 1991, p.297, n.24=25]	*ina[n]ti e detto*
line 14 *con*	*cor*	*con*
FOL.78v, 88v A machine for launching projectiles, armed ships, a naval siege tower, battering-rams and a pontoon bridge (Maltese 1967, I, p.223, line 18–p.224, line 26)	FOL.78v, 88v A machine for launching projectiles, armed ships, a naval siege tower, battering-rams and a pontoon bridge (Mussini 1991, pp.238–9, n.8–14)	FOL.78v, 88v A machine for launching projectiles, armed ships, a naval siege tower, battering-rams and a pontoon bridge
p.223		
line 18 *e l'argano*	*et argano*	*et argano*
line 25 *e da fare. E tale stormento piu che altro*	*e da fare; e questo piu che altro stormento* [Mussini 1991, p.238, n.27–8]	*e da fare et questo piuche altro instrume[n]to*
p.224		
line 11 *fuore*	*fuore*	*far[e]*
line 19 *cuprime cuoro*	*cuprime cuoro*	*coprire di corio*
line 20 *coverto*	*coverto*	*coverto* omitted
line 24 *d'imballata*	*d'imballata*	*de ballata*
FOL.79r, 89r Bridges and underwater devices for sinking ships (Maltese 1967, I, p.224, line 26–p.226, line 2)	FOL.79r, 89r Bridges and underwater devices for sinking ships (Mussini 1991, pp.239–40, cap.14–17)	FOL.79r, 89r Bridges and underwater devices for sinking ships
p.224		
line 26 *faccisi*	*faccinsi*	*facciansi*
line 27 *Di longhezza pie*	*di longezza di pie*	as MS R *di longhezza di* omitted
p.225		
line 3 *o vemente*	*overamente* [Mussini 1991, p.297, cap.31–2]	
line 7 *dal largo tratto*	*dall arco tratto* 1v	*da l'arco atrato*
line 9 *gonfiare*	*gonfiare*	*infiare*
line 24 *dicrinar*	*dicrinar*	*drito*
line 26 *anco*	*ancora*	*anchora*
p.226		
line 1 *rappe*	*rappe*	*rampe*
FOL.79v, 89v Devices for blocking rivers, a tension-bow (Maltese 1967, I, p.226, line 3–p.227, line 7)	FOL.79v, 89v Devices for blocking rivers, a tension-bow (Mussini 1991, p.241, n.18–21)	FOL.79v, 89v Devices for blocking rivers, a tension-bow (180) (Maltese 1967, I, p.226, line 3–p.227, line 7)
p.226		
line 6 *legati con perni*	*legate con perni*	*legati p[er]ni*
lines 7–8 *venghi. E infra la torre della fortezza e'l travito l'entrata e da lassare con una catena atta a sostenere…*	*sosteneran* linked to *la quale*, [Mussini 1991, p.298, n.36–7] omitted	as MS T
FOL.80r, 90r Trebuchets, a ladder bridge (Maltese 1967, I, p.227, line 7–p.228, lines 9–10)	FOL.80r, 90r Trebuchets, a ladder bridge (Mussini 1991, pp.241–2, cap.21–3)	FOL.80r, 90r Trebuchets, a ladder bridge
p.227		
line 9 *si riferischi, e all'anello di mezzo al lasso*	*referische e ll'anello di mezzo al lasso* [Mussini 1991, p.298, n.37–8]	*si riferischi et l'anello di mezo alasso*
line 10 *azar*	*co alzar* [Mussini 1991, p.298, n.39–40]	*alzare*
line 11 *el lasso*	*ellasso*	*lo asso*
line 13 *ribatte. 20*	*ribatte siccome la figura.* [Mussini 1991, p.298, n.40–41]	*ribatte si come dimostra la figura*
line 18 *intenne*	*intenne*	*antene*
line 30 *intenne*	*intenne*	*antene*
line 31 *Sia*	*sia*	*et*
pp.227–8		
line 31 *en-tenne*	*entenne*	*antene*

SALUZZIANO	LAURENZIANA	SOANE
FOL.80v, 90v Articulated siege ladders (Maltese 1967, I, p.228, line 10–p.229, line 12)	FOL.80v, 90v Articulated seige ladders (Mussini 1991, pp.242–3, cap.23–7)	FOL.80v, 90v Articulated siege ladders
p.228		
line 13 *siccome la figura manifesta* C	*Siccome manifesta* C [Mussini 1991, p.298, n.51–2]	*si come manifesta la figura* A
line 18 *siccome la figura* D *manifesta*	*siccome la figura* D [Mussini 1991, p.298, n.52–3]	*si come manifesta la figura* B
line 21 *sommo*	*sommo*	*fondo*
line 22 *referischi*	*riferischa* [correction, Mussini 1991, p.298, n.53–4]	*riferischa*
line 27 *montar si possi* A	*montar si possi* A	*montar si possi* C
line 32 *ordenata*	*ordinata sera* [Mussini 1991, p.299, n.54–5]	*ordinata sera*
p.229		
line 5 *servir*	*servir*	*securo*
line 7 *salire, siccome la figura manifesta* B	*al ponte salire* B [Mussini 1991, p.299, n.55–6]	*sopra il ponte salire* D
line 8 *due diritte intenne e da formare e nella*	*due diritte intenne e da fermare ene…* [Mussini 1991, p.299, n.56–7]	*due dritte antene sono da firmare et nella*
FOL.81r, 91r Articulated mobile siege ladders (Maltese 1967, I, p.229, line 12–p.230, line 14;	FOL.81r, 91r Articulated mobile siege ladders (Mussini 1991, pp.243–4, cap.27–31)	FOL.81r, 91r Articulated mobile siege ladders
p.229		
line 18 *er rullo*	*el rullo*	*el rullo*
line 34 *il sopra posto peso*. G.	*…peso* omitted *Siccome la figura* G [Mussini 1991, p.299, n.59–60]	*…pesoo si come la figura* G *manifesta*
p.230		
line 6 *ponti el*	*ponti el*	*porti al*
line 13 *stremita sua* [*e da fare* erased n.63]	*stremita sua da fare*	as MS R
FOL.81v, 91v Mobile siege lift s and a ladder bridge (Maltese 1967, I, p.230, line 14–p.231, line 14)	FOL.81v, 91v Mobile siege lifts and a ladder bridge (Mussini 1991, pp.244–6, cap.31–5, fig.8)	FOL.81v, 91v Mobile seige lifts and a ladder bridge
p.230		
line 14 *der*	*del* [Mussini 1991, p.299, n.62]	*del*
line 15 *accomandato* [*sia* erased, n.63]	*accomandato sia*	*accomandato sia*
line 20 *vada*. I	*vada si come la figura* .I. [Mussini 1991, p.299, n.65]	*vada si come la figura* .I.
line 27 *alquanto*	*alquanto*	*alquanto* omitted
line 30 *offendar*	*offendar*	*offeniare*
FOL.82r, 92r Mobile corridor bridge and mobile shelters (Maltese 1967, I, p.231, line 15–p.232, line 17)	FOL.82r, 92r Mobile corridor bridge and mobile shelters (Mussini 1991, p.246, cap.36–8, figs 8–9)	FOL.82r, 92r Mobile corridor bridge and mobile shelters
p.231		
line 20 *intenne*	*entenne* [Mussini 1991, p.299, n.68–9]	*antene*
line 21 *diriete; riferischino*	*diriete; referischono* [Mussini 1991, p.299, n.69–70]	*dritte; referiscono*
line 22 *tirato*	*tirato sera* [Mussini 1991, p.299, n.70–71]	*tirata sera*
line 24 *accomandato sia* erased [n.71–2]	*accomodato sia* [Mussini 1991, p.299, n.71–2]	as MS R
line 27 O	*Siccome la figura* O	O *si manifesta*
line 28 *sospettasse*	*sospettassi* [Mussini 1991, p.299, n.73–4]	*sospettassi*
line 30 *chioccola*	*chioccia* [Mussini 1991, p.299, n.74–5]	*cioccia*
p.232		
line 3 *der ritorto*	*del ritorto* [Mussini 1991, p.300, n.75–6]	*del ritorto*
line 6 *en dirietro*		
line 9 .P.	*siccome la figura* .P. [Mussini 1991, p.300, n.77–8]	*e'n dietro*
line 14 *in ballette*	*in ballette* [Mussini 1991, p.300, n.78–9]	*ballette*
line 17 *siccome la fugura demostra* Q	*siccome la figura* Q [Mussini 1991, p.300, n.80–81]	.Q. *ci manifesta Finis / Nihil tam difficile quod studio/ Et arte, non fiat facillimus*

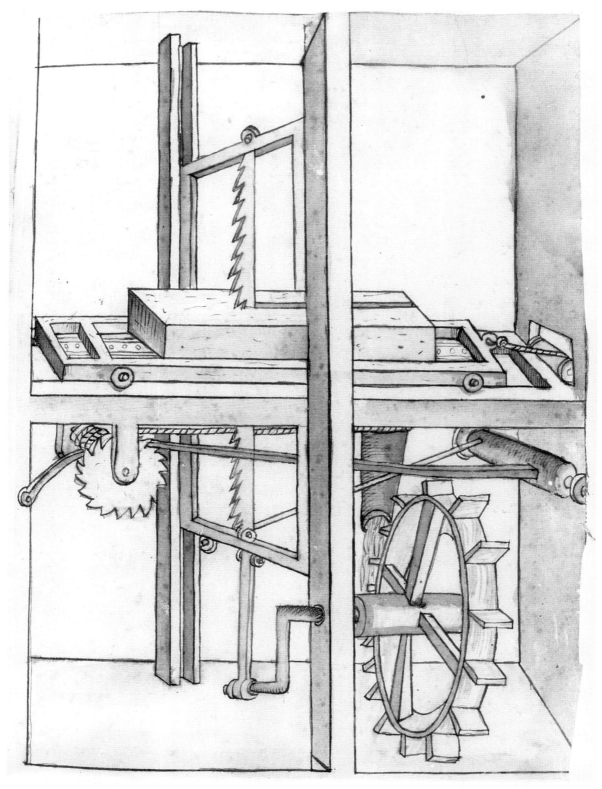

255

Meccanica
Drawings of machines
*c.*1560–1600

The volume contains drawings of machines, on folios dating from the mid 16th century. The collection of drawings belonged to the architect and engineer Carlo Fontana (1634–1714), who bound and annotated them in black ink.

The machines derive from various sources. The ancient examples were described by Athenaeus, Apollodorus of Damascus and Hero of Alexandria; the drawings of them are copied from folios of 15th-century copies of 10th- or 11th-century Byzantine manuscripts of Athenaeus' *De machinis* and Apollodorus of Damascus' *Poliorcetica* or *Belopoiica,* which were reproduced by Melchisedek Thévenot when he published a transcription of the Greek texts in 1693.

Many drawings derive from the experiments of the Renaissance military engineer, architect and theorist Francesco di Giorgio. They were copied from his *Opusculum di architectura* of 1472–7, a copybook of engine drawings and plans of forts on vellum, which was presented to Federigo da Montefeltro, Duke of Urbino, *c.*1477. It remained in the ducal library in Urbino until the 18th century and is now in the British Museum, London.[1] Francesco di Giorgio's contribution to the history of engineering was first acknowledged in 1841, when Promis rediscovered and published his manuscripts; in the 16th and 17th centuries his designs for machines had been published without reference to him by Strada, Zonca and Zeising.[2]

Other drawings derive from the woodcut illustrations of Georg Bauer, called Agricola, whose treatise on mining, *De re metallica* (Basel, 1556), illustrated the machines in general use in the industry in the Renaissance, and which were still being used in the 18th century. The source for the Classical tympana on fol.65r (cat.278) is Daniele Barbaro's edition of Vitruvius of 1556. The drawing on fol.53v (cat.266), in a different hand, is not copied from any of these sources. It shows the drops, posts and capstan of a pile-driver with a note recording the rebuilding of the Ponte S. Maria in Rome by Matteo di Città di Castello during the papacy of Gregory XIII (1575–83), the possible *terminus post quem* for the collection of drawings.

The publication date of 1556 for both Agricola's treatise and Barbaro's Vitruvius is the only evidence for dating the drawings. Those deriving from Francesco di Giorgio and Agricola are in the same light brown ink, and Scaglia has suggested that they were drawn by an anonymous draughtsman working in the ducal library in Urbino. The condition of the drawings suggests that they were all stored together, and they may have originated together (see below, p.178). The drawing style of the Greek machines, in a darker brown ink, is in a more confident hand, although the difference could be due to the fact that the Greek drawings were easier to copy, using only a pen and ruler. The drawings of ancient machines are interesting for the engines they record, and as evidence of Renaissance architects' interest in the revival of ancient drawing conventions.

The study of ancient machines, well established by the middle of the 16th century, developed from the study of Vitruvius. In 1430 Lorenzo Ghiberti was examining Vitruvius' Greek sources directly; through the mediation of Ambrogio Traversari he asked Giovanni Aurispa for the loan of a Byzantine manuscript of Athenaeus.[3] It is not clear whether he was successful, but he could have studied the manuscript in 1427 when it was on loan to Traversari.[4] Giorgio Vasari recorded that Francesco di Giorgio's archaeological interests included ancient machines and instruments of war.[5] Fra Giocondo, who was in contact with Francesco in Naples from 1491,[6] moved in the same humanist circles in Paris and Venice as Ianus Lascaris, who copied a Byzantine manuscript recording these machines.[7] The illustrations from his manuscript are listed in the entries in this catalogue. Fra Giocondo may also have been in contact with Roberto Valturio, a humanist at the court of Sigismundo Malatesta in Rimini. Valturio specialized in military matters and wrote a treatise on ancient warfare, *De re militari*. He knew Poggio Bracciolini, who probably introduced him to Fra Giocondo.[8] Both architects illustrated Hero's torsion bow drawn on fol.18r (cat.231), but whereas Valturio interpreted the ancient drawings to illustrate a perspective view of the machine set on top of a tower, Fra Giocondo, in the 1511 edition of Vitruvius, recorded the ancient drawing convention from the Greek manuscript, in an effort to integrate Vitruvius' text with the illustration.[9] The consistency of his interest in recording early conventions is confirmed by copies of calculation diagrams from another 10th- or 11th-century Byzantine manuscript.[10] In the second half of the 16th century Ligorio revived conventions used in Roman reliefs in his architectural drawings: he showed the side and front of a building, and left all other lines parallel.[11]

Greek mechanical treatises did not survive in the West, but they were revived by the Arabs in the 9th century, when Muhammad, Ahmad and al-Hasan Banu Musa went to Constantinople to study them; the texts were translated into Persian and Latin and circulated, eventually, in the 13th century, reaching Villard de Honnecourt.[12] The ancient drawing conventions in part survived in the Arabic translations, but some of the characteristics of the illustrations may show the influence of Arabic or medieval drawing conventions. Some of the drawings, showing machines in operation, combine conventions to show the principal geometrical outline with a bird's-eye view for greater clarity, as on fol.47r (cat.260). Other illustrations, such as the torsion bow and the *cheiroballista* on fols 15r and 18r (cat.228, 231) respectively, are drawn in a more scientific, though schematic manner; in the early manuscripts they are lettered and keyed to technical descriptions so that the machine can be constructed on the basis of the data

1. Mussini 1991, pp.377–8; Scaglia 1992b, p.43, cat.1.

2. Reti 1963.

3. Sabbadini 1931, pp.66–8; Pagliara 1986, p.24.

4. Krautheimer 1956, pp.311–12, and n.21.

5. Vasari 1967, III, p.12.

6. Fontana 1988, pp.29ff.

7. Paris, BN, MS GR.2442; Pagliara 1977, pp.113–15.

8. Rodakiewicz 1940, pp.26–7.

9. Pagliara 1977, pp.114–15.

10. Fontana 1988, p.48, fig.51.

11. Coffin 1960, pp.76–7; Burns 1988b, pp.37–8.

12. Settis 1986, pp.416–17.

given in the diagram and text,[13] as Valturio reconstructed the bow.

The clearest description of technical drawings that relates to this tradition is given by al-Jazari, an engineer from Mesopotamia in the service of the Artuqid ruler of Diyarbakır, whose drawings resemble the drawings of the torsion bow. In his *Book of Knowledge of Ingenious Mechanical Devices* of *c*.1204 he wrote:

> 'In drawing it I have not aimed for completeness. My purpose was to present a [general] arrangement so that it can be understood in the whole and in detail. One realises that there is obscurity in the representation of solid bodies, but in the imagination one can fit one thing to another, view it from an angle, dissect it and thus assemble it step by step. All of the drawings which I have made are simple, so that they give a clear picture. I show a drawing of part of what I have described, as I have done in other chapters, split into its separate parts'.[14]

Al-Jazari described a convention in which the geometrical features and relative sizes of the parts of the plan and elevation were drawn empirically without using orthogonal projection or linear perspective, a drawing procedure that can be easily copied using a pen and ruler.

Alan Braham (communication), who first recognized that the volume had belonged to Carlo Fontana, has suggested that he may have inherited the drawings from his famous Renaissance ancestor Domenico Fontana, who moved the obelisks of Rome (see Montano III, fol.41, cat.1263). The binding is very similar to that of Carlo Fontana's album, *Tor di Nona* (SJSM, vol.105). Like other volumes from Fontana's library, *Meccanica* is numbered on the front cover at the top, 6; *Tor de Nona* is no.12. The inventory of the Fontana volumes, made for valuation by Giovanni Battista Contini on 26 September 1716, lists the volume at no.6 as *Diversi disegni d Altare, Machine, macine/d oglio trombe, et altri ordegni mattema[ti]ci*.[15] Scaglia's note of an inscription, *machina*, on the spine, visible through a hole in the binding, is inaccurate. The final letter A, of a title, possibly MECCANICA, is written on a paper label glued to a red panel between the raised bands on the spine; the singular form of *machina* rather than *machinis* is unlikely to have been used as the title for the work.[16] There is no evidence of a second binding, described by Scaglia.

For a survey of early drawing, see Booker 1963; Weitzmann 1952; Weitzmann 1959, pp.5–30. For Agricola, see appendix.

LITERATURE Scaglia 1992b, pp.89–91, cat.28.

CATALOGUE NOTE

The volume has a 17th-century binding of brown Morocco leather, which is double ruled and tooled in gilt with panels of lilies and foliage in the corners. The boards are covered with marbled paper, with one free end-paper and a flyleaf. The tooled brown leather spine has five raised bands with a red panel between them, to which is attached a paper label, almost completely disintegrated, inscribed A. The binding measures 292 × 220 mm, the folios 281 × 208 mm. The drawings are glued to the white laid folios, with a watermark listed at cat.27 in the catalogue of watermarks.

The verso of the flyleaf is inscribed *Mr Adams Sale 20 May 1818 / 1.5.0.* in Sir John Soane's hand, and *pages 72* in graphite in a librarian's hand.

PROVENANCE Carlo Fontana, Pope Clement XI, Cardinal Albani, Robert Adam. The volume was acquired at the Robert Adam Sale at Christie's on 20 May 1818, lot 30.[17]

The entry in Richardson's catalogue of Sir John Soane's Library is inscribed: *Mechanics containing various Machines, bought at Mr Adam's Sale*

May 1818 price 1.5.0 … 16.[18] The volume was located in case 16 on the east wall to the left of the fireplace in the library/dining-room with a miscellany of other architectural and travel literature.

The inscription *carte 79* on fol.1r (cat.214) suggests that the collection originally contained 79 drawings; the altars mentioned in Contini's inventory are probably the missing drawings.

The drawings copied from the Byzantine source are on the following folios: 1r, 2r, 15r, 16r, 17r, 18r, 21r, 22r, 27r, 28r and 47r. Those copied from Francesco di Giorgio's *Opusculum* are on fols 3r, 4r, 5r, 6r, 9v, 10v, 11r, 12r, 13r, 14r, 19r, 20r, 25v, 26v, 29r, 32r, 33r, 34r, 35r, 36r, 37r, 42r, 43r, 44r, 45r, 46r, 48r, 49r, 50r, 51r, 52r, 54v, 55r, 57r, 60r, 61r, 62r, 63r, 66r, 67r, 68r, 69r, 70r and 71r. Those copied from Agricola's *De re metallica* are on fols 7r, 8r, 23r, 30r, 31r, 38r, 39r, 40r, 41r, 58r, 59r, 64r, 65r and 72r.

The condition of the drawings suggests that the different groups of machines were stored together. Some of the drawings have a large water stain spreading from the upper or lower corners: these are fols 5r, 6r, 9v, 10v, 14r, 26v, 35r, 43r, 51r, 57r, 61r, 63r and 66r, all deriving from Francesco di Giorgio. Others are torn at the sides, fols 2r, 16r, 18r, 22r, 28r, 46r and 72r, all deriving from the Greek drawings except fols 46r and 72r, which show machines after both Francesco di Giorgio and Agricola. Others have small burn marks at the bottom or top edge, fols 4r, 8r, 11r, 12r, 30r, 31r, 32r, 36r, 40r, 41r, 44r, 45r, 48r, 52r, 64r, 65r, 70r and 71r, from Agricola and Francesco di Giorgio.

All of the drawings are on white laid writing paper, in pen and pale brown iron-gall ink over grey chalk underdrawing; some are washed, and these are described in the entries. The dimensions of the drawn folio are also given in the entries and the references to the catalogue of watermarks in Vol II. The heading 'Prototype drawings' refers to the original drawings from which all of the various copies derive. In the case of Francesco di Giorgio, they refer to the drawings in Francesco's small notebook with sketches known as *Codicetto*, and to the fair copy drawings in the *Opusculum*. When the machine is included in Francesco di Giorgio's treatise on architecture, the reference to the archetype manuscripts (the manuscripts closest to Francesco's lost original) are listed under 'Francesco di Giorgio manuscripts'. 'Prototype woodcut' is the reference to Agricola's original. 'Other representations' are drawings of the same machines by other artists. The 15th- and 16th-century copies of Greek manuscripts, Giovanni Aurispa's MS GR.2442 in the Bibliothèque Nationale[19] and Guillaume Pellicier's copy of the Greek manuscripts made in Venice between 1539 and 1542, both in the British Library, MS add.15276 and MS Burney 69, are listed as 'Other representations'.[20]

View, an engineer's term for the drawing of a machine, has been used instead of design because it preserves the notion of the perspectival rendering of machines, central to their modern representation, while avoiding the implication that the drawing was made for the purpose of building the machine. Except for Agricola's machines, which record machines in use, the drawings record experimental arrangements of components, the ensembles often deriving from Antiquity. When the arrangement is novel a note in the entry records the fact.

13. Weitzmann 1959, pp.7–8, pl.III, figs 5–6.
14. Hill 1974, p.192.
15. Braham & Hager 1977, p.3.
16. Scaglia 1992b, p.89, cat.20.
17. Watkin 1972, p.157.
18. Richardson 1830, p.82.
19. Pagliara 1977.
20. Palau 1986.

A NOTE ON AGRICOLA

Georg Bauer (1494–1555), known as Agricola, took a medical degree in Italy before practising as a physician in Joachimsthal, a mining district in Bohemia, and in Chemnitz in Saxony. He travelled widely, becoming interested in mining and metallurgy and recording his observations on both interests. In 1546 he published four essays, the first on geography, *De ortu et causis subterraneorum*; the second on sub-surface water and gases, *De natura eorum quae effluunt externa*; the third a treatise on mineralogy, *De natura fossilium*; and the fourth a history of mining and metallurgy since Antiquity, *De veteribus et novis metallis*, to which he added a glossary in Latin and German. Between 1533 and 1553 he wrote his main work, *De re metallica*, in 12 books, which was published posthumously in Basel in 1556; there were three subsequent Latin editions in 1561, 1621 and 1657. The book was translated into German and published in 1557 in Basel, in 1580 in Frankfurt and 1621 in Basel; the Italian edition appeared in Basel in 1563.

De re metallica was the most important textbook on mining and metallurgy for two centuries (Singer *et al.* 1956, II, pp.13, 27–8). It described and illustrated machinery in general use in the mining industry in Agricola's day, and is a reliable source for the state of mechanical science in the middle of the 16th century. The treatise was translated into English from the first Latin edition of 1556 by Herbert Clark Hoover and Lou Henry Hoover and published in London in 1912. They give a detailed biography in the introduction.

For mining practice in the 16th century, see Singer *et al.* 1956, II, pp.13–24.

214

AFTER A BYZANTINE DRAUGHTSMAN
Siege tower; view
Inscribed *Carte 79* in grey chalk
Numbered 52 in grey chalk and ink
WM cat.17; 159 × 185 mm
SJSM, vol.128, fol.1r

The illustration shows ladders and
netting used to besiege a crenellated
tower, described by Apollodorus in the
Poliorcetica and published by Thévenot.
The inscription refers to the original
number of folios as 79; only 72 folios
have been mounted in the volume.

OTHER REPRESENTATIONS Paris, BN,
MS GR.2442, fol.89r.
ENGRAVED Thévenot 1693, p.42.

215

AFTER A BYZANTINE DRAUGHTSMAN
Tension bows; views
Numbered 7–8 in dark brown ink
No WM; 217 × 146 mm
Torn on the left
SJSM, vol.128, fol.2r

No. 7 The frames are like those of belly
bows, no.15 on fol.15r (cat.228), with
the bow and stock consisting of a case
or rectangular frame and slider above
saw-toothed elements, or ratchets,
below the slider. No. 8 The double-
arched bow is operated by winches,
which replaced the stomach-bruising
withdrawal rest shown on no.15.
Marsden (1969, pl.2) illustrates an
antique gem showing Cupid working
a bow in this way; medieval cross-
bowmen operated their bows in exactly
the same way. For a graphic recon-
struction of the tension bow and a
technical description of the difference
between the tension and torsion bows,
see Soedal & Foley 1979.

Both machines, for launching
stones, are described by Biton in
De machinis (Wescher 1867, pp.45–51,
figs XIV–XV; translated in Marsden
1971, pp.67–8). Machine no.7 was
invented and made by Charon of
Rhodes. Marsden estimates that the
bow, designed to take a stone of about
5lbs, was about 9 feet long and 3 inches
deep at the springs. Machine no.8 was
invented by Isodorus of Abydos. It
was about 15 feet long, 1 foot thick and
capable of hurling a stone of about
40 lbs. Both bows achieved a range of
*c.*300 metres – exceeding belly bows
by 50 metres and hand bows and
slings by more than 100 metres – and
they could also project longer and
heavier missiles over greater distances
(Marsden 1969, pp.14–15). The bows
invented by Charon and Isodorus
are reconstructed by Marsden (1971,
pp.80–81, diagrams 1 and 2).

OTHER REPRESENTATIONS Paris, BN,
MS GR.2442, [no.7] fol.63r, [no.8]
fol.63v; London, BL, MS Burney 69,
[no.8] fol.11v.
ENGRAVED [no.8] Vitruvius 1511,
book x, fol.106v; Thévenot 1693,
pp.107–8; Montfauçon 1719, IV/i, p.91.

216

AFTER FRANCESCO DI GIORGIO
Four-wheeled vehicle; view
No WM; 179 × 197 mm
SJSM, vol.128, fol.3r

A four-wheeled vehicle, each wheel
propelled independently by a worm-
screw and lantern-pinion. The car is
steered by two central columns, one for
the front, the other for the rear wheels,
with a lantern-pinion and toothed
sector linked to the T-frames of the
wheels. According to Francesco di
Giorgio, 16 men were required to drive it.

The device does not seem to be fully
worked out.

PROTOTYPE DRAWINGS Rome, BAV,
Codicetto, fol.117r; London, BM,
Opusculum, fol.25v.
FRANCESCO DI GIORGIO MANUSCRIPTS
Turin, BR, MS Saluzziano 148, fol.52v
(Maltese 1967, I, p.270, tav.96);
Florence, BML, MS Ashburnham 361,
fol.46v (Marani 1979, p.94,
cap.CCLXXXVI; Siena 1991, p.410);
London, SJSM, vol.120, fol.67r bis,
77r (cat.191).
OTHER REPRESENTATIONS Florence,
BNCF, MS Palatino 767; MS E.B.16.5,
fol.106r; Uffizi 7731AV; Los Angeles,
GRIRC, Codex 870439, fol.30v; Modena,
BE, MS alpha G.4.21, fol.26r; Turin, BR,
MS 383, unnumbered folio; Venice,
BMV, MS 4817, fol.26v.

217

AFTER FRANCESCO DI GIORGIO
Carts; view
No WM; 265 × 203 mm
SJSM, vol.128, fol.4r

[1] The cart has been adapted as a
plough. A single spiked wheel is driven
by a lantern-pinion and crown-gear
on the wheel. It is linked by connection
rods to a toothed sector and a lantern-
pinion that steers the cart. A plough
or ditch cutter is attached to the centre
of the frame. A plough with only one
wheel would fall over. A similar cart
without a plough attachment and
with two wheels attached to the chassis
at the front is shown in *Opusculum*
(fol.23v).
[2] A wheeled platform, carrying an
obelisk, is drawn along a frame by
nuts to be worked by capstan bars,
which draw screws through holes in
the upright end of the frame. Anti-
friction rollers are introduced between
the nuts and the frame.

PROTOTYPE DRAWINGS Rome, BAV,
Codicetto, [1] fol.116v; London, BM,
Opusculum, fol.23r and v.
OTHER REPRESENTATIONS Florence,
BML, MS Ashburnham 1357, [1] fol.12r,
[1, 2] fol.98r; BNCF, MS Panciatichi
361, [1] fol.325r, [2] fol.333v; MS
Magliabecchiano II.III.314, fol.96r;
MS Palatino 767; Uffizi 7661AV; [2]
Uffizi 7672A; Los Angeles, GRIRC,
Codex, fol.3r; [1, 2] Modena, BE, MS
alpha G.4.21, fol.23r; Siena, BC, [1] MS
S.IV.5, fol.20v; MS S.IV.1, fol.128r; Turin,
BR, MS 383, unnumbered folio; Urbino,
SC, Santini Codex, [1] fol.11r, [2] fol.11v;
[1, 2] Rome, BAV, MS Urb. Lat. 1397,
fol.35r; Venice, BMV, MS 4817, fol.22r;
MS 3048, fol.18v.

214

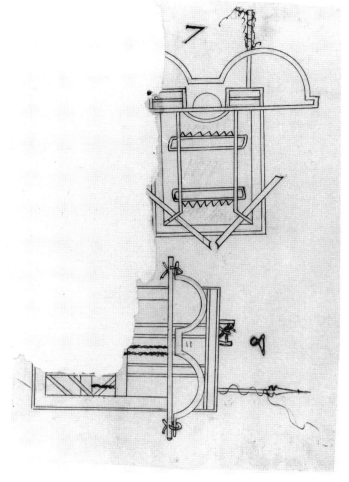

215

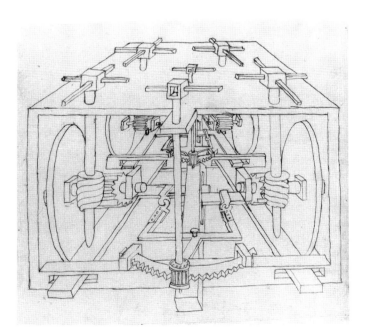

216

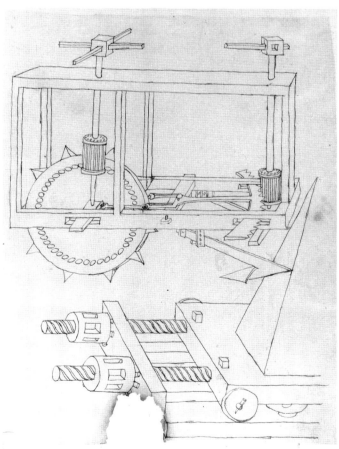

217

218

AFTER FRANCESCO DI GIORGIO
Horse-driven mill; view
No wm; pale beige wash, within a single
ink line border, cut on the right;
273 × 194 mm
SJSM, vol.128, fol.5r

A conventional horse-engine drives a
roller lantern-pinion engaging a larger
toothed wheel; a second ring of teeth
on the wheel engages a smaller lantern-
pinion on the upright shaft of the
conventional mill. In effect, the large
wheel is probably an idle wheel. The
drawing in *Meccanica* is identical to
that in *Opusculum* but reversed.

PROTOTYPE DRAWINGS London, BM,
Opusculum, fol.64r.
OTHER REPRESENTATIONS Florence,
BNCF, MS Magliabecchiano XVIII.2,
fol.20r; BML, MS Ashburnham 1357,
fol.60r; Modena, BE, MS App. Campori
1755, unnumbered folio; Los Angeles,
GRIRC, Codex, fol.20r reversed; Turin,
BR, MS 383, unnumbered folio; Urbino,
SC, Santini Codex, fol.27v: Rome, BAV,
MS Urb. Lat. 1397, fol.55r.

219

AFTER FRANCESCO DI GIORGIO
Edge-runner mill; view
NO WM cat.; 252 × 198 mm
SJSM, vol.128, fol.6r

An edge-runner mill, drawn through a
geared ring that surrounds the station-
ary bedstone, is hung from spokes
attached high up on the axle, forming
a cone. The geared ring is driven by a
roller lantern-pinion, which is driven
by a worm and wheel turned by a
winch.

The drawing in the Soane volume is
identical to *Opusculum* but reversed.

PROTOTYPE DRAWINGS London, BM,
Opusculum, fol.64v.
OTHER REPRESENTATIONS Florence,
BML, MS Ashburnham 1357, fol.57r;
BNCF, MS Magliabecchiano II.III.314,
fol.59r; Los Angeles, GRIRC, Codex,
fol.20v reversed; Modena, BE, MS alpha
G.4.21, fol.33bis; Alberto Alberti, Rome,
GNDS, F.N.2886v (Herrmann-Fiore 1983,
p.263, cat.180); Siena, BC, MS S.IV.1,
fol.127r; Turin, BR, MS 383, unnumbered
folio; Urbino, SC, Santini Codex,
fol.59r; Rome, BAV, MS Urb. Lat. 1397,
fol.77r.

220

AFTER AGRICOLA
*A ventilating machine and a pump
for drawing water; views*
No WM; within a single ink line border;
261 × 145 mm
SJSM, vol.128, fol.7r

[1] A view of a machine to ventilate a
mine. An axle has a stationary drum
on one end and a lantern-pinion at
the other that is driven by a toothed
wheel on a lower axle turned by a wheel
whose buckets receive the impetus of
the water.

The machine is most useful in an
area with an abundant water supply,
because men are not needed to turn
the crank, and it ceaselessly forces
air through the conduit into the shaft
(Hoover & Hoover 1912, pp.204–6).
Agricola (1556, VI, p.162) shows a detail
of the arrangement of the drum. Fans
fitted to the axle are contained in a
hollow drum made of two wheels
joined by wooden boards. The drum
is stationary and closed at the sides
except for two round holes for the axle

and two square blow holes: the upper
one receives the air while the lower one
empties into a conduit through which
air is directed down the shaft. The
drum is shown inaccurately here as
a wheel without blow holes. Other
ventilation machines are shown on
fols 40r and 41v (cat.253, 254).
[2] Water is raised from a mine by a
chain of buckets on an axle operated
by a treadmill; the water is deposited
in the trough as the buckets rise. The
copyist has recorded a mistake in the
original: the buckets are shown passing
through the trough.

Agricola comments that the machine
derives from Vitruvius (book X, cap.IX).
Because it raises dippers rapidly, it
is useful in shafts with continuously
flowing water. The axle, fitted to a
wooden treadmill, does not last very
long because it has no drum around
it (Hoover & Hoover 1912, pp.174–5).

PROTOTYPE WOODCUT Agricola 1556,
[1] VI, p.162; [2] VI, p.132.

221

AFTER AGRICOLA AND FRANCESCO
DI GIORGIO
*A chain pump and a machine for
pulling heavy weights; views*
No WM; within a single ink line border;
229 × 176 mm
SJSM, vol.128, fol.8r

[1] A pump with two horizontal axles
and three drums. Two men or four
turning capstan bars move a spur-gear
on an axle that engages a lantern-
pinion above it to turn the second axle
of a wheel with a paternoster chain-
pump on a drum, which deposits the
water above ground (Hoover & Hoover
1912, pp.195–6). This is the fifth pump
of this kind shown by Agricola; the
others are shown in *Meccanica* on fols
31r, 38r, 58r and 59r (cat.244, 251, 271
and 272). The machine is a develop-
ment of that shown on fol.31r[1]
(cat.244).
[2] A worm is turned by a capstan
bar that engages a rack attached to
horizontal jointed bars, working
between rollers.

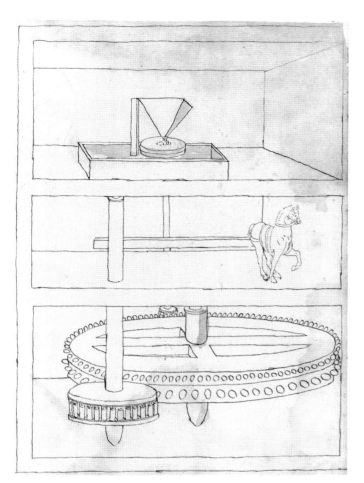

218

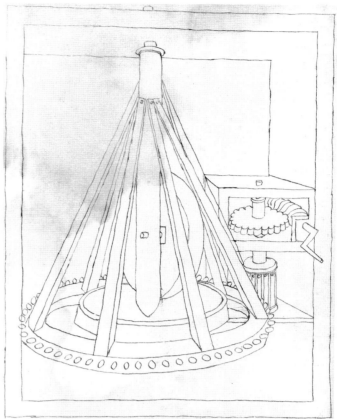

219

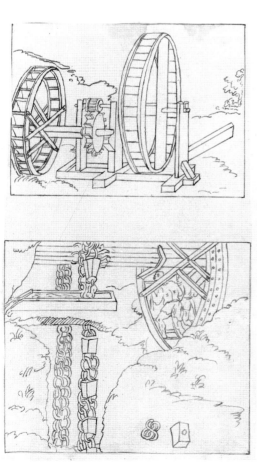

220

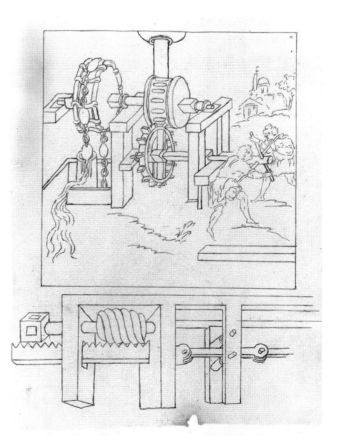

221

222

AFTER FRANCESCO DI GIORGIO
Hoist for raising columns; view
NO WM; 257 × 172 mm; glued to the
verso
SJSM, vol.128, fol.9v

A crane is supported on a pedestal with
cross legs on four wheels, with a right-
handed screw between the legs at the
base. When turned by capstans at
either end, the screw increases and
decreases the height of the crane. On
the upper platform a trolley on rollers
has a screw, arranged for capstan bars
at one end, threaded through a nut that
moves the trolley horizontally; a screw
with a hook on the end of it, suspended
from one end of this platform, can be
cranked up and down.

This appears to be a powerful tool
with restricted movement, which would
probably be used for specialized tasks.

PROTOTYPE DRAWINGS Rome, BAV,
Codicetto, fol.100r; London, BM,
Opusculum, fol.13v.

FRANCESCO DI GIORGIO MANUSCRIPTS
Turin, BR, MS Saluzziano 148, fol.51v
(Maltese 1967, I, p.270, tav.94); Florence,
BML, MS Ashburnham 361, fol.46r
(Marani 1979, p.93, cap.CCLXXVII);
BNCF, MS Magliabecchiano II.I.141,
fol.92v (Maltese 1967, II, p.494, cat.568,
tav.320).
OTHER REPRESENTATIONS
Florence, BNCF, MS Palatino 767;
MS Magliabecchiano XVIII.2, fol.22r;
MS Magliabecchiano II.III.314, fol.40r;
MS E.B.16.5, fol.121r; MS Palatino 1077,
fol.40v; MS BR 228, fol.129r; BML,
MS Ashburnham 1357, fol.37r; Pietro
Cataneo, Uffizi 3361A; anonymous,
16th-century, Uffizi 7663Ar; Los
Angeles, GRIRC, Codex, fol.41v;
Modena, BE, MS alpha G.4.21, fol.11v
(Siena 1991, p.210); App. Campori 1755,
unnumbered folio; Padua, BU, MS 764,
fol.92v; Siena, BC, MS S.IV.1, fol.129r;
Turin, BR, MS 383, unnumbered folio;
Urbino, SC, Santini Codex, fol.49r;
Venice, BMV, MS 4817, fol.32r.

223

AFTER FRANCESCO DI GIORGIO
Hoist; view
No WM; 264 × 158.5 mm
SJSM, vol.128, fol.10v

Two screws, passed through nuts to be
turned by capstan bars, are suspended
from a frame and connected by a yoke
with a cannon hanging from it, resting
on a low platform with wheels. The
screws are gently turned and the
cannon slowly rises. There are friction
rollers below the left nut. The square
block below the component being
lifted may be a square plate or the
breech block behind the barrel of a gun
that can be seen in early gun carriages.
The article being lifted may also be an
architectural component.

PROTOTYPE DRAWINGS Rome, BAV,
Codicetto, fol.165r; London, BM,
Opusculum, fol.14r (Siena 1991, p.150,
fig.7).

FRANCESCO DI GIORGIO MANUSCRIPTS
Turin, BR, MS Saluzziano 148, fol.49v
(Maltese 1967, I, p.269, tav.90);
Florence, BML, MS Ashburnham 361,
fol.44v (Marani 1979, p.90, cap.CCLV);
London, SJSM, vol.120, fol.65v bis, 75v
(cat.188).
OTHER REPRESENTATIONS Florence,
BNCF, MS Palatino 767; MS
Magliabecchiano II.III.314, fol.86r; BML,
MS Ashburnham 1357, fol.84r; Pietro
Cataneo, Uffizi 3350A; anonymous,
16th century, Uffizi 7663Av; Los
Angeles, GRIRC, Codex, fol.25r;
Modena, BE, MS alpha G.4.21, fol.12r;
Padua, BU, MS 764, fol.90v; Siena, BC,
MS S.IV.5, fol.83v; S.IV.1, fol.119r; Turin,
BR, MS 383, unnumbered folio; Urbino,
SC, Santini Codex, fol.7r; Rome, BAV,
MS Urb. Lat. 1397, fol.31v; Venice, BMV,
MS 3048, fol.6r; MS 4817, fol.40v.

224

AFTER FRANCESCO DI GIORGIO
Lift and plunger pumps; views
Inscribed *Piu sicura/men sicura* in
Carlo Fontana's hand
NO WM cat.; 274 × 171 mm
SJSM, vol.128, fol.11r

The novelty of the illustration lies in
the driving mechanisms rather than
the pumps, which are common types.
[1] A pair of lift pumps mounted in a
domestic well. When the bucket rises,
the foot valve in the barrel opens to
let in water; when the bucket descends
the foot valve closes and the valve in
the bucket opens, allowing water to
enter. It is driven by a compound crank
worked by two winches.

The device has been misunderstood
by the draughtsman, who shows the left
crank on the same level as the winches
instead of far below them, as the right
crank rises above them. The same
misunderstanding is recorded in the
Opusculum drawing. The crank is
correctly rendered in the Soane
manuscript (fol.62v bis, 72v; cat.182).
[2] A pair of plunger pumps of the
Classical type worked by a pair of
tappets on a spindle, which has to be
rotated continuously by a hand winch.
Plungers are suspended in a barrel
from pump rods. Water is drawn
through the foot valve at the bottom of
the barrel and passes through a delivery
valve at the side of the bottom of the

barrel; it then rises up the narrow tube
to be released through spouts at the top.

Lift pumps, which first appeared in
the 15th century, are illustrated by
Taccola. The invention of plunger
pumps, described by Heron and
Vitruvius, is attributed to Ctesebius.
They were widely used. The paired
arrangement is also Classical; there is
a pair made from bronze in the British
Museum, London (Walters 1899,
pp.331–2, cat.2574 and 2575).

PROTOTYPE DRAWINGS London, BM,
Opusculum, fol.61v.
FRANCESCO DI GIORGIO MANUSCRIPTS
Turin, BR, MS Saluzziano 148, fol.45v
(Maltese 1967, I, p.268, tav.82);
Florence, BML, MS Ashburnham 361,
fol.41v (Marani 1979, p.84, no.CCXX);
London, SJSM, vol.120, fol.62v bis, 72v
(cat.182).
OTHER REPRESENTATIONS Florence,
BNCF, MS Palatino 767; MS
Magliabecchiano II.III.314, fol.20r; BML,
MS Ashburnham 1357, fol.19r; Uffizi
7726Av; Los Angeles, GRIRC, Codex,
fol.5v; Modena, BE, MS alpha G.4.21,
fol.27v; Siena, BC, MS S.IV.1, fol.108r;
Turin, BR, MS 383, unnumbered folio;
Urbino, SC, Santini Codex, fol.29v;
Rome, BAV, MS Urb. Lat. 1397, [2]
fol.82v; Venice, BMV, MS 4817, fol.62v.
ENGRAVED Branca 1629, fig.VIII.

225

AFTER FRANCESCO DI GIORGIO
Edge-runner mill; view
Inscribed *magina d'olivo e molella vall/e
noci diversa e altro* in Carlo Fontana's
hand
No WM; 272 × 188 mm
SJSM, vol.128, fol.12r

A conventional horizontal waterwheel
driving a convex edge-runner mill
through a roller lantern-pinion and
spur-wheel.

The mill on fol.56r (cat.269) is oper-
ated on the same principle. The scoops
on the horizontal wheel resemble those
of the Pelton wheel. The confining of
the stream of water to a narrow tube
to give a jet effect, which improves the
efficiency of the wheel, is a usual feature
of this type of mill. Leonardo shows
a similar system in Codex Atlanticus
(fols 2r and 322r); Strada adds human
figures to the drawing and a second
wheel, which is technically less sound
than Francesco di Giorgio's drawing
(Reti 1963, p.293).

PROTOTYPE DRAWINGS Rome, BAV,
Codicetto, fol.163v; London, BM,
Opusculum, fol.63r.
FRANCESCO DI GIORGIO MANUSCRIPTS
Turin, BR, MS Saluzziano 148, fol.34r
(Maltese 1967, I, p.264, tav.63);
Florence, BML, MS Ashburnham 361,
fol.33v (Marani 1979, p.68, cap.CXLV);
London, SJSM, vol.120, fol.60r (cat.165).

OTHER REPRESENTATIONS Florence,
BNCF, MS Palatino 767; MS
Magliabecchiano II.III.314, fol.57r;
MS Palatino 1077, fol.72v; BML, MS
Ashburnham 1357, fol.55r; Los Angeles,
GRIRC, Codex, fol.2r; Modena, BE,
MS alpha G.4.21, fol.129v; Turin, BR,
MS 383, unnumbered folio; Venice,
BM, MS 4817, fol.78v.

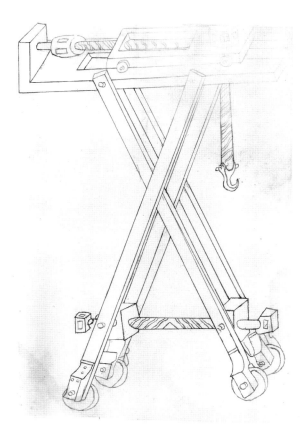

222

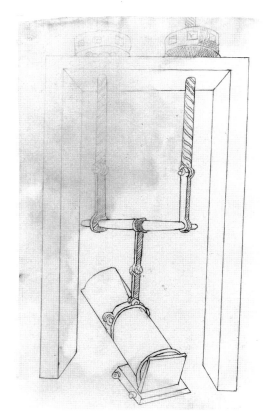

223

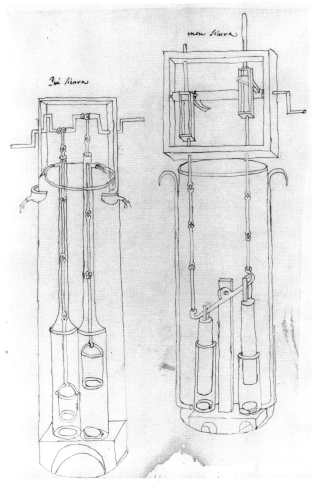

224

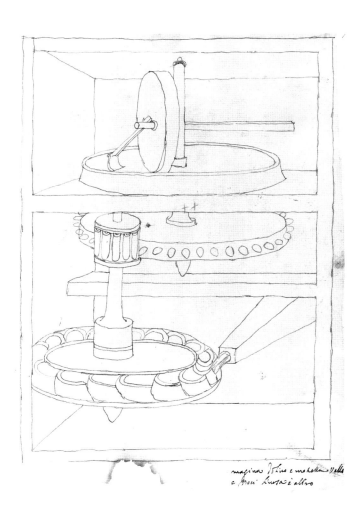

225

226

AFTER FRANCESCO DI GIORGIO
Hoist; view
Inscribed *p[er] levare pesi* in Carlo
Fontana's hand
No WM; 233 × 128 mm
SJSM, vol.128, fol.13r

A worm on a vertical shaft turned by
capstan bars drives a worm-wheel;
on the same arbour is a spur-wheel
engaging a roller lantern-pinion on the
arbour of the winding drum. Scaled as
it is, the machine does not make sense,
because the larger wheel drives a small-
er wheel. Usually a small lantern-
pinion drives a larger wheel.

PROTOTYPE DRAWINGS London, BM,
Opusculum, fol.16r.

OTHER REPRESENTATIONS Florence,
BNCF, MS Panciatichi 361, fol.311r;
MS Magliabecchiano II.III.314, fol.72r;
MS E.B.16.5, fol.114r; MS Palatino 1077,
fol.46v; BML, MS Ashburnham 1357,
fol.70r; Uffizi 7731AV; Los Angeles,
GRIRC, Codex, fol.28v; Modena, BE,
MS alpha G.4.21, fol.14r; Alberto Alberti,
Rome, GNDS, inv. no.F.N.2865r (Rome
1983, pp.259 and 262, cat.179); Turin,
BR, MS 383, unnumbered folio; Urbino,
SC, Santini Codex, fol.48r; Rome, BAV,
MS Urb. Lat. 1397, fol.65v; Venice, BMV,
MS 3048, fol.36v.

227

AFTER FRANCESCO DI GIORGIO
Hoist; view
Inscribed *p[er] solevare pesi*
in Carlo Fontana's hand
No WM; 271 × 202 mm
SJSM, vol.128, fol.14r

A rocking lever used to raise a column
has a gudgeon carried on a fixed
vertical frame. One end of the lever is
connected by links to the head of the
column; the other end is attached to a
rope, which is wound on to the drum
by a capstan bar. The base of the col-
umn slides on a wheeled truck and
timbers are packed under the top of
the column as it is raised. The pulley
shown at the top of the frame is proba-
bly to raise the lever into place and to

raise the gudgeon as the column is lift-
ed. The machine is identical to the ones
drawn in *Opusculum* and *Codicetto* but
the capital is not shown in *Meccanica*.

PROTOTYPE DRAWINGS Rome, BAV,
Codicetto, fol.121v, (the capital of the
column is shown); London, BM,
Opusculum, fol.56r (Siena 1991, p.385).
OTHER REPRESENTATIONS Florence,
BNCF, MS Panciatichi 361, fol.319r; MS
Palatino 1077, fol.57r; Uffizi 7661AR;
Los Angeles, GRIRC, Codex, fol.42r
(Siena 1991, p.210); Modena, BE, MS
alpha G.4.21, fol.15r; Turin, BR, MS 383,
unnumbered folio; Urbino, SC, Santini
Codex, fol.8r; Rome, BAV, MS Urb. Lat.
1397, fol.32v; Venice, BMV, MS 3048,
fol.12r.

228

AFTER A BYZANTINE DRAUGHTSMAN
Components of the cheiroballista
and gastraphetes *or belly-bow; views*
Inscribed *P[er] saetta, dardi/di molla* in
Carlo Fontana's hand
Numbered 12–15 in dark brown ink
WM cat.17; 257 × 189 mm
SJSM, vol.128, fol.15r

Nos 12–14 are three of the eight items
required for the construction of the
arrow-shooting hand-bow described
by Hero in the *Cheiroballista* (trans-
lated in Marsden 1971, pp.212ff). No.12
shows the light bronze cylinders and
no.14 the two cone-shaped arms.
No.13 is an illustration of the arch
and ladder of the *cheiroballista* that
connect two field-frames (Wescher
1867, p.130, fig.XLII; pp.133–4, fig.XLV;
pp.129–32, fig.XLIII; Marsden 1971,
pp.215–17, fig.9, diagram 12). The
cheiroballista is similar to the artillery
shown in use in the Dacian Wars
of AD101–6 on Trajan's column, in
scene LXVI (cat421..and Settis 1988,
p.362); it has a prominent arched
strut holding the spring frames apart.
Sinews were used as springs to
provide the propulsive power.
 Machine no.15, the belly-bow known
as a *gastraphetes*, is the first piece of
artillery for launching arrows. Hero's
Belopoeica is the only description of
it in its earliest form (Wescher 1867,
pp.75–81, fig.XXIII; translated in
Marsden 1971, p.21–3, illustrated on
p.47, fig.3). It was made from two com-
ponents, the stock and the bow, which
was made from two pieces of horn, fit
ted to the front of the stock. The stock
had a lower section, the case, fixed

solidly to the bow, and an upper
section, the slider, about the same size
as the case, which slides freely along the
full length of the case in a dove-tailed
groove (Wescher 1867, pp.75–6). There
was a straight ratchet along each side of
the case, and at the back a withdrawal
rest with a concavity for the operator's
stomach. The slider had two pawls to
work in the ratchets (op.cit., pp.79–81)
and a trigger mechanism (op.cit.,
pp.76–7) with a groove for the missile.
In use the bow string was placed
behind the finger and locked there by
the trigger. The front end of the slider
was placed against the ground or a
wall, while the archer held the bow and
pressed with his chest against the rest.
He used his weight and body muscles
to force back the slider and bend the
bow. With the slider under tension, the
archer placed an arrow in the groove;
when he pulled the trigger the lock was
free to move, releasing the bow-string
from the finger to drive the arrow for-
ward (Singer *et al.* 1956, II, pp.708–9).
Machines nos 7 and 8 on fol.2r (cat.215)
mark the next stage in the development
of artillery.

OTHER REPRESENTATIONS Paris, BN,
MS GR.2442, [no.12] fol.69v, [no.13]
fol.70r, [no.14] fol.70v, [no.15] fol.72v;
London, BL, MS Burney 69, [no.12]
fol.18r, [no.13] fol.18v, [no.14] fol.19r,
[no.15] fol.22r.
ENGRAVED Thévenot 1693, [no.12] p.118,
[no.13] p.119, [no.14] p.120, [no.15]
p.123; Montfauçon 1719, IV/i, p.79.

229

AFTER A BYZANTINE DRAUGHTSMAN
Helepolis, mobile siege tower,
cheiroballista *components*
Inscribed *Machina portabile* in Carlo
Fontana's hand
Numbered 9–11 in ink
No WM; 264 × 199 mm
Large holes on the right
SJSM, vol.128, fol.16r

Machine no.9 is a view of a mobile
wooden siege tower, on an open frame
supported on colonnettes, resting
against the stone walls of the enemy
fortress.
 Siege towers, usually built as and
when required after ladders had failed,
were huge wooden structures tall
enough to provide a view of the
defenders' activity in the stronghold
or to allow archers to fire over the wall.
Sometimes towers were equipped
with a moveable drawbridge that could
be dropped on to the wall to allow the
storming party to rush across. The
projecting penthouse roof at the base
of the tower provides cover for the
sappers at work undermining the walls
of the fortress. The open lower storey
is shown here for clarity; it would not
have been built in practice, because
cover was necessary for the men who
used crowbars to move the wheels and
the oxen who pushed the machine into
place against the tower. The siege tower
equipped with drawbridges designed
by Posidonius of Macedonia for
Alexander the Great is first described
by Biton in *De machinis* (Wescher 1867,
p.57, fig.XVIII; Marsden 1971, pp.71–3
and pp.86–7, n.31–2), followed by
Vitruvius (1511, book x, p.105v).

Nos 10 and 11 are diagrams of two
of the eight items for the construction
of the *cheiroballista* listed by Hero;
no.10 refers to the two dove-tailed
boards; no.11 is a diagram of the trigger
mechanism (Wescher 1867, pp.123–8,
figs XXXVIII, XXXIX and XLI; translated
in Marsden 1971, pp.213–15). Nos 12
and 14 are two other items for the
construction of the *cheiroballista* on
fol.15r (cat.228).

OTHER REPRESENTATIONS Paris, BN,
MS GR.2442, [no.9] fol.65r (Siena 1991,
p.27), [no.10] fol.68v, [no.11] fol.69r;
London, BL, MS Burney 69, [no.9]
fol.12v, [no.10] fol.16v, [no.11] fol.17v.
ENGRAVED Thévenot 1693, [no.9] p.110,
[nos 10–11] pp.116–17; Montfauçon
1719, IV/i, p.91.

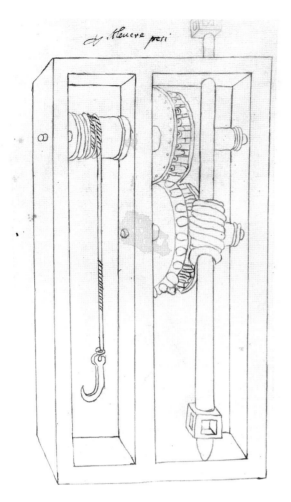

226

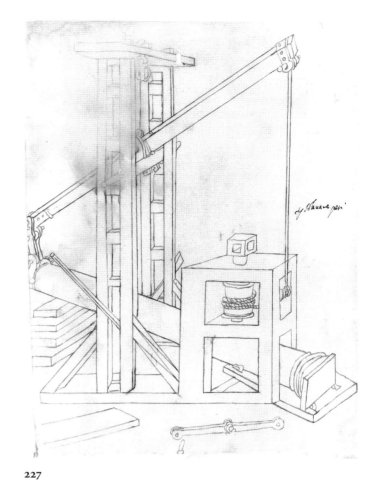

227

228

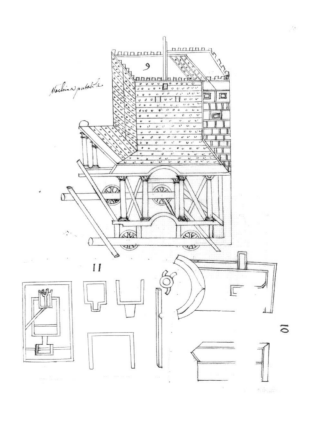

229

230

AFTER A BYZANTINE DRAUGHTSMAN
*Torsion bow, an early frame; plan
and views of the base, side stanchion
and hole carrier*
Inscribed *Dardi rinforzati*
in Carlo Fontana's hand
Numbered 16–20 in ink
WM cat.17; 269 × 184 mm
SJSM, vol.128, fol.17r

The machines are described by
Hero in the *Belopoeica*, translated
by Marsden (1971, pp.23ff). Torsion
artillery developed from experiments
with sinew rope. Machine no.16,
an early stage in the development,
replaced the composite bow of no.15
with two stronger, square wooden
frames wrapped with layers of sinew
to make two bundles, each one forming
a spring on its own frame. The frames
were fitted, on each side of the fixed
part of the stock, to the front of the
case. Another frame, holding the two
frames rigid, separated them and fas-
tened the stock to them firmly. A taper-
ing wooden arm was inserted, the thin
end first, through the middle of each
bundle of sinews, and then pulled until
the thicker end was left just projecting.
The strengthened bow-string was then
fitted from the thin end of one arm to
the thin end of the other by making
loops and securing them to the arms
of the pins to prevent the bow-string
slipping off. Each arm was tightly
gripped by the cords of its spring
because tension was applied in each
frame by tightening iron levers inserted
between the layers of sinew and the
cross-pieces of the frame itself. The
arms were then twisted in opposite
directions, so that the arms were forced
outward by the torsion until they
pressed against the uprights of the tim-
ber frame (Marsden 1969, pp.17–18;

Wescher 1867, pp.82–3 and 87, fig.xxv;
translated in Marsden 1971, pp.23–5,
illustrated on p.49, fig.7). The next
stage in the technical development
of the torsion bow is no.21 on fol.18r
(cat.231).

Hero describes how the whole
engine, no.17, was put on a base to
raise it off the ground, so that it could
be turned in all directions and aligned
with the target, and it was easier to
pull the trigger (Marsden 1969, p.16;
Wescher 1867, pp.87–90, fig.xxvii,
translated in Marsden 1971, p.27).

No.18 is a side-view of the side
stanchion of the v-spring in machine
no.21 on fol.18r (cat.231; Wescher
1867, pp.92–3, fig.xxviii, translated
in Marsden 1971, pp.29 and illustrated
on p.52, fig.13).

No.19 is a diagram of the hole carrier
of no.21 on fol.18r (cat.231); no.23 on
fol.18r is the side view of it. Both are
reconstructed by Marsden (1969,
pp.27–30, fig.14; Wescher 1867, pp.94–8,
fig.xxix; Marsden 1971, pp.29-31 and
p.52, fig.15).

No.20 is a diagram of the washer
fitted to the hole carrier (Wescher 1867,
pp.96–8, fig.xxx; Marsden 1971,
pp.31–3).

For the reconstruction of the torsion
bow and the difference between the
tension and torsion bows, see Soedal
& Foley 1979, pp.150–60.

OTHER REPRESENTATIONS Paris, BN, MS
GR.2442, [no.16] fol.74r, [no.17] fol.74v,
[no.18] fol.75r, [no.19] fol.75v, [no.20]
fol.76r; London, BL, MS Burney 69,
[no.16] fol.24r, [no.17] fol.25r, [no.18]
fol.26r, [no.19] fol.26v, [no.20] fol.27r.
ENGRAVED Thévenot 1693, [no.16] p.131,
[no.17] p.130, [nos 18–19] pp.132–3
(perspectival views of the machines are
shown).

231

AFTER A BYZANTINE DRAUGHTSMAN
*Torsion bows and a mobile siege
machine; views*
Numbered 21–5 in ink
No WM; 269 × 198 mm
Torn on the right
SJSM, vol.128, fol.18r

No.21, the latest model described by
Hero (Marsden 1971, pp.29ff.), is a
development of the spring engine no.16
on fol.17r (cat.230): the cross-pieces
at the top and the bottom of the frame
are extended and joined by cylindrical
struts or cross-pieces with large holes
bored into them, one for each cross-
piece (Wescher 1867, pp.91–103,
fig.xxxi; Marsden 1971, pp.29ff).
The iron levers for twisting the sinew
cord were placed over the holes, and
the sinew cord threaded through the
holes around the iron levers. Hero
observed that the twisting of the lever
was difficult: it could not be turned
while it rested on the cross-piece
because it touched everywhere. The
Greek term for the cross-piece of the
frame is rendered as hole-carriers by
Marsden (1969, pp.18–20, also for his
experiments with this machine). Plates
in Valturio's *De re militari* show an
interpretation of the machine on top
of a tower; Fra Giocondo's plate in his
edition of Vitruvius shows the machine
as drawn by the Greek engineer.

No.22 is the straight spring-engine
described by Hero. No.23 is the side
view of the hole-carrier of the early
torsion frame, shown as machine
no.19 on fol.17r (cat.230; Wescher 1867,
pp.105–10, fig.xxxiv; Marsden 1971,
p.35 and p.52, fig.5).

A mobile siege machine, no.25,
is described by Apollodorus in the
Poliorcetica (Wescher 1867, p.142,
fig.xlvi). The shelter with a platform

and a ladder attached to it is supported
on colonnettes. The four open sides
show the chassis; in practice three of
the sides would have been closed.

OTHER REPRESENTATIONS Paris, BN,
MS GR.2442, [no.21] fol.76v, [no.22]
fol.77r, [no.23] fol.78v, [no.25] fol.80r;
London, BL, MS Burney 69, [no.21]
fol.28r, [no.22] fol.29r, [no.23] fol.32r,
[no.25] fol.35r.
ENGRAVED [no.21] Valturius 1472,
fol.159r; Vitruvius 1511, book x,
fol.105v (both illustrated in
Rodakiewicz 1940, pp.20–21);
Thévenot 1693, [no.25] p.15, [no.21]
p.136, [no.22] p.139; Montfaucon 1719,
IV/i, p.86.

232

AFTER FRANCESCO DI GIORGIO
*Plough, machine for moving
obelisks; views*
No WM; 199 × 165 mm; glued to the folio
upside down
SJSM, vol.128, fol.19r

[1] The cart is driven by the two wheels
with diamond studs, which are pow-
ered by a single vertical worm-screw
and gear on the same axle as the wheels.
The vehicle is steered from the rear; the
steering column has a lantern-pinion
and toothed sector joined by rods to
the wheels. At the back of the cart there
are two moveable ploughshares. A pin

can be inserted into a hole to block the
movement of the ploughshare, to
increase or decrease the depth of the
furrows. An error in the drawing shows
the capstan-head unaligned with the
worm, which should take its bearings
from the wheels and not from the fixed
frame of the carriage as shown. The
means of driving the cart by a worm
and a large wheel is identical to the cart
on fol.4r[1] (cat.217), but this machine
with two wheels would be more stable.
Taccola also shows a plough-cart with
wheels with diamond studs pulled
along by animals (*De ingeneis*, books
I–II, fol.75v; Prager, Scaglia & Montag

1984, I, p.93, II, fol.75v).
[2] A platform on wheels with an
obelisk on top is pushed along by a
mechanism of two capstan heads,
which turn vertical worm-screws
connecting with horizontal pinions
on the same axle as a lantern-pinion
that engages a rack and propels the
platform forward. The obelisk is
shown on the cart to convey weight
rather than as a serious suggestion as
a method of moving obelisks, which
would be excessively vulnerable shifted
vertically in this way.

PROTOTYPE DRAWINGS Rome, BAV,
Codicetto, fol.116r; London, BM,
Opusculum, fol.22v (Siena 1991, p.413).
OTHER REPRESENTATIONS Florence,
BNCF, MS Magliabecchiano II.III.314,
fol.14r; MS Palatino 1077, fol.29v; BML,
MS Ashburnham 1357, fol.13r; Uffizi
7679A; Los Angeles, GRIRC, Codex,
fol.37v; Modena, BE, MS alpha G.4.21,
fol.22r; Turin, BR, MS 383, unnumbered
folio; Urbino, SC, Santini Codex,
fol.42r; Rome, BAV, Barberini Codex,
fol.62r (Siena 1991, p.212); MS Urb. Lat.
1397, fol.19r; Venice, BMV, MS 3048,
fol.20r.

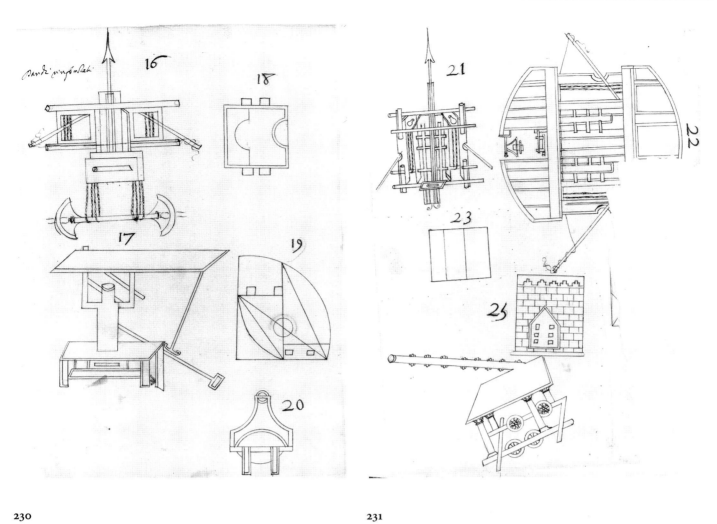

230

231

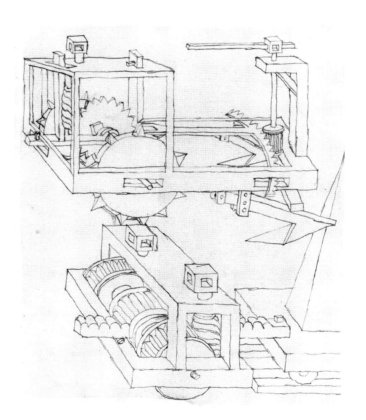

232

233

AFTER FRANCESCO DI GIORGIO
Machines for lifting or pulling heavy weights; views
Inscribed *Vite perpetua da solevare/pesi a lolivella* in Carlo Fontana's hand
No WM; 255 × 200 mm
SJSM, vol.128, fol.20r

[1] A worm, which can be turned by a winch or capstan bars, is linked to a lantern-pinion on an axle set at right angles to it; it turns a winch with two ropes that raise a capital, counter-balanced by a tub filled with stones. Alternative means of driving the machine with a winch or capstan bars are shown. Capstan bars allow greater effort to be exerted but the machine will be slower. If the tub is really intended as a counterweight then its rope should be wound on the winding drum in the opposite direction to the rope attached to the capital.
[2] A gadget to exert a very strong pull over a short distance; it is limited by the length of the rack, which is engaged by a screw turned by a worm and a

lantern-pinion. The worm is turned by a capstan bar.

PROTOTYPE DRAWINGS London, BM, *Opusculum*, fol.25r.
OTHER REPRESENTATIONS [1] Florence, BML, MS Ashburnham 1357, fol.73r; BNCF, MS Magliabecchiano II.III.314, unnumbered folio (the machine has a winch rather than a capstan and no counterweight is shown); [2] MS Palatino 767; MS Magliabecchiano XVIII.2, fol.15r; MS Magliabecchiano II.III.314, fol.75r; MS BR228, fol.127v; Uffizi 7664Ar; Los Angeles, GRIRC, Codex, fol.30r; [1, 2] Modena, BE, MS alpha G.4.21, fol.26r; Alberto Alberti, Rome, GNDS, inv. no.F.N.2866r (Siena 1991, p.254); Turin, BR, MS 383, unnumbered folio; Venice, BMV, MS 4817, fol.35v.

234

AFTER A BYZANTINE DRAUGHTSMAN
Mobile siege towers; views
Numbered 4 in dark brown ink
WM cat.17 ; 247 × 145 mm
SJSM, vol.128, fol.21r

A wooden siege tower on wheels stands next to a circular city wall of stone with a splendid entrance gate. The two structures are linked by a bridge.

No4. For maritime warfare, a bastion-shaped platform on a tower is shown, with ropes as hoists with a scaling ladder attached to them (Wescher 1967, p.33, fig.VIII).

Siege towers were used from Antiquity to the Middle Ages, and usually built as and when required; here the tower is equipped with wheels to enable it to be moved in any direction. They were described by Athenaeus in *De machinis*, published by Thévenot and by Wescher (1867, p.30, fig.VI), and they are shown by Valturio in his manuscript for *De re militari* (fol.83v; Bassignana, no date, tav.XXI) and by Taccola in *De machina* (fol.23r; op. cit.,

tav.XXI; Scaglia 1971, p.93).

In Antiquity catapults were often mounted on merchant ships and other vessels to protect the cargo and to enable them to assist warships (Marsden 1969, pp.169ff). There were no special war vessels in the Middle Ages, but a ship could be converted into a 'man-of-war' in case of attack. Wooden towers were erected at each end, the fore and stern castles, and a fighting top, usually shaped like a barrel, was fastened to the mast to serve as a look-out and to give archers an advantage. Valturio shows a ship dressed for war in the Dresden manuscript (fol.169r; Rodakiewicz 1940, p.32).

OTHER REPRESENTATIONS Paris, BN, MS GR.2442, [1] fol.60r, [no.4] fol.61r; London, BL, MS Burney 69, [1] fol.7r, [no.4] fol.7v.
ENGRAVED Valturius 1532, p.248; Thévenot 1693, pp.8–9 (Siena 1991, p.175); Montfauçon 1719, VI/i, pls 84 and 85.

235

AFTER A BYZANTINE DRAUGHTSMAN
Cart and a mobile siege tower; views
Numbered 5–6 in ink
No WM; 198 × 161 mm
SJSM, vol.128, fol.22r

No. 5. The two-wheeled cart is shown in plan and the siege tower in elevation. No. 6. The tower with a bastion-shaped crow's nest has a bridge resting on a frame like a see-saw, with a ladder for scaling walls at one end (Wescher 1867, pp.35 and 37, figs X and XII).

The machines are described by Athenaeus in *De machinis*.

OTHER REPRESENTATIONS Paris, BN, MS GR.2442, [no.5] fol.61v, [no.6] fol.62r; London, BL, MS Burney 69, [no.5] fol.8r, [no.6] fol.9r.
ENGRAVED Thévenot 1693, pp.10 and 12; Montfauçon 1719, IV/i, pl.85.

236

AFTER AGRICOLA
Chain pump; view
No WM; within a ruled single ink line border; 144 × 141 mm; turned through 90 degrees and glued to the recto
SJSM, vol.128, fol.23r

The illustration shows the third machine of this kind described by Agricola; the second is shown on fol.7r[2] (cat.220; the first chain pump is illustrated by Agricola, 1556, VI, p.131, but not drawn in *Meccanica*). Water is raised by buckets on a continuous circular chain moved by an internal vertical waterwheel, which turns the axle and drum the chain is attached to. As the buckets rise they turn upside down and empty the water into a trough. The machine is used on a site where a running stream can be diverted to a mine to turn the waterwheel;

the stream is not shown on the drawing. The drum was fitted with triple curved iron clamps that connect with the links of the chain, to avoid being torn away by a great weight (Hoover & Hoover 1912, p.172). The dippers were easily broken, so miners rarely used them; they lifted smaller quantities of water by hoist and buckets or used suction pumps (op. cit., p.175).

PROTOTYPE WOODCUT Agricola 1556, VI, p.133.

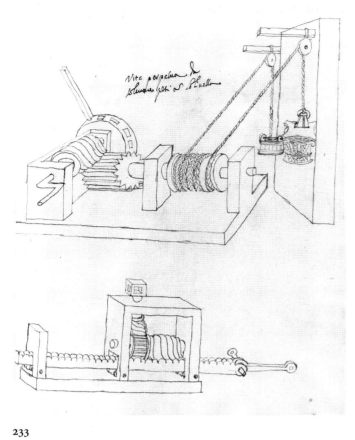

233

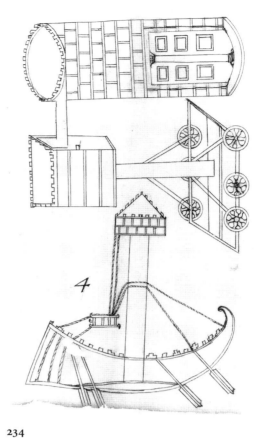

234

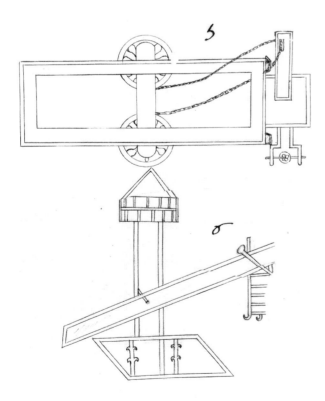

235

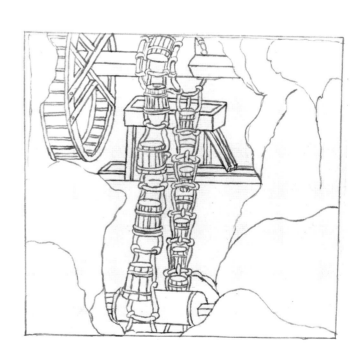

236

237

AFTER AGRICOLA
Crane lifting a cover
No WM; within a ruled, single ink line border; 201 × 129 mm
SJSM, vol.128, fol.24r

The crane was for lifting the domed cover from the crucible used in the process of separating silver from lead. The crane is described in detail by Agricola (translated in Hoover & Hoover 1912, pp.476–80). It is set on a large L-shaped frame of wood that swings on its vertical post. Inside the frame on the left a handle turns a lantern-pinion and engages a second lantern-pinion and spur-gear with a winding drum on its axle to raise and lower the cover of a furnace.

A double, geared windlass as shown would have been of little practical use, because the pinions are the same size as the wheel they turn; to be useful they should be smaller.

PROTOTYPE WOODCUT Agricola 1556, X, p.382.

238

AFTER FRANCESCO DI GIORGIO
A winch mounted on two boats; view
No WM; 229 × 140 mm
SJSM, vol.128, fol.25v

Two boats support a framework made of beams, which encloses the mechanism. A capstan turns a vertical worm-screw that moves a horizontal pinion-ratchet on the same axle as a winch with a rope, which is suspended between the boats. The rope is attached to tongs that grip a column and raise it from the sea-bed.

The device is described by Taccola in *De ingeneis* (book III, fol.44r; Prager & Scaglia 1972, pp.104–5, fig.52).

PROTOTYPE DRAWINGS Rome, BAV, *Codicetto*, fol.126r; London, BM, *Opusculum*, fol.50v.
OTHER REPRESENTATIONS Florence, Uffizi, 7667A; Los Angeles, GRIRC, Codex, fol.8v; Modena, BE, MS alpha G.4.21, fol.107v; Siena, BC, MS S.IV.1, fol.115r; Turin, BR, MS 383, unnumbered folio.

239

AFTER FRANCESCO DI GIORGIO
Machines for blocking rivers; views
No WM; 240 × 210 mm; glued to the verso
SJSM, vol.128, fol.26v

[1] Metal chains link spear-shaped beams with metal tips. Alternatively, rivers are blocked by chains linking towers to barricades made from clusters of beams held together by metal bands, hinged and bolted together and supported by weighted poles below. [2] Harbour gates with chains suspended between towers that can be winched in at night are also drawn by Taccola in *De ingeneis* (book I, fol.13r; Prager & Scaglia 1972, pp.35 and 40, fig.1).

PROTOTYPE DRAWINGS Rome, BAV, *Codicetto*, fol.101v; London, BM, *Opusculum*, fol.51r.
OTHER REPRESENTATIONS Florence, BNCF, MS Panciatichi 361, [1] fol.331v; MS Palatino 767; Modena, BE, MS alpha G.4.21, [1, 2] fol.109r; Siena, BC, MS S.IV.1, [2] fol.115r; Turin, BR, MS 383, [2] unnumbered folio; Urbino, SC, Santini Codex, [1] fol.18r; Rome, BAV, MS Urb. Lat. 1397, [1] fol.41v, [2] fol.41r; Venice, BMV, MS 4817, fol.61r; MS 3048, [2] fol.26v.

240

AFTER A BYZANTINE DRAUGHTSMAN
Shelters and a bore; views
Numbered 26–9 in dark brown ink
No WM; 212 × 180 mm
SJSM, vol.128, fol.27r

No.26 is a rectangular battlemented platform of ashlar with a shelter pushed up against it. The shelter, shown also at no.28, has a triangular section and is open on one side and covered with boards on another to protect the sappers while they undermine the walls of the target. The shelters can be covered with raw hides or damp earth and grass to prevent them catching fire in an attack. They could also be used to make a rampart of movable defences around a camp as shown in a manuscript of 1487 (London, BL, MS Royal E.VI, fols 19v–20r). The shelters are described by Apollodorus in the *Poliorcetica* (Wescher 1867, pp.144–7, figs XLVII–LI) and published by Thévenot. Taccola shows them in *De machina* (fol.20v; Scaglia 1971, p.90, fig.24) and calls them *caroballista*, as does Valturio in *De re militari* (fol.81v; Bassignana no date, tav.LVII).

Semicircular and rectangular towers, which were easier to build and therefore more common, occurred in the Greek world before the technical revolution in the 4th century BC. No.27, an artillery tower built of ashlar with two superimposed chambers, the upper one equipped with windows, is a development from the battlemented platform shown at no.26. Two entrances provide easy access for moving the machines in and out. Both are described by Apollodorus and illustrated by Wescher (1867, pp.144 and 146, figs XLVII–XLVIII).

No.29 is a bore for undermining a wall described by Apollodorus (op.cit., p.149, fig.LI). A drill in a shaft is worked by pulling on the strong cord of the bow, which is wrapped around the shaft and rotates it. The shaft is attached to a stationary post. The bore was useful for undermining sharp angles and required few hands to operate it (Gravett 1990, p.47). A similar machine, called by Bucher a surveying cross-bow, was drawn by Villard de Honnecourt, using the same drawing convention (Bucher 1979, pp.130–33).

OTHER REPRESENTATIONS Paris, BN, MS GR.2442, [no.26] fol.80v, [no.27] fol.81r, [no.28] fol.81v, [no.29] fol.82r; London, BL, MS Burney 69, [no.26] fol.35v, [no.27] fol.36v, [nos 28 and 29] fol.37r; MS add. 15276, [no.26] fol.4v, [no.28] fol.6r, [no.29] fol.7r.
ENGRAVED Valturius 1532, p.244; Thévenot 1693, [no.26] p.16, [no.27] p.17, [no.28] p.18, [no.29] p.19; Montfauçon 1719, IV/i, pls 86 and 88.

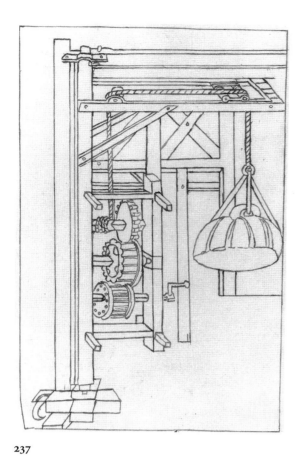

237

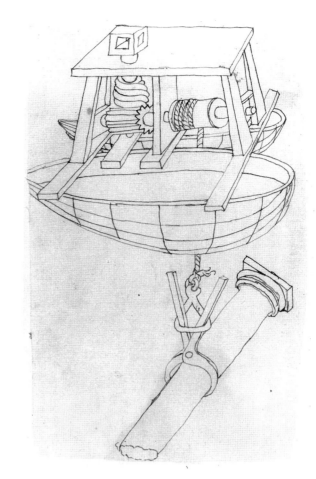

238

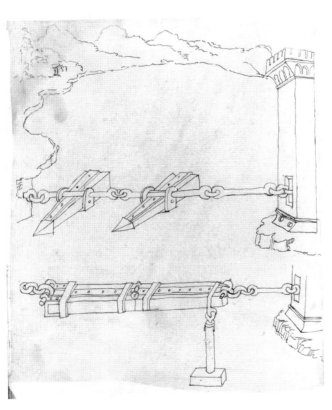

239

240

241

AFTER A BYZANTINE DRAUGHTSMAN
Undermining
Numbered 30–32 in ink
WM cat.17; 276 × 182 mm
SJSM, vol.128, fol.28r

The bore shown on fol.27r (cat.240) is here illustrated in action, no.30. A hole is bored into the wall so that combustible matter can be inserted in order to burn down the walls. No.31 is a corruption of the image in Apollodorus, which shows bellows fanning the flames. No.32 shows a flame-thrower operated by a bellows.

The machines are described by Apollodorus in the *Poliorcetica* (Wescher 1867, pp.150–51, 153, figs LIII–LV) and published by Thévenot. The most effective way to breach a stone wall was to undermine the foundations and cause a section to collapse. A simple method was to attack the base with picks; the cavity could then be shored with timbers and filled with combustibles. An illustration in the Francesco di Giorgio manuscript

(fol.71v bis, 81v; cat.193) offers a more sophisticated method of undermining.

OTHER REPRESENTATIONS Paris, BN, MS GR.2442, [no.30] fol.82v, [no.31] fol.83r, [no.33] fol.83v; London, BL, MS Burney 69, [no.30] fol.37v, [no.31] fol.38r, [no.32] fol.38v; MS add. 15276, [no.30] fol.7v, [no.32] fol.8v.
ENGRAVED Thévenot 1693, pp.19–21.

242

AFTER FRANCESCO DI GIORGIO
A four-wheeled vehicle with two wheels for driving and two for steering; view
No WM; 148 × 177 mm; turned through 90 degrees and glued to the recto
SJSM, vol.128, fol.29r

The vehicle is powered by a vertical worm-screw engaging a pinion and a horizontal worm-screw on the same axle. The second worm-screw connects with a horizontal worm-wheel, with crown-gear teeth set on its lower face, which engages a lantern-pinion on the axle carrying the wheels. The spur-gear, on the steering column, connects with a lantern-pinion and toothed sector attached to the rear wheels.

By setting many crown-teeth near the edge of the worm-wheel much of the power, which should be obtained by the large wheel, is lost. The drawing in the Laurenziana manuscript, MS Ashburnham 361 (fol.46v), is similar to this drawing but the connection between the central horizontal worm-

wheel and the wheels is more complex, and a worm-screw below the crown-gear drives a pinion that moves the wheels. The wheels in the Ashburnham drawing have diamond-shaped studs, enabling the car to move over all types of terrain.

PROTOTYPE DRAWINGS Rome, BAV, *Codicetto*, fol.118v; London, BM, *Opusculum*, fol.29v.
FRANCESCO DI GIORGIO MANUSCRIPTS Turin, BR, MS Saluzziano 148, fol.52r (Maltese 1967, p.270, tav.95); Florence, BML, MS Ashburnham 361, fol.46v (Siena 1991, p.404).
OTHER REPRESENTATIONS Florence, BML, MS Ashburnham 1357, fol.3r; BNCF, MS Magliabecchiano II.III.314, fol.4r; Uffizi 7675AV; Los Angeles, GRIRC, Codex, fol.34v, reversed; Modena, BE, MS alpha G.4.21, fol.30bis; Turin, BR, MS 383, unnumbered folio; Urbino, SC, Santini Codex, fol.24r; Rome, BAV, MS Urb. Lat. 1397, fol.17r; Venice, BMV, MS 4817, fol.26r.

243

AFTER AGRICOLA
Piston pumps, section through a mine; view
No WM; within a single ink line border; 240 × 151 mm
SJSM, vol.128, fol.30r

This is the fourth piston-pump, the fifth is shown on fol.72r (cat.285). A man turns a crank-handle outside a rectangular casing that contains two crank-operated lift-pumps, which draw the water from the mine. The two arms on the crank-axle carry fly-weights. The water passes through the closed box into the pipe above it. Various components of the lift-pump are shown separately on the right. Agricola notes that when the crank

is turned the pistons draw the water through their discs; since this is done quickly, and since the area of the openings of the two pipes over which the box is set is twice as large as the openings of the pipe that rises from the box, and since the pistons do not lift the water far, the impetus of the water from the lower pipes forces it to rise and flow out of the column pipe into the drain of the tunnel.

Wooden boxes frequently crack open; it is better to make them of lead, copper or brass (Hoover & Hoover 1912, pp.180–81).

PROTOTYPE WOODCUT Agricola 1556, VI, p.139.

244

AFTER AGRICOLA
Rag and chain pump; view
No WM; two drawings within single ink line borders; 270 × 157 mm
SJSM, vol.128, fol.31r

[1] The drawing shows the fourth pump of this kind; the third is drawn on fol.59r, the fifth on fol.8r and the sixth on fol.58r (cat.221, 251, 271 and 272). It shows two ways of driving a chain pump with a winch on the right and with capstan bars on the left. Two uprights are erected; the barrel revolves in openings in them. Two strong men or four turn the barrel by pulling and pushing the cranks. The barrel has a drum fitted with clamps that catch the links of a chain fitted with balls. Agricola observed that the engine will draw water from a depth of 48 *piedi*; only water-power drives this drum continuously (Hoover & Hoover 1912, p.195).
[2] The illustration shows how water-power outside the mine can power a waterwheel, to be worked within the mine, to raise water from the shaft below to an adit drain. The upper wheel drives a pump to lift some of the water from the adit level to drive

a waterwheel that is pumping water from below. The machine was designed for use in areas where the water supply was low; it has a wheel so light and low that little water is required to turn it. This water, falling into a race, runs on to a second, high and heavy wheel of a lower machine, whose pump lifts the water from the deep shaft. Since the water of such a small stream cannot alone revolve the wheel, at the start the axle of the wheel is turned by a crank worked by two men, but as soon as the water has poured out into a pool, the upper wheel draws up this water by its own pump and pours it into the race; from here it flows on to the lower waterwheel and strikes its buckets. So both the water from the mine and the water from the stream are used to turn the wheels and to pump water from the deeper part of the shaft by means of two or three pumps (Hoover & Hoover 1912, p.187–8).

PROTOTYPE WOODCUT Agricola 1556, VI, [1] p.153, [2] p.146.
ENGRAVED [2] Strada 1617–18, I, tav.32.

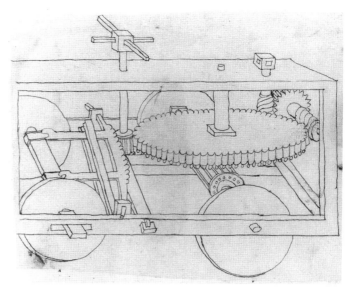

242

241

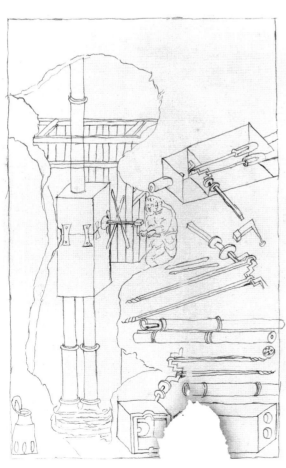

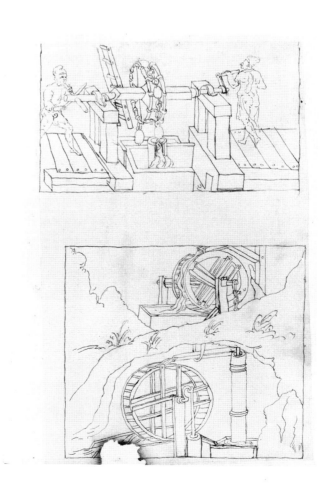

243

244

245

AFTER FRANCESCO DI GIORGIO
*Machine for raising columns into
place; view*
No WM; 253 × 188 mm
SJSM, vol.128, fol.32r

A lifting arm is embraced by a short
beam attached to the front of a crane
frame and operated by a windlass. It
is balanced on a cross-bar of the frame
and attached to the column at the neck.
The device is driven by capstan-bars
turning a worm-screw that engages a
toothed rack. The purpose of the short
second beam is unclear. The purpose
of the short arm attached by pulley to a
windlass may be to pull the lifting arm
down to attach it to the column.

PROTOTYPE DRAWINGS Rome, BAV,
Codicetto, fol.123v (the capital is cut off
at the neck of the column); London,
BM, *Opusculum*, fol.57v.
OTHER REPRESENTATIONS
Florence, BNCF, MS Palatino 767; MS
Magliabecchiano II.III.314, fol.76r;
MS E.B.16.5, fol.126v; MS Palatino 1077,
fol.58v; BML, MS Ashburnham 1357,
fol.74r; Los Angeles, GRIRC, Codex,
fol.24v; Modena, BE, MS alpha G.4.21,
fol.16bis; Siena, BC, MS S.IV.1, fol.123v;
Turin, BR, MS 383, unnumbered folio;
Urbino, SC, Santini Codex, fol.46r;
Rome, BAV, MS Urb. Lat. 1397, fol.63v.

246

AFTER FRANCESCO DI GIORGIO
Watermill
No WM; 221 × 153 mm; glued to the folio
upside down
SJSM, vol.128, fol.33r

An undershot waterwheel is connected
by a lantern-pinion on its axle to the
spur-teeth of a vertical spur and
crown-gear in the second chamber;
the crown-gear engages a second
lantern-pinion that drives the mill-
wheel above.

As drawn, the large gear is practically
an idle wheel. The drawing is identical
to that in *Opusculum*. The wheel on
a horizontal axle was described by
Vitruvius, and by the Renaissance it
was the prime mover. Both overshot
and undershot waterwheels feature in
Francesco's *Opusculum*, although the
wheels illustrated in *Meccanica* are all
undershot. Ferguson has suggested
that the preference for undershot or
overshot waterwheels seems to have
been divided by national boundaries;
the French preferred the undershot
wheel in the 18th century (Ramelli
1976, p.569, cat.2).

PROTOTYPE DRAWINGS London,
BM, *Opusculum*, fol.65v.
OTHER REPRESENTATIONS Florence,
BNCF, MS Palatino 767; MS
Magliabecchiano II.III.314, fol.60r;
BML, MS Ashburnham 1357, fol.58r;
Los Angeles, GRIRC, Codex, fol.14r;
Modena, BE, MS alpha G.4.21,
unnumbered folio; Siena, BC,
MS S.IV.1, fol.114r; Turin, BR, MS 383,
unnumbered folio; Venice, BMV,
MS 4817, fol.63v; MS 3048, fol.11r.

247

AFTER FRANCESCO DI GIORGIO
Machine for hauling; view
No WM; 221 × 155 mm; turned through
90 degrees and glued to the recto
SJSM, vol.128, fol.34r

A carriage on wheels drawn by a rack
engaged by a worm-screw. The screw
on the spindle carries a pinion turned
by a second worm on an upright shaft
with a capstan-head. This shaft also
carries a spur-wheel that is engaged
by a roller lantern-pinion on a second
upright shaft threaded through a
capstan-head. The machine is worked
by placing the bars in either of the
two capstan heads. The device offers a
choice of two power systems to drive it.

The drawing is identical to that in
Opusculum.

PROTOTYPE DRAWINGS London, BM,
Opusculum, fol.17r.
OTHER REPRESENTATIONS Florence,
BML, MS Ashburnham 1357, fol.93r;
Uffizi 7676AV; BNCF, MS
Magliabecchiano II.III.314, fol.95r;
MS Palatino 1077, fol.27v; Los Angeles,
GRIRC, Codex, fol.31r; Modena, BE,
MS alpha G.4.21, fol.17r; Venice, BMV,
MS 3048, fol.7.

248

AFTER FRANCESCO DI GIORGIO
*Boat armed with an auger and
portable boats in sections; view*
No WM; 220 × 201 mm; turned through
90 degrees and glued to the recto
SJSM, vol.128, fol.35r

[1] Handles in the sides of two boxes,
on each side of the hull of a boat, turn
horizontal worm-screws and vertical
lantern-pinions with vertical worm-
screws attached to them; these engage
long pinion-heads and turn screws
with augers. The winch outside the
boat is probably used to release the
augers quickly once the hull has been
pierced.
[2] The hull of a boat in four sections
can be carried and then bolted together
for use.

Boats in several sections are shown
by Valturio (fol.111r; Bassignana,
no date, tav.LX).

PROTOTYPE DRAWINGS Rome, BAV,
Codicetto, fols 124r and 125r; [2]
London, BM, *Opusculum*, fol.43r.
OTHER REPRESENTATIONS [2] Florence,
BNCF, MS Palatino 767; MS
Magliabecchiano II.I.341, fol.202v;
Turin, BR, MS 238, fol.245v; MS 383,
unnumbered folio; Urbino, SC, Santini
Codex, fol.20v; Rome, BAV, MS Urb.
Lat. 1397, [1] fol.35r, [2] fol.44r; Venice,
BMV, MS 4817, fol.52v; MS 3048, fol.33r.
ENGRAVED Valturius 1532, p.315.

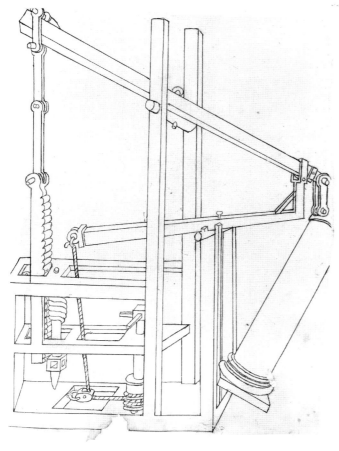

245

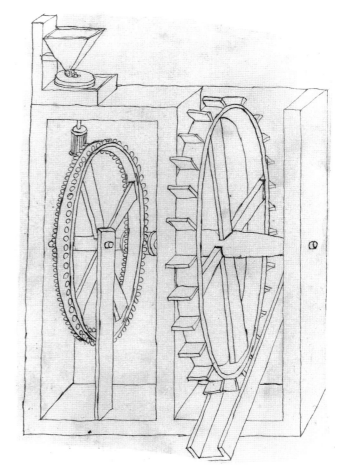

246

247

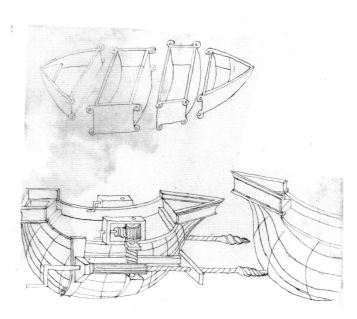

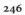

248

249

AFTER FRANCESCO DI GIORGIO
Chain-of-buckets pump, lift pump; views
No WM; 277 × 172 mm
SJSM, vol.128, fol.36r

[1] The chain-of-buckets pump is drawn on a domestic scale. A square shaft is sunk in the centre of a round well. Above the shaft is a frame with a two-handled winch that raises and lowers a continuous chain formed by two chains supporting small troughs at regular intervals. On the descent the chain is outside the shaft; on the turn for the ascent the troughs enter the shaft through an arch at the bottom, scoop up water and deposit it in the shaft on the ascent. To maintain the level of the water, it overflows through a spout.

Chain pumps are illustrated by Taccola in *De ingeneis*, fol.30r, and he refers to them as a new invention; they probably derive from China (Prager &

Scaglia 1972, pp.76–7, figs 27–8). [2] The illustration shows a conventional lift-pump in a well, but the sides of the buckets have not been drawn; they are shown on fol.11r[1] (cat.224). The pump is driven by means of a rocking lever connecting a rod and crank turned by a winch.

PROTOTYPE DRAWINGS London, BM, *Opusculum*, fol.53v.
OTHER REPRESENTATIONS Anonymous, 16th century, Florence, Uffizi 4054A; Uffizi 4047A; [2] BNCF, MS Panciatichi 361; [1] MS Palatino 1077, fol.144r; BML, MS Ashburnham 1357, [1] fol.36r, [2] fol.23r; Los Angeles, GRIRC, Codex, fol.13r; Turin, BR, MS 383, unnumbered folio; Urbino, SC, Santini Codex, [1, 2] fol.32r, [1] fol.22r (Prager, Scaglia & Montag 1984, appendix, fig.14); Rome, BAV, MS Urb. Lat. 1397, [1] fol.45r, [2] fol.39r; Venice, BMV, MS 3048, [1, 2] fol.7r, [1] fol.27r; MS 4817, fol.40r.

250

AFTER FRANCESCO DI GIORGIO
Watermill operated by siphoned water; view
No WM; 167 × 199 mm
SJSM, vol.128, fol.37r

Water, brought by aqueduct, is delivered from a siphon to an undershot waterwheel. A lantern-pinion attached to the axle rotates a spur-wheel and drives a lantern-pinion on the spindle, which turns the mill-stone above. The lantern-pinion on the spindle is often referred to as the stone nut.

The idea of siphoned water operating a mill derives from Taccola's work on siphons in *De ingeneis* (Prager & Scaglia 1972, pp.122–3). The machine is identical to that in *Opusculum*.

PROTOTYPE DRAWINGS Rome, BAV, *Codicetto*, fol.148r; London, BM, *Opusculum*, fol.54r.
OTHER REPRESENTATIONS Los Angeles, GRIRC, Codex, fol.13v; Modena, BE, MS alpha G.4.21, fol.37r; Turin, BR, MS 383, unnumbered folio.

251

AFTER AGRICOLA
Rag and chain pump; view
No WM; within a single ink line border; 234 × 145 mm
SJSM, vol.128, fol.38r

This is the first chain pump described by Agricola; the third is drawn in *Meccanica* on fol.59r, the fourth on fol.31r, the fifth on fol.8r and the sixth on fol.58r (cat.272, 244, 221 and 271). An overshot waterwheel in a cave turns an angular axle with a drum fitted with iron clamps that catch the links of the chain. The chain, turning around the drum, brings up water by balls through the pipes. The balls are 6 *piedi* apart and can be held in the hand. If the machine is set up on the surface, the stream that turns the wheel is led away through ditches, in a mine through subterranean drains. The buckets of the wheel move forward under the impact of the stream and turn the axle and drum; the chain is wound up and the balls expel water through the pipes. If the wheel is 24 *piedi* in diameter it will

draw water up from 210 *piedi*, if it is 30 *piedi* in diameter from 240 *piedi*; it requires a stream with great force. The pump works automatically; a bell is rigged up to ring continuously to indicate that the pump is working (Hoover & Hoover 1912, pp.188–92).

A detail of the barrel of the chain pump is shown on the right; the roller guide for the chain is shown at the bottom of the barrel.

PROTOTYPE WOODCUT Agricola 1556, VI, p.149.

252

AFTER AGRICOLA
Cranes; views
No WM; within a single ink line border; 265 × 154 mm
SJSM, vol.128, fol.39r

[1] A crane with a single chain operated by a winch and pulleys over an L-shaped frame.
[2] A man turns a winch that drives a lantern-pinion and spur-gear, which winches the chain on to the winding drum over pulleys. The load is held by self-closing tongs. The L-shaped frame is capable of turning.

The drawing illustrates a detail of a plate showing copper smelters' furnaces. The crane was used for lifting copper cakes from their moulds and stacking them for storage.

PROTOTYPE WOODCUT Agricola 1556, XI, [1] p.408, [2] p.412.

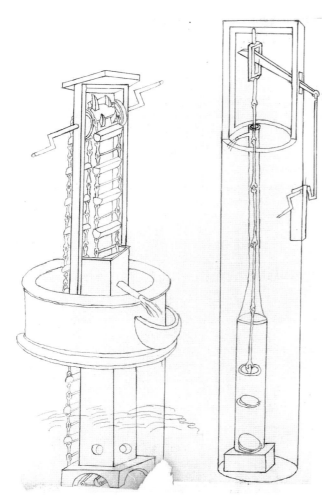

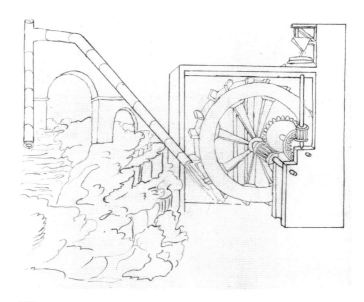

250

249

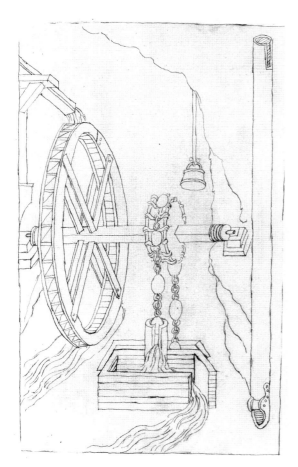

251

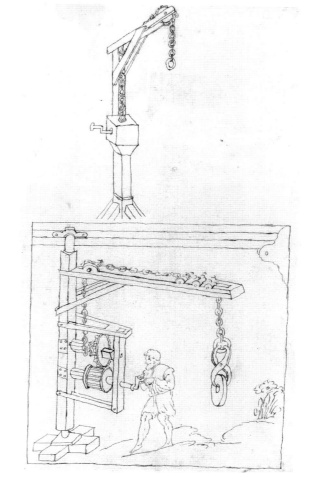

252

253

AFTER AGRICOLA
Ventilating equipment powered by bellows and fans; view
No WM; within single ink line borders; 151 × 256 mm
SJSM, vol.128, fol.40r

A mine can be ventilated by bellows that fill the shafts and tunnels with air by their blasts, and clear heavy poisonous gases from the mine by suction. When open, the bellows draw the gases in and blow them out through a hole in the upper board; when compressed, they drive the air through the nozzle into the pipes or conduits.
[1] The second machine described by Agricola. The machine has two axles, one turned by a horse. The teeth of the crown-wheel turn a lantern-pinion on a horizontal axle; the cams on the axle work the bellows.
[2] The first machine described by Agricola. It has a vertical wheel on an axle driven by a horse, held between bars treading the steps of a wheel. The cams on the axle press down the sweeps, which compress the bellows (Hoover & Hoover 1912, p.210).
[3] Three drawings at the bottom of the folio show fans fitted to the barrel of a windlass contained in a box-shaped casing set up on the ground like a windmill. Four sails set on an axle turn it when they are struck by the wind; the fans inside the casing turn and drive the air through the blow-hole and conduit into the shaft. The machines work on the same principle as the machine with drum casings on fol.7r (cat.220), but they are less efficient. When fans are fitted to a drum they fill it, driving all of the accumulated air into the conduit. The fans cannot fill the box-shaped casings. The drawing on the right shows an arrangement of fans on a winch; the drawing on the left derives from another plate in Agricola (1556, VI, p.165; Hoover & Hoover 1912, pp.203–5).

PROTOTYPE WOODCUT Agricola 1556, VI, [1] p.169, [2] p.163, [3] p.165.

254

AFTER AGRICOLA
Wind-operated ventilating equipment, a piston pump, a well; views
No WM; 234 × 177 mm; glued to the verso
SJSM, vol.128, fol.41v

[1] The detail at top left is the third wind-operated ventilating machine; the first is shown on fol.64r (cat.277). A wooden barrel, four *piedi* high and three *piedi* in diameter, with wooden hoops, is fitted above a pipe. The barrel has a square blow-hole that is always open to catch the breezes and guide them either by one pipe into a conduit or by many pipes into the shaft. The pipe projects out of the table and is fixed in the round opening in the centre of the bottom of the barrel, so that the barrel can turn on it. A perpendicular axle that runs through the centre of the barrel into the hole in the cover is fixed to the pipe. The barrel is turned on the fixed axle by wind turning a wing made of thin wood, fixed to the upper part of the barrel opposite the blow-hole. The wind blowing from any direction drives the wing in the opposite direction, and the barrel turns the blow-hole towards the wind to receive the air (Hoover & Hoover 1912, pp.201–2).
[2] On the right is a simple piston-pump that raises water by suction. Two lengths of pipe joined together are let down to the bottom of a sump and fixed with pointed iron clamps. The lower end of the pipe is enclosed in a hollow trunk two *piedi* deep; its lower opening is blocked and it has perforations at the side through which water flows. When the piston descends into the pipe their discs draw the water, and when they are raised these force the water out through the pipes. On the left details are given of the components of the piston-pump, the trunk, discs, piston-rods and cylinders shown in Agricola's piston-pump plate in book VI (p.135; Hoover & Hoover 1912, p.176). The second pump of this kind is shown on fol.64r[3](cat.277).
[3] A well operated by a winch that turns a spur-gear and lantern-pinion (Hoover & Hoover 1912, p.549). The feet shown to the left of well are of the uncompleted figure of a man turning the winch. Below it and to the left are details of components of lift-pumps based on Agricola (1556, VI, p.135). Above the winch on the left is a pair of augers for boring wooden pump-barrels.

PROTOTYPE WOODCUT Agricola 1556, VI, [1] p.161, [2] p.135 (the pump components are shown on this plate); XII, [3] p.443.

255

AFTER FRANCESCO DI GIORGIO
Hydraulic saw; view
No WM; one beige, two brown washes; 242 × 180 mm; glued to the verso
SJSM, vol.128, fol.42v

The saw-frame is guided between two parallel upright guides. An undershot waterwheel is powered by water funnelled on to the blades at great speed. Francesco di Giorgio stresses the need for a great force of water to operate this machine. The saw-frame is driven by a connecting rod worked by a crank on the axle of the waterwheel. The frame supporting the saw is connected by a system of ropes and pulleys to the horizontal trolley on wheels supporting the block of wood to be sawn. A pair of levers is attached to a rocking axle; one is moved by the saw-frame and the other turns a ratchet-wheel tooth by tooth to move the timber carriage. The force of the water drives the saw up and down while the carriage below the block of wood is drawn forward by the winch.

This is the earliest illustration of a saw-frame driven by connecting rods. Villard de Honnecourt shows a saw drawn down by tappets and spring poles. A hydraulic saw to turn tree trunks into planks is described in *Codicetto* (fol.165v) and drawn in *Opusculum* (fol.72v). It is certain that Francesco di Giorgio was not the inventor of the machine, although his drawing may be the source of the many illustrations of this kind of saw from Leonardo to Agostino Ramelli. The saw is shown in Francesco di Giorgio's terracotta frieze of machines formerly on the facade of the ducal palace in Urbino, above the bench, and now inside the palace (Rotondi 1970, p.78). A note on a drawing by the anonymous Sienese records a saw of this kind at *Al ermeto al Abadia a S. Salvatore* (Scaglia 1981, pp.16–32, with a survey of drawings of saws; Siena 1991, pp.235 and 433).

PROTOTYPE DRAWINGS Rome, BAV, *Codicetto*, fol.165v; London, BM, *Opusculum*, fol.72v (Siena 1991, p.38, fig.50).
FRANCESCO DI GIORGIO MANUSCRIPTS Turin, BR, MS Saluzziano 148, fol.88r (Maltese 1967, p.269, tav.88); Florence, BML, MS Ashburnham 361, fol.43v (Marani 1979, p.88, cap.CCXLIX).

OTHER REPRESENTATIONS Florence, BNCF, MS Palatino 767; MS E.B.16.5, fols 62r and 124r; MS Magliabecchiano II.III.314, fol.2r; MS Palatino 1077, fol.63r (Siena 1991, p.235; Venice 1993, p.487, cat.101); BML, MS Ashburnham 1357, fol.1r; Modena, BE, MS alpha G.4.21, fol.119v; Padua, BU, MS 764, fol.90r; Alberto Alberti, Rome, GNDS, inv. no.F.N.2864r (Herrmann Fiore 1983, pp.254–5, cat.178); Siena, BC, MS S.IV.1, fol.121r; Turin, BR, MS 383, unnumbered folio; Rome, BAV, MS Urb. Lat. 1397, fol.20v; Venice, BMV, MS 5363, unnumbered folio; MS 3048, fol.8r; MS 4817, fol.83r.
ENGRAVED Strada 1617–18, tav.48 (the watermill is replaced by a treadmill); Zeising 1614–21, II, no.17.

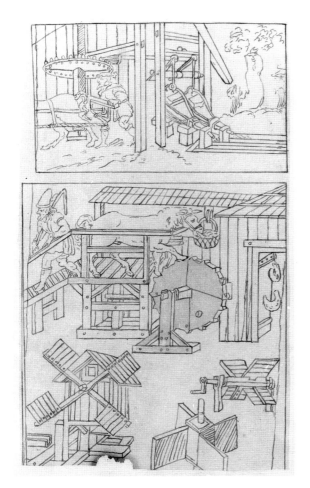

253

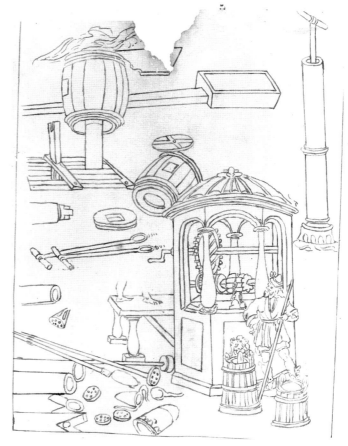

254

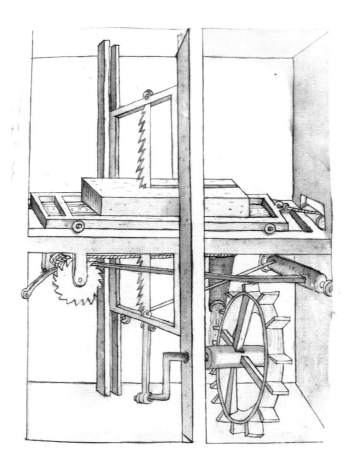

255

256

AFTER FRANCESCO DI GIORGIO
Swape or a machine for scooping water, siphoning water; views
No WM; 257 × 210 mm
SJSM, vol.128, fol.43r

[1] A developed form of the swape, a water-raising device on a rocking beam. A simple version of the swape is commonly used for irrigation. A half-barrel on the end of a balanced lever, which is scooped out as a funnel and suspended over a large barrel on the ground, hangs from a second lever attached to a winch. The half-barrel is lowered and raised in and out of the water by the long lever; as the barrel tilts the water falls into the large barrel. (For the swape, see Hill 1984, p.130) [2] Water from the sea is siphoned through an opening in the pier of an aqueduct resting in the sea; the other piers are on land. The aqueduct spans uneven ground by means of steps and gradually diminishing arches, and the water rushes out into a basin. The drawing probably illustrates the idea

that a current can set a siphon going.
The drawing of the aqueduct derives from Taccola's *De ingeneis*.

PROTOTYPE DRAWINGS London, BM, *Opusculum*, fol.58r.
FRANCESCO DI GIORGIO MANUSCRIPTS [1] Turin, BR, MS Saluzziano 148, fol.45v (Maltese 1967, p.268, tav.82); Florence, BML, MS Ashburnham 361, fol.43v (Marani 1979, p.88, cap.CCXXIII).
OTHER REPRESENTATIONS Anonymous, 16th century, Florence, Uffizi 4057AV; BML, MS Ashburnham 1357, fol.25r; BNCF, MS Magliabecchiano II.III.314, fol.26r; MS Palatino 1077, fol.143r; IMSS, MS Ant.532, fol.43r; Los Angeles, GRIRC, Codex, fol.12v; Modena, BE, MS alpha G.4.21; Siena, BC, MS S.IV.6, fol.33r; Padua, BU, MS 764, fol.87r; Urbino, SC, Santini Codex, fol.17v; [1] Rome, BAV, MS Urb. Lat. 1397, fol.41r; Venice, BMV, MS 3048, fol.26v; MS 4817, fol.60v.
ENGRAVED [1] Zeising 1614–21, I, no.17; Strada 1617–18, tav.25; Leupold 1724–5, Taf.XXXIX.

257

AFTER FRANCESCO DI GIORGIO
Scaling ladder; view
No WM; 187 × 179 mm
SJSM, vol.128, fol.44r

A three-wheel armoured cart has a beam with a platform embraced by an L-shaped lever, balanced on the cross-bar of the frame, connected by rope to a winch. A shorter beam is hinged to the bend of the L-shaped lever and balanced on the lower cross-bar of the main frame and connected to the rope ladder. When the long bar of the L-shaped lever is lowered the platform rises to a vertical position; when it rises the platform descends to a horizontal position and the rope ladder can be pulled up to enable men to scale the walls.

The machine is identical to that in *Opusculum*.

PROTOTYPE DRAWINGS London, BL, *Opusculum*, fol.79v.
OTHER REPRESENTATIONS Florence, BM, MS Ashburnham 1357, fol.79r; Modena, BE, MS alpha G.4.21, fol.38r; Turin, BR, MS 383, unnumbered folio.

258

AFTER FRANCESCO DI GIORGIO
Scaling ladders; views
No WM; 268 × 167 mm
SJSM, vol.128, fol.45r

On the left a scaling device, with a central collapsible column in three sections, with spurs at the bottom and hooks at the top to secure the ladder, has a rope ladder that can be wound up through the central column. On the right are three poles with spurs and hooks with foot supports that can be clamped on to the pole, to be used like crampons.

The devices are identical to those in *Opusculum*. Similar scaling devices are shown by Valturio in *De re militare* (1532, pp.254–6) and in Taccola's *De ingeneis* (fol.17r and v; Prager, Scaglia & Montag 1984, pp.33–4). In practice, scaling ladders were often simple wooden objects, perhaps with iron

hooks at the top to grip the parapet, and sometimes with iron points at the base to dig into the ground. Forked poles, used to help erect the ladders, were also used by the defenders to push ladders away.

PROTOTYPE DRAWINGS Rome, BAV, *Codicetto*, fols 77v–78r; London, BM, *Opusculum*, fol.11r.
OTHER REPRESENTATIONS Florence, BNCF, MS Palatino 767; MS BR.228, fol.200r and v; MS Panciatichi 361, fols 328v–329r; MS E.B.16.5, fols 73r–74r; anonymous, Uffizi 7677A; Los Angeles, GRIRC, Codex, fol.48v; Modena, BE, MS alpha G.4.21, fol.39r; Siena, BC, MS S.IV.6, fol.33v; Turin, BR, MS 383, unnumbered folio; Urbino, SC, Santini Codex, fol.23r; Rome, BAV, MS Urb. Lat. 1397, fol.46r and v; Venice, BMV, MS 4817, fols 14v–15r.

259

AFTER A BYZANTINE DRAUGHTSMAN
Covered shelter and battering-rams; views
Numbered 34–7 in ink
WM cat.17; 256 × 153 mm
SJSM, vol.128, fol.46r

The diagrams show a mobile cage for a battering-ram, a detail of a ram and three different ways of suspending a ram from a framework of beams. The battering-rams are described by Apollodorus in the *Poliorcetica* (Wescher 1867, pp.159–61, figs LXVI–LXIV) and published by Thévenot. The ram usually consisted of a tree trunk repeatedly swung against a wall until it dislodged and cracked the masonry. It could take up to 60 men to operate the beam, unlike the bore no.29 on fol.27r (cat.240), which could be operated by a few men. Both rams and bores were used under shelters; they were

often called *testudo* because their heads went in and out like tortoises. Rams were often set on a chassis with wheels (Gravett 1990, p.47).

OTHER REPRESENTATIONS Paris, BN, MS GR.2442, [no.33] fol.84v, [nos 34 and 35] fol.86r, [nos 36 and 37] fol.86v; London, BL, MS Burney 69, [nos 34–6] fol.40v, [no.37] fol.41r; BL, MS add. 15276, [no.33] fol.10v.
ENGRAVED Valturius 1472, fols 147r, 193v and 194v (Vitruvius is cited as the source for the suspended rams shown on fol.194v); Vitruvius 1511, fol.108r (all illustrated in Rodakiewicz 1940, pp.19, 22 and 29, n.11); Thévenot 1693, pp.23–6.

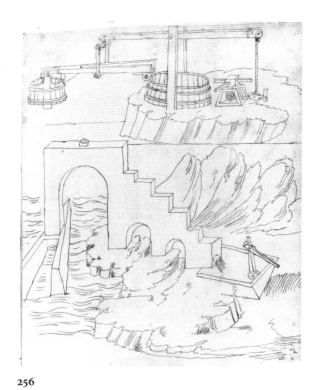

256

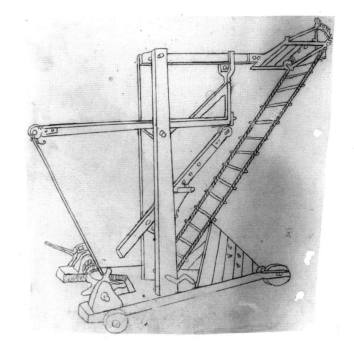

257

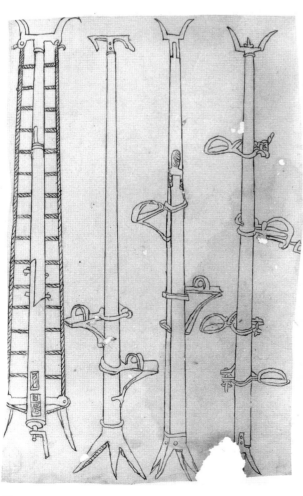

258

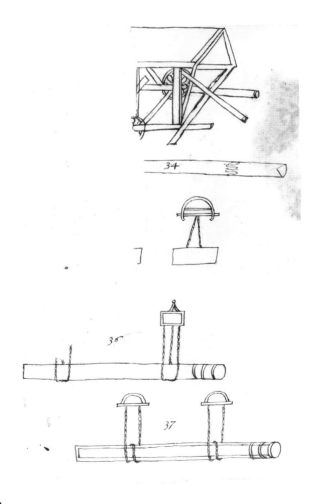

259

260

AFTER A BYZANTINE DRAUGHTSMAN
Scaling devices; views
Numbered 38–9 in ink
No WM; 229 × 166 mm
SJSM, vol.128, fol.47r

No.38 is a wooden ladder with a pointed top, set on a hinged collapsible frame next to a fortified, rusticated and crenellated tower. No.39 is a tower made by linking ladders at the corners with horizontal and diagonal wooden supports. Siege towers are described by Apollodorus in the *Poliorcetica*

(Wescher 1867, pp.163 and 167, figs LXVI–LXVII) published by Thévenot. A similar ladder is shown by Valturio (fol.88r; Bassignana, no date, tav.XXX).

OTHER REPRESENTATIONS Paris, BN, MS GR.2442, [no.38] fol.87v, [no.39] fol.88v; London, BL, MS Burney 69, [no.38] fol.41v; [no.39] fol.43r.
ENGRAVED Thévenot 1693, pp.27 and 29.

261

AFTER FRANCESCO DI GIORGIO
Plunger pump; view
No WM; 243 × 208 mm
SJSM, vol.128, fol.48r

This is a development of the plunger pump shown on fol.11r[2] (cat.224). The plungers are the rectangular blocks working in rectangular barrels; the delivery valves are not shown. Each plunger has a screw fixed to the upper face, which is raised and lowered by nuts in rotating frames that embrace the screw. The frames are turned

simultaneously by the engagement of the pinions at the top of each frame with a single worm worked by a winch. The machine could have been developed in order to raise water from a very great depth. The machine is identical to the one in *Opusculum* (fol.58r).

PROTOTYPE DRAWINGS London, BM, *Opusculum*, fol.58r.
OTHER REPRESENTATIONS Los Angeles, GRIRC, Codex, fol.18v; Modena, BE, MS alpha G.4.21, fol.117r; Turin, BR, MS 383, unnumbered folio.

262

AFTER FRANCESCO DI GIORGIO
Loading hoist; view
WM cat.12; 247 × 179 mm
SJSM, vol.128, fol.49r

A pole with a pointed end, allowing it to rotate through 360 degrees, resting against the bottom of a large vertical rectangular frame, balances a wooden lever with ropes attached to rings at one end and a rope and hook at the other to be attached to bales or barrels, which are then lifted and swung on to the boat. The machine derives from Taccola's *De machina* (fol.27v; Scaglia 1971, p.98); it is identical to the drawing in *Opusculum*.

PROTOTYPE DRAWINGS Rome, BAV, *Codicetto*, fol.25v; London, BM, *Opusculum*, fol.72r (Siena 1991, p.37, fig.49).

FRANCESCO DI GIORGIO MANUSCRIPTS Turin, BR, MS Saluzziano 148, fol.49r (Maltese 1967, I, p.269, tav.89); Florence, BML, MS Ashburnham 361, fol.44r (Marani 1979, p.89, cap.CCLII).
OTHER REPRESENTATIONS Florence, BML, MS Ashburnham 1357, fol.36r; Antonio da Sangallo, Uffizi 4068A; BNCF, MS E.B.16.5, fols 62v and 180r (Siena 1991, p.263); MS Palatino 767, fol.35r; MS Magliabecchiano II.III.314, fol.39r; MS Magliabecchiano XVIII.2, fol.36r; MS Palatino 1077, fol.6r; Los Angeles, GRIRC, Codex, fol.9v; Modena, BE, MS alpha G.4.21, fol.119r; Padua, BU, MS 764, fol.90v; Siena, BC, MS S.IV.6, fol.31v (Siena 1991, p.225); MS S.IV.1 fol.115r; Turin, BR, MS 383r, unnumbered folio.

263

AFTER FRANCESCO DI GIORGIO
Machine for hoisting columns into place; view
No WM; 257 × 198 mm
SJSM, vol.128, fol.50r

A capstan turns a lantern-pinion and vertical crown-gear that rotates an axle with a worm and worm-wheel with vertical screws, turning opposite-handed, attached to them. They raise and lower a bar that supports the shaft of the column as it is raised. Pin-holes in the uprights of the main frame show how the movement can be stopped by inserting pins below the bar. A pinion at the lower end of the axle of one of the worm-wheels engages a rack that moves a trolley below the base of the column as it is raised or lowered. The machine is identical to that in *Opusculum*.

PROTOTYPE DRAWINGS Rome, BAV, *Codicetto*, fol.118r (Siena 1991, p.35, fig.44); London, BM, *Opusculum*, fol.27v (Siena 1991, pp.380–81).
OTHER REPRESENTATIONS Florence, BNCF, MS Palatino 767; MS Magliabecchiano XVIII.2, fol.20; MS Magliabecchiano II.III.314, fol.83r; MS E.B.16.5, fol.119r; MS Palatino 1077, fol.59v; BML, MS Ashburnham 1357, fol.81r; Uffizi 7730AV; Los Angeles, GRIRC, Codex, fol.26v (a man is shown on the treadmill); Modena, BE, MS alpha G.4.21, fol.38bis; Siena, BC, MS S.IV.5, fol.91v; Turin, BR, MS 383, unnumbered folio; Urbino, SC, Santini Codex, fol.15r; Rome, BAV, Barberini Codex, fol.7r; MS Urb. Lat. 1397, fol.38v; Venice, BMV, MS 4817, fol.29v; MS 3048, fol.34r.

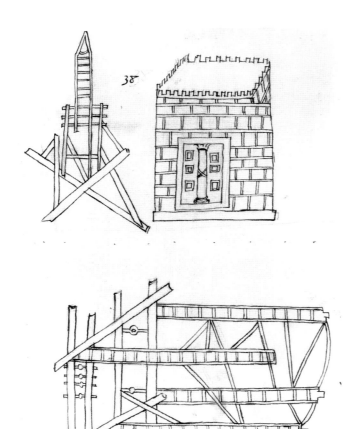

261

260

262

263

264

AFTER FRANCESCO DI GIORGIO
*Hoist for heavy building compo-
nents, devaricators; views*
No WM; 274 × 187 mm
SJSM, vol.128, fol.51r

[1] The winding drum worked through
a worm and pinion is powered by a
treadmill. The block is raised using a
lewis, and a basket is shown that can be
filled as a counterpoise. The ropes are
shown winding correctly in opposite
directions.
[2] The devaricators are jacks, worked
on worm-screws to force apart bars
in metal gratings (Venice 1994, p.484,
cat.96).

PROTOTYPE DRAWINGS Rome, BAV,
Codicetto, [2] fol.169r; London, BM,
Opusculum, fol.29r.
FRANCESCO DI GIORGIO MANUSCRIPTS
Florence, BNCF, MS Magliabecchiano

II.I.141, fols 91v and 93v (Maltese 1967,
tt, p7. 396, 499, tav. 318, 322).
OTHER REPRESENTATIONS
MS Magliabecchiano II.III.314,
[1] unnumbered folio (the capital
and counterweight are not shown),
[1] fol.80r, [2] fol.9r; MS Panciatichi 361,
[1] fol.324r; MS E.B.16.5, [2] fol.76v;
[1] Uffizi 7664AV and 7670AV; BML,
MS Ashburnham 1357, [2] fols 6r, 7r
and 78r; Los Angeles, GRIRC, Codex,
[1] fol.34r (a man is shown in the tread-
mill and the worm-screw and ratchet
mechanism are absent); Modena, BE,
MS alpha G.4.21, [1] fol.24bis, [2] fol.29r;
Urbino, SC, Santini Codex, [1] fol.25r,
[2] fol.14r; Rome, BAV, MS Urb. Lat.
1397, [1] fol.48r, [2] fol.37v; Siena, BC,
MS S.IV.1, [1] fol.124r; Turin, BR, MS 383,
[1] unnumbered folio; Rome, BAV,
Barberini Codex, [1] fol.62v.

266

ANONYMOUS DRAUGHTSMAN
Components of a pile driver; views
Inscribed in the same ink: *a po[n]te sisto
incluso il vigniola–legno distia–palo
castagno–i[n]pulea–vigo–al po[n]te
sa[n]ta maria luso m[aest]ro mateo
dacostallo*
On white laid writing paper, WM cat.50;
pen and iron-gall ink, free-hand
sketches parallel hatched;
280 × 208 mm; glued to the verso
SJSM, vol.128, fol.53v

The drawing shows the posts and
weighted drops of a pile driver, which
is associated by the inscription with
both Ponte Sisto and Ponte S. Maria
in Rome. The Ponte Sisto was built by
Baccio Pontelli in 1474; in the inscrip-
tion Vignola is associated with it.
The Ponte S. Maria was rebuilt on the
orders of Gregory XIII by Matteo di

Città di Castello, *c*.1575. The probable
date of the drawing after 1575 may
provide a *terminus post quem* for
the compilation of the collection
(Scaglia 1992b, p.90).

Taccola in his notebook also made a
design for a pile driver (Prager, Scaglia
& Montag 1984, II, appendix, fig.9).

No other drawings.

265

AFTER FRANCESCO DI GIORGIO
Pumping machinery; view
No WM; 253 × 185 mm
SJSM, vol.128, fol.52r

Capstan bars turn a balanced spindle
that supports a crown-gear and
lantern-pinion and turns a horizontal
axle suspended over a well. Six spokes
with forked ends project from the axle
and a circular chain has disks fitted to
the barrels rather than the traditional
balls of rags. The forks meet the disks
as they rise and release them as they
fall back into the well. The dishes
deposit water in the tube on the right
as they rise from the well and the water
overflows into the trough on the right.
The upright shaft seems to take its
bearing from the capstan-head screw.

The machine is almost identical to
Opusculum but the water shown emerg-
ing from the water spout at bottom

right is not shown in *Meccanica*. This
is the first illustration of such an
adjustable footstep bearing.

PROTOTYPE DRAWINGS Rome, BAV,
Codicetto, fol.148v; London, BM,
Opusculum, fol.61r.
OTHER REPRESENTATIONS Antonio
da Sangallo, Florence, Uffizi 4081A
(a capstan drives an axle with a vertical
lantern that engages a vertical crown-
gear); anonymous, Uffizi 7671Ar; BNCF,
MS Magliabecchiano II.III.314, fol.27r;
BML, MS Ashburnham 1357, fol.26r;
IMSS, MS Ant.532, vol.II, fol.31r;
Los Angeles, GRIRC, Codex, fol.5r
(Siena 1991, p.317); Modena, BE, MS
alpha G.4.21, fol.127r; Turin, BR, MS 383r,
unnumbered folio.
ENGRAVED Strada 1617–18, tav.56.

267

AFTER FRANCESCO DI GIORGIO
Vehicle; view
No WM; 154 × 169 mm; glued to the
verso
SJSM, vol.128, fol.54v

The illustration shows two alternative
ways of steering. On the left a capstan
turns a worm-screw that engages a
pinion, which turns the axle of the
wheels, while a second capstan turns a
lantern-pinion that engages a toothed
sector and steers the two wheels on
the left of the vehicle. On the right a
capstan turns a worm-screw, gear and
lantern-pinion on the axle of the gear
driving the steering rack. The front
wheel is driven by a capstan turning a
worm-screw and ratchet. The steering
system on the right is more elaborate
and gives more control. The machine
is identical to that in *Opusculum*.

PROTOTYPE DRAWINGS Rome, BAV,
Codicetto, fol.117v; London, BM,
Opusculum, fol.26v.
FRANCESCO DI GIORGIO MANUSCRIPTS
Turin, BR, MS Saluzziano 148, fol.52r
(Maltese 1967, I, p.270, tav.96);
Florence, BML, MS Ashburnham 361,
fol.47 (Marani 1979, p.95,
cap.CCLXXXVII; Siena 1991, p.411);
London, SJSM, vol.120, fol.67r bis,
77r (cat.191).
OTHER REPRESENTATIONS Florence,
Uffizi 7674Ar; BNCF, MS
Magliabecchiano II.III.314, fol.10r;
BML, MS Ashburnham 1357, fol.7r;
Los Angeles, GRIRC, Codex, fol.33v;
Modena, BE, MS alpha G.4.21, fol.27bis;
Turin, BR, MS 383, unnumbered folio;
Urbino, SC, Santini Codex, fol.14v;
Rome, BAV, MS Urb. Lat. 1397, fol.38r;
Venice, BMV, MS 3048, fol.34r.

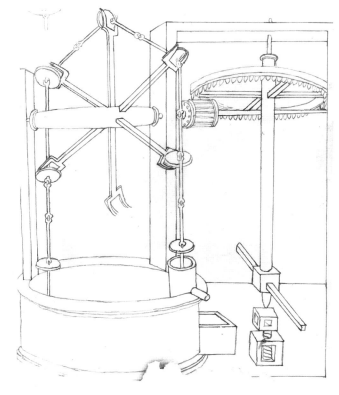

265

264

266

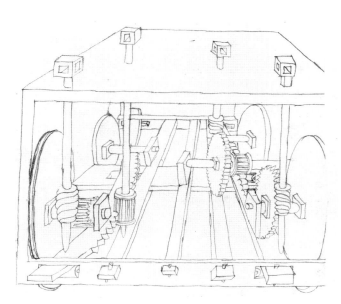

267

268

AFTER FRANCESCO DI GIORGIO
Machine for raising columns into place; view
No WM; 192 × 213 mm; turned through
90 degrees and glued to the recto
SJSM, vol.128, fol.55r

The machine works on the same prin-
cipal as that shown on fol.50r (cat.263).
A lantern-pinion turns a horizontal
spur and crown-gear with a screw
mounted above it threaded through a
bar with an upright supporting a hori-
zontal bar below the hypertrachelion of
the column. The crown-gear connects
with a lantern-pinion that turns a
worm-screw and moves the rack and
trolley below the base of the column.
As the column is raised the foot of the
column is pulled in. The capstan bars,
shown inserted into the head below the
screw, probably provide a way of
adjusting or resetting the machine
quickly.

The machine is identical to that
in *Opusculum*; in both the means of
turning the first gear is not shown.
Another kind of machine for raising
columns into position is shown on
fol.32r of *Meccanica* (cat.245).

PROTOTYPE DRAWINGS Rome, BAV,
Codicetto, fol.117v; London, BM,
Opusculum, fol.27r (Siena 1991, p.381).
OTHER REPRESENTATIONS Florence,
BNCF, MS Palatino 767; MS Palatino 1077,
fol.61v; MS Panciatichi 361, fol.323v;
BML, MS Ashburnham 1357, fol.77r;
Modena, BE, MS alpha G.4.21, fol.28r;
Los Angeles, GRIRC, Codex, fol.26r;
Siena, BC, MS S.IV.5, fol.82r; Turin, BR,
MS 383, unnumbered folio; Venice,
BMV, MS 4817, fol.29r; Urbino, SC,
Santini Codex, fol.27r.

269

AFTER FRANCESCO DI GIORGIO
Watermill; view
No WM; 245 × 179 mm
SJSM, vol.128, fol.56r

Water, funnelled down a tapering
spout at great force, fills the scoop
vessels on a horizontal waterwheel
on an axle in the lower chamber. This
drives a roller lantern-pinion, in the
middle chamber, which engages a
horizontal spur and crown-gear
connecting with a horizontal lantern-
pinion with a crown-gear that turns
the lantern-pinion on the axle of the
mill wheel above. The composite spur
and crown-wheel as drawn is practically
an idle wheel; it serves to change the
direction of the motion. The second
pair of gears increased the speed, but
it is doubtful if this would be desirable.

The machine on fol.12r (cat.225)
operates on the same principle. The
drawing is identical to the machine in
Opusculum but it is reversed.
Horizontal waterwheels derive from
the Roman period; they were used
world-wide over a long period of time.
Wheels with scoops were discussed
by Leupold (1724–5, cap.XX, p.163,
Taf.LXVI).

PROTOTYPE DRAWINGS London, BM,
Opusculum, fol.75r.
FRANCESCO DI GIORGIO MANUSCRIPTS
Florence, BML, MS Ashburnham 361,
fol.34r (Marani 1979, p.69, cap.CL).
OTHER REPRESENTATIONS Florence,
BML, MS Ashburnham 1357, fol.62r;
BNCF, MS Magliabecchiano II.III.314,
fol.64r; Los Angeles, GRIRC, Codex,
fol.39r; Modena, BE, MS alpha G.4.21,
fol.131r; Turin, BR, MS 383, unnumbered
folio.
ENGRAVED Strada 1617–18, tav.83.

270

AFTER FRANCESCO DI GIORGIO
Horse-powered mill; view
No WM; pale brown and beige washes;
240 × 185 mm
SJSM, vol.128, fol.57r

A horse tethered to a wall, its head
raised to eat from a bale of hay, drives
a horizontal treadmill with its hind
legs. A roller lantern-pinion threaded
on to the axle of the treadmill engages a
double spur-gear; the upper spur-gear
connects with a lantern-pinion at the
rear of the chamber on the same axle as
the mill-wheel in the upper chamber.

The machine is identical to the
Opusculum machine but it is reversed.
As drawn, the intermediate wheel is
idle. The draughtsman misunderstood
the device. To maintain the machine
in operation, the treadmill should be
inclined; steps have been introduced
into the drawings, which would indi-
cate a change in the level. The wheel
is shown inclined in the Biblioteca
Laurenziana and Soane codices.

PROTOTYPE DRAWINGS Rome, BAV,
Codicetto, fol.138v; London, BM,
Opusculum, fol.74v.
FRANCESCO DI GIORGIO MANUSCRIPTS
Turin, BR, MS Saluzziano 148, fol.57v
(Maltese 1967, I, p.266, tav.70); BML,
Florence, MS Ashburnham 361, fol.36v
(Marani 1979, p.74, cap.CLXXIX; Siena
1991, p.140, fig.11); London, SJSM,
vol.120, fol.64r (cat.173).
OTHER REPRESENTATIONS Florence,
BNCF, MS Palatino 767; MS E.B.16.5,
fol.13v; MS Magliabecchiano XVIII.2,
fol.2r; MS Magliabecchiano II.III.314,
fol.67r; MS Palatino 1077, fol.103v;
BML, MS Ashburnham 1357, fol.65r;
Los Angeles, GRIRC, Codex, fol.15v
reversed; Modena, BE, MS alpha G.4.21,
fol.129v; Padua, BU, MS 764, fol.84r;
Siena, BC, MS S.IV.1, fol.121r; Turin, BR,
MS 383, unnumbered folio; Venice,
BMV, MS 4817, fol.70r.

271

AFTER AGRICOLA
Paternoster chain pump; view
No WM; within a single ink line border,
cut at the top; 225 × 152 mm
SJSM, vol.128, fol.58r

This is the sixth pump of this kind; the
fifth is on fol.8r, the fourth on fol.31r
and the third on fol.59r (cat.272). The
chain pump is worked by a treadmill
through step-up gearing; a flywheel is
added to the top spindle. A treadmill
on an axle driven by two men turns a
spur-gear that connects with a lantern-
pinion on a second axle with a flywheel
and drum supporting a paternoster
chain-pump. The chain descends into
a well and rises through a circular pipe
depositing water, which overflows into
a basin.

The machine proposes the same
principle as *Meccanica* fols 8r, 31r, 38r
and 59r (cat.221, 244, 251 and 272), and
as the machine by Francesco di Giorgio
on fol.36r (cat.249). According to
Agricola, it could draw water through
a pipe from a depth of 66 *piedi* (Hoover
& Hoover 1912, p.196).

PROTOTYPE WOODCUT Agricola 1556, VI,
p.155.

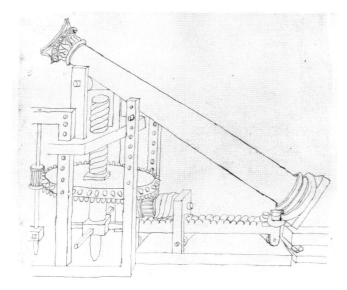

268

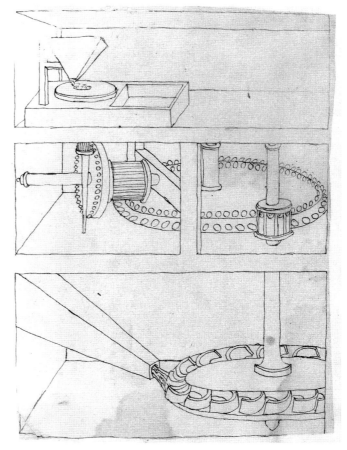

269

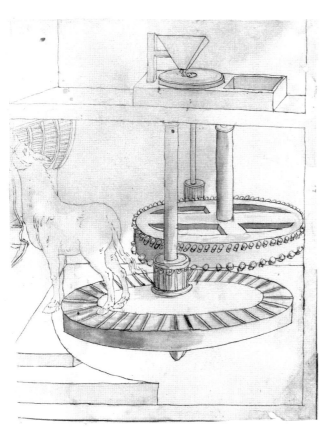

270

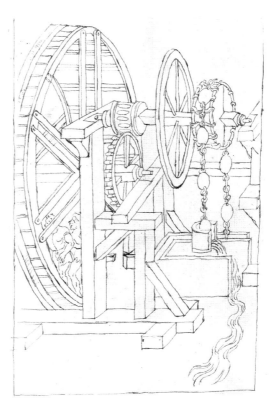

271

272

AFTER AGRICOLA
Chain pump; view
No wm; within a single ink line border,
cut at the bottom; 220 × 158 mm
sjsm, vol.128, fol.59r

Above ground the section of a large
conical roof is partially shown with a
central pole with four radial spokes
that turn a vertical square beam, which
descends to a chamber below ground.
The beam drives a crown-gear that
engages a lantern-pinion on the axle
and turns a drum with a paternoster
chain-pump.

The drawing shows the third machine
of this kind; the first is on fol.38r, the
fourth on fol.31r, the fifth on fol.8r and
the sixth on fol.58r (cat.221, 244, 251
and 271). Agricola commented that
this kind of pump was employed by

miners when no river could be diverted
to power the waterwheel. The circula-
tion area below the conical roof is 50
piedi wide. The machine, which can
draw up water from a shaft 240 *piedi*
deep, is worked by 32 horses, working
for 4 hours and resting for 12, in batches
of 8. The machine was used in the mines
at the foot of the Harz mountains.
Several pumps were often built to mine
one vein; they were set up in several
places according to depth (Hoover &
Hoover 1912, pp.192–5).

PROTOTYPE WOODCUT Agricola 1556, vi,
p.152.
OTHER REPRESENTATIONS Jacopo
Strada, Florence, imss, ms Ant.532, ii,
fol.50r.

273

AFTER FRANCESCO DI GIORGIO
Siphoning; view
No wm; 199 × 203 mm
sjsm, vol.128, fol.60r

The siphon, which draws water from a
lake and moves it over a mountain to
deliver it to a valley on the other side, is
filled in the tower at the top of the hill.

The drawing derives from Taccola's
De ingeneis (book ii, fol.105r; Prager,
Scaglia & Montag 1984, p.211).

PROTOTYPE DRAWINGS Rome, bav,
Codicetto, fols 7v and 12v; London, bm,
Opusculum, fol.59v.
OTHER REPRESENTATIONS Florence,
bml, ms Ashburnham 1357, fol.22r (this
is identical to the Santini Codex and
ms Urb. Lat. 1397); Los Angeles, grirc,

Codex, fol.12r; Modena, be, ms alpha
g.4.21, fol.123v; Turin, br, ms 383,
unnumbered folio; Urbino, sc, Santini
Codex, fol.66v; Rome, bav, ms Urb.
Lat. 1397, fol.26r.

274

AFTER FRANCESCO DI GIORGIO
Watermill; view
No wm; 203 × 187 mm
sjsm, vol.128, fol.61r

An undershot waterwheel turns an axle
and lantern-pinion that connects with
a crown and spur-gear and drives a
second lantern-pinion on the mill shaft.

The large crown and spur-gear
seems to serve merely to change
the direction of the motion. It is not
arranged to increase the speed to the
stones, which would probably be
desirable (see fol.58r, cat.271). The
machine is identical to the one in
Opusculum.

PROTOTYPE DRAWINGS London, bl,
Opusculum, fol.60r.
FRANCESCO DI GIORGIO MANUSCRIPTS
Florence, bml, ms Ashburnham 361,
fol.33v (Marani 1979, p.68, cap..cxlvi).
OTHER REPRESENTATIONS Florence,
bml, ms Ashburnham 1357, fol.51r;
Los Angeles, grirc, Codex, fol.22r;
Modena, be, ms alpha g.4.21, fol.125r;
Siena, bc, ms s.iv.1, fol.119v; Turin,
br, ms 383, unnumbered folio.

275

AFTER FRANCESCO DI GIORGIO
Double watermill; view
No wm; 255 × 153 mm
sjsm, vol.128, fol.62r

An undershot waterwheel turns a
lantern-pinion on the right that
connects with a vertical spur-gear on
an axle driving crown-gears at each
end, which connect with two lantern-
pinions driving two millstones. The
foot of the right-hand spindle is carried
on the end of a capstan-headed screw,
which provides a means of adjusting
the stones.

The unequal pairing of the wheel and
lantern-pinion, which greatly reduces
the speed of the second shaft, seems
undesirable.

OTHER REPRESENTATIONS Anonymous,
16th century, Florence, Uffizi 4057av;
bncf, ms Magliabecchiano ii.iii.314,
fol.61r; bml, ms Ashburnham 1357,
fol.59r; Los Angeles, grirc, Codex,
fol.19r; Siena, bc, ms s.iv.5, fol.92v;
Turin, br, ms 383, unnumbered folio.

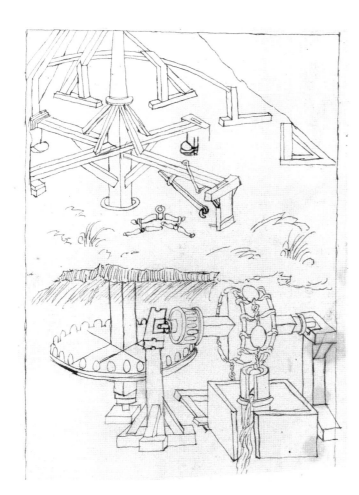

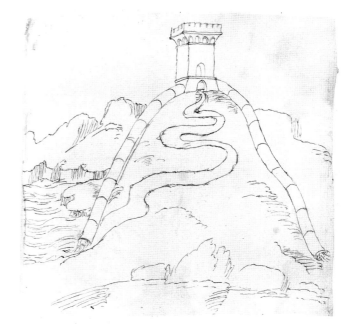

273

272

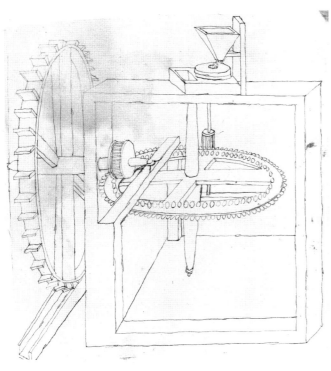

274

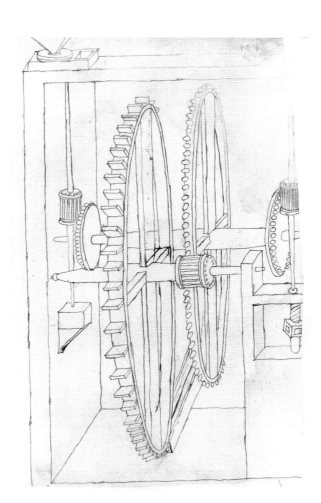

275

276

AFTER FRANCESCO DI GIORGIO
Siphon worked by a current; view
No WM; 210 × 244 mm
SJSM, vol.128, fol.63r

The drawing shows an arch with one pier constructed on a spur-shaped foundation in a fast-moving stream, the other pier standing on dry land. Water is siphoned from the river through an arch in the foundation over the arch and released through a hole at the base of the pier on the shore.

The drawing derives from *Opusculum* (fol.58r), which shows the siphon operated by a current being conducted over mountains, the prototype for the mill drawn on fol.37r (cat.250).

PROTOTYPE DRAWINGS London, BM, *Opusculum*, fol.58r.
OTHER REPRESENTATIONS Los Angeles, GRIRC, Codex, fol.19v; Modena, BE, MS alpha G.4.21, fol.123r; Turin, BR, MS 383, unnumbered folio.

277

AFTER AGRICOLA
Ventilating machine, mill head with a whim and a machine for lifting material out of a mine, piston pump; views
No WM; 260 × 198 mm
SJSM, vol.128, fol.64r

[1] At top left three sills are placed over a shaft and fixed so that they cannot move. Planks are fixed at right angles to the second sill and cross beam, which are over the middle of the shaft; the planks collect the wind blowing from any direction. The planks are roofed with a circular cover, not shown in the drawing, so that the wind cannot be diverted upward and escape, and instead is forced down into the mine (Hoover & Hoover 1912, p.200). The machine is the first ventilating machine described by Agricola; others are shown on fols 40r, 41v and 7r (cat.253, 252 and 220).
[2] A whim with the conical roofs that always covered the horse-powered whims or lifting engines at the heads of mines. The construction of the roof and of the whim is described in detail by Agricola (op. cit., pp.163–6). Two horses turn the whim, and as one bucket is drawn up full, the other is lowered empty. If the shaft is very deep four horses turn the whim. The short pieces of wood with blocks hanging from them on the cross beams inserted into the axle are the seats for the drivers.
[3] On the left a man operates a simple lift-pump with a rocking beam. This is the second machine of this kind; the first is described on fol.41v[2].
[4] On the right is a machine for raising material from a mine. Two men on a horizontal treadmill turn a crown-gear and lantern-pinion on an axle with a winding rope above their heads. The device winches up buckets full of material. The workmen grasp the pole, fixed to two upright posts, and pushing the cleats of the lower wheel backward with their feet, they revolve the machine; when they have drawn up and emptied one bucket full of excavated material, they turn the machine in the opposite direction and draw out another. The machine was less tiring for workmen and raised larger loads; although it was slower, it reached the greater depth of 180 *piedi* (op. cit., pp.162–3).

PROTOTYPE WOODCUT Agricola 1556, VI, [1] p.159, [2] p.123, [3] p.136, [4] p.120.

278

AFTER DANIELE BARBARO
Tympana, mill, piston pump; views
No WM; 254 × 178 mm
SJSM, vol.128, fol.65r

The illustrations show two versions of the baling device that is called a tympanum, as described by Vitruvius (1986, book X, cap.IV, 4; 1934, pp.303–5; for tympana, see Hill 1984, pp.133–5). It does not raise water to a great height, but it is practical for collecting large quantities.
[1] On the left a hollow wheel is divided radially into chambers, each with an opening at the rim and communicating with the hollow interior. The wheel is turned by a hand-winch. In use, the rim of the wheel dips below the water, some of which enters the compartment and is raised; it flows out through the hollow axle.
[2] A vertical wheel turned by a winch has hollow boxes attached to it that scoop up the water as it rises and deposit it as it falls.
[3] A simple mill drawn by an upright crown-wheel and lantern-pinion. The prime mover is not shown.
[4] A pair of piston pumps arranged like a Classical ensemble of a plunger pump delivering water to a central rising main. The pistons are worked from above by levers on a rocking shaft worked from a crank and the axle of an undershot waterwheel.

The machines are copied from Daniele Barbaro's edition of Vitruvius (1567, book X, pp.462–4); the figures and landscape have been omitted.

ENGRAVED Valturius 1532, p.242; Vitruvius 1511, book X, fols 99v–100r; Vitruvius 1521, book X, fol.CLXIXr and v (the invention of the tympanum is attributed to Ctesebius).

279

AFTER FRANCESCO DI GIORGIO
Bridges; views
No WM; 214 × 207 mm; glued to the recto upside down
SJSM, vol.128, fol.66r

[1] Boats are connected by bridges dropped from chains by winches from the prow of one boat to the stern of another.
[2] Flat panels of wood are locked together and suspended over barrels across a stream.
[3] Short planks of wood are joined to barrels that float on the river and form a bridge.

The bridges are identical to those drawn in *Opusculum*. Valturio described similar bridges, of boats (fol.110r), of barrels (fol.109v) and of planks of wood (fol.109v). Taccola drew an identical bridge of boats in *De ingeneis* (fol.38v; Bassignana, no date, tav.LVIII, LVII; Prager, Scaglia & Montag 1984, p.76).

PROTOTYPE DRAWINGS Rome, BAV, *Codicetto*, [1] fol.100v, [2] fol.40r; London, BM, *Opusculum*, fol.44v.
FRANCESCO DI GIORGIO MANUSCRIPTS Turin, BR, MS Saluzziano 148, fol.61r (Maltese 1967, I, pp.272, tav.113); London, SJSM, vol.120, fols 79r bis, 89r (cat.207).
OTHER REPRESENTATIONS Florence, BNCF, MS Palatino 767; MS Palatino 1077, fols 185r and 190r; Antonio da Sangallo, Florence, Uffizi 1476A and 4068A; anonymous, Uffizi 7667Ar and v; Los Angeles, GRIRC, Codex, fol.50r; Modena, BE, MS alpha G.4.21, unnumbered folio; Turin, BR, MS 383, unnumbered folio; Urbino, SC, Santini Codex, fol.20r (bridge on barrels); Rome, BAV, MS Urb. Lat. 1397, fols 12r and 43v; Venice, BMV, MS 3048, fol.14v (bridge of boats).

276

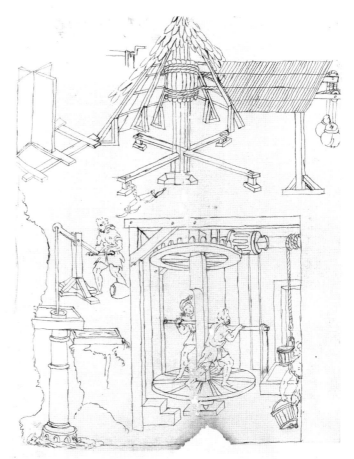

277

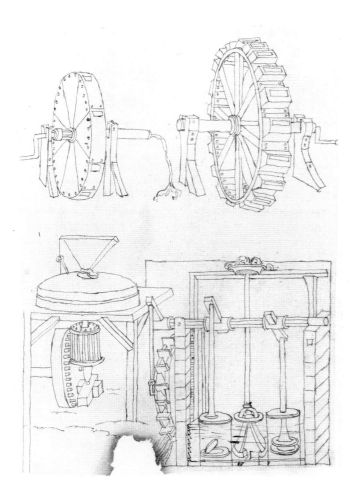

278

279

280

AFTER FRANCESCO DI GIORGIO
Edge-runner mill; view
No WM; 226 × 199 mm
SJSM, vol.128, fol.67r

An undershot waterwheel in a narrow
chamber turns a lantern-pinion, which
moves a crown-gear and turns the
vertical shaft of an edge-runner mill.

The machine is identical to the one
in *Opusculum*. The vertical waterwheel
with projecting blades is discussed
by Leupold (1724–5, cap.XX, p.164,
Taf.LXVII).

PROTOTYPE DRAWINGS Rome, BAV,
Codicetto, fol.162r; London, BM,
Opusculum, fol.65r.

OTHER REPRESENTATIONS Florence,
BNCF, MS Palatino 767; MS
Magliabecchiano XVIII.2, fol.21;
MS Palatino 1077, fol.72r; Los Angeles,
GRIRC, Codex, fol.50v (an axle is shown
on top of the roller mill); Modena, BE,
MS alpha G.4.21, fol.101?; App. Campori
1755, unnumbered folio; Siena, BC,
MS S.IV.1, fol.119r; Turin, BR, MS 383,
unnumbered folio; Urbino, SC, Santini
Codex, fol.28r; Rome, BAV, MS Urb.
Lat. 1397, fol.81v; Venice, BMV, MS 4817,
fol.78r.

281

AFTER FRANCESCO DI GIORGIO
*Machine for raising columns into
position; view*
No WM; 263 × 198 mm
SJSM, vol.128, fol.68r

On the right a column is suspended by
a metal collar below the capital from a
double lever, which is balanced on a
vertical frame. The base of the column
is on a low mobile platform. The
column is gradually raised, continually
supported by planks inserted below it.
As the base moves slowly forward the
weight of the column is transferred
to the ground by means of a lantern-
pinion and rack mechanism that
lowers the balanced levers to the
ground. The worm-screw on an axle
with a capstan does not connect with
any other mechanical device. A roller
is shown supporting the rack. For the
view to make sense, a spur wheel on the
axis of the lantern-pinion that engages
the worm-screw should be inserted
into the drawing. It is shown in the
Opusculum drawing.

The machine is almost identical to
the one drawn in *Opusculum*, where the
worm-screw is shown connecting
with a spur-gear and lantern-pinion
on its axle, which moves along the
rack (Siena 1991, p.386). An analogous
machine is shown in *Meccanica* on
fol.14r (cat.227).

PROTOTYPE DRAWINGS Rome, BAV,
Codicetto, fol.123r (the capital is not
shown); London, BM, *Opusculum*,
fol.57r (Siena 1991, p.386).
OTHER REPRESENTATIONS Florence,
BNCF, MS Palatino 767; MS Panciatichi
361, fol.329r (a spur-gear has been intro-
duced to connect with the worm-screw);
MS E.B.16.5, fol.115r; MS Palatino 1077,
fol.59r (a spur-gear connects with the
worm screw); BML, MS Ashburnham
1357, fol.72r; Los Angeles, GRIRC, Codex,
fol.24r (a wheel is shown on the axle
behind the lantern on the left); Modena,
BE, MS alpha G.4.21, fol.16r; Siena, BC,
MS S.IV.5, fol.19v; MS S.IV.1, fol.123r;
Turin, BR, MS 383, unnumbered folio;
Rome, BAV, MS Urb. Lat. 1397, fol.64v;
Venice, BMV, MS 4817, fol.28v.

282

AFTER FRANCESCO DI GIORGIO
Hand-powered mill; view
No WM; 232 × 153 mm
SJSM, vol.128, fol.69r

A horizontal crank, one end outside
the first chamber and the other in the
second chamber, turns, in the first
chamber, a lantern-pinion and a
vertical wheel on the same axle as a
crown-gear in the second chamber,
which turns a lantern-pinion and
the mill stone above.

The wheel is shown as a cog-wheel
rather than as the more usual peg-
toothed wheel. The enormous gear
ratio allows two men to turn the wheel,
but it would be too slow to be of much
use. The machine is identical to the
drawing in *Opusculum*.

PROTOTYPE DRAWINGS Rome, BAV,
Codicetto, fol.122r; London, BM,
Opusculum, fol.56v.

OTHER REPRESENTATIONS Los Angeles,
GRIRC, Codex, fol.42v; Modena, BE, MS
alpha G.4.21, fol.15bis; Florence, BML,
MS Ashburnham 1357, fol.56r; BNCF,
MS Magliabecchiano II.III.314, fol.58r;
MS Panciatichi 361, fol.320r; Uffizi
7670AV; Urbino, SC, Santini Codex,
fol.8v; Rome, BAV, MS Urb. Lat. 1397,
fol.33r; Venice, BMV, MS 3048, fol.12v.

283

AFTER FRANCESCO DI GIORGIO
Pumping machinery; views
No WM; 268 × 141 mm
SJSM, vol.128, fol.70r

[1] A Classical arrangement of a pair of
plunger-pumps with well-developed
suction limbs built into a well-head.
Winch handles turn a pinion-and-rack
mechanism backwards and forwards
to raise and lower two plungers in their
barrels, which are connected by two
tubes to a central narrow tapering tube
that descends into a well. When the
plungers are lowered the water is
drawn up through the foot-valve and
enters the barrel when the plunger is
raised. The water is released through a
delivery valve, not shown, to spouts at
the bottom of the cylinders into basins.
The vacuums created in the cylinders
fill them up again.
[2] The drawing shows the same princi-
ple with a single plunger and no outlet
for the water. The little pinion outside
the bottom of the barrel is a misunder-
standing of the spout shown on the
Opusculum drawing. A wheel and
ratchet without any obvious function
are shown in *Meccanica*, and the feature
is unclear in *Opusculum*.

PROTOTYPE DRAWINGS Rome, BAV,
Codicetto, fol.132v; London, BM,
Opusculum, fol.52v ([1] is identical and
[2] varies slightly in the mechanical
devices shown next to the piston at
the bottom of the chamber on the left).
OTHER REPRESENTATIONS Florence,
BML, MS Ashburnham 1357, fol.17r;
BNCF, MS Magliabecchiano II. III.314,
fol.18r; MS Panciatichi 361, fol.317r;
Uffizi 4080A (Siena 1991, p.250);
Los Angeles, GRIRC, Codex, fol.11r;
Modena, BE, MS alpha G.4.21, fol.11v;
Turin, BR, MS 383, unnumbered folio;
Urbino, SC, Santini Codex, fol.31r,
[1] fol.16r; Rome, BAV, MS Urb. Lat.
1397, [1] fol.39v, [2] fol.82v.
ENGRAVED Ramelli 1588, fig.XX.

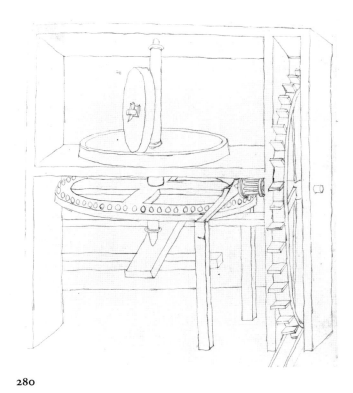

280

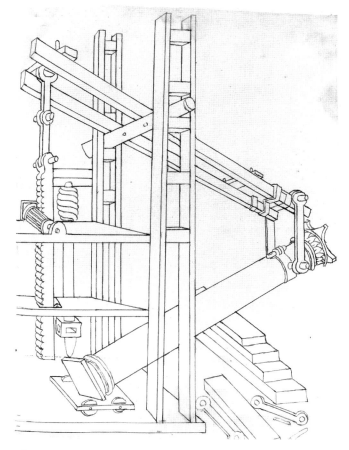

281

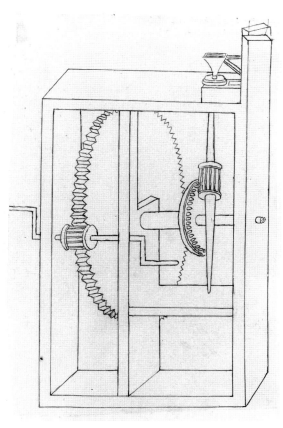

282

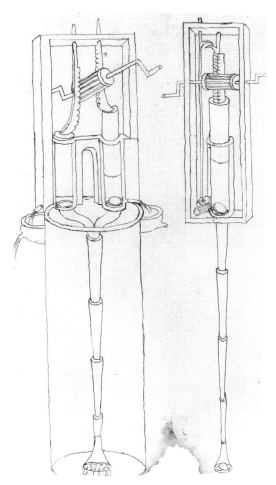

283

284

AFTER FRANCESCO DI GIORGIO
Double pump; view
Inscribed in Carlo Fontana's hand:
fiume–A scagnio che vi/passa l'acqua–
B Animella–C Canna o sia/Cilindro–
D Succhio o sia/Pistone–E Castello di
sosteg/–F Gurbite da moto uno contro/
laltro–G Seghe overo /intacchie– Rochetto
–H leve scorente/nelle leve–L getto
d[e]ll/Acqua–Salita una se volgie/la
Gurbita fa cadera or calara laltra
No WM; 225 × 211 mm
SJSM, vol.128, fol.71r

Two plungers, suspended from crossed
balanced levers H, rest on a vertical
frame E. They are raised and lowered
into barrels by a handle F turning a
pinion-and-rack mechanism G. The
barrels are set on a hollow base A in the
water; as the plunger falls air is expelled
and the vacuum created draws the
water through a foot valve B into the
barrel C; as the plunger D rises the jet
of water L falls into a basin from spouts
on the left.

The machine is identical to the one
drawn in *Opusculum*. The grooves in
the pistons intended by Francesco di
Giorgio as an anti-friction device are
misunderstood by Strada, who shows
jets of water issuing from the pistons
(Reti 1963, p.293). Drawings in other
Francesco di Giorgio manuscripts
show a similar misunderstanding of the
grooves. Taccola drew a similar pump
in *De ingeneis* (book III, fol.34r; Prager
and Scaglia 1972, pp.84–5, fig.34).

PROTOTYPE DRAWINGS London, BM,
Opusculum, fol.53r.
FRANCESCO DI GIORGIO MANUSCRIPTS
Turin, MS Saluzziano 148, fol.45v
(Maltese 1967, I, p.268, tav.82);
Florence, BML, MS Ashburnham 361,
fol.41v (Marani 1979, p.84, cap.CCXXII);
London, SJSM, vol.120, fol.62v (cat.170).
OTHER REPRESENTATIONS Florence,
BML, MS Ashburnham 1357, fol.18r;
BNCF, MS Magliabecchiano II.III.314,
fol.19r; MS Panciatichi 361, fol.316v
(the groove in the piston to prevent
friction is not shown); [2] anonymous,
16th century, Florence, Uffizi 4054A;
Uffizi 4057A; Uffizi 7665AV and 7666AV;
Ammannati, Uffizi 4071A; Venice, BMV,
MS 4817, fol.60r; Los Angeles, GRIRC,
Codex, fol.11v; Modena, BE, MS alpha
G.4.21, fol.113v; Padua, BU, MS 764,
fol.86v; Siena, BC, MS S.IV.1, fol.108r;
Turin, BR, MS 383, unnumbered folio;
Urbino, SC, Santini Codex, fol.31v;
Rome, BAV, MS Urb. Lat. 1397, fol.83r.
ENGRAVED Strada 1617–18, tav.35;
Branca 1629, fig.VI.

285

AFTER AGRICOLA
Pump; view
No WM; within a single ink line border;
218 × 147 mm
SJSM, vol.128, fol.72r

The drawing shows the fifth pump of
this kind; the fourth is shown on fol.30r
(cat.243). The pump is composed of
three pumps with pistons raised by
tappets, which fall by their own weight.
The two men working the machine
show two different ways of driving
the tappets, by capstan bars and by a
winch. If the pipes are wide, only two
pumps are used; if they are narrow,
three, so that the volume of water is the
same. Fols 41r and 64r (cat.254 and 277)
show simple piston-pumps. According
to Agricola, this pump could raise
water higher, to a height of 24 *piedi*
(Hoover & Hoover 1912, pp.181–4).
The drawing in the Strada manuscript
is powered by a waterwheel.

PROTOTYPE WOODCUT Agricola 1556,
VI, p.141.
OTHER REPRESENTATIONS Strada,
Florence, IMSS, MS 532, vol.II, fol.41r.

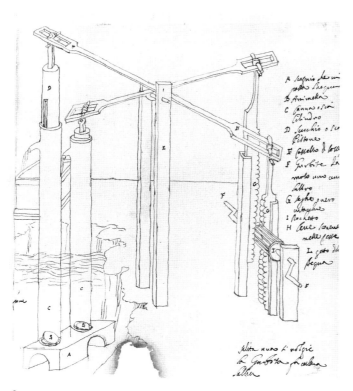

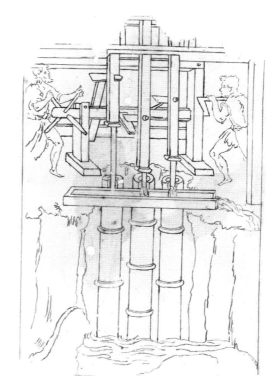

284

285

ANNO SALLVTE. M.D.L.X.X.XIII

SIBI POSTERIS
ET AMICIS. F. P.

MENSIS APRILLIS
DIE III DE DOMINICI

367

The Margaret Chinnery Album

The scrapbook album contains a collection of Italian and Northern European Renaissance designs for ornament by various artists. Many of the drawings are of very high quality. The volume is called the Margaret Chinnery album after the name inscribed on the first folio in an 18th-century hand. The collection was probably assembled in the late 17th or early 18th century, when the drawings were glued to the folios of the album. Numerous Northern drawings in the album and the inscription on the verso of fol.70 ('this cost me 5 guilders') suggest that it might have been assembled in the Netherlands.

Margaret Chinnery was one of three daughters of Leonard Tresilian, of Brompton, Middlesex. She married William Bassett Chinnery, brother of the artist George Chinnery, in October 1790. William Chinnery was employed in the Treasury with an annual salary of £4,000. He was a patron of the arts who lived far beyond his means; he eventually defaulted to the Treasury for £81,000. Margaret Chinnery had been particularly generous towards Giovanni Battista Viotti, the great violinist, who was rumoured to be the father of her daughter Caroline, a talented girl who, like her brothers, died before her parents. After the bankruptcy the Chinnerys went to Paris, where Margaret died in 1840. George Chinnery, her brother-in-law, painted her portrait, which was reproduced in an article on Viotti in *Die Musik* (June 1902). The Chinnery's country house in England was Gillwell Hall, Sewardstone, Essex (letter of 18 October 1956 to Sir John Summerson from Mr J.R. Vigne).[1]

CATALOGUE NOTE

The album is bound in early 18th-century Italian gilt upper and lower boards of double-ruled Cambridge pane with a gilt-tooled arabesque cartouche in the centre and a gilt-tooled spine with nine raised bands. The torn silk ties have been replaced by modern ties of green silk. The pasted-down endpaper is inscribed M 124 and bears Sir John Soane's *Ex libris*, inscribed *Case 28 (40)*; one free endpaper is inscribed *NO.56 is the last*. The album measures 532 × 358 mm, open 532 × 698 mm.

Drawings of different sizes are glued to folios of white laid writing paper; there are no watermarks. The folios measure 515 × 327 mm. The pattern on the pink-and-gold endpapers of the Talman-St John album (London, V&A, inv. no.92.D.46), which was acquired at the Talman sale on 2 February 1725 and is bound in leather, is very similar to the tooled pattern on the arabesque cartouches on the Chinnery album. The binding is almost identical to those of *I Cinque Libri di Architettura* de Gio. Batta. Montano 1684, published in five volumes by Giovanni Iacomo de Rossi in the *British Architectural Library*.

PROVENANCE

William Chinnery was a client of Sir John Soane; documents in the Archive of the Sir John Soane's Museum record that Soane made improvements to the Chinnery's house in Mortimer Street, London, in August 1798.[2] The notebooks also contain records of the Chinnery sale at Christie's on 4 June 1812: 'sale of [Chinnery's] effects 7 June 1812 went to Chinnery's with Mrs S. 8 June 1812 Went with Mr Spiller at 2 ocl to Chinnery's … Pd Porter's carriage of sundry articles from Christie Sale Room.' The album is not listed in the catalogue of the sale. Sir John Soane probably acquired it earlier, possibly in lieu of fees. The entry in Richardson's catalogue of Sir John Soane's Library is inscribed:[3]

Drawings, a collection of interiors and exteriors of buildings in Italy. Architectural ornaments. a very useful and valuable work formerly in the possession of Margaret Chinnery folio 28 Original drawings formerly belonging to Margaret Chinnery.

The volume was with other architectural works in case 28 in the library, in the loggia on the right of the left-hand window.

1. The fullest account of the Chinnerys is by W.H. Welply in *Notes and Queries*, January 1792, pp.75–7.

2. *Soane Archive, Journal* 4, p.44; the plans of the house are in drawer 38, set 1.9.

3. Richardson 1830, p.168.

286

AMICO ASPERTINI
(Bologna, 1475-Bologna, 1552)
*Sculptural project for the elevation of
a tomb of a scholar*
Inscribed *mosto amico no* in a darker
ink in an 18th-century hand
On white laid writing paper, no WM;
pen and yellow-brown iron-gall ink,
with one pale brown and one beige
wash within a ruled ink border;
263 × 172 mm; glued to a backing sheet
SJSM, vol.114, fol.1, drawing 1

A roundel containing the bust of a man
holding a book is upheld by two putti
standing on a square cartouche with a
scroll for an inscription. A scull rests
on one of three books lying on the sill
of an aedicular frame, which has square
piers and fluted capitals supporting an
architrave and cornice with satyr-mask
acroteria at each corner. The tabernacle
rests on the shoulders of a bald man,
below a coat of arms with a crayfish.

On stylistic grounds the drawing
can be attributed to the Bolognese artist
Amico Aspertini. The profiles and the
use and colour of the wash are close
to Uffizi 12821f (Faietti & Scaglietta
Kalescian 1995, pp.311–12, cat. 100

Vasari (1967, IV, p.460) recorded
sculptural work by Aspertini at S.
Petronio, Bologna; a *Dead Christ Upheld
by Nicodemus* is still *in situ* at the right

entrance. The drawing is particularly
interesting because it is one of only
three surviving drawings by Amico for
funerary monuments (the others are
in the Fitzwilliam Museum, Cambridge,
and the Galleria di Palazzo Rosso,
Genoa; Faietti & Scaglietta Kelescian
1995, pp.268–9 and 299–300, cat.53 and
83). It can be dated to *c*.1525–30, from
the same period as the *Dead Christ* in
S. Petronio.

The presence of books on the tomb
indicates that the subject was a scholar,
and the coat of arms refers to the dal
Gambaro family, with whom Aspertini
had documented connections. The
tomb could have been for one of two
brothers, Giacomo or Tommaso dal
Gambaro. Tommaso dal Gambaro,
who died in 1525, was a reader in civil
and canon law at the University
of Bologna from 1481 to 1507. If the
project was for Tommaso it was never
executed, because there is a simple
sepulchral stone dedicated to him
by his brother Piero in the church
of S. Francesco, Bologna.

LITERATURE Faietti & Scaglietta
Kelescian 1995, p.294, cat.78.

287

GIOVANNI ANGELO MONTORSOLI
(Florence, 1507–Florence, 1563)
*Project for the elevation of a
cardinal's tomb;*

Inscribed POCA POLVERE/SON·CHE
NVLA/SENTO
On white laid writing paper, no WM;
pen and two brown iron-gall inks over
incised and grey-chalk construction
lines and underdrawing, pink, green,
grey and two grey-beige washes within
a ruled ink border; 383 × 228 mm;
glued to a backing sheet
SJSM, vol.114, fol.2, drawing 2

The cardinal, probably called Michele,
reclines on a sarcophagus in front
of an arched frame enclosing a relief
on a pedestal of St Michael killing a
dragon. The sarcophagus and relief
are framed in a tabernacle. In the
basement below the sarcophagus two
putti hold a cartouche bearing the
inscription. A Composite order on
pedestals supports an entablature
that breaks forward over the columns
and a triangular pediment. A putto
holding a cross and a chalice represent-
ing Faith and a putto holding a book
and a banner sit on the pediment
below the Crucifix.

The tomb, with a reclining effigy
supported on one elbow on the
sarcophagus, is a common type,

established by Andrea Sansovino's
tomb of *Ascanio Sforza* in S. Maria
del Popolo, Rome. This example is
influenced by Michelangelo's tomb
of *Pope Julius II*. The recessed columns
and the capital type are both typical
of Michelangelo, and the figure of
Christ recalls Michelangelo's *Crucifix*
(Florence, Casa Buonarroti). The
recumbent figure with a divine protec-
tor is especially associated with the
tombs of Michelangelo Naccherino
(Venturi 1936, X/II, pp.583ff.).

The clear, sharp outlines of the
architectural drawing most resemble
Montorsoli's designs in the Casale
album in the Biblioteca Nacional,
Madrid. The tomb project on fol.134,
which avoids rigorous orthogonal
drawing by showing selected mould-
ings in perspective, provides the best
parallel for the architectural drawing
(Madrid 1991, p.294, cat.C124). The
same facial type is found on fol.134
and on the putto on fol.106c (op. cit.,
p.283, cat.C95). The standing saint in
Uffizi 16104F is also of the same facial
type, and his hand with raised index
finger is very close to both the hands
on this drawing.

288

BACCIO D'AGNOLO (?)
(Florence, 1462–Florence, 1543)
*Design for the stucco decoration
of a barrel-vaulted room*
On white laid writing paper, no WM;
pen and brown iron-gall ink over grey
chalk, one brown and one beige wash;
192 × 283 mm; glued to a backing sheet
SJSM, vol.114, fol.3, drawing 3

The drawing shows the setting of the
stuccoes of the central passage on the
north side of the Colosseum as recon-
structed by Giovanni da Udine. His
design, formerly in the Cabinet Crozat,
was recorded by the Comte de Caylus
in 1729 in an engraving now in the Witt
Collection, Courtauld Institute of Art,
London. It is also recorded in a draw-
ing attributed to Perino del Vaga at
Chatsworth House (Jaffé 1994, p.224,
cat.361) and in the Codex Destailleur in
the Kunstbibliothek, Berlin (fol.40v).
All of the representations show a frieze
with square panels of mythological
or battle scenes separated by single
standing figures, and pairs of reclining
figures and putti in the border immedi-
ately below the lunette. In the engraving

the lunette relief shows several figures
and a horse, while in the Chinnery
drawing a central figure stands between
two nudes seated in contrapposto on
antique male torsos, their long arms
stretching forward and holding orbs.
Neither the Chatsworth drawing
nor the Codex Destailleur drawing
reconstruct the stucco decoration
in the lunette.

The same torso is drawn twice.
It resembles the Torso Belvedere in
the Vatican, which was in Palazzo
Colonna, Rome, from the time of
Martin V (1417–31). Acquired for the
papacy by Clement VII, it was lying
on the ground when Marten van
Heemskerck drew it, *c*.1535. A similar
torso was excavated in 1513 and drawn
by an anonymous artist at the house of
Giovanni Ciampolini in Rome (Byam
Shaw 1976, I, p.148, cat.518; II, pl.278).
It is not clear from the drawing which
of the two torsos is represented. If it is
the Torso Belvedere, it must have been
drawn while it was in Palazzo Colonna.

The draughtsman's affinity for the
plasticity of the stucco mouldings sug-
gests that the drawing could be a project

for the decoration of a room based
on the Colosseum rather than a recon-
struction. The attenuated, bald-headed
figures suggest a late 15th-century date.
The position of the seated figures with
extraordinarily long arms resembles
two similar figures seated on either
side of a cartouche above a design for
a fire-place for Palazzo Borgherini,
attributed by Cecchi to Baccio
d'Agnolo and dated 1505–15 (Uffizi
663E; Florence 1996a, pp.258–9, cat.87).
The handwriting is close to Uffizi 1561A
published by Elam (1985, fig.11); the
same abbreviation of *braccia* is used
and the artist used a similar granular
wash. The wash in this drawing is
much paler.

286

287

288

289

**ANONYMOUS 17TH-CENTURY
ITALIAN DRAUGHTSMAN AFTER
GIOVANNI LANFRANCO**
(Parma, 1582–Rome, 1647)
Design for a coved ceiling
On white laid writing paper, no WM;
pen and brown ink over grey chalk
construction lines, with one pale
brown and two beige washes;
255 × 514 mm
Repaired on the verso on either side
of the lunette
SJSM, vol.114, fol.4, drawing 4

Nude telamons at the corners and
draped caryatids on either side of a

triangular compartment above a
lunette in the centre of the drawing
support a flat coffered border around
a square-framed ceiling. Two oval
painted panels between the telamons
and the caryatids contain a battle
scene on the left and a procession
with a drunken Silenus on the right.

The architecture of the coved ceiling
is based on Giovanni Lanfranco's
ceiling of 1624–5 in the Salone of the
Casino Borghese, Rome, depicting
the *Gods of Olympus and Personifications
of Rivers*, in which paired nude figures
hold up the entablature, which is open
to the sky (Voss 1920, pl.225).

Lanfranco's scheme is derived from
Annibale Carracci's ceiling of 1597–
1604 in the Galleria of the Palazzo
Farnese, where male nudes support
the entablature, which opens to the
sky and encloses framed panels and
roundels with *grisailles* (Wittkower
1965, fig.14). The combination of the
architecture with roundels seems to
depend on both schemes (op. cit.,
fig.173). A drawing of the ceiling in the
Biblioteca Reale, Turin (inv. no.Cart
8/1/37), attributed to an anonymous
Bolognese artist after Annibale Carracci,
is probably by the same hand (Bertini
1958, p.60, cat.461).

290

**A CLOSE FOLLOWER OF
FRANCESCO SALVIATI**
(Florence, 1510–Rome, 1563)
ROME: *Palazzo Del Monte-Firenze
Project for the decoration of a portico*
On white laid writing paper with a rope
mark, WM cat.; pen and brown iron-gall
ink over grey chalk construction lines
and underdrawing, one grey-brown
and two beige washes; 327 × 363 mm;
glued to a backing sheet
SJSM, vol.114, fol.5, drawing 5

The drawing shows the left half of an
arcade; the right half is drawn on fol.10
(cat.292). The arcade is supported on
square piers with impost capitals. In
the spandrels of the arches, below a
plain wide string course, reclining
ignudi reach towards the three mounts,
the insignia of the Del Monte family,
above each arch. In the upper storey
rectangular windows centred over the
arches open at the level of the string
course. To the left of the window in the
end bay is a standing figure of *Hercules*
in a niche. In the space between the
first pair of windows on the left there
is a *trompe-l'oeil* rectangular opening
enclosing an oval frame with a standing
nude figure of *Phanes*; between the
second pair of windows is a group of
five female figures with instruments;
and in the last bay on the right a group
of eight female figures, perhaps repre-
senting the Muses. A deep cornice
with consoles crowns the loggia.

Nova (1988, pp.209ff.) identified
the frescos as those commissioned by
Pope Julius III for the palace on Campo
Marzio later acquired by Ferdinando
de' Medici and called Palazzo di
Firenze. Julius III acquired the prop-
erty from the Cardelli family in 1550,
and Bartolomeo Ammannati was

employed to develop the pre-existing
structures into two palace blocks on a
large irregular site; the block on Piazza
di Firenze was intended for Julius's
brother Balduino Del Monte, the
other, on Via Trinitatis, for his brother
Fabiano (the latter is now part of the
Palazzo dell'Intendenza di Finanza).
Ammannati intended to connect the
two blocks by a corridor wing. The
presence of the helmet, Balduino's
personal insignia, in the frieze with
the *ignudi* above the windows, and the
Del Monte mounts on the drawings
confirms Nova's identification. The
plain string course above the arches
is identical to that in the courtyard,
and the capitals are like those in the
loggia of Primaticcio in the palace
(Letrarouilly 1874, III, tav.319). Nova
(1988, p.288, n.2) deduced that the
arcade must originally have been
seven pillars and six arches in length.
If the drawings are placed side by
side, the two central piers are shown
orthogonally while those to the left
and right of them are rendered in
perspective.

The rope mark in the paper, which
is not found on fol.10, suggests that
the drawings were not originally on
one sheet of paper.

LITERATURE Nova 1988, p.209; London
1995, cat.5–6.

291

Inscribed *l'hoste/qui–l'hoste* in a
17th-century hand
SJSM, vol.114, fol.5, drawing 5v

292

**A CLOSE FOLLOWER OF
FRANCESCO SALVIATI**
ROME: *Palazzo Del Monte-Firenze
Project for the decoration of a portico*
On white laid writing paper, no WM;
pen and iron-gall ink over grey chalk,
one grey-brown and one pale beige
wash; 331 × 290 mm
SJSM, vol.114, fol.10, drawing 10

The drawing shows the fourth, fifth and
sixth bays and part of the seventh bay
of the right half of the arcuated portico
shown on fol.5 (cat. 290), which was
probably originally seven bays long;
half of the seventh bay on the right,
the window above it and a niche to the
right of the window completed the
symmetry of the façade. The figures
in the rectangular field on the left of
the sheet represent *Virtue Seizing the
Occasion*, an impress of Pope Julius III,
Justice and Abundance in the second
scene and either *Hygeia*, the goddess of
good health, or *Bona Dea*. For the icono-
graphy of the scenes, see Nova 1988.

The drawings are close to a design
for a loggia with the Del Monte arms
in the Kunstbibliothek, Berlin (inv.
no.Hdz6695), which Alessandro
Cecchi (1994, pp.18 and 21, fig.20)
attributed to Francesco Salviati.

LITERATURE Nova 1988; London 1995,
cat.5–6.

293

ANONYMOUS DRAUGHTSMAN
Pedestal
SJSM, vol.114, fol.10, drawing 10v

When the drawing was repaired it
was glued to a measured drawing of
a pedestal in a fine 16th-century hand.
The drawing is barely legible.

289

290

292

294

BACCIO D'AGNOLO
(Florence, 1462–Florence, 1543)
ROME: *Pantheon; copy of a view of the interior of the portico*

Inscribed *l[a roto]nda* in the same ink; *di bronzo–p. 20 persino a larchitrave–vano daluno architrave alatro–l[a roto]nda–vi sie lecholone/del porticho dj/santa maria/ritonda djdrento–opra le cholone si santa/maria rjtonda/di drento* in a different ink; *sopra la porta* in a second hand
On two sheets of white laid writing paper joined irregularly horizontally, no WM; pen and three iron-gall inks, over incised construction lines, diagonal and cross-hatching; 434 × 267 mm, in the mount 451 × 287 mm; glued to a backing sheet
SJSM, vol.114, fol.6, drawing 6

The folio has been described as the work of three artists. The first, an artist close to Raphael, drew a view of the portico in a yellow-brown ink. A second hand from the circle of Sangallo reworked the original. Following the architecture, he cut out an irregular shape from the bottom of the sheet, leaving the view of the portico and a fragment of the original inscription, *l[a roto]nda*. He replaced the lower part of the sheet and added his own studies of the Pantheon in a grey-brown ink: from right to left the profiles of the trabeation over the columns inside the portico, the entablature of the main order of the interior, and of the pediment of the portico. He added the notes and measurements in *braccia* to the main drawing and the small figure in the column at top right. A third person, a collector, put the folio in a paper mount with a cartouche and retouched the drawing of the two Corinthian entablatures, adding dentils and bead-and-reel astragals; he mistakenly added the note *Sopra la porta* (above the door) below the entablature of the pediment in a dark brown ink. The paper mount bears an old attribution, *M. D. Rafalo*. The bottom right-hand corner of the folio in the album also bears an old cut attribution to Raphael, *Mano di Rafaelo* (Shearman 1977, pp.120–21).

The view, from a vantage point just at the entrance to the vestibule, is admirable for the vast vertical space, which enables the rear wall of the portico to be viewed together with the bronze roof-beams. The effect is achieved by an inventive use of an almost bifocal perspective (op. cit., p.141, n.17). The perspectival mastery of the drawing probably explains the numerous copies; it could have been used as an example for the teaching of perspective (Lotz 1977, pp.24ff.).

Six copies after a lost original have survived.

The most important of the six copies of the view of the portico was drawn by Raphael on the verso of Uffizi 164Ar, which is his beautiful free-hand drawing of the panoramic view of the interior of the Pantheon. John Shearman (1977, pp.111–15, pls 1–3) demonstrated conclusively that Raphael's view of the interior, showing the apse on the left, its order and entablature to the end of the second rectangular recess on the right, the coffering of the dome and the cornice of the upper order, was extended by a second artist who drew the bay leading to the vestibule on the right and the details of the cladding of the upper storey. Raphael's drawing of the portico on Uffizi 164Av is copied from another drawing, and is constructed geometrically using compasses and incised construction lines. The similarities and differences between the copies of the view of the portico have been thoroughly described by Shearman. From his analysis, the drawings in the Chinnery album and in Codex Escurialensis emerged as the most significant; the others are copied either from Raphael's drawing on Uffizi 164Av or from Codex Escurialensis. Shearman (pp.120–22), who argued strongly for Raphael as the author of the original drawing, nevertheless acknowledged that the Chinnery and Escurialensis drawings could depart from a different prototype.

A drawing of the arch of Constantine on Uffizi 1120 shows the same hatch technique, and the inscription *archo di tra/[si]* can be compared with the cut inscription on the Chinnery sheet. The loop on the upright of the *d* and the raised tail on the *a* are sufficiently close to suggest that the drawings may be by the same hand. A drawing of the arch of Trajan in Ancona on the verso is closer to the Chinnery sheet, and a comparison between the inscription *anchona* and the writing on the addition to the Chinnery sheet reveals that they are also by the same hand. The range of hatch techniques, featuring enmeshed diagonals and hatch intersecting at right angles applied in a neatly controlled, almost measured fashion, is also characteristic of both drawings.

The handwriting on Uffizi 1120 matches the autograph letter sent from Baccio d'Agnolo to Michelangelo on 30 December 1516 (Elam 1985, figs 10–11 and 13). The looped *d*, the *l* leaning backwards, the horizontal tail on the *a* as well as the *ch* match the characteristic forms found in the letter. The same forms are found in the hand of the additions to the Chinnery sheet, which

confirms the tentative suggestion of Arnold Nesselrath (1986a, pp.131–2, n.7, 15) that Baccio d'Agnolo was the second of the three draughtsmen described by Shearman, and the draughtsman of Uffizi 1120. The cut inscription on the Chinnery drawing reveals that the *l* slopes backwards, the *a* has the same raised tail and the *d* the same loop. It is therefore reasonable to suggest that the drawing is by two rather than three hands, one of them at two different dates. The drawing in its early state was a copy by Baccio d'Agnolo of a lost original that, like the Escurialensis sheet, bore only the view and the inscription. D'Agnolo cut the lower half of the sheet and inserted details of the mouldings, possibly when he went to Rome after 1511. He changed the profiles and inserted the details of the mouldings before the collector added the erroneous inscription *sopra la porta*, sketched in the bead mouldings in the entablature and framed the drawing.

Uffizi 1120 is also copied from a lost original, which was drawn in Codex Escurialensis. The drawing on 1120r, the arch of Constantine, is copied on fol.45r, and the arch at Ancona appears on fol.27r (Egger 1905–6, pp.118–19, 90–91). Natali used the fact that the architecture on Uffizi 1120 was unfinished to argue the case for an attribution of the drawing to Ghirlandaio as an early study for the arch of Constantine. However, the incised underdrawing and the pentimento on the shoulder of the barbarian on the left suggest that the drawing is a copy rather than an original. The procedure followed by d'Agnolo and the Escurialensis draughtsman indicates that both artists used the same prototype. The inscriptions are in identical positions. Both artists constructed their drawings in the same way: they divided the folio horizontally and vertically to frame the reliefs and to show the main lines of the architecture. Both drawings align the horizontal line that defines the bottom of the moulding at the top of the pedestal with the baseline of the reliefs on the back plane of the attic; both show the vertical line that marks the front corner of the projecting attic pilasters and continues down through the basement of the attic to the top of the entablature. The line is incised in Uffizi 1120; it is drawn in ink in Codex Escurialensis. The position of the plane of the corner of the basement in relation to the projecting pier above it is illegible in the Escurialensis drawing. The draughtsman of Uffizi 1120 abandoned his attempt to correct this, probably because it was not clear in the

original whether the corner of the basement was level with the front of the pilaster or on the same plane as the reliefs. Indeed, scruples about the architectural drawing may have been the reason for not copying the architecture, which was reproduced intact and unresolved in Codex Escurialensis from the same prototype. The idea fits well with the identification of d'Agnolo as the draughtsman of Uffizi 1120, who copied an earlier architectural drawing that he could not fully interpret.

The drawing of the arch at Ancona on the verso of the Uffizi sheet also shows very little attention to details that would be important to an architect: mouldings are rendered with a few unconnected horizontal lines without concern for the profiles. The mouldings were probably indicated in the same way on the Chinnery sheet before the profiles were added. These details could suggest that the draughtsman of the original may not have been an architect. The identity of the draughtsman of the original drawings of the arches and of the view of the portico is still unclear and opinion about the origin of Codex Escurialensis has polarized.

Arnold Nesselrath noticed the similarity between the Chinnery drawing and Uffizi 1120, and he drew attention to Huelsen's observation (1910, pp.XXI–XXXII) about the dependence of fol.72 of Codex Escurialensis on Giuliano da Sangallo's *libro piccolo*, which was incorporated into the Barberini Codex. He reliably attributed fols 70–75 of Codex Escurialensis to Baccio d'Agnolo (Nesselrath 1986a, pp.130–31). All are copied from the Barberini Codex, and they must predate 1506–8, when Don Rodrigo de Mendoza presumably acquired the Codex in Rome; it was in Spain in 1509. The *terminus ante quem* for the drawings would be the date when the *libro piccolo* was incorporated into the Barberini Codex. Nesselrath used the fact that d'Agnolo copied drawings into Codex Escurialensis to support the view that it came from Sangallo's workshop rather than from Ghirlandaio's. He dated the incorporation of the *libro piccolo* into the Barberini Codex to the beginning of the 16th century and rejected a date in the 1490s before 1494, the date of Ghirlandaio's death, accepted by those scholars who believe that Codex Escurialensis was made by artists in the circle of Ghirlandaio. Nesselrath's belief that the Chinnery drawing was copied from one by Raphael of *c.*1506 helps to justify a late date for the incorporation of the *libro piccolo* into the Barberini Codex

(Nesselrath 1986a, p.131).

Baccio d'Agnolo was closely connected with both Ghirlandaio and Sangallo. He carved the tabernacle for Ghirlandaio's last work, the altar in the Tornabuoni chapel in S. Maria Novella, Florence (payments were made to him between 1491 and 1496; Cecchi 1990a, pp.43–4; Vasari 1887, II, p.336), and, in 1506, with Giuliano and Antonio da Sangallo, he became one of the *capomaestri* of the Opera di S. Maria del Fiore in Florence (Cecchi 1990b, p.40). He was host in his Florence workshop to the famous circle of artists, including Giuliano da Sangallo, Raphael and Michelangelo, who met to discuss architecture in the early years of the 16th century (Vasari 1967, V, p.140).

The fact that the perspective in the Chinnery drawing differs from that in Raphael's drawing, Uffizi 164A, indicates that it was not copied from it. The drawing is incised but the perspective is less carefully constructed than Raphael's, which is also not fully geometrically constructed. In the Chinnery drawing the receding lines on the left go to different points, whereas in Uffizi 164A they recede to a point slightly more than one-third of the height of the second column on the right. Raphael corrected the coffering of the vault and the position of the apse, which is shown in the Chinnery drawing as though it is on the same plane as the door rather than in front of it (Shearman 1977, pp.121–2). He recorded optical effects: the architrave above the apse runs slightly downwards and not straight as it is shown in the Chinnery drawing. The relationship of the cornice of the door with the receding cornice of the trabeation is more accurately drawn.

The most striking difference between the two drawings is in the rendering of the roof structures, especially of the beam above the columns on the right. Baccio incised the roof structures; Raphael drew them free-hand. In the Chinnery drawing two ink lines connect the capitals. The first runs from the vertical line of the shaft above the capital to the springing of the arch above the first pilaster; the area between the columns, which is densely hatched, represents the underside of the beam. The second line parallel to the first on the left seems to represent the vertical face of the beam, which is less densely hatched. Raphael incised these lines in slightly different positions, and used them to align the capitals. He did not fill them in ink, and the trabeation, which is over-descriptive in the Chinnery drawing, is expressed lucidly as the underside of the beam. It seems that Baccio was not copying

Uffizi 164A; neither is it likely that he was copying an earlier drawing by Raphael.

We should therefore assume that Baccio's copy is an accurate rendering of an original that is not Uffizi 164A. Without a detailed review of the whole of Codex Escurialensis it would be rash to take a fixed view of the identity of the draughtsman of the original drawing, but the following points can be repeated in favour of Egger's arguments.

The developed use of perspective is evocative of Ghirlandaio. The perspective in the drawing of the *Apparition of St Francis at Arles* (Rome, GNDS) for the fresco in the Sassetti chapel in S. Trinità, Florence, shows a mastery of space that is consistent with the most advanced trends in Florentine painting of the 1480s and with the vastness of the vertical space in this drawing (Rosenauer 1972, pp.187ff.; Fort Worth 1994, pp.24–5, cat.4). Ghirlandaio pushed the descriptive powers of perspective beyond its limits vertically in his study (London, BM, inv. no.1866-7-14-9) for the fresco of the *Birth of the Virgin* in S. Maria Novella, Florence. He disciplined it in the fresco, as Raphael disciplined the perspective in the Chinnery drawing (Cadogan 1977, pl.1 and fig.2). Aspects of the technique also recall Ghirlandaio's drawings. He used many kinds of hatching, including the type that intersects at right angles, which appears in the drawing of the *Apparition of St Francis at Arles*, where it is applied much more impetuously. Cadogan (1974, pp.164–5, pl.13) discussed his development and use of a range of abbreviated conventions that are consistent with similar conventions in the view. Ghirlandaio's use of an abbreviated convention to convey figures could be seen as equivalent to the abbreviated fluting, for which no precise equivalent can be found in existing drawings; the capitals and similar volutes are found in his drawings; in the *Angel Appearing to Zaccharias* (Vienna, Albertina, inv. no.26), he draws bases with unconnected horizontal lines similar to the mouldings on the drawing of the arch at Ancona on Uffizi 1120v, possibly as they were originally drawn on the Chinnery drawing and on the extension to Raphael's drawing of the interior of the Pantheon, which Shearman (1977, pp.112–13, pl.3) attributed to the circle of Ghirlandaio.

Ghirlandaio was capable of producing a landmark drawing. We should not underestimate Vasari's anecdote (III, 1967, p.167) about the accuracy of his drawings after the Antique: 'Dicono

che ritraendo anticaglie di Roma: archi, terme, colonne, colisei, aguglie, amfiteatri et acquidotti, era sì giusto nel disegno che le faceva a occhio, senza regolo o seste e misure; e misurandole da poi fatte che l'aveva, erano giustissime, come se e'le avesse misurate. E ritraendo a occhio il Coliseo, vi fece una figura ritta appiè, che misurando quella tutto l'edificio si misurava; e fattone esperienza da maestri dopo la morte sua, si ritrovo giustissimo' (They say that when he drew the Antiquities of Rome – arches, baths, columns, colosseum, obelisks, amphitheatres and aqueducts – he was so accurate in his drawing, which he did by sight, without measurements, that when they measured them afterwards they were so accurate as to seem measured. In his drawing of the Colosseum by sight he drew the elevation so accurately that the whole building could be measured from it; and after his death other masters experimented with the drawing and found it very accurate).

OTHER REPRESENTATIONS Raphael, Uffizi 164A (Bartoli 1914–22, I, tav.LXV, fig.100; Florence 1984; Venice 1994); anonymous, not Jacopo Sansovino, Uffizi 1948AV (Scaglia 1995, p.11, fig.2); Uffizi 1949A (Scaglia 1995, p.13, fig.4); anonymous after Domenico Ghirlandaio, Escorial, Codex Escurialensis, fol.29 (Egger 1905–6, p.92); anonymous, after Raphael, Salzburg, UL, inv. no.H193, fol.1r (Nesselrath 1986b, 1, pp.358ff., tav.CXLIV, fig.8).
LITERATURE Egger 1905–6, p.92 as fol.30; Shearman 1977; London 1995, cat.2; Scaglia 1995.

This entry was written before Gustina Scaglia published her article on the view in 1995. I am unable to accept her chronology because I do not agree with the attribution of drawings in the Universitätsbibliothek, Salzburg, to Raphael. She based the attribution on the handwriting on the drawings, which in my view Arnold Nesselrath (1986b, p.359) described accurately as an imitation of Raphael's handwriting. None of the letters in the inscription on the Salzburg drawings joins, and the hand betrays a different rhythm.

Templo antiquo in Nimis et prouenza

295

296

297

295

ANTONIO LABACCO
(Vercelli, 1495–Rome, 1567)
NÎMES: *Maison Carrée*
Perspectival elevation; preparatory
drawing for an engraving
Inscribed *Tempio antiquo in Nimes di*
prove[n]za in a 16th-century hand;
Maison quarrée de Nimes in a different
ink on the folio of the album in the
same 18th-century hand as on fol.1
On white laid writing paper, no WM;
pen and brown iron-gall ink over grey
chalk, grey-brown and beige washes
within a single line border;
232 × 271 mm
SJSM, vol.114, fol.7, drawing 7

The perspective shows the hexastyle
Corinthian portico and pediment and
one side of the temple.

The attribution to Antonio Labacco
was tentatively made by Noach. Labacco
trained under Bramante from at least
1508 and he probably collaborated with
Peruzzi and Sangallo in making sur-
veys of ancient buildings (Burns 1988a,
p.216 and n.42). From 1539 he was
engaged in making the great model of
Antonio da Sangallo's project for the
completion of St Peter's, Rome, under
Paul III, which was left incomplete on
Sangallo's death in 1546. In 1542–3 he
was among the founder-members of

the Compagnia delli Virtuosi al Panteon,
who met to examine drawings and
discuss problems of ancient architec-
ture; another member was Francesco
Salviati, who made the design for the
frontispiece of Labacco's *Libro… appar-*
tenente all'architettura (1559; Popham &
Wilde 1949, pp.327–8, cat.897, fig.172),
the earliest published set of engravings
of ancient buildings after Serlio's book
III in 1540. Their distinguishing feature
is that the ruined buildings are repre-
sented restored and whole. The temple
of Diana at Nîmes is not reproduced in
the *Libro*. The correct number of
columns in the portico and on the
chamber wall is reconstructed but the
temple is shown without the podium
and the moulding that connects the
bases shown in Palladio's engraving
(1570, book IV, cap.XXVIII). Features of
the engravings – the stepped platform
base like a base for a model, the draw-
ing of the consoles in the cornice and
the profiles of the mouldings and bases
– are all consistent with other drawings
by Labacco. The drawing for pl.20 at
Windsor (RL, inv. no.19278) is by the
same hand: the capitals and the slight
distortions of the bases are identical to
this drawing.

For a survey of the building, see Amy
& Gros 1979.

296

AFTER FEDERICO ZUCCARO
(S. Angelo in Vado, Marche,
1540/42–Ancona, 1609)
Copy of a study for a wall decoration
On white laid writing paper, WM cat.7;
pen and brown iron-gall ink over grey
chalk, pinkish-beige wash, violet ink
stains; 320 × 351 mm
Repaired on the verso on the right
SJSM, vol.114, fol.9, drawing 9

The scene represents a pope receiving
homage or granting a privilege with a
vista of Rome seen through an archi-
tectural setting, of a central trabeated
portico with paired central Corinthian
columns. On the left the door into the
room is framed by a tall basement
below piers containing niches with
statues; these niches frame a niche
above the door, which contains an
enthroned female figure surrounded
by a crowd. Chinnery fol.8 (cat.297)
shows an alternative elevation with a
Corinthian order framing the niche
above the door.

Chinnery fols 8 and 9 are copied
exactly from a drawing in the Lugt
Collection attributed to Federico
Zuccaro and described by Byam Shaw
(1983, I, p.147, cat.138; II, pl.162) as
characteristic of his late style. He
described it as a *modello* for an

important, apparently unexecuted,
papal commission treated in a grand
Venetian manner with a giant
Corinthian order. John Gere suggested
that there could be a relationship
between this drawing and Federico's
fresco of *Pope Gregory VII Removing the*
Ban of Excommunication from the
German King, later Emperor Henry IV,
painted in the Sala Regia in the Vatican
(for drawings in the Louvre and British
Museum connected with this project,
see Gere 1969, pp.53–4, cat.60, pl.XIV).
The connection was rejected by Byam
Shaw because the scale and relation-
ship of the figures to the background
are quite different and because Henry's
act of submission took place in
Canossa and not in Rome as depicted
here.

Uffizi 247A, attributed to Taddeo
Zuccaro (Ferri 1885, p.119), shows a
Corinthian colonnade with figures in
niches and a similar architectural set-
ting, with the order framing niches and
a deep trabeated portico in front of an
architectural view; Uffizi 246A is an
Ionic pendant to this drawing.

297

AFTER FEDERICO ZUCCARO
Copy of a study for a wall decoration
On white laid writing paper, no WM;
pen and pale brown iron-gall ink over
grey chalk, beige wash, violet ink
stains; 321 × 180 mm
SJSM, vol.114, fol.8, drawing 8

The drawing, the right side of fol.9
(cat.296), has been cut unevenly on the
right. It shows an alternative elevation
with high pedestals framing a door and
a giant Corinthian order supporting an
attic with rectangular windows and
putti standing on the cornice below the
entablature. The two columns frame
female figures climbing on to the door
and sitting at the feet of an enthroned
figure in a niche surrounded by a
crowd. A warrior holding a shield
stands in a rectangular niche on the
left.

SJSM, vol.114, fol.11, No drawing was
recorded in 1837

298

MASTER OF THE MANTEGNA
SKETCHBOOK
(active in Mantua, *c*.1500)
A folio from a sketch book with a
pilaster and two entablatures
On white laid writing paper, no WM;
pen and brown iron-gall ink over
incised construction lines and diagonal
hatching in grey chalk, within a ruled
ink border; 237 × 162 mm
SJSM, vol.114, fol.12, drawing 11

The folio, with rounded corners,
apparently comes from an architec-
tural sketchbook. The design for a bor-
der pattern or pilaster relief has a
cluster of acanthus leaves at the base
and rinceaux with rosettes springing
out of the acanthus and enclosing a
baluster below a vase. At the top of the
relief two dolphins joined at their tails
dive downwards into the rim of the
vase.

The entablature above a Composite
capital has an architrave with three fas-
ciae and an ovolo with palmettes. The
frieze is plain and the cornice has a

cyma reversa with palmette decor-
ation, dentils, an ovolo with egg-and-
dart moulding, a corona with scoop
ornament and a cyma recta with lily
leaves below a segmental pediment
with a bolster.

The second entablature has an archi-
trave with two fasciae decorated with
shells and guilloche and a decorated
cyma reversa. The frieze relief shows a
bucrane and garland and the cornice a
lily-leaf cyma recta, palmette cyma
reversa, an egg-and-dart ovolo, a
corona with scoop decoration, a bead-
and-reel fillet and a cyma recta with
anthemion and acanthus flowers.

Arnold Nesselrath noticed the simi-
larity between this folio and one in the
Getty Center in Brentwood (Resource
Collection, Archival no.920097),
which Luca Leoncini attributed to the
same hand as the Mantegna sketch-
book in the Kunstbibliothek, Berlin
(Pagan 1992, item 145; the Mantegna
sketchbook is attributed to a draughts-
man at the Gonzaga court in Mantua
(Leoncini 1993, pp.71 ff.). The cornice

and segmental pediment are the same
in both drawings. The use of diagonal
hatch to establish the ground, the thin
vertical line and the hatching along the
body of the dolphin, like the dolphins
on fol.71r of the Mantegna sketchbook,
and the drawing of the foliage and
rosettes find many parallels in the
Berlin volume (op. cit., pp.120–21 and
208).

The Chinnery folio is smaller than
the folios of the Mantegna sketchbook,
which have an average size of
288 × 213 mm, but the draughtsman-
ship is closer to it than to the Getty
folio, which is larger than the Chinnery
sheet and more loosely drawn. The
drawing of the dolphin on fol.134h
of the Larger Talman album in the
Ashmolean Museum, Oxford, com-
pares well with the Chinnery folio, as
does the drawing of the egg and dart
on the base on fol.134e (op. cit., pp.234
and 239, fig.28).

LITERATURE London 1995, cat.1.

298

299

299

MASTER OF THE MANTEGNA SKETCHBOOK

TIVOLI: *An entablature, cornices and architrave. Folio from a sketch book, profiles and elevations*

Inscribed *Atibolj jn Roma–Alarcho di santo vito jntera/jnsula strada alta b[raccia] .1.–grossa pie adita questa cornise––atiboli jnpr[o]ta/stura*
Pen and iron-gall ink, over incised and grey chalk, diagonal hatching
SJSM, vol.114, fol.12, drawing 11v

At the top left is a cornice with dentils and a cavetto moulding with rosettes below an egg-and-dart ovolo with an acanthus leaf at the corner, a plain cavetto, corona with an acanthus-ogee cyma reversa, plain slab and egg-and-dart ovolo with an acanthus leaf at the corner. Below it on the left is a plain cavetto above the architrave below the plain frieze ending in a cavetto, bead-and-reel fillet and plain cyma reversa below the plain corona, egg-and-dart ovolo, plain cyma recta, fillet and slab. At the top right of the drawing is an architrave with a plain cyma reversa, two plain fasciae separated by a bead moulding and a leaf-and-tongue cyma reversa. Below is an impost with an astragal, cyma recta with full and

simplified acanthus leaves, a fillet below an astragal and a slab below a leaf-and-tongue cyma reversa.

The handwriting on fol.206 of the Larger Talman Album is identical to the writing on the verso of this sheet (Leoncini 1993, pp.235 and 242, fig.31).

300

AFTER POLIDORO DA CARAVAGGIO
(Caravaggio, near Bergamo, *c.*1499–Messina, *c.*1543)

MESSINA: *Ephemeral architecture for the entry of Charles v; copy of a project*

On white laid writing paper, no WM; pen and brown iron-gall ink over grey chalk, pale brown and beige washes within a ruled border; 173 × 375 mm
Torn along a central fold and repaired on the verso
SJSM, vol.114, fol.13, drawing 12

Double twisted columns, seen from below, with spiral flutes and vines support the frieze and cornice and divide the field into three bays. A *Crucifixion* with the two Marys at the base of the cross fills the central bay; SS John and Luke with their attributes the eagle and the oxen stand in the left bay, and St Mark with his lion and St Matthew with his angel in the right bay; above them are cartouches with double eagles and an imperial crown.

The attribution was first made by Philip Pouncey, who associated the drawing with the entry of Charles v into Messina in 1535. A drawing by Polidoro in a private collection, published in the Polidoro exhibition,

demonstrates the justice of the attribution (Naples 1988, cat.XI, p.8).

The scheme was probably intended for a decoration in Messina Cathedral. The project shows the influence of Raphael's architecture: the use of a giant colonnade with figures between them is close to a drawing by Polidoro (Uffizi 13370F) that shows a double hemicycle with giant Ionic columns similar to Raphael's hemicycle in the courtyard of Villa Madama, Rome (Ravelli 1978, pp.207–8, fig.238). In this drawing the twisted and trabeated Salomonic columns resemble the columns in Raphael's tapestry cartoons in the Victoria and Albert Museum, London, and Giulio Romano's fresco of the Donation of Rome in the Sala di Costantino in the Vatican, showing the altar of St Peter's framed by a screen of twisted columns (Hartt 1981, fig.60).

A volume of 126 drawings entitled *Disegni e studi di Polidoro da Caravaggio fatti in Roma e in Messina*, now in the Kupferstichkabinett, Berlin, contains Polidoro's drawings for the entry, (Cassirer 1920, figs 3–8; Ravelli 1978, pp.192–7, cat.204–6; Naples 1988, pp.132ff.).

301

FRANCESCO SALVIATI
(Florence, 1510–Rome, 1563)

Design for an vessel

Inscribed *a vostro modo/olitere o storie* in Salviati's hand
On white laid writing paper, cut irregularly, no WM; pen and pale brown iron-gall ink, traces of grey chalk, one pale brown and one beige wash;
156 × 184 mm
SJSM, vol.114, fol.14, drawing 13

The vessel in the shape of a boat is supported on a pedestal made from the tails of two diving dolphins. At the prow a putto-faun half-figure puffs out his cheeks like a wind and blows; at the stern a nude man seated as though on a postillion bends forward over a cushion and pulls on a swag to furl a sail. The bow is decorated at the front with a volute enclosing a putto-mask with a wing below it and a fruit garland, and at the stern with foliage ornament. In the centre is a tablet, for an inscription or scene, with a segmental pediment.

The attribution to Salviati was made by Philip Pouncey. It is confirmed by the vigour of the drawing, the confidence of the summary description of the lid and torch, and the conviction with which the ornament is involved in

an internal narrative. The inscription is in the same hand as Salviati's contract note on the verso of the drawings for the *Doubting Thomas* in the Louvre (Monbeig Goguel 1972, p.124, cat.146). The long *s*, hooked *c* and *g* with the tail projecting forward and the first *questo* are clearly the same. It is close to Uffizi 1627E, a study for a grotesque wall decoration, with an inscription in the same hand (Florence 1986, II, p.673). The putto-faun is close to a winged putto on Uffizi 15010. The drawing is the first idea for a type of vessel that was used to contain spices, to hold dining utensils or as sauce boats. The design of *c.*1550 could easily be transformed into a cradle.

An anonymous drawing, Uffizi 1556E, with an attribution to Polidoro da Caravaggio rejected by John Gere, shows a similar vessel with a standing winged figure on the cover (Florence 1986, II, pp.646–7). Uffizi 5690, attributed to Giovanni da Udine, is an inferior version of the Soane drawing. For a discussion of the functions and materials of vessels of this kind, see New York 1997b, pp.72–4, cat.15.

LITERATURE London 1995, cat.4.

302

NICCOLÒ TRIBOLO
(Florence, 1500–Florence, 1550)

FLORENCE: *Villa di Castello, c.1537–8 Fountain, project showing alternative elevations*

On white laid writing paper, cut around the profile, no WM; pen and two brown iron-gall inks over grey chalk, diagonal hatching, pale beige wash;
212 × 167 mm
SJSM, vol.114, fol.14, drawing 14

The fountain has a serliana elevation resting on a high basement with a relief of a sea-horse. The serliana is supported on Ionic half-columns and the central apse contains the statue of a faun sitting on top of a rocky cave. In the shallow rectangular niche on the right a young faun swings on a garland and blows a trumpet; on the left is a relief with trophies, a cornucopia and garlands. Above the entablature over the side bays two fauns sit on arches framing baskets of flowers and lean forward towards the faun-mask keystone of the central arch, with a shell-niche below a round window.

The drawing has been attributed to Tribolo, and related to the grotta in the gardens of Villa Medici at Castello which were designed by Tribolo in

1537–8 (Vasari 1967, v, pp.459ff). Aschoff published a drawing in Berlin as a study for the grotta. It has a similar overall design, with the serliana setting, but Pan stands on top of the rocky cave in a shell niche and the rectangular niches on either side contain baskets of flowers. Another drawing in the Louvre (inv. no.9), formerly attributed to Ammannati, has also been attributed to Tribolo and associated by Keutner with a design for the same fountain (Monbeig Goguel 1972, p.145, cat.184r). Keutner, Aschoff and Monbeig Goguel all agree that the three drawings are by the same hand; indeed the architectural drawing, facial types and the hatching in the background of all confirm this.

Aschoff recognized the sketches on the verso of the drawing in the Louvre as studies for Tribolo's bronze of *Pan Playing a Flute* dated 1549 in the Bargello, Florence. The faun swinging on a garland on the verso of the Paris drawing is close to the figure on the right of this drawing.

Other drawings Berlin, SMK, inv. no.Kdz25281; Paris, Louvre, inv. no.9 (Monbeig Goguel 1972, p.145, cat.184r).
LITERATURE Keutner 1965, pp.240–41; Aschoff 1967, p.46, pl.59; Lloyd 1968, pp.243–5.

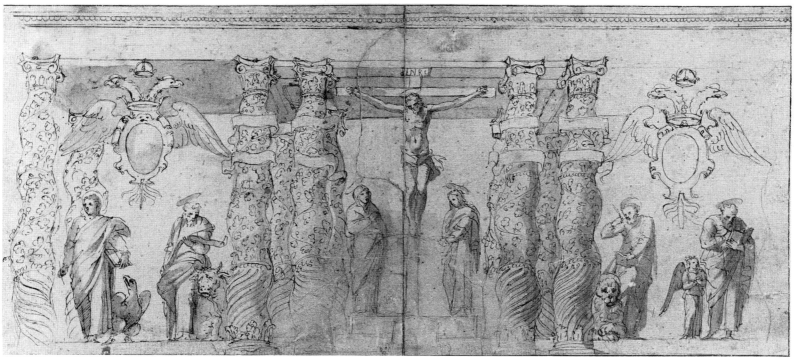

300

301

302

303

ANONYMOUS LATE 16TH-CENTURY
ITALIAN DRAUGHTSMAN
Design for a table fountain
On white laid writing paper, no WM;
pen and pale brown iron-gall ink over
grey chalk, grey and grey-beige washes,
heightened with white within a single
line wash border; 159 × 232 mm
SJSM, vol.114, fol.15, drawing 15

Three griffins with raised heads spout-
ing water are seated on a shallow dish.
A central gadrooned pedestal topped
by a dome with scales supports four
dolphins leaping up towards a central
dragon.

The dragon could be a personal
emblem; it was the emblem of Gregory
XIII.

304

ANONYMOUS LATE 16TH-CENTURY
FLORENTINE DRAUGHTSMAN
*Architectural composition for the
background of a painting*
On white laid writing paper, WM cat.60;
pen and brown iron-gall ink, beige
washes; 294 × 390 mm
SJSM, vol.114 fol.16, drawing 16

The asymmetrical view shows a city
square with a palatial building on the
right with three superimposed orders
and a stair of seven steps rising to a
loggia above a basement. In the dis-
tance are a church and a six-storey
campanile next to the arched entrance
to the city square and a basilica or
palace of Justice with two superim-
posed arcuated loggias on the left.

At first sight the drawing appears to
be a 17th-century scenography, but
nothing in the architecture justifies
such a late date. The drawing could

relate to a group of city views by differ-
ent hands that can be attributed to the
circle of Vasari. There is a striking sim-
ilarity between the Chinnery drawing
and *St Peter's Under Construction*
(Cambridge, Fitzwilliam Museum,
inv. no.3114; illustrated in *Architectural
Review*, XV, 1904, frontispiece), which
is based on Vasari's drawing for the
Return of Pope Gregory XI *from Avignon*
in the Louvre (Monbeig Goguel 1972,
cat.221, pp.171-2). The Fitzwilliam
drawing has been attributed to Jacopo
Zucchi. Although there are no figures
in the Chinnery drawing that would
help to confirm an attribution to
Zucchi, the rapid sketching of the
architecture, the pinnacles, the colour
of the wash and its independence from
the ink line are all typical of him. Other
examples from the same group by dif-
ferent hands are *A View of the Forecourt
of a Medieval Palace* in the Lugt

Collection, Institut Néerlandais, Paris,
which derives from the background
of Lucas van Leyden's 1510 engraving
of *Ecce Homo* and is attributed to a
Florentine artist in the circle of Salviati
or Vasari (Byam Shaw 1983, I, p.39,
cat.31; III, pl.33), and a view of *Piazza
S. Marco, Venice* (Rome, GNDS, Codex
2510, fol.45). The view of Venice could
be derived from a drawing by Federico
Zuccaro, who returned to Rome from
Venice via Florence in 1565. His hunt-
ing scene setting for the wedding of
1565 influenced the young artists in
Vasari's circle (Voss 1920, p29). The
lively, sketching of the architecture,
the cusp and spires are close to the
buildings in the background of the
Chinnery drawing, although they are
not by the same hand.

305

CIRCLE OF SIR JAMES THORNHILL
(Woolland?, Dorset, 1675-Stalbridge,
Dorset, 1734)
Design for a coffered ceiling
On blue wrapping paper containing
blue, grey and white linen, no WM; pen
and dark brown ink over grey chalk
construction lines, two brown washes,
white highlights; 241.5 × 207 mm
SJSM, vol.114, fol.17, drawing 17

The design, probably for a compart-
ment above a staircase, shows a square
ceiling supported on consoles with
acanthus-leaf ornament. The central
square is divided into four by cross
beams and has a central circular panel
containing a *trompe-l'oeil* figure of Mars
descending to earth. The frames of the
panels are decorated with rosettes
enclosed in ovals. The wooden coffered
ceiling derives from the kinds of
Venetian ceiling that were imported to
England by William Kent and Lord
Burlington at Chiswick House.

The uncertain drawing of the archi-
tectural ornament – particularly the
rosettes and the balusters – suggests
that the drawing is English rather than
Italian. The perspective of the figure
is similar to Thornhill's work, but the

drawing of the frame is less fluent than
one would expect from him. There are
no known examples of other drawings
by him with this type of architectural
frame, although he is known to
have designed a coffered ceiling for
Kensington Palace, London, and he
had ambitions to work as an architect.
He applied for the post of the Keeper
of the King's Works (communication
B.Tuppen.).

306

ANONYMOUS LATE 16TH-CENTURY
FLORENTINE DRAUGHTSMAN
*Design for a decorative plaque with
portrait medallion*
Inscribed VINCENTIO DA ROSSI
CELEBERRIMO/ARCHITETTORE
FIORENTINO; *V. Da Rossi*
On white laid writing paper, no WM;
pen and brown iron-gall ink, parallel
hatched, warm brown wash;
100 × 128 mm
SJSM, vol.114, fol.18, drawing 18

The portrait is in an oval frame with an
inscription identifying the subject,
Vincenzo de' Rossi, who is shown as a
bust in contemporary dress. The frame
is set in a rectangular landscape field
with shells in quadrants at the corners.

The portrait, inspired by those in
Vasari's *Vite*, is similar to another
drawing by the same hand in the
Courtauld Institute of Art, London
(private collection, inv. no.19), which
was attributed to Vasari and published
correctly as anonymous by Cecchi
(Arezzo 1981, VIII, cat.15, p.261, fig.192;
Rennes 1990, p.229, cat.293).

Vincenzo de' Rossi, who was born in
Fiesole in 1525 and died in Florence in
1587, was a pupil of Baccio Bandinelli.

He was mentioned by Vasari (1967,
VIII, pp.48-50) as a sculptor and
architect and listed among the
founder-members of the Florentine
Accademia del Disegno. A drawing by
him has an autograph letter to Vincenzo
Borghini on the verso (Louvre, inv.
no.1573; Monbeig Goguel 1972, p.105,
cat.125; for his biography, see Borghini
1967, I, pp.595-8; II, p.125; Baldinucci
1845-7, III, pp.495-8).

Vasari's use of woodcut portraits
to document artists in the *Vite* and
the *Libro de' disegni*, the collection of
drawings that complemented the *Vite*,
was also used by the Accademia. The
statutes record that on their deaths
members names were to be inscribed
in registers with a list of their works,
and portraits of the artists made for a
commemorative frieze. The drawing
could be for either of these projects.

307

*Fragment of an elevation of a
window and a lunette*
Pen and brown iron-gall ink, a pale
brown and a beige wash
SJSM, vol.114, fol.18v, drawing 18v

303

304

305

306

308

NICCOLÒ TRIBOLO
(Florence, 1500–Florence, 1550)
Design for a pedimented niche
Inscribed IMIPIGL/·ROV·
On white laid writing paper, no WM;
pen and grey-brown iron-gall ink over
grey chalk construction lines and
underdrawing, grey-brown wash;
193 × 138 mm
SJSM, vol.114, fol.18, drawing 19

Two pilaster herms, the one on the left
with a capital with a rosette, the other
with a lion's mask, support an entabla-
ture and segmental pediment and
frame a niche. They stand on a base-
ment that breaks forward beneath
them. The wall behind the niche is
decorated with a drapery canopy
that hangs from trophies.

The drawing has not previously been
attributed to Tribolo. The unsophisti-
cated treatment of the profiles and
mouldings, connected by straight,
diagonal lines, and the perspective of
the impost and apse are typical of his
draughtsmanship (Morrogh 1985,
cat.7, p.29).

The motif of the hermes pilaster and
capital with a lion's mask probably
derives from Perino del Vaga, for
example, his study for the side wall
of the Massimi chapel in S. Trinità
dei Monti, Rome (Ward Jackson 1979,
pp.170–71, cat.362). Uffizi 17720 attrib-
uted to him also shows a herm with
volutes drawn like ears. Drapery as a
framing device is also usually associ-
ated with his designs; it frames the
tablet with the coat of arms on the
tomb of *Pope Hadrian v* in S. Maria
dell'Anima, Rome. The same device,
probably designed by Vasari, is used
to frame the cartouche above the door
to Julius III's entrance to the Belvedere,
as shown in the Vatican Codex of
Giovanni Colonna (fol.97r; Micheli
1982, p.147, fig.97).

309

NICCOLÒ TRIBOLO
*Studies for the elevations of garden
niches*
Inscribed *moduli*
Pen and brown iron-gall ink
SJSM, vol.114, fol.18, drawing 19v

On the left is the attic storey of a build-
ing, of three bays, with a square panel
in the central bay and pilasters framing
niches on either side. The entablature
supports a triangular pediment, which
is broken by an enormous cartouche. A
detail of a lion's-head mask is drawn to
the right, and above it is the profile of
the scrolled console of a fireplace. On
the right there are two other studies
for the garden niche on the recto of the
folio. Herms flanking a panelled shell
niche support an entablature with a
broken segmental pediment with
volutes and a garland hanging from
them. Below the niche is a sketch of a
male nude standing with his left arm on
his thigh and his right arm raised.
On the far right of the folio is a half
elevation of the niche with a statue of
a male nude in the niche and a broken
triangular pediment enclosing an
oval cartouche.

The architectural drawing of the
impost of the arch, the niche and pan-
elling, the hatch technique, the figure
drawing and the facial types are very
close to Tribolo's project for a fountain
in the Louvre (inv. no.49; Monbeig
Goguel 1972, p.145, cat.184r and v).

310

FILIPPINO LIPPI
(Prato, *c*.1457–Florence, 1504)
Study for a standing bishop
On white laid writing paper, no WM;
pen and brown iron-gall ink, over grey
chalk, beige wash; 324 × 63 mm; glued
to a backing sheet
SJSM, vol.114, fol.19, drawing 20

A bishop-saint holding a book and a
crozier stands in a niche surmounted
by David in a roundel.

The attribution was made by Philip
Pouncey. The rare example of a pen,
ink and wash drawing is a modello
for a lost work, which finds its closest
parallel in the design for a stained-glass
window for the Nerli Chapel in S.Spirito,
Florence, Uffizi 1169E (Florence 1992b,
p.259). For Lippi as a draughtsman,
see Shoemaker 1975.

LITERATURE Pouncey 1964, p.286,
pl.34;New York 1997b, p.220 cat.57

311

FILIPPINO LIPPI
Study for a standing saint
On white laid writing paper, no WM;
pen and brown iron-gall ink over grey
chalk, beige wash; 329 × 65 mm; glued
to a backing sheet
SJSM, vol.114, fol.19, drawing 21

St. Bernard stands in a niche holding
a book; above the niche a *moses* in a
roundel holds a book.

When the drawings were lifted, they
were found to be glued to a backing
sheet on three sides and free on the
long central edge, confirming that the
central part of the composition has
been lost. It is close to a drawing of a
standing saint (Uffizi 249E), which
can probably be dated to Lippi's first
Roman studies in 1489. Although less
vigorous, it is also close to Uffizi 1258f,
one of Lippi's last studies before leav-
ing Florence in 1489 (Florence 1955,
cat.18 and 1).

LITERATURE New York 1997b, p.220,
cat.57

312

**ANONYMOUS 16TH-CENTURY
ITALIAN DRAUGHTSMAN**
Ornamental mouldings
On white laid writing paper, no WM;
pen and iron-gall ink over grey chalk,
two beige washes, white lead highlights
that have blackened; 87 × 195 mm;
glued to a backing sheet
SJSM, vol.114, fol.19, drawing 22

The drawing shows two egg-and-dart
mouldings, probably for ovolos, and
two acanthus mouldings for a cyma
reversa or recta.

308

310 312 311

309

313A

GIOVANNI BOLSI

(active in Siena, late 16th century)

AFTER BARTOLOMEO NERONI

SIENA: *Theatre of the Intronati*
Stage set

Inscribed *poesis–miscet vtili/dvlci–poetae*
praesidiv–riccivs se/nen inve–meliora
latent–cfvrojo intronato/thvscor[um]
principi/intronator[vm] hilaritas–comoe-
dia–vitae specvlv[m]–comicor[vm]
favtor–meliora latent–hier. gols/senesis
On white laid writing paper, WM cat.15;
286 × 359 mm; hinged on top of the
dedicatory letter, which is glued to
the folio of the album
The folio has been cut
SJSM, vol.114, fol.20, drawing 23

The proscenium is framed and sup-
ported on square piers with niches
containing a statue of *Augustus* below a
seated allegorical figure of *Poetry* on the
left and a statue of *Scipio Africanus*
below an allegorical figure of *Comedy*

on the right. The piers support an
entablature with consoles and trophies
in the modillions. The cornice breaks
for the central cartouche bearing the
ducal coat of arms and with a gourd,
the emblem of the Accademia degli
Intronati, hanging from it. In the
pedestals on either side are the coat
of arms of the Accademia, and the
motto *Meliora latent*. Two shallow
flights of steps placed against the stage
rise to a view of a wide central street,
which could be an idealised view of
Via del Capitano with Palazzo del
Arcivescovado and the façade of Siena
Cathedral in the background.

The proscenium is recorded until
1647 (Ugurgieri 1649, II, p.358). The
original drawing for the woodcut by
Riccio is in the Victoria and Albert
Museum (inv. no.E.191-1954). The dif-
ferences between the drawing and the
woodcut are probably due to changes
made during the realization of the

work. Bartsch distinguished two states
for the woodcut. The first (Bartsch
vol.48, 1983, p.265, 29–1 (156)),
published by Andreani in 1589 and
dedicated to Scipione Bargagli, the
Accademico degli Intronati, known
as il schietto, bears the names of Bolzio
and Riccio and below it the long dedi-
catory letter of Andreani; the copy in
the British Museum (inv. no.1874-8-8-
209) and the Chinnery copy are exam-
ples of this state. In the second state
the names of Riccio and Bolsio were
omitted and the dedication moved
lower on the folio; a copy in the
Bertarelli Collection, Milan, is an
example of this state. Another example
in the Biblioteca Marucelliana (vol.CII,
no.132) bears the signature of Riccio
and Bolsio but lacks the dedicatory
letter; it could be an edition by Bolsi
before the edition of 1589 (Siena 1980,
cat.92, pp.234–5).

313B

GIOVANNI BOLSI

The dedicatory letter

Inscribed *All'Honorato Sig[no]re Scipion*
Bargagli
Nobile Senete Andrea Andreani
Mantovano Jo mi son fatto certo e credere
che si come la Commedia dell Ortensio
degl' Accademici Intronati e piaciuta e
piace agl intendenti di Poesia: parimenti
debba riuscir caro semprema a chiunque
intende di Prospettiva il Proscenio dove ella
fu mirabilissimam rappresentata al Gran
Duca Cosimo in Sienna. Quando non fu
agevol cosa a discernere qual piu empisse
di maraviglia gli anime degli spettatori, o
quella, o q[ue]sto Il quale drizzato venne
in piede p[er] opera di bartolomeo Neroni
sopranominato il Riccio Sanese Pittore,
Architetore Ecc[ellen]te. Per tanto non ho
potuto dubitare: che donando io
lietam[en]te, come faccio. alla SV. in
q(ue)sto miei nuovi intagli il sudetto
proscenio, ella non sia per molto gradirlo, e
con esso la verace mia affectione verso
q[ue]lla sua propria benigna, et honorevol
qualita d'amare, e carezzare a poter suo
qualunque sorte d'ingegnose, e virtuose
p[er]sone Che nostro s[igno]re Iddio la
prosperi in conformita di simil
digniss[im]o e singulariss[i]mo intendi-
mento che alberga in tutti. Di Siena il di 25
d'Agosto MDLXXXIX
Woodcut; 180 × 321 mm
Cut from the woodcut and hinged to the
folio
SJSM, vol.114, fol.20, drawing 23bis

SJSM, vol.114, fol.21
No drawing, was recorded in 1837

314

AFTER GILLIS VAN VALKENBORCH

(Antwerp, 1570–Frankfurt am Main,
1622)

ROME: *Roman Forum; view*

Initialed DEC? at the bottom-right corner
On white laid writing paper, no WM;
pen and two grey-brown iron-gall inks,
hatching, within a ruled ink border;
192 × 251 mm
SJSM, vol.114, fol.22, drawing 24

A contrived view across the Roman
forum, known in the Renaissance as
the Campo Vaccino (cattle field), is
taken as though the artist is standing at
the end of Via di S. Teodoro. The three
columns of the temple of Castor and
Pollux stand in the middle, with the
temple of Antoninus and Faustina
behind them. To the right are the
church of SS Cosma e Damiano, with
the round structure of the temple of
Romulus in front, and the basilica of
Constantine to the right of the church.

The similarities between this draw-
ing and the views of Rome in the
Kupferstichkabinett in Vienna, which
are considerably smaller, justify the
attribution to after van Valckenborch
(Egger 1931, II, pls 45, 81, 73 and 17). The
vertical hatching to express banks, the
drawing of foliage, figures and animals,
and the pattern of the hatched architec-
tural infill between the major monu-
ments all derive from the drawings in
Vienna, but the quality of the drawing
is inferior to them. The pink wash and
white highlights were added later.

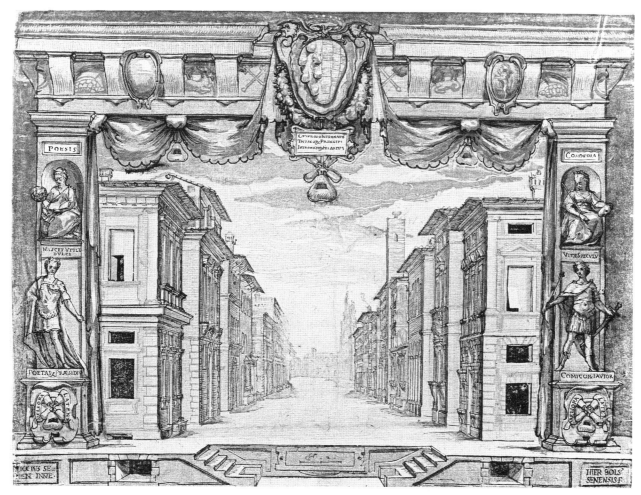

313A

314

315
CIRCLE OF SIR JOHN SOANE
Tomb, sketch of the elevation
On oiled paper, no wm; pen and dark
brown ink, brown, red, green, grey and
black washes; 139 × 215 mm; glued to a
backing sheet
SJSM, vol.114, fol.23, drawing 25

On top of three steps is a sarcophagus
with a recumbent figure lying on a bier
below an altar. Above the altar are four
double-lancet windows with square
panes of glass. The four lancets are
united above by a pointed window with
tracery volutes at the corners. The
drawing, possibly by a child, could date
from the time of Sir John Soane.

316
ANONYMOUS 18TH-CENTURY
ENGLISH? DRAUGHTSMAN,
AFTER MARTEN VAN HEEMSKERCK
(Heemskerck, 1498–Haarlem, 1574)
ROME: *Interior of St Peter's under
construction; copy of a view*
On white laid writing paper, wm cat.28
pen and brown ink over grey chalk, one
brown and two beige washes;
205 × 298 mm; glued to a backing sheet
SJSM, vol.114, fol.24, drawing 26

The view, which is copied from van
Heemskerck's Album II in the
Kupferstichkabinett, Berlin (fol.52r;
Huelsen & Egger 1913–16, pp.32-3,
pl.69), is an important document for
the building history of St Peter's. The
view shows the nave of Constantine's
five-aisled basilica and the crossing of
the new building under construction
c.1510: the paired pilasters, coffered
barrel vaults and diagonal piers, which
were designed by Bramante to support
the massive dome planned by him to
cover the crossing, and his shell niche
at the east end. The three-bay Doric
building in the crossing was built by
Bramante to protect St Peter's tomb
during the rebuilding.

OTHER REPRESENTATIONS Giovanni
Battista Naldiñi, Hamburg, Kunsthalle,
inv. no.21311 (Venice 1994, pp.398 and
666, cat.400)

317
JAN ASSELYN
(Diemen, *c.*1610–Amsterdam, 1652)
ROME: *Arch of Constantine
View*
On white laid writing paper, no wm;
brush and brown, beige and grey
washes over graphite within a ruled ink
border; 382 × 251 mm
SJSM, vol.114, fol.25, drawing 27

The drawing shows a raking view of the
central arch and the left side bays of the
arch of Constantine.
 The drawing style is very close to a
drawing of ruins attributed to Asselyn
in Rome (GNDS, inv. no.F.C.125134;
Rome 1992, cat.52). Another drawing
of the arch of Constantine, showing the
view of the whole taken from the side,
is signed and dated 1650 (Louvre inv.
no.22.420; Steland 1989, cat.134,
fig.175).

318
JAN ASSELYN
(Diemen, *c.*1610 - Amsterdam, 1652)
Unfinished drawing of a landscape
Signed *J[an] Asselyn*
One brown and one beige wash
SJSM, vol.114, fol.25, drawing 27v

A landscape with a ruined aqueduct
crossing a steep ravine with a mill at
the bottom of the cliff.

319
ANONYMOUS 17TH-CENTURY
NORTHERN DRAUGHTSMAN
ROME: *Palatine view*
Inscribed *Jn. Roma. .Palatso Maior* 1624.
A M or *f.*E M (collectors' monograms
not listed in Lugt 1921)
On white laid writing paper, no wm;
pen and brown and yellow-brown
iron-gall ink, grey, brown and beige
washes, within a ruled ink border;
223 × 287 mm
SJSM, vol.114, fol.26, drawing 28

The view shows the overgrown vaults
of the Palatine. The excellent condition
of the folio enables us to appreciate the
variation in colour of the iron-gall inks,
which have faded to give a range of
colours. The drawing is copied from a
well-known drawing by Brill or
Bruegel, which is now lost. The grey
wash may have been added to the
drawing in the 18th century. The right
half of the drawing is almost identical
to a Dutch drawing of *c.*1650 of the
baths of Caracalla (Rome, GNDS, inv.
no.F.C.128557; Rome 1992, cat.143).
 There are many versions of this
drawing, including one by
Bartolomeus Breenbergh of *c.*1630
(Edinburgh, National Gallery of
Scotland, inv. no.D1334) and one by
Stefano della Bella of *c.*1640 (GNDS,
inv. no.F.C.126076; op. cit., cat.31).
The motif is also found in the series of
etchings of Roman ruins by Hieronymus
Cock of 1551 (op. cit., cat.9). The
draughtsman shows his interest in
the architecture by carefully recording
the construction of the arch and the
brickwork.

315

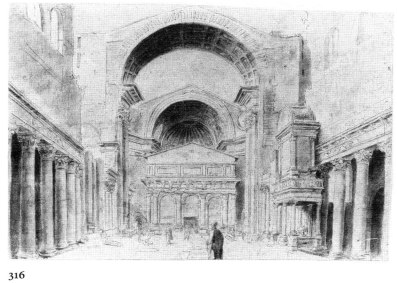

316

317

319

320

ANONYMOUS EARLY 17TH-CENTURY
NETHERLANDISH DRAUGHTSMAN
*Classical landscape, fantasy
composition*
On white laid writing paper, no wm;
pen and light and warm brown iron-
gall inks over graphite, warm brown
and grey-beige wash within a ruled
ink border; 192 × 307 mm; glued on
to a backing sheet
Cut at top left
sjsm, vol.114, fol.27, drawing 29

On the right a rusticated Classical
building with vaulted passages and an
open central space like a theatre sits
on a road above the river bank. In the
river are two rocky islands. On the left
small domestic buildings sit on top of
a cliff and a fountain of water falls into
a cistern-shaped pool below. In the
background a bridge with a central
rotunda leads to a circular temple,
like the temple of Vesta at Tivoli.

Although the inked parts of the
drawing are underdrawn in graphite,
the exposed graphite is used here as
a medium in its own right to render
distance. The drawing may have been
disfigured by the addition of clouds;
there are traces of clouds at top left
where the drawing has been cut and
glued to a backing sheet.

321

HIERONYMUS COCK (?)
(Antwerp, c.1510–Antwerp, 1570)
AFTER THE CIRCLE OF ÐOMENICO
GHIRLANDAIO
ROME: *Colosseum; design for an
engraved view*
On white laid writing paper, no wm;
pen and grey-brown and dark brown
iron-gall ink over incised and grey
chalk underdrawing, diagonal and
cross-hatching, brown wash, within
a ruled ink border; 242 × 342 mm;
glued to a backing sheet
sjsm, vol.114, fol.28, drawing 30

The perspective shows the whole eleva-
tion of the exterior of the Colosseum.
The little beads shown on the left side
of the building in the top storey are the
profiles of the consoles that supported
the poles for the *velarium*. The views
through the arcade provide glimpses
of the arena inside.

The drawing is almost identical,
down to the pin-men, to the view of
the Colosseum in Codex Escurialensis
(fol.41r; Egger 1905–6, p.113), but the
ground behind the building on the
left and on the right has been elimi-
nated in this version. The drawing is
of exceptionally high quality; the fine
lines in the foreground in front of the
Colosseum have the quality of burin

lines, which suggests that the drawing
was made by an engraver in prepara-
tion for a print. Noach tentatively
attributed the drawing to Hieronymous
Cock. From 1550 Cock worked on a
set of Roman views that were copied
from drawings made by other artists,
especially Marten van Heemskerck,
although the view of the forum of Nerva
was also copied from a source close to
Codex Escurialensis which was in Spain
by 1509. The set of views, such as the
etching and engravings of the baths of
Diocletian, were dedicated to Antoine
Perrenot, Bishop of Arras, who was
first minister to Charles v from 1550.
The prints are generally accepted as
both drawn and etched by Cock, but
there is no proof that they were made
from his own drawings. Some of the
captions are misleading, which suggests
that he relied on other draughtsmen
(Riggs 1977, pp.47–8, 256–64, cat.1–25).
The empty foreground is not typical
of him. Drawings attributed to Cock
usually have a much thicker line than
the delicate line on this drawing,
but the dense cross-hatching in
the shadows and the short, parallel,
vertical strokes on the columns are also
found in a suite of etchings after Cock,
the *Operum antiquorum Romanorum* of
1562 (Uffizi, *Stampe*, VIII, nos 12133–53.
Riggs 1977, p.299ff; cat.110 - 30).

322

ANONYMOUS LATE 16TH- OR
EARLY 17TH-CENTURY TUSCAN
DRAUGHTSMAN
Designn for a reliquary tabernacle
On white laid writing paper, no visible
wm; pen and dark brown iron-gall ink,
free-hand sketch; 100 × 37 mm
sjsm, vol.114, fol.29, drawing 31

The domed hexagonal reliquary on a
stand with arched openings on each
side has corner pilasters with console
capitals supporting the frieze and
cornice. Above the cornice reversed
scrolls hold a cartouche. The taberna-
cle is close to designs by artists in
Vasari's circle (see Vasari cat.747).

323

AFTER GIORGIO VASARI (?)
(Bologna, 1557–Rome, 1602)
*Copy of the corner detail of a design
for a coved ceiling*
On white laid writing paper, no visible
wm; pen and grey-brown iron-gall ink,
overdrawn in places in dark brown ink;
79 × 141 mm; glued to a backing sheet
sjsm, vol.114, fol.29, drawing 32

The ceiling is divided into fields by
bands of guilloche decoration. In the
corner two nude male figures sit on the
cornice holding up the Del Monte coat
of arms and a laurel crown; two putti
hover above them holding the papal
tiara above the mounts. On the right
a rectangular niche with a moulded
frame and a broken segmental pedi-
ment bearing the arms contains a
standing figure of St Mark and his lion.

The papal tiara and the Del Monte
arms indicate that the ceiling was a
design for Julius iii. Vasari's office
made designs for him at Villa Giulia,
the Del Monte palace in Campo Marzo,
and for his apartment in the Vatican.

The decorative scheme derives from
Perino del Vaga's friezes with *ignudi*.

The inscription on the verso attri-
buting the drawing to Annibale
Carracci is unlikely to be correct,
although the drawing has features
in common with Agostino Carracci.
Open-palmed hands with widespread,
tapering fingers feature in his figure
drawing. St Mark is very close to a
bald figure on the right of God the
Father in a sheet of studies at Windsor
(Wittkower 1952, cat.133, pl.34);
the Windsor drawing of a panel of
grotesque ornament shows a border
handled in a similar way to this
drawing (op. cit., cat.185, pp.124–5).
The drawing could be a later copy of a
design from Vasari's office, which was
made as an academic exercise; it seems
to record the studio practice of using
wooden mannequins as proportional
models to build a composition.

LITERATURE Nova 1988, fig.132.

324

Inscribed *An:Carratio 1.2.*
sjsm, vol.114, fol.29, drawing 32v

320

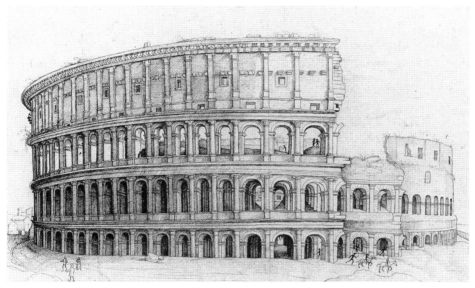

321

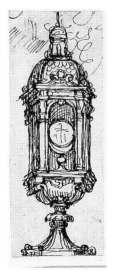

322

323

325

IPPOLITO ANDREASI (?)
(Mantua, 1548–Mantua, 1608)
Copy of a design for a fireplace
On white laid writing paper, no visible
WM; pen and warm brown iron-gall ink
over grey chalk, one pale beige and two
pale brown washes; 196 × 121 mm
Cut around the profile of the drawing
SJSM, vol.114, fol.29, drawing 33

The fireplace has a moulded frame
between fluted pilasters with lion's feet
and scroll volutes with three flutes sup-
porting an architrave of a single fascia,
a frieze with scoop decoration and a
cornice with a cyma recta, a cavetto
with scoops and an ovolo below the
hood. The elegant hood is decorated
with acanthus scrolls enclosing a rec-
tangular framed painting of *Jupiter*
with his eagle hurling a thunderbolt.
The corners of the frame project and
enclose lion's heads. Two vases sit on
top of the cornice on either side of the
central cartouche, which has a plumed
helmet above it.

The fireplace is similar to one in the
Sala delle Aquile in Palazzo del Te,
Mantua (Hartt 1981, fig.187). The
mouldings are much simpler and the
hood framed with acanthus leaf has
strigillated ornament rather than the
representation of Jupiter shown on this
drawing. The iconography of Jupiter,

a Gonzaga theme, especially in the
Sala dei Giganti, would have been
appropriate in the Sala delle Aquile.
The drawing could be a copy of an
original design by Giulio Romano for
the fireplace, which was either not
executed according to the design or
which was modified in the 18th-century
restoration of the palace (for the
restoration, see Forster & Tuttle 1971).

Giulio's original drawings, now lost,
showing the exterior and interior ele-
vations were copied for the Imperial
Antiquarian Jacopo Strada by Ippolito
Andreasi; the copies are now in the
Kunstmuseum, Düsseldorf (Verheyen
1967, pp.62–70). The architectural
drawing is close to these drawings
and the caricatural drawings of the
lions recalls Giulio's work (Hartt 1981,
fig.139). Another drawing by Andreasi,
whose style is characterized as 'wiry
calligraphy with soft use of wash',
can also be compared with this one
(Pouncey & Gere 1983, p.226, cat.367,
pl.335).

Other fireplaces in Palazzo del Te are
recorded in Marten van Heemskerck's
album in Berlin (vol.II, fols 25, 27, 30
and 35; Huelsen & Egger 1913–16, II,
pp.19, 20, 21, 22 and 24).

For Andreasi as a draughtsman,
see Harprath 1984.

326

**ANONYMOUS 16TH-CENTURY
ITALIAN DRAUGHTSMAN**
Copy of a design for a covered vessel
Numbered N.199 in the bottom right
corner
On white laid writing paper, no visible
WM; pen and warm brown iron-gall
ink over grey chalk, one beige and
two brown washes, within a ruled ink
border; 139 × 76 mm
SJSM, vol.114, fol.30, drawing 34

The drawing shows alternative
elevations for a covered vessel. On
the left the profile of the bowl is
plain. On the right the lower half of
the bowl is gadrooned, the middle
is plain and the upper part bears
a concave band of rinceau rolling
from a central grotesque mask.
The concave neck of the vase is fluted
below the rim, and the pointed cover
has gadroon and scoop decoration
below an inverted bell-flower. The
round pedestal is decorated with
bead and fluted mouldings.

The drawing is in the same hand
as drawings 36, 59, 62 and 63 (cat.328,
351, 354 and 355).

327

AFTER POLIDORO DA CARAVAGGIO
(near Bergamo, *c*.1499–Messina, *c*.1543)
Copy of designs for two ewers
Numbered N.195 in ink in the bottom
right corner
On buff coloured paper, no WM; pen
and light brown iron-gall ink, beige
wash within a ruled ink double line
border; 120 × 161 mm
SJSM, vol.114, fol.30, drawing 35

The ewers are seen from below; their
bases are not visible. The ewer on the
left has a spiral-fluted base, a narrow
relief with swans and a broad relief with
a sacrificial scene of figures grouped
around a bull, below a cable astragal,
ribbon decoration and a long plain
neck with a grotesque mask and a shell
spout with a lion's leg-and-foot handle.
The ewer on the right has a narrow
lower bowl with a relief of two figures
meeting and a wider upper bowl with
a relief of several figures running or
dancing; the shoulder is gadrooned
and the handle joins the spout as a
ram's head. A Triton plunges over
the upper bowl on the right.

The drawing is inspired by Polidoro's
project for Palazzo Milesi in Via della
Maschera d'Oro, Rome (Ravelli 1978,

pp.367–9, cat.667; for copies from
Palazzo Milesi, see pp.367ff; for copies
of these ewers, see pp.416–17, cat.809
and pp.435, cat.864–5).

328

**ANONYMOUS 16TH-CENTURY
ITALIAN DRAUGHTSMAN**
*Copy of alternative designs for a
covered vessel*
Numbered N.200 in ink in the bottom
right corner
On white laid writing paper, no visible
WM; pen and warm brown iron-gall
ink, two beige washes, within a ruled
ink double line border; 149 × 83.5 mm
SJSM, vol.114, fol.30, drawing 36

The mouldings are left plain on the left.
On the right the pedestal is decorated
with coin ornament and flutes, and
gadrooned at the top. The bowl is
gadrooned at the bottom and above
it are two tiers of fluted ornament with
a central mask in the upper tier and a
garland hanging from a ribbon. The
cover has a gadrooned ovolo, a leaf-
and-tongue cyma recta, a foliage ovolo
and a baluster handle with leaf-and-
tongue and fluted decoration.

The drawing has been traditionally
attributed to after Giulio Romano, but
it is not especially close to his designs.
It is in the same hand as drawings 34,
59, 62 and 63 (cat.326, 351, 354 and 355).

325

327

326

328

329

JACOB MATHAM

(Haarlem, 1571–Haarlem, 1631)

ROME: S. Agnese fuori le Mura and S. Costanza. Two candelabra and a hanging lamp; preparatory drawing for an engraving

Numbered in ink N.189 in the bottom right corner

On white laid writing paper, no WM; pen and brown iron-gall ink over grey chalk, pale brown and grey-beige washes, within a ruled ink double line border; 182 × 125 mm; glued to a backing sheet

SJSM, vol.114, fol.31, drawing 37

Both marble candelabra are on tripod bases with sphinx feet; they bear reliefs with putto half-figures in rinceaux and ram's heads at each corner in the cornices. The candelabrum on the left has a single bulb-shaped baluster with acanthus-leaf decoration and a gadrooned bowl. It was found at S. Agnese fuori le Mura. The candelabrum on the right, with a tapering waisted baluster with acanthus foliage below a bulb-shaped baluster and a gadrooned upper bowl, was found at S. Costanza; both are now in the Galleria dei Candelabri in the Vatican ([1] inv. no.2482; [2] inv. no.2566; Cain 1985, cat.99, pp.184–5, Taf.38; cat.102, pp.186–7, Taf.37.2). The candelabra were often imitated in the Renaissance (Vatican 1984, pp.97–9).

Fuhring demonstrated convincingly that this drawing and no.39 (cat.331) are the preparatory studies for two plates in a set of rare engravings designed by Iacob Matham for *Antiqua aliquot elegantiae Romana urbis, omnibus artium studiosis utilis*. He suggested that 1616 was the *terminus ante quem* for these engravings because the pose of the two artists shown on the frontispiece is identical to that of the two artists on the frontispiece of Jan Janssonius' *Diagraphia sive ars delineatoria*, which was published in that year.

The candelabra provided the source for reliefs of foliate putti, which were reinvented as ornamental motifs from the late quattrocento; the tripod bases with the ram's heads and sphinx feet were also frequent sources of invention (Northampton 1978, cat.117).

For Matham's career, see Widerkehr 1991–2.

LITERATURE Fuhring 1992, pp.64–6 and 71–2, cat.14.

330

JACOB MATHAM

ROME: S. Agnese and S. Costanza, Candelabra
Copy of a drawing by Goltzius

Numbered NO.190 in the bottom right corner

On white laid writing paper, no WM; red and grey chalk within a ruled ink double line border; 212 × 139 mm; glued to a backing sheet

SJSM, vol.114, fol.31, drawing 38

Peter Fuhring noted that the drawing technique in red and black chalk recalls that of Goltzius, but he observed that since the handling in this drawing is looser, and the outline and definition of the objects are less precise, the drawing could be by a pupil, possibly Matham, who was also his stepson. Two drawings by Goltzius in the Teylers Museum in Haarlem show identical candelabra (Scholten 1904, p.42, cat.32 and 33; Fuhring 1992, pp.63–4, figs 10–11).

LITERATURE Fuhring 1992, p.65, fig.15.

331

JACOB MATHAM

Candelabra and a font; preparatory design for an engraving

Numbered N.207 in ink in the bottom right corner.

On white laid writing paper, no visible WM; pen and brown iron-gall ink over grey chalk, pale brown and grey-beige washes, within a ruled ink double line border; 180 × 125 mm; glued to a backing sheet

SJSM, vol.114, fol.31, drawing 39

The candelabrum on the left on a tripod base with lion's feet and volute scrolls has a gadrooned; bulb-shaped baluster decorated with acanthus leaf below a vase with a gadrooned bowl and two plain reversed cavetti. The bracket above the baluster, decorated with acanthus leaf, suggests that the design could also be used for bedposts; the bracket would hold the curtain pole. The candlestick on the right on a gadrooned tripod base with acanthus leaves at the corners above lion's feet has a spiral-fluted twisted column with an acanthus capital below a vase. Candle wax runs down the candle on the candelabrum. A bracket on the right decorated with acanthus leaves suggests that the design had a dual purpose, as a candlestick and a bedpost. The font in the centre, on a square base with lion's feet on a socle, has a tapering, fluted central column with a ring below the shallow gadrooned circular bowl.

The candelabrum with the twisted column is copied by van Heemskerck in the Berlin album (vol.II, fol.31r; Huelsen & Egger 1913–16, II, p.22, pl.37) on the same folio as a setting for a fur piece in the shape of a marten-head, usually attributed to Giulio Romano, which suggests that the drawing is copied from an original by him. Drawings of Giulio's furniture, ornamental tableware and jewellery circulated after his death in drawn copies for use as models from the Strada workshop, which was based in Prague (Fucikowá 1982). Bukovinská, Fuciková & Konecny 1984).

Peter Fuhring (1992, pp.59–60) suggested that the engravings were probably the first prints made after such drawings; the only other prints of the 1630's after similar designs by Giulio are by Hendrik van der Borcht or his son Hendrik II, from original drawings in Lord Arundel's collection. The set of engravings by Matham contains antiquities and many 16th-century designs, including designs by Giulio Romano for works in metal and precious stones that were not published in the 16th century.

ENGRAVED Amsterdam, Rijksmuseum, Library inv. no.1886:1448 under Matham Iac., fol.13 reversed.

LITERATURE Fuhring 1992, pp.64ff. and p.71, cat.13.

332

ANONYMOUS LATE 15TH-CENTURY NORTH ITALIAN DRAUGHTSMAN
Pilaster design

No WM; pen and brown iron-gall ink, diagonal hatching, one brown and two beige washes, pricked for transfer; 276 × 42 mm

SJSM, vol.114, fol.32, drawing 40

The design rises out of a cluster of acanthus leaves below a palmette enclosed in a lozenge formed by scrolls clasping central superimposed vases. Rinceaux roll symmetrically out of the vases and support cranes standing on either side. Near the top of the pilaster a crane spreads its wings and the design is closed by a shell surmounted by a palmette.

The pilaster strip is constructed on a central axis as in the quattrocento types designed by Ghirlandaio and Pinturicchio. The design of the ornament is similar to the pilaster strips in the engraving of the *Corselet Bearers* by the Premier engraver from Mantegna's *Triumphs of Caesar*; in both the rinceaux spring from an acanthus plant at the bottom, and from vases on the central stem, but there are no birds on them (Bartsch 1803-21, XIII, 236.14). The engraved pilasters probably represent Mantegna's project for the installation of the canvases in their first setting (London 1992, cat.120, pp.381–2). The design for a pilaster with cranes in the Master of the Mantegna Sketchbook is close to this one (Berlin, Kunstbibliothek, fol.57r; Leoncini 1993, p.117, p.194). An Antique example of a pilaster with rinceaux springing in elaborate scrolls from an acanthus plant survives in the garden of the Palazzo de Conservatori, Rome, of unknown provenance (inv. no.48; Stuart Jones 1926, pp.239–40, pl.93).

329

330

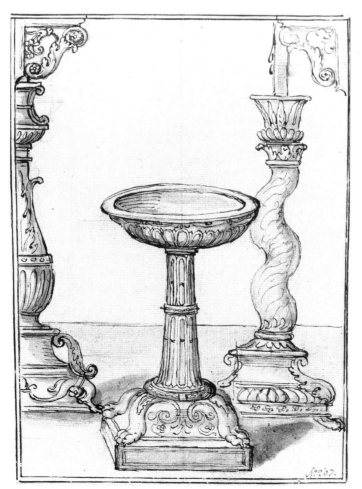

331

332

333

GIOVANNI BATTISTA MONTANO
(Milan, 1534–Rome, 1621)
*Designs for columns or bedposts
with vases*
On four narrow strips of white laid
writing paper, each strip joined below
the vases and inlaid into a folio, no WM;
pen and warm brown iron-gall ink over
grey chalk, brown and beige washes,
within a ruled ink border on the
mount; [1] 262 × 33 mm; [2]
261 × 48 mm; [3] 255 × 34 mm; [4]
252 × 30 mm; mount 312 × 241 mm
SJSM, vol.114, fol.33, drawing 41

The drawings were probably made
as office records of designs. They all
have rings of lily leaves at the bases
of the shafts.
[1] The shaft is decorated with foliage
scrolls with putti climbing up them.
The Ionic capital has a tall frieze and
an eagle with outspread wings standing
in front of it. The vase on top of the
column has a plain bowl, scroll handles
and brackets below the rim, as on a
vase found at SS Apostoli, Rome.
[2] Nymphs stand on the lily leaves at
the base of the shaft, which is decorated
with foliage lozenges enclosing acan-
thus shoots and putti. The Ionic capital
has a mask between the volutes. The
vase has a plain lower bowl and a wide
rim decorated with drapery swags

hanging from inverted volutes.
[3] The shaft is decorated with foliage
lozenges enclosing putti. The Ionic
capital has an eagle with open wings
between the volutes. The vase has scroll
handles and a putto standing between
the volutes in high relief.
[4] The lower third of the shaft has
spiral flutes below a ring of standing
nymphs surmounted by three rings
of lily leaves; the top of the column is
fluted, and it has a Doric capital. The
vase has two seated putto half-figures
on the lower bowl.

334

GIOVANNI BATTISTA MONTANO
Alternative designs for bedposts
On white laid writing paper, WM cat.49;
pen and warm brown iron-gall ink over
grey chalk, pale brown wash;
234 × 264 mm
SJSM, vol.114, fol.34, drawing 42

All of the posts have plain pedestals
with bases; to the right of each column
is the frame for the webbing that
supported the mattress. All of the
columns have a ring of full or
simplified acanthus above the bases.
[1] The column is divided into four
fields in which spiral flutes alternate
with foliage scrolls. The frame support-
ing the canopy is sketched above the
Composite capital, as well as the putto
finial.
[2] The shaft is divided into three by
a wide band of foliage ornament; the
lower shaft is fluted, the upper shaft
spiral-fluted. Putto masks and bell-
flowers separate the fields. The support
for the canopy is shown above the
Composite capital and marked A.
A vase is sketched as the finial.
[3] The lower shaft is spiral-fluted
below a band of foliage and a ring
of standing nymphs, with a ring of
rosettes below the fluted upper shaft.
The Composite capital has an eagle

between the volutes.
[4] The lower shaft is decorated
with foliage rising in spirals with putti
climbing up them. A ring with drapery
swags separates it from the fluted
upper shaft. A curtain post above the
Composite capital has a standing putto
as a finial.
[5] The lower shaft, decorated with
oak-leaf scales, is separated by a band
from the upper twisted shaft with vines
climbing up it. The Composite capital
has a putto standing in the centre below
the post, with a putto finial, which
supports a curtain rail with rings.
[6] The twisted shaft has climbing
vines and a Composite capital with
a standing putto; an eagle with out-
stretched wings is shown as the finial.

The eagles in [3] and [6] probably
refer to the Borghese arms.

Bedposts of this kind were turned
on a lathe using templates. Besson
illustrates a lathe with a template in his
Theatrum instrumentorum (Lyon, 1582).
Charles Plumier shows a machine for
turning columns in *L'Art de tourner en
perfection* (Lyon, 1701; book VIII, cap.II,
pp.157–8, pl.45; he shows how to make
fluted columns in cap.III, pp.159–64,
pl.48, and twisted columns in cap.IV,
pp.165–6, pl.82; for the history of turn-
ing, see Connors 1990).

335

GIOVANNI BATTISTA MONTANO
*Record drawings of designs for
ornamental vases*
On white laid paper, no WM; pen and
warm brown iron-gall ink over grey
chalk, two pale brown washes;
240 × 124 mm; glued to a backing sheet
Cut diagonally at the corners
SJSM, vol.114, fol.35, drawing 43

The five vases to be used in decorative
wood-carving, possibly as finials, are
decorated with winged putti, foliage,
grotesque masks, putto half-figures
and volutes. The handles on the covers
are formed from acanthus leaves or
standing putti. A Borghese eagle sits
on the cover of the first vase.

336

BATTISTA FRANCO (?)
(Venice?, 1510–Venice, 1561)
Design for a candelabrum
On white laid writing paper, WM cat.;
pen and iron-gall ink, hatched, beige
wash; 192 × 184 mm
Cut around the profile of the drawing
SJSM, vol.114, fol.35, drawing 44

The candelabrum, which is incom-
plete, is drawn in bird's-eye perspec-
tive. The hexagonal base has scrolled
strapwork legs with female half-figures
and lion's feet, and lion's masks alter-
nating with satyr masks above garlands
of flowers and fruit. The baluster of the
candelabrum, with two tiers of acan-
thus leaves, rises from a gadrooned
base above the heads of the half-figures
on the strapwork scrolls.
 The manipulated viewpoint enables
all aspects of the design to be seen. The
facial types and hatching reveal the
influence of Giulio Romano. The rapid
rhythm of the drawing and the render-
ing of the breasts are similar to Battista

Franco's *Lamentation over the Dead
Christ* (Uffizi 15143F); the face of the
Virgin and the drawing of the angel's
hair are also close to the Chinnery
drawing. A folio with studies for orna-
mental designs with prows of ships,
Uffizi 17870, formerly attributed to
Perino del Vaga but given by John Gere
(in a note on the mount) to Battista
Franco, has very similar masks and
recumbent female half-figures below
scroll volutes as decorative motifs for a
candelabrum similar to the one on this
folio. A design for metalwork in the
Royal Library, Windsor, attributed
to Battista Franco, is in the same hand
(inv. no.10888; Blunt 1971, p.85, cat.181).
The drawing of the guilloche ornament,
the claylike locks of hair, facial types
and grotesque masks are all very close
to this drawing.
 The drawing is interesting because
Vasari relates that when Battista
Franco went to Urbino in 1545 he
designed objects in maiolica, produced
at Castel Durante, for display on

credenza (Vasari 1967, VI, p.425; for
Franco's drawing for maiolica, see
Lessman 1976).
 The condition of the drawing is very
similar to Chinnery, fol.51, drawing 70
(cat.364).

333

334

335

336

337–339

**ANONYMOUS ITALIAN
DRAUGHTSMAN OF *c*.1560,
AFTER FRANCESCO SALVIATI**
Three designs for knives

337
On white laid writing paper, no WM;
pen and brown iron-gall ink, warm
brown and beige washes; 211 × 28 mm
Cut along the profile of the drawing
SJSM, vol.114, fol.36, drawing 45

The handle is decorated with a recessed
panel containing flowers and ribbons
and a monkey mask with a gadrooned
skull.

338
On white laid writing paper, no WM;
pen and brown iron-gall ink, grey-
brown and beige washes; 275 × 30 mm
SJSM 114, fol.36, drawing 46

The handle is in the form of a grotesque
satyr with a lion's mask, whose tongue
stretches over his chest.

339
On white laid writing paper, no WM;
pen and brown iron-gall ink, brown
and beige washes; 232 × 28 mm
SJSM, vol.114, fol.36, drawing 47

The blade curving to a point indicates
that the knife is for carving (Bailey
1927, pp.2–3). The handle is decorated
with a recessed panel outlined with
beading containing a grotesque mask
and drapery and a lion's-head scroll
with acanthus ornament. The handles
could be made from gold, silver, ivory
or wood (Hayward 1954, p.164; London
1979, p.2).

Designs for silverware of this kind are
traditionally attributed to Francesco
Salviati: an engraving by Cherubino
Alberti from a design by Salviati for
much more elaborately decorated
knives, probably used in ceremonies, is
the source of the attribution (New
York 1997a, pp.91–3, cat.20).
Decorative motifs such as the hair
flowing and dissolving into gadroon
ornament that twists and turns into
volutes and beading are found in a
drawing in the Horne Museum in
Florence (inv. no.5895), while the
mask-head with the tongue lolling on
to beaded strapwork is present in a
drawing in the Musée des Beaux-Arts,
Budapest (inv. no.2025); both are
attributed to Salviati. The way in which
the foliage meets the bead moulding
and the rinceaux drawn with thin lines

in Uffizi 1627E, also attributed to
Salviati, are particularly close to the
blade of drawing 45 (cat.337; Florence
1986b, II, p.673). However, many of the
decorative devices, the long-tongued
animals and ribbons twisted through
foliage are also present in Perino del
Vaga's design for a salt cellar in
Windsor Castle (inv. no.10747;
Popham & Wilde 1949, p.343, cat.983).
 For the development of the use of
dining utensils, see New York 1997a,
pp.66–7.

340

PAULUS VAN VIANEN
(Utrecht, *c*.1570–Prague, 1613)
Design for a vase
Inscribed *Omnia dat.*
Numbered N.215 in ink in the bottom
right corner
On white laid writing paper, no WM;
pen and two brown iron-gall inks
over grey chalk, diagonal hatching,
coloured with grey and red chalk
within a ruled ink double line border;
328 × 284 mm; glued to a backing sheet
SJSM, vol.114, fol.37, drawing 48

The vase stands on a circular base with
putto masks and an acanthus-leaf
cyma recta. The bowl has a large oval
panel for a relief of the *Judgement of
Paris*. The scotia at the top of the vase
is fluted and the rim is decorated with
acanthus flowers. The cover bears
acanthus flower-and-leaf ornament
and the handle is in the form of a vase
with a finial on top. A nude male figure
reclining on the left handle looks
towards a draped female figure lying
on the handle on the right.
 Peter Fuhring recognized the hand
of Paulus van Vianen, the most suc-
cessful member of a Dutch family of
gold- and silversmiths. He was
employed in Munich at the courts of
Willem V and Maximilian I of Bavaria
before working for Emperor Rudolf II
in Prague. Only four other designs for
silverware by him are known, while
many of his drawings for landscapes
have survived. He is recorded as a
painter but no pictures by him have
been traced. He repeated the subject
of the *Judgement of Paris* several times.

341

AFTER POLIDORO DA CARAVAGGIO
(Caravaggio, near Bergamo,
c.1499–Messina, *c*.1543)
ROME: *Palazzo Milesi, Via della
Maschera d'Oro; copy of a fresco
with trophies on the façade*
On buff-coloured laid writing paper,
WM cat.16; pen and brown iron-gall
ink, brown and grey-beige washes
within traces of a ruled ink border;
189 × 258 mm
SJSM, vol.114, fol.38, drawing 49

The drawing, one of many records of
the famous painted façade of Palazzo
Milesi, shows two shields and a helmet
painted over the fifth window on the
extreme right of the façade on the
second floor. Maccari's etching of
the façade is published by Ravelli
(1978, pp.367 and 369, cat.667).
Chinnery fols 35 and 69v (cat.327, 363)
also record vases painted on the façade.
 For copies of this drawing, see
Ravelli 1978, pp.444 and 448–9,
cat.908–9.

342

PETER FLÖTNER
(Thurgau, 1486/95–Nürnberg, 1546)
*Studies for a design of a table
fountain*
On white laid writing paper, WM cat.11;
pen and two grey-brown iron-gall inks,
parallel hatching, traces of red chalk
within a ruled ink border;
314 × 208 mm; glued to a backing sheet
SJSM, vol.114, fol.39, drawing 50

The fountain stands on a domed
dodecagonal base. The central column
is in the shape of a baluster with acan-
thus leaves and a central ring and scales,
below a round bowl surmounted by a
shallow dish. Two putti blowing jets
of liquid stand in the dish on either side
of a pomegranate baluster supporting
a shell tazza with a standing male nude
holding a jet for water or wine. Five
alternative designs for the ring con-
necting the two fields of foliage orna-
ment on the baluster are shown, as well
as a detail of an elongated acanthus leaf
on the right of the folio.
 Whitfield reproduced drawings by
Dürer in the Ashmolean Museum,
Oxford, and in the British Museum that
are close to this drawing. He suggested
that Dürer could have made designs for
execution by Hans Frey. Frey made
hollow figures for use in portable table
fountains and he also used air to raise
water, probably inspired by Vitruvius'
description of a device for raising water
by air invented by Ctesibius (book X,
cap.XII; Whitfield 1938, p.31). Three
surviving drawings by Frey for table
fountains at Erlangen are much sim-
pler than Dürer's fountain designs and

this one, although drawings on fols 146
and 147 have domed bases as reserves
for liquid, small figures standing on top
and jets that curve inwards in the wist-
ful manner of this drawing (Bock 1929,
cat.145–7).
 The drawing was attributed by
Popham to Dürer. The motif of the
plaited branches in the baluster of the
Soane drawing is found in the table
fountain by Dürer in the Ashmolean
Museum and in a slightly different
form in the British Museum drawing;
the bird's-eye perspective of the base
is also similar to the Chinnery drawing,
but the draughtsmanship of the
Chinnery drawing is much drier than
the British Museum drawing (London
1971, p.13, cat.69).
 A small album in Erlangen attrib-
uted to Peter Flötner and illustrating
the the five books of Moses has small
figures and a style of ornament that are
close to this drawing. The drawing of a
thin leaf and the handle of a vase in a
design from the same collection recalls
the rendering of the acanthus leaf in
this drawing (Stuttgart 1979, pp.20–21,
cat.A.20).

LITERATURE Popham 1950, p.338, fig.1.

337-339

342

340

341

343

JACOPO COPPI DEL MIGLIO (?)
(Florence, 1523–Florence, 1591)
A faun
On white laid writing paper, no WM;
pen and brown iron-gall ink, diagonal
hatching, shaded with grey chalk;
224 × 70 mm
Cut around the drawing
SJSM, vol.114, fol.40, drawing 51

The faun holds a bird and stands in
contrapposto, his legs and belly
turning towards the right, his shoulders
facing forwards and his head turned
to the left.

Drawing 55 (cat.347) is by the same
artist, who also seems to have drawn
Uffizi 15556F (Gernsheim photo 10673).
The rendering of the hair, short diago-
nal hatching and the short tapering

fingers are the same in all three draw-
ings. Uffizi 15556F was attributed by
Ferri to Salviati and then reattributed
to Stradanus. On the mount Philip
Pouncey questioned the attribution
to Stradanus, and Alessandro Cecchi
in 1984 rejected the attributions to
both Stradanus and Salviati. He noted
the old manuscript attribution on the
verso to Jacopo Coppi and suggested
Coppi as the possible author of the
drawing. *Hercules Killing the Many-
Headed Hydra* (Uffizi inv. no.880F;
Baldini 1950, cat.117) attributed to
Coppi tends to confirm Cecchi's
identification. The sensual faces, which
are close to those of Rosso and Salviati,
are also found in a *Pietà* attributed to
Coppi (Pace 1973, pp.69–70, tav.28).

344

**ANONYMOUS 16TH-CENTURY
ITALIAN DRAUGHTSMAN**
*Design for a border with grotesque
ornament*
On white laid writing paper, no visible
WM; pen and pale brown iron-gall ink;
33 × 134 mm
SJSM, vol.114, fol.40, drawing 52

The border shows rinceaux and a
putto bearing a scroll on his back
while another turns away.

Drawings 52 and 53 (cat.345) are
in a hand close to Giovanni da Udine.
The slender spiral lines of the rinceaux
that break suddenly into foliage are
typical of the decorations in Cardinal
Bibbiena's bathroom and of the bands
of ornament framing the vaults at the
Villa Madama, Rome (Dacos & Furlan

1989, pp.49 and116). A drawing of
grotesques in the Royal Library,
Windsor, attributed to the manner
of Giovanni da Udine (inv. no.10860;
Blunt 1971, pp.87–8, cat.201), is close
to this drawing.

For Giovanni da Udine as a draughts-
man, see Nesselrath 1989a.

345

**ANONYMOUS 16TH-CENTURY
ITALIAN DRAUGHTSMAN**
*Design for a border with grotesque
ornament*
On white laid writing paper, no visible
WM; pen and brown iron-gall ink;
63 × 155.5 mm
SJSM, vol.114, fol.40, drawing 53

The drawing, which is close to
Giovanni da Udine, shows two putto
half-figures in profile and holding
hands, their legs breaking into rinceaux.
The format of the ornamental strip
suggests that the figures frame the
narrow end of a pilaster.

346

GIORGIO VASARI (?)
(Arezzo, 1511–Florence, 1574)
*Studies for a design for a tripod base
with grotesque ornament*
On white laid writing paper, no visible
WM; pen and brown iron-gall ink over
red chalk, diagonal hatching;
139 × 121 mm
SJSM, vol.114, fol.41, drawing 54

A long-necked sphinx leans against a
cartouche with an oval field containing
the image of a seated winged putto.

343 347

344

345

347

JACOPO COPPI DEL MIGLIO (?)
(Florence, 1523–Florence, 1591)
Faun
On white laid writing paper, no visible
WM; pen and iron-gall ink over grey
chalk, diagonal hatching; 223 × 67 mm
Cut along the outline
SJSM, vol.114, fol.41, drawing 55

This is the companion to drawing 51
on fol.40 (cat.343). The faun, holding
a bird, stands in contrapposto, his
legs and belly twisting towards the
right, his shoulders facing forwards
and his head turned to the left. Both
fauns turn in the same direction.

348

CIRCLE OF GIOVANNI DA UDINE
Designs for decorative borders
with grotesque ornament
On white laid writing paper, no visible
WM; pen and grey-brown iron-gall ink,
grey-brown and beige washes;
100 × 188 mm
SJSM, vol.114, fol.41, drawing 56

In the upper register two deer and a
dog run through rinceaux, while in the
centre a hare standing on his hind legs
separates the scrolls. Two acrobatic
putti play in the scrolls below them.

The character of the ornament with
foliage and animals is close to Giovanni
da Udine's style in the Vatican Logge,
and the technique recalls a drawing
by him showing Venus surrounded
by putti in the Schindler Collection,
New York (Dacos & Furlan 1989,
p.247, cat.13).

349

ANONYMOUS 16TH-CENTURY
ITALIAN DRAUGHTSMAN
Copies of three antique vases
Numbered NO.194 in ink in the bottom
right corner
On white laid writing paper, no WM;
pen and pale brown iron-gall ink, over
incised construction lines, within a
ruled ink double line border;
197 × 175 mm
SJSM, vol.114, fol.42, drawing 57

On the left a vase on a circular pedestal
has a shallow gadrooned bowl and a
neck with a double scotia and double
astragals between them. Alternative
handles are shown: on the left the han-
dle joins the bowl with a mask, on the
right the handle has two knots. A vase
in the form of a jar stands in the centre
of the sheet. On the right a vase with
a large hemispherical body stands on
a small round base; the handle coils
upwards and rests on the flat top of
the body, and the bowl has a small
plain cover with a handle.

OTHER REPRESENTATIONS [1] Cosimo
Bartoli, Florence, BNCF, Codex Pal.1417,
fol.130r; anonymous draughtsman
*c.*1600, Windsor, RL, inv. no.10297r.

350

ROSSO FIORENTINO (?)
(Florence, 1494–Paris, 1540)
Design for two glassware ewers
On white laid writing paper, no WM;
red chalk over scored underdrawing,
diagonal and cross-hatching, within
traces of a ruled ink border;
158 × 195 mm
SJSM, vol.114, fol.42, drawing 58

The ewers, on tiny feet, have long oval
bodies with tall necks and scrolled
spouts. The handle of the ewer on the
left is joined at the spout with a satyr
mask. The handle of the ewer on the
right takes the form of two snakes, their
tails coiled together on the body of the
ewer; they bite the rim at the spout. The
suggestion of the transparency of the
material, the vibrancy of the drawing of
the mask and the relish with which the
snakes bite into the rim are particularly
marked in this drawing. The amusing
contrast between the tiny stand and the
large bowl is a hallmark of Mannerist
designs for glassware.

The continuous, thin elegant line,
the scintillating line in the handle of the
left ewer – so expressive of the shimmer
and fragility of glass – the enmeshed
cross-hatch that opens here to express

transparency and the profile with the
pointed nose and open mouth all recall
the draughtsmanship of Rosso. Uffizi
6492F, showing a draped female saint,
associated by Carroll (1976, pp.224–9,
D.13, fig.31) with the *Dei* altarpiece of
1522 in the Palazzo Pitti, Florence, and
dated soon after Rosso's arrival in
Rome in 1524, has a similar clear slen-
der outline and cross-hatch. The
design of the glassware may suggest a
slightly later date. The curling serpent's
tails and snake's heads biting into the
rim of the ewer are evocative of designs
for tableware produced at Fontainbleau.
The double snake handles on the ewer
probably derive from Polidoro's vase
on the façade of Palazzo Milesi (illus-
trated in Ravelli 1978, pp.367 and 369,
cat.667).

There is a pentimento on the lip of
the ewer on the left. The designs were
copied very exactly in ink by an anony-
mous 16th-century draughtsman.

OTHER REPRESENTATIONS London,
private collection.
LITERATURE London 1995, cat.3.

346

349

348

350

351

AFTER GIULIO ROMANO

(Rome, c.1499–Mantua, 1546)

Copy of a design for a ewer

Numbered N.214 in ink in the bottom
right corner

On white laid writing paper, WM cat.8;
pen and grey-brown iron-gall ink
over grey chalk, pale brown and beige
washes within a ruled ink double line
border; 300 × 234 mm

SJSM, vol.114, fol.43, drawing 59

The ewer stands on a gadrooned
circular base. The bottom of the bowl
is also gadrooned, and the upper part
is decorated with ram's-head masks
and drapery swags below scoop decor-
ation and a tall neck with ribbons and
garlands. The handle rises from a foli-
ate grotesque lion's mask at the rim; as
it bends downwards the acanthus orna-
ment changes into a lion's leg clawing
a snake, which twists upwards to bite it.

The drawing is in the same hand as
drawings 34, 36, 62 and 63 (cat.326, 328,
354 and 355). An identical ewer was
drawn by a different artist in the
Liechtenstein Codex, which is now
dismembered; it is in the same hand
as the Victoria and Albert Museum
Codex no.5342, published by Hayward
(1972, pp.378–86, fig.32).

352

M. MOSYN (?)

(b. Amsterdam, c.1630)

Design for a glass-holder

On white laid writing paper dyed
yellow, no visible WM; charcoal;
195 × 124 mm

SJSM, vol.114, fol.44, drawing 60

A naked putto holding a bunch of
grapes and a billowing stole sits on
a stand made from four grotesque
masks; his right arm is raised to
support a shell with grotesque
ornament and three dragons, which
clasp the ring to hold the glass.

A design for a ewer, signed M.
Mosyn of Amsterdam and published
by Guilmard (1880–81, I, p.509, no.33;
II, pl.176) has very similar grotesques
to the glass-holder. Guilmard (1968,
p.509, cat.32) listed four designs by
this master and noted that a series with
putti was engraved by M. Mosyn and
published by G. Eeckhoud, who was
active in Amsterdam in the mid-17th
century.

353

**ANONYMOUS EARLY
16TH-CENTURY GERMAN
DRAUGHTSMAN**

*Border design with grotesque
decoration*

On white laid writing paper, no visible
WM; pen and grey-brown iron-gall ink,
parallel hatching, within traces of a
ruled ink border; 56 × 135 mm; glued
to a backing sheet

SJSM, vol.114, fol.44, drawing 61

Foliage scrolls on either side of a
central vase enclose a putto blowing
a horn on the left and a putto holding
the scroll on the right.

The type of putti and the scrolls
alternating with vases recall the scroll
ornament in the *Hypnerotomachia
Polifili*. The putti have the same facial
types and unconvincing connection
of arms to body as those on the engrav-
ing of *A Genius Riding a Sea Monster*
designed by Jacob Bink (Cologne,
c.1500–Königsberg, now Kaliningrad,
c.1569; Bartsch vol.16, 1980, p.46,
no.47 (275)). The drawing could be
by him or copied from him.

354

AFTER GIULIO ROMANO

*Copy of alternative designs for
a wine cooler*

Numbered N.213 in ink in the bottom
right corner

On white laid writing paper, WM cat.9;
pen and dark brown iron-gall ink over
grey chalk, brown and beige washes,
within a ruled ink double line border;
200 × 278 mm

SJSM, vol.114, fol.45, drawing 62

The wine cooler sits on a circular
base. The lower part of the bowl is
gadrooned below a relief with ducks
on a river and two swans fighting.
Two alternative designs are given for
the upper part of the bowl: on the right,
a band of scoop decoration, a beaded
fillet and a plain rim; on the left, a
band of trophies, leaf-and-tongue,
bead and shell mouldings and a rim
with scoop decoration.

The drawing is by the same hand as
drawings 34, 36, 59 and 63 (cat.326, 328,
351 and 355). A drawing attributed to
Giulio Romano in the Royal Library,
Windsor, shows a large bowl with swan

decoration from the same service
(inv. no.5453; Popham & Wilde 1949,
cat.356, p.236). The attribution to
Giulio was not accepted by Hartt.
Swans were a device of Cardinal Ercole
Gonzaga and the design is probably
copied from an original design by
Giulio for him. In a letter to his brother
Ferrante informing him of Giulio's
death in 1546, the Cardinal recalled
the designs for precious objects that
Giulio had made for him, and related
how the artist's death has robbed
him of the appetite for such works
(D'Arco 1838–42, appendix II, doc.42,
pp.LII-LIII; Hartt 1981, p.255).

351

352

353

354

355

AFTER FRANCESCO SALVIATI
(Florence, 1510–Rome, 1563)
Copy of alternative designs for a
tripod base of a candelabrum,
Numbered N.212 in ink in the bottom
right corner
On white laid writing paper, no WM;
pen and dark brown iron-gall ink over
grey chalk, grey-brown and beige
washes, within a ruled ink border;
288 × 213 mm
SJSM, vol.114, fol.46, drawing 63

On the left the tripod on lion's feet
bears a winged female half-figure
leaning against a volute that encloses
a circular panel framed with guilloche
ornament. Garlands fall from the horns

of ram's heads at the top of the tripod.
The base of the candelabrum has scoop
and leaf-and-tongue ornament. On
the right the tripod on lion's feet has a
simplified acanthus enclosing a full
acanthus leaf and an oval cartouche
framed below by a garland with a satyr
mask and above by ram's heads with
a garland hanging from the horns,
which frames the central winged
putto head above. The base of the
candelabrum has rope, ribbon and
gadrooned ornament.

The drawing is in the same hand as
drawings 34, 36, 59 and 62 (cat.326, 328,
351, 354). The ornamental language is
typical of Francesco Salviati.

356

BATTISTA FRANCO (?)
(Venice?, 1510–Venice, 1561)
Design for an egg dish
Numbered N.192 in ink in the bottom
right corner
On white laid writing paper, no WM;
pen and two pale brown iron-gall inks
over traces of grey chalk, parallel
hatching, grey-brown and pale beige
washes, within a ruled ink double line
border; 98 × 116 mm
SJSM, vol.114, fol.47, drawing 64

The egg dish is supported on a stand
with two grotesque satyr-masks linked
by strapwork scrolls that are joined by
a ring at the front. The gadrooned tri-
angular bowl has winged female half-

figures with long necks supporting the
rim. The bird's-eye perspective shows
four holes for eggs.

The ornamental taste and the long-
necked winged sphinxes recall Perino
and Salviati, but the uncertain design,
especially the way in which the corner
sphinxes dissolve into the bowl, sug-
gests that the drawing may be an exer-
cise in their style. The hand and the
design are very close to a drawing for a
fountain attributed to Battista Franco?
in the British Museum (inv. no.1874-8-
8-19; Pouncey & Gere 1983, p.93,
cat.148, pl.139; for egg dishes, see New
York 1997a, pp.78–84, cat.17).

357

ANONYMOUS 16TH-CENTURY
ITALIAN DRAUGHTSMAN
Alternative designs for
a dish and cover
Numbered N.210 in ink in the bottom
right corner
On white laid writing paper, no visible
WM; pen and dark brown iron-gall ink
over grey chalk, grey-beige and beige
washes, within a ruled ink double line
border; 204 × 168 mm
SJSM, vol.114, fol.47, drawing 65

The dish has two winged female half-
figures on volutes with lion's feet
standing on a circular base and a
grotesque mask in the centre below
the rim. On the left the surface between
the figure and the mask is decorated
with the wing of the half-figure and
a drapery swag; on the right it is left
plain. The cover has a plain cavetto
with strapwork scrolls and a domed
cover decorated with strapwork
scrolls and a winged putto head.

A group of drawings for silverware
in the Uffizi attributed to the school
of Polidoro da Caravaggio are by the

same hand as this drawing (Uffizi
1304S, 1305S and 1306S; Ravelli 1978,
pp.226–7, figs 283–5). The way in which
the profiles break at the bridge of the
nose, the drawing of the breasts and
the handling of the wash are especially
close. Uffizi 574S and 577S, designs for
silverware attributed to Cellino Cellini,
are also probably by the same hand.
The female types, thick lines, broad
highlighted areas and strapwork scrolls
on the cover are similar to this drawing.

358

CIRCLE OF FRANS FLORIS (?)
(Antwerp, 1516/20–Antwerp, 1570)
Design for a ciborium
On white laid writing paper; illegible
WM; pen and yellow-brown iron-gall
ink, pale brown and beige washes,
highlighted with lead white blacken-
ing, within a ruled ink border;
223 × 198 mm
SJSM, vol.114, fol.48, drawing 66

The ciborium has a circular base sup-
ported on three dragons below a Virgin
and Child with the infant St John in
front of the stem supporting the bowl
above. Two standing caryatid figures
of Faith with a chalice and cross and
Hope with a ewer and a bird support
the gadrooned rim of the dish, on
which stand three winged putti with
their hands upraised.

The elongated figures, small heads
with eccentric profiles, the way in
which the wash follows the inked line
of the drapery folds with small touches
to model the torsos and the razor-
sharp drawing of the ornament are all

reminiscent of Frans Floris. The female
figures on the right of the *Beheading of*
St John in the Kupferstichkabinett,
Dresden, and the figures in the Basel
sketchbook by Floris and an anony-
mous artist copying him are particu-
larly close to the figures on the recto
and verso of the Chinnery folio (van
de Velde 1969, p.262, fig.3 and pp.255ff.,
pls 1–15; for Floris and the Basel sketch-
book, see Stuchy 1986, pp.215–20).

A design for a table fountain attrib-
uted to Joris Hoefnagel in the Kunst-
bibliothek, Berlin, has similar thin
metallic strapwork. frenetic putti and
eagles that recall the griffins at the
base of this drawing. (Stuttgart 1979,
pp.92, cat.8).

359

Woman pouring water from a ewer
into a bowl
Pen and pale brown iron-gall ink,
grey-brown and beige washes
SJSM, vol.114, fol.48, drawing 66v

355

357

356

358

360

GIOVANNI BATTISTA MONTANO
(Milan, 1534–Rome, 1621)
Designs for four candelabra
On white laid writing paper, no WM;
pen and pale brown iron-gall ink over
graphite, pale brown wash;
138 × 216 mm
SJSM, vol.114, fol.49, drawing 67

[1] On a tripod base with scrolled feet
with putto heads on either side of a
standing winged putto, the cande-
labrum has three winged putti holding
a double vase on their shoulders
below a bulb-shaped baluster and vase.
[2] On a tripod with winged sphinxes
on lion's feet framing a putto head
below a cartouche, the candelabrum is
composed of a vase, baluster and vase.
[3] On a tripod with reclining putti
holding crosettes that frame a lozenge
with a standing putto, the candelabrum
has a pedestal and vase with putto
heads as strapwork below a putto
supporting the bowl.
[4] On a tripod with scrolled feet sup-
porting a triangular base with crosettes
and reclining putti framing a taberna-
cle with four pediments, the cande-
labrum has a vase with standing putti
and a bulb-shaped baluster with a vase
on top.

361

GIOVANNI BATTISTA MONTANO
(Milan, 1534–Rome, 1621)
Designs for four candelabra
On white laid writing paper, no WM;
pen and pale brown iron-gall ink over
graphite, pale brown wash;
162 × 217 mm
SJSM, vol.114, fol.49, drawing 68

[1] On a tripod on lion's feet and putti
sitting on scrolls framing a standing
putto, the candelabrum has a vase
with relief decoration and seated putti,
below a plain vase and a bulb-shaped
baluster.
[2] On a tripod with putti sitting on
rinceaux, the candelabrum has a
vase with putti standing in front of
the bowl and a bulb-shaped baluster
below the dish.
[3] On a tripod with putto half-figures
terminating in foliage scrolls supporting
the stem, the candelabrum consists of
a vase with a rectangular relief panel
below a pedestal supporting a standing
putto and dish.
[4] On a tripod supported on dragons
and decorated at the upper corners
with putto heads, the candelabrum is
composed of a vase with seated putti,
below a second vase and bulb-shaped
baluster.

362

**AFTER JACQUES ANDROUET DU
CERCEAU**
(Paris, c.1515–Annecy, 1585)
*Copy of an engraving of a design
for a ewer*
On white laid writing paper, no WM;
pen and pale brown iron-gall ink,
yellow-brown wash, within a ruled ink
border; 207 × 131 mm
SJSM, vol.114, fol.50, drawing 69

The ewer stands on a circular base; the
long oval body is gadrooned at the bot-
tom and decorated with acanthus leaves
and a rosette. The central relief panel
has foliage decoration with grotesque
masks and a wave motif above it. The
uppermost panels have rectangular
indentations below a gadrooned shoul-
der. The short spiral-fluted neck has
a seated winged sphinx on top. The
handle is attached to the body with a
grotesque mask; it bends up over the
rim and ends with a predatory eagle's
head, open-beaked over the tiny sphinx.

363

AFTER POLIDORO DA CARAVAGGIO
(Caravaggio, near Bergamo,
c.1499–Messina, c.1543)
*Copy of an engraving of a design
for a ewer*
Pen and pale brown iron-gall ink,
pale brown wash
SJSM, vol.114, fol.50, drawing 69v

The ewer stands on a circular base
with a long stem decorated with acan-
thus leaves. The elongated body is
gadrooned at the base and above it
there is a panel of relief decoration
with figures and a lion's-head mask
below a second relief panel of figures
sacrificing a bull. The shoulder and
neck of the vase are decorated with
acanthus leaves and a grotesque mask
below the spout. The handle has a ser-
pentine shape that breaks into foliage.
 The drawing is similar but not
identical to Chinnery drawing no.35
(cat.327). It is based on the vases
designed by Polidoro da Caravaggio

for the painted façade of Palazzo Milesi
in Rome. The small size of the drawing
suggests that they were copied from
Du Cerceau's set of etchings of 67 small
vases, without title, text, signature,
monogram or date, which are reduced
versions of designs by other artists
such as Enea Vico and Polidoro. Du
Cerceau's images, 100–120 mm high by
50-76 mm wide, are much smaller than
the originals; they can be dated 1535–75
(Byrne 1977, p.147).

ENGRAVED Bartsch, vol.46, I, 1982,
p.106, 49 (64); II, 1985, p.172.

364

MARCO MARCHETTI DA FAENZA
(before 1528–Faenza, 1588)
Design for a vase
On buff laid writing paper, no WM; pen
and pale brown iron-gall ink over grey
chalk, pale brown and beige washes,
within a ruled ink border;
369 × 224 mm
SJSM, vol.114, fol.51, drawing 70

The base of the vase has been cut. Nude
male figures sit on either side of an oval
field framed by flat strapwork with a
bucrane at the bottom and a grotesque
mask at the top, with putti sitting on
the sides of the frame on either side.
The frame contains a scene with a
Silenus or Bacchus. The shoulder of
the vase is decorated with anthemion
and grotesque masks below a bead
moulding and gadrooned rim. Two
winged female half-figures, kneeling
on grotesque masks on the shoulder
of the vase, are joined by an arched
handle to a central grotesque mask.
 The style of the drawing, technique
and physical types are typical of Marco
Marchetti da Faenza. A drawing in the

British Museum, the *Virgin and Child
Adored by Six Franciscan Saints* (inv.
no.1946-7-13-363; Pouncey & Gere
1983, p.124, cat.215, pl.202), compares
well with this drawing – it shows
similar facial types and child's body.
 Two designs now in Christchurch
which are attributed to Marco Marchetti
are of ewers similar to this example
(Byam Shaw 1976, I, cat.885–6).
 Marco Marchetti's skill in designing
grotesques was recorded by Vasari. He
executed much of the decorative work
for Vasari in the Quartiere in Palazzo
Vecchio, Florence (Vasari 1967, VII,
p.300), and he supervised all of the
grotesques in the decoration of the
Logge of Pope Gregory XIII. His draw-
ings for them are copied in the Vasari
album from fol.20 (see SJSM, vol.132,
Vasari album, fol.19, cat.554; his biogra-
phy is given in Baglione 1642, I, pp.22-3).

365

Inscribed on the verso *Dil koot mijn
5 gulden* (This cost me 5 guilders)
SJSM, vol.114, fol.51, drawing 70v

360

361

362

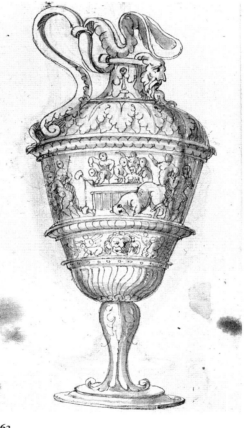

363

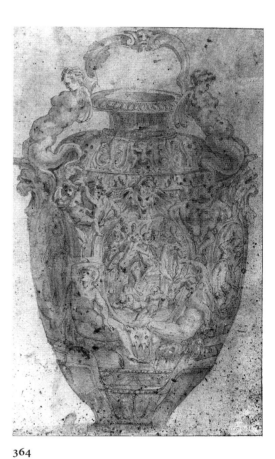

364

366

THREE ANONYMOUS LATE
16TH-CENTURY ITALIAN
DRAUGHTSMEN
Elevation of a tabernacle
Presentation design
On white laid writing paper, WM cat.57;
pen and three brown iron-gall inks,
grey, brown, grey-beige and beige
washes; 773 × 488 mm
SJSM, vol.114, fol.52, drawing 71

The drawing shows a three-bay domed
tabernacle with an octagonal drum
supporting the dome over a square
central bay. Small domes supported
on drums of balusters stand above the
side bays with arched niches.

The architecture was drawn orthog-
onally by the first artist, who drew the
order, profiles and swags between the
orders in pale brown ink; a second
hand added the strapwork in a dark
brown ink; and a third hand added the
figures, in a yellowish, grey-brown ink.

367

VINCENZO SCAMOZZI (?)
(Vicenza, 1568–Venice, 1616)
IN COLLABORATION WITH
ALESSANDRO VITTORIA (?)
(Trent ?, 1525–Venice, 1608)
Project for the elevation of a tomb
Inscribed ANNO SALLVTE
MDLXXXIII–SIBI POSTERIS / ET AMICIS
·F·P· MENSIS APRILLIS / DIE III DE
DOMENICI
On white laid writing paper, WM cat.25;
pen and two brown iron-gall inks over
incised construction lines and
graphite, one pale grey and two beige
washes; 525 × 396 mm
SJSM, vol.114, fol.56, drawing 75

A project for a tomb or for fictive
architecture in the form of a triumphal
arch with vaulted side entrances and
an arched central bay on a basement.
Fluted Corinthian columns support an
entablature that breaks forward above
them. In the attic are figures of *Faith,
Hope, Charity* and *Justice* in front of
pedestals framing reliefs with scenes of
resurrection and the central inscription
with the date.

The arch and the precision of the
draughtsmanship are Palladian, but the
use of perspective is uncharacteristic of
him. The drawing was made by two
artists: the first drew the architecture,
the second the figures in a paler brown
ink with a thicker pen over graphite.
The figure drawing in the statues and
on the reliefs is similar to a drawing
attributed to Alessandro Vittoria
(Uffizi 1904F). The profiles of the archi-
tectural drawing and the capitals are
similar but more precisely drawn than
the same features in a documented
drawing by Vittoria in the Archivio
di Stato in Venice, for the altar of
the Scuola di S. Rocco, which was
published by Timofiewitsch (1968,
pp.342ff., fig.1). The delicate drawing
of the architecture and the use of per-
spective recall a drawing for a fireplace
with caryatids attributed to Battista
Zelloti (Paris 1922, p.5, cat.22, pl.XVI).
Zorzi (1966, pp.84ff.) attributed similar
fireplaces supported by caryatids in the
Villa Caldogno to Lorenzo Rubini, who
collaborated with Vittoria on the exe-
cution of the door with large caryatids
at the entrance to Sansovino's Library
in Venice.

The architectural drawing is close
to Vincenzo Scamozzi, whose draw-
ings, like Palladio's, are also usually
orthogonal. The thin wiry line is typical
of him, and the convention used to
draw the Corinthian capitals is close to
the capitals on his sheet with studies for
the Corinthian order after Palladio's
Quattro libri (RIBA, Palladio, x, fol.11r),
where the plan is also drawn in the
same way. In the 1580s Vittoria's archi-
tectural career was thriving: from 1582
he was collaborating with Scamozzi;
he worked on the monument to *Niccolò
da Ponte* in the Carità, Venice, which
also took the form of a triumphal arch
with the bust of the deceased in the
central arch on the basement (Dal Mas
1989, p.255ff; Breiner 1994, pp.663 and
1022, fig.VI.2), and in 1583 he designed
a tomb for *Matteo Fini* in S. Niccolò,
Treviso, also now demolished (Del
Giovanelli 1858, p.86).

368

ANONYMOUS MID-16TH-CENTURY
FRENCH DRAUGHTSMAN
*Design for an altar for an entry of
Henry II of France*
Scale 224 mm=6 *piedi*, 37 mm=1 *piede*
Inscribed *Magnanimitas–tenperantia–
Iustitia–pax–prudentia divi[n]a/regit
omnes terra– concordia–fortitudo–
Libertas–humillitas–VIRTVS ILLVSTRAT
REGITVR– ER/IC/VS–VIRTVTE LOCVM
REGITVR*
On white laid writing paper, WM cat.3;
pen and grey brown, grey and yellow-
brown iron-gall ink, violet and beige
washes; 519 × 420 mm
The folio is cut above the figures on
the left and right
SJSM, vol.114, fol.54, drawing 73

An altar shaped like a sarcophagus on
three steps has two columns on either
side of it and statues on pedestals
of *Magnanimity, Temperance, Justice*
and *Peace* on the left of a central statue
of *Divine Prudence*, and statues of
Concord, Fortitude, Liberty and *Humility*
descending on the right side. Royal
crowns above the columns suggest
that the design was for a royal entry,
and the inscription ERICVS indicates
that the drawing was probably for one
of the entries made by Henry II during
the first two years of his reign.

After he was crowned in Reims in

1547 Henry toured his states and made
30 triumphal entries. The tour closed
with his solemn entry into Paris through
the Porte S. Denis. The architecture of
the principal entries is documented
with woodcut illustrations and the
arches built for the 1549 entry into Paris
survive in a description published by
Jacques Roffet in that year. The arch
at the entrance of Pont Nôtre Dame
on fol.27 has cartouches with Henry's
arms surmounted by a crown, as in this
drawing, and Catherine de' Medici's
arms topped by a coronet. None of
the woodcuts illustrates altars.

The programme for the entry into
Paris was written by Jean Martin, the
antiquarian who translated Vitruvius,
Alberti and Serlio; from 1548 the com-
missioner for royal buildings was
Philibert de L'Orme; Jean Cousin and
Jean Martin designed the painting and
sculpture. The stands built by Philibert
inside the Abbey of St Denis for the
coronation of Catherine de' Medici
are discussed by Roy (1929, pp.187ff.).

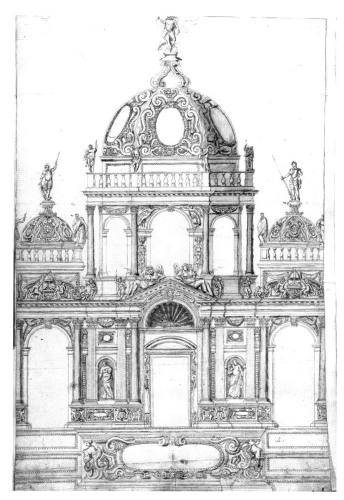

366

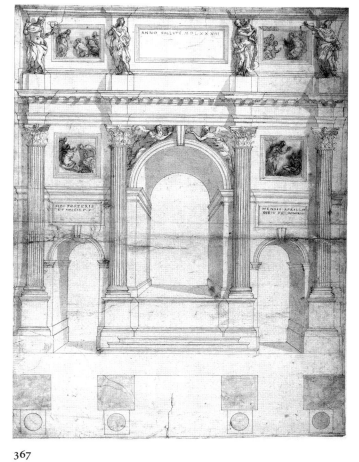

367

368

369

369

**WORKSHOP OF JACQUES
ANDROUET DU CERCEAU**
(Paris?, *c.*1515–Annecy?, 1585)
*Façade of a town house
Copy of a design*
Inscribed FINIS+CORONAT+1534+
On the smooth side of the vellum, pen
and carbon ink, two grey-brown
washes; 920 × 470 mm
SJSM, vol.114, fol.55, drawing 74

The façade of a three-bay town house,
the three storeys articulated by paired
half-columns on pedestals with deco-
rated lower shafts and fluted upper
shafts. The columns frame stone-
mullioned windows and support attics
with reliefs of rinceaux and classical
busts in wreaths.

The drawing is very close to draw-
ings attributed to Du Cerceau by Janet
Bryne (1977, pp.147–61, pls 10–16).
The preparation of the vellum, the
use of wash and the viewpoints are
particularly close to a drawing in the
Victoria and Albert Museum (inv.
no.1542; op. cit., pl.13). The use of

orthogonal drawing combined with
the perspectival drawing of the
windows is also characteristic of him.
Ornamental details – the portraits and
the winged putto heads below them in
the rinceaux and the vases with animal-
head handles at the top of the piers at
the side of the first storey – are close to
the same features in the Victoria and
Albert Museum drawing, and the
brackets framing the windows at the
top of the façade with acanthus leaves
on lion's feet are also found there (op.
cit., fig.17, pls 11 and 13). However the
date on the drawing, 1534, is too early
if the architecture is by du Cerceau.

Almost nothing is known about
the Du Cerceau workshop, which
produced enormous numbers of
drawings. Du Cerceau made three
pattern books for architects. The first,
post 1547, was dedicated to Henry II
and contained plans and façades of
town houses; the second, of 1560–70,
dedicated to Charles IX, dealt with
interiors; and the third, of 1572, con-
cerned country houses. Du Cerceau

wrote a comprehensive record of French
Renaissance architecture, *Les Plus
Excellents Bastiments de France* (1576–9).
The drawing could be a record of a
dated design by another artist.

David Thompson suggested that the
design could be by Jacques Dubroeucq
(Saint Omer or Mons, 1505–Mons,
1584), who was in Rome between 1530
and 1535. Only one drawing by him, a
perspective on vellum, dated 1535, of
the choir screen at St Waudru in Mons
survives, in the Mons State Archives.
Ornament deriving from the Nether-
landish Renaissance, with rinceaux,
wreaths, diamond-panelled pedestals
and the arched decoration between
the pilasters, is common to both
drawings. But the orders and the archi-
tecture are proportioned quite differ-
ently (Hedicke 1904, pl.II, pp.18ff; for
Dubroeucq's life and an example of
his autograph, see Wellen 1962).

370
Numbered no.57
SJSM, vol.114, fol.55, drawing 74 v

371

**ANONYMOUS LATE 16TH-CENTURY
ITALIAN DRAUGHTSMEN**
*Presentation design for the elevation
of an altar with a painting of*
Noli me tangere
On white laid writing paper, no visible
WM; pen and two iron-gall inks, one
beige and two brown washes;
687 × 474 mm
SJSM vol.114, fol.53, drawing 72

The drawing shows a frame with a
paired Corinthian order, the entablature
breaking forward above it, carrying a
triangular pediment with standing
figures and seated prophets on either
side of a Crucifix. There are doors
to sacristies on either side of the altar;
above the door on the left is the mono-
gram of Christ that became the insignia
of the Jesuits and which appears on the
cartouche on the façade of the Gesù
in Rome. The frame contains an altar
with *Noli me tangere*; in the basement

there is a *Nativity* on the left and a *Pietà*
on the right.

The drawing has been executed by
several hands. The architectural eleva-
tion with the profiles of the mouldings
was drawn first; the strapwork and
ornament in the mouldings were added
by a second hand; and the figures were
drawn by a third. The altarpiece is
drawn on a separate sheet of paper in a
fourth hand and glued into the frame.
The tabernacle was also drawn on a
separate sheet and glued to the design.
The setting of the altar has been
modified: folios with drawings of the
doors to the sacristies were glued on
either side of the altar, and the figures
were added on top of the pediment.
The doors cover pre-existing sacristy
doors, which were lower in the original
project; they also had the Jesuit insignia
above them.

The architecture of the altar is close
to Vasari's project for the altar with

the *Last Judgement* for S. Croce in Bosco
Marengo (Monbeig Goguel 1972, p.153,
cat.198). The altarpiece, with tall,
slender and graceful figures in a land-
scape with angels hovering above, is
reminiscent of Alessandro Allori's
compositions; he was also an architect
(for Allori as an architect, see Lecchini
Giovannoni *c.*1991, pp.311–12, figs
441–5). The Jesuit house in Florence,
S. Giovannino, was begun in 1579 by
Bartolomeo Ammannati, who worked
on the church until his death in 1592.
Allori's altarpiece of *Christ and the
Woman from Canaan* (Lecchini
Giovannoni 1991, pp.272–3, cat.133),
in the chapel where Ammannati is
buried, is very similar to the altarpiece
in the drawing.

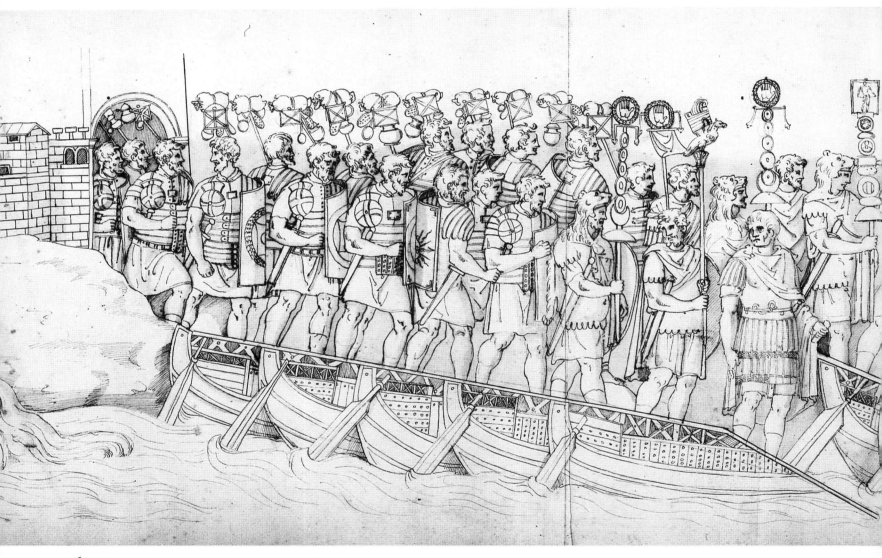

376-377

Trajan's column
A copy of the spiral frieze
*c.*1570

This previously unpublished drawing of the spiral frieze on Trajan's column, dating from the second half of the 16th century, is one of the earliest surviving representations of the relief. The frieze was an important source for the study of Roman ritual, heroic and tragic gesture in Classical art, as well as antiquarian and military details.[1] The engravings published by Lazare de Baif (1536) and Guillaume du Choul (1569), with their images of ancient ships, standards, armour, etc., are examples of the use of scenes from the column for the visual documentation of military history.

The column was erected in Rome in AD 113 to commemorate Trajan's victories over the Dacians. It stood behind the Basilica Ulpia and was flanked by two libraries, one for Latin and one for Greek books. According to tradition, Trajan's ashes were placed in a golden urn in the base. The column, which is 39.8 metres in height, was originally surmounted by a bronze statue of the Emperor, but this was later removed, probably in AD 663 by Constans II, who decimated the bronzes left in Rome after the invasions.[2] The buildings that surrounded the column in Antiquity would have provided many viewing points, so that the relief decoration could be examined from close range.[3] The spiral frieze is more than 200 metres long and depicts events in the Dacian wars of AD 101–2 and AD 105–6. The reliefs were originally coloured, and the soldiers were armed with bronze weapons, which have gradually disappeared.

The ground level was higher during the early Renaissance than it is today, and the tall pedestal was partially buried. The column was then surrounded by a cluster of medieval buildings, and only the lowest reliefs of the spiral could be studied in detail. During the pontificate of Paul III (1534–49) the pedestal was excavated and the invasive later structures were demolished.

The first reference to a drawing deriving from Trajan's column is in Filarete's treatise.[4] The drawing, of a bridge, no longer survives, but Filarete's knowledge of Roman bridges of boats was based on his study of the column. Six anonymous drawings at Chatsworth bearing the date 1467 are the earliest surviving group of drawings. They were probably copied from earlier ones, and are based on reliefs low on the column.

In the *Commentariorum urbanorum* of 1506, Raffaele Maffei relates how Jacopo Ripanda was suspended in a basket from a hoist and lowered around the column storey by storey. Ripanda was the first artist to draw the complete frieze, in a sequence of 55 frames. His drawings, made under such dangerous conditions, must have been redrawn in fair copy, and the set of 55 drawings on vellum known as Codex Ripanda (Rome, Palazzo Venezia, BIASA, MS 254) are probably copied from the fair copies. Giulio Romano, whose deep knowledge of the column is confirmed by his stucco decoration in the Sala degli Stucchi in the Palazzo del Te, Mantua, is thought to be the first artist to record the narrative in a continuous scroll, but none of his original drawings of complete scenes on the frieze survives. Polidoro da Caravaggio, who is credited as the author of the Soane drawing on the spine of the volume, studied the column and based grisaille decorations on the reliefs, but no drawings by him survive.[5] In 1544 Lafreri published a view of the entire column, which serves as the frontispiece to the Soane volume. Artists relied on drawn copies of the reliefs until 1576, when Chacon published his history of the Dacian wars accompanied by a set of engravings by Girolamo Muziano.

Two kinds of drawings survive, in several copies. The first are framed drawings deriving from Ripanda's studies; they are on loose folios bound into volumes. The second are continuous drawings on two or three rolls made by glueing sheets of paper of different widths together. The rolls were probably viewed on a stand with a roller (the rolled drawing in the Louvre of the column of Theodosius in Constantinople still has such a stand).

OTHER REPRESENTATIONS OF THE COMPLETE SPIRAL RELIEF
Anonymous Italian draughtsman, first half of the 16th century:
The Codex Ripanda
ROME: PALAZZO VENEZIA, BIASA, MS 254

The volume, in a modern binding, was first attributed to Jacopo Ripanda by Roberto Paribeni,[6] and dated to the first half of the 16th century. Annotations on the folios, which refer to the state of the monument before Sixtus V (1585–90) reorganized the site, are in the same ink as the drawings. The use of dialect reveals the northern origin of the draughtsman.[7] The scenes bear two numbering systems, an old one of 160 to 1 (fol.1 showing the uppermost relief, fol.160 the lowest relief on the column), and a more recent one in which the first relief from the bottom is fol.5.

The drawings, on vellum folios measuring 280 × 580 mm, are executed in pen and a grey-brown iron-gall ink, with parallel diagonal and cross hatch. A grey-beige wash has been applied very sparingly. Each full opening is enclosed by a frame of a single ink line. The division of the fields is still visible on fol.79 (Soane fol.69, cat.440), where the sheet of vellum is divided vertically by grey chalk lines into four fields, each one 150 mm wide and with a top line and a base line giving a height of 250 mm for the scenes. Two folios are tipped into the volume at the beginning.

On fol.1 there is a plan of the column and stair at the bottom and top, inscribed *Imo schapo dela dite colone tragane–e schale so[n] alumaga/grose o[nce] 10/largeza p[almi] 2 o([ce] i–fenestra–sumo chapo de la colone–finestre-largeza p[almi] 4–Li pecj dela Colona Cioe quelj che vano i[n] to[n]do cho[n]puta[n]do lo quadri che va di sop[ra] sono 21 peci/et sono 7 p[rim]a p[er] pezo pocho piu emeno p[er] modo che de tuta qua[n]tita sene leva p[almi] 4 et [-] p[er] no[n] esser Justa misura et sono aquesta qua[n]tita 144 palmj Tutj jn sieme–1 palmo=222 mm.* Fols 2 and 3 show the elevation of the column, with an inscription on fol.2: *Lo fusto dela colona che/gira i[n]tondo come[n]ca[n]do lo/festone dela basa sono/p[almi] 126 fino soto lovolo.* Fol.4, the elevation of the pedestal with details of the trophies, is inscribed *Questo el posame[n]to de*

1. Brilliant 1963, pp.118ff.
2. Bober & Rubinstein 1986, p.192.
3. Agosti & Farinella 1984, p.390.
4. Filarete 1972, p.369.
5. Agosti & Farinella 1984, pp.413–14.
6. Pasqualitti 1978, pp.161–2.
7. Paribeni 1929.

dita Colona Tragana–Tre sorte sono le spolie quale so[n] da tre lati del dito posame[n]to/et queste disoto fate sono dela parte rischo[n]tro ala facata/di nantj Cioe de la faca di driento et no[n] d[e]la latitudine.

LITERATURE Paribeni 1929; Pasqualitti 1978; Agosti & Farinella 1984, pp.390–427; Rome 1988a, pp.56–7.

Anonymous Italian draughtsman, second half of the 16th century
ROME: PALAZZO VENEZIA, BIASA, MS 320, INV. NO.6123

The drawings, by an anonymous artist of the second half of the 16th century, are based on those of Ripanda. The scenes follow on from each other, providing a continuous representation of the action on the column. They were published without comment in the *Enciclopedia dell'arte antica, atalante dei complessi figurati e degli ordini architettonici* (1973, tav.75ff.). They follow the division of the scenes as defined by Conrad Cichorius,[8] indicated by Roman numerals, which are also followed in this catalogue. The three rolls are made up of folios of white laid writing paper; the watermark is a crossbow in an oval, but no similar mark is reproduced in Briquet.[9] The folios measure approximately 290 × 440 mm; they are glued together and numbered 1–131.

LITERATURE Rome 1956, cat.164; Pasqualitti 1978.

Circle of Giulio Romano, middle of the 16th century
PARIS, PRIVATE COLLECTION

The surviving drawings come from a continuous narrative, possibly in a series of panels, as in the 12 long drawings in Modena. Monbeig Goguel attributed them to the circle of Giulio Romano,[10] possibly copied from originals made for Chacon's plates. They are listed here among the other representations; they have not been examined directly, or collated with the other drawings.

LITERATURE Chevalier 1977–8; Florence 1984a, pp.13ff.

Attributed to Giulio Romano
MODENA: GE, INV. NOS 8128–39

A series of 12 long drawings, hanging in the store of the Galleria Estense. They were implausibly attributed to Giulio Romano by Macrea.[11] The drawings, executed in brown wash applied with a brush, are very damaged; they have been cut along the top and mounted into paper frames with blue margins and painted beading. They are executed on 124 folios measuring approximately 400 × 440 mm; most of the drawings are 430 mm in length, although some are less than 400 mm, and one drawing is 585 mm long; they have a uniform height of 250 mm. The total length of the drawing is approximately 57 m. Lettering has been introduced to collate the folios, which are glued together to form the 12 long drawings. The scenes follow each other in a continuous fashion, but while the scenes on the column follow an oblique spiral, here they are represented on a horizontal plane.

Anonymous Italian draughtsman, late 16th century
WINDSOR: RL, INV. NOS 7786–917

An album of pen and ink and brown wash drawings attributed on the architectural frontispiece by Antonio Visentini to Giulio Campi. They measure 270 × 430 mm. They came from the collection of Joseph Smith,

a banker and collector in Venice who acted as British consul there from 1744 to 1760. An incomplete set, which corresponds with Soane drawings 1–37 survives in the British Museum, Department of Prints and Drawings, reg.no.1972.U685/U716.[12] The Windsor drawings are collated in the diagram below the illustrations. They are not listed in OTHER REPRESENTATIONS.
LITERATURE Michaelis 1882, no.XXIV; Blunt 1971, p.58, cat.74.

Pietro Santi Bartoli
WINDSOR: RL, INV. NOS 7918–93
Bound and entitled DISEGNI ORIGINALI DELLA COLONNA TRAIANA FATTI DA PIETRO SANTI BARTOLI

An album of pen and ink drawings, some washed, which can be attributed to Pietro Santi Bartoli. Executed between 1667 and 1672, these are the most faithful drawings of the column. They formed the basis for Bartoli's engravings, which were first published in 1672. The drawings came from the Albani collection, which was acquired by Consul Smith.

LITERATURE Michaelis 1882, p.720, no.XX; Blunt 1971, p.58, cat.74; Bora 1976.

COLLECTIONS OF ENGRAVINGS OF TRAJAN'S COLUMN
A. CHACON, *Historia vtrivsqve belli dacici/a Traiano Caesar gesti/ et simvlachris qvae in colvmna/eivsdem Roma visvntvr collecta/avctore F. Alfonso Ciacono hispano/ad catholicvm Hispaniarvm regem Philippvm, II, 1576*

This, the first complete series of engravings of the column, was published in Rome by Zanetti, with a commentary and dedication to Philip II of Spain by the scholar and cleric Alphonse Chacon (active 1576). The drawings for the plates are associated with Francesco Villamena and Girolamo Muziano, to whom the designs are attributed.[13] In the introduction to the work, Chacon refers to drawings of the column by Raphael and his school, by Giulio Romano and by Polidoro da Caravaggio; Giulio Romano is mentioned more specifically in connection with the work in the reprint of 1616.[14] The documents refer to three artists working under Muziano on the plates between 1570 and 1573: Antonio di Gentile, a goldsmith from Faenza, Lorenzo di Rosale, a Roman illuminator, and Leonardo, a cleric and engraver from Orvieto.[15] They may have used designs deriving from Raphael and Giulio Romano.[16] The second edition, with plates prepared between 1576 and 1601 by Francesco Villamena, possibly with the collaboration of Giovanni Battista Cavalieri, was published in 1616.[17] A volume in the Uffizi (Stampe 5164–294) comprises a full set of Villamena's and Giovanni Battista Cavalieri's very rare engravings. The 62 red chalk drawings in Thomas Ashby's collection in the Vatican were made in the 18th century from Chacon's engravings.[18]

LITERATURE Da Como 1930, pp.95–100, docs 178–9; Agosti & Farinella 1985, pp.1108ff.; Rome 1988a, p.59.

P.S. BARTOLI AND G.P. BELLORI, *Colonna Traiana/erettsa dal Senato, e Popolo Romano/all imperastore Traiano Avgvsto/nel svo foro in Roma/scolpito con l'historie della gverra dacica la prima/e la seconda espeditione e vittoria/ contro il re Decebalo/nvovamente disegnata et intagliata da Pietro Santi Bartoli/ con l'espoditione latina d'Alfonso Ciaccone, compendiata nella volgare lingua sotto/ciacvna immagine accrescivta di medaglie, inscrittioni e trofei da Gio. Bellori/*

The volume was published by Giovanni Giacomo dei Rossi in 1672. The

8. Cichorius 1896–1900.
9. Briquet 1968.
10. Florence 1984a, pp.15ff.
11. Macrea 1937.

12. London, British Museum, Department of Prints and Drawings 1837, MS general inventory, p.55, case MM, no.7.

13. Rome 1988a, p.59.
14. Da Como 1930, pp.97ff, n.1.
15. Op. cit., p.97 and app.IV, pp.192–3.
16. Florence 1984a, pp.15–16.

17. Pasqualitti 1978.
18. Fols 1–9, 11–17, 19–64; Bodart 1975, p.123, cat.357–420.

engravings, executed by Pietro Santi Bartoli after 1667, were based on his own drawings and partially derive from Chacon's engravings (see his preface to the engravings). Giovanni Bellori based his comments on Chacon.

LITERATURE Agosti & Farinella 1984, p.424 and n.18; Rome 1988b, pp.61–2; Pomponi 1991–2.

CATALOGUE NOTE

The volume has a 19th-century Cambridge-style binding of diced calf, blind-tooled with gilt, with ruled borders and marbled boards. The blind-tooled spine with four raised bands is inscribed TRAJAN'S COLUMN/ORIGINAL DRAWINGS/POLIDORO DI CARAVAGIO.

The folios, of different widths, are glued together. They were folded in concertina folds before the volume was bound, probably for Sir John Soane after his acquisition in 1818. The volume measures 360 × 648 mm; there are two endpapers.

Antonio Lafreri's engraving of the column with the plans of the stair at the base, in the shaft and attic, and the view and elevation of the column showing the spiral and section, has been cut out and glued to one of the end papers as a frontispiece in imitation of MS 254.

The support is white laid writing paper; the watermarks are listed at nos 1 and 10 in the catalogue of watermarks in vol.II. All of the drawings are executed in pen and pale brown iron-gall ink, washed in pale brown and beige. They are approximately 54.5 m long, with an incised base line that gives a height ranging from 295 mm to 320 mm.

PROVENANCE The volume was acquired by Soane from John Britton. A letter from Britton in the Archive of the Sir John Soane's Museum dated 11 August 1818 refers to *Drawings of Trajan's column £12. 12. 0. Paid by draft 12 Aug 1818.*[19]

The entry in Richardson's catalogue of Sir John Soane's Library is inscribed: *Trajan's Column, Original drawings of, by Polidora Caldara peintre long folio 33.* The volume was located in the library in case 33 in the loggia to the left of the right window. The case contained other topographical material.[20] The 19th-century attribution to Polidoro was probably based on Chacon's text.

Another copy of the drawing of the spiral frieze on Trajan's column, in three rolls, described as Bartoli's originals, was sold at Christie's at the Messrs Adam's Sale on 26 and 27 February, and 1 and 2 March 1773 (p.8, no.3). It came from the collection of Pope Albani and was acquired by Signor Biondi, an Italian painter living in London, who sold 81 paintings and 23 drawings from his collection on 21 February 1777.[21] The drawings are catalogued as 186 feet (approximately 60 m) in length and 11 inches (308 mm) in height, lower than the Soane drawings.

The drawings, on sheets of paper glued together to form a continuous sequence, have been catalogued here according to the order of the sheets of paper rather than the openings of the book, which are 19th century. In order to establish the framing of the scenes in each drawing, the drawings are numbered and collated first with the framed MS 254 and then with the continuous drawings of the column listed above, followed by the framed engraved sets. Series or sketchbooks from the 16th and 17th centuries with copies of whole scenes from the column but which do not attempt to reproduce the whole spiral relief are listed under OTHER REPRESENTATIONS. They include the series of drawings in Chatsworth by an anonymous Florentine draughtsman of *c.*1467; an anonymous artist in the circle of Domenico Ghirlandaio before 1506 in Codex Escurialensis; Amico Aspertini's London codices and his Wolfegg Codex; the drawings by

an anonymous artist in the circle of Fulvio Orsini, antiquarian to the Farnese, which were copied from Pirro Ligorio at an uncertain date before 1568;[22] the album of Pierre Jacques of Reims in the Bibliothèque Nationale, Paris, drawn in Rome between 1572 and 1577; and folios from Pietro da Cortona's album of drawings in the Royal Ontario Museum, Toronto, as well as the scenes shown in his elevations of the column in Eton College and the Gabinetto Nazionale dei Disegni, Rome. Single sheets with reproductions of whole scenes are also listed by artist, ranging from Fra Bartolommeo to Poussin, with their bibliographical references. Lazare de Baif and du Choul are listed under 'engraved'. The Roman numeral at the beginning of each entry is the number given to the scene by Conrad Cichorius,[23] who described the narrative of the column and whose numbering system has been followed in subsequent publications; the Settis reference after it corresponds to the modern monograph and photographic survey of the column.

The drawings in the Soane volume are by two artists copying MS 254, the copy of Ripanda's drawings. The first artist was interested in details of costume and architecture and his drawings are executed in pen and ink with crisp, fine lines. The second artist, more interested in the narrative, primarily used wash.

19. Priv. Corr.XVI.E.3. 8, 1818, 11 August.
20. Richardson 1830, p.195.
21. Lugt 1938, no.2646.
22. Nolhac 1887.
23. Cichorius 1896–1900.

372
Scene I
Settis 1988, pp.259–60
No WM; 345 × 335 mm
SJSM, vol.113, fol.1

The drawing shows two wooden encampments, with a supply of timber for building, two haystacks for daily use and a watch-tower enclosed in a wooden palisade on the right bank of the Danube.

The Soane drawing is identical to that in the Ripanda Codex (MS 254), which extends to a point beyond the first soldier. The rendering of the haystacks, the pentimenti in the roof lines and the view of the wood-stack are all identical. The view, showing two sides of the wood-stack as well as the top of it, is like MSS 254 and 320, the Modena and British Museum drawings; it differs from the representations on the frieze and in the engravings of Muziano and Bartoli.

OTHER REPRESENTATIONS Anonymous Florentine of 1467?, Chatsworth, inv. no.925 (Rome 1988b, pp.187–9, cat.58); Ripanda Codex, Rome, BIASA, MS 254, fol.5; anonymous Italian, second half of the 16th century, Rome, BIASA, MS 320, fol.1; attributed to Giulio Romano, Modena, GE, inv. no.8129A (Macrea 1937, fig.1); Pietro da Cortona, Rome, GNDS, inv. no.F.C.124319; Pietro Santi Bartoli, Windsor, RL, inv. no.7918.
ENGRAVED Du Choul 1569, p.39; Chacon 1576, fol.1 by Girolamo Muziano; Bartoli 1708, fol.1; Montfauçon 1719, IV/I, p.42.

373
Scene II
Settis 1988, p.261
WM cat.10; 345 × 481 mm
SJSM, vol.113, fol.2

The drawing shows two towers with torches at the windows to detect night raids and three guards controlling the border between the Empire and the Dacian territory.

The river and ground are barely rendered in the Soane drawing. The towers are slighter in MS 254 and in the Soane drawing than in the other representations; the pentimenti in the rooflines, showing steeper roofs, also shown in MS 254, are copied from the frieze. Muziano and the draughtsman of MS 320 do not record pentimenti. There is more space between the soldier on the left and the third tower than is shown in MS 320 and Muziano's engraving, probably because the soldier stands at the edge of the folio in MS 254.

OTHER REPRESENTATIONS Anonymous Florentine of 1467?, Chatsworth, inv. no.925 (Rome 1988b, pp.187–9, cat.58); Ripanda Codex, Rome, BIASA, MS 254, fols 5 and 6 (Pasqualitti 1978); anonymous Italian, second half of the 16th century, Rome, BIASA, MS 320, fol.2; attributed to Giulio Romano, Modena, GE, inv. no.8129B (Macrea 1937, fig.2); Pietro Santi Bartoli, Windsor, RL, inv. no.7918.
ENGRAVED Du Choul 1569, p.33; Chacon 1576, fol.2 by Girolamo Muziano; Bartoli 1708, fol.2; Montfauçon 1719, IV/I, p.42.

SJSM VOL.113	1
ROME, BIASA, MS.254	5
ROME, BIASA, MS.320	1
MODENA, G.E. INV. NOS	8129A
WINDSOR, RL, INV. NOS	7787
WINDSOR, RL, INV. NOS	7918
ALPHONSE CHACON	1
PIETRO SANTI BARTOLI	1

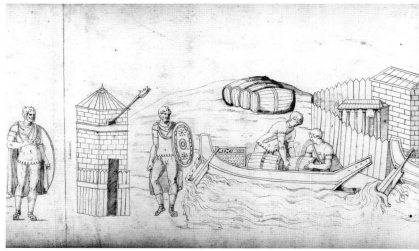

3				7
	3			
	8129C			
	7788			
		7919		
	3			
		3		

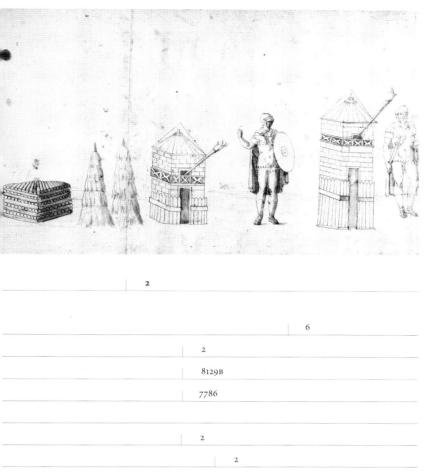

2

6

2

8129B

7786

2

2

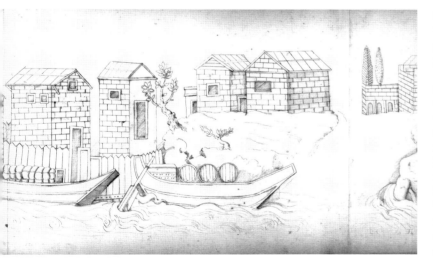

4 5

4 5

8129D 8129E

7789 7790

4 5

4

374
Scenes I–II
Settis 1988, p.262
WM cat.10; 345 × 500 mm
SJSM, vol.113, fol.3

A third tower with a torch at the window is guarded by a Roman soldier. Roman soldiers unload barrels from a boat. Four barrels with wine or vinegar sit on the river bank waiting to be stored.

There is more space between the Roman on the left and the tower than in MS 320. The space is similar in MS 254 and in Muziano's engraving. The shape of the oars shown here is the same as in MS 254, the frieze and Muziano's engraving. Only one ring is shown in the middle of the barrels, as in MS 254 and in the frieze; two rings are shown in MS 320, the Modena drawing and in the engravings of Muziano and Bartoli. The plain wedge of ground left blank below the fence on the right corresponds to MS 254 and the frieze; it is visible to a lesser extent in the Modena drawing. In MS 320 and in Muziano's engraving this unfinished area of the frieze has been covered by waves. The façade of the tower is shown plain here, but on the frieze it is of drafted masonry and there is a window above the door.

Scenes I–XIV are depicted in frescos attributed to Battista Franco in Palazzo Chiericati, Vicenza (Muraro 1978, pp.187–94; Agosti & Farinella 1984, pp.420–21).

OTHER REPRESENTATIONS Ripanda Codex, Rome, BIASA, MS 254, fol.6 (Pasqualitti 1978); anonymous Italian, second half of the 16th century, Rome, BIASA, MS 320, fol.3; attributed to Giulio Romano, Modena, GE, inv. no.8129C (Macrea 1937, fig.3); Pietro da Cortona, Eton College; Pietro Santi Bartoli, Windsor, RL, inv. no.7919.
ENGRAVED Chacon 1576, fol.3 by Girolamo Muziano; Bartoli 1708, fols 2–3; Montfauçon 1719, IV/I, p.135.

375
Scene II
Settis 1988, pp.263–4
WM cat.10; 345 × 442 mm
SJSM, vol.113, fol.4

Boats full of supplies – sacks of grain and barrels of wine – are anchored along the River Danube. The supplies will be stored in stone warehouses protected by timber palisades.

The shape of the oars corresponds to MS 254 and to Bartoli's engraving, while those shown in MS 320 and in Muziano's engraving correspond to the frieze. The Soane drawing does not show the two windows on the side of the building on the right that are present in the frieze and in all the other representations. The façade of the building between the two boats is plain in the Soane drawing; it has drafted masonry and a window above the door in the frieze and in all the other representations. The treatment of the water and ground is consistently unfinished in the Soane drawing and identical to MS 254; it is similar in MS 320 and in Muziano's engraving. The trees are more robust, with rounded clusters of leaves, in MS 320. The rendering of trees in the Soane volume, with spindly trunks and clusters of elongated leaves, is consistently closer to the frieze, MS 254 and Bartoli's engraving.

OTHER REPRESENTATIONS Ripanda Codex, Rome, BIASA, MS 254, fol.7; anonymous Italian, second half of the 16th century, Rome, BIASA, MS 320, fol.4; attributed to Giulio Romano, Modena, GE, inv. no.8129D; Pietro da Cortona, Toronto, Codex, fol.38r; Pietro da Cortona, Eton College; Pietro Santi Bartoli, Windsor, RL, inv. no.7919; Campi.
ENGRAVED De Baif 1536, p.109; Du Choul 1569, p.40; Chacon 1576, fol.4 by Girolamo Muziano; Bartoli 1708, fols 3–4; Montfauçon 1719, IV/II, p.136.

376
Scenes II–IV
Settis 1988, pp.264–5
WM cat.10; 345 × 502 mm
SJSM, vol.113, fol.5

On the left the bearded personification
of the Danube, crowned with reeds and
facing east, watches the Roman army.
Above his head is a cityscape with walls,
gates and many different types of build-
ings. The Romans march out from the
gates and cross the Danube on a bridge
of boats. The legionaries, in armour,
their helmets on their shoulders, carry
rectangular shields and hold staffs to
which are tied their rations.

The gesture of the river god, who
touches the bridge of boats as a blessing
for the expedition, does not survive
complete in the frieze, and is not
recorded in any of the representations.
The city here is identical to MS 254,
and close to MS 320 and to Muziano's
engraving. The drafted masonry wall
below the cypress trees is also shown in
MSS 254 and 320; in the Modena draw-
ing, the frieze and Muziano's engraving
it is rendered as an arched portico with
an attic with three windows. In Santi
Bartoli's engraving the city is treated
differently. The arched gate to the
bridge is unfinished here, in MSS 254
and 320 and the Modena drawing, but it
has drafted masonry in the frieze and
Muziano's engraving. The building
with two arches and a blind drafted bay
to the left of the gate is shown as in MSS
254 and 320, the Modena drawing and
Muziano's engraving; three arches are
shown on the column.

OTHER REPRESENTATIONS Anonymous
Florentine of 1467?, Chatsworth, inv.
no.926 (Rome 1988b, pp.187–9, cat.58;
Jaffé 1994, p.160, cat.130); Ripanda
Codex, Rome, BIASA, MS 254, fol.8;
Amico Aspertini, Wolfegg Codex,
fol.37r and v (Schweikhart 1986, pp.90–
91, Abb.20–21); London, BM, Codex I,
fols 31v–32r (Bober 1957, p.67, fig.73);
anonymous Italian, second half of the
16th century, Rome, BIASA, MS 320,
fol.5; attributed to Giulio Romano,
Modena, GE, inv. no.8129E (Macrea
1937, fig 3); anonymous French 16th-
century draughtsman, Dresden, KKSK,
1970, no.44; Pietro da Cortona,
Toronto, ROM, Codex, scenes II–III on
fol.37r, scene III on fols 39r, 40r and 41r
(Brett 1957, pp.4–5); Pietro Santi
Bartoli, Windsor, RL, inv. no.7920.
ENGRAVED De Baif 1536, p.110; Du Choul
1569, p.43; Chacon 1576, fol.5 by
Girolamo Muziano; Giovanni Battista
Fontana (Agosti & Farinella 1985,
p.1108, tav.LXI.2); Bartoli 1708, fol.4;
Montfauçon 1719, IV/I, p.50.

377
Scenes IV–V
Settis 1988, p.266
No WM; 345 × 492 mm
SJSM, vol.113, fol.6

There are two bridges of boats side-by-
side across the Danube. The standard-
bearers wear cloaks with lion's heads in
imitation of Hercules. The trumpeters
and some of the cavalry are the first to
reach Dacian territory on the left bank
of the Danube.

Bartoli shows the soldiers going
through an arch on the other side of
the Danube after crossing the bridge
of boats, but this feature does not exist
in the frieze or in the other representa-
tions. The second bridge of boats is
supported on four boats without
foundation, as in MS 254; in the frieze,
MS 320 and in Muziano's and Santi
Bartoli's engravings it is supported
on two boats with a foundation and
a railing.

The wooden bridge structures on
Trajan's column were noticed and
described by Filarete in his treatise
(1972, I, book XIII, p.369). They may
also have influenced Palladio's designs
for wooden bridges (London 1975,
p.213, cat.380).

OTHER REPRESENTATIONS Circle of
Domenico Ghirlandaio, Escorial,
Codex Escurialensis, fol.61v (Egger
1905–6, p.152); Ripanda Codex, Rome,
BIASA, MS 254, fols 8–9; Amico
Aspertini, Wolfegg Codex, fol.38r and v
(Schweikhart 1986, p.91, Abb.21–2);
anonymous Italian, second half of the
16th century, Rome, BIASA, MS 320, fols
6–7; attributed to Giulio Romano,
Modena, GE, inv. no.8129F (Macrea
1937, fig.3); Pietro Santi Bartoli,
Windsor, RL, inv. no.79207.
ENGRAVED Du Choul 1569, p.79;
Chacon 1576, fol.6 by Girolamo
Muziano; Bartoli 1708, fols 4–5;
Montfauçon 1719, IV/I, p.32.

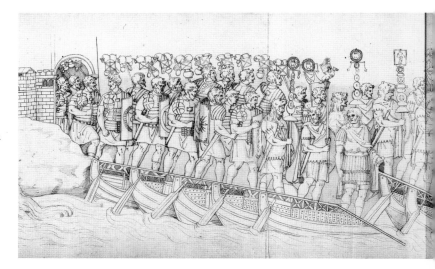

	6	
8		9
	6	
		8129F
	7791	
7920		
	6	
	5	

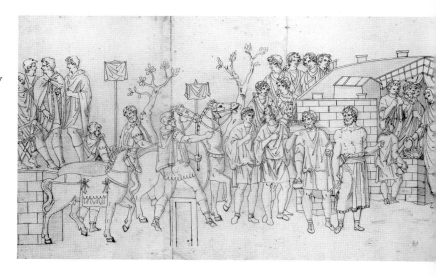

	8	
		11
8		9
	8129H	
7793		7794
8		9
	7	

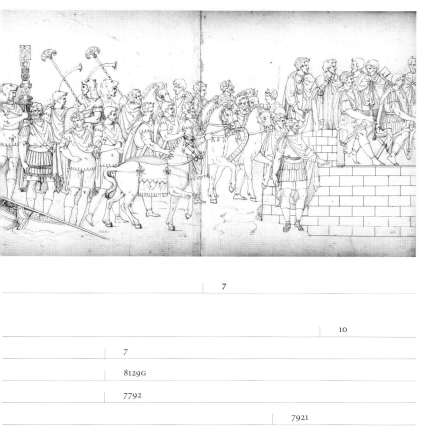

7

10

7

8129G

7792

7921

7

6

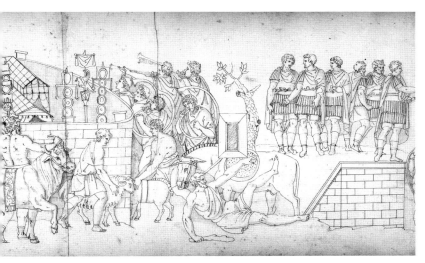

9

12

10

8129I

7795

7792

10

8

378
Scenes V–VI

Settis 1988, pp.267–8
WM cat.10 ; 345 × 495 mm
SJSM, vol.113, fol.7

Trajan is seated on a high podium between two officers; the officer on the left is Lucius Licinio Sura, his close adviser. They hold a council of war to decide routes and tactics. A group of horses and horsemen moves off to the right.

The group of soldiers to the right of Trajan, copied from the frieze and seen in all of the representations, is changed by Bartoli in the engraving: he shows the soldiers grouped in front of Trajan and a longer cavalry procession on the right. The feet of the soldier leading the horse on the right are shown from below here; in MS 254 and in all the other drawings they are shown in profile.

Filarete's image of the seated Nero at Seneca's suicide, on the obverse of one of his medallions of Roman emperors, is a quotation from the figure seated behind Trajan in the relief.

OTHER REPRESENTATIONS Ripanda Codex, Rome, BIASA, MS 254, fols 9–10; anonymous Italian, second half of the 16th century, Rome, BIASA, MS 320, fols 7–8; attributed to Giulio Romano, Modena, GE, inv.no.8129G; anonymous French 16th-century draughtsman, Dresden, KKSK, 1970, cat.45; Pietro da Cortona, Rome, GNDS, inv. no.F.C.124319; Pietro Santi Bartoli, Windsor, RL, inv. no.7921.
ENGRAVED Du Choul 1569, p.71; Chacon 1576, fols 7–8 by Girolamo Muziano; Bartoli 1708, fols 5–6; Montfauçon 1719, IV/I, p.43.

379
Scenes VII–VIII

Settis 1988, pp.268–9
No WM; 345 × 508 mm
SJSM, vol.113, fol.8

Trajan dressed as a high priest celebrates the first solemn sacrifice to the gods. The *Lustratio*, or bloodless part of the sacrifice, takes place inside the walls of the fortified camp, which enclose tents. Trajan holds the patera in which the wine and the victim's blood will be mixed. On the right, a bull is led in procession around the camp.

The wall behind the central figure with the dagger is rusticated in the frieze, MS 254, the Soane and Modena drawings, and in Muziano's engraving; it is plain in MS 320.

A scene painted on the soffit of the arch in front of the fresco of the *Liberation of St Peter*, in the Stanza d'Eliodoro in the Vatican, is a re-elaboration of this scene (Agosti & Farinella 1984, p.402, and n.12).

OTHER REPRESENTATIONS Ripanda Codex, Rome, BIASA, MS 254, fols 10–11; anonymous Italian, second half of the 16th century, Rome, BIASA, MS 320, fols 8–9; attributed to Giulio Romano, Modena, GE, inv. no.8129H; anonymous French 16th-century draughtsman, Dresden, KKSK, 1970, cat.45; circle of Fulvio Orsini, Rome, BAV, Codex Ursinianus, fol.71r; Pietro da Cortona, Rome, GNDS, inv. no.F.C.124319; Pietro Santi Bartoli, Windsor, RL, inv. no.7921.
ENGRAVED Chacon 1576, fols 8–9 by Girolamo Muziano; Bartoli 1708, fols 6–7.

380
Scenes IX–X

Settis 1988, pp 270–72
WM cat.10; 345 × 501 mm
SJSM, vol.113, fol.9

Music accompanies the procession as a ram and a pig are led by the soldiers and trumpeters around the walls of the camp, watched by Trajan and two of his officers on the right. Meanwhile a slave falls off his mule in the centre foreground. On the far right Trajan, with two officers behind him, addresses the troops. The two groups of two officers with Trajan in the two scenes, which are differentiated by a change of level on the frieze, are rendered in all the drawings and engravings as one group of six.

None of the drawings shows the change of level in the podium. The top of the podium, not shown in the frieze, is depicted in all the representations. The ground of the platform is also left blank and unfinished in MS 254 and the Modena drawing, where the diagonal step is washed dark brown.

OTHER REPRESENTATIONS Ripanda Codex, Rome, BIASA, MS 254, fols 11–12; anonymous Italian, second half of the 16th century, Rome, BIASA, MS 320, fols 9–10; attributed to Giulio Romano, Modena, GE, inv. no.8129I (Macrea 1937, fig.21); Pietro da Cortona, Eton College; Pietro Santi Bartoli, Windsor, RL, inv. no.7922.
ENGRAVED Scene X, Chacon 1576, fols 9–10 by Girolamo Muziano; Bartoli 1708, fols 7–8; Montfauçon 1719, IV/I, p.44.

381
Scenes XI–XII
Settis 1988, pp.272–3
No WM; 345 × 493 mm
SJSM, vol.113, fol.10

On the left Trajan's armed soldiers cluster in a semicircle around him and listen to his address. On the right they begin the occupation of the territory by building a vast network of fortifications. In the centre and on the right the legionaries cut down trees and carry the trunks for foundations, as well as masonry and baskets of lime, earth and sand for cement; they build two parallel walls. Courses of *opus quadratum* are interrupted by courses of rondins, charred olive branches to tie together the walls, as recommended by Vitruvius (book I, cap.V, 3; 1931–4, I, p.49).

In MS 320, the Modena drawing and in Muziano's and Bartoli's engravings there is a projection or a break in the building, which is shown as a single line to the right of the window; this corresponds to the single line marking the edge of the folio of MS 254. The half-figure next to it is close to the break in the wall here, in MS 320 and in Muziano's engraving; it is slightly further away in the Modena drawing and in Bartoli's engraving. All of the representations show the break in the building to the right of the window and the three figures well to the right of it. In reality, the three soldiers work below the window. The arched opening behind the soldier building in the upper register has a plain frame here and in MS 254, but it is rusticated in MS 320. The sole of the right-hand soldier's foot is shown on the right; the foot is shown in profile in MS 254 and in the Modena drawing.

OTHER REPRESENTATIONS Ripanda Codex, Rome, BIASA, MS 254, fols 12–13 (Macrea 1937, figs 21–2); anonymous Italian, second half of the 16th century, Rome, BIASA, MS 320, fols 11–12; attributed to Giulio Romano, Modena, GE, inv. no.8129J (Macrea 1937, fig.4); Pietro da Cortona, Eton College; Pietro Santi Bartoli, Windsor, RL, inv. no.7923.
ENGRAVED Chacon 1576, fol.11 by Girolamo Muziano; Bartoli 1708, fols 8–9.

382
Scenes XII–XIII
Settis 1988, pp.273–4
WM cat.10; 345 × 504 mm
SJSM, vol.113, fol.11

Two auxiliary sentries with oval shields stand guard. The legionaries' arms are cast aside as they complete their tasks. Trajan appears on the right to inspect the completed wooden bridge and the defensive bastion. A workman completes the bridge by hammering in a bronze nail, and tents are erected within the enclosure walls of the camp.

The wall on the far right is shown plain here, but it is of drafted masonry in the frieze, MSS 254 and 320, the Modena drawing and the engravings of Muziano (fol.13) and Bartoli (fol.10). The plank structure of the bridge is shown in the frieze, MS 320, the Modena drawing and in Muziano's engraving; here and in MS 254 it is made of rectangular panels of wood.

There is a drawing by Polidoro da Caravaggio based on the two Roman sentries (Louvre, inv. no.6118; Agosti & Farinella 1984, p.414).

OTHER REPRESENTATIONS Anonymous Florentine 1467?, Chatsworth, inv. no.927 (Rome 1988b, pp.187–9, cat.58); Ripanda Codex, Rome, BIASA, MS 254, fols 13–14 (Macrea 1937, fig.22; Pasqualitti 1978); anonymous Italian, second half of the 16th century, Rome, BIASA, MS 320, fols 12–13; attributed to Giulio Romano, Modena, GE, inv. nos 8129K–8133A; Pietro Santi Bartoli, Windsor, RL, inv. no.7923.
ENGRAVED Chacon 1576, fols 12–13 by Girolamo Muziano; Bartoli 1708, fols 9–10.

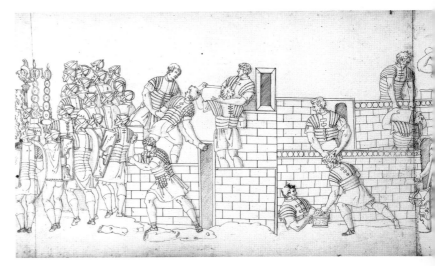

	13	
11		12
8129J		8129K
7796		7797
		7923
11		12
	9	

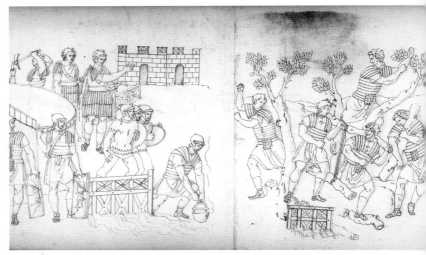

	13	
	15	
14		
8133B		
7799		
7924		
14		
11		

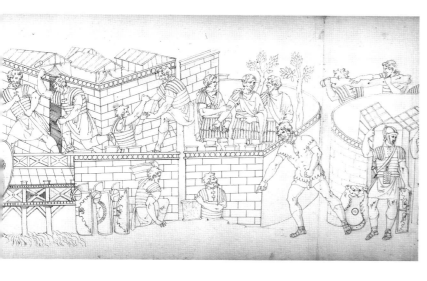

12

14

13

8133A

7798

13

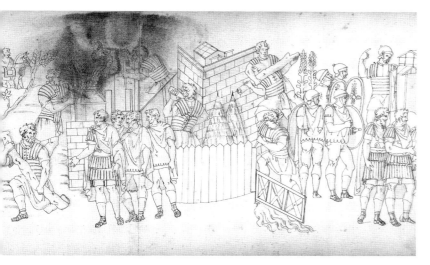

14

16

16

33C

8133D

7800

7801

7925

15

16

13

383
Scenes XIII–XIV
Settis 1988, pp.275–6
No WM; 345 × 454 mm
SJSM, vol.113, fol.12

Three legionaries are left standing
guard over the fortified camp with tents
inside the walls. In the background
Trajan reaches an oval fortress on high
ground that has been abandoned by
the enemy. In the foreground three
auxiliaries cross a wooden bridge
over a stream. On the right a legionary
bends down to collect water in a vessel.

The inside of the enclosure wall is left
plain here, in the frieze and in MSS 254
and 320; it is of drafted masonry in
Muziano's engraving and in the
Modena drawing. The building in the
background to the right of the enclo-
sure is articulated with vertical string
courses in MS 320, the Modena drawing
and Muziano's engraving; they are
absent here and in the frieze. There is
more space next to the figure fetching
water on the far right in MS 254, proba-
bly because it is near the edge of a folio.

OTHER REPRESENTATIONS Anonymous
Florentine of 1467?, Chatsworth, inv.
no.927 (Rome 1988b, pp.187–9, cat.58;
Jaffé 1994, p.161, cat.133); Ripanda
Codex, Rome, BIASA, MS 254, fol.14
(Pasqualitti 1978); anonymous Italian,
second half of the 16th century, Rome,
BIASA, MS 320, fols 13–14; attributed
to Giulio Romano, Modena, GE, inv.
no.8133A (Macrea 1937, fig.5); Pietro
Santi Bartoli, Windsor, RL, inv.
no.7924.
ENGRAVED Chacon 1576, fols 13–14
by Girolamo Muziano; Bartoli 1708,
fols 10–11; Montfauçon 1719, IV/I,
pp.48 and 74.

384
Scenes XV–XVI
Settis 1988, pp.277–8
WM cat.10; 345 × 503 mm
SJSM, vol.113, fol.13

Soldiers cut down trees while on the
right Trajan continues to supervise the
work.

The drawing shows the same details
as MS 320, the Modena drawing and
Muziano's engraving, but the ground
has been left undetailed, as in MS 254,
although more detail is shown there.

OTHER REPRESENTATIONS Anonymous
Florentine of 1467?, Chatsworth, inv.
no.928 (Rome 1988b, pp.187–9, cat.58;
Jaffé 1994, p.160, cat.131); Ripanda
Codex, Rome, BIASA, MS 254, fol.15;
anonymous Italian, second half of the
16th century, Rome, BIASA, MS 320, fols

14–15; attributed to Giulio Romano,
Modena, GE, inv. no.8133B and C
(Macrea 1937, fig.6); Pietro da Cortona,
Rome, GNDS, inv. no. F.N.124319;
Pietro Santi Bartoli, Windsor, RL,
inv. no.7924.
ENGRAVED Chacon 1576, fols 14–15 by
Girolamo Muziano; Bartoli 1708, fols
11–12; Montfauçon 1719, IV/I, pp.37 and
41.

385
Scenes XVI–XVIII
Settis 1988, pp.278–9
No WM; 345 × 511 mm
SJSM, vol.113, fol.14

A wooden bridge over a stream and
a wooden fence have been built to
protect the hay gathered from the
fields. In the background a permanent
camp is being built of stone. In the
foreground on the right a prisoner
is pushed into the presence of the
emperor. His head is bare, and the
detail shows that he comes from the
lowest rank of Dacian society. In
the background the legionaries carry
tree trunks.

The nails in the wooden stockade
and the beaded moulding on the
rusticated wall within the stockade,
present in MSS 254 and 320, the Modena
drawing and Muziano's engraving, are
not shown here. The foundation of the
bridge shown on the frieze, and in all
of the other representations, is absent
here.

OTHER REPRESENTATIONS Anonymous
Florentine of 1467?, Chatsworth, inv.
nos 929 and 930 (Rome 1988b,
pp.187–9, cat.58); Ripanda Codex,
Rome, BIASA, MS 254, fol.16; Amico
Aspertini, London, BM, I, fols 30v–31r
(Bober 1957, p.67, fig.73); anonymous
Italian, second half of the 16th century,
Rome, BIASA, MS 320, fol.16; attributed
to Giulio Romano, Modena, GE, 8133C
and D (Macrea 1937, fig.6); Pierre
Jacques, Paris, CE (Reinach 1902,
tav.87bis, 90bis); Pietro da Cortona,
Rome, GNDS, inv. no.F.N.124313; Pietro
da Cortona, Eton College; Nicholas
Poussin (Blunt 1974, cat.331, pl.258);
Pietro Santi Bartoli, Windsor, RL, inv.
no.7925, inscribed *viene lo scudo* below
the group of four soldiers.
ENGRAVED Anonymous, circle of
Raphael; Chacon 1576, fols 15–16 by
Girolamo Muziano; Bartoli 1708, fols
12–13.

386
Scenes XIX–XX
Settis 1988, pp.280–81
No WM; 345 × 500 mm
SJSM, vol.113, fol.15

Trajan stands in the centre inside the
enclosure while the fifth wooden bridge
is constructed on the left. Timber is
carried to the site and sand is dug from
a pit on the right, while the soldiers in
the background, their arms laid aside
on the right, build a wall, taking stone
from a figure with a hod on the right.

On the far left the foot of the Roman
soldier bringing the Dacian spy before
Trajan is shown behind the captive
here, in MS 254 and in the Modena
drawing in agreement with the frieze;
in MS 320 and Muziano's engraving the
foot is shown in front of the captive.

A long sequence of monochromes
taken from scenes XIX–XXVI (fols
15r–21r) was reproduced in a *sgraffito*
decoration between the windows of a
house at 9 Via della Maschera d'Oro,
Rome, attributed to the circle of Jacopo
Ripanda and Baldassare Peruzzi and
dated *c*.1506 (Agosti & Farinella 1984,
pp.401–2).

OTHER REPRESENTATIONS Anonymous
Florentine of 1467?, Chatsworth, inv.
no.930 (Rome 1988b, pp.187–9, cat.58;
Jaffé 1994, p.160, cat.132); Ripanda
Codex, Rome, BIASA, MS 254, fols 16–17;
Amico Aspertini, London BM, I, fols
30v–31r (Bober 1957, p.67, fig.72);
anonymous Italian, second half of
the 16th century, Rome, BIASA, MS 320,
fols 17–18; attributed to Giulio Romano,
Modena, GE, inv. no.8133E (Macrea
1937, fig.6); Pietro da Cortona, Eton
College; Pietro Santi Bartoli, Windsor,
RL, inv. no.7926, inscribed *bisgoria
[bisogneria] avertire che tutte sono/cosi
lavorate* next to a detail of a cuirass
above the soldier with a hod.
ENGRAVED Anonymous, circle of
Raphael (Bartsch vol.26, 1978,
p.202(166); the background is unde-
tailed in these engravings); Chacon
1576, fols 16–17 by Girolamo Muziano;
Bartoli 1708, fols 13–14; Montfauçon
1719, IV/I, p.38.

387
Scene XXI
Settis 1988, pp.281–2
No WM; 345 × 501 mm
SJSM, vol.113, fol.16

On the left the cavalry waits to go
into action while soldiers ride out
over a wooden bridge. In the back-
ground two sentries stand in front
of a fortified camp.

The curtains at the entrances of the
buildings inside the wall behind the
round tower, shown as in MS 254,
are less clearly drawn than in MS 320,
the Modena drawing and Muziano's
engraving. A second arched opening
in the enclosure wall behind the bank
of the stream is clearly shown here,
in MS 254, the Modena drawing and
Muziano's engraving; it is only partially
shown in the frieze, behind the soldier
standing in front of it, who is displaced
in the drawing to the right.

Raphael based the horse and rider in
the border of the tapestry cartoon of
the *Martyrdom of St Stephen* on this
scene (Agosti & Farinella 1984, p.412).

OTHER REPRESENTATIONS Circle of
Domenico Ghirlandaio, Escorial,
Codex Escurialensis, fols 61 and 64
(Egger 1905–6, pp.152–3); Ripanda
Codex, Rome, BIASA, MS 254, fols 17–18
(Pasqualitti 1978); Amico Aspertini,
London, BM, I, fols 29v–30r (Bober
1957, p.66, fig.71); anonymous Italian,
second half of the 16th century, Rome,
BIASA, MS 320, fols 18–19; attributed
to Giulio Romano, Modena, GE, inv.
no.8133E and F; Pierre Jacques (Reinach
1902, tav.31bis); Pietro Santi Bartoli,
Windsor, RL, inv. no.7926.
ENGRAVED Anonymous, circle of
Raphael (Bartsch vol.26, 1978,
pp.200–1, 203–4(166)); Du Choul 1569,
p.49; Chacon 1576, fol.18 by Girolamo
Muziano; Bartoli 1708, fols 14–15.

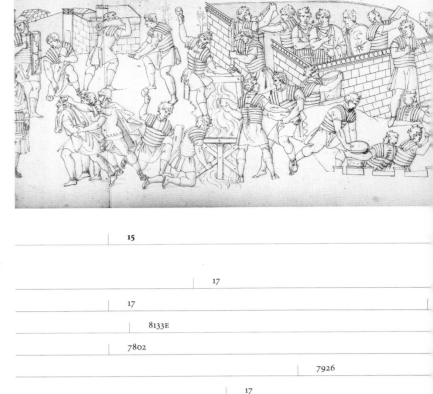

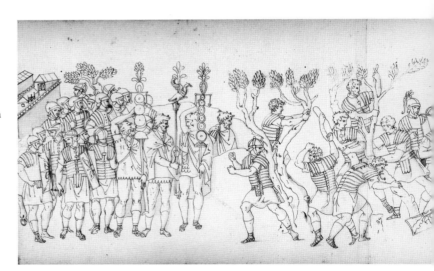

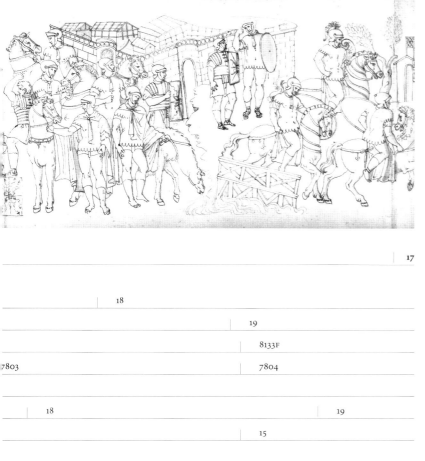

17

18

19

8133F

7803 7804

18 19

15

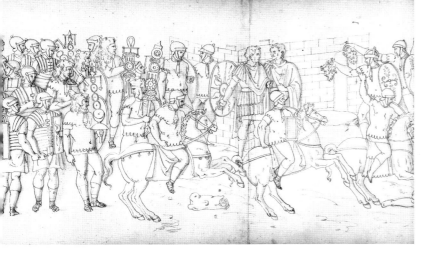

19

20

21 22

8133H 8133I

7806 7807

7928

21

17

388
Scenes XXII–XXIII
Settis 1988, pp.283–4
WM cat.10; 345 × 404 mm
SJSM, vol.113, fol.17

On the left a legion, ready to enter battle, waits while soldiers cut down trees on the right to make a path through the wood.

The window to the right of the centre in the frieze, MSS 254 and 320, the Modena drawing and the Bartoli engraving has been left out here. The shield resting on the ground in front of the first soldier and covering his legs to the left of the window in the frieze has been omitted in all of the representations. The city in the background on the left is close to the city in MSS 254 and 320, the Modena drawing and Muziano's engraving; following the frieze, Bartoli (fol.15) shows a drafted masonry wall, with a drafted masonry wall added on the left, and only the top of the entrance arch, which is recessed behind a projecting wall.

OTHER REPRESENTATIONS Ripanda Codex, Rome, BIASA, MS 254, fols 18–19 (Pasqualitti 1978); anonymous Italian, second half of the 16th century, Rome, BIASA, MS 320, fols 19–20; attributed to Giulio Romano, Modena, GE, inv. no.8133F and G; Pietro Santi Bartoli, Windsor, RL, inv. no.7927.
ENGRAVED Anonymous, circle of Raphael (Bartsch vol.26, 1978, p.202 (165)); Du Choul 1569, p.27; Chacon 1576, fols 19–20 by Girolamo Muziano; Bartoli 1708, fols 15–16.

389
Scenes XXIII–XXIV
Settis 1988, pp.284–5
WM cat.10; 345 × 479 mm
SJSM, vol.113, fol.18

The infantry waits in reserve as the cavalry charges into battle. The ensign of an eagle below a golden crown is shown clearly in MS 320 and in Muziano's and Bartoli's engravings, but it is not clear in the Soane or Modena drawings.

A scene of the *Liberation of St Peter* painted on the soffit of the arch in the Stanza d'Eliodoro in the Vatican is based on scene XXIV (Agosti & Farinella 1984, p.402, n.12).

OTHER REPRESENTATIONS Ripanda Codex, Rome, BIASA, MS 254, fols 19–20; anonymous Italian, second half of the 16th century, Rome, BIASA, MS 320, fols 20–21; attributed to Giulio Romano, Modena, GE, inv. no.8133G and H; Pierre Jacques (Reinach 1902, tav.85bis, 91, 93, 95); Pietro da Cortona, Rome, GNDS,

inv. no.F.N.124319; Pietro Santi Bartoli, Windsor, RL, inv. no.7927.
ENGRAVED Du Choul 1569, p.26 (scene XXIII); Chacon 1576, fols 20–21 by Girolamo Muziano; Bartoli 1708, fol.16.

390
Scene XXIV
Settis 1988, pp.286–7
No WM; 472 × 473 mm
SJSM, vol.113, fol.19

The battle of Tapae is the first encounter between the Romans and the Dacian army. On the left Trajan receives the heads of the enemy as they fall. The Roman horsemen, their right arms raised, gallop towards the enemy; originally the horsemen gripped bronze weapons in their fists, but these have not survived. Bodies fall lifeless to the ground. A German from a special unit, with a naked torso, swings a club, while an auxiliary presses forward with the severed head of a Dacian between his teeth.

An arched opening in the drafted masonry wall in the background of the frieze, shown here and in MSS 254 and 320 and the Modena drawing, is not present in Muziano's engraving.

OTHER REPRESENTATIONS Ripanda Codex, Rome, BIASA, MS 254, fols 20–21 (Pasqualitti 1978); anonymous Italian, second half of the 16th century, Rome, BIASA, MS 320, fols 21–2; attributed to Giulio Romano, Modena GE, inv. no.8133H–I; Pietro da Cortona, Rome, GNDS, inv. no.F.N.124319; Jan de Bisschop, London, V & A, inv. no.D1212–67–1889 (van Gelder 1971, p.271, fig.33, and p.201, n.1); Pietro Santi Bartoli, Windsor, RL, inv. no.7928.
ENGRAVED Du Choul 1569, pp.56–7; Chacon 1576, fols 21–2 by Girolamo Muziano; Bartoli 1708, fols 17–18; Montfauçon 1719, IV/I, p.63.

391
Scenes XXIV–XXV
Settis 1988, pp.289–90
No WM; 345 × 489 mm
SJSM, vol.113, fol.20

Jupiter Tonans hovers over the Roman troops and hurls a thunderbolt at the enemy. The Dacians are overcome and flee with their wounded. In the centre to the right of the window there is a head with a *pileato*, the hat worn by noble Dacians. This is the first appearance on the column of King Decebal. Trajan points his lance to the ground as a sign of his occupation of the place and orders the burning of the town, seen on the right.

The first, foreground figure of a fighting barbarian shows the sole of his foot here, in the frieze and in MS 254; the foot is flat on the ground in MS 320, in the Modena drawing and Muziano's engraving. The wall around the Dacian town is shown as a plain scroll also in MSS 254 and 320, the Modena drawing and in Muziano's engraving; it is depicted as a wooden fence in Santi Bartoli's engraving in agreement with the frieze. The house inside the fence stands on stilts as in the frieze, MS 320 and the Modena drawing, but it is shown with a boarded ground floor in Muziano's engraving; the wall has no vertical division in the upper storey, as in the house in MSS 254 and 320, the Modena drawing and the frieze. Although the outline of the moat inside the city wall and the bridge across it is shown here and in MS 254 as it is in the frieze, the water in the moat seen in MS 320 and in Muziano's engraving is not represented here. Windows and a door in the second timber building in MS 320 are not depicted here, in MS 254 or in Muziano's engraving.

The young Dacian taken away for burial appears in a drawing attributed to Giovanni Francesco Penni (Pouncey & Gere 1983, p.225, cat.363).

OTHER REPRESENTATIONS Ripanda Codex, BIASA, MS 254, fol.21 (Pasqualitti 1978); anonymous Italian, second half of the 16th century, Rome, BIASA, MS 320, fols 22–3; attributed to Giulio Romano, Modena, GE, inv. no.8133I–J; Pierre Jacques (Reinach 1902, tav.62bis, 90, 93 and 95); Pietro da Cortona, Eton College; Jan de Bisschop, London, V & A, inv. no.D1212–67–1889 (van Gelder 1971, p.271, cat.33); Pietro Santi Bartoli, Windsor, RL, inv. no.7928. ENGRAVED Chacon 1576, fols 22–3 by Girolamo Muziano; Bartoli 1708, fols 18–19; Montfauçon 1719, IV/I, p.63.

392
Scenes XXVI–XXVII
Settis 1988, pp.290–91
No WM; 345 × 599 mm
SJSM, vol.113, fol.21

The heads of slaughtered Romans are displayed on the walls of the Dacian village. The Dacians flee to the woods. The victorious Roman legionaries cross a river; in the background one takes off his clothes in order to cross and carries his clothes and arms in his shield. An officer, dry and fully clothed, waits for the soldiers on the other side.

The building in the background to the right of the tree has a plain end bay on the right that is also shown in MS 254 in agreement with the frieze; it is shown built of drafted masonry in MS 320, the Modena drawing and in Muziano's engraving. The podium of drafted masonry is shown as plain in MS 320. A view of the top of the podium is found in the Modena drawing only.

OTHER REPRESENTATIONS Circle of Domenico Ghirlandaio, Escorial, Codex Escurialensis, fol.63 (Egger 1905–6, pp.153–4); Ripanda Codex, Rome, BIASA, MS 254, fol.22; anonymous Italian, second half of the 16th century, Rome, BIASA, MS 320, fols 24–5; circle of Giulio Romano, Paris, PC, sequence 19–20 (Florence 1984a, p.26); attributed to Giulio Romano, Modena, GE, inv. no.8133K–8128A; Pierre Jacques (Reinach 1902, tav.63bis); Pietro da Cortona, Eton College; Pietro Santi Bartoli, Windsor, RL, inv. no.7929. ENGRAVED Du Choul 1569, p.81 (Rome 1988b, p.25, fig.6); Chacon 1576, fols 23–4 by Girolamo Muziano; Bartoli 1708, fols 19–20; Montfauçon 1719, IV/I, p.31.

393
Scenes XXVII–XXVIII
Settis 1988, pp.292–3
WM cat.10 ; 345 × 498 mm
SJSM, vol.113, fol.22

Trajan congratulates his soldiers on their victory at Tapae. Two Germans and some Dacians on horseback wait outside the camp. On the right Trajan stands in front of the camp and receives a Dacian embassy. The tree at the far right rises the full height of the scene and brings the episode to a close. This scene-changing device is used consistently in the frieze.

The tent inside the semicircular fortress on the left is shown plain here, but it has horizontal and vertical rope webbing across the surface in the frieze, MSS 254 and 320, the Paris drawings and in the engravings of Muziano and

20			
21			
		23	
		8133J	
		7808	
22			
	18		

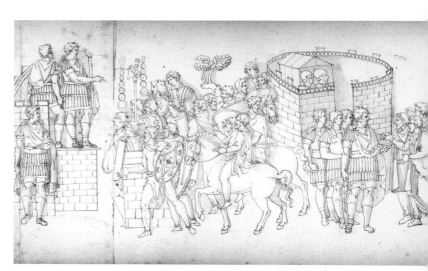

22		
23		
25		26
8128A		8128B
		7811
7930		
25		
20		

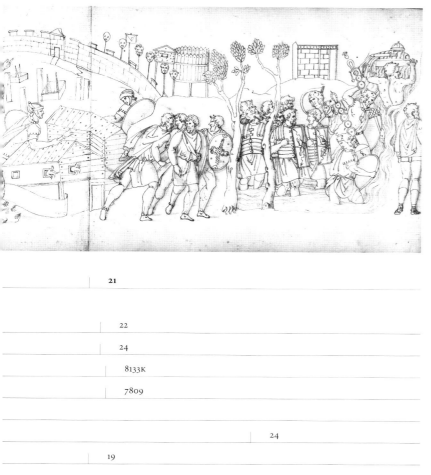

21

22

24

8133K

7809

24

19

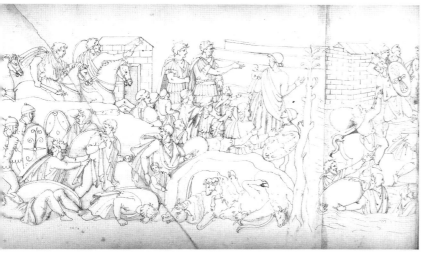

23 24

24

27

8128C

7812

7931

27

21

Bartoli; only the vertical lines are rendered in the Modena drawing. The two crenellations shown in front of the side of the building are also depicted in the Modena drawing; one appears on the frieze; none is shown in MS 320 or in Muziano's engraving. The curve of the enclosure wall is shown in MS 254, the Modena drawing and Muziano's engraving as well as in the frieze, but it is not found in the Paris drawing, where a section of wall seems to project forward. The trees and the absence of ground in the Paris and Soane drawings are similar.

A scene painted on the soffit of the arch in front of the *Liberation of St Peter* in the Stanza d'Eliodoro in the Vatican is based on scene XXVII (Agosti & Farinella 1984, p.402 and n.12). The two Dacian horsemen from scene XXVII appear in a stucco relief in the loggia of Villa Lante on the Gianiculum in Rome by Giulio Romano (Agosti & Farinella 1985, p.1106).

OTHER REPRESENTATIONS Circle of Ghirlandaio, Escorial, Codex Escurialensis, fol.62v (Egger 1905–6, p.156); Ripanda Codex, Rome, BIASA, MS 254, fol.23; anonymous Italian, second half of the 16th century, Rome, BIASA, MS 320, fols 25–6; attributed to Giulio Romano, Modena, GE, inv. no.8128A–B; circle of Giulio Romano, Paris, PC, sequence 19–20 (Florence 1984a, p.26): Pierre Jacques (Reinach 1902, tav.86, 87bis, 91, 94); Pietro Santi Bartoli, Windsor, RL, inv. no.7930. ENGRAVED Chacon 1576, fol.25 by Girolamo Muziano; Bartoli 1708, fol.20.

394
Scenes XXIX–XXX
Settis 1988, pp.294–5
No WM; 345 × 448 mm
SJSM, vol.113, fol.23

The scene is composed of several vignettes divided by a rocky landscape. In the background the Romans are setting fire to Dacian villages. In the foreground men trying to escape from the Romans are killed and their animals lie slaughtered. The women and children are deported to the opposite bank of the Danube. One woman turns to face Trajan. A tree marks a scene change.

The building on the far right behind the woman and baby is also present in the frieze, MS 254, the Modena drawing and Muziano's and Bartoli's engravings, but not in MS 320. In the Paris drawing it is changed to a rusticated wall with a fence on top. The drawing of the ground and the three horizontal divisions of the fields are less specific and closer to MS 254 than to MS 320, the

Paris and Modena drawings and Muziano's engraving. The group of dead animals in this drawing, as well as in the Paris and Modena drawings, seems to be copied from MS 254. The dead Dacian and the defiant Dacian hold clubs in the Paris drawing, but not in the frieze or in the other versions.

Scene XXIX is reproduced in a painting on the soffit of the arch in front of the *Liberation of St Peter* in the Stanza d'Eliodoro in the Vatican (Agosti & Farinella 1984, p.402 and n.12). The man and woman in the centre of the composition were drawn by Nicholas Poussin (Blunt 1974, cat.328, pl.257).

OTHER REPRESENTATIONS Ripanda Codex, Rome, BIASA, MS 254, fols 23–4 (Pasqualitti 1978); anonymous Italian, second half of the 16th century, Rome, BIASA, MS 320, fols 26–7; attributed to Giulio Romano, Modena, GE, inv. no.8128B–C; circle of Giulio Romano, Paris, PC, sequence 21 (Florence 1984a, p.26); Pietro Santi Bartoli, Windsor, RL, inv. no.7930, inscribed *questa seconda va terza e[t] la terza seconda* above the three horsemen in the background, and *la sotto veste delle donne/pare che sia di velo* below the drawing of a woman. ENGRAVED Chacon 1576, fol.26 by Girolamo Muziano; Bartoli 1708, fols 20–21 (Florence 1984a, p.39, fig.19).

395
Scene XXXI
Settis 1988, pp.295–6
WM cat.10; 345 × 512 mm
SJSM, vol.113, fol.24

The Dacians, attempting a counter-offensive, plunge into the Danube. A contingent of infantry reaches the shore on the Roman side. The horsemen, struggling against the current, sink below the water while their companions watch helplessly from the bank. The Dacians, weakened by the river crossing, launch an attack against the Roman garrisons in Moesia. The Sarmatian cavalry, wearing scaly armour that entirely covers the men and their horses, gallop to the aid of the Dacians.

The water of the river is barely indicated here; in MS 254 it is slightly more elaborated, with straight parallel strokes. Two figures, a Dacian reaching for a drowning man and the head of a drowning Dacian in the centre of the composition, not present in the frieze or in any of the other versions, have been introduced in the Paris drawing; the Paris drawing is the only representation to show the building on the left with a door and a circular window in the gable.

Fresco XI on the west wall of the

salone in Bishop Raffaele Riario's palace in Ostia, of 1511–13, described by Vasari (1967, IV, p.259) in his life of Baldassare Peruzzi and attributed to Peruzzi's circle, is based on this scene. This is the earliest decorative scheme based on scenes from Trajan's column (Agosti & Farinella 1984, pp.407–10).

OTHER REPRESENTATIONS Circle of Domenico Ghirlandaio, Escorial, Codex Escurialensis, fol.60v (Egger 1905-6, pp.151–2); Ripanda Codex, Rome, BIASA, MS 254, fols 24–5; Amico Aspertini, London, BM, I, fols 27v–28r (Bober 1957, p.66, fig.68); anonymous Italian, second half of the 16th century, Rome, BIASA, MS 320, fols 27–8; attributed to Giulio Romano, Modena, GE, inv. no.8128C–D; circle of Giulio Romano, Paris, PC, sequence 22 (Florence 1984a, p.26); Giovan' Antonio Dosio, Codex Berolinensis, Berlin, SKK, fol.35r (Huelsen 1933, p.20, cat.93, Taf.L); Windsor, RL (Popham & Wilde 1949, cat.119); Pietro da Cortona, Rome, GNDS, inv. no.F.C.124319; Pietro Santi Bartoli, Windsor, RL, inv. no.7931. ENGRAVED Chacon 1576, fols 27–8 by Girolamo Muziano; Bartoli 1708, fols 21–2; Montfauçon 1719, IV/I, p.60.

396
Scene XXXII
Settis 1988, pp.297–8
No WM; 345 × 319 mm
SJSM, vol.113, fol.25

The Dacians and Sarmatians lay siege to a Roman fortress. The Dacians press against the walls on all sides. The Roman auxiliary soldiers hurl javelins down on the enemy.

The tower on the wall with a double arched opening and plain walls, on the left, is also shown in Muziano's engraving; it is built of drafted masonry in MSS 254 and 320, in the Modena drawing and in the frieze.

OTHER REPRESENTATIONS Ripanda Codex, Rome, BIASA, MS 254, fol.25 (Pasqualitti 1978); anonymous Italian, second half of the 16th century, Rome, BIASA, MS 320, fols 28–9; attributed to Giulio Romano, Modena, GE, inv. no.8128D–E; circle of Giulio Romano, Paris, LCD, inv. no.3726 (Florence 1984a, p.23, cat.22); Pierre Jacques (Reinach 1902, tav.87); Pietro da Cortona, Eton College; Pietro da Cortona, Rome, GNDS, inv. no.F.C.124319; Pietro Santi Bartoli, Windsor, RL, inv. no.7931. ENGRAVED Du Choul 1569, p.85; Chacon 1576, fol.28 by Girolamo Muziano; Bartoli 1708, fols 22–3; Montfauçon 1719, IV/I, p.80.

397
Scene XXXIII
Settis 1988, pp.299–300
No WM; 345 × 502 mm
SJSM, vol.113, fol.26

A tree marks a scene change. At a river port on the banks of the Danube, in front of a fortified city with an amphitheatre, the Romans embark in river boats. On the right Trajan, dressed in a cloak for the journey, embarks with the fleet to bring aid to the invaded province. On the bank of the river is an arch surmounted by a quadriga.

The cross-pattern border on the prow of the boat in the frieze, MSS 254 and 320, the Modena drawing and Muziano's engraving has not been drawn here. The tops of the paddles are scrolled as in MS 254 and in Muziano's engraving; they are straight in the frieze, MS 320 and the Modena drawing. The pedimented building inside the city wall has walls of drafted masonry here, in the frieze and in the other drawings; they are plain in Bartoli's engraving. On the left of the city view, the three separate buildings in the frieze are rendered as a central pedimented bay flanked by symmetrical arcaded loggias here, in Muziano's engraving and in MSS 254 and 320. The pediment resting on a central pier on the right of the right-hand loggia is also shown by Muziano and in MSS 254 and 320. The drafted masonry arcade in the perimeter wall of the theatre in the frieze is not shown; an arched window in a masonry drum appears to derive from MSS 254 and 320 and from Muziano's engraving.

OTHER REPRESENTATIONS Ripanda Codex, Rome, BIASA, MS 254, fol.26; Amico Aspertini, London, BM, I, fols 23v–24r (Bober 1957, p.66, fig.61); anonymous Italian, second half of the 16th century, Rome, BIASA, MS 320, fols 29–30; attributed to Giulio Romano, Modena, GE, inv. no.8128E–F; Pietro da Cortona, Eton College; Pietro Santi Bartoli, Windsor, RL, inv. no.7932. ENGRAVED De Baif 1536, pp.16 and 24; Chacon 1576, fols 29–30 by Girolamo Muziano; Bartoli 1708, fols 23–4; Montfauçon 1719, IV/II, p.139.

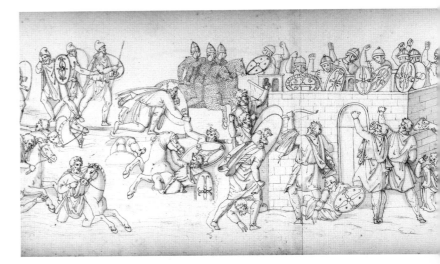

25

25

28

8128D

7813

28

22 23

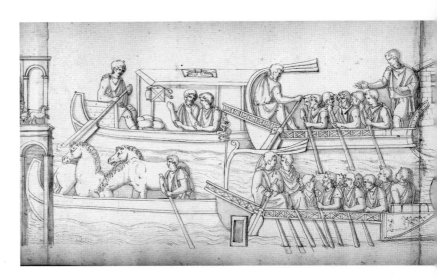

27

27

31

8128G

7816

7933

30

25

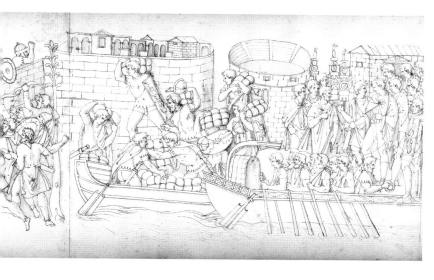

26

26

29

30

8128F

7815

7932

29

24

398
Scene XXXIV
Settis 1988, pp.301–2
WM cat.10; 345 × 488 mm
SJSM, vol.113, fol.27

The horses are transported by boat. On the right are two large boats with oarsmen; Trajan is shown at the helm of one of them.

The canopy covering the boat in the background is flat as in the frieze, MS 254 and Muziano's engraving; in MS 320 and the Modena drawing it has a pitched roof. It is extended and supported on four colonnettes also in the frieze, MS 254 and Muziano's engraving, on two colonnettes in MS 320.

OTHER REPRESENTATIONS Ripanda Codex, Rome, BIASA, MS 254, fol.27; Amico Aspertini, London, BM, I, fols 5v–6r and 23v–24r (Bober 1957, pp.53 and 66, figs 23 and 61); anonymous Italian, second half of the 16th century, Rome, BIASA, MS 320, fols 30–31; attributed to Giulio Romano, Modena, GE, inv. no.8128F–G; Cassiano dal Pozzo Album, London, BM, Dept of Greek and Roman Antiquities, vol.I, fol.32, no.37; Pietro Santi Bartoli, Windsor, RL, inv. no.7932.
ENGRAVED De Baif 1536, pp.12 and 15; Chacon 1576, fol.30 by Girolamo Muziano; Bartoli 1708, fols 24–5 (Florence 1984a, p.39, fig.20); Montfauçon 1719, IV/II, p.140.

399
Scene XXXV
Settis 1988, pp.303–4
WM cat.10; 345 × 450 mm
SJSM, vol.113, fol.28

The fleet arrives in Moesia. The soldiers unload their arms and provisions from the boats in front of a fortified place. In the centre Trajan, in military dress, sets foot in Moesia, preceded by a column of reinforcements.

The bundles in the boats are cylindrical rather than round, and wrapped in rope webbing. Three oval shields lie behind the bundles; there are five shields in the frieze, Muziano's engraving and in MSS 254 and 320. The packages below Trajan's feet in the frieze are not shown at all here, or in Muziano's engraving and MS 320.

OTHER REPRESENTATIONS Ripanda Codex, Rome, BIASA, MS 254, fols 27–8; anonymous Italian, second half of the 16th century, Rome, BIASA, MS 320, fols 31–2; attributed to Giulio Romano, Modena, GE, inv. no.8128G–H; Cassiano dal Pozzo Album, London, BM, Dept of

Greek and Roman Antiquities, vol.I, fol.32, no.37; Nicholas Poussin (Blunt 1974, cat.331, pl.258); Pietro Santi Bartoli, Windsor, RL, inv. no.7933.
ENGRAVED Chacon 1576, fol.31 by Girolamo Muziano; Bartoli 1708, fol.25.

400
Scene XXXVI
Settis 1988, pp.305–6
No WM; 345 × 473 mm
SJSM, vol.113, fol.29

Trajan rides at the head of his troops; he is followed by cavalry, auxiliary cohorts and special contingents. In a wood Trajan hears the report of the scouts, who had been sent to spy on the enemy.

The trees are rendered very differently: they have rounded forms in MS 320 and the Modena drawing, but they are pointed in this drawing and in MS 254, as in the frieze. The space between the tree and the horse to its right is wider in the Soane and MS 254 drawings than in the frieze, MS 320, the Modena drawing and Muziano's engraving.

OTHER REPRESENTATIONS Ripanda Codex, Rome, BIASA, MS 254, fols 28–9; anonymous Italian, second half of the 16th century, Rome, BIASA, MS 320, fols 32–3; attributed to Giulio Romano, Modena, GE, inv. no.8128I; Pietro Santi Bartoli, Windsor, RL, inv. no.7933.
ENGRAVED Du Choul 1569, p.52; Chacon 1576, fol.32 by Girolamo Muziano; Bartoli 1708, fol.26.

29

28

32

33

8128H

7817

32

26

401
Scene XXXVII
Settis 1988, pp.308–9
No WM; 345 × 506 mm
SJSM, vol.113, fol.30

The war begins in Moesia Minor as the cavalry gallops against the enemy. The Sarmatian cavalry flees from the attack and one falls dead under the horses' hooves, while another, wounded, falls from his horse.

The characteristic scaly armour of the Sarmatian cavalry is less clearly rendered in the Modena drawing than in the other representations, although it is very damaged in this area. Only the Modena drawing shows the horse armour clearly.

OTHER REPRESENTATIONS Ripanda Codex, Rome, BIASA, MS 254, fols 29–30 (Pasqualitti 1978); anonymous Italian, second half of the 16th century, Rome, BIASA, MS 320, fols 33–4 (fol.34 is inscribed *coperti di squame*); attributed to Giulio Romano, Modena, GE, inv. no.8128J; Pierre Jacques (Reinach 1902, tav.87); Amico Aspertini, Codex Wolfegg, fol.9 (Schweikhart 1986, p.57, Abb.1); attributed to Polidoro da Caravaggio, London, Courtauld Institute of Art, Witt Collection; Pietro da Cortona, Rome, GNDS, inv. no.F.C.124319; Pietro Santi Bartoli, Windsor, RL, inv. no.7934. ENGRAVED Chacon 1576, fols 33–4 by Girolamo Muziano; Bartoli 1708, fol.27; Montfauçon 1719, IV/I, p.62.

402
Scene XXXVIII
Settis 1988, pp.310–12
No WM; 345 × 502 mm
SJSM, vol.113, fol.31

On the left is a personification of a deity with a shawl billowing above her head. Night conceals the Roman attack, and the second battle in the Moesian campaign begins. The Roman troops attack the Dacians in front of their camp. In the background the carts are loaded with equipment.

The horizon line at top right, also shown in MS 254, is not present in the frieze, MS 320, the Modena drawing or in Muziano's engraving. The soldier to the left of the tree in the upper register raises his arm in the frieze, in MSS 254 and 320, the Modena drawing and Muziano's engraving. A break between the images occurs at this point in MS 254.

OTHER REPRESENTATIONS Ripanda Codex, Rome, BIASA, MS 254, fol.30 (Pasqualitti 1978); anonymous Italian, second half of the 16th century, Rome, BIASA, MS 320, fols 34–5; attributed to Giulio Romano, Modena, GE, inv. no.8128K–L; Pierre Jacques (Reinach 1902, tav.80, 90bis); Pietro da Cortona, Eton College; Pietro da Cortona, Rome, GNDS, inv. no.F.C.124319; Pietro Santi Bartoli, Windsor, RL, inv. nos 7934–5. ENGRAVED Chacon 1576, fols 34–5 by Girolamo Muziano; Bartoli 1708, fols 27–8; Montfauçon 1719, IV/I, p.54.

	30	
29		
		34
81281		8128J
7818		7819
7934		
	33	
		27

	32	
31		
	36	
8128L		
7821		
	7936	
		36
	29	

31

30

35

8128K

7820

7935

34 35

28

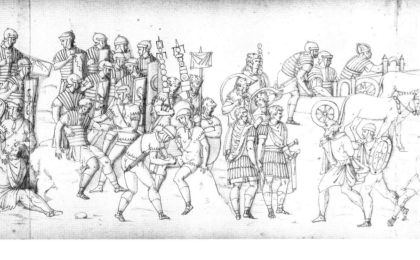

33

32

38

8136B

7823

7937

37

30

403
Scene XXXIX
Settis 1988, pp.313–14
WM cat.10; 345 × 487 mm
SJSM, vol.113, fol.32

After the defeat a group of Dacian women, children and elderly submit to the Emperor. Trajan, flanked by officers, receives some noble Dacians inside the camp, which is under construction. In the foreground the legionaries are at work building an octagonal camp, their gestures and poses belonging to a repertory used to express work in the many work episodes on the frieze. On the right three Dacian prisoners are held in chains by auxiliary soldiers.

There is a wider space between the woman in the upper register on the left and the tree in the Soane drawing than in the frieze, MSS 254 and 320, the Modena drawing and Muziano's engraving. The inside of the enclosure wall is drafted in the frieze, MSS 254 and 320, Muziano's and Bartoli's engravings. The Modena drawing breaks at this point. The wall to the left of the man holding a basket has horizontal lines in Muziano's engraving; it is shown with drafted masonry in the frieze, here and in MS 320. In the frieze, there is a second break in the wall, behind the man with the basket, which is not shown in any of the drawings.

A drawing in the British Museum, London, formerly attributed to Polidoro da Caravaggio and now to Taddeo Zuccaro, is based on the Dacian in chains on the far right of this scene (Pouncey & Gere 1983, p.204, cat.326r).

OTHER REPRESENTATIONS Ripanda Codex, Rome, BIASA, MS 254, fol.31 (Pasqualitti 1978); anonymous Italian, second half of the 16th century, Rome, BIASA, MS 320, fol.36; attributed to Giulio Romano, Modena, GE, inv. no.8128L–8136A; Pietro da Cortona, Eton College; Pietro Santi Bartoli, Windsor, RL, inv. no.7936.
ENGRAVED Chacon 1576, fols 35–6 by Girolamo Muziano; Bartoli 1708, fols 28–9.

404
Scene XL
Settis 1988, pp.315–17
No WM; 345 × 461 mm
SJSM, vol.113, fol.33

The field is divided into two horizontal registers. In the upper register a column of legionaries advances to the right, while in the foreground the military doctors treat two wounded soldiers: one, a legionary, is supported by his companion; the other, an auxiliary, is having his leg bandaged. On the right standard-bearers, trumpeters and carts loaded with war machines file past Trajan, who is meeting a Dacian prisoner.

The spokes of the wheels are straight here, in the frieze, in MSS 254 and 320, and in the Modena drawing, but they are baluster-shaped in Muziano's engraving.

Fresco VII on the west wall in the salone of Bishop Riario's palace in Ostia, dated 1511–13 and attributed to the circle of Peruzzi, derives from this scene (Borghini 1981, pp.91–103; Agosti & Farinella 1984, pp.407–10). Drawings based on this scene in the Albertina, Vienna (inv. SC.R.inv.390), and in the Uffizi, Florence (13095F), attributed to Polidoro da Caravaggio, refer to a lost Roman façade near Castel S. Angelo, Rome (op. cit., p.414).

OTHER REPRESENTATIONS Ripanda Codex, Rome, BIASA, MS 254, fol.32; anonymous Florentine of 1467?, Chatsworth, inv. no.930 (Jaffé 1994, p.161, cat.135); Amico Aspertini, Wolfegg Codex, fol.22v (Schweikhart 1986, p.64, Abb.7); London, BM, Aspertini Codex I, fols 9v–10r (Bober 1957, p.56, fig.34); anonymous Italian, second half of the 16th century, Rome, BIASA, MS 320, fols 37–8; attributed to Giulio Romano, Modena, GE, inv. no.8136A–B; Pierre Jacques (Reinach 1902, tav.32, 88, 92 and 93); Cambridge, Mass., HCL, MS 152H, fol.150; Pietro Santi Bartoli, Windsor, RL, inv. nos 7936–7.
ENGRAVED Chacon 1576, fols 36–7 by Girolamo Muziano; Bartoli 1708, fols 29–30; Montfauçon 1719, IV/II, p.122.

405
Scene XLI
Settis 1988, pp.318–19
No WM; 345 × 471 mm
SJSM, vol.113, fol.34

The decisive battle of the Moesian
campaign begins. The legionaries,
protecting themselves with their
rectangular shields, pursue and
oppress the Dacians.

OTHER REPRESENTATIONS Ripanda
Codex, Rome, BIASA, MS 254, fol.33;
anonymous Italian, second half of
the 16th century, Rome, BIASA,
MS 320, fols 38–9; attributed to
Giulio Romano, Modena, GE, inv.
no.8136B–C; Biagio Pupini, London,
BM, inv. no.1946-7-13-497 (Agosti
& Farinella 1985, p.1105, tav.LXIII);
Pietro Santi Bartoli, Windsor, RL,
inv. no.7937.
ENGRAVED Chacon 1576, fol.38 by
Girolamo Muziano; Bartoli 1708,
fols 30–31.

406
Scenes XLI–XLII
Settis 1988, pp.320–23
No WM; 345 × 471 mm
SJSM, vol.113, fol.35

The Roman cavalry intervenes from
above, and attacks the enemy from
behind. This decides the outcome of
the battle, which is fought in the fore-
ground. The Dacians who are unable to
escape are mercilessly massacred, their
shields and bodies piled in the centre.
Four Dacians in the background behind
their slaughtered companions try to
escape. Trajan makes a speech to the
troops surrounding him on the right.

OTHER REPRESENTATIONS Circle of
Domenico Ghirlandaio, Escorial,
Codex Escurialensis, fol.63v (Egger
1905–6, p.154); Ripanda Codex,
Rome, BIASA, MS 254, fols 33–4;
anonymous Italian, second half
of the 16th century, Rome, BIASA,
MS 320, fols 40–41; attributed to
Giulio Romano, Modena, GE, inv.
no.8136C–D; Pietro Santi Bartoli,
Windsor, RL, inv. nos 7937–8.
ENGRAVED Chacon 1576, fols 39–40
by Girolamo Muziano; Bartoli 1708,
fols 31–2.

407
Scenes XLII–XLIV
Settis 1988, pp.323–5
No WM; 345 × 488 mm
SJSM, vol.113, fol.36

The troops gather around Trajan in
a semicircle, while he congratulates
them on their success in the Moesian
campaign. On the right nine Dacians
are held prisoner in a Roman camp,
while a sentry stands guard; another
sentry inside the camp turns his head
to listen to Trajan. On the right Trajan
personally rewards the most deserving
soldiers: one bends down to kiss his
hand, while another departs loaded
with gifts. In the foreground two
soldiers embrace each other, and
others salute Trajan.
 The front of the fortress wall has a
horizontal band with a bead motif
here, in the frieze and in MS 254; it is
not shown in MS 320, the Modena
drawing or in Muziano's engraving.
 Fresco XIV on the west wall of Bishop
Riario's palace in Ostia, dated 1511–13
and attributed to the circle of Peruzzi,
is based on this scene (Borghini 1981,
fig.3).

OTHER REPRESENTATIONS Ripanda
Codex, Rome, BIASA, MS 254, fols 34–5;
anonymous Italian, second half of the
16th century, Rome, BIASA, MS 320,
fols 40–41; attributed to Giulio
Romano, Modena, GE, inv. no.8136E–F;
Dal Pozzo draughtsman, London,
BM, Dal Pozzo vol., fol.39v; Pietro Santi
Bartoli, Windsor, RL, inv. nos.7938–9.
ENGRAVED Chacon 1576, fols 40–41
by Girolamo Muziano; Bartoli 1708,
fols 32–3; Montfauçon 1719, IV/I, p.75.

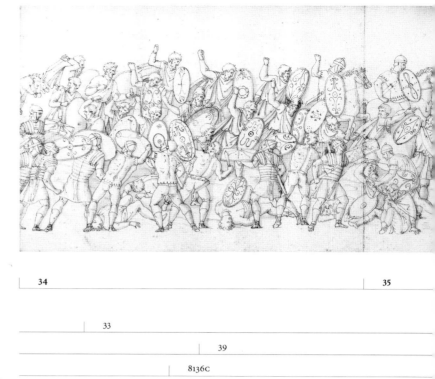

34　　　　　　　　　　　　　　　　　　35

33

39

8136C

7824

38　　　　　　　　　　　　　　　　　　39

31

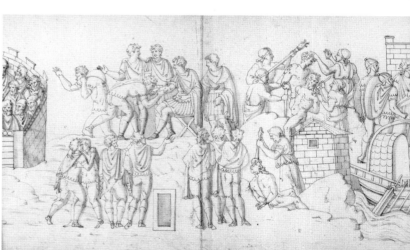

37

35

42

8136G

7827

7939

41

33

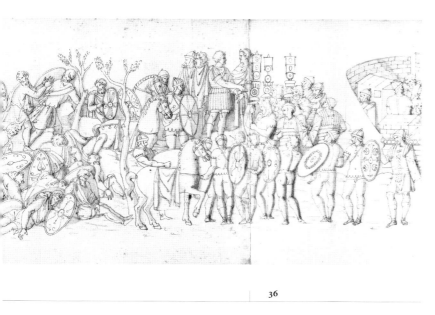

36

34
40 41
8136D 8136E 8136F
7825 7826
7938
40
32

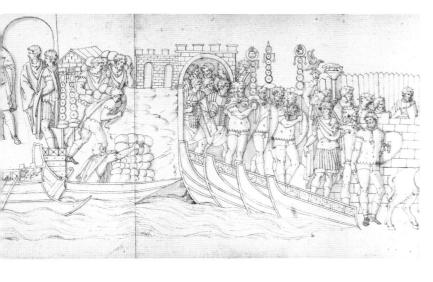

38

36
43
8136H
7828
7940
2 43
34

408
Scene XLV
Settis 1988, pp.326–8
No WM; 345 × 505 mm
SJSM, vol.113, fol.37

Three prisoners, their hands tied
behind their backs, are tortured with
flaming torches by a group of women.
The Emperor, in civilian clothes, is
about to embark on one of the ships
on the Danube. Some soldiers bring to
him two Dacian captives, who prostrate
themselves in supplication. On the
right soldiers load baggage on to the
ships.

The roof behind the drafted masonry
building below the tortured prisoners
is drawn ambiguously in naive perspec-
tive in the same way as in MS 254, where
the ink drafted masonry lines have
disappeared. It is clearly shown in
perspective as a roof in MS 320 and in
Muziano's engraving; it is not carved
on the frieze. In the background the
arch next to the rusticated wall corre-
sponds to the frieze and MS 254; it
does not appear in MS 320, the Modena
drawing or in Muziano's engraving.

OTHER REPRESENTATIONS Ripanda
Codex, Rome, BIASA, MS 254, fols 35–6;
anonymous Italian, second half of
the 16th century, Rome, BIASA, MS 320,
fols 41–2; attributed to Giulio Romano,
Modena, GE, inv. no.8136F–G;
Pietro Santi Bartoli, Windsor, RL,
inv. no.7939.
ENGRAVED Chacon 1576, fol.41 by
Girolamo Muziano; Bartoli 1708, fols
33–4 (Florence 1984a, p.38, fig.16).

409
Scenes XLVI–XLVIII
Settis 1988, pp.329–30
No WM; 345 × 490 mm
SJSM, vol.113, fol.38

At the beginning of the third campaign
of the Dacian War the legions march
out under the arched gate of a city and
cross the Danube over a bridge of
boats. The troops follow the ram ensign
of the first German legion. On the right
two parallel walls separated by a fence
indicate the troops' fortified road. The
horsemen advance while carts carry
provisions in the background.

In Bartoli (fol.34) and in the frieze
there is a rusticated wall in the back-
ground behind the fence, but this is not
shown in the Soane drawing, in MSS 254
and 320, the Modena drawing or in
Muziano's engraving.

OTHER REPRESENTATIONS Ripanda
Codex, Rome, BIASA, MS 254, fols 36–7;
anonymous Italian, second half of the
16th century, Rome, BIASA, MS 320,
fol.43; attributed to Giulio Romano,
Modena, GE, inv. no.8136H; Pietro Santi
Bartoli, Windsor, RL, inv. no.7940.
ENGRAVED Chacon 1576, fols 42–3 by
Girolamo Muziano; Bartoli 1708, fol.34;
Montfauçon 1719, IV/I, p.49.

410
Scenes XLIX–L
Settis 1988, pp.331–3
WM cat.10 ; 345 × 503 mm
SJSM, vol.113, fol.39

Trajan, standing on a path protected
by a fence, with a large round tower
next to him, greets the reinforcements.
Topographical details, such as the
fortress on the hill and the zigzag path
up to it, indicate that the figures are in
the mountains. The diamond-shaped
schematic plans on either side of the
path refer to places along the route,
which ends with an arch in the fore-
ground.

The cylindrical packs in the ox-cart,
also shown in MS 254 and the Modena
drawing, are represented as two-tiered
and containing many round packages
in MS 320 and Muziano's engraving.
This feature is not clear in the frieze.
The heads of the oxen face the spectator
in the frieze and in Muziano's engrav-
ing; they are shown in profile in MS 320
and turn very slightly towards the
spectator in the Modena drawing.

OTHER REPRESENTATIONS Ripanda
Codex, Rome, BIASA, MS 254, fol.37;
anonymous Italian, second half of the
16th century, Rome, BIASA, MS 320,
fols 44–5 (the first roll ends on fol.44,
after the standing figure of Trajan
on the right; fol.45 is the first folio of
the second roll); attributed to Giulio
Romano, Modena, GE, inv. no.8136I–J;
Pietro Santi Bartoli, Windsor, RL,
inv. no.7940.
ENGRAVED Chacon 1576, fols 43–4 by
Girolamo Muziano; Bartoli 1708, fols
35–6; Montfauçon 1719, IV/I, p.49.

411
Scenes LI–LII
Settis 1988, pp.334–6
No WM; 345 × 503 mm
SJSM, vol.113, fol.40

In front of a fortress, Trajan at the head
of his reinforcements meets represen-
tatives from the garrisons left behind
by the Romans to protect the invaded
territory. In the centre the legionaries
cut down trees and carry them away to
make a road through the forest. In the
foreground other soldiers, buried up
to their waists, pass baskets of earth or
sand up to their companions. On the
right, in the midst of the work, Trajan
receives an embassy.

Two openings in the drafted
masonry building behind the tree
on the frieze are rendered imprecisely
as two square openings in all of the
drawings. The baskets, which are
rendered as pots here and in MS 254,
are made from basketwork in MS 320,
the Modena drawing and Muziano's
engraving. The window on the right
of the figure chopping down a tree in
the background exists in the frieze; it
is not shown in MSS 254 and 320 or in
the Modena drawing.

OTHER REPRESENTATIONS Ripanda
Codex, Rome, BIASA, MS 254, fol.38;
Amico Aspertini, London, BM, I,
fols 34v–35r (Bober 1957, p.67, fig.76);
anonymous Italian, second half of the
16th century, Rome, BIASA, MS 320,
fols 45–6; attributed to Giulio Romano,
Modena, GE, inv. no.8136K–L; Pietro
Santi Bartoli, Windsor, RL, inv. no.7941.
ENGRAVED Chacon 1576, fols 44–5 by
Girolamo Muziano; Bartoli 1708, fol.37;
Montfauçon 1719, IV/I, p.49.

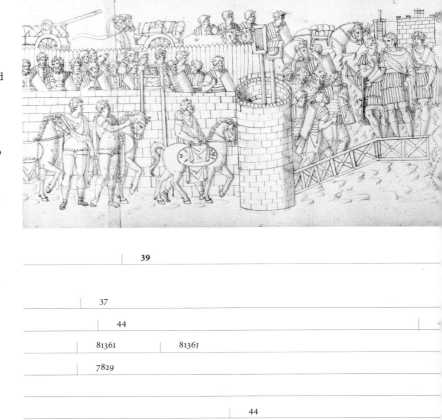

39
37
44
8136I 8136J
7829
44
35

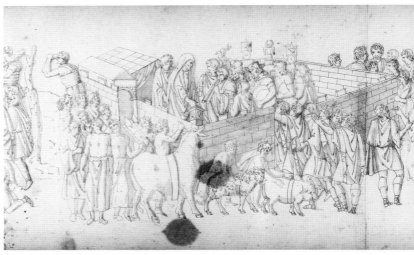

41 42
39
47
8136M
7832
7942
46 47
37

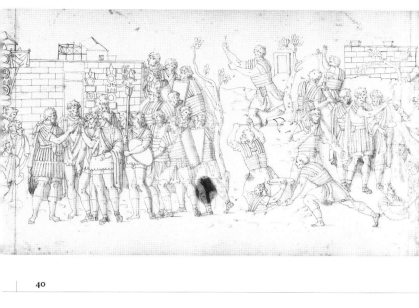

40

38

46

8136K 8136L

830 7831

7941

45

36

43

40

48 49

8137B

7833 7834

7943

48

39

412
Scene LIII
Settis 1988, pp.337–9
WM cat.10; 345 × 500 mm
SJSM, vol.113, fol.41

On the left four Dacians come to Trajan, apparently on an unsuccessful mission. The scene changes to the ceremonial rites performed to ensure the success of the new offensive in enemy territory. The emperor is shown in the centre inside the camp, preparing the ritual libation at the altar to purify the sacrifice, while outside the walls the procession of animals continues, the trumpeter leading them into the camp on the right.

The straight perimeter walls, also found on the frieze, are curved in the background of MSS 254 and 320, and the Modena drawing. The opening in the wall with the tent behind it in the frieze has been misinterpreted here, in MSS 254 and 320 and in Muziano's engraving as a pedimented gate.

OTHER REPRESENTATIONS Ripanda Codex, Rome, BIASA, MS 254, fol.39; Amico Aspertini, London, BM, I, fols 34v–35r (Bober 1957, p.67, fig.76); anonymous Italian, second half of the 16th century, Rome, BIASA, MS 320, fols 46–7; attributed to Giulio Romano, Modena, GE, inv. no.8136M; circle of Fulvio Orsini, Rome, BAV, Codex Ursinianus, fol.80r; Étienne Dupérac, Paris, BN, MS FR382, fol.78; Pietro Santi Bartoli, Windsor, RL, inv. nos 7941–2.
ENGRAVED Chacon 1576, fol.46 by Girolamo Muziano; Bartoli 1708, fol.37.

413
Scenes LIV–LV
Settis 1988, pp.339–41
No WM; 345 × 458 mm
SJSM, vol.113, fol.42

The soldiers assisting at the ceremony press against the outside of the camp walls. The sacrifice to the gods is followed by an address to the troops. The troops advance over mountainous terrain.

In the Soane drawing much more space is introduced between the figure in profile on the left holding a shield and the figure, also holding a shield, facing Trajan with his back turned than is found in the frieze, MS 320 or in Muziano's engraving. Only one shield is shown in the frieze. In MS 254 the break in the scene marks the end of fol.39 and the beginning of fol.40.

OTHER REPRESENTATIONS Ripanda Codex, Rome, BIASA, MS 254, fols 39–40; Amico Aspertini, London, BM, I, fols 34v–35r (Bober 1957, p.67, fig.76); anonymous Italian, second half of the 16th century, Rome, BIASA, MS 320, fols 47–8; attributed to Giulio Romano, Modena, GE, inv. nos 8136M–8137A; circle of Giulio Romano, Paris, PC, sequence 38 (Florence 1984a, p.25); Pietro Santi Bartoli, Windsor, RL, inv. no.7942.
ENGRAVED Chacon 1576, fol.47 by Girolamo Muziano; Bartoli 1708, fols 37–8; Montfauçon 1719, IV/I, p.44.

414
Scenes LV–LVII
Settis 1988, pp.341–2
No WM; 345 × 467 mm
SJSM, vol.113, fol.43

The Roman legionaries chop down trees with axes to flatten the ground and make a path; their shields and helmets are abandoned while they work. Two severed heads of Dacians are displayed on stakes at the entrance of the camp to frighten the enemy.

The foliage on the trees is treated differently in MS 320, the Modena drawing and Muziano's engraving, where it is rounded; the Soane and MS 254 drawings and Santi Bartoli's engraving have sparse, pointed foliage, similar to the trees on the frieze. The drafted masonry enclosure wall of the camp with an opening and two tents rising above it in the frieze is shown as two buildings with pitched roofs in this drawing, MSS 254 and 320, the Modena drawing and in Muziano's engraving.

OTHER REPRESENTATIONS Ripanda Codex, Rome, BIASA, MS 254, fols 40–41; anonymous Italian, second half of the 16th century, Rome, BIASA, MS 320, fol.49; attributed to Giulio Romano, Modena, GE, inv. no.8137B; circle of Giulio Romano, Paris, PC, sequence 38–9 (Florence 1984a, p.25); Pietro Santi Bartoli, Windsor, RL, inv. no.7942.
ENGRAVED Chacon 1576, fol.48 by Girolamo Muziano; Bartoli 1708, fols 38–9.

415
Scenes LVII–LVIII
Settis 1988, pp.343–4
WM cat.10; 345 × 494 mm
SJSM, vol.113, fol.44

Two contingents of cavalry and of
infantry inspect the territory while
in the background a Dacian fortress
is set alight. Trajan, on horseback
followed by an escort, rides out over
a wooden bridge; a horse behind him
rears up and refuses to follow. A group
of Dacians half-hidden behind a rocky
ridge watch the Emperor's advance,
while on the right three auxiliaries set
an abandoned village alight.

The frieze shows a fence behind
the soldier setting fire to the Dacian
fortress and rocky ground between
him and the building on the left, but
these features do not appear in MS 320
or in Muziano's engraving. The fence
linking the bridge with the building to
the right of it has one bay here, and two
bays in the frieze, MSS 254 and 320 and
in Muziano's engraving. The building
on the left of the Paris drawing is made
of courses, not blocks, and the roof is
plain. The busts behind the building
here, also shown in the other represen-
tations, appear on the frieze as three
three-quarter length figures next to
a tree, one holding a Dacian dragon
ensign, watching Trajan's advance.

OTHER REPRESENTATIONS Ripanda
Codex, Rome, BIASA, MS 254, fols 41–2
(Pasqualitti 1978); anonymous Italian,
second half of the 16th century, Rome,
BIASA, MS 320, fols 49–51; attributed
to Giulio Romano, Modena, GE, inv.
no.8137C–D (Macrea 1937, fig.8); circle
of Giulio Romano, Paris, PC, sequence
39–40 (Florence 1984a, p.25); Pietro
Santi Bartoli, Windsor, RL, inv. nos
7943–4.
ENGRAVED Chacon 1576, fols 49–50
by Girolamo Muziano; Bartoli 1708,
fols 39–40 (Florence 1984a, p.17, fig.7).

416
Scenes LX–LXI
Settis 1988, pp.346–9
No WM; 345 × 510 mm
SJSM, vol.113, fol.45

The construction of the Roman
fortification is watched by three
sentries whose heads appear over the
terrain in the background. One of the
legionaries, who has carried building
material in a hod on his back, stands
almost behind the Emperor, who is
taking part in the next scene of the
frieze. He stands surrounded by his
advisers in front of a fortified camp,
while a noble Dacian throws down
his shield in front of him in a gesture
of submission. He is watched by
the army, who are lined up in ranks
outside the walls of the camp.

The rocky background between
the buildings in the frieze and MS 320
is rendered by a fine horizon line only
in the Soane drawing. The small tent
in the enclosure wall is shown as a
small gabled building without a
window here, in MS 320 and Muziano's
engraving. Bartoli draws a window.
In the Paris drawing the building of
the fortification is rendered very
differently. The enclosure wall with
workmen inside has been missed out
altogether. Two soldiers, not one as
in the frieze and in the other drawings,
are shown carrying stone and both of
them wear helmets, although according
to the story they cast aside their arms,
shields and helmets in order to build.

Fresco IX on the west wall of the
salone in Bishop Riario's palace in
Ostia, dated 1511–13 and attributed
to the circle of Peruzzi, is based on scene
LX (Rome 1981a, figs 6 and 10; Agosti
& Farinella 1984, pp.407–10).

OTHER REPRESENTATIONS Ripanda
Codex, Rome, BIASA, MS 254, fols 42–3;
anonymous Italian, second half of the
16th century, Rome, BIASA, MS 320,
fols 51–51bis; attributed to Giulio
Romano, Modena, GE, inv. no.8137D–F;
circle of Giulio Romano, Paris, PC,
sequence 40 (Florence 1984a, p.25);
Pietro Santi Bartoli, Windsor, RL,
inv. nos 7944–5.
ENGRAVED Chacon 1576, fols 50–51
by Girolamo Muziano; Bartoli 1708,
fols 40–41 (Florence 1984a, fig.8).

| | 45 | | |

	42		43
	51		51BIS
	8137D	8137E	8137F
	7836		7837
944			
50		51	
		41	

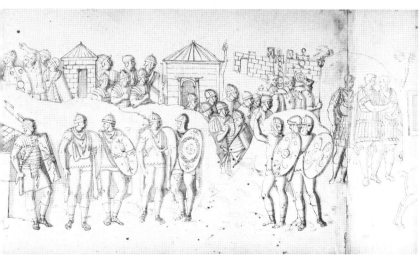

| 47 | | 48 |

		45
	54	
	8137H	
	7840	
	7946	
53		54
	43	

417
Scene LXII
Settis 1988, pp.350–51
WM cat.10; 345 × 485 mm
SJSM, vol.113, fol.46

On the left the scene is divided horizontally into two planes by rocky ridges. Carts drawn by mules and oxen are laden with barrels of wine. Three guards stand at the entrance to the camp, while legionaries oversee the transportation of provisions. In the background legionaries behind the camp stand between centrally planned buildings.

The small buildings in the background outside the enclosure wall, perhaps representing tombs, have diagonal buttresses in the frieze and in Bartoli's engraving, but these are not shown here or in MSS 254 and 320, the Paris and Modena drawings, or in Muziano's engraving. The view of the barrels on the carts, rising as they recede, is different in the frieze from the Soane, Modena and Paris drawings, MSS 254 and 320, and Muziano's engraving.

OTHER REPRESENTATIONS Ripanda Codex, Rome, BIASA, MS 254, fols 43–4; anonymous Italian, second half of the 16th century, Rome, BIASA, MS 320, fols 52–3; attributed to Giulio Romano, Modena, GE, inv. no.8137F–G; circle of Giulio Romano, Paris, PC, sequence 42 (Florence 1984a, p.25); Pietro Santi Bartoli, Windsor, RL, inv. no.7945.
ENGRAVED Chacon 1576, fol.52 by Girolamo Muziano; Bartoli 1708, fols 41–2; Montfaucon 1719, IV/I, p.75.

418
Scenes LXII–LXIII
Settis 1988, pp.352–3
No WM; 345 × 457 mm
SJSM, vol.113, fol.47

In the foreground groups of auxiliaries preside over the enemy territory. The circular buildings do not hold any pockets of resistance.

The trees and landscape in the Soane drawing and MS 254 are less detailed than in MS 320 and Muziano's engraving. The whole of the central section of scene LXIII, from the left of the last tempietto to the three armed Romans with shields behind Trajan, has been left out of the Paris drawing. The central building is fully drafted in MSS 254 and 320 and the Modena drawing; it has plain strips at the side in this drawing.

OTHER REPRESENTATIONS Ripanda Codex, Rome, BIASA, MS 254, fol.44; anonymous Italian, second half of the

16th century, Rome, BIASA, MS 320, fols 53–4; attributed to Giulio Romano, Modena, GE, inv. no.8137G–H; circle of Giulio Romano, Paris, PC, sequence 42 (Florence 1984a, p.26); Pietro Santi Bartoli, Windsor, RL, inv. no.7946, inscribed *pare vesito [vestito] giacio* below the group of three soldiers with shields.
ENGRAVED Chacon 1576, fol.53 by Girolamo Muziano; Bartoli 1708, fol.42 (Florence 1984a, p.20).

419
Scene LXIV
Settis 1988, pp.354–6
WM cat.1; 345 × 494 mm
SJSM, vol.113, fol.48

Trajan on the left, in discussion with an officer, points towards African horsemen from Mauritania under his command. The horsemen, riding bareback without bridles, wear short tunics and braided hair. They enter battle at a gallop and cut down the enemy, whose corpses lie on the ground.

The characteristic hair-style is not clearly shown in the drawings and engravings. The trees and landscape are less detailed here and in MS 254 than in MS 320 and in Muziano's engraving. The cavalry charges from right to left in the Paris version, and from left to right on the frieze and in the other versions. This could suggest that the Paris drawings were made from an engraver's plate (Florence 1984a, p.27).

OTHER REPRESENTATIONS Ripanda Codex, Rome, BIASA, MS 254, fol.45; anonymous Italian, second half of the 16th century, Rome, BIASA, MS 320, fols 54–5; attributed to Giulio Romano, Modena, GE, inv. no.8137H–I (Macrea 1937, fig.9); circle of Giulio Romano, Paris, PC, sequence 44 (Florence 1984a, p.27); Pietro Santi Bartoli, Windsor, RL, inv. nos 7946–7.
ENGRAVED Chacon 1576, fols 54–5 by Girolamo Muziano; Bartoli 1708, fols 43–4 (Florence 1984a, p.20, fig.14); Montfaucon 1719, IV/I, p.61.

420

Scenes LXIV–LXV
Settis 1988, pp.357–8
WM cat.10; 345 × 517 mm
SJSM, vol.113, fol.49

The Dacian infantry, abandoning
their dead, fly in disarray into the
woods. The Roman army continues
its advance, while Dacians hidden
behind the rocks observe the scene
from above. The legionaries build
more fortifications to ensure stability
in the occupied territory.

The scene is reversed in the Paris
drawing, suggesting that it may have
been made from an engraver's plate
(Florence 1984a, p.27).

OTHER REPRESENTATIONS Ripanda
Codex, Rome, BIASA, MS 254, fol.46;
anonymous Italian, second half of the
16th century, Rome, BIASA, MS 320,
fols 55–6; attributed to Giulio Romano,
Modena, GE, inv. no.81371–J; circle of
Giulio Romano, Paris, PC, sequence 43
(Florence 1984a, p.27); Pietro Santi
Bartoli, Windsor, RL, inv. nos 7947–8.
ENGRAVED Chacon 1576, fols 55–6
by Girolamo Muziano; Bartoli 1708,
fols 45–6.

421

Scenes LXV–LXVI
Settis 1988, pp.359–61
No WM; 345 × 494 mm
SJSM, vol.113, fol.50

The figures of the soldiers building
are half-buried in ditches and hidden
by walls. In the foreground a legionary
accompanies a cart carrying a catapult.
In the centre an embassy of two noble
Dacians approaches Trajan; they
take his hand to ask for a cease-fire.
The preparations for battle continue:
the legionaries build wooden struc-
tures, war machines are set up on the
walls and in the background a legion
lines up for action.

The enclosure wall with drafted
masonry on the inside is shown as
a hemicycle here and in MS 254 and
as a straight wall in MS 320 and in
Muziano's engraving. Only part of
the curving wall is present in the frieze.
There is a break in the middle of the
rear of the enclosure wall on the left in
Bartoli (fol.45), but it is not shown in
this drawing, in the frieze, MSS 254 and
320, or in Muziano's engraving. The
cart has baluster-shaped spokes in
MS 320 and in Muziano's engraving.
They are straight here as in MS 254
and the frieze; in the Modena drawing
they are more slender, like the spokes
in the relief.

OTHER REPRESENTATIONS Ripanda
Codex, Rome, BIASA, MS 254, fols 46–7;
anonymous Italian, second half of
the 16th century, Rome, BIASA, MS 320,
fols 56–7; attributed to Giulio Romano,
Modena, GE, inv. no.8137J–K–8134A;
Pietro Santi Bartoli, Windsor, RL, inv.
no.7948 (signed *Pietro Santi Di Bartoli*).
ENGRAVED Chacon 1576, fols 56–7
by Girolamo Muziano; Bartoli 1708,
fols 45–6; Montfaucon 1719, IV/I, p.40.

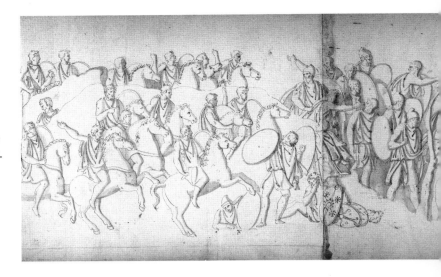

	49
	46
55	
81371	
7841	
	7947
	55
44	

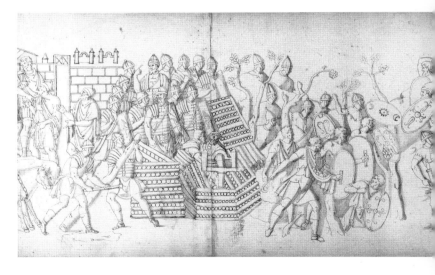

	51
	48
	58
	8134A
	7844
	7949
57	58
46	

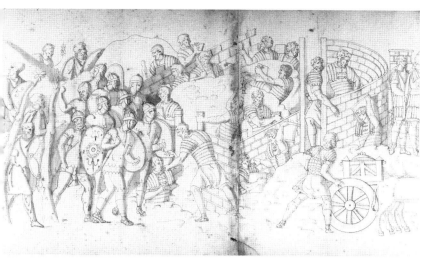

50

47

56

57

8137J

8137K

7842

7843

7948

56

45

422
Scene LXVI
Settis 1988, pp.363–4
WM cat.10; 345 × 509 mm
SJSM, vol.113, fol.51

A catapult is set up for action on one of
the wooden structures. The battle is
fought in a wood by auxiliary troops,
various special contingents of Spanish
slingers, Germans with naked torsos
and oriental archers wearing their typi-
cal conical helmets. They fight in front
of a fortress. Above them two Dacians
use a catapult, similar to those of the
Romans.

The foliage and landscape are less
detailed than in MS 320, and are closer
to MS 254. Bartoli has inserted a fence
below the catapult, but this is not shown
here, in the frieze, MSS 254 and 320,
or the Modena drawing, and Bartoli
has drawn the machine much more
specifically. In the frieze the top of the
wooden structure above the catapult
is not rendered as sections of logs
alternating with long logs as it is here,
in MS 320 and in Muziano's engraving.
A half-figure with a raised arm, shown
in Bartoli's engraving, is not present
here, in the frieze, MSS 254 and 320
or in the Modena drawing.

OTHER REPRESENTATIONS Ripanda
Codex, Rome, BIASA, MS 254, fols 47–8;
anonymous Italian, second half of
the 16th century, Rome, BIASA, MS 320,
fol.58; attributed to Giulio Romano,
Modena, GE, inv. no.8134A; Pietro Santi
Bartoli, Windsor, RL, inv. no.7949.
ENGRAVED Chacon 1576, fols 57–8
by Girolamo Muziano; Bartoli 1708,
fol.47; Montfauçon 1719, IV/I, p.16.

423
Scenes LXVII–LXVIII
Settis 1988, pp.366–7
No WM; 345 × 504 mm
SJSM, vol.113, fol.52

From behind a rocky crest, a contin-
gent of Dacians rushes to the aid of
their companions in the wood. In
the centre Dacians cut down trees to
complete their defensive structures,
which are shown in the background.
Two trees, the full height of the frieze,
end the episode.

There are more trees here, in the
frieze and in MS 254 than in MS 320,
the Modena drawing and Muziano's
engraving. The position of the feet
are not correctly observed in any of
the representations. The right foot of
the chopping figure on the left is raised
and in front of the leg of the figure
with a shield moving away from him
on the left. In the frieze the chopping
figure turning to the right has his right
foot resting on a log.

OTHER REPRESENTATIONS Ripanda
Codex, Rome, BIASA, MS 254, fols 48–9;
anonymous Italian, second half of the
16th century, Rome, BIASA, MS 320, fols
59–60; attributed to Giulio Romano,
Modena, GE, inv. no.8134B; Pietro Santi
Bartoli, Windsor, RL, inv. nos 7949–50.
ENGRAVED Chacon 1576, fols 58–9
by Girolamo Muziano; Bartoli 1708,
fols 47–8.

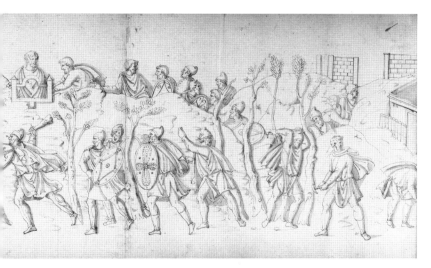

52

49

59

8134B

7845

7950

59

48

424

Scenes LXVIII–LXIX
Settis 1988, pp.369–70
No WM; 345 × 482 mm
SJSM, vol.113, fol.53

The Roman soldiers bring tree trunks
and build new walls. The Emperor
and his entourage stand outside the
building. Two auxiliaries bring a
prisoner with his hands bound behind
his back. The helmets and shields of
the legionaries are cast aside while they
cut down trees. In the background
the troops begin to assemble ready
for battle.

The wide space between the tree
on the right and the soldier to the
right of it is not present in the frieze,
MS 320 or in Bartoli's engraving; it is
found in MS 254, where it marks the end
of the folio. The three shields standing
below the rock on the right in the frieze,
MSS 254 and 320, the Modena drawing
and in Muziano's and Bartoli's engrav-
ings are not shown here. The plain wall
on the front of the enclosure is shown
as drafted masonry in the frieze, MSS
254 and 320, the Modena drawing and
in Muziano's engraving.

OTHER REPRESENTATIONS Ripanda
Codex, Rome, BIASA, MS 254, fol.49;
anonymous Italian, second half of
the 16th century, Rome, BIASA,
MS 320, fol.60; attributed to Giulio
Romano, GE, Modena, inv. no.8134C–D;
Pietro Santi Bartoli, Windsor, RL,
inv. no.7950.
ENGRAVED Chacon 1576, fols 59–60 by
Girolamo Muziano; Bartoli 1708, fol.49.

425

Scenes LXIX–LXX
Settis 1988, pp.372–3
WM cat.10; 345 × 512 mm
SJSM, vol.113, fol.54

The siege and capture of the mountain
fortress of the Dacian capital are
depicted in two scenes. The first
shows the meeting of the two armies,
represented by the diagonal group of
shields separating them. The Dacians
are overcome, and fall dead beneath
the Roman assault. Some manage to
escape to a fortress behind a wooden
palisade.

The legs of a dead man resting on
the first corpse in the frieze are not
recorded in MSS 254 and 320, Muziano's
engraving or in this drawing. The
position of the right leg of the last
dying Dacian before the tree is also
incorrectly recorded; it is extended
in the frieze, in MSS 254 and 320, and
in Muziano's engraving. In MS 254
the figure is in the gutter of the volume.

Fresco v in the salone of Bishop
Riario's palace in Ostia, dated 1511–13
and attributed to the circle of Peruzzi,
is based on this scene (Agosti &
Farinella 1984, pp.407–10).

OTHER REPRESENTATIONS Ripanda
Codex, Rome, BIASA, MS 254, fol.50;
anonymous Italian, second half of
the 16th century, Rome, BIASA, MS 320,
fols 61–2; attributed to Giulio Romano,
Modena, GE, inv. no.8134D–E; Pietro
Santi Bartoli, Windsor, RL, inv. nos
7950–51, inscribed *p. Sante Bartoli.*
ENGRAVED Du Choul 1569, p.15; Chacon
1576, fols 60–61 by Girolamo Muziano;
Bartoli 1708, fols 49–50; Montfauçon
1719, IV/I, p.55.

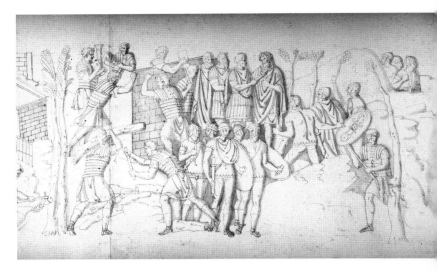

	53	
60		61
8134C		8134D
7846		7847
	60	
		49

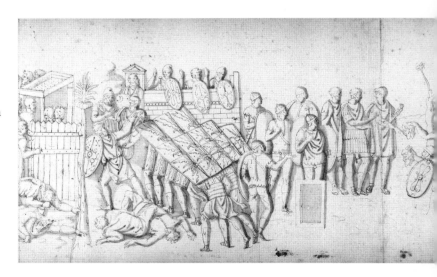

55		56
51		52
	63	
	8134F	
	7849	
7952		
62		63
	51	

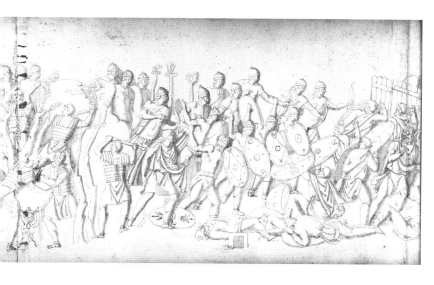

54

62

8134E

7848

7951

61

50

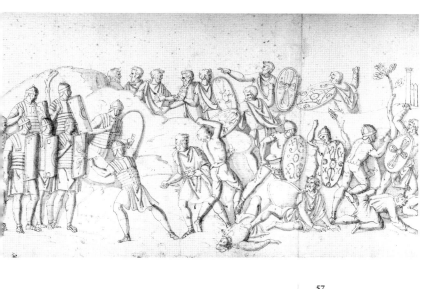

57

53

64 65

8134G 8134H

7850 7851

7953

64

52 53

426
Scene LXXI
Settis 1988, pp.376–7
No WM; 345 × 488 mm
SJSM, vol.113, fol.55

A tree marks the change of scene.
Dead bodies lie below it on either side.
The second scene of the siege shows
the Roman legion adopting a typical
formation called *testudo*. They hold
their shields above their heads and
try to break the defences and penetrate
the fortress. Trajan stands on a rocky
ridge on the right.

In the frieze the whole leg of the
soldier standing above the window is
visible; the legs are cut by the window
here, in MSS 254 and 320 and in
Muziano's engraving. The window
is not shown in the Paris drawing (at
this point the Paris drawing sequence
43 joins sequence 50–51, scenes
LXXI–LXXII). The round stone tower
and group of soldiers preparing to
depart on the right of the *testudo* scene
in the Paris drawing belong to scenes
LXXIV and LXXV. The *testudo* is repro-
duced exactly by Giulio Romano in
one of the *trompe-l'oeil* bronze reliefs
in the Sala di Costantino in the Vatican
(Agosti & Farinella 1984, p.412).

OTHER REPRESENTATIONS Ripanda
Codex, Rome, BIASA, MS 254, fol.51;
anonymous Italian, second half of
the 16th century, Rome, BIASA, MS 320,
fols 62–3; attributed to Giulio Romano,
Modena, GE, inv. no.8134E–F; circle
of Giulio Romano, Paris, PC, sequence
50–51 (Florence 1984a, p.27); circle
of Fulvio Orsini, Rome, BAV, Codex
Ursinianus, fol.81r; Pietro Santi Bartoli,
Windsor, RL, inv. no.7952.
ENGRAVED Du Choul 1569, p.83; Chacon
1576, fol.62 by Girolamo Muziano;
Bartoli 1708, fols 50–51; Montfauçon
1719, IV/I, pp.55 and 92 (Rome 1988a,
p.36, fig.12).

427
Scene LXXII
Settis 1988, pp.378–9
No WM; 345 × 512 mm
SJSM, vol.113, fol.56

The heads of two Dacian chieftains are
brought to Trajan as a symbol of his
victory over Decebal. The last battle of
the Dacian war begins. A legion in ser-
ried ranks waits in the woods to enter
battle. Two legionaries rush forward
to support the auxiliaries. The Dacians
are shown fleeing in the background.

The trees are in leaf behind the
figures holding the chieftains' heads
in the frieze, MSS 254 and 320 and in
Muziano's engraving.

OTHER REPRESENTATIONS Ripanda
Codex, Rome, BIASA, MS 254, fol.52;
anonymous Italian, second half of
the 16th century, Rome, BIASA, MS 320,
fols 63–4; attributed to Giulio Romano,
Modena, GE, inv. no.8134F–G; circle
of Giulio Romano, Paris, PC, sequence
51 (Florence 1984a, p.27); Pietro da
Cortona, Eton College; Pietro Santi
Bartoli, Windsor, RL, inv. nos 7952–3.
ENGRAVED Chacon 1576, fols 63–4
by Girolamo Muziano; Bartoli 1708,
fols 51–2.

428
Scenes LXXII–LXXII
Settis 1988, pp.381–2
WM cat.10; 345 × 501 mm
SJSM, vol.113, fol.57

The encounters in the heat of battle
are characterized by a repertory of
violent gestures. The Romans break
the resistance of the Dacians. Trajan
talks to his soldiers inside an enemy
fortress. In front of the fortress the
legionaries continue the occupation
of the territory by building and
making roads.

The window on the left of the tree
next to the soldier with the upraised
arm has not been drawn here, and
the fence above the window in the
frieze is not shown in any of the
representations. The half-figure on
the left of the window in the frieze
is also absent here, but it appears in
MSS 254 and 320 and in Muziano's
engraving. The fence to the right of
the window and the post and tree to its
left are shown as they are here in the
frieze, MSS 254 and 320, the Modena
drawing and Muziano's engraving.
The tree is omitted and the fence is
two bays long in Bartoli's engraving
(fol.53). The tomb or temple with
the pediment, also shown in MSS 254
and 320, the Modena drawing and
Muziano's engraving, is absent from
the frieze and from Bartoli's engraving.

OTHER REPRESENTATIONS Ripanda
Codex, Rome, BIASA, MS 254, fol.53;
anonymous Italian, second half of
the 16th century, Rome, BIASA, MS 320,
fols 64–5; attributed to Giulio Romano,
Modena, GE, inv. no.8134G–H; Pietro
da Cortona, Eton College; Pietro Santi
Bartoli, Windsor, RL, inv. no.7953.
ENGRAVED Chacon 1576, fols 64–5
by Girolamo Muziano; Bartoli 1708,
fols 52–3.

429
Scenes LXXIII–LXXIV
Settis 1988, pp.384–5
No WM; 345 × 495 mm
SJSM, vol.113, fol.58

Auxiliaries collect water from a stream, while others wait with their horses. On the right Trajan sits on a podium surrounded by many officers and the praetorian guard with ensigns. Inside the fortress, probably representing Sarmizegetusa, the legionaries with packs on their backs prepare to return home. Another Dacian fortress is shown on fol.90 (cat.461).

The wide space between the figure filling a vessel on the left and the horse is also found in MS 254, where it is caused by a break in the page; it is not present in the frieze, MS 320, the Modena drawing or in Muziano's engraving. The receding enclosure wall behind the gates into the fort depicted in the frieze, MSS 254 and 320 and in Muziano's engraving does not appear here or in the Modena drawing. There is a ladder in the background on the right of Bartoli's engraving, but it is not present in the frieze, here, in MS 320 or in the Modena drawing.

OTHER REPRESENTATIONS Ripanda Codex, Rome, BIASA, MS 254, fols 53–4; anonymous Italian, second half of the 16th century, Rome, BIASA, MS 320, fols 66–7; attributed to Giulio Romano, Modena, GE, inv. no.8134H–I; circle of Giulio Romano, Paris, PC, sequence 54; Pietro Santi Bartoli, Windsor, RL, inv. no.7954.
ENGRAVED Chacon 1576, fols 65–6 by Girolamo Muziano; Bartoli 1708, fols 53–4.

430
Scene LXXV
Settis 1988, pp.386–7
No WM; 345 × 498 mm
SJSM, vol.113, fol.59

The Dacian embassy, their arms cast aside, kneel in defeat and ask for mercy. Behind them a group of standing Dacians, their hands bound behind their backs, listen to Trajan.

The background wall, which is broken in the Soane drawing, is partially filled by a gate in the frieze, MSS 254 and 320, the Paris drawing and Muziano's engraving; it is joined in Bartoli's engraving. The receding drafted masonry wall next to the fence is not shown in the Modena drawing.

Fresco XIV on the north wall of Bishop Riario's palace in Ostia, dated 1511–13 and attributed to the circle of Peruzzi, is based on this scene (Rome 1981a; Agosti & Farinella 1984, pp.407–10).

OTHER REPRESENTATIONS Ripanda Codex, Rome, BIASA, MS 254, fols 54–5; Amico Aspertini, London, BM, I, fols 1v–2r, 41v–42r (Bober 1957, pp.47 and 72, figs 6 and 91); anonymous Italian, second half of the 16th century, Rome, BIASA, MS 320, fol.67; attributed to Giulio Romano, Modena, GE, inv. no.81341–J; circle of Giulio Romano, Paris, PC, sequence 54–5 (Florence 1984a, p.28); Pietro Santi Bartoli, Windsor, RL, inv. nos 7954–5.
ENGRAVED Chacon 1576, fols 66–7 by Girolamo Muziano; Bartoli 1708, fols 54–5.

 58

 54

 66

 81341

 7852

 7954

 65

 54

 60

 68

 8134K

 8135A

 7854

 68

 56

59

55

67

8134J

7853

7955

66 67

55

61

70

8135B

7855 7856

7956

69

57

431
Scenes LXXV–LXXVI
Settis 1988, pp.389–91
WM cat.10; 345 × 502 mm
SJSM, vol.113, fol.60

The Dacians throw their shields to
the ground and beg for mercy; in the
centre Decebal towers above the group
and makes a great gesture of supplica-
tion to Trajan. Behind Decebal, two
Dacians demolish defences, enforcing
the terms of the peace; on the right
the Dacian men, women and children
abandon their homes and land.

The coats of arms are not drawn
on the shield as they are in the frieze,
MSS 254 and 320, the Modena drawing
and Muziano's engraving. In the frieze
the first gabled building above the
wall has two rectangular openings, the
one on the left shorter than that on the
right, and the building to the right of it
also has two apertures. All three build-
ings inside the wall have tall, rectangu-
lar doors and crenellations are shown
on the wall. None of these features is
shown here, in MS 320 or in Muziano's
engraving. The schematic architecture
in the background of the frieze, repro-
duced here, in MSS 254 and 320, the
Paris and Modena drawings and in
Muziano's engraving, is rendered very
differently in Bartoli's engraving. In
the Paris drawing the architecture is
much more neatly drawn than in any
of the other versions, with plain fasciae
framing the masonry blocks of the wall,
not present in the relief.

Fresco XIV on the north wall of
Bishop Riario's palace in Ostia, dated
1511–13 and attributed to the circle of
Peruzzi, is based on this scene (Agosti
& Farinella 1984, p.409).

OTHER REPRESENTATIONS Ripanda
Codex, Rome, BIASA, MS 254, fols 55–6;
anonymous Italian, second half of the
16th century, Rome, BIASA, MS 320,
fols 68–9; attributed to Giulio Romano,
Modena, GE, inv. no.8134K–8135A;
circle of Giulio Romano, Paris, PC,
sequence 56–7 (Florence 1984a, p.28);
Pietro Santi Bartoli, Windsor, RL,
inv. nos 7955–6.
ENGRAVED Chacon 1576, fols 67–8
by Girolamo Muziano; Bartoli 1708,
fols 56–7 (Florence 1984a, fig.10).

432
Scene LXXVII
Settis 1988, pp.392–3
No WM; 345 × 407 mm
SJSM, vol.113, fol.61

The domestic animals wait quietly
before leaving with the Dacians. A
tree marks the scene change. In the
centre, Trajan, dressed for travelling,
stands on a podium and salutes the
soldiers he is leaving behind in Dacia.

The top of the podium is visible in
MS 320, the Modena drawing and in
Muziano's engraving; it is not shown
here, in the frieze or in MS 254.

OTHER REPRESENTATIONS Ripanda
Codex, Rome, BIASA, MS 254, fol.56;
anonymous Italian, second half of
the 16th century, Rome, BIASA, MS 320,
fols 69–70; attributed to Giulio
Romano, Modena, GE, inv. no.8135A–B
(Macrea 1937, fig.10); circle of Giulio
Romano, Paris, PC, sequences 56–7
and 57–8 (Florence 1984a, p.28); circle
of Fulvio Orsini, Rome, BAV, Codex
Ursinianus, fol.74; Pietro Santi Bartoli,
Windsor, RL, inv. no.7956, inscribed
sel soldato di sotto/va congiato con lalatro
in the centre above the standards.
ENGRAVED Chacon 1576, fols 68–9
by Girolamo Muziano; Bartoli 1708,
fols 57–8.

433
Scene LXXVIII
Settis 1988, pp.395–6
No WM; 345 × 300 mm
SJSM, vol.113, fol.62

A winged victory stands in profile with one foot resting on a helmet. She is writing on a shield about the events and the success of the Roman army. There are trophies on either side of her in the frieze, MS 320, the Paris drawing and Muziano's engraving.

There is a break in the sequence at this point, and the group of trophies on the left has been omitted.

OTHER REPRESENTATIONS Ripanda Codex, Rome, BIASA, MS 254, fol.57; anonymous Italian, second half of the 16th century, Rome, BIASA, MS 320, fols 70–71; attributed to Giulio Romano, Modena, GE, inv. no.8135B–C (Macrea 1937, fig.10); circle of Giulio Romano, Paris, PC, sequence 57–8 (Florence 1984a, p.28); circle of Fulvio Orsini, Rome, BAV, Codex Ursinianus, fol.97r; Pietro Santi Bartoli, Windsor, RL, inv. nos 7956–7; Turin, BR, Codex Varia, no.212.
ENGRAVED Du Choul 1569, p.65r; Chacon 1576, fols 69–70 by Girolamo Muziano; Bartoli 1708, fol.58; Montfauçon 1719, IV/I, p.93; Piranesi 1774-9, pl.XIV (Wilton-Ely 1994, fig.702).

434
Scene LXXIX
Settis 1988, pp.397–8
No WM; 345 × 503 mm
SJSM, vol.113, fol.63

The scene is described by Chacon as Trajan's return to Rome. It is interpreted correctly by Santi Bartoli as his return to Dacia from Rome for the second Dacian War against Decebal.

The Roman ships leave from the port of Ancona at night in the spring of AD 105. The temple of Venus situated at the top of the hill and the triumphal arch with three figures on top at the entrance to the port represent the temple and arch at Ancona, which is probably the only recognizable city in the frieze. In the lamplight, Trajan, standing in the centre, beats out the rhythm for the oarsmen. (On whether Ancona is the city depicted, see Turcan Déléani 1958, p.15.)

The architecture of the frieze is rendered correctly here, in MSS 254 and 320, in the Modena and Paris drawings and in Muziano's engraving; in Bartoli's engraving a long rectangular building is shown behind Trajan, instead of the barrel-vaulted bays shown in the frieze, MSS 254 and 320 and in Muziano's engraving. However, the barrel-vaulted bays have a rectangular roof behind them in the frieze that is not shown in any of the drawings, suggesting that Bartoli interpreted the Roman convention of the elevational view, where the principal characteristics of the elevation, section and plan are shown in a single image.

Fresco X on the west wall of the salone in Bishop Riario's palace in Ostia, dated 1511–13 and attributed to the circle of Peruzzi, is based on this scene (Borghini 1981, fig.3; Agosti & Farinella 1984, pp.407–10).

OTHER REPRESENTATIONS Ripanda Codex, Rome, BIASA, MS 254, fol.58; anonymous Italian, second half of the 16th century, Rome, BIASA, MS 320, fols 71–2; attributed to Giulio Romano, Modena, GE, inv. no.8135C–D (Macrea 1937, fig.11); circle of Giulio Romano, Paris, PC, sequence 59 (Florence 1984a, p.29); circle of Fulvio Orsini, Rome, BAV, Codex Ursinianus, fol.97; Nicholas Poussin, Turin, BR, inv. no.16307B (Blunt 1974, cat.334, pl.260); Pietro Santi Bartoli, Windsor, RL, inv. no.7957.
ENGRAVED De Baif 1536, fol.24; Chacon 1576, fols 71–2 by Girolamo Muziano; Bartoli 1708, fol.59; Montfauçon 1719, IV/II, p.141.

62		63	
57		58	
71			7
	8135C		
	7857		
	7957		
70		71	
58		59	

65			
		60	
	74		
8135F			
	7860		
		7959	
73			74
	61		

64

59
73
8135D 8135E
7859
7958
72
60

66

61
75 76
8135G 8135H
7861 7862
7960
75
62 63

435

Scenes LXXIX–LXXX

Settis 1988, pp.399–400

WM cat.10; 345 × 505 mm

SJSM, vol.113, fol.64

Although the ships are already within sight of land, dolphins dive beneath the waves to show that they have crossed a stretch of open sea. On the jetty, reinforced by arches, a bull has been sacrificed to the gods as a ritual offering to protect Trajan's journey. The entire population of the port, on the coast of Dalmatia, waits to greet the Emperor.

In this drawing, MS 254 and the Modena drawing the arcade of the jetty continues below the two-arched basement of the narrow gabled building; no basement is shown below the building in the frieze, MSS 254 and 320, or in Muziano's and Bartoli's engravings. The architecture is treated very differently and far less schematically by Bartoli. The window that cuts the figure to the right of Trajan in the column is not shown in any of the drawings.

OTHER REPRESENTATIONS Ripanda Codex, Rome, BIASA, MS 254, fol.59; anonymous Italian, second half of the 16th century, Rome, BIASA, MS 320, fols 72–3; attributed to Giulio Romano, Modena, GE, inv. no.8135D–E (Macrea 1937, fig.11); Pierre Jacques (Reinach 1902, tav.94); Nicholas Poussin, Chantilly, MC, inv.no.A1205: NI249 (Blunt 1974, cat.335, pl.260); Pietro Santi Bartoli, Windsor, RL, inv. nos 7957–8.

ENGRAVED De Baif 1536, fol.24; Chacon 1576, fol.72; Bartoli 1708, fols 59–60.

436

Scenes LXXXI–LXXXII

Settis 1988, pp.402–4

WM cat.10; 345 × 500 mm

SJSM, vol.113, fol.65

Trajan greets the citizens in front of a large building with a square trabeated courtyard. Locals form a queue along the jetty to welcome him. Soldiers on the ships anchored offshore furl the sails to the masts and clean the hulls, in preparation for the second leg of the journey. A group of men and children form a procession behind a crest of rock, before taking part in a sacrifice.

The canopy on the boat is plain here; it is decorated in MSS 254 and 320, in the Modena drawing and in Muziano's engraving. On the column this area is badly damaged. The central tower in Bartoli's engraving is round and has

two arches below it, as in the frieze. Three arches are shown here, in MSS 254 and 320, the Modena drawing and in Muziano's engraving.

OTHER REPRESENTATIONS Ripanda Codex, Rome, BIASA, MS 254, fols 59–60; anonymous Italian, second half of the 16th century, Rome, BIASA, MS 320, fols 74–5; attributed to Giulio Romano, Modena, GE, inv. no.8135F; Pietro Santi Bartoli, Windsor, RL, inv. nos 7958–9.

ENGRAVED De Baif 1536, fol.14; Chacon 1576, fols 74–5 by Girolamo Muziano; Bartoli 1708, fol.61; Montfauçon 1719, IV/II, p.138.

437

Scenes LXXXII–LXXXIV

Settis 1988, pp.405–6

No WM; 345 × 498 mm

SJSM, vol.113, fol.66

The procession of citizens continues in the second place visited by Trajan on his journey; it is interrupted by an arch. In the centre of the composition Trajan advances towards the bulls waiting to be sacrificed.

Bartoli (fol.62) moves the position of the window on Trajan's column a little to the right in order to align it with the pilaster of the arch. The window is accurately drawn in the other representations.

OTHER REPRESENTATIONS Ripanda Codex, Rome, BIASA, MS 254, fols 60–61; anonymous Italian, second half of the 16th century, Rome, BIASA, MS 320, fols 75–6; attributed to Giulio Romano, Modena, GE, inv. no.8135G–H; Pietro Santi Bartoli, Windsor, RL, inv. nos 7959–60.

ENGRAVED Chacon 1576, fols 74–5 by Girolamo Muziano; Bartoli 1708, fols 62–3.

438
Scene LXXXV
Settis 1988, pp.409–10
WM cat.10; 345 × 474 mm
SJSM, vol.113, fol.67

While attending the sacrifice, the soldiers, in civilian dress, are ranged in ranks in front of the fortress, with two sentries on duty inside. The stern of a boat in the centre and the prow of another behind the wall allude to the third leg of the journey. The soldiers disembark at a coastal city. The long jetty is reinforced with arches below it.

OTHER REPRESENTATIONS Ripanda Codex, Rome, BIASA, MS 254, fols 61–2; anonymous Italian, second half of the 16th century, Rome, BIASA, MS 320, fols 76–7; attributed to Giulio Romano, Modena, GE, inv. no.8135H–I; circle of Fulvio Orsini, Rome, BAV, Codex Ursinianus, fol.78r; Pietro da Cortona, Berlin, SKK, inv. no.HDZ3679 (Berlin 1967, pp.71–3, cat.47, Taf.25); Pietro da Cortona, Eton College; Pietro Santi Bartoli, Windsor, RL, inv. nos 7960–61.
ENGRAVED Chacon 1576, fols 75–6 by Girolamo Muziano; Bartoli 1708, fols 63–4.

439
Scenes LXXXVI–LXXXVII
Settis 1988, pp.411–14
WM cat.10; 345 × 495 mm
SJSM, vol.113, fol.68

Trajan makes another sacrifice. The crowd clusters around the bull, which lies dead at the altar. A theatre is the main feature of the cityscape in the background. In the centre, a ship with sails furled refers to the next leg of the sea voyage. Soldiers disembark on the right and cluster around Trajan.

The drawing of the theatre is much more specific in Bartoli's engraving than it is here, in the frieze, in MS 320, the Modena drawing and in Muziano's engraving. The seating arrangement of the theatre and the plan of the stage are shown here and in MS 254 according to Roman architectural drawing convention recorded on the column, which shows the façade, plan and interior features of the building in a single image. The canopy above the stage, shown with horizontal lines only, is drawn with vertical lines as well in MSS 254 and 320. The draughtsman of the Modena drawing has not understood the image completely. The whole of the anchor is shown in the frieze, MS 254, the Modena drawing and in Muziano's engraving; only half of it is shown in MS 320.

OTHER REPRESENTATIONS Ripanda Codex, Rome, BIASA, MS 254, fols 62–3; Amico Aspertini, London, BM, I, fols 31v–32r (Bober 1957, p.67, fig.73); anonymous Italian, second half of the 16th century, Rome, BIASA, MS 320, fols 77–8; attributed to Giulio Romano, Modena, GE, inv. nos 81351–8138A; circle of Fulvio Orsini, Rome, BAV, Codex Ursinianus, fol.78 (scene LXXXVI); Berlin, SKK, inv. no.Hdz3679 (Berlin 1967, pp.71–3, cat.4, Taf.25); Nicholas Poussin, Chantilly, MC, inv. no.AI206, NI250 and Turin, BR. inv.no.16307B (Rosemberg & Prat 1994, I, pp.372–3, cat.195; pp.382–3, cat.200); Pietro Santi Bartoli, Windsor, RL, inv. no.7961.
ENGRAVED Chacon 1576, fols 76–7 by Girolamo Muziano; Bartoli 1708, fols 64–5.

440
Scenes LXXXVIII–LXXXIX
Settis 1988, pp.414–16
No WM; 345 × 505 mm
SJSM, vol.113, fol.69

At the end of the long sea voyage, Trajan begins the journey by land to Dacia. The ensigns and carts loaded with arms and baggage follow the soldiers, who turn towards the Emperor. The cavalcade that will lead Trajan and his army to Dacia forms in front of a fortified city. The brisk pace of the gallop is expressed by the cloaks flying in the wind. The horsemen pass three towers; only one is shown in all of the drawings.

Chacon interprets the unarmed figures as priests, Bartoli as soldiers whose lances are not shown because of the difficulty of carving them.

OTHER REPRESENTATIONS Ripanda Codex, Rome, BIASA, MS 254, fols 63–4; anonymous Italian, second half of the 16th century, Rome, BIASA, MS 320, fols 78–9; attributed to Giulio Romano, Modena, GE, inv. no.8138A–B; attributed to Perino del Vaga, Bratislava (scene LXXXVIII), photographic collection of the Uffizi, GDS; Pietro Santi Bartoli, Windsor, RL, inv. no.7962.
ENGRAVED Chacon 1576, fol.78 by Girolamo Muziano; Bartoli 1708, fols 65–6.

67		68
	62	
	77	
	81351	
	7863	
7961		
76		
64		

70	
64	
79	80
8138B	8138C
7865	7866
	796
79	
67	

69

63

78

8138A

7864

7962

77 78

65 66

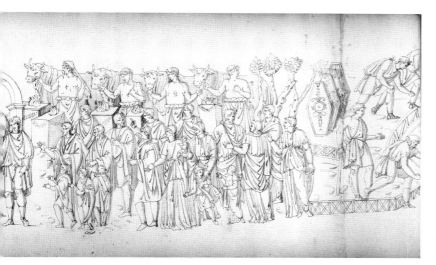

1 72

65

81

8138D

7867

80 81

68

441

Scenes XC–XCI

Settis 1988, pp.417–18

No WM; 345 × 339 mm

SJSM, vol.113, fol.70

Trajan at the head of the cavalcade is greeted joyfully by a group of civilian men and boys in clothes like those worn by Dacians.

OTHER REPRESENTATIONS Ripanda Codex, Rome, BIASA, MS 254, fol.64; anonymous Italian, second half of the 16th century, Rome, BIASA, MS 320, fol.79; attributed to Giulio Romano, Modena, GE, inv. no.8138B–C; Pietro Santi Bartoli, Windsor, RL, inv. nos 7962–3.

ENGRAVED Chacon 1576, fol.79 by Girolamo Muziano; Bartoli 1708, fol.67; Montfauçon 1719, IV/I, p.51.

442

Scene XCI

Settis 1988, pp.419–20

WM cat.10; 345 × 501 mm

SJSM, vol.113, fol.71

Another solemn sacrifice takes place under an arch. Trajan pours the libation on the altar in the presence of the citizens and the *victimarii* with the bulls. On the right a group of Roman soldiers, their shields cast aside, cut down trees to make way for a road through the forest. Between the trees the bridges and railings of a complex system of roads can be seen.

The fences with criss-cross panels at the side of the road in the drawing are like those in the frieze, MSS 254 and 320, the Modena drawing and Muziano's engraving. In the foreground of the frieze, below the four shields resting on the ground, are two fences, one above the other; only one fence is shown in MS 320 and in Muziano's engraving.

A drawing by Francesco Primaticcio for the fresco of *Paris Killed Below the Walls of Troy* in the vestibule at Fontainebleau derives from this scene.

OTHER REPRESENTATIONS Ripanda Codex, Rome, BIASA, MS 254, fols 64–5; anonymous Italian, second half of the 16th century, Rome, BIASA, MS 320, fol.80; attributed to Giulio Romano, Modena, GE, inv. no.8138C–D; circle of Fulvio Orsini, Rome, BAV, Codex Ursinianus, fol.76r; attributed to Polidoro da Caravaggio, Florence, Uffizi 13401F; Francesco Primaticcio, Frankfurt am Main, SK (Malke 1980, pp.173–5, cat.84; Rome 1988a, fig.3); L. D. [Leon Davent?], Vienna, Albertina (Rome 1988a, p.23, fig.4); Pietro da Cortona, Eton College; Pietro da

Cortona, Berlin, SKK, inv. no.Hdz3679 (Berlin 1967, pp.73–4, cat.47, Taf.25); Pietro Santi Bartoli, Windsor, RL, inv. no.7963.

ENGRAVED Chacon 1576, fols 79–80 by Girolamo Muziano; Bartoli 1708, fols 67–8.

443

Scene XCII

Settis 1988, pp.422–4

WM cat.10; 345 × 499 mm

SJSM, vol.113, fol.72

The soldiers cut down trees with axes, while in the background two soldiers demolish a fortification with picks. On the left a tree rising the full height of the frieze closes the scene and ends this phase of the narrative. On the right of it the Dacians regroup their army at a fortress.

The half-gable in the enclosure, behind the figure on the left chopping trees, also shown in MSS 254 and 320 and in Muziano's engraving in precisely the same way, appears as a fully gabled building in the frieze. A triangular element on the left of the left post in the background is shown in MS 320 and the Modena drawing; it is not shown in full here or in MS 254, where a diagonal line has been drawn.

Nicholas Poussin drew the torsos of two figures chopping down trees (Blunt 1974, p.36, cat.328, pl.257).

OTHER REPRESENTATIONS Ripanda Codex, Rome, BIASA, MS 254, fol.66 (Pasqualitti 1978); anonymous Italian, second half of the 16th century, Rome, BIASA, MS 320, fol.82; attributed to Giulio Romano, Modena, GE, inv. no.8138E; Pietro da Cortona, Eton College; anonymous Roman, first half of the 17th century, Berlin, SKK, inv. no.Hdz3679 (Berlin 1967, pp.73–4, cat.47, Taf.25); Pietro Santi Bartoli, Windsor, RL, inv. nos 7963–4.

ENGRAVED Du Choul 1569, p.34; Chacon 1576, fols 81–2 by Girolamo Muziano; Bartoli 1708, pp.68–9; Montfauçon 1719, IV/I, p.39.

444
Scenes XCIII–XCIV
Settis 1988, pp.424–7
No WM; 345 × 498 mm
SJSM, vol.113, fol.73

The Dacians in a fortress in a mountainous area prepare to start fighting again with the Romans left behind in Dacia. The figure pointing to the first-floor window in the gate of the fortress is probably Decebal. On the right the Dacians return to Decebal's fortress, in flight from their attempted siege.

The gate on the right is rendered three-dimensionally in the frieze, MSS 254 and 320, the Modena and Paris drawings, and in Muziano's and Bartoli's engravings, but not in the Soane drawing. The wall on the right of the first entrance tower is plain in the Modena drawing; it is of drafted masonry here, in the frieze, in MSS 254 and 320 and in Muziano's engraving. The city wall is lower in the Bartoli engraving (fol.70) than in the other representations.

OTHER REPRESENTATIONS Ripanda Codex, Rome, BIASA, MS 254, fols 66–7 (Pasqualitti 1978); anonymous Italian, second half of the 16th century, Rome, BIASA, MS 320, fols 83–4; attributed to Giulio Romano, Modena, GE, inv. no.8138F–G; circle of Giulio Romano, Paris, PC, sequence 70–72; circle of Fulvio Orsini, Rome, BAV, Codex Ursinianus, fol.77; Pietro da Cortona, Berlin, SKK, inv. no.Hdz3679 (Berlin 1967, pp.73–4, cat.47, Taf.25); Pietro Santi Bartoli, Windsor, RL, inv. nos 7964–5.
ENGRAVED Chacon 1576, fols 82–3 by Girolamo Muziano; Bartoli 1708, fols 69–70.

445
Scene XCIV
Settis 1988, pp.427–30
No WM; 345 × 504 mm
SJSM, vol.113, fol.74

The Dacians attack the Roman fortified camp and are overcome by the immediate reaction of the besieged troops. Auxiliaries ceaselessly shower them with darts from the walls, and the Roman sortie on to the battlefield is entirely successful.

The curved drafted masonry wall behind the window in the centre here, in the frieze, MSS 254 and 320, and the Modena drawing is shown plain in Muziano's engraving. It does not appear in the Paris drawing, where the figures are represented on the same plane.

OTHER REPRESENTATIONS Ripanda Codex, Rome, BIASA, MS 254, fols 67–8; anonymous Italian, second half of the 16th century, Rome, BIASA, MS 320, fols 84–5; attributed to Giulio Romano, Modena, GE, inv. no.8138G–H; circle of Giulio Romano, Paris, PC, sequence 70–72 (Florence 1984a, p.29); Pietro Santi Bartoli, Windsor, RL, inv. no.7965.
ENGRAVED Chacon 1576, fols 83–4 by Girolamo Muziano; Bartoli 1708, fol.71; Montfauçon 1719, IV/I, p.58.

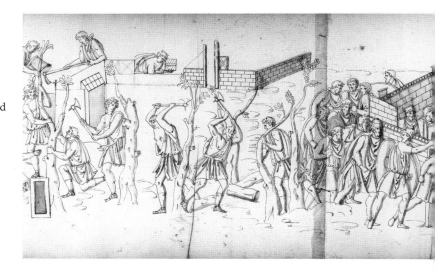

	73	
66		
82		83
8138E		8138F
7868		7869
	7964	
		82
69		

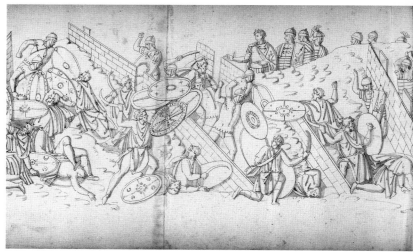

	75	
68		
85		
8138H		
7871		
		7966
84		85
72		

446
Scenes XCV–XCVI
Settis 1988, pp.431–3
WM cat.10; 345 × 498 mm
SJSM, vol.113, fol.75

The battle continues close to fortifications built in the mountains. The soldiers cross shields and the enemy falls. In the background a Roman column, led by an officer, comes to their aid. A Dacian prisoner, the man without a helmet inside the walls, is shown to the officer as a symbol of victory. The arrival of Trajan on horseback marks the end of the series of encounters and expresses the complete success of the Roman army.

The faintly drawn window behind Trajan leading the cavalry on the right is present in the frieze, MS 254 and the Modena drawing, but it is not shown in MS 320 or in Muziano's engraving.

OTHER REPRESENTATIONS Ripanda Codex, Rome, BIASA, MS 254, fols 68–9; anonymous Italian, second half of the 16th century, Rome, BIASA, MS 320, fols 85–6; attributed to Giulio Romano, Modena, GE, inv. no.8138H–I; circle of Giulio Romano, Paris, PC, sequence 72–4 (Florence 1984a, p.30); Pietro Santi Bartoli, Windsor, RL, inv. nos 7965–6.
ENGRAVED Chacon 1576, fols 84–5 by Girolamo Muziano; Bartoli 1708, fols 72–3; Montfauçon 1719, IV/I, p.57.

447
Scenes XCVII–XCVIII
Settis 1988, pp.434–6
WM cat.10; 345 × 502 mm
SJSM, vol.113, fol.76

The Roman cavalry led by Trajan advances through the trees. In the foreground three soldiers in civilian dress cut down trees to make a road through the forest. In the centre one is shown felling a tree close to a legionary who is taking part in the next scene. The armed legionaries line up for the solemn sacrifice in front of one of the very few places that can be securely identified in the frieze, the encampment at Pontes. The entrance gate to the bridge over the Danube between Drobeta and Pontes is shown.

The position of the standing soldier to the right of the soldier chopping down the tree, with a short distance between them, is the same in MS 254 and the Modena drawing; in the frieze they are shoulder-to-shoulder. MS 320 is damaged on the far right so that the relative positions of the soldiers cannot be assessed.

OTHER REPRESENTATIONS Ripanda Codex, Rome, BIASA, MS 254, fol.69 (Pasqualitti 1978); anonymous Italian, second half of the 16th century, Rome, BIASA, MS 320, fols 86–7; attributed to Giulio Romano, Modena, GE, inv. no.8138I–J; circle of Giulio Romano, Paris, PC, sequence 73–4 (Florence 1984a, p.30); circle of Fulvio Orsini, Rome, BAV, Codex Ursinianus, fol.79r; Étienne Dupérac, Paris, BN, MS FR383, fol.97; Pietro Santi Bartoli, Windsor, RL, inv. no.7966.
ENGRAVED Chacon 1576, fols 85–6 by Girolamo Muziano; Bartoli 1708, fol.73.

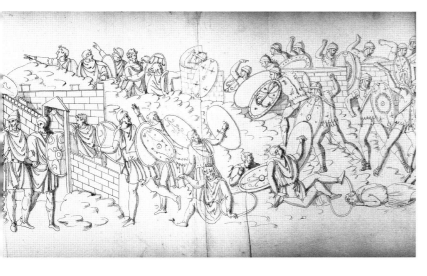

74

67

84

8138G

7870

7965

83

71

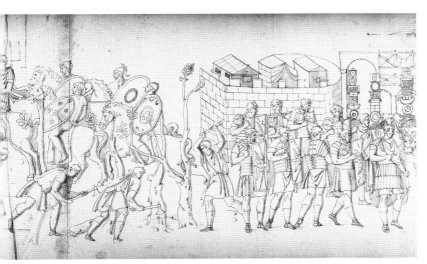

76

69

87

381

8138J

372

7873

86

74

448
Scenes XCVIII–XCVIX
Settis 1988, pp.437–9
WM cat.10; 345 × 504 mm
SJSM, vol.113, fol.77

Trajan makes the solemn sacrifice in
front of the bridge over the Danube.
The bridge is reproduced in an abbrevi-
ated but accurate form showing the
distinction between the stone piers
and the wooden superstructure. The
figure in the foreground behind and
to the right of Trajan is probably
Apollodorus of Damascus, the
architect of the bridge, who took part
in the war. Delegations of barbarian
tribes sent to negotiate with the
Emperor wait in front of the Roman
city of Dorbeta, which was built on
the left bank of the Danube. In the
background the most important
buildings of the city are shown: the city
wall and the wooden amphitheatre out-
side the walls. (For military amphithe-
atres, see Klima & Vetters 1953.)

The structure of the bridge with its
stone piers and timber-frame arches is
recorded accurately from the frieze in
this drawing, in MS 254, the Windsor
drawing and in Santi Bartoli's engrav-
ing. It is not clearly rendered in the
Modena drawing, MS 320, the Paris
drawing or Muziano's engraving,
which show semicircular stone arches
supporting a parapet. (For the excava-
tion of the bridge, see Aschbach 1858;
Tudor 1931, pp.41–6; it had 20 stone
piers in the water, and fragments of
the wooden superstructure were found
in the river.) The drafted masonry
enclosure wall on the right joins or
disappears behind the theatre here and
in MSS 254 and 320, the Paris drawing
and Muziano's engraving. In the frieze
the wall rises above the theatre to
indicate recession. A gap between
the buildings has been understood in
Bartoli's engraving. In the Paris draw-
ing the theatre on the right is rendered
diagrammatically as a tube with con-
centric half circles inside, and a large
rocky hill is shown behind it, not
present in any of the other drawings.
The seating plan is clear in the frieze,
in this drawing and in MS 254, but it is
not legible in the Modena drawing.

OTHER REPRESENTATIONS Ripanda
Codex, Rome, BIASA, MS 254, fols 69–70
(Pasqualitti 1978); anonymous Italian,
second half of the 16th century, Rome,
BIASA, MS 320, fols 87–8; attributed to
Giulio Romano, Modena, GE, inv. nos
8139J–8139A (Macrea 1937, fig.12); circle
of Giulio Romano, Paris, PC, sequence
74–5 (Florence 1984a, p.30); circle of
Fulvio Orsini, Rome, BAV, Codex

Ursinianus, fol.79r; Pietro da Cortona,
Eton College; Étienne Dupérac, Paris,
BN, MS FR382, fol.79; Nicholas Poussin,
Chantilly, MC, inv. no.PI206, NI250
(Blunt 1974, p.36, cat.329, pl.257);
Pietro Santi Bartoli, Windsor, RL,
inv. no.7967.
ENGRAVED Chacon 1576, fols 86–7
by Girolamo Muziano; Bartoli 1708,
fols 74–5; Montfauçon 1719, IV/II, p.115
(the bridge is illustrated).

449
Scenes C–CI
Settis 1988, pp.440–41
No WM; 345 × 501 mm
SJSM, vol.113, fol.78

While Trajan receives a group of
ambassadors, the troops, fully
equipped for war, use the new
permanent bridge over the Danube.
They pass through the terminal arch
of the bridge and reach the Dacian
bank of the river to begin the decisive
campaign against the Dacians.

The arch is drawn in perspectively
at an oblique angle in the frieze, in
this drawing, in MSS 254 and 320,
the Modena drawing and Muziano's
engraving; it is shown frontally in
Bartoli's engraving. The top of the arch
is damaged in the frieze. In the Paris
drawing it has a gable with an oculus
in it; it is shown surmounted by a flat
cornice in the other representations.
The foundation of the bridge shown
here is like the foundation in the
Modena drawing; the substructure
of the fence on the left of the Soane
drawing does not appear in the
Modena drawing.

OTHER REPRESENTATIONS Ripanda
Codex, Rome, BIASA, MS 254, fols 70–71;
anonymous Italian, second half of
the 16th century, Rome, BIASA, MS 320,
fols 88–9; attributed to Giulio Romano,
Modena, GE, inv. no.8139B–C (Macrea
1937, fig.13); Pietro Santi Bartoli,
Windsor, RL, inv. nos 7967–8.
ENGRAVED Chacon 1576, fol.88
by Girolamo Muziano; Bartoli 1708,
fols 75–6.

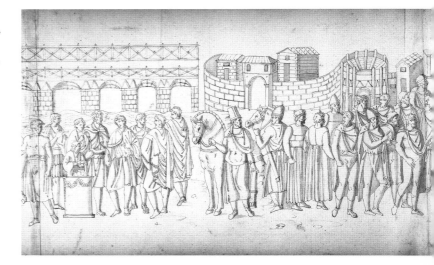

77

70
88
8139A 81
7874
7967
87
75

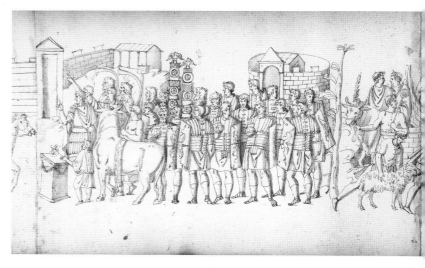

80

72
91
8139D
7877
7969
90
77 78

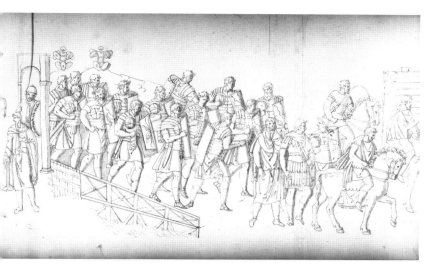

79

71

89 90

8139C

7875 7876

7968

89

76

82

73

92

8139E

7878 7879

7970

92

79

450
Scenes CI–CII
Settis 1988, p.443
No WM; 345 × 203 mm
SJSM, vol.113, fol.79

The march of the legions, fully
equipped for the expedition, is led
by officers and a contingent of cavalry.
The Emperor rides out at the head
of the troops.

A standing figure wearing Roman
armour on the left, behind the mounted
figures, is present in the frieze and all
the other representations, but it is not
shown in this drawing.

OTHER REPRESENTATIONS Ripanda
Codex, Rome, BIASA, MS 254, fol.71;
anonymous Italian, second half of the
16th century, Rome, BIASA, MS 320,
fol.90; attributed to Giulio Romano,
Modena, GE, inv. no.8139C; circle of
Giulio Romano, Paris, PC, sequence
76–7 (Florence 1984a, p.30); circle
of Fulvio Orsini, Rome, BAV, Codex
Ursinianus, fol.82r; Pietro Santi Bartoli,
Windsor, RL, inv. no.7968.
ENGRAVED Chacon 1576, fol.89
by Girolamo Muziano; Bartoli 1708,
fols 76–7.

451
Scenes CII–CIII
Settis 1988, pp.444–5
WM cat.10; 345 × 501 mm
SJSM, vol.113, fol.80

The troops from the garrison left
behind in Dacia gather in front of a
fortified place with a portico next to it.
Outside the camp, with their standard-
bearers and trumpeters, they make
preparations for a sacrifice as they
wait for the arrival of the new troops
led by Trajan.

The portico on the left is trabeated
here and in MS 320, the Modena draw-
ing and Muziano's engraving; it is
arcaded in the frieze and the Paris
drawing. In the Soane and Paris draw-
ings the entrance to the circular walled
enclosure in the background has an
arch with a pediment, concealing the
roof of the building behind it; it has
a flat cornice in the frieze, MSS 254
and 320, the Modena drawing, and in
Muziano's and Bartoli's engravings.
The tent inside the wall is entirely
misunderstood in the Paris drawing.

OTHER REPRESENTATIONS Ripanda
Codex, Rome, BIASA, MS 254, fol.72;
anonymous Italian, second half of the
16th century, Rome, BIASA, MS 320, fols
90–91; attributed to Giulio Romano,
Modena, GE, inv. no.8139C–D; circle of
Giulio Romano, Paris, PC, sequence 77

(Florence 1984a, p.30); circle of Fulvio
Orsini, Rome, BAV, Codex Ursinianus,
fol.82r; Pietro Santi Bartoli, Windsor,
RL, inv. nos 7968–9.
ENGRAVED Du Choul 1569, p.50;
Chacon 1576, fol.90 by Girolamo
Muziano; Bartoli 1708, fols 77–8.

452
Scenes CIII–CIV
Settis 1988, pp.447–9
No WM; 345 × 503 mm
SJSM, vol.113, fol.81

Inside the camp Trajan makes the
libation on the altar. Outside the walls,
in the foreground, the animals and
trumpeters process towards the
sacrifice behind the perimeter wall
of the camp. In the centre a small tree
and the profile of the podium mark
the change of scene from the rites to
Trajan's oration to the troops. Trajan,
in conversation with Lucius Licinius
Sura, turns towards them. The soldiers,
in serried ranks with their ensigns
behind them, listen to the oration.

There are three tents inside the
enclosure on the left in the frieze, and
in all of the representations except
Bartoli's engraving, where only two
are shown. The tree at the edge of the
platform is cut by the leg of the figure
retreating to the left here, in the frieze,
MS 254 and in Bartoli's engraving. In
MS 320, the Modena and Paris
drawings and Muziano's engraving
the tree rises out of the platform. The
broken edge of the podium is shown
as stepped in the frieze, MSS 254 and
320, the Modena and Paris drawings
and in Muziano's engraving.

OTHER REPRESENTATIONS Ripanda
Codex, Rome, BIASA, MS 254, fol.73;
anonymous Italian, second half of the
16th century, Rome, BIASA, MS 320, fols
91–2; attributed to Giulio Romano,
Modena, GE, inv. no.8139D–E (Macrea
1937, fig.14); circle of Giulio Romano,
Paris, PC, sequence 78–9 (Florence
1984a, p.31); circle of Fulvio Orsini,
Rome, BAV, Codex Ursinianus, fol.77r;
Étienne Dupérac, Paris, BN, MS FR382,
fol.77; Nicholas Poussin, Chantilly, MC,
inv. no.P206 (Blunt 1974, p.36, cat.328,
pl.257); Pietro Santi Bartoli, Windsor,
RL, inv. no.7969.
ENGRAVED Du Choul 1569, pp.95–6, 104;
Chacon 1576, fol.91 by Girolamo
Muziano; Bartoli 1708, fol.78 (Florence
1984a, p.38, fig.17); Montfauçon 1719,
IV/I, p.45.

453
Scenes CIV–CV
Settis 1988, pp.450–52
No WM; 345 × 498 mm
SJSM, vol.113, fol.82

The troops and the cavalry turn
towards the Emperor for his speech.
In the centre, isolated by an outcrop
of rock, a dismounted soldier listens
to Trajan's words. In the background
there is a large fortified camp with
crenellated walls and corner towers.
Inside the fortress Trajan holds a coun-
cil of war, discussing routes and tactics
in the presence of the soldiers.

In the Paris drawing the wall on the
left between the towers has a flat, plain
surface and an applied order and there
is a door with a segmental pediment
behind Trajan. These features do not
appear in the frieze or in any of the
other drawings.

OTHER REPRESENTATIONS Ripanda
Codex, Rome, BIASA, MS 254, fols 73–4;
anonymous Italian, second half of the
16th century, Rome, BIASA, MS 320,
fols 92–3; attributed to Giulio Romano,
Modena, GE, inv. no.8139D–E (Macrea
1937, figs 14–15); circle of Giulio
Romano, Paris, PC, sequence 80
(Florence 1984a, p.31); Pietro da
Cortona, Eton College; Pietro Santi
Bartoli, Windsor, RL, inv. nos 7969–70.
ENGRAVED Du Choul 1569, p.52; Chacon
1576, fols 92–3 by Girolamo Muziano;
Bartoli 1708, fols 79–80 (Florence 1984a,
p.38, fig.18); Montfauçon 1719, IV/I, p.45.

454
Scenes CVI–CVII
Settis 1988, pp.454–5
No WM; 345 × 232 mm
SJSM, vol.113, fol.83

The Roman army, divided into two
contingents separated horizontally by
a rocky ridge, advances on the enemy
territory along two different routes.
In the background, in safety, the carts
pulled by mules are preceded by bare-
headed soldiers. The legionaries in
the foreground march fully armed.

OTHER REPRESENTATIONS Ripanda
Codex, Rome, BIASA, MS 254, fols 74–5;
anonymous Italian, second half of the
16th century, Rome, BIASA, MS 320,
fols 94–5; attributed to Giulio Romano,
Modena, GE, inv. no.8139E–F; circle of
Giulio Romano, Paris, PC, sequence
80–81 (Florence 1984a, p.31); Pietro
Santi Bartoli, Windsor, RL, inv.
no.7970.
ENGRAVED Chacon 1576, fols 93–4
by Girolamo Muziano; Bartoli 1708,
fol.80.

455
Scenes CVII–CVIII
Settis 1988, pp.456–7
WM cat.10; 345 × 479 mm
SJSM, vol.113, fol.84

The two contingents led by officers
and trumpeters reach a fortified camp
where the provisions are unloaded
from the mules and carts. An auxiliary
soldier stands on sentry duty on a
wooden drawbridge in front of the
wall, while another kneels to fill a vessel
with water from a stream.

OTHER REPRESENTATIONS Ripanda
Codex, Rome, BIASA, MS 254, fol.75;
anonymous Italian, second half of the
16th century, Rome, BIASA, MS 320,
fols 94–5; attributed to Giulio Romano,
Modena, GE, inv. no.8139G–H (Macrea
1937, fig.16); Pietro Santi Bartoli,
Windsor, inv. no.7971.
ENGRAVED Chacon 1576, fols 94–5
by Girolamo Muziano; Bartoli 1708,
fols 80–81.

456
Scenes CVIII–CIX
Settis 1988, pp.456–8
No WM; 345 × 498 mm
SJSM, vol.113, fol.85

On the right the army advances from a
fortified town on the left. The soldiers
are divided into two tiers by the rocky
ridge that runs above the heads of those
in the foreground. Special contingents
of soldiers can be identified, the
Germans by their naked torsos and the
archers by their long oriental robes.

The water of the river is not fully
drawn here or in MS 254.

OTHER REPRESENTATIONS Ripanda
Codex, Rome, BIASA, MS 254, fol.76;
anonymous Italian, second half of
the 16th century, Rome, BIASA, MS 320,
fols 95–6; attributed to Giulio Romano,
Modena, GE, inv. no.8139H–I (Macrea
1937, fig.16); circle of Giulio Romano,
Paris, PC, sequence 82–3 (Florence
1984a, p.31); Pietro Santi Bartoli,
Windsor, RL, inv. nos 7971–2.
ENGRAVED Chacon 1576, fol.95 by
Girolamo Muziano; Bartoli 1708, fol.82.

83
74
93 94
8139F 8139G
 7880
 93
 80

86
96
8139I
7882
 7972
95 96
 83

85

5

36

95

8139H

7881

7971

94

81

82

457
Scene CX

Settis 1988, pp.459–61
No WM; 345 × 464 mm
SJSM, vol.113, fol.86

A legionary is putting up a tent inside a camp guarded by an auxiliary sentry. On the right the soldiers harvest grain in the fields and load the sheaves on to the backs of mules in front of a fortified camp.

In the background there are three tents inside the walled enclosure on the right, as in the frieze and all the representations except for Bartoli's engraving, where only two are shown. The scene showing the soldiers supplying the legion provides important information about the chronology: the scene is taking place in the summer of the last year of the war, AD 106.

OTHER REPRESENTATIONS Ripanda Codex, Rome, BIASA, MS 254, fols 76–7; anonymous Italian, second half of the 16th century, Rome, BIASA, MS 320, fols 96–7; attributed to Giulio Romano, Modena, GE, inv. no.81391; Pietro Santi Bartoli, Windsor, RL, inv. no.7972.
ENGRAVED Chacon 1576, fol.96 by Girolamo Muziano; Bartoli 1708, fol.83; Montfauçon 1719, IV/I, p.40.

458
Scene CXI

Settis 1988, pp.461–3
No WM; 345 × 493 mm
SJSM, vol.113, fol.87

In front of a mountainous landscape with three trees, three auxiliary soldiers in the vanguard watch the enemy. Outside the fortification the Dacians observe with disquiet the approach of the Roman troops. Inside the walls other extremely agitated figures prepare to encounter the Romans. The first casualties of the battle fall at the feet of two Dacians engaged in conversation below the wall.

The trees are rendered like those in MS 254. In the middle of the background the figure to the right of the second building has an arm raised in a gesture, as in the frieze, MS 254 and the Modena and Paris drawings; the arm is partially raised in MS 320 and in Muziano's engraving, but the figures are more compactly massed than they are in this drawing. There is more space in this drawing between the figure who is pointing forwards and the group of four on his right than in the frieze or in any other representation, probably because the drawing is copied from MS 254, where the figure marks the end of the folio.

OTHER REPRESENTATIONS Ripanda Codex, Rome, BIASA, MS 254, fols 77–8; anonymous Italian, second half of the 16th century, Rome, BIASA, MS 320, fols 97–8; attributed to Giulio Romano, Modena, GE, inv. nos 81391–8130A; circle of Giulio Romano, Paris, PC, sequence 83–4 (Florence 1984a, p.31); Pietro da Cortona, Eton College; Pietro Santi Bartoli, Windsor, RL, inv. no.7973.
ENGRAVED Chacon 1576, fol.97 by Girolamo Muziano; Bartoli 1708, fols 84–5.

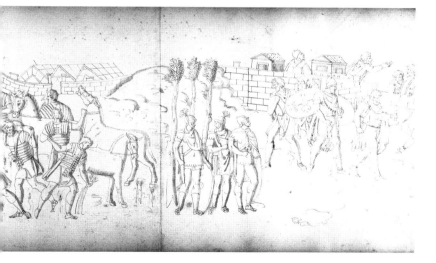

87

98

8130A

7884

7973

97

84

459
Scene CXII
Settis 1988, pp.464–6
No WM; 345 × 468 mm
SJSM, vol.113, fol.88

The battle is depicted as a series of duels taking place in the foreground, while a group of Dacians look on in despair from behind a rocky ridge. A clump of trees marks a break in the narrative; on the right two sentries guard a fortress.

OTHER REPRESENTATIONS Ripanda Codex, Rome, BIASA, MS 254, fols 78–9; Amico Aspertini, London, BM, I, fols 26v–27r (Bober 1957, p.66, fig.65); anonymous Italian, second half of the 16th century, Rome, BIASA, MS 320, fols 98–9; attributed to Giulio Romano, Modena, GE, inv. no.8130A; circle of Giulio Romano, Paris, PC, sequence 85 (Florence 1984a, p.32); Pietro Santi Bartoli, Windsor, RL, inv. no.7973.
ENGRAVED Chacon 1576, fol.98 by Girolamo Muziano; Bartoli 1708, fols 85–6; Montfauçon 1719, IV/I, p.52.

460
Scene CXIII
Settis 1988, pp.466–9
No WM; 345 × 468 mm
SJSM, vol.113, fol.89

There are tents inside the camp. The siege of the complex Dacian fortress, probably built to protect the capital Sarmizegetusa, begins. The Roman soldiers raise their shields to protect their heads, and try to place ladders against the enemy bastion while the Dacians hurl rocks at them from above. A Roman auxiliary who has scaled the wall holds the severed head of a Dacian, who is left hanging from the wall.

The architecture in MS 320, the Paris drawing and Muziano's engraving is much more neat and compact than in this drawing, which is identical to MS 254. The figure with his head chopped off is imagined in MS 254 as a sculpture – the neck is drawn hollow as in a bronze or a plaster cast. No other version copies this feature.

Fresco VI on the east wall of the salone in Bishop Riario's palace in Ostia, dated 1511–13 and attributed to the circle of Peruzzi, is based on this scene (Borghini 1981, fig.8; Agosti & Farinella 1984, pp.407–10).

OTHER REPRESENTATIONS Ripanda Codex, Rome, BIASA, MS 254, fols 79–80 (the vellum of fol.79 has been divided by grey chalk lines into four fields, each 150 mm wide; a top line and a baseline have been drawn, giving a uniform height of 250 mm); Amico Aspertini,

London, BM, I, fols 32v–33r (Bober 1957, p.67, fig.74); anonymous Italian, second half of the 16th century, Rome, BIASA, MS 320, fols 100–01; attributed to Giulio Romano, Modena, GE, inv. no.8130B; circle of Giulio Romano, Paris, PC, sequence 86 (Florence 1984a, p.32); Pietro Santi Bartoli, Windsor, RL, inv. no.7974.
ENGRAVED Chacon 1576, fol.99 by Girolamo Muziano; Bartoli 1708, fols 86–7; Montfauçon 1719, IV/I, p.36.

461
Scene CXIV
Settis 1988, pp.469–71
WM cat.10; 345 × 491 mm
SJSM, vol.113, fol.90

The Dacians succeed in containing the first attack. The body of a fallen Dacian lies in the foreground. Trajan, in front of the enemy fortress and surrounded by advisers, examines the situation and chooses his tactics. The city wall continues in the background. In the foreground legionaries and auxiliaries group in formation as an imperial escort, and siege machines are assembled below the walls.

The rectangular well on the ground, shown in the frieze, MS 254, the Modena drawing and in Bartoli's engraving, does not appear in MS 320 or in Muziano's engraving. The building technique used for the wall is less clearly rendered in the Modena drawing.

The Dacians used many constructional techniques. The fortress representing Sarmizegetusa drawn on fols 59r and 60r (cat.430 and 431) is polygonal and built of dressed stone; this building is of stone interrupted by courses of rondins as recommended by Vitruvius (book I, cap.v, 3; 1931–4, I, p.49). Dacian buildings were especially complex during the reign of Huneduora (see Teodorescu 1923; Daicoviciu 1955).

A fresco on the east wall of the salone in Bishop Riario's palace in Ostia, dated 1511–13 and attributed to the circle of Peruzzi, is based on this scene (Borghini 1981, fig.9; Agosti & Farinella 1984, pp.407–10).

OTHER REPRESENTATIONS Ripanda Codex, Rome, BIASA, MS 254, fol.80; anonymous Italian, second half of the 16th century, Rome, BIASA, MS 320, fols 101–2; attributed to Giulio Romano, Modena, GE, inv. no.8130C; circle of Giulio Romano, Paris, PC, sequence 86–7 (Florence 1984a, p.32); Pietro Santi Bartoli, Windsor, RL, inv. nos 7974–5.
ENGRAVED Chacon 1576, fols 100–01 by Girolamo Muziano; Bartoli 1708, fols 87–8 (Florence 1984a, p.43, fig.24).

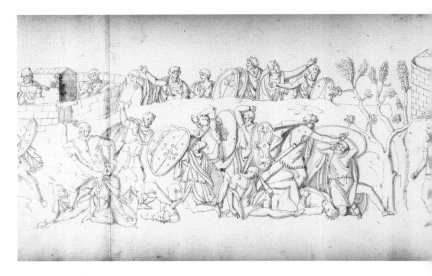

88

78

99

7885

98

85

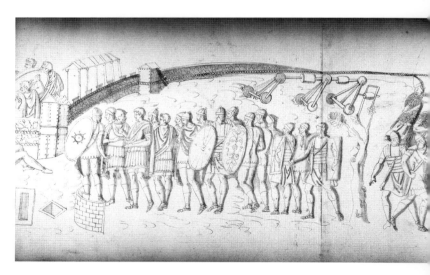

91

81

102

8130D

7888

7975

101

87

88

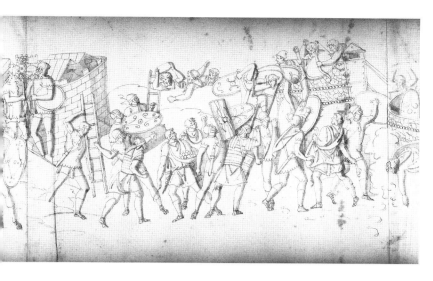

89 90

	80
100	101
8130B	8130C
7886	7887
7974	
99	100
86	

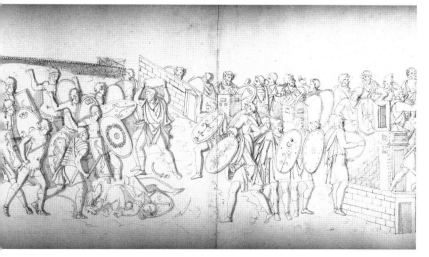

92

	82
103	
8130E	
7889	
7976	
102	103
89	

462
Scene CXV
Settis 1988, pp.472–4
No WM; 345 × 512 mm
SJSM, vol.113, fol.91

A small tree marks the change of scene, although the city wall continues in the background. The Roman soldiers set off towards the right, while in the background the oriental archers lean against the rocky ridge to shoot their arrows. Roman soldiers in front of them push back an enemy sortie. On the right the heroic figure of a defiant Dacian stands on the ridge above a heap of fallen comrades; he hurls a rock with all his might against the relentless advance of the enemy.

Settis (1986, pp.472–4) recalled how Julius Caesar, in a passage from *De bello Gallico* (1908, p.46, book II, cap.XXVII, 3–5), celebrated the valour of the enemy by relating how they stood on the bodies of their companions and hurled projectiles in defiance against the Roman soldiers.

The arm of the Roman to the right of the tree points downwards; it points across the trunk in the frieze, MSS 254 and 320, the Modena drawing and Muziano's engraving. Two bays of fencing on top of the wall are also shown in MS 254 and the Modena drawing; there are three bays in MS 320. The break between the rubble and the fortified walls, also shown in MS 320, the Modena drawing and Muziano's engraving, is not present in Bartoli's engraving; the area is very damaged in the frieze.

OTHER REPRESENTATIONS Ripanda Codex, Rome, BIASA, MS 254, fols 80–81; anonymous Italian, second half of the 16th century, Rome, BIASA, MS 320, fols 102–3; attributed to Giulio Romano, Modena, GE, inv. no.8130D–E; Pietro Santi Bartoli, Windsor, RL, inv. no.7975.
ENGRAVED Chacon 1576, fols 101–2 by Girolamo Muziano; Bartoli 1708, fols 88–9; Montfauçon 1719, IV/I, p.52.

463
Scenes CXVI–CXVII
Settis 1988, pp.475–7
WM cat.10; 345 × 495 mm
SJSM, vol.113, fol.92

Outside the wall of the fortress, built with blocks of stone, some Dacians hurl themselves against the Romans; others stand by without striking a blow. Inside the city panic reigns. In the centre two legionaries who have penetrated the defensive wall strike at it with axes. On the right auxiliaries raise their shields and hurl their javelins to protect the legionaries who are trying to breach the wall.

Fresco VIII on the west wall of the salone in Bishop Riario's palace at Ostia, dated 1511–13 and attributed to the circle of Peruzzi, is based on this scene (Borghini 1981, fig.6; Agosti & Farinella 1984, p,409).

OTHER REPRESENTATIONS Ripanda Codex, Rome, BIASA, MS 254, fols 81–2; anonymous Italian, second half of the 16th century, Rome, BIASA, MS 320, fols 103–4; attributed to Giulio Romano, Modena, GE, inv. no.8130E–F; Pietro da Cortona, Eton College; Pietro Santi Bartoli, Windsor, RL, inv. no.7976.
ENGRAVED Chacon 1576, fols 102–3 by Girolamo Muziano; Bartoli 1708, fols 89–90.

464
Scenes CXVII–CXVIII
Settis 1988, pp.478–80
WM cat.10; 345 × 503 mm
SJSM, vol.113, fol.93

The legionaries cut down trees
and make piles of wood. They make
wooden structures for the final stage in
the siege of the enemy fortress. On the
right a nobleman wearing the *pileatus*, a
horned cap, kneels before Trajan with
his arms outstretched in supplication.

The pile of wood and the rectangular
form above it, to the left of the central
window, are reproduced in MS 254
but not in MS 320 or in the Modena
drawing. The rectangle is not drawn
in Muziano's engraving.

OTHER REPRESENTATIONS Ripanda
Codex, Rome, BIASA, MS 254, fols 82–3;
anonymous Italian, second half of
the 16th century, Rome, BIASA, MS 320,
fols 104–5; attributed to Giulio Romano,
Modena, GE, inv. no.8130F–G; Pietro
Santi Bartoli, Windsor, RL, inv. nos
7976–7.
ENGRAVED Chacon 1576, fols 103–4
by Girolamo Muziano; Bartoli 1708,
fols 90–91.

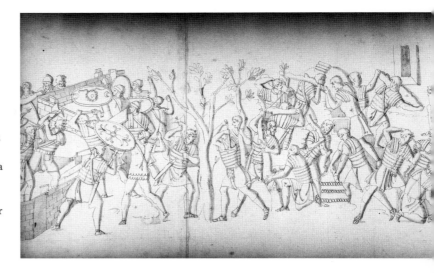

93

83
104 105
8130F 8130G
7890 7891
7977
104
90 9

465
Scenes CXVIII–CXIX
Settis 1988, pp.481–3
No WM; 345 × 503 mm
SJSM, vol.113, fol.94

The praetorian guard, in two ranks at
the submission of the enemy, protects
the Emperor while the enemy submit
themselves to him. In the centre a
group of trees marks a change in the
narrative. On the right, sensing defeat,
the Dacians set fire to their homes and
possessions, so that they are not seized
by the Romans.

The window in the building behind
the first figure with a torch has a
bipartite opening; this is tripartite
in the frieze and in all of the other
representations.

OTHER REPRESENTATIONS Ripanda
Codex, Rome, BIASA, MS 254, fols 83–4;
anonymous Italian, second half of
the 16th century, Rome, BIASA, MS 320,
fols 105–6; attributed to Giulio Romano,
Modena, GE, inv. no.8130G–H (Macrea
1937, fig.17); Pietro Santi Bartoli,
Windsor, RL, inv nos. 7977–8.
ENGRAVED Chacon 1576, fols 104–5
by Girolamo Muziano; Bartoli 1708,
fols 91–2.

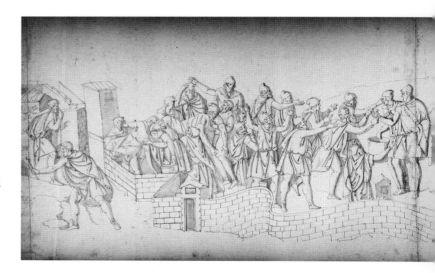

95
85
107
8130I
7893
7
106 107
93

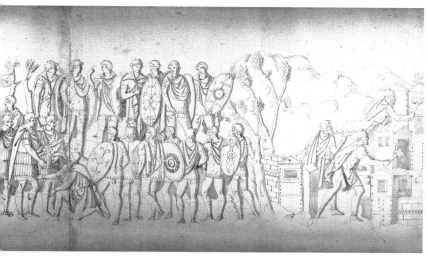

94

84

106

8130H

7892

7978

105

92

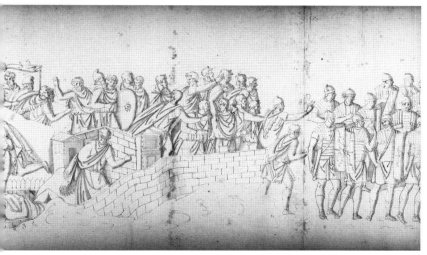

97

86

109

8132A

7895

7980

108

94

95

466
Scene CXX
Settis 1988, pp.484–6
WM cat.10; 345 × 502 mm
SJSM, vol.113, fol.95

As their homes are destroyed a scene
of mass suicide takes place inside the
curving wall of the fortress. A mass of
dying or desperate Dacians, with heroic
poses or gestures, display intense
emotion *in extremis*. Some of them,
choosing suicide rather than flight,
lurch towards a bowl of poison. A
noble Dacian on the right takes the
cup offered to him.

OTHER REPRESENTATIONS Ripanda
Codex, Rome, BIASA, MS 254, fols 84–5;
anonymous Italian, second half of
the 16th century, Rome, BIASA, MS 320,
fols 106–7; attributed to Giulio Romano,
Modena, GE, inv. no.8130H–I (Macrea
1937, fig.17); Pietro Santi Bartoli,
Windsor, RL, inv. no.7978.
ENGRAVED Chacon 1576, fols 106–7
by Girolamo Muziano; Bartoli 1708,
fols 92–3.

467
Scenes CXXI–CXXII
Settis 1988, pp.488–90
WM cat.; 345 × 503 mm
SJSM, vol.113, fol.96

One Dacian kneels and leans weeping
over a corpse; Dacian bodies lie
beneath him. Others try to escape,
and some of them turn back to look
at the scene of death. On the right
they abandon their fortress in disarray.
A tree closes the episode.

The tree shown in the frieze, MSS 254
and 320, Muziano's and Bartoli's
engravings does not appear here. The
Modena drawing breaks at that point.

OTHER REPRESENTATIONS Ripanda
Codex, Rome, BIASA, MS 254, fols 85–6;
anonymous Italian, second half of the
16th century, Rome, BIASA, MS 320, fols
108–9; attributed to Giulio Romano,
Modena, GE, inv. no.8130J; Pietro da
Cortona, Eton College; Pietro Santi
Bartoli, Windsor, RL, inv. no.7979.
ENGRAVED Chacon 1576, fols 107–8
by Girolamo Muziano; Bartoli 1708,
fols 94–5.

468
Scene CXXIII
Settis 1988, pp.491–3
No WM; 345 × 482 mm
SJSM, vol.113, fol.97

A legion lines up in ranks behind
Trajan, who is in the centre surrounded
by standard-bearers and trumpeters.
He receives the submission of a group
of Dacians.

OTHER REPRESENTATIONS Ripanda
Codex, Rome, BIASA, MS 254, fol.86;
anonymous Italian, second half of the
16th century, Rome, BIASA, MS 320,
fols 109–10; attributed to Giulio
Romano, Modena, GE, inv. no.8132A–B;
Pietro Santi Bartoli, Windsor, RL,
inv. no.7980.
ENGRAVED Chacon 1576, fols 108–9
by Girolamo Muziano; Bartoli 1708,
fols 96–7.

469
Scenes CXXIV–CXXV
Settis 1988, pp.494–5
No WM; 345 × 478 mm
SJSM, vol.113, fol.98

After leaving the besieged city the
enemy prostrate themselves before the
Emperor. In the city the Roman troops
collect the booty and carry it on their
backs. Roman tents have been erected
inside the enemy defensive walls.
Trajan speaks to the troops and
congratulates them on their victory.

The barrel-vaulted grain store and
the zigzag road, in the background on
the left, are shown as in this drawing in
the frieze, MSS 254 and 320, the Modena
drawing and Muziano's engraving.
In Bartoli's engraving (fol.96) the
store has rectangular piers at the
corners. The long diagonal wall is built
of drafted masonry, like the wall in the
frieze; it is plain in MSS 254 and 320 and
in the Modena drawing. The drawing of
the top of the three tents is identical to
MS 254. The tent on the left is correctly
drawn in all the versions, but the tents
on the right are misunderstood as one
in this drawing and in MS 254; they are
drawn correctly as two tents in MS 320
and in Muziano's engraving.

OTHER REPRESENTATIONS Ripanda
Codex, Rome, BIASA, MS 254, fol.87;
anonymous Italian, second half of
the 16th century, Rome, BIASA, MS 320,
fols 110–11; attributed to Giulio Romano,
Modena, GE, inv. no.8132B–C; Pietro
Santi Bartoli, Windsor, RL, inv. no.7981.
ENGRAVED Chacon 1576, fols 109–10
by Girolamo Muziano; Bartoli 1708,
fols 96–7.

470
Scene CXXVI
Settis 1988, pp.496–8
No WM; 345 × 502 mm
SJSM, vol.113, fol.99

In the background, behind the wall of
the enemy city, a column of auxiliaries
marches out through a wide monu-
mental gate. On the right the legionar-
ies begin work, after laying down their
shields.

The gate on the right is arched in
this drawing, in MSS 254 and 320, the
Modena drawing and Muziano's
engraving; it is trabeated in Bartoli's
engraving (fol.98). The top of the
tent on the right inside the enclosure
wall has horizontal and vertical lines
drawn on it in the frieze, MS 254 and the
Modena drawing; it has verticals only
in MS 320 and Muziano's engraving.
The area is very damaged on the frieze.

OTHER REPRESENTATIONS Ripanda
Codex, Rome, BIASA, MS 254, fol.88;
anonymous Italian, second half of
the 16th century, Rome, BIASA, MS 320,
fol.112; attributed to Giulio Romano,
Modena, GE, inv. no.8132 C–D;
Pietro Santi Bartoli, Windsor, RL,
inv. nos 7981–2.
ENGRAVED Chacon 1576, fols 110–11
by Girolamo Muziano; Bartoli 1708,
fols 97–8.

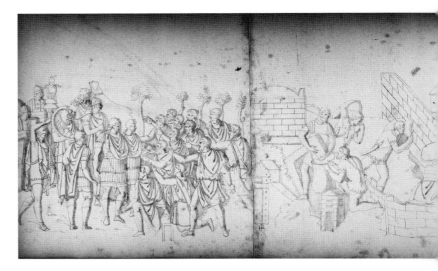

	98	
	87	
110		111
8132B		8132C
7896		7897
	7981	
109		
	96	

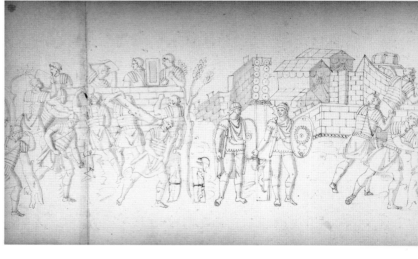

	100	
	89	
113		
	8132E	
7899		
7982		
112		
98		

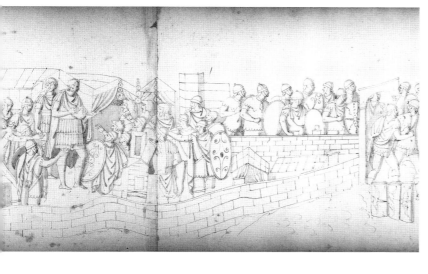

99

88

112

8132D

7898

111

97

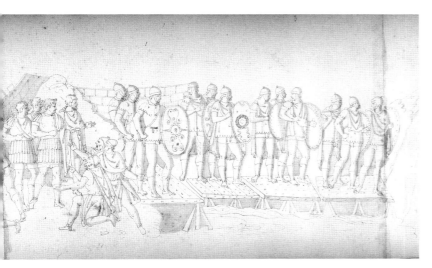

101 102

90

115

8132G

7901

114

⁹9 100

471
Scenes CXXVII–CXXIX
Settis 1988, pp.499–500
No WM; 345 × 507 mm
SJSM, vol.113, fol.100

The soldiers chop down trees and carry logs and blocks of stone. A tree closes the scene. In the centre of the next scene two sentries stand in front of a fortified camp with tents and ensigns inside its walls. On the right soldiers carry tree trunks and square blocks of stone to build a circular stretch of wall. Inside the walls are carts with barrels on them.

A sentry, with his back to the spectator and watching the legionaries at work on the other side of the tree dividing the episode, is present in the frieze, MS 320, the Modena drawing, and in Muziano's and Bartoli's engravings; he is not shown in this drawing, probably because the figure is in the gutter of the volume of MS 254. The drafted masonry wall is unbroken also in MS 320 and in Muziano's engraving; it has an opening in Bartoli's engraving (fol.98) and the wall rises above the heads of the soldiers. The barrels in the background on the right have two rings in the centre in MS 320, the Modena drawing and Muziano's engraving; there is only one here, in the frieze, MS 254 and Bartoli's engraving. The architecture in MS 254 is identical to this drawing.

OTHER REPRESENTATIONS Ripanda Codex, Rome, BIASA, MS 254, fols 88–9; anonymous Italian, second half of the 16th century, Rome, BIASA, MS 320, fols 113–14; attributed to Giulio Romano, Modena, GE, inv. no.8132D–E; Pietro Santi Bartoli, Windsor, RL, inv. no.7982, inscribed *E in queste doi figure io a sbaglio che la prima deve essere la seconda in atto di discorrere in sieme con laltra* below the two sentries in the centre.
ENGRAVED Chacon 1576, fol.112 by Girolamo Muziano; Bartoli 1708, fol.98.

472
Scene CXXX
Settis 1988, pp.501–3
No WM; 345 × 499 mm
SJSM, vol.113, fol.101

Three Dacians prostrate themselves in front of Trajan and his officers. On the right a column of auxiliaries crosses a bridge, using a system of mobile bridges that are thrown into the water.

Similar bridges are drawn by Francesco di Giorgio (cat.91 and 207). The drawing of the river is very similar to MS 254, where it is rendered with very few lines.

OTHER REPRESENTATIONS Ripanda Codex, Rome, BIASA, MS 254, fols 89–90; anonymous Italian, second half of the 16th century, Rome, BIASA, MS 320, fols 114–15; attributed to Giulio Romano, Modena, GE, inv.no.8132F–G; Pietro da Cortona, Eton College; Pietro Santi Bartoli, Windsor, RL, inv. no.7983.
ENGRAVED Chacon 1576, fol.113 by Girolamo Muziano; Bartoli 1708, fols 99–100.

473
Scenes CXXXI–CXXXIII
Settis 1988, pp.504–6
WM cat.10; 345 × 490 mm
SJSM, vol.113, fol.102

The course of the river curves abruptly
and an isolated tree indicates the end
of an episode. On the left a column of
Dacians marching to the right comes
out of a fortress built of stone at the
front and of wooden logs on the other
three sides, and marches across the
foreground. In the background and
bounded by the river a circular Roman
fortress is protected by wooden
ramparts. Inside two legionaries
prepare the ships for their departure.

The plant that grows from the
ground in the centre foreground in the
frieze, MS 320, the Modena drawing and
Muziano's engraving is only a shoot
here. The tree is drawn in the gutter of
the volume in MS 254. The river cascad-
ing downhill is much less specifically
drawn than in MSS 254 and 320.

OTHER REPRESENTATIONS Ripanda
Codex, Rome, BIASA, MS 254, fols 90–91;
anonymous Italian, second half of
the 16th century, Rome, BIASA, MS 320,
fols 115–16; attributed to Giulio
Romano, Modena, GE, inv. no.8132G–H
(Macrea 1937, fig.18); Pietro Santi
Bartoli, Windsor, RL, inv. no.7984.
ENGRAVED Chacon 1576, fols 114–15
by Girolamo Muziano; Bartoli 1708,
fols 100–01.

474
Scenes CXXXIV–CXXXV
Settis 1988, pp.506–7
No WM; 345 × 374 mm
SJSM, vol.113, fol.103

The Dacian troops besiege the Roman
fort. The Romans hurl down javelins
and stones on the enemy. The Dacians
crowd below the walls and protect
themselves by holding shields above
their heads, while corpses slide to
the ground. While the Dacians try to
penetrate the fortress, the corpse of
one of them is hung by a chain from a
beam outside the wall.

OTHER REPRESENTATIONS Ripanda
Codex, Rome, BIASA, MS 254, fols 91–2;
Amico Aspertini, London, BM, I, fols
33v–34r (Bober 1957, p.67, fig.75);
anonymous Italian, second half of
the 16th century, Rome, BIASA, MS 320,
fols 116–17; attributed to Giulio Romano,
Modena, GE, inv. no.8132H–I (Macrea
1937, fig.18); Pietro Santi Bartoli,
Windsor, RL, inv. no.7984.
ENGRAVED Chacon 1576, fols 115–16
by Girolamo Muziano; Bartoli 1708,
fol.101; Montfauçon 1719, IV/I, p.64.

475
Scenes CXXXVI–CXXXVII
Settis 1988, pp.508–11
WM cat.10; 345 × 490 mm
SJSM, vol.113, fol.104

Three Dacians in the tree on the left
watch the sad end of the battle; the
central figure is Decebal. A group of
men on the right of him, escaping
from the battle, turn and look back.
There are the walls of a city in the back-
ground among the trees. On the right,
in front of a fortified city, Trajan stands
on a podium and thanks the troops
for their efforts.

The building to the right of the
break in the enclosure wall on the left
is a single, plain-walled building with
a roof; it is shown with two gables in
this drawing, in MSS 254 and 320, the
Modena drawing and Muziano's
engraving.

OTHER REPRESENTATIONS Ripanda
Codex, Rome, BIASA, MS 254, fol.92;
anonymous Italian, second half of
the 16th century, Rome, BIASA, MS 320,
fols 117–18; attributed to Giulio Romano,
Modena, GE, inv. no.8132 I–J;
Pietro Santi Bartoli, Windsor, RL,
inv. no.7985.
ENGRAVED Chacon 1576, fols 116–17
by Girolamo Muziano; Bartoli 1708,
fols 102–3.

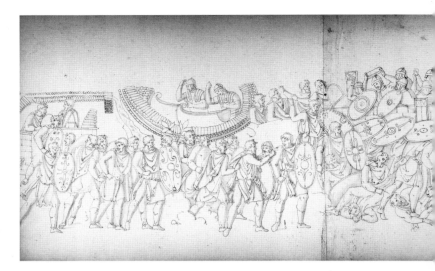

103

91

116

8132H

7202

7984

115

101

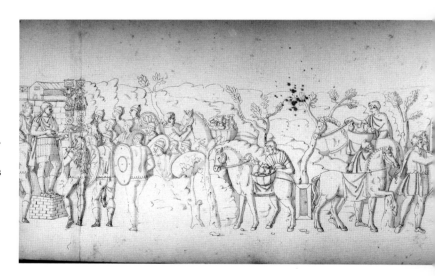

105

93

119

8132K

7905

7986

118

103

104

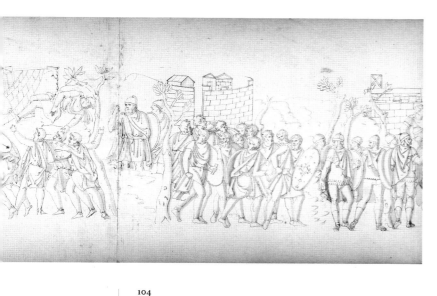

104

92

117 118

81321 8132J

7903 7904

7985

116 117

102

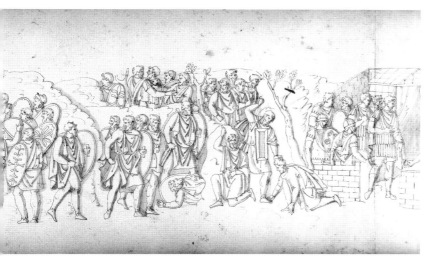

106 107

94

120

8132L

7906 7907

7987

119

105

476
Scenes CXXXVII–CXXXVIII
Settis 1988, pp.512–14
No WM; 345 × 501 mm
SJSM, vol.113, fol.105

On the left the auxiliaries listen to
Trajan's address; among the trees on
the right the Dacian royal treasure,
which had been hidden by Decebal on
the river bed, is loaded on to the backs
of mules to be sent to Rome as war
booty. On the right Decebal makes
his last speech to his troops while a
Dacian holds his horse by the bridle.

Fresco XII in the salone in Bishop
Riario's palace in Ostia, of 1511-13 and
attributed to the circle of Peruzzi, is
based on this scene (Agosti & Farinella
1984, pp.407–10).

OTHER REPRESENTATIONS Ripanda
Codex, Rome, BIASA, MS 254, fols 92–3;
anonymous Italian, second half of
the 16th century, Rome, BIASA, MS 320,
fols 118–19; attributed to Giulio Romano,
Modena, GE, inv. no.81321–J; Pietro da
Cortona, Eton College; Pietro Santi
Bartoli, Windsor, RL, inv. nos 7985–6.
ENGRAVED Chacon 1576, fols 117–18
by Girolamo Muziano; Bartoli 1708,
fols 103–4.

477
Scenes CXXXIX–CXL
Settis 1988, pp.515–17
WM cat.10; 345 × 500 mm
SJSM, vol.113, fol.106

After hearing Decebal's words a group
of Dacians flee to the woods. Another
group decide to die by the sword; one
lies dead while another prepares to stab
himself. A Dacian holds the head of his
companion, who kneels in front of him
for his head to be severed. On the right
Trajan, inside the fortified camp,
receives the submission of a noble
Dacian.

There is a fresco based on this scene
in Bishop Riario's palace in Ostia,
dated 1511–13 and attributed to the
circle of Peruzzi (Agosti & Farinella
1984, pp.407–10).

OTHER REPRESENTATIONS Ripanda
Codex, Rome, BIASA, MS 254, fols 93–4;
Amico Aspertini, London, BM, I,
fols 28v–29r (Bober 1957, p.66, fig.69);
anonymous Italian, second half of the
16th century, Rome, BIASA, MS 320,
fols 119–20; attributed to Giulio Romano,
Modena, GE, inv. no.8132K–L; Pietro
da Cortona, Eton College; Pietro Santi
Bartoli, Windsor, RL, inv. nos 7986–7.
ENGRAVED Chacon 1576, fols 118–19
by Girolamo Muziano; Bartoli 1708,
fols 104–5; Montfauçon 1719, IV/I, p.37.

478
Scenes CXLI–CXLII
Settis 1988, pp.517–19
WM. cat.10; 345 × 498 mm
SJSM, vol.113, fol.107

The noble Dacian kneels at Trajan's feet. Outside the walls a group of Dacians beg for mercy; one man in the foreground holds gifts for Trajan in his arms. To the right a tall tree concludes the episode.

The corner of the enclosure is drawn differently in MS 320 and Muziano's engraving, where the wall is shown returning. It simply ends here, in the frieze and MS 254; the Modena drawing breaks at this point.

OTHER REPRESENTATIONS Ripanda Codex, Rome, BIASA, MS 254, fols 94–5; Amico Aspertini, London, BM, I, fols 28v–29r (Bober 1957, p.66, fig.69); anonymous Italian, second half of the 16th century, Rome, BIASA, MS 320, fols 120–21; attributed to Giulio Romano, Modena, GE, inv. nos 8132L–8131A; Pietro Santi Bartoli, Windsor, RL, inv. nos 7987–8.
ENGRAVED Chacon 1576, fols 119–20 by Girolamo Muziano; Bartoli 1708, fols 105–6.

479
Scenes CXLIII–CXLIV
Settis 1988, pp.522–3
WM cat.10; 345 × 498 mm
SJSM, vol.113, fol.108

The Roman cavalry, their cloaks flying out in the wind and their javelins in their fists, pursue a group of Dacians fleeing with Decebal through the trees; one Dacian turns to see the enemy position, another points forward. A figure ahead of them turns back with his right arm outstretched.

OTHER REPRESENTATIONS Ripanda Codex, Rome, BIASA, MS 254, fols 95–6; anonymous Italian, second half of the 16th century, Rome, BIASA, MS 320, fols 122–3; attributed to Giulio Romano, Modena, GE, inv. no.8131A–B; Pietro Santi Bartoli, Windsor, RL, inv. no.7988.
ENGRAVED Chacon 1576, fols 120–21 by Girolamo Muziano; Bartoli 1708, fols 106–7.

480
Scene CXLV
Settis 1988, pp.524–6
No WM; 354 × 490 mm
SJSM, vol.113, fol.109

A rocky ridge separates the Dacian fugitives from the Roman cavalry. The last followers of Decebal lie dead on the ground, and the Roman cavalry gallops forward to the right in an attempt to capture him alive. On the right Decebal kneels below a tree, surrounded by Roman cavalry, and prepares to commit suicide by cutting his throat. Tiberio Claudio Massimo (who brought the severed head of Decebal to Trajan as a trophy) reaches him first.

The clumsy way in which the upraised arms in the centre and right background connect to the body is identical to MS 254; it is not shown in MS 320 or in Muziano's engraving.

Fresco XII on the west wall of the salone of Bishop Riario's palace in Ostia, dated 1511–13 and attributed to the circle of Peruzzi, is based on this scene (Agosti & Farinella 1984, p.409).

OTHER REPRESENTATIONS Ripanda Codex, Rome, BIASA, MS 254, fol.96; anonymous Italian, second half of the 16th century, Rome, BIASA, MS 320, fol.123; attributed to Giulio Romano, Modena, GE, inv. no.8131B–C; Pietro da Cortona, Eton College; Pietro Santi Bartoli, Windsor, RL, inv. no.7989.
ENGRAVED Chacon 1576, fols 122–3 by Girolamo Muziano; Bartoli 1708, fols 108–9.

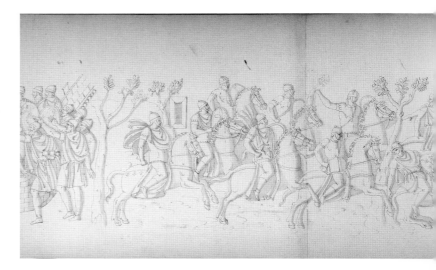

		108
95		
121		122
8131A		8131B
		7908
	7988	
120		121
106		

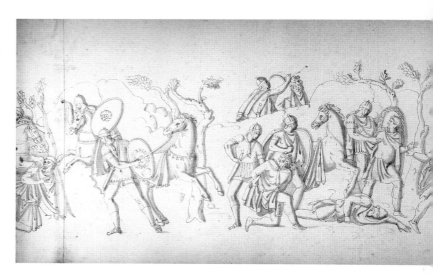

	110	
97		
124		
8131D		
7910		
		7990
123		
		109

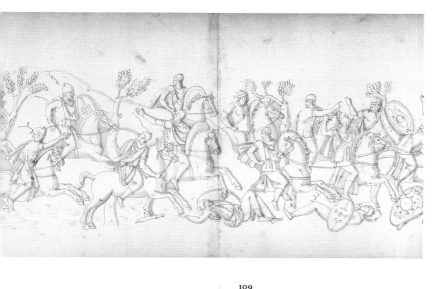

109

96

123

8131C

7909

7989

122

107

108

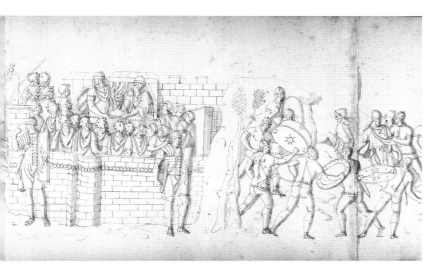

11

112

98

126

8131F

7912

124

125

110

481

Scenes CXLV–CXLVI

Settis 1988, pp.527–9

WM cat.10; 345 × 501 mm

SJSM, vol.113, fol.110

A Roman soldier approaches Decebal, leading his horse by the bridle. The scene changes with two trees. The Romans crush the last pockets of resistance; a Dacian is forced to his knees, his hands tied behind his back. In the background another is held by his hair. On the right two Dacian youths have fallen into the hands of the Roman auxiliaries.

The drawing of the man in the background gripping the lock of hair is identical to MS 254.

OTHER REPRESENTATIONS Ripanda Codex, Rome, BIASA, MS 254, fols 96–7; anonymous Italian, second half of the 16th century, Rome, BIASA, MS 320, fols 123–4; attributed to Giulio Romano, Modena, GE, inv. no.8131D–E; Pietro Santi Bartoli, Windsor, RL, inv. nos 7989–90.

ENGRAVED Chacon 1576, fols 122–3 by Girolamo Muziano; Bartoli 1708, fol.109.

482

Scenes CXLVII–CXLVIII

Settis 1988, pp.530–31

No WM; 345 × 506 mm

SJSM, vol.113, fol.111

The head and right hand of Decebal on a salver are held up by two officers and shown to the troops inside the walls of the camp, while two sentries stand guard outside. Two trees close the episode. On the right Roman soldiers set off to occupy the enemy territory.

The roof on the canopy behind the soldier displaying the head of Decebal is plain in MS 320, the Modena drawing and Muziano's engraving; it has vertical lines in this drawing and in MS 254. The pelmet of the canopy, plain here, has vertical lines in MS 254. The frieze is damaged in this area and illegible.

OTHER REPRESENTATIONS Ripanda Codex, Rome, BIASA, MS 254, fols 97–8; anonymous Italian, second half of the 16th century, Rome, BIASA, MS 320, fols 125–6; attributed to Giulio Romano, Modena, GE, inv. no.8131E–F; Pietro Santi Bartoli, Windsor, RL, inv. no.7990.

ENGRAVED Chacon 1576, fol.124 by Girolamo Muziano; Bartoli 1708, fols 109–10.

483

Scenes CXLVIII–CXLIX

Settis 1988, pp.533–5

WM cat.10; 345 × 506 mm

SJSM, vol.113, fol.112

The Dacians are surrounded, bound and taken prisoner by the Roman auxiliaries. In the mountains the hunt continues for the Dacians who refuse to submit. In the centre there is a mountain scene, with a bull, a wild boar and a deer. In the trees, a half-bust with a billowing cloak, probably a personification of Aurora, is present while the last pockets of resistance are crushed.

OTHER REPRESENTATIONS Ripanda Codex, Rome, BIASA, MS 254, fols 98–9 (Pasqualitti 1978); Amico Aspertini, London, BM, I, fols 22v–23r, 26v–27r (Bober 1957, pp.65 and 66, figs 60 and 65); anonymous Italian, second half of the 16th century, Rome, BIASA, MS 320, fols 126–7; attributed to Giulio Romano, Modena, GE, inv. no.8131F–G; Pietro Santi Bartoli, Windsor, RL, inv. no.7991.

ENGRAVED Chacon 1576, fols 125–6 by Girolamo Muziano; Bartoli 1708, fols 110–11.

484
Scenes CL–CLI
Settis 1988, pp.536–8
No WM; 345 × 485 mm
SJSM, vol.113, fol.113

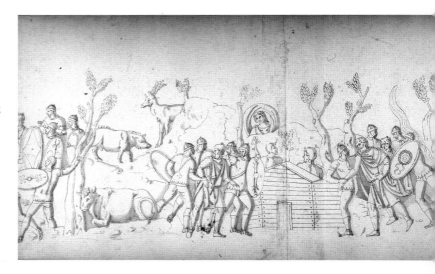

The prisoners are brought to a building in the foreground. In the background the last spiral of the frieze begins to contract. In front of the high city wall the auxiliaries meet a group of barbarians, probably the people who gave refuge to the Dacians. As they lurch towards the Romans, one figure kneels on the ground, his right arm upraised, begging for mercy.

A semicircular fence curves behind the pedimented building on the left in MS 254, the Modena drawing, Muziano's engraving and in the frieze.

OTHER REPRESENTATIONS Ripanda Codex, Rome, BIASA, MS 254, fols 99–100; anonymous Italian, second half of the 16th century, Rome, BIASA, MS 320, fols 127–8; attributed to Giulio Romano, Modena, GE, inv. no.8131G–H; Pietro da Cortona, Eton College; Pietro Santi Bartoli, Windsor, RL, inv. nos 7991–2.
ENGRAVED Chacon 1576, fols 126–7 by Girolamo Muziano; Bartoli 1708, fols 111–12.

485
Scenes CLII–CLIV
Settis 1988, pp.539–42
WM cat.10; 345 × 516 mm
SJSM, vol.113, fol.114

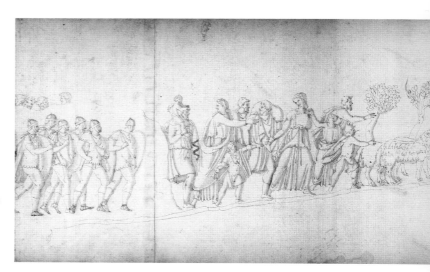

After winning the submission of the neighbouring populations, the last Dacian prisoners are rounded up. The Roman troops set their city and fortress alight. While they burn the city, the last scene of the frieze unfolds. In front of a rocky ridge the veterans march towards the colonies that Trajan founded in Dacia. The soldiers have been sent to become the new inhabitants of the new Roman province. Heads of Dacians watching their arrival peep over the ridge.

The break in the building in the background is narrower in MS 320 and the Modena drawing than it is in this drawing, in MS 254, in Muziano's engraving and in the frieze. There are two buildings behind and to the right of the wooden palisade in the frieze and in this drawing, MS 254, the Modena drawing and Muziano's engraving; no building is shown in MS 320.

OTHER REPRESENTATIONS Ripanda Codex, Rome, BIASA, MS 254, fols 100–01; anonymous Italian, second half of the 16th century, Rome, BIASA,

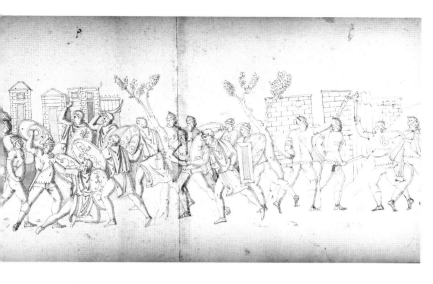

114

100

128 129

8131H 8131I

7914 7915

7992

127

112

116

102

131

8131K

7917

130

114

MS 320, fols 128–9; attributed to Giulio
Romano, Modena, GE, inv. no.8131H–I;
Pietro da Cortona, Eton College;
Pietro Santi Bartoli, Windsor, RL,
inv. no.7992.
ENGRAVED Chacon 1576, fols 127–8
by Girolamo Muziano; Bartoli 1708,
fol.112.

486
Scene CLIV
Settis 1988, pp.543–4
WM cat.10; 345 × 501 mm
SJSM, vol.113, fol.115

From behind the rocky ridge a group of
Dacians go towards the land assigned
to them by the Romans. A man carries
a child on his shoulder, another leads a
child by the hand; ahead of them are
the elderly, women and children, and
their flocks.

The scene is painted by artists in
Peruzzi's circle in fresco XIII on the
north wall in the salone of Bishop
Riario's palace in Ostia, dated 1511–13.
The fresco was recorded by Pirro
Ligorio (Amsterdam 1981, cat.43,
p.82; Agosti & Farinella 1985, p.1105,
tav.LIX.1 and 2).

OTHER REPRESENTATIONS Ripanda
Codex, Rome, BIASA, MS 254, fols 101–2;
anonymous Italian, second half of
the 16th century, Rome, BIASA, MS 320,
fols 129–30; attributed to Giulio
Romano, Modena, GE, inv. no.8131I–J
(Macrea 1937, fig.19); Pietro Santi
Bartoli, Windsor, RL, inv. no.7993.
ENGRAVED Chacon 1576, fols 128–9
by Girolamo Muziano; Bartoli 1708,
fol.114.

487
Scene CLV
Settis 1988, p.545
No WM; 345 × 486 mm
SJSM, vol.113, fol.116r

A line of animals – goats, sheep and
oxen – fills the last turn of the spiral,
migrating to their new homes.

OTHER REPRESENTATIONS Ripanda
Codex, Rome, BIASA, MS 254, fol.102;
anonymous Italian, second half of the
16th century, Rome, BIASA, MS 320,
fol.130; attributed to Giulio Romano,
Modena, GE, inv. no.8131K (Macrea
1937, fig.20); Pietro Santi Bartoli,
Windsor, RL, inv. no.7993.
ENGRAVED Chacon 1576, fol.130 by
Girolamo Muziano; Bartoli 1708,
fol.114; Piranesi 1774–9, pl.XVII
(Wilton-Ely 1994, fig.705).

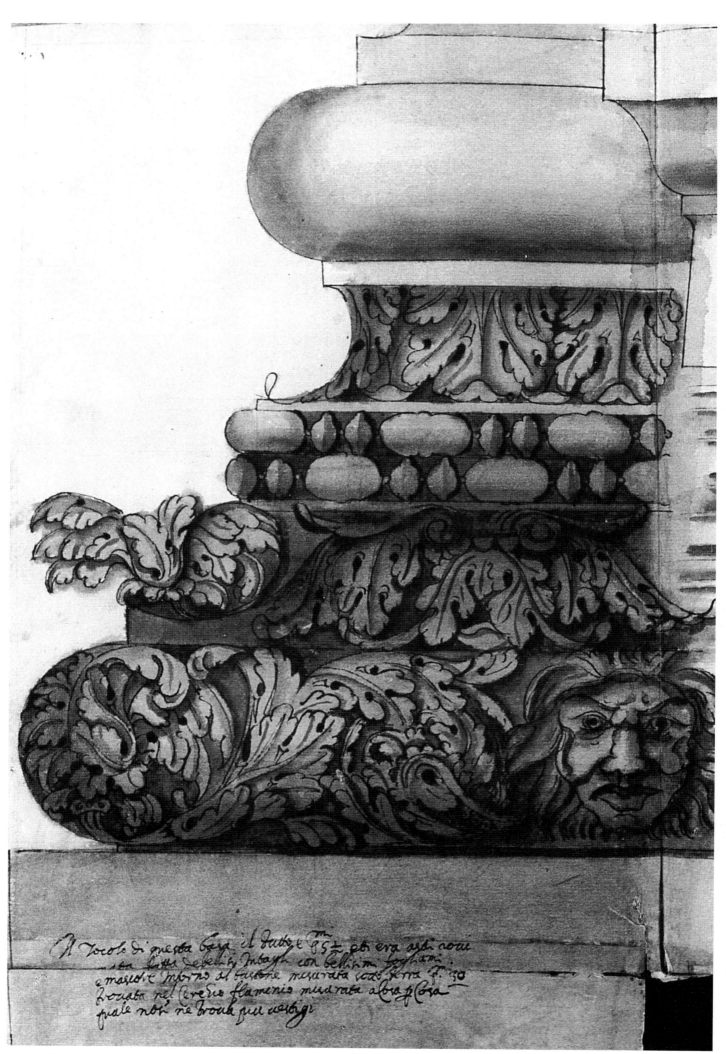

Il zocolo di questa basa il dutto è m 85½ ½ che era asai noui
sta tutta debellis Intagli con bellissim fogliami
e mascole intorno al cantone misurata cod terra f 30
trouata nel terreno flaminio murata altra p cosa
quale noi ne troua piu vestigi

517 detail

Frammenti
Cornices, capitals and entablatures after Alberto Alberti
*c.*1600

The volume contains drawings of entablatures, cornices, bases and capitals, copied from four volumes of drawings of architectural fragments in the Gabinetto Nazionale dei Disegni e Stampe in Rome. They record antique architectural fragments that were discovered in the Renaissance, and often then reused in other buildings. The inscriptions on the drawings bear dates ranging from 1570 to 1598.

The title *Frammenti* was also used by the draughtsman of Codex Ursinianus (Rome, BAV, Vat. Lat.3439), in the circle of Fulvio Orsini, to describe similar drawings; the term was used deliberately in order to evoke a work that had not survived in its entirety. Rodolfo Lanciani attributed the drawings in Rome to the architect and woodcarver Alberto Alberti and to his son, the printmaker Cherubino.[1] On the basis of the handwriting in the inscriptions, Giovanna Maria Forni, who catalogued and published the drawings in 1991, attributed them solely to Alberti. Using his autograph diary, which was published by degli Azzi in 1914, she outlined his biography and the activity of his important Roman workshop, which opened in 1560 on the Via della Scrofa.[2] The Rome drawings, which until recently were stored in four codices, A, B, C and D, were acquired in 1882 from a descendant of the Alberti family in Borgo San Sepolcro.[3] They all date from the 1590s. The handsome fragments are usually shown in profile, either full-, half- or quarter-size. Forni attributed to Alberti the representational convention used in many of the drawings: the profiles and sections of all the parts of the entablatures are shown overlapping, in order to fit an image, drawn to large-scale, on a single sheet of paper. Alberti may have been influenced by Michelangelo, who followed a similar convention in a drawing in the Casa Buonarroti, Florence: he drew a cornice and a fragmentary line to indicate the frieze, and at the side added the profile with details of the architrave mouldings in a similar way.[4]

The inscriptions imply that Michelangelo had measured the fragments; he certainly knew some of the cornices from his study of Codex Coner,[5] a model book of exemplary ancient and modern architecture from the circle of Sangallo, which was studied by 16th-century architects and which shows 16 of the cornices or bases drawn in the volume. Other fragments were also drawn by Fra Giocondo, Palladio and Giovann' Antonio Dosio. The drawings in the Soane volume are explicitly associated with Michelangelo. The inscriptions make frequent references to him, suggesting that he particularly approved of the pieces, and on the first folio (cat.488) is a Michelangelesque sarcophagus (the original drawing of it by Alberti is lost). Although Michelangelo is mentioned in the inscriptions on some of the Rome drawings, he is not cited in all the prototype drawings for the ones in the Soane album that make mention of him.

Alberti's son Cherubino became the foremost engraver of his generation in Rome. It is therefore tempting to associate the drawings with a publishing initiative, to accommodate the taste of an increasing number of dilettante architects in the academies in the late 16th century. The taste for collecting engraved images, originally stimulated by Marc'Antonio Raimondi's engravings of Raphael's designs, was well developed by the middle of the 16th century. Agostino Veneziano and Marco Dente were the first to engrave famous antiquities and fragments, and by the mid-1560s the large-scale engravings of Antonio Salamanca, published by Antonio Lafreri, were available.[6] There is, however, no evidence to suggest that the drawings were to be engraved, and some of the overlapping images were probably too complex for engravings. The drawings in the Soane volume were probably selected by a client from the master set and copied by an assistant in the workshop for sale. They must date from the late 1590s or early 1600s.

LITERATURE The Soane drawings are unpublished. For the master set of drawings attributed to Alberto Alberti, see Forni 1991.

CATALOGUE NOTE

The 88 pages are bound in vellum-covered boards measuring 438 × 320 mm. A vellum label glued to the top of the spine is inscribed *Architet[tura]/ Civile/ Fram=/menti* L/*13;* a label glued to the bottom of the spine is numbered XIII, and a small paper label glued to it is numbered 6 in an 18th-century hand. The endpaper glued to the back board is inscribed *Sono in tutto Fogli 89.*

The support is a white laid writing paper; the watermarks are listed at nos 21–3, 34–7 in the catalogue of watermarks in volume II. The drawings are underdrawn in graphite with a ruler and compass, then drawn in pen and dark brown iron-gall ink over graphite construction lines and underdrawing, and washed with watercolour; areas left unwashed give the effect of white areas of colour. The colours of the washes are described in the entries. Each folio is folded and tipped on to a guard. The folios bear two numbers, the uneven numbers are on the versos, and the even numbers are on the top right corners of the rectos. Some drawings have an earlier number in ink at the top right corner. Most drawings are marked with a small graphite cross, and every inscription is initialled *f;* on the verso of the last folio a signature reading *Io francesco firera, fireza* or *fireta* is written with an identical *f.*

Flaps of paper have been glued to the large folios to complete the mouldings; both the size of the folio and the extended dimensions are given in the entries.

1. Lanciani 1881–2, p.280.
2. Forni 1991, p.16
3. Lanciani 1881–2, p.280.

4. Florence, Casa Buonarroti, inv. no.5; illustrated in de Tolnay 1980, IV, p.46, cat.514r.

5. SJSM, vol.115; Ashby 1904; for Michelangelo's copies, see Agosti & Farinella 1987.

6. Deswartze Rosa 1989, pp.47ff.
7. Watkin 1972, p.157.

PROVENANCE Robert Adam Sale, Christie's, 20 May 1818, lot 28.[7]
The front board is inscribed *Mr Adam's Sale May 1818 £1.11.6.* in Sir John
Soane's hand. The entry in Richardson's catalogue of Sir John Soane's
Library is inscribed in red ink by Bailey: *Manuscript Architecture
L'Architecture Civile/Fragments cornices Friezes etc/folio 97.— A volume of
drawings.*[8] The volume was located in case 97 in the study with other
drawings, including Montano's drawings and manuscripts.

The unit of measurement employed is the Roman *palmo* (=2.23 metres),
which is subdivided into 12 *once*; one *oncia* is 5 *minuti* (186 mm), one
minuto is 2 *decimi* (37 mm). In two cases, the fragment is measured with
the Florentine *braccia* (584 mm), divided into 12 *once*; 1 *oncia* is 46.8 mm.

The inscriptions on the drawings all state that the fragments were mea-
sured with the greatest diligence, and they often record that the fragment

no longer survives. Translations are not usually provided for these parts
of the inscriptions, but they are given for information pertaining to the
scale of the drawings, the locations of the finds and their reuse in other
buildings. In order to distinguish the shape of the cymas, the modern
terms cyma recta and cyma reversa with their ornament leaf and tongue
or acanthus have been used instead of the Vitruvian terms lesbian and
Ionic Kymatia.[9]

8. Richardson 1830, p.489.
9. For the development of the Roman
mouldings, see Berlin 1988, pp.116–21.

488

LOCATION UNKNOWN
Sarcophagus, cornices and an architrave
Elevation and profiles with oblique projections of cornices
Scale 189 mm=3 *palmi*; the palmo is divided into *once*; 1 *once*=5.5 mm
Inscribed on fol.1v: *Cas[s]a che vie da Michelangelo Bonarota*, fol.2r: *Cornice
Architravate misurate nelle Cose/Antiche delli edefizi f* [initial] – *Scala Romana*
WM cat.37; two brown and three beige washes, areas of white unwashed
paper; 413 × 551 mm
SJSM, vol.119, fols 1v–2r

The sarcophagus is gripped by two axe-head consoles on legs with triglyphs and
decorated with an oval cartouche set in a rectangular panel of strapwork. The
coved cover has a satyr-mask in the centre and acanthus ornament at the corners
below an egg-and-dart moulding.

On the right is an architrave with two fasciae separated by a plain ovolo and
ending in an astragal, and a cornice with a cyma reversa, fillet and astragal below
the cyma recta, plain corona, astragal, cyma recta and slab. The second cornice
has a cyma reversa above the flat frieze below a plain fascia, cavetto, corona,
cyma reversa and slab.

No original drawing survives. The inscription records that the drawing shows
Michelangelo's sarcophagus, but it is not the same as the sarcophagus on the
monument to him erected in S. Croce, Florence (Wittkower & Wittkower 1964,
pl.20). The drawing could record a design for it. The shape of the sarcophagus
and the supports are similar to the sarcophagus in the Medici chapel in S. Lorenzo,
Florence (Ackerman 1961, pl.7a).

489

ROME: *St Peter's, Basilica Aemilia*
*Two Doric entablatures, a column, base, impost and details of a metope and a
bucrane; profiles and oblique projections of the elevations*
Inscribed on fol.3v: *Doricha – menuti 35 – menuti 35⅓ – Questa cornice fu trovata
nelli/fondamenti di S[an]to Pietro jnva/nticano et Bramante Architetto/la fece rimettere
nel medesimo/logho misurata acosa p[er] Cosa con/Gran diligenzia quale menbro/
di Cornice nose ne trova piu/vestigi f* [initial]; fol.4r: *Questa Cornice e misurata col
braccio fiorentino/misurata con ogni deligenzia nelli edifizi/Antichi partito in menuti
sesanta–Doricha–minuti 63–noceva–bracia 9 m[enuti] 3 o[nce] stilo–le stresie/sono 9
vote/de alto sino al/mezzo che varia molto/dal altre–brac[chi]a 2 minuti 6–tre rose
p[er] facca–menuti* [three times] *basamento sotto/alli gradi del medesimo/edifizio*
WM cat.36; two brown and three beige washes, areas of white unwashed paper;
558 × 425 mm
SJSM, vol.119, fols 3v–4r

On the left is a detail of the Doric order found by Bramante at St Peter's. The
entablature has an architrave with two fasciae, a frieze with triglyphs and six guttae
– the capitals of the triglyphs and the slabs below them projecting into the frieze –
and a cornice with a cavetto, fillet, ovolo and fillet below mutule blocks with cyma
recta and a fillet supporting the plain corona, cyma reversa, fillet and cyma recta.

The entablature on the right has an architrave with two fasciae ending in a flat
slab with the guttae hanging from it, a frieze with triglyphs and a bucrane in the
metope. The projecting triglyph capitals support a cornice with a plain cavetto,
fillet and ovolo below mutules with rosettes in the coffers between them, below a
plain corona, fillet, cyma reversa, fillet and cyma recta with lion's masks.

Alberto Alberti's original drawing does not survive. The inscription on fol.3v
locates the find in the foundations of St Peter's; Bramante replaced it where it
was found. The architrave and frieze on fol.3v were both drawn in Codex Coner
(Ashby 1904, cat.71), and identified by Ashby as from the Doric order outside the
temporary choir. The inscription on fol.4r records: 'the cornice is measured using
the Florentine *braccia* divided into 60 *minuti*. The dimensions of the capital and
column are given. The column with 9 empty flutes from the top to the middle of
the column varies from the other. The base comes from below the steps of the
same building.' Also drawn in Codex Coner (Ashby 1904, cat.77), the fragment
was identified by Ashby as the Doric order of the Basilica Aemilia from the façade
towards the Forum. The slab below the triglyph does not project in the Coner
drawing, which was copied by Michelangelo (Florence, Casa Buonarroti, fol.2Ar);
he shows the projection below the triglyphs as in the Soane drawing (de Tolnay
1975–80, IV, pp.48 and 50, cat.517r and 520v). Fragments of the order also came
to light; they are discussed by Huelsen (1902, p.45; Nash 1968, fig.196).

Città che uide la. Michelangelo Roma a. cosa.

Cornice Architravata misurata nelle
Antichi delli edefisi di R.

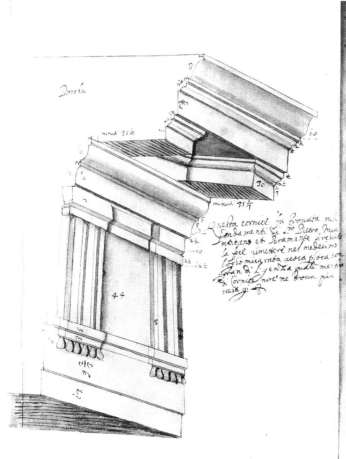

488

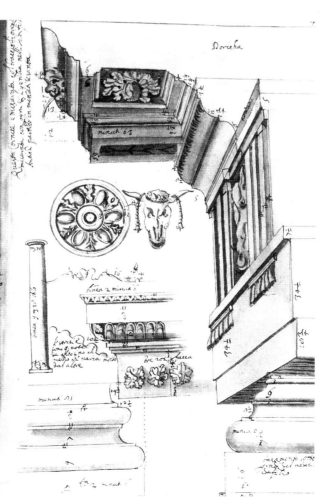

489

490

ROME: *Basilica of Neptune*
Corinthian column, architrave, base, cornice and capital; profile and elevations
Inscribed on fol.5v: *6 palmi – p[al]mi 47 once 5 mi[nuti] uno–questo corpo di Colonna senza la basa e p[al]mi 47 once 9 – grosezza da basso/p[al]mi 4 once minuti 3 – Cornice architrave et basa sono sminuaite per meta li da/lfini vano nel fregio ch'e alto q[ues]to larchitrave A il ca/pitello B le sue misure sono di tutta grandezza nosie pos/suto corre altre misure per esser ruvinato cosi il cor/po di colonna sono guaste misurate interra trovate soto/terra p[al]mi 40 et e asai del ordine della ritonda dal ca/nto di mezzo giorno cerano grandisime stanze dove/ancho si vedeva ordini et nicchie dove stavano idoli/sonno fate con diligenza achore delle altezze f [initial]; fol.6r: 6 once/9 m[inut]i–il capitello a p[al]mi 5 once 8 m[inuti]–1/iltutto–p[al]mi 6 scala–fregio alto quanto lar/chitrave segnate A*
Flaps are added at top left to complete the cyma and at the bottom to complete the socle; WM cat.34; two brown and three beige washes, areas of white unwashed paper; 564 × 423 mm; 681 × 551 mm
SJSM, vol.119, fols 5v–6r

The elevation of the Corinthian column and capital is shown on the left of the drawing. The architrave to its right, drawn half-size and marked A, has three fasciae, increasing in height and separated by bead-and-reel astragals below a cyma recta with acanthus-ogee decoration. The base, with a projecting lower torus, a fillet, two scotias separated by two astragals below the upper scotia, a fillet and torus, is shown on the lower half of the drawing to the right of the architrave. The frieze with diving dolphins and anthemion decoration is shown at the top as though it is the decoration of the cyma recta, and the Corinthian capital below it is shown in the elevation of the corona of the cornice, which is drawn on the right. The cornice has dentils, a plain fillet and a bead-and-reel astragal below the egg-and-dart ovolo with an acanthus leaf decorating the corner, a fillet, plain corona, cyma reversa with leaf-and-tongue decoration, and a fillet below the cyma recta.

The inscriptions record the height of the column and capital, and that other measurements could not be taken because of the ruinous state of the capital and the column shaft. They note that the frieze is the same height as the architrave A. The find is located at the Pantheon towards midday 'in very large rooms with orders and niches containing idols'.

The drawing was copied from Alberto Alberti's Codex C, in which the base is incomplete. A plan on his drawing shows where the cornice was found, in rooms south of the Pantheon, in the area of Via della Palumbella, which was excavated twice in the Renaissance, during the pontificates of Paul III and Gregory XIII (Lanciani 1902–12, II, p.237).

The capital is preserved in the Cortile della Pigna in the Vatican (Respighi 1933, pp.109ff.). Part of the frieze was reused in the pavement of the Cappella Gregoriana. Alberti alone recorded the capital and full entablature.

MASTER DRAWINGS Rome, GNDS, Alberti Codex C, fols 14v–15r, inv. nos F.N.8071v–F.N.8072r (Forni 1991, pp.106–8, tav.CLXXXVI–CLXXXVII); Codex D, fols 12v–13r, inv. nos F.N.8182v–F.N.8183r (Forni 1991, p.180, tav. CCCXLVI–CCCXLVII; the drawing is a fair copy of Codex C without showing the full-size egg-and-dart detail, or the acanthus ogee, shown here and in Codex C).

For other representations, see Forni 1991, p.108.

491

ROME: *Baths of Caracalla and Temple of Serapis on the Quirinal*
Cornice, entablature and pedestal; profiles and perspective elevations
Scale on fol.7v: 160 mm=3 palmi; fol.8r: 90 mm= 2 palmi
Inscribed on fol.7v: *p[alm]i 2 once sette–fregio quale nouera p[er]ero noce mesura f [initial]–Questa cornice la misurai sotto terra/asai nel Antogniana ben lavorata/de bellisimi jntagli fatti con grandi/sima deligenzia misurato ogni Cosa/aCosa per cosa et redutola in picolo conforme si vede f [initial] e dalgetto a p[al]mi 3 on/ce octo–Scala della misura di d[et]ta Cornice di p[al]mi tre; fol.8r: Nel Palazzo di Nerone apresso il frontespizio/verso mezzo giorno ui era un apartamento di/trauertino lavorato con grande deligenzia/questo piedestallo lo uisto jnopera sotto terra/piu di 50 palmi la Cornice con architrave/erano Coperti di stucho ben lauorato et feni/to il fregio ancho cosi fatto era spezzato del altezza che poteua essere opiu omancho q[ue]sta/fabricha ruuinata era nel giardino di S[igno]ri Sil/vestro p[er] quanto ouisto sotto terra alcun pezzo/di Colonne circha doi terzi di tondo nopotei/Cauare altre misure che posauano con le/base sopra q[ues]to piedestallo et de grande/redutolo Jn picolo come si vede et la Cor/nice pontegiata et la Cornice del piedestallo–Scala Romana de p[al]mi doi–Zocolo e Zocoletto che/ua sotto la lettra A cio/e Cordone del di sotto del/piedestallo segnato Q f [initial]*
WM cat.36; one grey, two brown and two beige washes, areas of white unwashed paper; 423.5 × 563 mm
SJSM, vol.119, fols 7v–8r

The cornice on the left has a cavetto decorated with a satyr-mask and acanthus, a fillet, an ovolo with acanthus leaves and a corona with a wave motif above rosettes in coffers with bead moulding. Above the corona there are an ovolo and a cyma recta with a relief of dolphins diving below anthemion flowers. Alberto Alberti's drawing of the cornice does not survive.

On the right the entablature from Nero's palace has an architrave with three fasciae – the top one decorated with putto masks – separated by a cyma reversa with leaf-and-tongue decoration and a bead-and-reel moulding, ending in a cyma recta with acanthus-ogee ornament. The frieze above is decorated with putto masks, with two projecting slabs above and below. The cornice has a cyma reversa with simplified acanthus leaves below a plain corona and cyma reversa. The profile of the pedestal is shown on the right behind the entablature.

The inscription on fol.7v records the height of the cornice, 2 *palmi*, 7 *once*, and reads: 'It was found below ground close to the Baths of Antoninus; the carving was very beautiful and it is reduced to a small scale. The frieze was not found.' A drawing by Palladio (London, RIBA, VI, fol.8) of the entablature from the Baths of Caracalla shows similar grotesque masks and foliage on the corona, which may confirm the location given in the inscription (Zorzi 1958, p.69, fig.119). The inscription on fol.8r records the find: 'in an apartment of travertine, towards midday at the Palace of Nero near the frontispiece [the temple of Serapis on the Quirinal]. The pedestal was more than 50 *piedi* underground; the cornice and architrave covered with stucco was well-made; the frieze which was broken was in the Silvestro garden.'

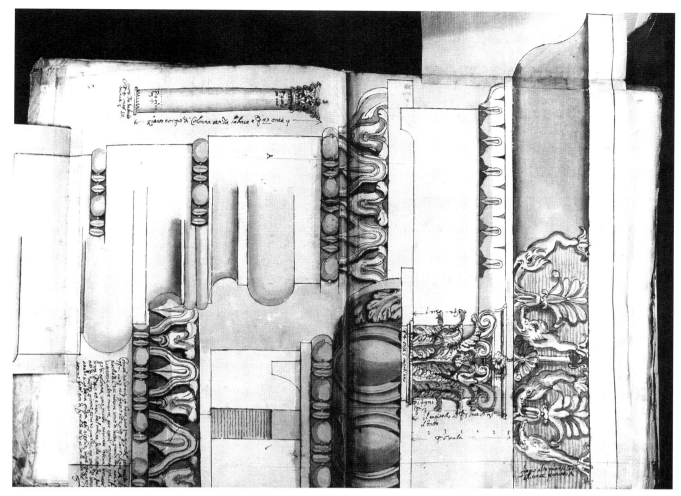

490

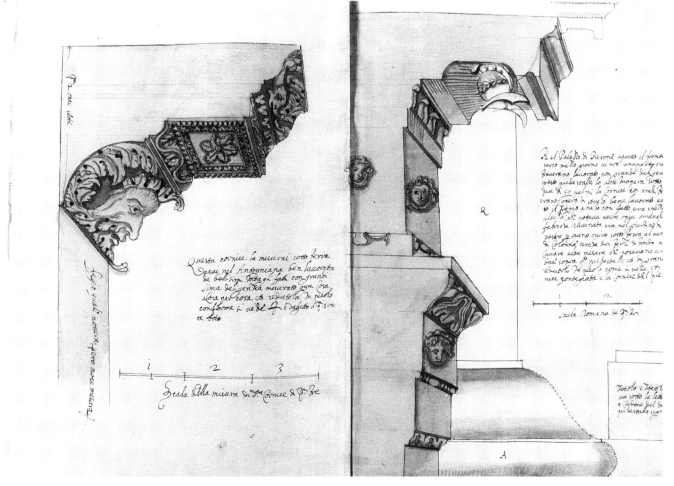

491

492

ROME: *Trajan's forum, Basilica Ulpia*
Cornice; profile and elevation of the Doric order

Inscribed on fol.9v: *altezza del fregio e tanto*; fol.10r: *ovolo di tutta grandezza – Questa cornice misurata nelli Pezzi naturali/delle Antichita di roma quale cornice la/sua altezza e divisa per meta come si vede/et ridotta puntualmente e mesurata con/ogni Diligenzia louo e di tutta grandezza/stanpato sopra il proprio Marmoro quale/Cornice e bene lauorata et jntagliata come se vede quali Michelangelo bonarota ce fu uisto/che la misuro – sminovia p[er] meta*

A flap has been attached at top right to complete the cyma recta; WM cat.36; two brown and three beige washes, areas of white unwashed paper; 560 × 423 and 537 mm
SJSM, vol.119, fols 9v–10r

The elevation is shown half-size; the detail of the egg-and-dart moulding is full-size. The cornice has a bead-and-reel moulding below a cyma reversa with acanthus-ogee decoration, a fillet, a dentil moulding, a fillet, an ovolo with egg-and-dart moulding, a fillet, foliage scroll modillions below a leaf-and-tongue cyma reversa, plain corona, fillet, cyma recta and slab. Profiles of the rosettes are shown between the modillions.

The inscription records: 'the cornice was measured from the ancient ruins of Rome; it is well made, carved in marble and it was seen by Michelangelo who measured it'. The inscription on Alberto Alberti's drawing in Codex D located the cornice at Trajan's forum. It is drawn in Codex Coner (Ashby 1904, p.46, cat.88). The inscription implies that Michelangelo had seen the original, but no drawing of it by him survives. The same cornice, which was published by Leon (1971, p.74, Taf.1.1–1.2, 21.1), is also shown on fols 23v–24r of *Frammenti* (cat.499). The drawing here is similar but not identical to that on fols 15v–16r (cat.495).

MASTER DRAWINGS Rome, GNDS, Alberti Codex C, fols 66v–67r, inv. no.F.N.8117v (Forni 1991, pp.144–5, tav.CCLXIV; Michelangelo is not mentioned in the inscription); Codex D, fols 12v–13r, inv. nos F.N.8182v–F.N.8183r (Forni 1991, p.180, tav. CCCXLVI–CCCXLVII; the drawing is a fair copy of Codex C without showing the full-size egg-and-dart detail, or the acanthus ogee, shown here and in Codex C). LITERATURE Lanciani 1902–12, II, p.126.

493

ROME: *Trajan's forum*
Capital and entablature; profile and elevations of the cornice, capital and entablature and architrave

Scale 36 mm=2 p[almi]

Inscribed on fol.12r: *sminuite p[er] meta–fregio alto q[ues]to larchitrave–Nel edifitio di Troiano Imperatore erano le presente Cornice/e capitello et Architrave segniato K sonno sminuite della/sua grandezza che sonno Jnopere per meta e misurate con/ogni deligenzia il fregio si vedeua essere Jntagliato come/doue è la lettra V de bellisimi fogliami tutto rouinato louolo/grande a di tutta grandezza stanpato sul proprio Marmoro [mi] è [par deleted] farto con grande deligenzia et jnopera fa benissimo et il Capitello/R e lavorato con grandissima diligenzia tutto rouinato è misurato/ogni Cosa sotto terra asai le quale cose si cauorno e ridutte inopera da altri/edifizij guaste e ruuinate nose ne troua piu vestigi nesuno et la sua colona era di Marmoro gialda scaNellata sino alterzo sodi e di sopra cauati in/sul terzo della Colonna era spezzata la sua grosezza di essa era p[al]mi 4 once ii/nosi e potutto cauare altre misure li scanelli erano n[ume]ro 24. f [initial]–p[al]mi 4 once doi Jncima – p[almi] 2 il tutto*

WM cat.36; two brown and three beige washes, areas of white unwashed paper; 564 × 421 mm
SJSM, vol.119, fols 11v–12r

On the right the profile of the architrave, reduced to half-size and marked K, has three fasciae separated by bead-and-reel mouldings below a cyma reversa with acanthus-ogee ornament. On the left the cornice has a cyma reversa with acanthus-ogee ornament, a fillet, dentils, a fillet and bead-and-reel astragal, ovolo with egg-and-dart mouldings and an acanthus leaf at the corner, a fillet below the plain corona, cyma reversa with leaf-and-tongue decoration, a fillet and plain cyma recta. Below the cornice, the Corinthian capital, architrave and frieze decorated with foliage scrolls are drawn to a smaller scale. A detail of the egg-and-dart moulding is shown full-size on the right. The cornice is drawn on the right of fols 21v–22r (cat.498).

The inscription locates the fragments in Trajan's building: 'the capital, completely ruined, was measured in every detail below ground. They were excavated and reused. The broken column, *4 palmi 11 once* in diameter, was of yellow marble and fluted with 24 flutes to one third of its height.' The cornice was drawn in Codex Coner (Ashby 1904, cat.113), without the carved mouldings. An architrave with similar mouldings was published by Leon (1971, pp.59ff., Taf.5.2).

MASTER DRAWINGS Rome, GNDS, Alberti Codex C, fols 79r and v, F.N.8130; fol.80r, F.N.8131 (Forni 1989, pp.154–5, tav.CCLXXXVII–CCLXXXIX); the architrave is shown on fol.79r, the cornice to the egg-and-dart ovolo and the detail of the egg-and-dart moulding on fol.79v, and the top of the cornice and the detail of the capital and entablature on the right in the same way as this drawing on fol.80r. LITERATURE Lanciani 1902–12, II, p.126.

For other representations, see Forni 1991, pp.154–5.

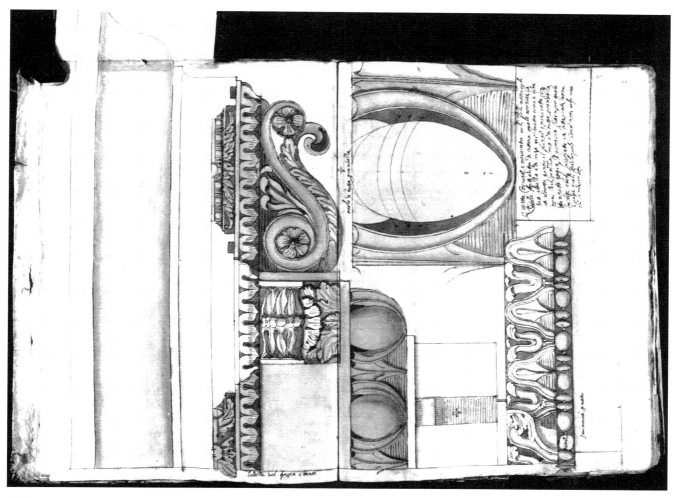

492

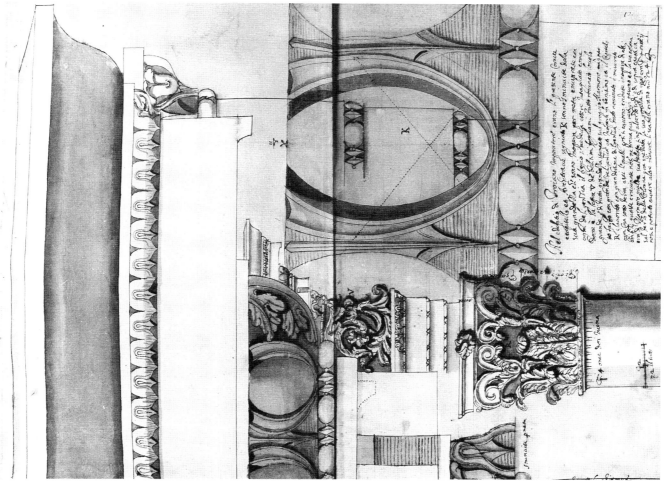

493

494

ROME: *Pantheon, interior*

Corinthian order, the entablature of the first order; profiles of the architrave and two cornices

Inscribed on fol.13v: *Il fregio sopra alarchitrave è p[al]mi 3 oncie 4 sensa siminuire grande f [initial]–La cornice presente con li Modiglioni cosi/larchitrave colorito di verdaco sono siminu/uiti del altezza che e inopera per meta esopra/le p[ri]mi Colonne di dentro all tempio della roto/nda le misure della colonna segniata+sono/jntiere senza sminuuire delle Colonne Magiore/di dentro la Cornice segnato B è lultima cor/nice dove gomincia à voltare la cuppula di d[et]ta Ritonda siminuuita p[er] meta misurate acosa p[er]cosa con ogni diligenzia e redotte per meta f [initial]–Laltezza di questa colonna ebasa ecapitello e p[al]mi 47 oncie 8–p[al]mi 6 oncie 9 mi/nudi 4; fol.14r: Architrave*

A flap has been added at top right; WM cat.36; one yellow, two brown and three beige washes, areas of white unwashed paper; 555 × 423 mm, flap 273 × 106 mm
SJSM, vol.119, fols 13v–14r

On the left at the edge of the folio the architrave with three fasciae separated by plain astragals and ending in a plain cyma recta is coloured yellow and drawn half-size. Below it on the left edge the profile of the plain frieze is also drawn half-size. It ends in a bead-and-reel astragal and an acanthus-ogee cyma recta and fillet below a plain fascia and fillet, bead-and-reel astragal and egg-and-dart ovolo under the modillions, which support a plain corona, fillet, cyma reversa and slab. Further to the right is the profile of the cornice below the dome on the interior of the Pantheon. It has a bead-and-reel astragal, acanthus-ogee cavetto and fillet below a plain fascia, bead-and-reel astragal, egg-and-dart ovolo, fillet, plain corona, cyma recta and fillet below a decorated cyma reversa. The elevation of the Corinthian column is shown below.

The measurements of the columns from the interior marked X are given full-size. The cornice marked B is the upper cornice below the dome of the rotunda. The height of the column with base and capital is 47 *palmi* 8 *once*. The width of the base 6 *palmi* 9 *once* 4 *minuti*. The entablature is also drawn in Codex Coner (Ashby 1904, p.85, cat.86).

MASTER DRAWINGS Rome, GNDS, Alberti Codex C, fols 19v–20r, inv. no.F.N.8077 (Forni 1991, pp.110–11, tav.CXCIV–CXCV); fol.19v shows the base and cornice, fol.20r the architrave and the top of the cornice.
LITERATURE Lanciani 1882, p.344.

For other representations, see Forni 1991, p.111.

495

ROME: *Trajan's forum*

Cornice; profile and elevation

Inscribed on fol.16r: *La presente Cornice era fra le ruuine de Troiano in Peratore e d[et]ta/Cornice sminuuito per metta della sua grandezza ridotta con/diligenza ogni Modiglione àsotto nel mezzo louolo e fra luno elaltro modiglione et tre ovoli e ogni ovolo posa sul sodo/del Dentello acorda ogni Cosa Insieme ben conpasto cosi lavor/ato gentilmente, louolo edi tutta grandezza stanpato sul pro/pio Marmoro Questa cornice cifu visto Michelangelo Bona/rota piu volte et la lodo asai come Cosa meritevole d[et]to Cornice/fu guasto efattone stipidi de finestre Picole f [initial]*

A flap has been added at top left to complete the cyma recta; WM cat.36; one brown and three beige washes, areas of white unwashed paper; 559 × 423 and 479 mm
SJSM, vol.119, fols 15v–16r

The same cornice is drawn on the right of fols 77v–78r (cat.527). It is similar to that drawn on fols 9v–10r (cat.492), but it is slightly smaller and has an extra bead moulding under the egg-and-dart moulding, and an acanthus-ogee cyma moulding above the modillions rather than the leaf-and-tongue moulding shown in the other drawing; the profile of the ovolo is also different. The cornice is drawn half-size; the detail showing the egg-and-dart and bead-and-reel mouldings on the left is full-size.

The inscription locates the find in the ruins of Trajan's forum: 'Each modillion is in the middle of the space between the eggs and each egg rests on a dentil and all of the parts agree well with each other. The cornice was seen several times by Michelangelo who praised it. It was broken and used as uprights for small windows.'

A cornice drawn in Codex Coner (Ashby 1904, p.46, cat.89a), identified by the inscription as near the Torre della Milizie above the Forum on the north-east, is probably the same as this one. The image is also reversed. The cornice is published by Leon (1971, p.74, tav.17.1, 18.1–18.2, 21.1).

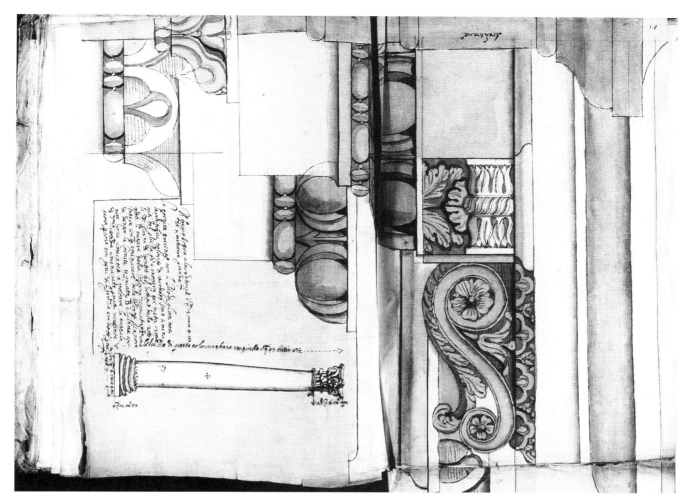

494

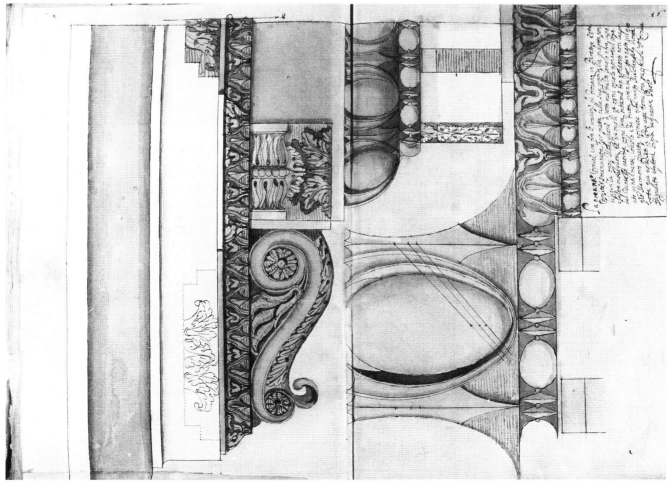

495

496

ROME: *Temple of Venus*
Base, cornice, impost and pedestal; profiles and elevations
Inscribed on fol.18r: *Cornice e basa/et altri menbri di tutta/grandezza ecetto* x *ch'e/devisa Jn quara sonno/delli edifizi di venere/vincetrice coli medesimi Jn/tagli quale noce ne piu vesti/gi f* [initial]
WM cat.21; two brown and three beige washes, areas of white unwashed paper; 421 × 567 mm
SJSM, vol.119, fols 17v–18r

The drawing shows the architectural elements full-size except x. On the left the profile of the base has an egg-and-dart moulding on the lower projecting torus and acanthus leaves in the lower scotia. Two astragals, with cable mouldings twisting in opposite directions, separate the two scotia. The upper scotia is decorated with egg and dart; the upper torus bears braided oak-leaf ornament and has a fillet inserted below it. On the right of the base, and overlapping with it, is a cornice, above a plain frieze, with a plain cyma reversa, fascia, a cyma recta with anthemion and scrolls and a fillet below the plain corona, upper cyma reversa and slab. The plain impost x is reduced to quarter-size. It has a cyma reversa and two fillets below a cyma reversa, slab, cavetto and cyma reversa below the corona, fillet, cyma reversa and slab.

The inscription locates the find at the temple of Venus Vincitrix. The drawing is copied from Codex D. According to the inscriptions on other drawings of the base, it was found at the temple of Castor and Pollux at SS Cosma e Damiano.

MASTER DRAWINGS Rome, GNDS, Alberti Codex D, fols 9v–10r, inv. nos F.N.8179v–F.N.8180r, without an inscription (Forni 1991, p.179, tav.CCCXL–CCCLI).

For other representations, see Forni 1991, p.179.

497

ROME: *The Aventine, a vineyard near the Colosseum; Nero's palace on the Quirinal; mouldings of a frame*
Inscribed on fol.19v: *questo Architrave era nel Monte aventino Jnscontro aripa/di tutta grandezza f* [initial]; fol.20r: *Jnposta di unarcho–gueste Corncie erano sopra alla/porta del entrata del palazzo/di nerone dove si uedeua lor/dine di un bel pitaffio quale/lo volse il Card[inal]e farnese di tutta grandezza f* [initial]
A flap has been added at the bottom to complete the architrave; WM cat.23; two brown and two beige washes, areas of white unwashed paper; 565 and 649 × 414 mm
SJSM, vol.119, fols 19v–20r

The architrave, which has three fasciae separated by decorated astragals, ends in a bead-and-reel moulding below a cyma reversa with acanthus ornament and a fillet. The impost of an arch and the frame of the inscription tablet above the portal are also shown full-size, horizontally within the fasciae of the architrave.

The inscription gives the scale and location of the fragments: 'the architrave on the Aventine, the moulded frame above the entrance to Nero's palace on the Quirinal. Cardinal Farnese wanted the fine inscription. The impost was found in a vineyard near to the arch of Constantine.'

MASTER DRAWINGS Rome, GNDS, Alberti Codex D, fols 10v–11r, inv. nos F.N.8180v–F.N.8181r (Forni 1991, p.179, tav.CCCXLII–CCCXLIII).

498

ROME: *Trajan's forum*
Base of a column on the exterior and a cornice; profiles and elevations
Inscribed on fol.22r: *Questa Cornice Consua basa e di tutta/grandezza trouate nelli vestigi di/ponpeo mesurato ogni cosa con diligenza f* [initial]
WM cat.21; two brown and two beige washes, areas of white unwashed paper; 420 × 557 mm
SJSM, vol.119, fols 21v–22r

The base on a socle has a projecting lower torus, a fillet and scotia, a fillet, two astragals, a fillet, an upper scotia, fillet and torus. The same cornice is drawn on fols 11v–12r (cat.493).

The inscription records that the base and cornice are drawn full-size and that they were found in the ruins of Pompey.

MASTER DRAWINGS Rome, GNDS, Alberti Codex D, fols 11v–12r, inv. nos F.N.8181v–F.N.8182r (Forni 1991, p.179, tav.CCCXLIV–CCCXLV); the cornice is drawn in Codex C, fol.66r and fols 79v–80r, inv. nos F.N.8116v–F.N.8117r (Forni 1991, p.144d, tav.CCLXII–CCLXIII).
LITERATURE Lanciani 1902–12, II, pp.120ff.

For other representations, see Forni 1991, p.144.

499

ROME: *Trajan's market*
Cornice; profile and elevation
Inscribed on fol.24r: *Questa Cornice e delle rovine di traiano Jnperatore quale fu rouinata p[er] fare altri lauori sminuuita/p[er] meta fra unmodiglione et laltro cera bellisime/rose colle medesime jntagli come si uede trouata/sotto terra asai quali noce ne piu vestigi f* [initial]
A flap has been added at the bottom to complete the cyma and frieze; WM cat.21; one grey, two brown and two beige washes, areas of white unwashed paper; 423 and 578 × 563 mm
SJSM, vol.119, fols 23v–24r

The drawing, showing only a cornice, is a variant of that on fols 9v–10r (cat.492), which gives the full entablature, capital and full-size egg and dart. The inscription records that the cornice, drawn half-size, 'was found in Trajan's ruins, it was ruined to make other things. It had beautiful rosettes, between the modillions, carved in the same manner as others found underground nearby.'

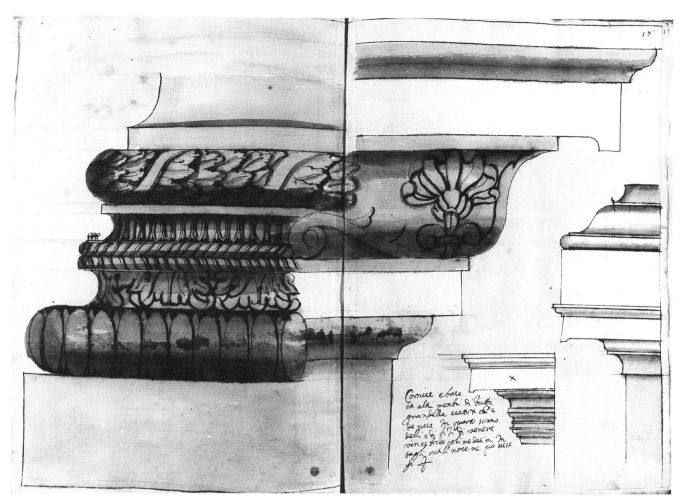

496

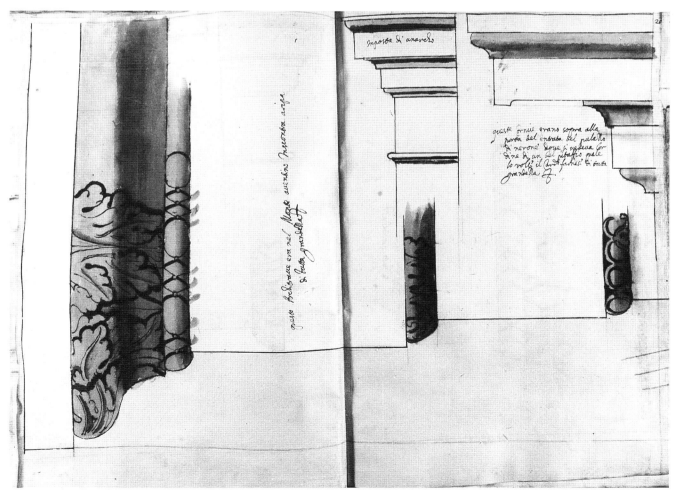

497

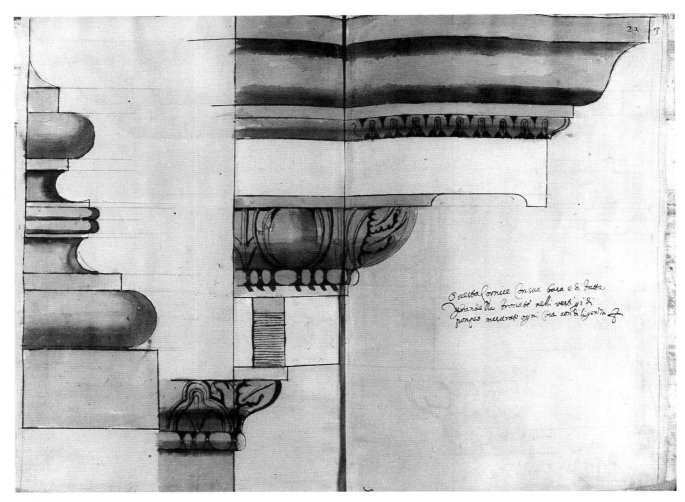

498

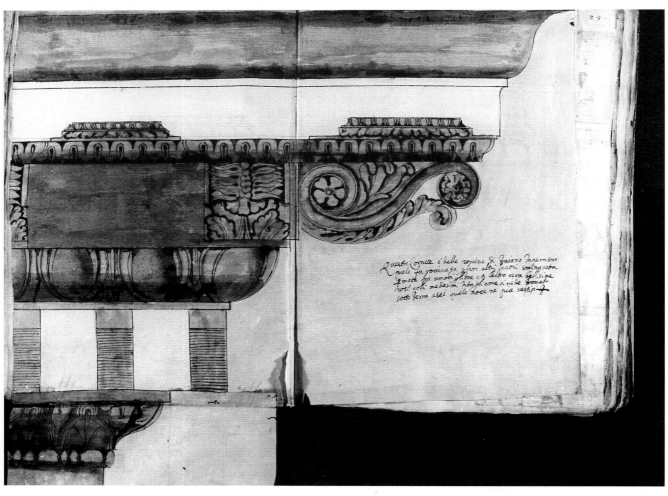

499

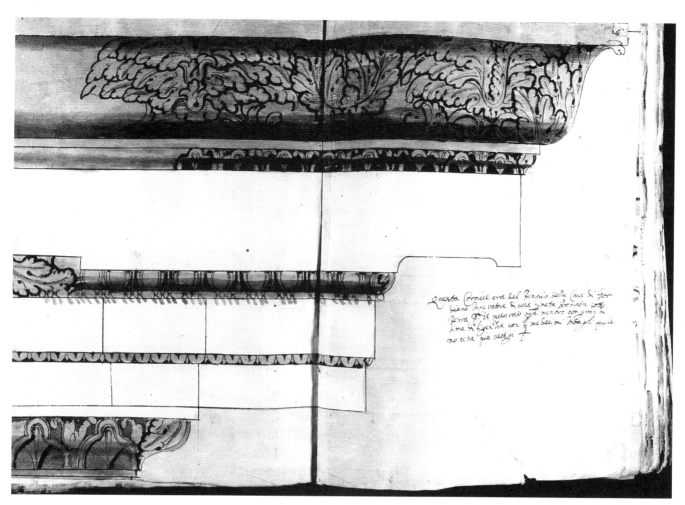

Questa Cornice era del Pinnio della Casa di fior
ciano Imperatore è era Imeta Bronzia sotto
terra et il misurato ogni mentro con gran di
lima di ligentia con li medesimi Magli quale
no ce ne più vestigi

500

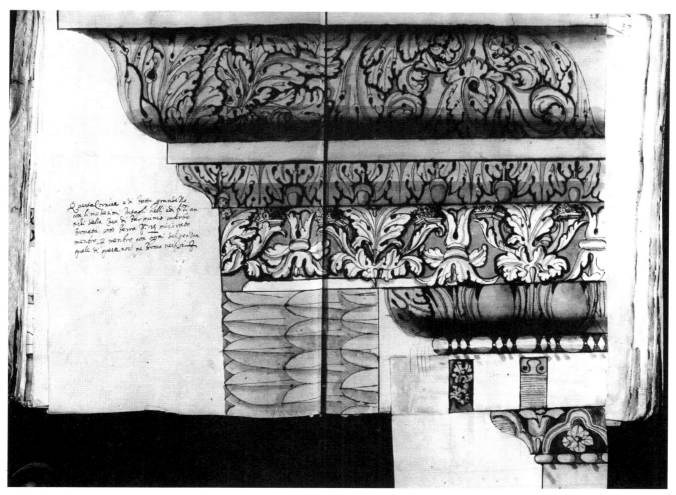

Questa Cornice è di Pietra grande No
con li medesimi Magli nell ed fi Tian
achi della Casa di Patronino sotterra
Bronzia sotto terra è è è misurato
mentro il mentro con ogni diligentia
quale di pietra no è ne Bronia vestigi

501

500

ROME: *Hadrianeum*
Cornice; profile and elevation

Inscribed on fol.26r: *Questa Cornice era del tenpio della Casa di Gor/diano Inperatore diuisa p[er] meta trouata sotto/terra p[al]mi 15 misurato ogni menbro con grandi/sima diligenzia con li medesimi Jntagli quale nocene piu vestigi f* [initial]
WM cat.21; one grey, one beige and two brown washes; 424 × 562 mm
SJSM, vol.119, fols 25v–26r

The cornice has a cyma reversa with acanthus-ogee ornament and an acanthus leaf at the corner, a fillet and two plain fasciae separated by an ovolo with leaf-and-tongue ornament, surmounted by a bead-and-reel moulding and egg-and-dart ovolo with an acanthus leaf at the corner supporting a plain corona, a cyma reversa with acanthus ogee, a fillet and a cyma recta with acanthus-leaf decoration. The section in the corona shows the acanthus ornament in the coffers below the corona.

The inscription records that the cornice, 'drawn half-size, from the temple at the house of Emperor Gordianus', was found 15 *palmi* below ground. According to Alberto Alberti's inscription on the Codex C drawing, the cornice was 'among the marbles at St Peter's, which were broken during the work for Gregory XIII on the Capella Gregoriana in the Vatican'.

Forni identified the cornice as from the Hadrianeum. She observed that Alberti's Codex D drawing originally continued on the verso of a folio that is now lost. The right side of fol.26r is an exact copy of Codex D (fol.14r); the left side is probably copied from the missing folio. According to Strong (1953, p.124), the cornice could be from the enclosure.

MASTER DRAWINGS Rome, GNDS, Alberti Codex D, fol.14r, inv. no.F.N.8184r (Forni 1991, p.180, tav.CCCLXXXIII); Codex C, fols 64v–65r, inv. no.F.N.8116r (Forni 1991, p.143, tav.CCLX–CCLXI).

For other representations, see Forni 1991, p.143.

501

ROME: *Baths of Caracalla, frigidarium*
Cornice; profile and elevation

Inscribed on fol.27v: *Questa cornice e di tutta grandezza/con li medesimi Jntagli nelli edefizi an/tichi della Casa di tarquinio superbo/trovata sotto terra p[al]mi 25 misurato/menbro p[er] menbro con ogni deligenzia/quale di questa nose ne trova vestigi f* [initial]
A flap has been added at bottom right; WM cat.21; one brown, one grey-brown and two beige washes; 415 and 554 × 559 mm
SJSM, vol.119, fols 27v–28r

The plain frieze is shown at the bottom of the folio. The cornice has a beaded astragal below a cyma reversa with acanthus-ogee ornament, dentils, a bead-and-reel astragal, an ovolo with an acanthus leaf at the corner and an egg-and-dart moulding. The corona is worked with acanthus and cornucopia ornament. Above the corona the cyma reversa decorated with acanthus leaf and acorns supports a plain fillet and a cyma recta with acanthus-leaf decoration. Lily leaves decorate the coffers below the corona.

The inscription records that the cornice, '25 *piedi* underground, was measured and drawn full-size; the carvings are like those on the house of Tarquin the Proud'. The drawing in Codex D has the corona ornament indicated faintly in graphite; the drawing continued on a verso, which is now lost. It is shown complete in Codex C and in the Soane drawing.

MASTER DRAWINGS Rome, GNDS, Alberti Codex C, fols 62v–63r, inv. nos F.N.8113V–F.N.8114r (the laurel-tip ornament is not shown and the inscription records the find in the demolition of Old St Peter's; Forni 1991, p.141, tav. CCLVI–CCLVII); Codex D, fol.15r, inv. no.F.N.8185, the cornice from the baths of Caracalla (Forni 1991, p.181, tav.CCCXLIX); the cornice on fols 87v–88r (cat.532) is shown on the left.

For other representations, see Forni 1991, p.141.

502

ROME: *Porticus Deorum Consentium, Capitol*
Cornice; profile and elevation

Inscribed on fol.29v: *Questa Cornice sono delli/menbri del Campidoglio/il pontegiato ene tondo di pocho giro et uaria/asai la gola e gola riversa li altri menbri vano/quasi simile et li Jntagli sono simili quale aueua/Jl frontespizio et era di molti pezzi quale Cornice/e di tutta grandezza eno/ce ne piu vestigi f* [initial]
WM cat.21; one dark brown, one grey-brown and two beige washes; 421 × 560 mm
SJSM, vol.119, fols 29v–30r

On the left a grey wash outline of the full-size cornice, drawn larger, is cancelled with ink hatch. The plain frieze is crowned by a cyma reversa with leaf-and-tongue ornament and a fillet below the dentils, an ovolo with egg-and-dart moulding below modillions with acanthus scrolls supporting a plain cyma reversa and fillet, plain corona, fillet, cyma reversa with leaf-and-tongue ornament, fillet and a plain cyma recta. The rosettes between the modillions are shown in section on the corona.

The inscription locates the find on the Capitol: 'The carving is like the frontispiece [the temple of Serapis]. It was broken.' The cornice was identified by Forni as from the Porticus Deorum Consentium below the Capitol. A base from the same portico is shown on fol.33v (cat.504). The drawing is copied from Alberto Alberti's drawing in Codex D.

MASTER DRAWINGS Rome, GNDS, Alberti Codex D, fols 15bis v–16r, inv. nos F.N.8191V–F.N.8186r (Forni 1991, p.182, tav.CCCLII–CCCLIII).

For other representations, see Forni 1991, p.182.

503

ROME: *Temple of Venus and Rome, Porticus Deorum Consentium*
Ionic and Composite bases and a Composite capital and column; profiles and elevations and detail of the fluting on the shaft

Scale 69 mm=2 *p[al]mi*

Inscribed on fol.31v: *Basa Jonicha de tutta grandezza/del tenpio di venere trouata sotto/te[r]ra p[al]mi 30 conli medesimi/intagli quale noce ne piu/vestigi misurata con diligenzia—va sul piano—tutta detta e p[al]mi 2/once 4 la colon/na—sino al mezzo p[al]mi uno once/4; fol.32r: Questa base e di tutta grandezza trouata/Jncapidoglio verso la Consolazione et Cosi/Il Capitello B et altri menbri sotto coli/medesimi Jntagli quale adesso nocene piu vestigi f* [initial]*–p[al]mi 2 once 10–scala de p[alm]i 2–fondo da basso – striata cosi*
A flap has been added for the socle at bottom left; WM cat.23; one pale brown, one grey-brown and two beige washes; 411 and 507 × 554 mm
SJSM, vol.119, fols 31v–32r

On the left is a full-size Ionic base on a socle bearing anthemion decoration. The base has two astragals with cable ornament below a scotia decorated with flute and tongue, two astragals with cable ornament and a plain upper scotia and two more cable astragals, all the cable mouldings twisting in opposite directions. The upper torus is decorated with an acanthus flower and leaf. On the right a base, full-size, has a projecting lower torus decorated with ribbons, a fillet and an upper torus bearing acanthus-flower decoration, separated by two plain scotia with fillets above and below them and an astragal with cable ornament in between. The Composite capital has a tier of acanthus half-leaves below a tier of full leaves supporting the volutes, and a trophy with a tunic, breastplate and helmet standing between them.

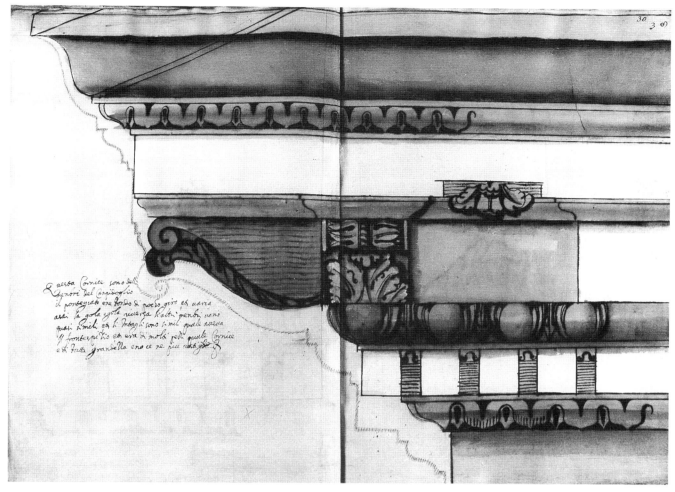

502

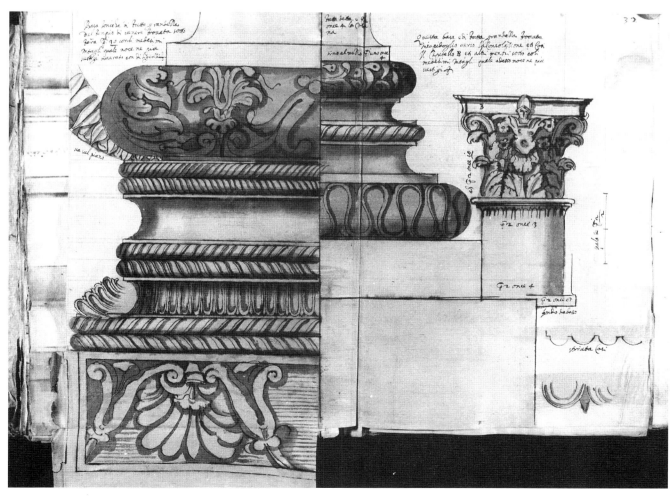

503

503 ctd.

The inscriptions on fol.31v locate the find at the temple of Venus and Rome. The base on fol.32r was 'found on the Capitol, towards the Consolation as was the capital marked B and other members with the same carving'. On the basis of the measurements, Forni identified the base on fol.32r as from the Porticus. The drawing is copied from Codex D. In Codex C the upper torus is shown broken but restored in profile. The break is not clearly shown in Codex D, and the outline of acanthus sweeps across it; the base is shown fully restored in *Frammenti*.

MASTER DRAWINGS fols 31v–32r, Rome, GNDS, Alberti Codex D, fols 15v–15bis, inv. nos F.N.8185v and F.N.8191r; fol.31v, Codex C, fol.7r, inv. no.F.N.8064r (Forni 1991, pp.101–2, tav.CLXXV; pp.181–2, tav.CCCL–CCCLI).

For other representations of fol.31v, see Forni 1991, p.102.

504

ROME: *Porticus Deorum Consentium, Capitol and the forum of Augustus*
Two attic bases; profiles and elevations

Inscribed on fol.33v: *p[al]mi uno once 4 al mezzo–Questa basa e trouata nelli uesti/gi del Canpidoglio sotto terra/p[alm]i 40 di tutta grandezza mi/surato ogni Cosa aCosa p[er] Cosa/ecosi la sua Cornice et archi/trave adietro seg[nat]o K f* [initial]; *fol.34r: va sul piano di d[et]ta basa–Dal mezzo della d[et]ta basa ce p[al]mi 2 once Nove trovata sotto Terra eno/ce ne piu vestigi conbellisi intagli conforme si vede quale/era nelli vestigi del tenpio di Giunone misurata con gran/disima Diligenzia a menbro p[er] menbro f* [initial]
Numbered 18 in ink at top right
A flap for the socle has been glued to fol.34r; WM cat.21; one brown, one beige and two grey-brown washes; 419 and 546 × 560 mm
SJSM, vol.119, fols 33v–34r

On the left the plain full-size base has a scotia and fillets between a lower projecting torus on a socle and an upper torus. The base on the right stands on a plain socle and has a projecting lower torus with ribbon ornament, two astragals with cable mouldings twisting in opposite directions and a scotia with two tiers of simplified acanthus leaves alternating with lily leaves, an astragal with a guilloche moulding and an upper torus with laurel ornament.

The inscription on fol.33v locates the base '40 *piedi* below ground on the Capitol. The cornice and architrave are drawn and marked K.' On fol.34r it records: 'half the width of the base is 2 *palmi* 9 *once*. It has beautiful carvings like those in the remains of the temple of Juno.' The entablature from the portico is shown marked K on fols 35v–36r (cat.505).

Fol.33v was identified by Forni as a base from the Porticus Deorum Consentium; it is copied from Codex D. The carved attic base is also drawn in Codex Coner, identified by Ashby (1904, cat.132) as belonging to the entrance on the north-west hemicycle of the forum of Augustus. In both Codices B and D palmettes are shown in the ribbons of the lower torus, but these are absent in the Soane drawing and in Codex Coner. Wegner (1966, p.64, fig.15) relates the base to bases at the temple of Diana in Nîmes.

According to inscriptions on other drawings, the decorated base was in the palace of Melchior Baldassini at 8 Via delle Cappelle, Rome, built by Antonio da Sangallo the Younger.

MASTER DRAWINGS Rome, GNDS, Alberti Codex B, fols 38v–39r, inv. nos F.N.8046v–F.N.8047r (studies for both bases); Codex C, fol.10r, inv. no.F.N.8067r; Codex D, fol.17r and v, inv. nos F.N.8187r and v, copied from Codex C (Forni 1991, p.87, tav.CXLII–CXLIII; p.104, tav.CLXXX; p.183, tav.CCCLV–CCCLVI).

For other representations, see Forni 1991, p.87.

505

ROME: *Porticus Deorum Consentium, Capitol*
Entablature; profile and elevation of the architrave and perspectival elevation of the cornice

Inscribed on fol.36r: *Mezzo fondo del archi/trave–Cornice trovata sotto terra/p[al]mi 40 delli vestigi Antichi/del Canpidoglio misurato men/bro p[er] menbro Con diligenzia f* [initial]/*di tutta grandezza f* [initial]
A flap is glued to fol.36r for the ovolo and frieze; WM cat.21; one dark brown, one beige and two grey-beige washes; 420 and 568 × 553 mm
SJSM, vol.119, fols 35v–36r

The full-size cornice on the left has an architrave with three fasciae separated by a plain cyma reversa and astragal; it is completed with a plain cyma reversa and slab and marked K. On the right the plain frieze with a fillet above it is shown below the cornice supported on two plain ovolo mouldings. A slab is surmounted by an astragal, cyma recta, corona marked K, a second astragal and cyma recta. In the centre of the drawing and marked K are two details: on the left a cyma reversa decorated with acanthus-leaf carving, on the right a pulvinated moulding decorated with oak leaves and acorns.

The inscription locates the find '40 *piedi* below ground on the Capitol'. The drawing was copied from Codex D; the lower parts of the cornice missing in that drawing are shown complete here. A different cornice from the same building is shown on fols 29v–30r (cat.502).

MASTER DRAWINGS Rome, GNDS, Alberti Codex D, fols 16v–17r, inv. no.F.N.8186v (Forni 1991, p.183, tav.CCCLIV); the inscription records that the foliage moulding was on a garland below the architrave.

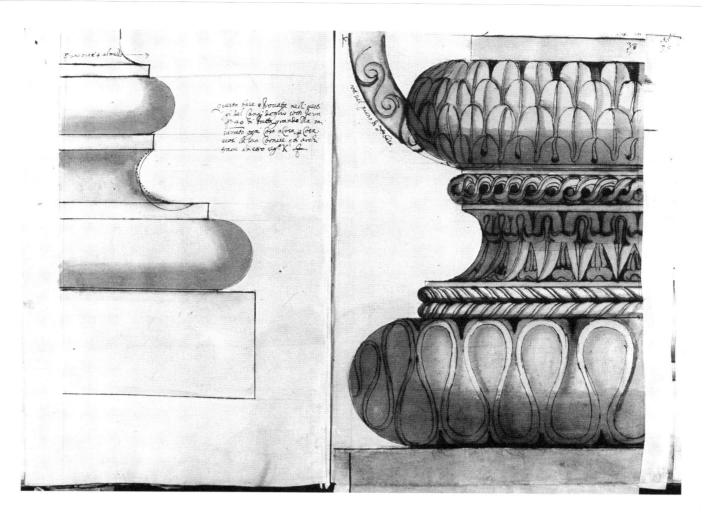

504

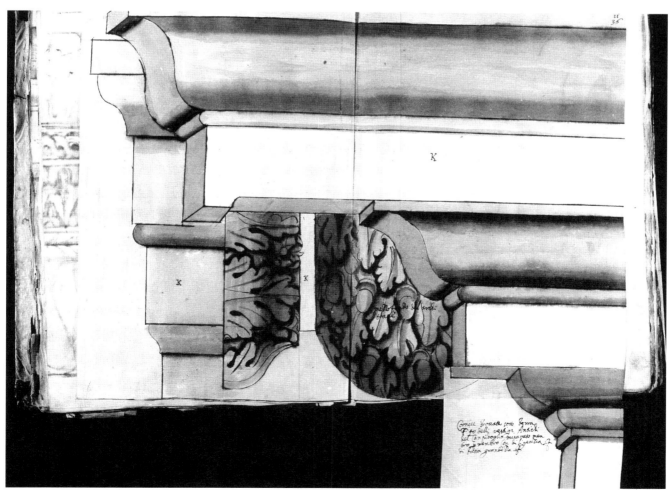

505

506

ROME: *Tomb of Cecilia Metella, Via Appia*
Cornice; profile and elevation

Inscribed on fol.38r: *Questa cornice e di tutta grandezza trouata acapo/di Bove sotto terra p[al]mi 30 misurato ogni menbro/con diligenzia con suoi Jntagli come si vede quale/noce ne piu vestigi f [initial]*
Numbered 14 in ink at top right
WM cat.35; two beige and three brown washes; 420 × 560 mm
SJSM, vol.119, fols 37v–38r

The full-size cornice has a cyma reversa with leaf-and-tongue ornament, a fillet, dentils and a cyma reversa with acanthus-ogee ornament, a fillet below a corona decorated with a Greek-key meander pattern, a fillet, an ovolo with egg-and-dart moulding, a fillet and a cyma recta with scoop ornament and an acanthus leaf at the corner.

The inscription locates the cornice 30 *piedi* below ground at Capo di Bove, 'the tomb of Cecilia Metella'. The drawing is copied from Codex C. The cyma moulding, broken in the Alberti Codex D drawing, is shown complete here.

MASTER DRAWINGS Rome, GNDS, Alberti Codex C, fols 30v–31bis, inv. nos F.N.8087–F.N.8088; Codex D, fol.20v, inv. no.F.N.8190v, dated 1580 (Forni 1991, pp.117–18 and pp.184–5, tav.CCIX and CCCLXXVI).
LITERATURE Lanciani 1902–12, III, p.13.

507

ROME: *Near the tomb of Cecilia Metella, Via Appia*
Cornice; profile and elevation

Inscribed on fol.39v: *rotto era qui–fondo*; fol.40r: *Questa Cornice segniata D era a Capo di/Bove sotto terra asai apresso Jl tor/rone di tutta grandezza con suoi/Jntagli come si vede lauorata con/gran diligenzia sotto al louolo + era rotta et era altrimenbri et laltra/cornice seg[na]ta v edevisa p[er] meta f [initial] quale di queste Cornice nocene piu vestigi f [initial]*
Numbered 13 in ink at top right
A flap has been added at bottom left to complete the cornice; WM cat.37; two beige and three brown washes; 420 and 522 × 565 mm
SJSM, vol.119, fols 39v–40r

The full-size cornice marked D is overlaid by a second cornice marked V. D has a plain cyma recta, ovolo with egg-and-dart moulding, a fillet, dentils, a fillet and a cyma reversa with leaf-and-tongue decoration and an acanthus leaf at the corner below a corona with a Greek-key meander pattern; a cyma reversa with acanthus-ogee decoration is separated by a fillet from a cyma recta with flute-and-tongue ornament. Each flute contains an acanthus leaf and a full-leaf rises the full height of the cyma at the corner. A detail of the lily leaves below the corona is given in the centre. The cornice marked V on the right, drawn half-size, has a plain frieze below a cyma reversa with acanthus-ogee decoration, a corona with a Greek-key meander pattern, a bead-and-reel astragal and an ovolo with egg-and-dart moulding.

The inscription records that D was found at 'the tomb of Cecilia Metella underground fairly close to the tower. It was broken below the egg-and-dart moulding marked x and made differently.' The drawing was copied from Codex D. Although the inscription states that no trace survives, the cyma and corona of fol.39v are on the wall to the right of the entrance to the tomb of Cecilia Metella, and a fragment of the cornice on the same folio is conserved at the Castello dei Caetani next to a fragment of a strigillated sarcophagus (Forni 1991, p.118).

MASTER DRAWINGS Rome, GNDS, Alberti Codex C, fols 30v–30bis, inv. nos F.N.8087r–F.N.8088v, dated 1585; Codex D, fols 19v–20r, inv. nos F.N.8189v–F.N.8190r (Forni 1991, pp.117-18, tav.CCIX; p.184, tav.CCCLX–CCCLXI).
LITERATURE Lanciani 1902–12, III, p.13.

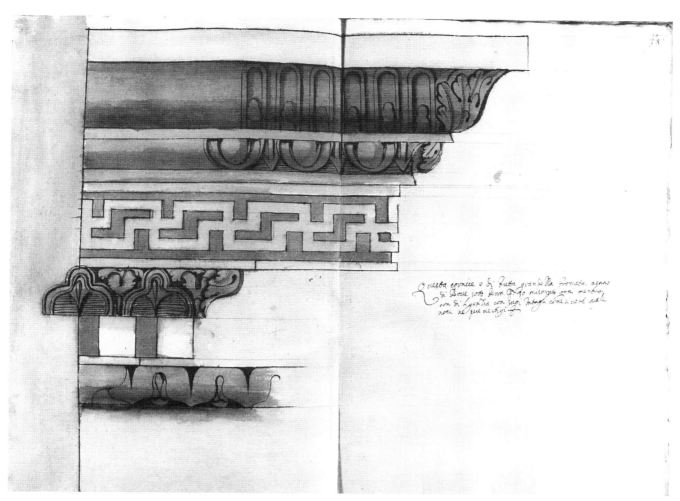

Questa cornice e di tutta grandeza la ꝺ'rocata, ꝺ'caꝺ di Doue sotto ferro ꝺ'rigo misurata con membra, con di liꝺ'entia con suoi Intaglia cime a uoi debb'i nota ꝺ' gui neꝺ'li...

506

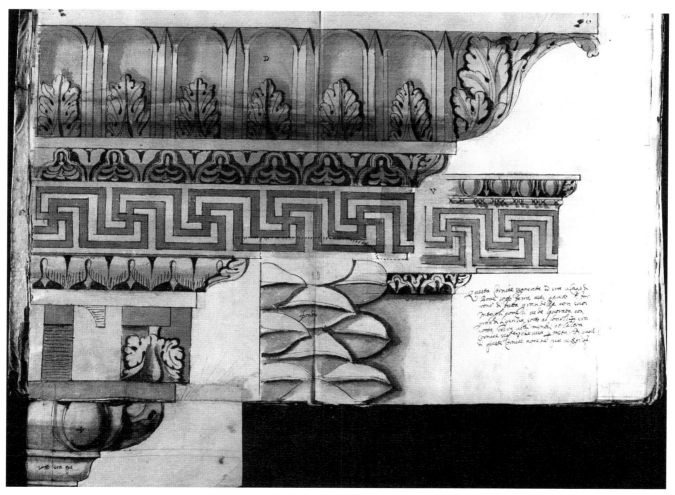

Questa cornice segnicata D uno a lato de Doue sotto ferro ala quasta di nore di tutta grandeza con suoi Intagli gome la uede segnita con gran liꝺ'entia sotto al b'cectete uno de i uolta te la ꝺ'olena ala monta et la b'ora cornice segenzaua uno memb'ete di male di quale cornice note nel gui neꝺ'li...

507

508
ROME: *Temple of Vulcan, Roman forum*
Cornice; profile and elevation
Inscribed on fol.42r: *Questa Cornice e di tutta grandezza del tenpio/di vulcano misurata con ogni diligenzia/quale noce piu vestigi f* [initial] – *Jn campo vacino f* [initial]
Numbered 16 in ink at top right
A flap has been added at the bottom to complete the cornice; WM cat.36; three brown and three beige washes, areas of white unwashed paper; 412 and 587 × 556 mm
SJSM, vol.119, fols 41v–42r

The full-size cornice has a plain cavetto, a fillet, dentils, a fillet, an ovolo with egg-and-dart moulding and an acanthus leaf at the corner, a plain corona, cyma reversa with acanthus-ogee ornament, a fillet and a cyma recta with flute-and-tongue moulding and a palmette at the corner.

The inscription locates the cornice at the temple of Vulcan. The Codex D drawing is incomplete at the bottom. The dentils are completed in the Soane drawing, where a cavetto is shown below them.

MASTER DRAWINGS Rome, GNDS, Alberti Codex D, fols 23v–24r, inv. nos F.N.8193v–F.N.8194r, dated September 1597 (Forni 1991, p.185, tav.CCCLXIV–CCCLXV).

509
ROME: *Arch of Camigliano, the Iseum and Serapeum*
Cornice; profile and elevation
Inscribed on fol.43v: *Questa Cornice e diuisa per meta misurata dal Antico/menbro p[er] menbro con ogni Diligenzia del Archo/di Camigniano quale non ce ne piu vestigi f* [initial]
Numbered 15 in ink at top right
A flap has been added at the bottom to complete the cyma and frieze; WM cat.36; one grey-brown and three beige washes, areas of white unwashed paper; 419 and 573 × 560 mm
SJSM, vol.119, fols 43v–44r

The cornice has a plain astragal, cyma reversa, fillet, a flat fascia, fillet, astragal, ovolo and fillet below a plain corona, cyma reversa, fillet and cyma recta.

The lower part of Codex D, fol.23r, is incomplete. The detail of the cyma reversa on the right of Codex D is interpreted as the top of an architrave. Here it is clearly shown as the lower cyma immediately above the frieze. The main entablature of the same arch is shown on fols 73v–74r (cat.524).

MASTER DRAWINGS Rome, GNDS, Alberti Codex D, fols 22v–23r, inv. nos F.N.8192v–F.N.8193r, dated 18 May 1597 (Forni 1991, p.185, tav.CCCLXIV–CCCLXV).

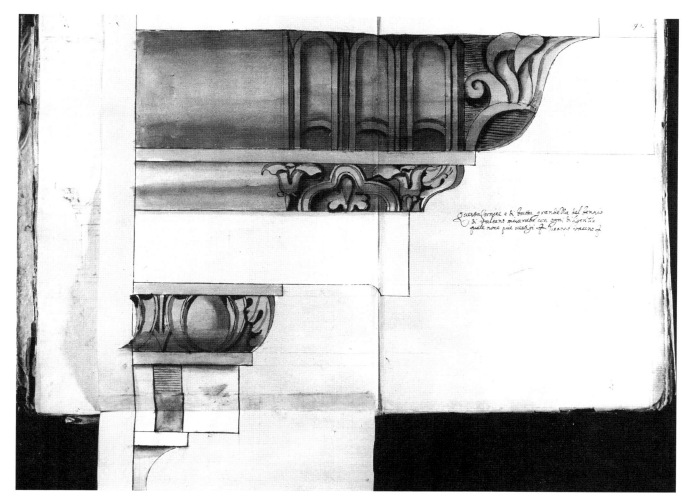

Questa Cornice e di tutta grandezza del Tempio
di Baccano misurato con ogni diligentia
quale noce più vestigi che vacuo

508

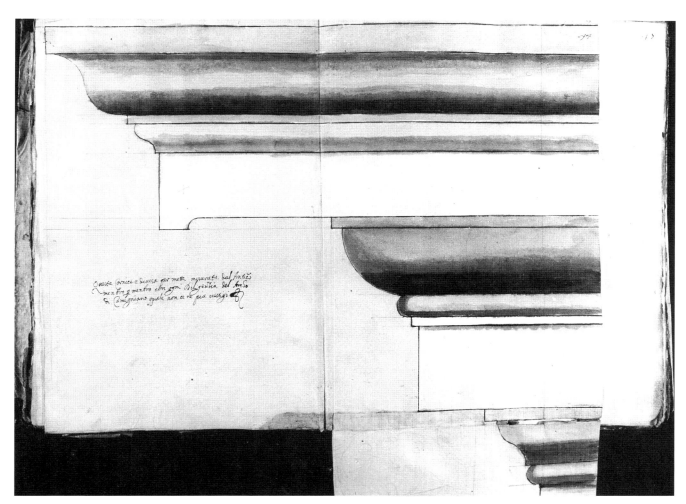

Questa cornice e scritta per metà misurata dal Antico
mentro fragmentro con ogni diligentia del tempio
di Bagniano quale non ci di più vestigi

509

510

ROME: *Temple of Jupiter, temple of the Sun*
Three cornices; profiles and elevations

Inscribed on fol.45v: *questa cornice/edi tutta gran/dezza del tenpio/di Giove mesurata/con diligenzia f*[initial]; fol.46r: *Ditutta grandezza tro/uata sotto terra de/tenpio del sole f*[initial]

Numbered 17 in ink at top right

WM cat.37; two brown and three beige washes, areas of white unwashed paper; 420 × 561 mm

SJSM, vol.119, fols 45v–46r

On the left, rendered full-size, the cornice from the temple of Jupiter has an ovolo with egg-and-dart moulding and a fillet below modillions supporting a cyma reversa with leaf-and-tongue ornament and a plain cyma reversa. On the right, drawn full-size, the cornice from the temple of the Sun has a cyma reversa with leaf-and-tongue ornament, a fillet, dentils, fillet and an ovolo with acanthus-leaf decoration below scrolled modillions supporting a corona with waves, a fillet and a cyma recta with acanthus-ogee ornament. Between them, in a small scale, is the profile and oblique projection of the cornice on the temple of the Sun. The inscription on fol.45v locates the cornice at the temple of Jupiter; that on fol.46r records that it was found underground at the temple of the Sun.

An inscription on a drawing by Lorenzo Donati (Florence, Uffizi 1842A) records that the cornice on fol.46r was
in the Della Valle collection, Rome.

MASTER DRAWINGS Rome, GNDS, Alberti Codex D, fols 24v–25r, inv. nos F.N.8194V–F.N.8195r; the temple of Jupiter is dated June 1598, the temple of the Sun November 1595 (Forni 1991, p.185, tav.CCCLXVI–CCCLXVII).

For other representations, see Forni 1991, pp.185–6.

511

LOCATION UNKOWN

Attic bases

Hypotrachelion of a column and bases; profiles and elevations

Inscribed on fol.47v: *scanelli 20 di trevertino/quale si crede che fussano co/perta di stucho di tutta gra/ndezza*; fol.48r: *scanelli e basa e di tutta grandezza–sino al fusto di d[et]ta basa a da essere p[al]mi 3. once 5. il tutto quale/agrandisimo agetto a il tutto p[almi] 1 once 8 menuti 3 misurato dal anticho acosa p[er] cosa f*[initial]

Numbered 18 in ink at top right

WM cat.35; one pale brown, one grey-brown and two beige washes; 421 × 558 mm

SJSM, vol.119, fols 47v–48r

Both bases, drawn full-size, are on a socle; they each have a projecting lower torus, a scotia with fillets above and below and an upper torus. The base on the right is much larger. The fluting on the trachelion of the columns is shown.

The inscription on fol.47v records: 'the column had 20 flutes of travertine, probably covered with stucco'. On fol.48r the dimension from the edge of the socle to the shaft at the base is 3 *palmi* 5 *once*; 'the projection of 1 *palmo* 8 *once* 3 *minuti* is very large'.

MASTER DRAWINGS Rome, GNDS, Alberti Codex D, fols 25v–26r, inv. nos F.N.8195V–F.N.8196r (Forni 1991, p.186, tav.CCCLVIII–CCCLXIX).

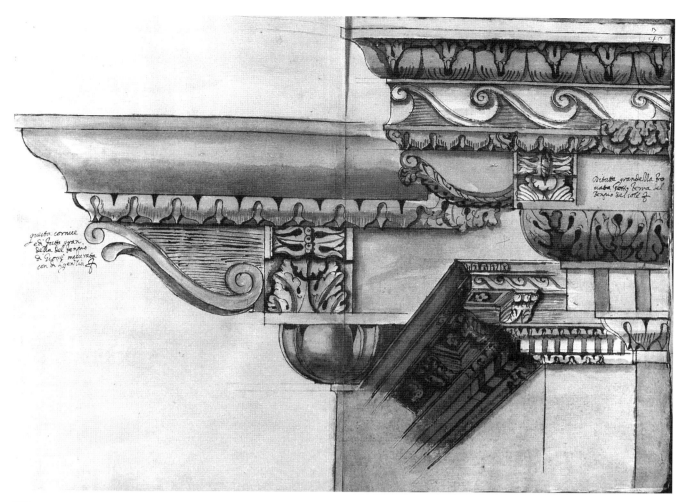

510

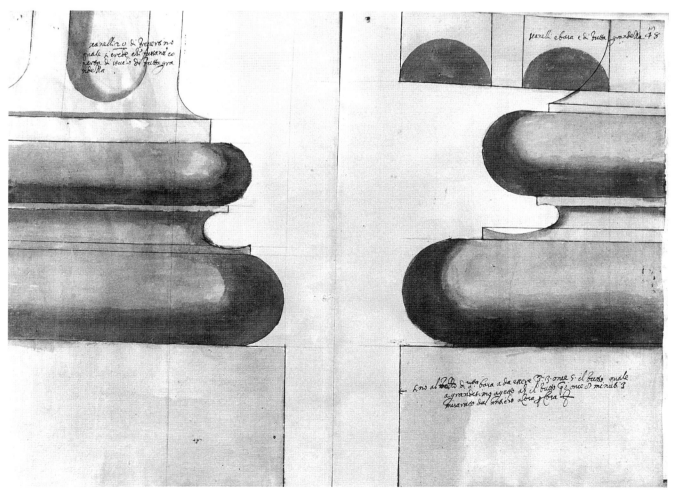

511

512

LOCATION UNKOWN

Unidentified Ionic capital; profile and half-elevation

Inscribed on fol.50r: *Questa voluta de Capitello Ionicho fatta di bellisimi/Jntagli et e di tutta grandezza trouata nelli/vestigi Antichi et gira bene misurato ogni/Cosa aCosa p[er] Cosa quale poi fu guasta p[er] seruirsene/Jnaltro enose ne trova piu vestigi f* [initial]

Numbered 20 in ink at top right

WM cat.36; two beige and three brown washes; 424 × 562 mm

SJSM, vol.119, fols 49v–50r

The capital, drawn full-size, has an echinus with an egg-and-dart moulding above a bead-and-reel astragal and a plain fillet. The channel is filled with acanthus leaves, two of which enter the volute. Two acanthus flowers and a bell-flower turn in the spiral and partially fill the volute, which has a rosette with four petals in the centre. The slab has a cyma reversa with acanthus-ogee decoration.

The inscription records: 'the Ionic capital with very beautiful carving was found in the ancient ruins; the spiral turns well. It was broken to make another.' The drawing is almost identical to Alberto Alberti's original except that the latter does not show the rosette and there is a slight variation in the bell-flower. In his Codex D drawing Alberti indicates that the centre point is marked incorrectly in the drawing of the egg-and-dart and bead-and-reel mouldings. The centre point is corrected here and a rosette is shown; the corrected version of the Codex D drawing no longer survives.

MASTER DRAWINGS Rome, GNDS, Alberti Codex D, fols 27v–28r, inv. nos F.N.8196v–F.N.8198r, dated 1595 (Forni 1991, pp.186–7, tav.CCCLXX–CCCLXXIII).

513

LOCATION UNKOWN

Unidentified Ionic capital; profile and half-elevation

Inscribed on fol.51v: *Questa voluta di Capitello Jonicho il suo girare varia/asai dall'altre che credo che labino fatta p[er] facilare asai/misurata dalli vestigi Antichi di tutta sua grandezza/fatta conbellisimi fogliami quale nose ne trova/piu vestigi f* [initial]

Numbered 19 in ink at top right

WM cat.35; two brown and two beige washes; 423 × 562 mm

SJSM, vol.119, fols 51v–52r

The half-capital, drawn full-size, has an echinus with an egg-and-dart moulding above a bead-and-reel astragal, a plain fillet and a channel filled with acanthus leaves. An acanthus leaf enters the volute and three acanthus flowers and a bell-flower turn in the spiral and partially fill the volute, which has a central double rosette with eight curling petals. The abacus has a cyma reversa with acanthus-ogee decoration.

Although the drawings here and on fols 49v–50r (cat.512) are almost identical, there are sufficient variations in the acanthus ornament, fleurons and rosettes to suggest that two different capitals are represented. The inscription on fol.51v records: 'the Ionic volute turns differently to the other and it may have been easier to make'.

MASTER DRAWINGS Rome, GNDS, Alberti Codex D, fols 26v–27r, inv. no.F.N.8197r, dated 1 October 1595 (Forni 1991, p.186, tav.CCCLXXII).

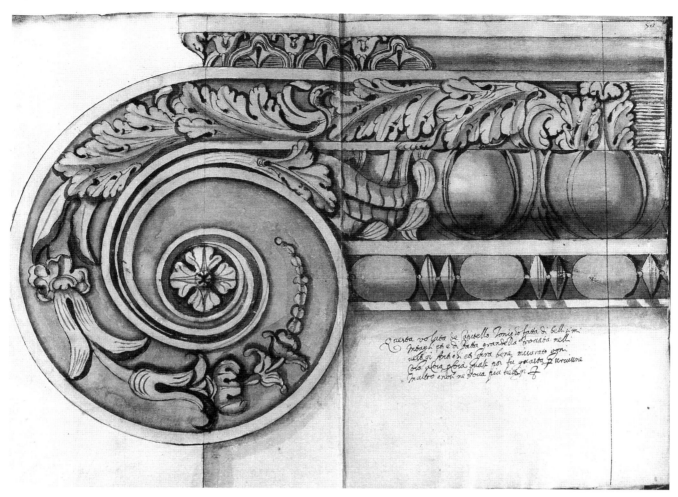

Questa voluta de Capitello Jonico è fatta di belli e mi
nor[...] et è di fatta grandeza grandosa nelli
vestigi fatti è si et gira bene, misurato ogni
cosa ubra [...] quale non fu guasta [...] ceruellone
[...]altro enon ne troua più bel[...]

512

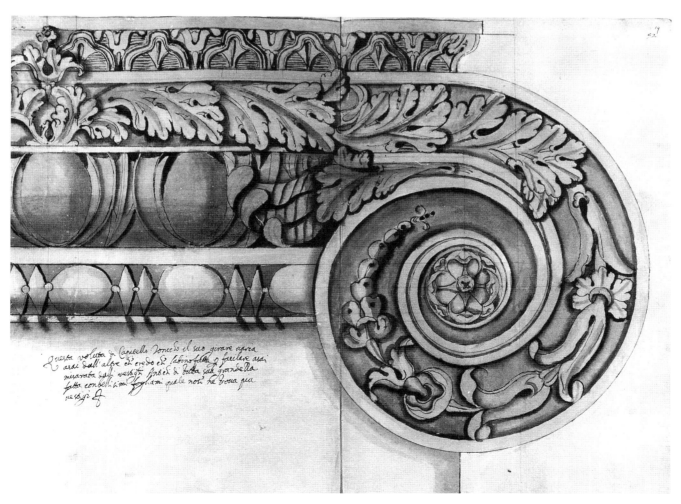

Questa voluta di Capitello Jonico et il suo girare [...]
[...] dall' altre ch' credo di latino [...] fecelere assai
misurata [...] vestigi [...] et di tutta sua grandeza
fatta con belli [...] qualche non ha troua più
vestigi

513

514

ROME: *Temple of Minerva*
Two cornices; profiles and elevations

Inscribed on fol.53v: *Queste doi Cornice sonno di tutta grandezza/mesurati nelli vestigi Antichi del tenpio/delli vestigi della dea Minerva misurate/con diligenza aCosa p[er] Cosa f* [initial]

Numbered 21 in ink at top right

WM cat.35; three brown and three beige washes, areas of white unwashed paper; 422 × 572 mm

SJSM, vol.119, fols 53v–54r

The cornices are drawn full-size. The one on the left has a plain cyma reversa, fascia, astragal, cyma recta, corona, fillet, astragal and cyma recta. The cornice on the right has a bead-and-reel moulding, a cyma reversa with leaf and tongue, a fillet, dentils, a fillet and an ovolo with egg-and-dart ornament and an acanthus leaf at the corner below a fillet and a plain corona, bead-and-reel astragal and plain cyma recta.

The inscription locates the cornices at the temple of Minerva. A note on Lorenzo Donati's drawing (Florence, Uffizi 1842A) states that the cornice was in the Della Valle collection.

MASTER DRAWINGS Rome, GNDS, Alberti Codex D, fols 28v–29r, inv. nos F.N.8198v–F.N.8199r, dated 1595 (Forni 1991, p.187, tav.CCCLXXIV–CCCLXXV).

For other representations, see Forni 1991, p.187.

515

ROME: *Pantheon, interior*
Base of the first order; profile and half-elevation

Inscribed on fol.56r: *Daqui al mezzo della basa e p[al]mi 4 menuti tre misurata dalli vestigi Antichi/e poi guasta per repezzare statuue jncanpidoglio quale era nelli/vestigi del tenpio bouario misurato aCosa p[er] Cosa con ogni diligenzia*

Numbered 12 in ink at top right and 22 at bottom left

On two pieces of paper joined horizontally at the bottom to complete the base; WM cat.35; two grey-brown and three beige washes; 537 and 790 × 425 mm

SJSM, vol.119, fols 55v–56r

The base is from the main order of the interior of the Pantheon. It rests on a socle and has a projecting lower torus and fillet, a scotia with a fillet below two astragals, a fillet, upper scotia, fillet and torus. The drawing is copied from Codex C. The inscription records the dimension from the edge of the socle to the middle of the base as 4 *palmi* 3 *minuti*: 'the base, from the ancient ruins, was broken to repair the statues that were moved from the temple in the Forum Boarium to the Capitoline Museum'. Marten van Heemskerck drew a view of the sculpture that Sixtus IV removed from the Forum Boarium to the Capitol (Huelsen & Egger 1913–16, pp.29–30, Taf.54).

MASTER DRAWINGS Rome, GNDS, Alberti Codex B, fol.47v, inv. no.F.N.8055v; Codex C, fol.19v, inv. no.F.N.8076v (Forni 1991, pp.94–5, tav.CLX; pp.110–11, tav.CXCIV). LITERATURE Lanciani (under the name of Cannizzaro) 1882; Lanciani 1882, p.344.

For other representations, see Forni 1991, pp.95–6.

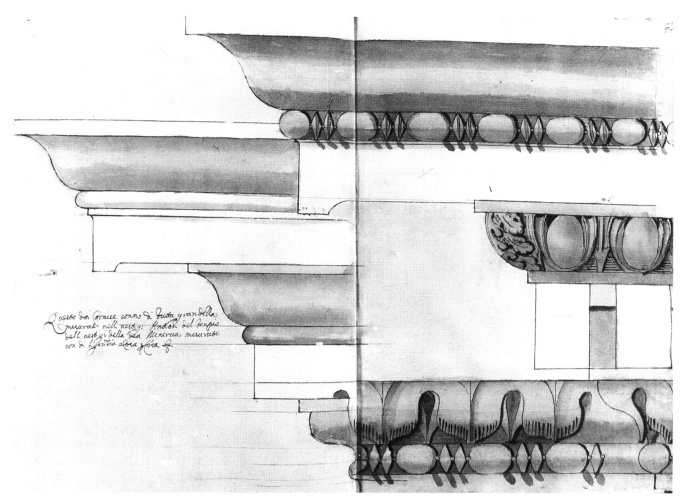

Queste d'a cornice sonno di tutta grandella
mesurad nelli vestigi findosi del tenpis
dell vestigi della Dea Minervia mesuriate
con di Pgeritia d'ora pfora f

514

Ogni il mesto della Scia è Trige mand Be ma uta ball mésign Artick
s por questio ceter infallere sestrial Ican sinonfut nadfum rodh
ssofigi dal Pefges Cordero mesuriea alcag ma largan Efsecolta

515

516

ROME: *Temple of Apollo*
Cornice; profile and half-elevation

Inscribed on fol.57v: *Core sino al mezzo p[al]mi once tre menuti 4 misurate con*
ogni dilegenzia–di tutta grandezza sino al/mezzo p[al]mi uno once tre mi/nuti 4 di
trevertino–Questa Cornice [gra deleted] e di tutta grandezza/misurata con ogni
diligenzia aCosa p[er] cosa Jntagliata con bellisimi Jntagli trouata/nelli vestigi del
tenpio del apollo trouata/sotto terra e poi guasta p[er] seruissene inaltro
A flap is glued to fol.57v below the bead-and-reel moulding; WM cat.35; two beige
and three brown washes, areas of white unwashed paper; 418 and 600 × 569 mm
SJSM, vol.119, fols 57v–58r

The base on the left has a torus on a socle. The plain cornice above, its profile
turned to the left, has a fillet, cavetto, fillet, plain corona, cavetto and slab. The
cornice on the right has an ovolo with acanthus ornament, dentils and a bead-
and-reel moulding, a cyma recta with acanthus, a fillet, an ovolo with egg and
dart and a fillet surmounted by a corona with acanthus and anthemion decoration
and an ovolo with acanthus leaves.

The inscription at the top gives the width of half of the cornice from the edge
of the slab as 1 *palmo* 3 *once* 4 *minuti*. The inscription on the full-size travertine base
gives the dimension 1 *palmo* 3 *once* 4 *minuti* from the edge of the socle to the middle.
The main inscription locates the full-size cornice 'with beautiful carving' below
ground in the ruins of the temple of Apollo, and records that it was 'broken to
make another'. The drawing is copied from Alberto Alberti's drawing, which
has the same measurements but does not record the location of the piece.

MASTER DRAWINGS Rome, GNDS, Alberti Codex D, fols 30v–31r,
inv. nos F.N.8200v–F.N.8201r, dated March 1596 (Forni 1991, pp.187–8,
tav.CCCLXXVIII–CCCLXXIX).

517

ROME:*House of Augustus*
Decorated Ionic bases and a cornice; profiles and elevations

Inscribed on fol.59v: *Il Zocolo di questa basa il tutto e p[al]mi 5 et era asai rovi/nata*
fatta de bellisi Jntagli con bellisimi fogliami/e mascere Jntorno al bastone misurata sotto
terra p[al]mi 30/trovata nel Cerchio flamenio misurata aCosa p[er]Cosa quale nose ne
trova piu vestigi; fol.60r: Questa Cornice fa fro/nta spizio e gira tondo quale/si vede
p[er] la lettra B di tutta gran/deza misurata con ogni deligenzia/nelle Rovine Antiche
Numbered 24 in ink at top right corner
A flap is glued to the folio at bottom left; WM cat.36; one grey wash, three brown
and three beige washes, areas of white unwashed paper; 420 and 504 × 569 mm
SJSM, vol.119, fols 59v–60r

On the left the base is drawn full-size. It has a plain socle, a lower projecting torus
with foliage scrolls and a central satyr-mask, a scotia with acanthus-leaf decoration
spilling over the fillet above the torus, two bead-and-reel astragals, a fillet, a scotia
with acanthus ornament and a plain torus above. A detail of the acanthus leaf is
shown in the profile of the scotia. On the right the cornice marked B, from a seg-
mental pediment, has a plain cyma reversa, fillet, fascia, fillet, cyma recta, fillet,
corona, fillet, cyma recta and slab.

The inscription on the socle gives the width of the base as 5 *palmi*, and records:
'it was 30 *piedi* below ground at the Circus Flaminius. It was carved with very
beautiful leaves and masks around the torus.'

In Alberto Alberti's drawing the upper torus is indicated with a feint outline,
which suggests that it was missing. The base with the upper torus was drawn by
Palladio (London, RIBA, XV, fol.11). There are similar bases at S. Maria in Trastevere,
Rome, and Wegner (1966, p.78, figs 24–5) noticed similarities with base fragments
found at the baths of Caracalla. The bases in the Alberti Codex have a plinth 5 *palmi*
(122.88cm) tall, the same height as the plinths in S. Maria in Trastevere (Forni 1991,
p.188).

MASTER DRAWINGS Rome, GNDS, Alberti Codex D, fols 31v–32r, inv. no.F.N.8201v; the
carved base is dated 1596; the cornices are dated 1598, without the locations (Forni
1991, p.188, tav.CCCLXXX).

For other representations, see Forni 1991, p.188.

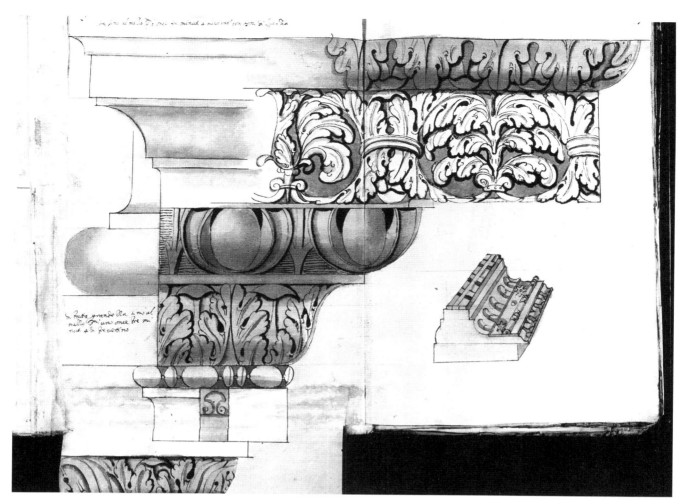

516

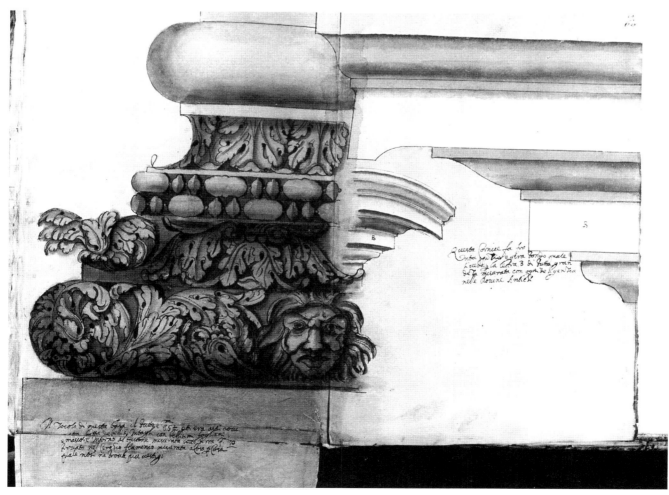

517

518

ROME: *Temple of Fortune*
Cornice; profile and elevation

Inscribed on fol.62r: *Questa Cornice e misurata dalle Rouine delli vestigi antichi/redotta per meta della sua altezza quale era nel edefizio/del tenpio Consag[r]ato alla fortuna pero nel legere le storie/Antiche si sapra dove era d[et]to tenpio misurato ogni Cosa/aCosa p[er] Cosa con ogni Diligenzia et lovolo ua imezzo/del dentello et la lancetta ua imezzo del vano del dentello*
Numbered 25 in ink at top right
WM cat.35.; one grey, two brown and two beige washes, areas of white unwashed paper; 418 × 561 mm
SJSM, vol.119, fols 61v–62r

The cornice is reduced to half-size. It has a plain astragal, cyma reversa and fillet below dentils, a bead-and-reel astragal and plain fillet below the ovolo with egg-and-dart moulding and an acanthus leaf at the corner, supporting the plain corona, bead-and-reel moulding, cyma reversa with acanthus ornament, fillet, cyma recta with acanthus and a plain slab.

The inscription locates the cornice 'at the temple consecrated to Fortune, known through ancient history. The egg is in the middle of the dentil and the dart is in the middle of the space between the dentils.'

No drawing of the cornice by Alberto Alberti survives.

519

ROME: *Theatre of Marcellus*
A base, Doric and Ionic orders; half-elevation, profile and oblique projection of the entablatures, plan of one bay

Inscribed on fol.63v: *da qui al tutto p[al]mi 3 once una di altro/cana*; fol.64r: *Cornice Jonicha misurata/nelli vestigi Antichi–brac[ci]a uno e m[enu]ti 28 – brac[ci]a 1 m[enu]ti 33 – Questa Cornice Doricha e del teatro/de Marcello fatta con ogni diligenza/misurata col Braccio fiorentino aCosa p[er] Cosa–bra[ccia] 1 e m[enuti] 16/in culon/tratura – el stilo e lon[go] bra[ccia] 12 – nona basa–spora/m[enuti] 14–grosezza–bra[ccia] i m[enuti] 33 – braca 6 m[enuti] 17 – minuti 22 – Plinto/bra[ccia] 1 m[enu]ti 53 – Capitello – Ogni metopa e ogni/terglefo sono pezzi/daloro opera di tib/urino–40 epistilio i sporto m[enu]ti 40 – stilio Jonico – b[racci]a 20 m[enuti] 33*
WM cat.34; one grey, two brown and two beige washes; 420 × 557 mm
SJSM, vol.119, fols 63v–64r

On the left the base, from the ancient ruins of Rome, has a socle with a projecting lower torus decorated with ribbons, an astragal, fillet, scotia, fillet, astragal and an upper torus with ribbon ornament. On the right the elevation of the column is shown above the plan of a single bay of the theatre of Marcellus. The section of the Doric capital and entablature gives the profile while the perspective shows the guttae in the architrave, and the triglyphs in the frieze with their capitals breaking forward above them, below the plain cyma reversa, dentils, plain corona and the plain cyma reversa, cavetto and slab. Details of the Ionic order show the profile of the capital with plain bolsters, an architrave with three fasciae and a plain cyma reversa and fillet below the frieze, fillet and ovolo, below a cornice with dentils, a fillet and cyma recta, plain corona, cyma reversa, fillet and cyma recta.

The inscriptions give dimensions, measured with the Florentine *braccia*, and locate the Ionic and Doric orders at the theatre of Marcellus.

The prototype drawing by Albeto Alberti does not survive. although drawings of the individual entablatures exist and are listed below. Michelangelo also drew the cornice of the theatre of Marcellus in his studies of Codex Coner (London, BM, 1859-6-25-560/1; see de Tolnay 1975–80, IV, p.47, cat.516r).

MASTER DRAWINGS fol.64r, Rome, GNDS, Alberti Codex A, fols 29v–30r, inv. nos F.N.7996v–F.N.7997r (the elevation of the Doric order is shown on fol.29v, and that of the Ionic order on fol.30r; Forni 1991, pp.40–41, tav.L–LI); profiles of the Doric capital and entablature are also drawn in Codex B, fol.33r (op. cit., p.82, tav.CXXI), and Codex C, fol.42r (op. cit., p.129, tav.CCXXIX).
LITERATURE Ciancio Rossetto 1982–3, p.16, no.24.

For other representations, see Forni 1991, pp.41 and 82–3.

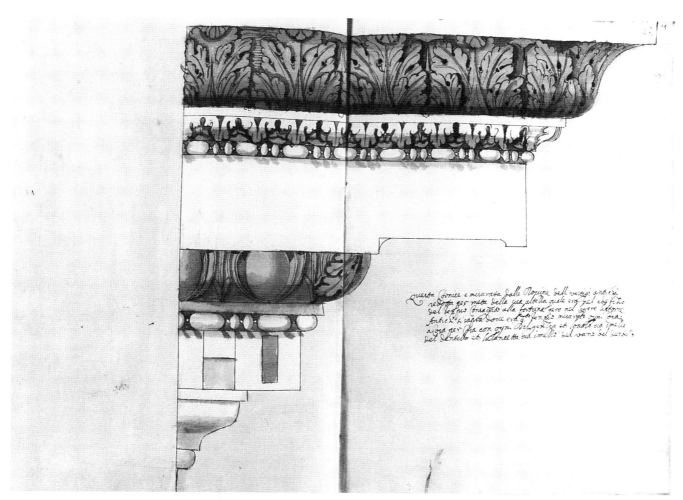

518

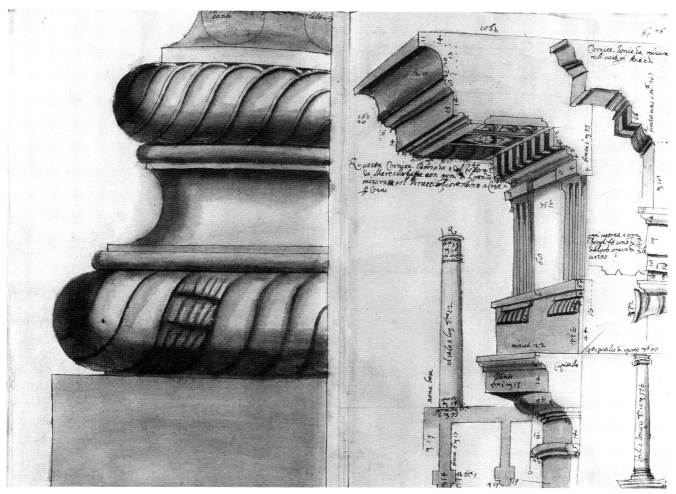

519

520

ROME: *Trajan's forum*

Corinthian capital and cornice; unfinished half-elevation and profile

Inscribed on fol.65v: *Questo Capitello Corintio e sm/inuuito p[er] meta eCosi la Cor/nice seg[na]ta ⊤ la sua Colonna/e gr[ande] p[almi] 4 once 4 mesurato/dal Anticho come Ancho la/sua basa seg[na]ta a dietro f* [initial]

Two flaps have been added, one at the top of the drawing to complete the volutes and the other on the right for the cyma and corona; WM cat.22; unwashed; 570 and 679 × 420 and 548 mm

SJSM, vol.119, fols 65v–66r

The capital, marked with a cross, is drawn half-size. It has two tiers of acanthus, full-leaves alternating with half-leaves; the volutes rise from a spiral-fluted caulicula containing two acanthus leaves, which support the volutes. The cornice marked ⊤ is slightly to the right of the central acanthus leaves of the capital. It has a bead-and-reel ovolo below a cyma reversa with acanthus-ogee ornament, a fillet, dentils, a fillet, a bead-and-reel astragal and an ovolo with egg-and-dart moulding below a fillet and plain corona with a cyma reversa decorated with tongue and leaf, a fillet, plain cyma recta and slab.

MASTER DRAWINGS Rome, GNDS, Alberti Codex C, fols 65v–66r (F.N.8116v–F.N.8117r; Forni 1991, p.144, tav.CCLXII).
LITERATURE Lanciani 1902–12, II, p.126.

For other representations, see Forni 1991, p.144.

521

ROME: *Baptistery of Constantine, S. Giovanni Laterano, interior peristyle Base, Doric, Ionic and Corinthian orders; half-elevation, profiles and elevations of the pedestal, base, capital and entablature of each order*

Inscribed on fol.67v: *Il Tutto del Zocholo e p[al]mi 3 f* [initial]; fol.68r: *Misurate dal/anticho con di/ligenzia*

WM cat.36; one beige and three brown washes, areas of white unwashed paper; 420 × 567 mm

SJSM, vol.119, fols 67v–68r

On the left the base, on a plain socle, has a projecting lower torus with a plaited ribbon decoration, a fillet, scotia with flute and tongue, a fillet and an upper torus with braided oak-leaf and acorn decoration. The inscription gives the width of the socle as 3 *palmi*.

On the right the Doric order, from the theatre of Marcellus, stands on a low pedestal; it has a base with a plain socle, projecting lower torus, scotia and upper torus. The capital has a tall frieze with three rosettes below two fillets and a plain echinus, slab and cyma recta and fillet. The entablature consists of an architrave with two fasciae with guttae hanging from the triglyphs in the frieze ending in a fillet and cavetto below the cornice with dentils, a plain corona, cyma reversa and cavetto. The Ionic order on a low pedestal has a base on a socle, double astragals, scotia, double astragals, scotia and torus; the capital has a plain echinus, channel and volutes and a slab with a cyma reversa; the entablature has an architrave with three fasciae, a frieze with a carved bearded satyr-mask and a cornice with a plain cyma reversa, fillet, slab, ovolo, corona, ovolo, fillet and cyma recta. The Corinthian order rests on a tall pedestal and plinth; the base on a socle has a projecting lower torus, scotia, double astragals and an upper scotia and torus; the capital, with two tiers of simplified leaves, supports an entablature comprising an architrave with two fasciae and a cornice with an ovolo decorated with egg and dart, block consoles with scale ornament and a plain corona, cyma reversa and slab.

The base on fol.67v is drawn in Codex Coner (Ashby 1904, pp.65–6, cat.132c). Alberti's prototype for fol.68r no longer survives. Few of the bases at the baptistery of Constantine survive: all of the capitals and some of the bases were replaced in the restoration of Urban VIII, in 1625 (Forni 1991, p.69). Wegner (1966, p.80, figs 26a.b.c and 27a) published three bases of this kind.

MASTER DRAWINGS fol.67v, Rome, GNDS, Alberti Codex B, fol.14v, inv. no.F.N.8027v; the inscription locates the base (Forni 1991, p.69, tav.CX).

For other representations, see Forni 1991, p.70.

520

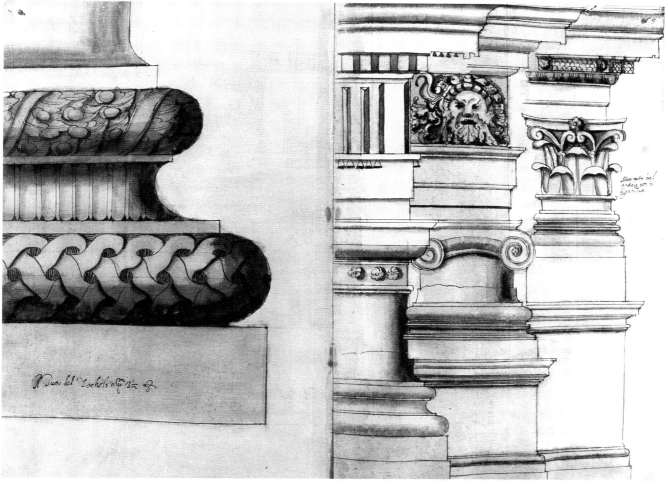

521

522

ROME: *Pantheon, the portico, the pilaster; baths of Caracalla*
Bases; profiles and half-elevations

Inscribed on fol.69v: *louolo di tutta gran/dezza della Cornice/seg[na]ta* T *a
dietro–fusarola–Canpana del Capitello seg[na]to* ✛; fol.70r: *Questa basa e/ditutta
grandezza/trovata alla Antogniana/coli medesimi Jntagli trovata/sotto terra asai
misurata con diligenza aCosa p[er]Cosa quale/adesso noce ne piu vestigi f* [initial]
WM cat.23; one beige, one grey and three brown washes; 421 × 563 mm
SJSM, vol.119, fols 69v–70r

On the left a base marked Q is shown above part of the half-elevation of the top of
the field of a Corinthian capital. The base has a projecting lower torus, fillet and
scotia, fillet and two astragals, a fillet, upper scotia, fillet and upper torus. To
the right of the base are a detail of a bead-and-reel moulding inscribed *fusarolo*
(spindle) and a full-size detail of the egg-and-dart moulding from the cornice.

The base is from a column in the pronaos of the Pantheon. A base from the
interior is drawn on fols 55v–56r (cat.515).

On the right is a half-elevation of a richly decorated base on a socle with a
bucrane and swags below a plain slab. The base has a projecting lower torus with
acanthus, a scotia with tongue-and-leaf and acanthus-flower ornament, a central
torus with ribbons, an upper scotia with acanthus-flower ornament and an upper
torus with acanthus-leaf ornament. Details of the acanthus leaves from the upper
torus are drawn on the right.

The inscription on fol.70r locates the base at the baths of Caracalla below
ground. The drawing on this folio was copied from Codex C, which also shows
the detail of the acanthus leaves. The ribbon decoration on the middle torus in
the Soane drawing is simplified and different from the other versions.

MASTER DRAWINGS fol.69v, Rome, GNDS, Alberti Codex C, fol.19r, inv. no.F.N.8076r
(Forni 1991, pp.109–10, tav.CXCIII); fol.70r, Codex A, fol.2r, inv. no.F.N.7972r (the
unit of measurement, a full *palmo*, is given; op. cit., p.19, tav.V); Codex C, fol.14r,
inv. no.F.N.8071r (the note records that Alberti found the base in a garden; op. cit.,
p.106, tav.CLXXXV).
LITERATURE Lanciani 1882, p.344.

For other representations, see Forni 1991, p.110.

523

LOCATION UNKNOWN
Cornice; unfinished profile and elevation

WM cat.21; one beige and two brown washes; 423 × 560 mm
SJSM, vol.119, fols 71v–72r

The cornice has a fillet and bead-and-reel astragal below a cyma reversa with
acanthus-ogee ornament, a fillet, a plain fascia, an ovolo with egg and dart and an
acanthus leaf at the corner, a fillet, a plain corona, a plain fillet and a bead-and-reel
astragal below the cyma recta with acanthus-flower ornament.

There are fragments of this frieze on the north-east side of the Basilica Aemilia
(Leon 1971, p.116 and passim., tav.41.1, 42.3).

MASTER DRAWINGS Rome, GNDS, Alberti Codex D, fols 6v–7r, inv. nos
F.N.8176v–F.N.8177r, dated August 1597 (Forni 1991, p.177, tav.CCCXXXIV).

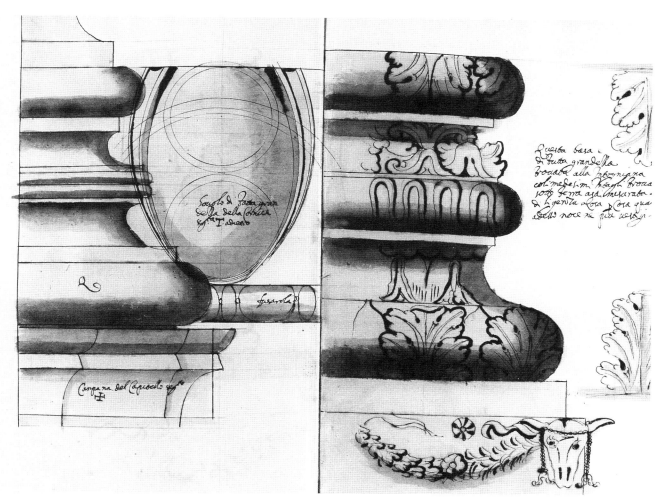

522

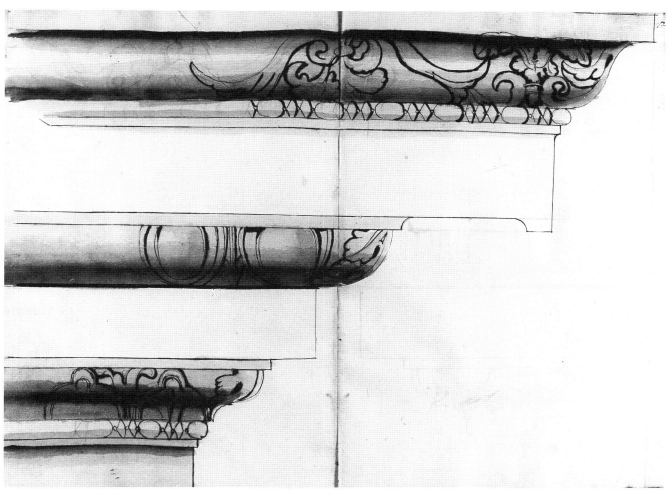

523

524

ROME: *Iseum and Serapeum*
Entablature and base; profiles and elevations

Inscribed on fol.74r: *Le presente cornice sonno dell'archo di Camigniano sonno di tutta/grandezza come si vede* A à A *misurate con grandes[si]ma dilige/nza quale era lauorata de bellisimi Jntagli et al presente no[n]/cene piu vestigi f* [initial] – *Jl fogliame grande* Q *e il fregio di d[et]a/Cornice la lettra* V *elarchitrave lalettra* D *ela basa di d[et]to/Archo et ogni Cosa et sonno di d[et]ti menbri – Archetto di tutta grandezza*
A flap has been glued to the top right of the drawing to complete the two cymas; a second flap completes the frieze; WM cat.21; unwashed; 560 and 868 × 420 and 514 mm
SJSM, vol.119, fols 73v–74r

The cornice marked A has a cyma reversa with leaf and tongue, a fillet, dentil moulding, fillet, ovolo with egg-and-dart moulding and a fillet with leaf-and-tongue ornament below foliage scroll consoles, cyma reversa with leaf-and-tongue ornament and corona with flute-and-tongue ornament, leaf-and-tongue moulding, fillet and cyma recta with anthemion alternating with acanthus flowers in acanthus scrolls. The frieze below it marked V is decorated with rinceaux, and the architrave, also marked by a V and shown slightly to the right of the frieze, has three fasciae. The base at the bottom right of the folio is marked D; it has a lower projecting torus with acanthus above a socle, a fillet, plain scotia, a fillet, two astragals, a fillet, a plain upper scotia, fillet and torus. The detail of the frieze with acanthus leaves embracing the rinceau is drawn above the architrave lettered V. It has a cyma reversa and three fasciae, the lower ones separated by a bead-and-reel moulding.

The inscription identifies the fragments, which are drawn full-size, as from the arch of Camigliano and 'carved with very beautiful carving'. Alberti's prototype no longer survives. A cornice from the same arch is shown on fols 43v (cat.509).

525

LOCATION UNKNOWN
A coffer between the modillions; graphite underdrawing of the plan of a coffer
SJSM, vol.119, fols 74v

The cyma moulding framing the coffer is richly decorated with acanthus leaves and flowers; in the centre of the coffer an acanthus leaf alternates with an acanthus flower.

526

ROME: *Temple of Hercules*
Composite base and capital; profiles and elevations

Inscribed on fol.76r: *Questo Capitello e basa e misurato/dal anticho del tenpio di ercole* [si deleted]/*sminuuito Jn quarto misurato con/ogni Diligenzia quale adesso noce/ne piu vestigi f* [initial]
WM cat.21; one beige and two brown washes; 419 × 558 mm
SJSM, vol.119, fols 75v–76r

The fragments are reduced to quarter-size. On the left the base is drawn perpendicular to the bottom of the folio. It has a plain socle with a projecting plain lower torus, a scotia and an upper torus with a cable moulding twisting to the right. The hypertrachelion of the column has a cartouche below the capital with a strapwork frame on the left and a winged female half-figure on the right. The Composite capital has two tiers of half- and full-acanthus leaves below an egg-and-dart echinus and two plain volutes springing from the fleuron in front of the abacus.

The inscription locates the find at the temple of Hercules. It is not identical to the Codex D drawing: more of the column is shown and the base, shown separately here, has a plain lower torus.

MASTER DRAWINGS Rome, GNDS, Alberti Codex D, fol.5r, inv. no.F.N.8175r, dated September 1598 (Forni 1991, p.176, tav.CCCXXXIII).

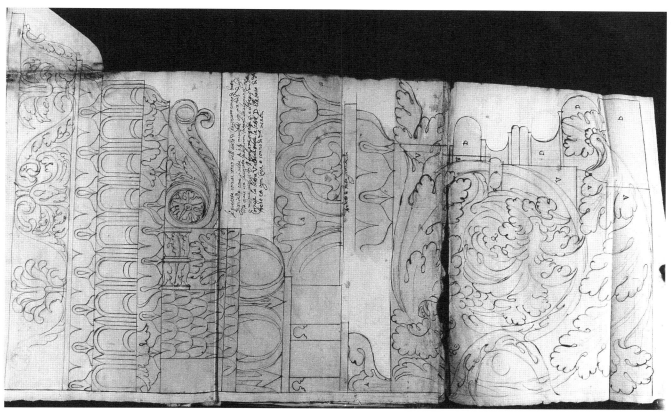

524

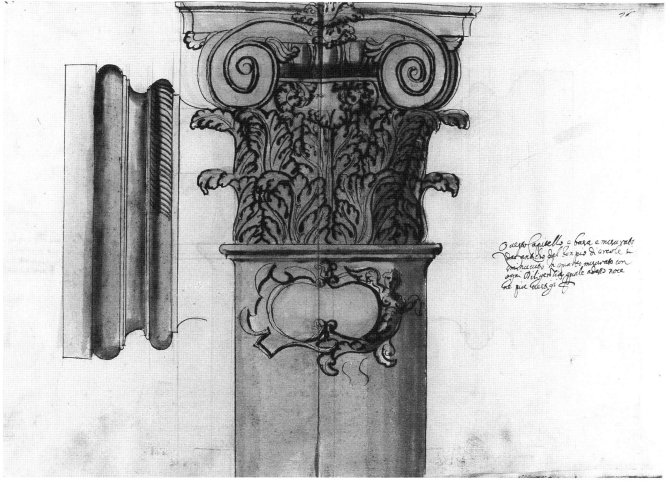

526

527
ROME:: *Capitol and Trajan's forum*
Two cornices; profile and elevation
Inscribed on fol.77v: *questa Cornice era asai/ruuinata et girava Jn/tondo misurata con dili/genzia e sminuvita p[er]/meta Jn Canpidoglio trovata/sotto terra asai f [initial]*; fol.78r: *Questa cornice era apresso a/spoglia Cristo misurata con/diligenzia sminuvita p[er] meta/quale michelangelo bonarota/la lodo asai et ne piglio misu/ra quale adesso nose ne tro/va piu vestigi f [initial]*
WM cat.21; beige wash; 429 × 570 mm
SJSM, vol.119, fols 77v–78r

On the left is a half-size cornice, found on the Capitol. It has a bead-and-reel astragal, cyma reversa with leaf-and-tongue ornament, dentils, fillet, bead-and-reel astragal, plain fillet and an ovolo with egg-and-dart ornament below a corona decorated with anthemion and acanthus flowers, then a fillet, cyma reversa with acanthus, a leaf-and-tongue astragal, plain fillet, cyma recta with anthemion decoration and a plain slab. The plan of the projecting corona is decorated with flute-and-tongue ornament.

Giovann' Antonio Dosio also drew the cornice (Florence, Uffizi 2093A; Bartoli 1914–22, tav.CCCCLXXVI, fol.876) and his inscription records that the fragment, 'which was at the Capitol, was found on the Palatine and as far as can be seen it came from a circular temple'.

The cornice on fol.78r is also drawn on fols 15v–16r (cat.495). The inscription records: 'it was found near the church of S. Maria in Spoglia Christo [later called S. Maria in Carleo]. It was praised by Michelangelo who measured it.' The cornice was copied by Michelangelo (London, BM, 1859-6-25-560/2R) from Codex Coner; Ashby (1904, p.46, cat.88; Barocchi 1987, fig.7) identified it as the cornice from the Basilica Ulpia.

MASTER DRAWINGS Rome, GNDS, Alberti Codex C, fols 63v–64r, inv. nos F.N.8114V–F.N.8115r (Forni 1991, p.142, tav.CCLVIII–CCLIX).
LITERATURE Lanciani 1902–12, II, p.94, and 126ff.; Bertoldi 1960–61, p.10.

For other representations, see Forni 1991, p.142–3.

528
ROME: *Vineyard of S. Pietro in Vinculi*
Ionic capital found at the baths of Titus; profile and half-elevation
Inscribed *mezzo – Questo Capitello Jonicho edi tutta grandezza misurata con ogni di/ligenzia delli vestigi Antichi trovato sotto terra piu de Cinquanta/p[al]mi Romani epoi desfatto per seruissene Jnaltro quale Capitello fu fatto/fare Jn un defizio che fece fare vitruvio Architetto che cosi era/scritto sopra alla tavola di d[ett]a Capitello quale e bene lavorato/de bellisimo Jntaglio epulito e la sua voluta gira molto bene*
On two sheets of paper joined vertically at the volute; WM cat.21; one beige, one grey and two brown washes; 510 × 713 mm
There is an old repair on the right where the folio is folded
SJSM, vol.119, fols 79v–80r

The Ionic capital has an echinus decorated with egg and dart and a channel with acanthus leaves, one of them entering the volute. Three acanthus leaves, an acanthus flower, two acanthus leaves and a bell-flower spiral in the volute and meet the rosette with five petals in the centre.

The inscription records: 'the capital, drawn full-size, was found more than 50 *palmi* below ground; it was reused to make another. According to the inscription on a plate of this capital, it was on a building designed by Vitruvius; it is well made with beautiful carving and the spiral of the volute is very good.' The inscription on Codex C (fol.47v) says that the fragments 'were found at the vineyard of San Pietro in Vinculi in the excavation of rooms with beautiful stucco decoration'. Pierre Jacques drew the capital, which he saw at the baths of Titus, and dated the drawing 1576. The capital could come from the Domus Aurea.

The drawing depicts only the capital, and not the base shown in Codices C and D.

MASTER DRAWINGS Rome, GNDS, Alberti Codex C, fols 47v–48r, inv. nos F.N.8103V–F.N.8104r+F.N.8152r; Codex D, fol.4r, inv. no.F.N.8174r (Forni 1991, p.134, tav.CCXL; p.176, tav.CCCXXXI).
LITERATURE Lanciani 1897, p.361; Lanciani 1902–12, II, p.227.

For other representations, see Forni 1991, p.136.

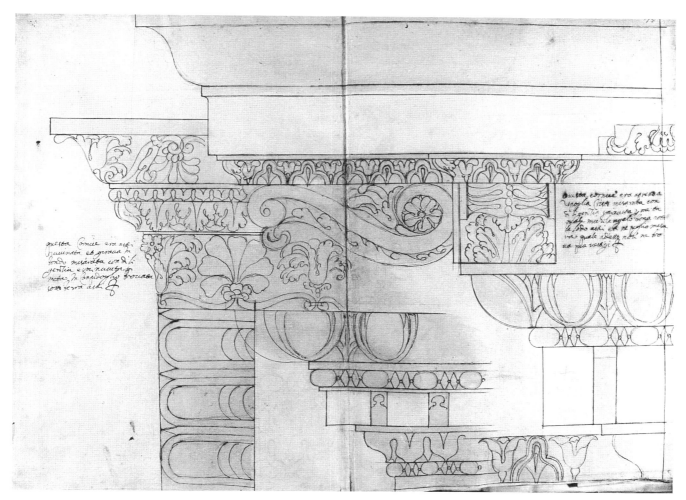

527

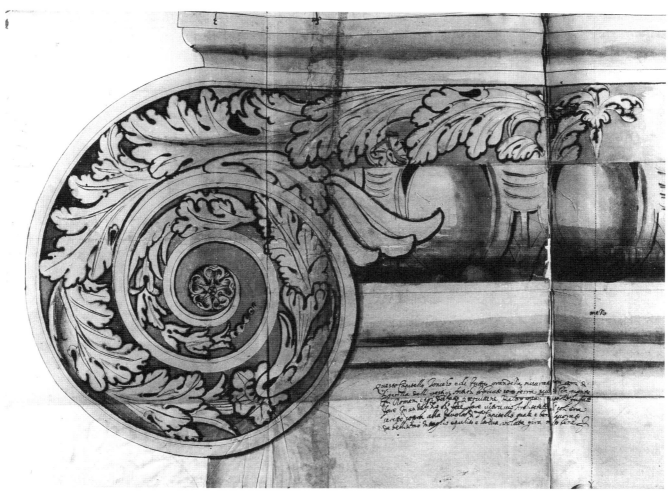

528

529
ROME: *Temple of Vespasian*
Ionic capital and base; profile and half-elevation
Two flaps are glued to the folio to complete the base and capital; WM cat.23;
two beige and three brown washes; 560 and 961 × 422 and 678 mm
SJSM, vol.119, fols 81v–82r

The capital, which is drawn full-size, has an echinus with egg-and-dart moulding
below a channel filled with acanthus leaves. Two acanthus leaves enter the volute
and twist in the spiral, followed by an acanthus flower and lotus. The foliate orna-
ment in the volute stops on the vertical axis of the first turn. The base on a socle has
a projecting lower torus, fillet, scotia, fillet and two astragals, fillet, upper scotia,
fillet and upper torus.

The base was also drawn by Bernardo della Volpaia in Codex Coner and by
Baldassare Peruzzi (Ashby 1904, cat.133; Wurm 1984, Taf.75).

The lower part of the temple of Vespasian called the Three Columns was buried
until 1811, when they were finally liberated, but there must have been excavations
during the Renaissance from which the bases were known.

530
LOCATION UNKNOWN
Unidentified Ionic base, capital and cornice; profiles and half elevations
WM cat.21; two beige and three brown washes; 421 × 562 mm
SJSM, vol.119, fols 83v–84r

The base on the left has a socle below a projecting lower torus, fillet, a scotia, fillet
and two astragals, fillet, upper scotia, fillet and torus. The Ionic capital is the same
as the capital drawn on fols 79v–80r (cat.528), except that the rosette here has four
petals. The cornice on the right has a bead-and-reel ovolo and plain fillet below
an ovolo with egg-and-dart ornament and an acanthus leaf at the corner, a fillet,
cyma recta with simplified acanthus alternating with lily leaves, fillet and a cyma
recta decorated with acanthus ornament below a plain slab. All of the mouldings
are separated by flat fillets.

The drawing is copied from Codex D, which according to Forni shows the same
capital and base as Codex C (fols 47v–48r). The capitals are not identical, however,
and there is sufficient variation in the bases, in the curvatures of the scotias and in
the projection of the mouldings from the shaft to suggest that a different base is
represented. The cornice or impost moulding on fol.84r is copied from Codex D
(fol.7r).

MASTER DRAWINGS fol.83v, Rome, GNDS, Codex D, fol.4r, inv. no.F.N.8174r; fol.84r,
Codex D, fol.7r, inv. no.F.N.8177r (Forni 1991, pp.176–7, tav.CCCXXXI and CCCXXXV).

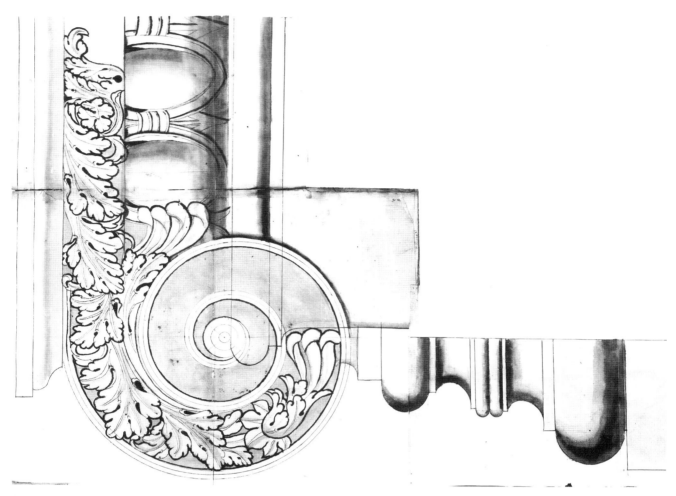

529

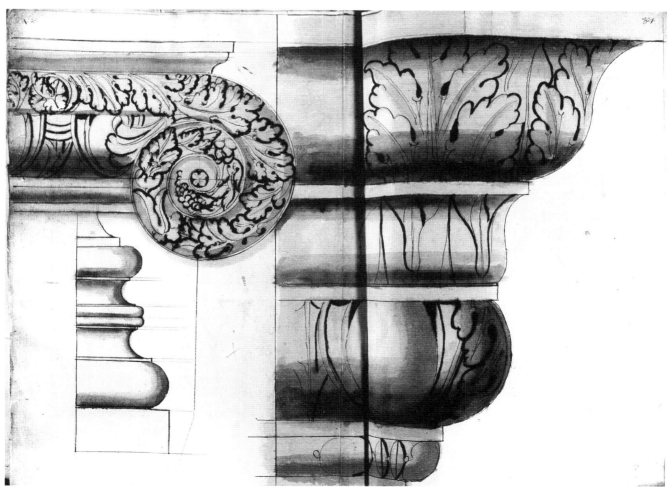

530

531

ROME:*Basilica of Neptune*
Capital and entablature; profile and elevation

Scale 54 mm=2 p[almi]

Inscribed on fol.85v: *p[almi] once 10 menuti 4–p[al]mi doi Romani*; fols 85v–86r:
Le presente Cornice sonno delle Rouine della/Rotonda trovate sotto terra p[al]mi 40 fatte sul/proprio lo[n]go quale Cornice e sminuuita p[er] meta/e cosi larchitrave il suo fregio e mancho p[al]mo /daltezza il Capitello non sie possuto corre altre/misure per essere ruuinato asai tutte le misure di/esso Capitello son di tutta grandezza senza sminu/vire lavorate con grandisima deligenzia della/Colonna cosi ne potutto Corre altre misure p[er] esse/re rouinata asai ecosi la sua basa nose ne po/tuto dar lume quale Cornice erano del Ca[n]po di fora/di d[et]to tenpio verso mezzo Giorno; fol.86r: *fondo darchitravi p[al]mi 2 on[cie]/10 il tutto*

WM cat.21; two beige and three brown washes; 422 × 560 mm

SJSM, vol.119, fols 85v–86r

The same entablature is drawn on fols 5v–6r (cat.490). The hypertrachelion of the fluted column and entablature are taken from Codex C (fol.14v).

The inscription states: 'the cornice is rendered half-size as is the architrave and its frieze and a *palmo* is missing from its height. It was not possible to give more measurements of the capital because of its ruinous state. All of the measurements of the capital are given full-size and taken with great care. It was not possible to obtain more measurements of the column because of its ruinous state and the base has not come to light. These cornices were at Campo dei Fiore [possibly Palazzo Farnese]; they came from the Basilica of Neptune towards midday.'

The architrave appears on the left in Codex C, and only the architrave is shown above the capital. Only Alberti records the entablature and capital.

The area was excavated twice in the Renaissance, during the papacies of Paul III and Gregory XIII. A section of the entablature showing the mouldings below it in Codex C suggests that the trabeation was placed above the free-standing columns that Lanciani reconstructed in the space connecting the great room with the adjacent rooms on the south (Forni 1991, p.108). The cornices may have been in the Farnese collection.

MASTER DRAWINGS Rome, GNDS, Alberti Codex C, fol.14v, inv. no.F.N.8071v (Forni 1991, pp.106–7, tav.CLXXXVI).
LITERATURE Lanciani 1882, p.355, tav.XX.

532

ROME:*Temple of the Sun*
Cornice; profile and elevation

Inscribed on fol.88r: *Questa Cornice e di tutta grandezza coli/medesimi Jntagli misurata menbro p[er]/menbro con ogni Diligenzia delli vesti/gi del tenpio di Gunone trovata sotto/terra p[almi] 20 eguasta p[er] farne un altro quale/di questa nose ne trova piu vestigi f[initial]*

On four sheets of paper; fol.88r, WM cat.21; one grey, two brown and two beige washes; 766 × 781 mm

SJSM, vol.119, fols 87r–88v

The fragment is shown full-size; a small part of the plain frieze is shown at the bottom of the drawing. Above the frieze there are two ovoli, one with leaf-and-tongue, the second with acanthus-leaf ornament, then a fillet, cyma recta with oak leaves and acorns and an ovolo with egg and dart below the dentils, bead-and-reel astragal, cyma recta with acanthus ornament, corona with rinceaux, bead-and-reel astragal, cyma reversa with oak leaves and acorns, fillet and cyma recta with acanthus scrolls below the plain slab. A detail of the lily-leaf ornament below the corona is shown on the right. The drawing is on four sheets of paper: the first frieze to the bead-and-reel moulding above the dentils is on the first sheet, the plain mouldings above them are on the second, the foliage mouldings on the right are on the third, and the plan of the lily leaves is on the fourth sheet.

The inscription locates the find at 'the temple of Juno, 20 *palmi* underground; it was broken to make another'.

At the bottom of the *Frammenti* sheet a fillet and a fragment of the egg-and-dart moulding are shown below the dentil moulding. Codex C shows the continuation of the cornice and a fragment of the plain frieze. A fragment of the lower part of the cornice survives in the Museo Nazionale Romana (Töbelmann 1923, tav.XVII). These drawings extend our knowledge of the cornice and its decorated cyma.

MASTER DRAWINGS Rome, GNDS, Alberti Codex D; a fragment of this drawing appears on fol.14v, inv. nos F.N.8184V–F.N.8204r, dated 20 July 1598 (Forni 1991, pp.180–81, tav.CCCXLVIII); Codex D, fol.15r, showing fols 27v–28r (cat.501), also shows a fragment of this folio on the left.

533

Inscribed Io francesco firera , fireza or fireta [?]

SJSM, vol.119, fol.88v

The inscription is on the verso of the detail of the plan of the lily leaves. The *f* is identical to the initial that appears on every folio of the album.

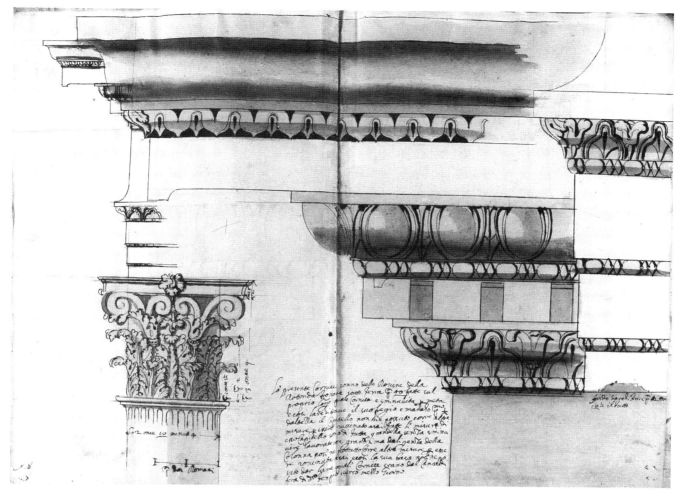

531

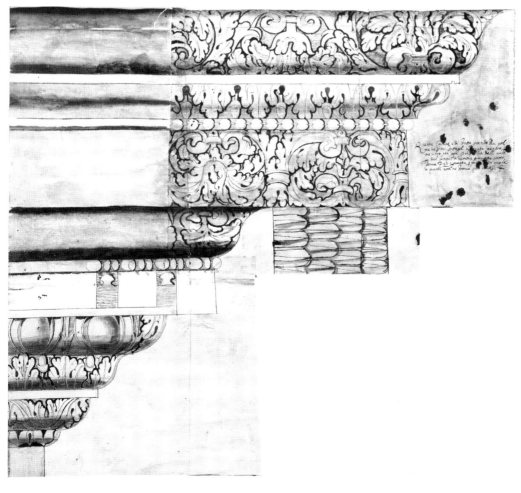

532

Catalogue of Watermarks

The drawings in Sir John Soane's collection are all conserved in volumes, which restricted the recording of the watermarks. They were photographed by inserting a thin light sheet below each folio; each mark was framed in a window cut to the size of a full-plate negative, and a scale was inserted at the side of the frame. Because of their position, it was not always possible to photograph the watermarks from the correct direction. Where a mark occurred several times, every example was photographed, traced, compared and grouped.

Not all the images were clear enough for publication, so the watermarks were scrupulously traced by a draughtsman from the photographs on to a sheet of tracing paper with a hard lead pencil. A hatch technique was used in order to record the thickness and density of the lines precisely; the chain lines and ten laid lines were traced. The tracings were checked against the original mark: they corresponded precisely to the original watermark traced, but not always exactly to other samples of the same watermarks in the albums. The watermarks are listed alphabetically according to their descriptive title; the dimensions of the salient features and the distances between the chain lines, which are often variable, are given. All are reproduced at 50%; cat. 10 and 45 are also shown full size on this page. The location of the watermark in the collection is given at the end of the entry; the occurrences of the same mark are listed after the number of the traced example.

No matches were found for any of the watermarks in Briquet 1968, Zonghi 1953, Piccard 1961–87 or Woodward 1996.

45

1 ARROWS, crossed under a six-point star
Distance between points 50 mm
Distance from centre to top of star 76 mm
Length of shafts top half 43 mm
Chain lines 34–43 mm
Trajan's column, SJSM, vol.113

2 CORNUCOPIA
Max height 79 mm, Chain lines 27–9 mm
Chinnery album, drawing 66

3 CRESCENT, below a four-petal flower above the name ED-OND[US] in an unwound scroll
Diam. of the crescent 16 mm, Max length of the scroll 46 mm, Chain lines 26 mm
Chinnery album, drawing 73

4 CROSSBOW, in a circle
Diam. 43 mm, Chain lines 23–37 mm
Chinnery album, drawing 5

5 CROSSBOW, stylised immediately above MA
Max width 52 mm, Chain lines 28–33 mm
Similar marks are listed by Eineder 1960, no.609, dated 1772.
North Italian album, frontispiece

6 MA mark with double lines immediately below the stylised crossbow
Height 26 mm
The REAL mark, which is also found in the binding, is from a different mould (communication Peter Bower).
North Italian album, free endpaper

7 CROWN, five point, below a six-point star
Max width 37 mm, Chain lines 30–34 mm
Chinnery album, drawing 9

8 CROWN, five point, below a six-point star
Height from bottom of crown to the top of the star 60 mm; width 50 mm
Chain lines 33–42 mm
Chinnery album, drawing 59

9 CROWN, five point, below a star?
Max width 45 mm, Chain lines 28–38 mm
Chinnery album, drawing 62

10 CROWN, five point, below a star
Max height 59 mm; width 41 mm
Chains lines 31–7 mm
According to Peter Bower, the mark is north Italian and dates from the middle of the 16th century (communication).
Trajan's column

11 CROWN, five point with a second crown rising from it
Max height 128 mm, Chain lines 32 mm
Chinnery album, drawing 50

12 CROWN, three point with a second crown rising from it, above P S
Max width of the crown 18 mm, of the letters 21 mm, Chain lines 17–26 mm feint
The crown is laid parallel to the chain lines in the French manner.
Meccanica, fol.49

13 EAGLE, displayed in a circle below a three-point crown with a flat base
Diam. 48 mm, Chain lines 36 mm
Montano, vol.III, fol.29

10

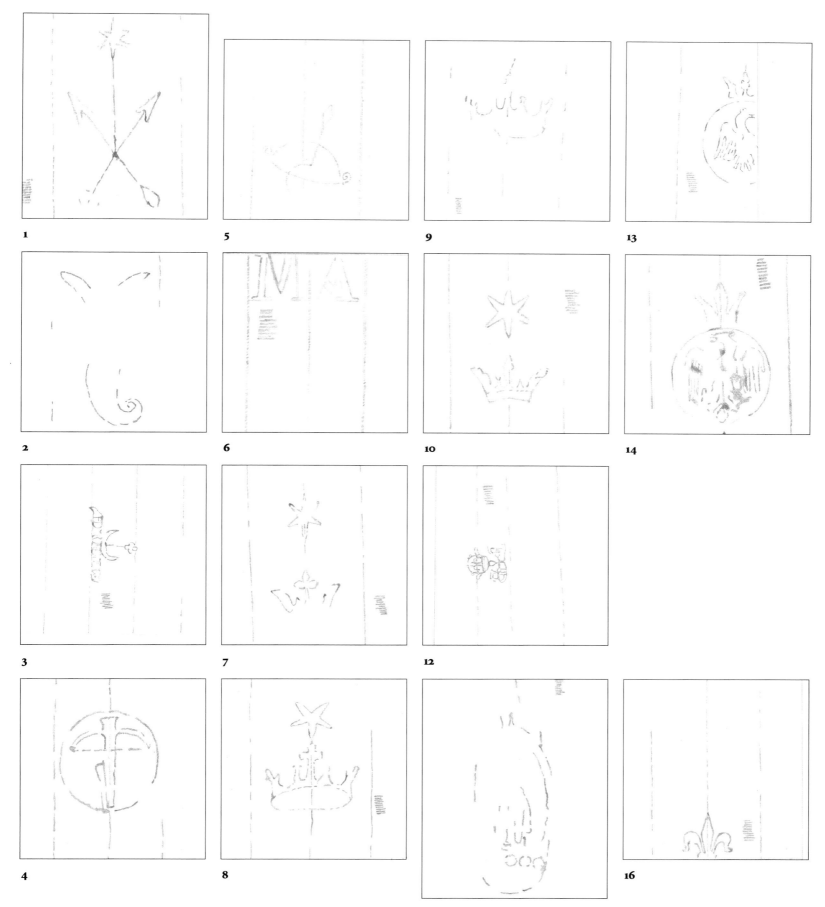

1

5

9

13

2

6

10

14

3

7

12

4

8

11

16

14 EAGLE, displayed in a circle below a
three-point crown
Diam. 40 mm, Chain lines 28–35 mm
Vasari album, p.49
One of the watermarks on the folios of the
first half of the Vasari album; it is also
found on fols 1, 15, 19, 21, 27, 31, 33, 37, 43,
45, 47, 49, 51, 57, 59, 63, 69, 71, 73, 91, 93, 95,
97 and 137.

15 EAGLE, displayed in a circle below a
three-point crown (Not illustrated)
Diam. 40 mm, Chains illegible
Chinnery album, drawing 23

16 FLEUR-DE-LIS
Max width 26 mm, Chain lines 28–33 mm
Chinnery album, drawing 49

17 FLEUR-DE-LIS, in a circle
Diam. 33 mm, Chain lines 27 mm
Meccanica, fols 15, 2, 17, 21, 28 and 46

18 FLEUR-DE-LIS, in a circle
Diam. 44 mm, Chain lines 28–32 mm
Vasari album, p.148

19 FLEUR-DE-LIS, in a circle below a six-
point star
Diam.43 mm, Chain lines 26 mm
Vasari album, pp.112[A], 145[A] and 199[A]?

20 FLEUR-DE-LIS, in a circle below C
Diam. 52 × 56 mm, Chain lines 30–35 mm
Vasari album, p.217

21 FLEUR-DE-LIS, in a circle below a five-
point crown with a flattened base
Diam. 42 mm, Chain lines 24–32 mm
Frammenti, fols 18, 21, 24, 25, 27, 29, 33, 35,
72, 74, 76, 78, 79, 80, 84, 86 and 87

22 FLEUR-DE-LIS, in a circle
Diam. 44 mm, Chain lines 28–35 mm
Frammenti, fols 65 and 66

23 FLEUR-DE-LIS, in a circle, below a five-
point crown with a rounded base
Diam. 42 mm, Chain lines 26–30 mm
Frammenti, fols 19, 32, 69 and 81

24 FLEUR-DE-LIS, three arranged in a trian-
gular plan in a wide shield
Max height and width 49 × 35 mm
Chain lines 23–41 mm
Chinnery album, drawing 75

25 FLEUR-DE-LIS, above crossed keys in a
wide shield.
Max height 76 mm; width 48 mm
Chain lines 30–36 mm
Montano, vol.III, fol.22

26 FLEUR-DE-LIS, in two concentric circles
below D or reversed C
Diam. 46 mm, Chain lines 30 mm
Montano, vols I, II and III, flyleaves

27 GOOSE, over three mounts in a circle
below F
Diam. 40 mm, Chain lines 29 mm
Meccanica, on the folios of the album on
fols 11, 13, 16, 18–9, 21, 24, 26, 29, 32, 33, 35,
37, 42, 43, 46, 48, 50, 56–62, 65, 69, 72

28 GRAPES, large stylised bunch of grapes
above RA
Max height 85 mm, Chains illegible
Chinnery album, drawing 26

29 JUSTICE, holding scales and standing on
a wheel
Max height 110 mm, Chain lines 35 mm
It occurs with BS below a clover leaf as the
counter mark.
Francesco di Giorgio manuscript

30 KEYS, crossed in a wide, round shield
Diam. 50 mm, Chain lines 34 mm
Montano, vol.II, fol.76

31 KNEELING SAINT, holding a small cross in
a narrow shield
Max height 65 mm, Chain lines 28 mm
Montano, vol.I, fol.135, 23

32 KNEELING SAINT, holding a large cross in
a wide shield
Max height 61 mm, Chain lines 27–32 mm
Montano, vol.I, fol.77

33 KNEELING SAINT, holding a small cross
in a narrow shield
Max height 55 mm, Chain lines 30 mm
Montano, vol.I, fol.15, fol.134, III, fol.90

34 KNEELING SAINT, holding a cross in a
wide shield
Max height 70 mm, Chain lines 23–8 mm
Frammenti, fols 5 and 64

35 KNEELING SAINT, holding a small cross
in a wide shield
Max height 69 mm, Chain lines 23–8 mm
Frammenti, fols 51, 37, 47, 54, 56, 58 and 61.

36 KNEELING SAINT in a shield
Max height 69 mm, Chain lines 24–31 mm
Frammenti, fols 68, 3, 7, 9, 12, 14, 16, 42, 44,
50 and 59

37 KNEELING SAINT in a narrow shield
Max height 70 mm, Chain lines 23–9 mm
Frammenti, fols 2, 40 and 45

17

21

18

22

19

23

20

24

25

29

33

37

26

30

34

38

27

31

35

39

28

32

36

40

38 KNEELING SAINT holding a small double-line cross in a shield with a flat bottom
Max height 64 mm, Chain lines 30–32 mm
Montano, vol.III, endleaf

39 LETTERS, BS, below clover-leaf counter-mark to JUSTICE
Max height 31 mm; height of the letters 24 mm and width 20 mm, Chain lines 32 mm
Francesco di Giorgio manuscript

40 REAL
Max height 22 mm; width 55 mm
Chain lines 24–9 mm
The other mark in the paper binding, the crossbow above MA, is from another mould.
North Italian album, paper binding

41 SBH in an oval
Max height 52 mm; width 43 mm
Chain lines 26–30 mm
Montano, vol.III, fol.92

42 LION, rampant in an oval below a crown
Max height 51 mm; width 40 mm
Chain lines 27 mm
Vasari album, p.160

43 LION, rampant in an oval below a five-point crown
Max height 51 mm; width 39 mm
Chain lines 30 mm
Vasari album, p.172; it is also found on the folios of the album: 116, 154, 168, 174, 176, 191, 209 and 212.

44 LION, rampant below a five-point crown
Max height 59 mm, Chain lines 27–9 mm
Vasari album, pp.216[A] and 214[A]

45 MERMAID, with two tails, in a circle
Diam. 42 mm, Chain lines 24–30 mm
Vasari album, p.184[A]

46 MOOR'S HEAD, with a head band, neck splayed at the base
Max width 22 mm, Chain lines 28–30 mm
Vasari album, p.61[A]

47 MOUNTS, three mounts in a circle
Diam. 42 mm, Chain lines 24–30 mm
Vasari album, p.2[A]

48 MOUNTS, three mounts in a circle surmounted by a star?
Diam. 47 mm, Chain lines 31–4 mm
Montano, vol.I, fol.131

49 MOUNTS, three mounts below a large cross? in a wide shield
Max height 61 mm, Chain lines 30 mm
Chinnery album, drawing 42 and 6

50 PASCHAL LAMB, with a straight standard in a crooked circle
Diam. 50 mm, Chain lines 26–9 mm
Meccanica, fol.53

51 PASCHAL LAMB, with a straight standard in a crooked circle (Not illustrated)
Diam.42 mm, Chain lines 30 mm
Vasari album, p.215[A]

52 PASCHAL LAMB, with a straight standard in a circle below a Latin cross
Diam. 45 mm, Chain lines 30 mm
Vasari album, p.120

53 PASCHAL LAMB, with a bent standard, in concentric circles below A and above w
Diam. 51 mm; max height 84 mm
Chain lines 31–3 mm
Vasari album, pp.198 and 211

54 PILGRIM, in a circle
Diam. 43 × 46 mm, Chain lines 28 × 30 mm
Montano, vol.I, fol.129

55 PILGRIM, in a circle
Diam. 49 × 52 mm, Chain lines 29 mm
Montano, vol.I, fol.132

56 PILGRIM, with a staff over his shoulder in a circle below a fragment of a star ?
Diam. 50 × 52 mm, Chain lines 28 × 31 mm
Montano, vol.I, fol.133

57 SERPENT
Max height 118 mm, Chain lines 31–3 mm
The serpent is parallel with the chain lines, a characteristic of French marks.
Chinnery album, drawing 48

58 STAR, six-pointed
Max height 40 mm Chains illegible
Vasari album, p.140

59 SUN, with straight and wavy rays
Diam. of the circle 17 mm Chain lines 30 mm
Vasari album, pp.215[B] and 148[B] 192[A]
Cut watermarks or marks which are difficult to decipher.

60 Unidentified animal in a circle
Diam. 45 mm, Chain lines 21–4 mm
Chinnery album, drawing 16

61 CRESCENT? in a circle
Diam. 46 × 49 mm, Chain lines 33–7 mm
Chinnery album, drawing 71

62 STAR in a circle, below a Latin cross
Diam. 44 mm, Chain lines 30–34 mm
Montano, vol.I, fol.110

41

45

42

46

43

47

44

48

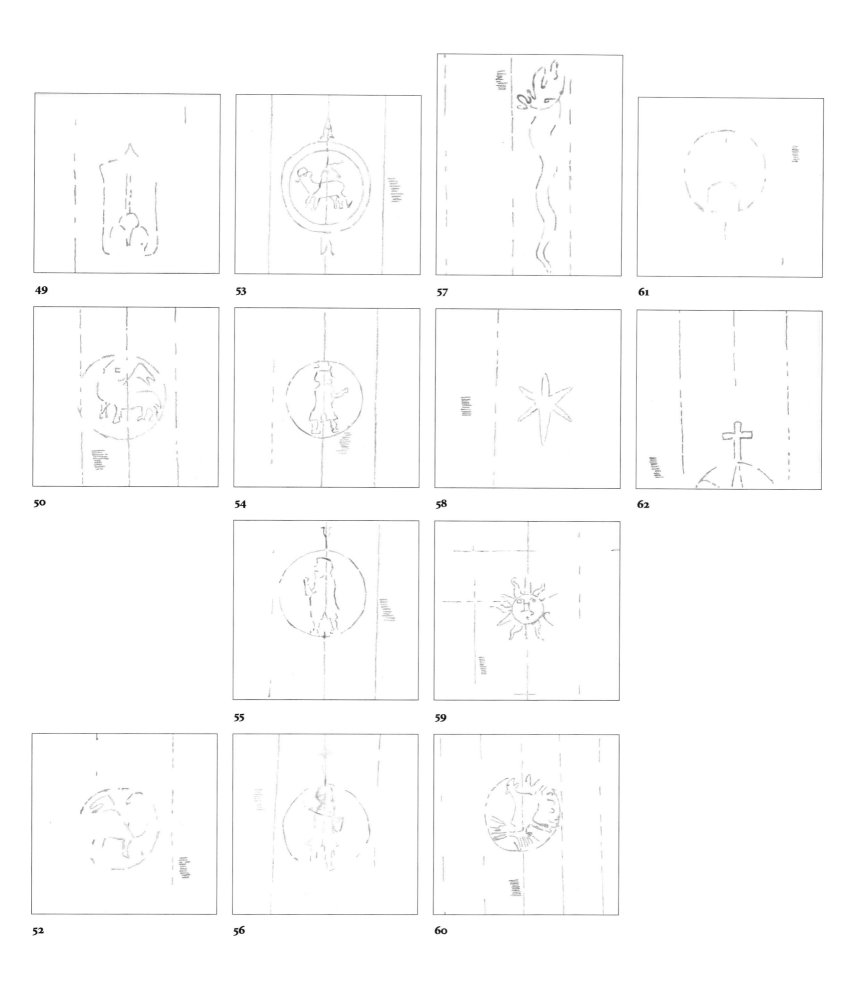

49

53

57

61

50

54

58

62

55

59

52

56

60

Bibliography

MANUSCRIPTS AND SKETCHBOOKS

AMPTHILL, BEDFORDSHIRE, ENGLAND
Houfe album (Scaglia 1992–3). A collection of architectural drawings by an anonymous 16th-century Italian draughtsman; some of them are copied from Giovanni Battista Alberti's sketchbook in BML, MS Ashburnham App.1828.

AREZZO, BIBLIOTECA CIVICA
MS 3: R. Restorelli, *Notizie istoriche delle nobilissime famiglie di Monte, Borgnognoni, Guidalotti e Simonelli…*, 1771.
MS 82: R. Restorelli, *Notizie della Pieve di Monte San Savino*, 1774.
MS 108: Teofilo Torri, *Ricordanze* (Brizi 1846; Verani 1937).
MS 474: Teofilo Torri, sketchbook (Borri Cristelli 1986).
MS 536: Teofilo Torri, sketchbook, now dismembered (Borri Cristelli 1986).

BERLIN, KUNSTBIBLIOTHEK
Inv. no.Hdz.4151: Codex Destailleur D, (Berkenhagen 1970). Architectural drawings by anonymous 16th-century French and Italian draughtsmen.
Inv. no.Oz.109 verso: Codex Destailleur A. Architectural drawings by anonymous 16th-century French and Italian draughtsmen.
Inv. no.Oz.111: Master of the Mantegna Sketchbook (Leoncini 1993).

BERLIN, STAATLICHE MUSEEN, KUPFERSTICHKABINETT
Inv. no.K 79D: Giovann' Antonio Dosio, Codex Berolinensis (Huelsen 1933).
Inv. nos 79D 2 and 79D 2A: Marten van Heemskerck, albums I and II (Huelsen & Egger 1913–16).

BERLIN, STAATBIBLIOTHEK PREUSSISCHER KULTURBESITZ
Lib. Pict.A.61: Stephanus Vinandus Pighianus, Codex Pighianus, (Jahn 1868). Drawings of Roman sculpture, c.1549–55.

BUDAPEST, FOVAROSÍ SZABÓ ERVIN KÖNÝVTÁR, NATIONAL LIBRARY
Inv. no.09/2690: Codex Zichy (Kolb 1988; Scaglia 1992b; Siena 1993a, p.370; Mussini 1991, pp.83ff.). An architectural sketchbook by an anonymous 16th-century copyist, containing a copy of an early version of Francesco di Giorgio's treatise.

CAMBRIDGE, MASS., FOGG ART MUSEUM
A copy of G. Barrozzi il Vignola's *Regola delli cinque ordini…* (1562) with architectural drawings bound into the volume. Acquired on the London art market in 1976.

CHATSWORTH HOUSE, DERBYSHIRE, DEVONSHIRE COLLECTION
Album 32 (Günther 1988, pp.341–3, Taf.42–53). Architectural drawings, formerly attributed to Master C of 1519 and now to Riniero Neruccio da Pisa.
Album 35 and 36. Two albums of architectural drawings by various masters.

COBURG, VESTE-COBURG
Inv. no.HZ II: Codex Coburgensis (Matz 1871; Wrede & Harprath 1986; Daly Davis 1989). An album of drawings of antique sculpture by an anonymous draughtsman, c.1549–55.

DIJON, MUSÉE DES BEAUX-ARTS
Inv. no.1994-4-1: Alberto Alberti, diary (Guillaume 1995).

DRESDEN, LANDESBIBLIOTHEK

MS R.28 m: R. Valturius, *De re militari*.

DÜSSELDORF, KUNSTMUSEUM DER STADT
Guglielmo della Porta, *Die düsseldorfer Skizzenbücher* (Gramberg 1964, cat.1–58).

FERRARA, BIBLIOTECA COMMUNALE ARIOSTEA
MS CL.I.217. A collection of architectural drawings and engravings.

FLORENCE, BIBLIOTECA MEDICEA LAURENZIANA
MS Ashburnham 361: Francesco di Giorgio (MS L; Marani 1979; Mussini 1991, pp.25ff.; Siena 1993a, pp.360–61, cat.XXI.2). First edition of the treatise on architecture.
MS Ashburnham 1357 (Scaglia 1992b, pp.64–8, cat.16). Drawings of machines after Francesco di Giorgio.
MS Ashburnham App.1828: Giovanni Battista Alberti, architectural sketchbook (Scaglia 1978, pp.104–24). With plans and elevations after Francesco di Giorgio.
Cod. Med. Pal.51: Gian Francesco Fortuna, *Regola generali di architettura* (Puppi 1978; Puppi 1987, p.492, n.2).

FLORENCE, BIBLIOTECA MARUCELLIANA
Codex A781: Battista Brunelleschi, architectural sketchbook (Giuliano 1971).

FLORENCE, BIBLIOTECA NAZIONALE COMMUNALE DI FIRENZE
MS E.B.16.5 (Scaglia 1992b, pp.78–82, cat.20). Architectural and mechanical drawings, attributed to Cosimo Bartoli.
MS BR.228: Buonaccorso Ghiberti, architectural sketchbook with drawings of machines (Scaglia 1992b, pp.120–22, cat.44).
MS Magliabecchiano II.I.140: Antonio Averlino, il Filarete, *Trattato di architettura* (Lazzaroni & Muñoz 1908, tav.1–16; Finoli & Grassi 1972).
MS Magliabecchiano II.I.141: Francesco di Giorgio (MS M; Maltese 1967; Siena 1993a, pp.366–8, cat.XXI.9). Second edition of the treatise on architecture, with his translation of Vitruvius.
MS Magliabecchiano II.III.314 (Scaglia 1992b, pp.68–70, cat.17). Drawings of machines by an anonymous 16th-century Italian draughtsman.
MS Magliabecchiano II.X.100: Vincenzo Borghini, *Libretto* (Ginori Conti 1936; Scorza 1981; Scorza 1991).
MS Magliabecchiano XVII.2 (Fiore 1985, pp.7–30; Scaglia 1992b, pp.160–62, cat.63). Drawings copied from Francesco di Giorgio's treatise by an anonymous 16th-century Italian draughtsman.
MS NA.1159: Giovann' Antonio Dosio, drawings of Roman altars (Casamassima & Rubinstein 1993).
MS Palatino 767 (Scaglia 1992b, pp.70–73, cat.18). Drawings of machines after Taccola and Francesco di Giorgio, by an anonymous early 16th-century draughtsman.
MS Palatino 1077: Bernardo Puccini, drawings of machines (Scaglia 1992b, pp.73–8, cat.19 as anonymous Florentine of 1548–56).

FLORENCE, ISTITUTO E MUSEO DELLA SCIENZA DI FIRENZE
MS Ant.532: Jacopo Strada, drawings of machines (Siena 1991, pp.236–7).

FLORENCE, UFFIZI
Baldassare Peruzzi and Sallustio Peruzzi, *Taccuino di fabbriche moderne*.

L. Scotti, *Catalogo dei disegni originali di pittori, scultori ed architetti che si conservano nelle imperiale e reale gallerie di Firenze*, 1832–7.
MS 2660A: Ludovico Cardi il Cigoli, treatise on perspective (Profumo 1992).
Uffizi 4945A–5045A: Giorgio Vasari il Giovane, treatise on perspective.
Uffizi 4715A–4944A: Giorgio Vasari il Giovane, doors and windows (Borsi 1980b).

FOSSOMBRONE, BIBLIOTECA PASSIONEI
Anonymous Foro Semproniensis, sketchbook (Nesselrath 1993).

HOLKHAM HALL, NORFOLK
MS 701. An album of architectural drawings by an anonymous 16th-century draughtsman after Raphael.

KASSEL, STAATLICHE KUNSTSAMMLUNGEN
Codex folio A 45 (Rome 1984a, p.418, cat.3.5.9; Günther 1988, cat.354–73, Taf.82–124). An architectural sketchbook by various draughtsmen including the Anonymous Mantovanus, an associate of Baldassare Peruzzi and then of Giulio Romano.

LILLE, MUSÉE WICAR
Codex attributed to Raffaello da Montelupo (Pluchart 1889, nos 161–904; Nesselrath 1983)

LONDON, BRITISH LIBRARY, DEPARTMENT OF MANUSCRIPTS
Additional MS 15276 (Palau 1986). Greek manuscript with drawings and descriptions of Greek machines.
Burney MS 69. Greek manuscript with drawings and descriptions of Greek machines.
Royal MS 14.e.VI: *Rusticon, du cultivement des terres* (London 1954, cat.4). A manuscript written for Edward IV and made in Bruges between 1473 and 1488.
Royal MS 20.d.I (Buchtal 1971, pp.16–17). A history of the world from the creation to the time of Julius Caesar by an anonymous Neopolitan.

LONDON, BRITISH MUSEUM, DEPARTMENT OF PRINTS AND DRAWINGS
Amico Aspertini, Codex I (Bober 1957).
Reg. no.197.b.21: Francesco di Giorgio, *Opusculum* (Scaglia 1992b, pp.43–50, cat.1; Siena 1993a, pp.377–8, cat.XXI.15).

LONDON, SIR JOHN SOANE S MUSEUM
Vol.115: Codex Coner, Bernardo della Volpaia and Cassiano dal Pozzo's draughtsman (Ashby 1904–13).

LOS ANGELES, GETTY CENTER, RESEARCH INSTITUTE
Resource Collections, Archival # 870439 (Scaglia 1992b, pp.98–100, cat.34). An album of drawings of machines after Francesco di Giorgio.

MADRID, BIBLIOTECA NACIONAL
Nos 8936–7: Leonardo da Vinci, Codices I and II (Reti 1974).
Raccolta Carderera (Madrid 1991). A collection of drawings including ones by Giovanni Battista Montano.

MADRID, ESCORIAL
Inv. no.28-I-20: Francisco d'Ollanda album (Tormo 1940). Views of Rome.

Inv. no.28-II-12: Circle of Domenico Ghirlandaio, Codex Escurialensis (Egger 1905–6). An album of views of Rome and Roman sculpture.

MILAN, BIBLIOTECA AMBROSIANA
Bramantino album (Mongeri 1880).
Leonardo da Vinci, *Codex Atlanticus* (Pedretti 1978).

MILAN, CASTELLO SFORZESCO
Raccolta Martinelli, vol.VI: Giovanni Battista Montano, Album (Pracchi 1991).

MODENA, BIBLIOTECA ESTENSE
App. Campori 1755: *Opusculum* (Scaglia 1992b, pp.95–6, cat.32). Drawings by an anonymous 16th-century Italian draughtsman after Francesco di Giorgio.
MS alpha G.4.21 (Siena 1993a, p.375, cat.XXI.13). An album of drawings of machines after Francesco di Giorgio, by an anonymous 16th-century Italian draughtsman.
MS lat.992: Giovanni Marcanova, *Quaedam antiquitatum fragmenta* (Rome 1988a).

MONTREAL, CANADIAN CENTER FOR ARCHITECTURE/CENTRE CANADIEN DE L'ARCHITECTURE
Dep. DR 1982:0020:001-033 (Rosenfeld 1989, pp.138–9 and n.45). Sketchbook of *c.*1530 by an anonymous Roman draughtsman. Simone del Pollaiuolo, called il Cronaca, sketchbook.

NAPLES, BIBLIOTECA NAZIONALE
MS XIII: Pirro Ligorio, *Libri delle Antichità*, books 1–10 (there is a complete set of photographs in the Warburg Institute, London).

NEW HAVEN, YALE UNIVERSITY, BEINECKE LIBRARY
MS 491 (Siena 1993a, pp.372–3, cat.XXI.9). A copy of Francesco di Giorgio's treatise on architecture (MS Ashburnham 361, MS L).

NEW YORK, METROPOLITAN LIBRARY
Vitruvius per Iocumdum solito castigator factus cum figuris et tabula ut iam legi et intellegi possit, edited by Fra Giocondo, Venice, 1511 (Scaglia 1991–2). With annotations and drawings by the Anonymous Addenda Architect.

NEW YORK, PIERPONT MORGAN LIBRARY
Mellon Codex (Rome 1984a, pp.418–22). An architectural sketchbook attributed to Domenico da Varignano by C.L. Frommel and to Anonymous Veneto by S. Storz.

OXFORD, ASHMOLEAN MUSEUM
Larger Talman album (Parker 1956, pp.552–4).

OXFORD, BODLEIAN LIBRARY
MS Ital.138: Pirro Ligorio's manuscript (Ashby 1919).

PADUA, BIBLIOTECA UNIVERSITARIA
MS 764 (Olivato 1978). An architectural sketchbook by a draughtsman in the circle of Bartolomeo Ammannati.

PARIS, BIBLIOTHÈQUE NATIONALE
MS GR.2442 (Pagliara 1977, pp.113–20; Siena 1991, pp.26 –7). A copy of a Greek manuscript made for Giovanni Aurispa by an anonymous draughtsman.
MS Ital.1292: Giulio Parigi, mechanical treatise (Lamberini 1990a, p.472, n.29).
MS Lat.13.123: Bellièvre manuscript (Perrat & Tricou 1956)

PARIS, BIBLIOTHÈQUE NATIONALE, CABINET DES ESTAMPES ET DE LA PHOTOGRAPHIE
Inv. no.HB.22.40: Giovanni Battista Montano, album of drawings.

PARIS, LOUVRE, CABINET DES DESSINS
Inv. nos 955–1012: Baldinucci album (Monbeig Goguel 1972, pp.224–37, cat.369–428; Monbeig Goguel 1992). Drawings of sculpture, architecture and painting formerly attributed to Pontormo, catalogued as Jacopo Zucchi and now attributed to Sebastiano Vini.

PARMA, BIBLIOTECA PALATINA
MS 1576: Piero della Francesca, *De prospectiva pingendi* (Nicco Fasola 1942).

PRAGUE, NATIONAL LIBRARY
MS XVII.A6: Codex Chlumczansky (Juren 1986). Anonymous draughtsman after Giulio Romano.

REGGIO EMILIA, BIBLIOTECA MUNICIPALE
MS Regg.A.46.9bis (MS E; Mussini 1991, pp.25ff; Siena 1993a, pp.362–3, cat.XXI.3). A fragment of the first edition of Francesco di Giorgio's treatise on architecture (Codex Ashburnham 361, MS L).
MS Regg.A.46.9 (Promis 1841, pp.95–7; Mussini 1991, pp.30ff.). Venturi copy of MS E.

ROME, BIBLIOTECA ANGELICA
Inv. no.1892 (Curti & Zampa 1995). A comparative study of the orders by an anonymous academic Italian architect of *c.*1680.

ROME, BIBLIOTECA APOSTOLICA VATICANA
MS Barb.Lat.4424: Giuliano da Sangallo, Barberini Codex (Huelsen 1910).
MS Ottob.Lat.3110 (Henneberg 1990, 1991 and 1992). An album of architectural drawings by several Florentine architects, containing many drawings related to the furnishings of S. Stefano dei Cavalieri in Pisa (see appendix 4).
MS Reg.Lat.1282 (Zangheri 1980, I, pp.323–71). An album of drawings of doors and windows by anonymous draughtsmen.
MS Urb.Lat.1397 (Scaglia 1992b, pp.108–12, cat.39). Drawings of machines copied from Francesco di Giorgio's *Opusculum* in the British Museum, London.
MS Urb.Lat.1757: Francesco di Giorgio, *Codicetto* (Scaglia 1992b, pp.51–2, cat.2; Siena 1993a, pp.359–60, cat.XXI.1).
MS Vat.Lat.3439. A collection of antiquities arranged thematically, from the circle of Fulvio Orsini; many of the drawings are copied from Ligorio.
MS Vat.Lat.7721: Giovanni Colonna da Tivoli, sketchbook (Micheli 1982). With drawings of sculpture and architecture dated 1554.
MS Vat.Lat.13751: Francisco della Vega (Vatican 1984, pp.214–15, III.4. cat.85).

ROME, GABINETTO NAZIONALE DI DISEGNI E STAMPE
Codex 2503: Alberto Alberti (Herrmann Fiore 1983).
Codex 2510, inv. nos FN32746, FN7670–7755 (Günther 1988, pp.350–53, Taf.68–78). An album of architectural drawings. Salzburg, Universitätsbibliothek
MS Ital.M.III.40 (Nesselrath 1989b). Anonymous north Italian draughtsman of *c.*1475.

SIENA, BIBLIOTECA COMMUNALE
MS L.IV.10. An architectural sketchbook, attributed here to Orazio Porta (see appendix 4).
MS S.IV.8: Giuliano da Sangallo, *taccuino* (Falb 1902).
MS S.IV.1: Oreste Vannocci Biringucci, *Architetture, fortificazione e macchine di Oreste Vannocci* (Heydenreich 1931; Ackerman & Lotz 1964; Scaglia 1992b, pp.136–8, cat.55). A architectural sketchbook with a history of modern projects and drawings of machines.
MS S.IV.5 (Scaglia 1992b, pp.141–2, cat.56). An album of drawings of machines after Francesco di Giorgio, by an anonymous Italian draughtsman.
MS S.IV.6 (Scaglia 1992b, pp.143–6, cat.57). An architectural sketchbook with designs for machines after Francesco di Giorgio, by an anonymous 16th-century Italian draughtsman, formerly attributed to Bartolomeo Neroni.
MS S.IV.7: 'Peruzzi' sketchbook (Toca 1971). After Baldassare Peruzzi; once owned by J. Meneghino.

ST PETERSBURG, HERMITAGE
Codices Destailleur A, B and C (Gukovsky 1963; Michailova 1969). Codex Destailleur B is attributed to Fra Giocondo.

STOCKHOLM, ROYAL LIBRARY
MS S.68: J.J. Boissard, *Inscriptionum antiquarum quae tam Romae in aliis quibusdam Italiae urbibus videntur, cum suis signis propriis ac veris lineamentis, exacta descriptio, per Jo.Jac. Boissartum Burgund. Romae. anno. MDLIX* (Mandowsky & Mitchell 1963, pp.27–8).

TORONTO, ROYAL ONTARIO MUSEUM
Pietro da Cortona, Codex (Brett 1957).

TURIN, ARCHIVIO DI STATO
Pirro Ligorio, *Antichità romane*, vols 1–30 (Mandowsky & Mitchell 1963, pp.35, 37–9; appendix II, pp.134–9; there is a complete set of photographs in the Warburg Institute, London). Written for Alfonso d'Este II, Duke of Ferrara, after 1569.

TURIN, BIBLIOTECA REALE
Codex serie Militare 383 (Scaglia 1992b, pp.101–4, cat.36; Siena 1993a, p.377, cat.XXI.15). An album of drawings of machines after Francesco di Giorgio, by an anonymous Italian draughtsman.
MS Saluzziano 148: Francesco di Giorgio (MS T; Maltese 1967; Scaglia 1992b, cat.80; Siena 1993a, pp.362–5, cat.XXI.4). Revised version of the treatise.
MS Salluzziano 8-5-1/39: Filippo Juvarra, *Galleria architettonica di Filippo Juvarra ossia Memorie e cenni diversi di archittura militare e civile* (Bianchi 1957)
MS 371: R. Valturius, *De re militari*.

URBINO, SANTINI COLLECTION
Santini Codex (Scaglia 1992b, pp.104–6, cat.37). An album of drawings of machines after Francesco di Giorgio, by an anonymous 16th-century Italian draughtsman.

VENICE, BIBLIOTECA MARCIANA
MS 4817 (Scaglia 1992b, pp.112–14, cat.40). An album of drawings of machines after Francesco di Giorgio, by an anonymous 16th-century Italian draughtsman.
MS It.IV.3-4=5541 (Siena 1993a, pp.373–4, cat.XXI.11). Anonymous 16th-century Italian copyist, after Francesco di Giorgio (MS Ashburnham 361, MS L).
MS 3048 (Scaglia 1992b, pp.115–16, cat.41; Siena 1991, p.222). An album of drawings of machines after Francesco di Giorgio, by an anonymous 16th-century Italian draughtsman.
MS 5363: Benvenuto della Volpaia, drawings of machines (Scaglia 1992b, pp.146–8, cat.58).
MS ital.IV.39 (=5548): Gherardo Spini, *I tre primi libri sopra l'instituzioni dei' Greci et Latini architettori intorno agl'ornamenti che convengono a tutte le fabbriche che l'architettura compone* (Acidini 1980).
MS ital.CL.IV.149(=5105) (Olivato 1978; Bedon 1983b). Sketchbook, here attributed to Orazio Porta (see appendix 4).
MS lat.VIII.2 (=2796): Antonio Averlino il Filarete, *Trattato di architettura* (Finoli & Grassi 1972, pp.CXII–CXIII). Made for Mattia Corvinus.

VICENZA, BIBLIOTECA BERTOLIANA DI VICENZA
MS G.3.5.3 (Siena 1993a, p.373, cat.XXI.10). Architectural sketchbook with drawings after Francesco di Giorgio, by an anonymous late 16th-century Italian draughtsman.

VIENNA, ALBERTINA
Egger nos 1–19 (Günther 1988, pp.339–41, Taf.23–41). Sketchbook, Master C of 1519, now attributed to Riniero Neruccio da Pisa.

VIENNA, ÖSTERREICHISCHEN NATIONALBIBLIOTHEK
Codex 10935 (Günther 1993, p.47). An album of architectural drawings after Baldassare Peruzzi, by an anonymous 16th-century Sienese draughtsman.

WINDSOR, ROYAL LIBRARY
Cassiano dal Pozzo's Paper Museum, *Architettura civile* volume (Haskell & Montague 1996–).

WOLFEGG
Codex Wolfegg: Amico Aspertini, (Schweikhart 1986).

SECONDARY SOURCES

ACIDINI 1980 C. Acidini, *G. Spini, I tre libri sopra l'instituzioni de' Greci et Latini architettori intorno agl'ormenti che convengono a tutte le fabbriche che l'architettura compone. Il disegno interrotto. Trattati medicei d'architettura*, edited by F. Borsi *et al.*, Florence 1980, pp.13–199.

ACIDINI LUCHINAT 1980 C. Acidini Luchinat, 'Niccolo Gaddi collezionista e dilettante del cinquecento', *Paragone*, nos 359–61, 1980, pp.141–75.

ACIDINI LUCHINAT 1987 —, editor, *Fiorenze in villa*, Florence, 1987.

ACIDINI LUCHINAT & GALLETTTI 1992 C. Acidini Luchinat and G. Gallettti, *Le ville e i giardini di Castello e Petraia a Firenze*, Florence, 1992.

ACKERMAN 1954 J. Ackerman, *The Cortile del Belvedere*, Vatican City, 1954.

ACKERMAN 1961 —, *The Architecture of Michelangelo*, 2 vols, London, 1961.

ACKERMAN 1983 —, 'The Tuscan/Rustic Order. A Study in the Metaphorical Language of Architecture', *Journal of the Society of Architectural Historians*, 42/1, 1983, pp.15–34.

ACKERMAN & LOTZ 1964 J. Ackerman and W. Lotz, 'Vignoliana', *Essays in Memory of Karl Lehmann*, edited by L. Freeman Sandler, New York, 1964, pp.1–24.

ADAMS 1984 N. Adams, 'Architecture for Fish. The Sienese Dam on the Bruna River. Structures and Design, 1468–*ca*.1530', *Technology and Culture*, 25, 1984, pp.768–97.

ADIMIRI 1616 R. Adimiri, *Sito Riminesi*, Rimini, 1616.

AGOSTI & FARINELLA 1984 G. Agosti and V. Farinella, 'Calore del marmo. Pratica e tipologia delle deduzione iconografiche', *Memoria dell'antico nell'arte italiana*, vol.I: *L'uso dei classici*, edited by S. Settis, Turin, 1984, pp.390–440.

AGOSTI & FARINELLA 1985 —, 'Il fregio della colonna Traiana avvio ad un registro della fortuna visiva', *Annali della Scuola Normale Superiore di Pisa*, series III, vol.XV/3, 1985, pp.1103–50.

AGOSTI & FARINELLA 1987 —, editors, *Michelangelo. Studi di antichità dal Codice Coner*, Turin, 1987.

AGOSTINELLI & MARIANO 1986 M. Agostinelli and F. Mariano, *Francesco di Giorgio e il Palazzo della Signoria di Jesi*, Jesi, 1986.

AGRICOLA 1556 G. Agricola, *De re metallica. Libri XII*, Basel, 1556.

AGUSTÌN 1592 A. Agustìn, *Dialoghi intorno alle medaglie, inscrittioni et altre antichità, tradotti da Dionigi Ottaviano Strada*, Rome, 1592.

ALBERTI 1968 L.B. Alberti, *Descriptio urbis Romae*, edited by J. Vagnetti and G. Orlandi, Quaderno I, Università di Genova, Genoa, 1968.

ALBERTI 1988 —, *On the Art of Building in Ten Books*, translated by J. Rykwert, N. Leach and R. Tavernor, Cambridge, MA, and London, 1988.

ALDROVANDI 1558 U. Aldrovandi (Aldroandi), *Delle statue antiche che per tutta Roma, on diversi luoghi, et case si veggono*, in L. Mauro, *Le antichità della Città di Roma*, Venice, 1558; 1562 (first edition, 1556).

ALLEGRI & CECCHI 1980 E. Allegri and A. Cecchi, *Palazzo Vecchio e i Medici. Guida storica*, Florence, 1980.

AMELUNG 1903-8 W. Amelung, *Die Skulpturen des Vatikanischen Museums*, vols I and II, Berlin 1903–8; for vol.III, see Lippold 1956.

AMMIANUS 1910-15 M. Ammianus, *Ammiani Marcellini rerum gestarum libri qui supersunt*, edited by C.U. Clark, Berlin, 2 vols, 1910–15.

AMY & GROS 1979 R. Amy and P. Gros, *La Maison Carrée de Nîmes*, Paris, 1979.

ANDROUET DU CERCEAU 1545-50 J. Androuet du Cerceau, *Temples et habitations fortifiées*, 1545–50.

ANNONI 1940 A. Annoni, 'In tema di trasporti di antichi edifici', *Atti del III Convegno nazionale di storia dell'architettura*, Rome, 1940, pp.391–8.

ANTINORI 1989 A. Antinori, 'Il rapporto con lo antico nella Roma di Sisto V. La controversia sulla demolizione della tomba di Cecilia Metella', *Architettura storia e documenti*, 1989, pp.55–63.

D'ARCO 1838-42 C. D'Arco, *Storie della vita e delle opere di Giulio Pippi Romano*, 2 vols, Mantua, 1838–42.

ARIAS 1977 P.E. Arias, editor, *Camposanto monumentale di Pisa. Le antichità*, Pisa, 1977.

ARINGHI 1659 P. Aringhi, *Roma subterranea novissima*, Cologne, 1659; reprinted Portland, OR, 1972.

ARMENINI 1587 G.B. Armenini, *De veri precetti della pittura*, Ravenna, 1587.

ARMSTRONG ANDERSON 1968 L. Armstrong Anderson, 'Copies of Pollaiuolo's *Battling Nudes*', *Art Quarterly*, 31, 1968, pp.155–67.

ARMSTRONG 1981 L. Armstrong, *Renaissance Miniature Painters and Classical Imagery. The Master of the Putti and His Venetian Workshop*, London, 1981.

AREZZO 1974 *Arte nel Aretino. Ricuperi e restauri dal 1968–1974*, catalogue of an exhibition held at S. Francesco, Arezzo, 1974.

AREZZO 1981A *Giorgio Vasari. Principi, letterati e artisti nelle carte di Giorgio Vasari a Casa Vasari*, catalogue of an exhibition held at Sottochiesa di S. Francesco, Arezzo, 1981.

AREZZO 1981B *Sub tutela matris, 1956–1981. Nuovi edifici in culto. Richerca sulla devozione alla Madonna nella diocesi di Arezzo*, catalogue of an exhibition held in Arezzo, 1981.

AREZZO 1985 *Architettura in Terra di Arezzo. I restauri di beni architettonici dal 1975 al 1984*, vol.I: *Arezzo-Valdichiana - Valdarno*, catalogue of an exhibition held at Sottochiesa di S. Francesco, Arezzo, 1985.

AREZZO 1992 *Architettura e arte in Toscana. Emergenze e territorio nell'Aretino*, catalogue of an exhibition held at Sottochiesa di S. Francesco, Arezzo, 1992.

AREZZO CONVEGNO 1981 Arezzo Convegno 1981, *Tra decorazione ambientale e storiografia artistica. Arezzo Convegno, 8–10 ottobre 1981*, Florence, 1985.

ARRIGHI 1966 G. Arrighi, editor, *Leonardo Fibonacci. La pratica di geometria volgarizzata di Gherardo di Dino cittadino pisano. Dal codice 2186 della Biblioteca Riccardiana di Firenze*, Pisa, 1966.

ARRIGHI 1970 —, editor, *Francesco di Giorgio Martini. La pratica di geometria. Dal cod. Ashb. 361 della Biblioteca Medicea Laurenziana di Firenze*, Florence, 1970.

ARSLAN 1956 E. Arslan, 'L'architettura Milanese nella seconda metà del'400', *Storia di Milano*, vol.VII, Milan, 1956, pp.619ff.

ASCHBACH 1858 J.R. von Aschbach, 'Uber Traians steinerne Donaubrücke', *Mitteilungen de Centralcommission zur Erforsch.u.Erhalt der Baudenk*, 1858, pp.198–220.

ASCHOFF 1967 W. Aschoff, 'Tribolo disegnatore', *Paragone*, no.209, 1967, pp.45–7.

ASHBY 1902 T. Ashby, 'Classical Topography of the Roman Campagna, Part I', *Papers of the British School at Rome*, 1, 1902, pp.125–281.

ASHBY 1904-13 — 'Sixteenth-Century Drawings of Roman Buildings Attributed to Andreas Coner', *Papers of the British School at Rome*, 2, 1904, with an appendix in *Papers of the British School at Rome*, 6, 1913, pp.184–210.

ASHBY 1906 —, 'The Classical Topography of the Roman Campagna, Part II', *Papers of the British School at Rome*, 3, 1906, pp.1–212.

ASHBY 1907 —, 'The Classical Topography of the Roman Campagna, Part III', *Papers of the British School at Rome*, 4, 1907, pp.3–158.

ASHBY 1915-16 —'Le diversi edizioni dei "Vestigi dell'antichità di Roma" di Stefano Dupérac', *La Bibliofila*, 16, 1915, pp.401–21; 17, 1915–16, pp.358–9.

ASHBY 1916 —, editor, *Topographical Study in Rome in 1581. Series of Views with a Fragmentary Text by Etienne du Pérac*, London 1916.

ASHBY 1919 —, 'The Bodleian Manuscript of Pirro Ligorio', *Journal of Roman Studies*, 9, 1919, pp.170–202.

ASHBY 1935 —, *The Aqueducts of Ancient Rome*, Oxford, 1935.

ASHBY & LUGLI 1928 T. Ashby and G. Lugli, 'La villa dei Flavii Cristiani "ad duos Lauros", e il suburbio imperiale a oriente di Roma', *Atti della Pontificia Accademia Romana di Archeologia. Memorie*, 2, 1928, pp.157–92.

ASHMOLE 1959 B. Ashmole, 'Cyriac of Ancona', *Proceedings of the British Academy*, 45, 1959, pp.25–41.

ATTILIA 1987 L. Attilia, *Il mausoleo di Augusto. Roma repubblicana dal 270ac al étà augustea*, Rome, 1987.

AURIGEMMA 1961 S. Aurigemma, *Villa Adriana*, Rome, 1961.

BAGLIONE 1642 G. Baglione, *Le vite de' pittore, scultori et architetti dal Pontificato di Gregorio XIII del 1572 fino a tutto quello d'Urbano Ottavo nel 1642*, Rome, 1642; facsimile edited by V. Mariani, Rome, 1935.

BAGLIONE 1649 G. Baglione, *Le vite de' pittore, scultori et architetti dal Pontificato di Gregorio XIII del 1572 fino a tutto quello d'Urbano Ottavo nel 1642*, second edition, Rome, 1649.

BAILEY 1927 C.T. Bailey, *Knives and Forks Selected and Described*, London and Boston, 1927.

BALDINI 1950 U. Baldini, *Catalogo dela mostra Vasariana*, Florence, 1950.

BALDINI 1980 G. Baldini, 'Una casa da Granduca', *Antichità viva*, 19/3, 1980, p.37.

BALDINUCCI 1845-7 F. Baldinucci (1625–96), *Notizie dei professori del disegno da Cimabue in qua…opera distinta in secoli de' decennali di 7 vols. Vols 2–5, con nuove annotazioni e supplimenti per cura di F. Ranalli*, Florence, 1845–7; reprinted Florence, 1974–5.

BALESTRACCI 1984 D. Balestracci, *I Bottini. Acquedotti medievali senesi*, Siena, 1984.

BALSAMO 1989 I. Balsamo, 'La Trinité des Monts à Rome. Les Décors du cloître (1580–1620)', *Histoire de l'art*, 8, 1989, pp.25–8.

BARATTOLO 1974-5 A. Barattolo, 'Sulla decorazione delle celle del tempio di Venere e Roma all'epoca di Adriano', *Bullettino della Commissione archeologica comunale di Roma*, 1974–5, pp.133–48.

BARATTOLO 1978 —, 'Il tempio di Venere e di Roma un tempio greceo nell'Urbe', *Mitteilungen des Deutschen Archäologischen Instituts. Römische Abteilung*, no.85, 1978, pp.397–410.

BARBARO 1568 D. Barbaro, *La pratica della perspettiva*, Venice, 1568.

BARNES 1982 C.F. Barnes, Jr, *Villard de Honnecourt. The Artist and His Drawings. A Critical Bibliography*, Boston, 1982.

BAROCCHI 1956-7 P. Barocchi, 'Il Vasari architetto', *Atti dell'Accademia Pontaniana*, 6, 1956–7, pp.113–36.

BAROCCHI 1963-4 —, 'Complimenti al Vasari, pittore', *Atti e memorie dell'Accademia Toscana di scienze e lettere, La Columbaria*, 38, 1963–4, pp.253–309.

BAROCCHI 1967 —, *Michelangelo e la sua scuola. I disegni di Casa Buonarroti e degli Uffizi*, Florence, 1967.

BAROLSKY 1979 P. Barolsky, *Danielle da Volterra (Ricciarelli). A Catalogue Raisonné*, New York, 1979.

BARONI 1940 C. Baroni, *Documenti per la storia dell'architettura a Milano nel Rinascimento e nel Barocco*, vol.I: *Edifici sacri, Parte i*, Florence, 1940.

BAROZZI 1562 G. Barozzi da Vignola, *Regola delli cinque ordini di architettura di M. Iacomo Barozzio da Vignola*, 1562; reprinted in *Trattati di architettura*, Milan, 1985.

BAROZZI 1646 —, *Regola…con la nuova aggionta di Michael-Angelo Buonarotti. La ii parte dell'architettura dell'Vignola et altri famosi architetti*, Amsterdam, 1646 (contains text in Dutch, French, German and English).

BAROZZI 1583 —, *Due regole della prospettiva prattica di M. Iacomo Barozzi da Vignola con i commentarij del R. P. M. Egnatio Danti del ordine de Predicatori dello studio di Bologna*, Rome, 1583; facsimile edition, Bologna, 1975.

BARTOLI 1914-22 A. Bartoli, *Monumenti antichi di Roma nei' disegni degli Uffizi di Firenze*, 6 vols, Rome, 1914–22.

BARTOLI 1924 —, 'La recinzione meridionale del foro Traiano', *Atti della Pontificia Accademia Romana di archeologia. Memorie*, series III, 1/2, 1924, pp.177–94.

BARTOLI 1564 C. Bartoli, *Del modo di misurare le distantie, le superficie, i corpi, le piante, le provincie, le prospettive & tutte le altre cose terrene…*, Venice, 1564 and 1589.

BARTOLI 1672 P. Santi Bartoli, *Colonna Traiana eretta dal Senato e popolo Romano all'Imperatore Traiano Augusto*, Rome, 1672.

BARTOLI 1704 —, *Gli antichi sepolcri overo mausolei Romani et Etruschi*, Rome, 1704.

BARTOLI 1708 —, *Colonna Traiana eretta dal Senato e popolo Romano all'Imperatore Traiano Augusto*, Rome, 1708.

BARTOLI 1768 —, *Gli antichi sepolcri overo mausolei Romani et Etruschi*, Rome, 1768.

BARTSCH 1803-21 A. Bartsch, *Le Peintre-graveur*, 21 vols, Vienna, 1803-21.

BARTSCH 1870 —, *Le Peintre-graveur par Adam Bartsch. Nouvelle édition*, vol.XVII, Leipzig, 1870.

BARTSCH 1971- A. Bartsch, *The Illustrated Bartsch*, 1971– (in progress), vol.1=Bartsch XII, University Park, PA, 1971 (with numbering corresponding to the original edition; with different numbering from 1978, general editor W. Strauss, New York).

BARTSCH 1980, VOL.16 (formerly vol.VIII/3), *Early German Masters. Jacob Bink, Georg Pencz, Heinrich Aldegrever*, edited by R.A. Koch, New York, 1980.

BARTSCH 1980-84, VOL.25 (formerly vol.XIII), *Early Italian Masters*, edited by M.J. Zucker, 2 vols, New York, 1980-84.

BARTSCH 1978-84, VOL.26 (formerly vol.XIV), *The Works of Marcantonio Raimondi and His School*, edited by K. Oberhuber, 2 vols, New York, 1978-84.

BARTSCH 1978, VOL.27 (formerly vol.XIV/2), *The Works of Marcantonio Raimondi and of His School*, edited by K. Oberhuber, New York, 1978.

BARTSCH 1982-5, VOL.46 (formerly vol.XXI/1), *The Italian Masters of the Seventeenth Century*, edited by P. Bellini, 2 vols, 1982-5.

BARTSCH 1983, VOL.36 (formerly vol.XVII/3) *Italian Masters of the Sixteenth Century. Antonio Tempesta*, edited by S. Buffa, New York, 1983.

BARTSCH 1985, VOL.30 (formerly vol.XV/3), *Italian Masters of the Sixteenth Century. Enea Vico*, edited by J. Spike, New York, 1985.

BARTSCH 1983, VOL.48 (formerly volume XII), *Italian Chiaroscuro Woodcuts*, edited by C. Karpinski, New York, 1983.

BARZMAN 1985 K-edis Barzman, *The Università ed Accademia del Disegno*, PhD dissertation, John Hopkins University; University Microfilms, Ann Arbor, MI, 1985.

BARZMAN 1991 —, 'Perception, Knowledge and the Theory of Disegno in Sixteenth-Century Florence', *From Studio to Studiolo. Florentine Draftsmanship under the First Medici Grand Dukes*, catalogue of an exhibition held at the Allen Memorial Art Museum, Oberlin College, Oberlin, OH, 1991, pp.37–48.

BASSIGNANA, NO DATE P.L. Bassignana, editor, *Le macchine di Valturio nei documenti dell'archivio storico amma*, Turin, n.d.

BATTISTI 1976 E. Battisti, *Filippo Brunelleschi*, Milan, 1976.

BATTISTI & SACCARO BATTISTI 1984 E. Battisti and G. Saccaro Battisti, *Le machine cifrate di Giovanni Fontana con la riproduzione del Cod. Icon.242 della Bayerische Staatsbibliothek di Monaco di Baviera e la descrittione di esso e del Cod. Lat. Nouv. Acq.635 della Bibliothèque Nationale di Parigi*, Milan, 1984.

BEAN 1960 J. Bean, *Les Dessins italiens de la collection Bonnat*, catalogue of an exhibition held at the Musée Bonnat, Bayonne, 1960.

BEAN 1982 J. Bean, assisted by L. Turcic, *15th- and 16th-Century Italian Drawings in the Metropolitan Museum of Art*, New York, 1982.

BECK 1899 T. Beck, *Beiträge zur Geschichte des Machinenbattes*, Berlin, 1899; 2nd edition, 1900.

BEDON 1982 A. Bedon, 'Disegni di G.B. Montano nelle collezioni europee', *Richerche di storia dell'arte*, 18, 1982, pp.77–85.

BEDON 1983A —, 'Architettura e archeologia nella Roma del Cinquecento. Giovanni Battista Montano', *Arte lombarda*, no.65, 1983, pp.111–26.

BEDON 1983B —, 'Il "Vitruvio" di Giovanni Antonio Rusconi', *Ricerche di storia dell'arte*, 19, 1983, pp.85–90.

BELLI 1570 S. Belli, *Libro di misurare con la vista*, Venice, 1570.

BELLODI 1905 R. Bellodi, *Il monastero di San Benedetto in Polirone nella storia e nell'arte*, S. Benedetto Po, 1905; reprinted 1974.

BELLONI 1935 C. Belloni, *Un banchiere del Rinascimento. Bindo Altoviti*, Rome, 1935.

BELTRAMI 1900 L. Beltrami, *La Ca'del Duca sul Canal Grande e altre reminiscenze sforzesche in Venezia*, Milan, 1900.

BENEDETTO 1970 S. Benedetto, 'Guarini ed il barocco romano', *Guarino Guarini e l'internazionalità del barocco. Atti del convegno internazionale promosso dall'Accademia della Scienza di Torino, 30 settembre–5 ottobre 1968*, vol.I, Turin, 1970, pp.705–50.

BENNDORF & SCHONE 1867 O. Benndorf and R. Schone, *Die antike Bildwerke des Lateranensischen Museums*, Leipzig, 1867.

BERCKENHAGEN 1970 E. Berckenhagen, *Die französischen Zeichnungen der Kunstnungen der Kunstbibliothek Berlin*, Berlin, 1970.

BERLIN 1939 Staatliche Museen zu Berlin, *Katalog der Ornamentstich-Sammlung der Staatlichen Kunstbibliothek Berlin*, Berlin, 1939.

BERLIN 1988 *Kaiser Augustus und die verlorene Republik*, catalogue of an exhibition held at the Staatliche Museen Preussischer Kulturbesitz, Berlin, 1988

BERNSTEIN 1992 J.G. Bernstein, 'Milanese and Antique Aspects of the Colleoni Chapel. Site and Symbolism', *Arte lombarda*, no.100, 1992, pp.45–52.

BERTI 1967 L. Berti, *Il principe dello studiolo. Francesco i dei Medici e la fine del Rinascimento fiorentino*, Florence, 1967.

BERTI 1980 F. Berti, 'Studi su alcuni aspetti del diario inedito di Girolamo Seriacopi e sui disegni buontalentiani per i costumi del 1589', *Quaderni di teatro*, 7, 1980, pp.157–68.

BERTINI 1958 A. Bertini, editor, *I disegni italiani della Biblioteca Reale di Torino*, Rome, 1958.

BERTOLOTTI 1881 A. Bertolotti, *Artisti lombardi a Roma nei secoli XV, XVI e XVII*, Milan, 1881.

BESSON 1582 J. Besson, *Theatrum instrumentorum*, Lyon, 1582.

BETTS 1971 R.J. Betts, *The Architectural Theories of Francesco di Giorgio*, PhD dissertation, Princeton University, 1971; University Microfilms, Ann Arbor, MI, 1981.

BETTS 1977 —, 'On the Chronology of Francesco di Giorgio's Treatises. New Evidence from an Unpublished Manuscript', *Journal of the Society of Architectural Historians*, 36, 1977, pp.3–14.

BERTOLDI 1960-61 M.E. Bertoldi, 'Ricerche sulla decorazione architettonica del Foro Traiano', *Studi miscellanei*, 3, 1960–61, pp.10ff.

BIANCHI 1957 T. Bianchi, 'Un manoscritto poco noto dello Juvarra', *Atti del X Congresso di storia dell'architettura, Turin, 1957*, pp.397–418.

BIONDO 1542 F. Biondo, *Roma ristaurata ed Italia illustrata*, Venice, 1542.

BIONDO 1559 —, *Roma ristaurata ed Italia illustrata*, Basel, 1559.

BIRINGUCCI 1582 O. Biringucci, *Parafrasi di Monsignor Alessandro Piccolomini sopra le Meccaniche di Aristotile, tradotti da Oreste Vannocci Biringucci*, Rome, 1582.

BIRINGUCCI 1942 V. Biringucci, *The Pirotechnia of Vannoccio Biringuccio* (first edition, 1540), translated by C.S. Smith and M.Teach Guidi, Boston, 1942.

BIRKE & KERTÉSZ 1992-5 V. Birke and J. Kertész, *Die italienischen Zeichnungen der Albertina. Generalverzeichnis*, 3 vols, Vienna, 1992–5.

BLAIR 1983 C. Blair, 'A Morion by Caremolo Modrone of Mantua', *Arms and Armour at the Dorchester*, London, 1983.

BLOMFIELD 1912 R. Blomfield, *Architectural Drawing and Draughtsmen*, London, 1912.

BLUMENTHAL 1973 A. Blumenthal, *Italian Renaissance Festival Designs*, catalogue of an exhibition held at Elvehjem Art Center, Madison, WI, 1973.

BLUMENTHAL 1980 —, *Theater Art of the Medici*, catalogue of an exhibition held at Dartmouth College Museum and Galleries, Hanover, NH, 1980.

BLUNT 1957 A. Blunt, *Venetian Drawings of the XVII and XVIII Centuries in the Collection of Her Majesty the Queen*, London, 1957.

BLUNT 1958 —, *Philibert de l'Orme*, London, 1958.

BLUNT 1963 —, 'Introduction', *Latin American Art and the Baroque Period in Europe. Studies in Western Art. Acts of the 20th International Congress of the History of Art. Baroque and Antiquity*, vol.III, Princeton, 1963.

BLUNT 1971 —, 'Supplements to the Catalogue of the Italian and French Drawings with a History of the Royal Collection', *The German Drawings in the Collection of Her Majesty the Queen at Windsor Castle*, edited by E. Schilling, London, 1971.

BLUNT 1974 —, *The Drawings of Nicholas Poussin*, vol.V, London, 1974.

BLUNT 1979 —, *Borromini*, London, 1979.

BOBER 1957 P.P. Bober, *Drawings after the Antique by Amico Aspertini. Sketchbooks in the British Museum*, London, 1957.

BOBER & RUBINSTEIN 1986 P.P. Bober and R. Rubinstein, *Renaissance Artists and Antique Sculpture*, Oxford, 1986.

BOCK 1929 E. Bock, *Die Zeichnungen in der Universitätsbibliothek*, Frankfurt am Main, 1929.

BODART 1975 D. Bodart, *Dessins de la collections T. Ashby à la Bibliothèque Vaticane*, Vatican City, 1975.

BODE 1910 W. von Bode, *Collection of J. Pierpont Morgan. Bronzes of the Renaissance and Subsequent Periods*, 2 vols, Paris, 1910.

BODON 1996 G. Bodon, 'I monumenti antichi di Roma negli studi numismatiche tra XV e XVI secolo', *Xenia antiqua*, 5, 1996, pp.107–42.

BOISSARD 1597 J.J. Boissard, *Romanae urbis topographiae & antiquitatem qua succinta & breviter describuntur omnia quae tam publice quam privatim videntur animadversione digna*, part I, Frankfurt am Main, 1597.

BOISSARD 1597-1602 —, *Antiquitatum urbanarum Romanarum*, vols III–VI, Frankfurt am Main, 1597–1602.

BOLTON 1924 A. Bolton, *The Works of Sir John Soane, FRA FSA (1753-1837)*, London, 1924.

BONCOMPAGNI 1862 B. Boncompagni, *Scritti di Leonardo Pisano matematico del secolo terzo publicati da Baldassare Boncompagni*, vol.II: *Pratica geometriae. Opusculi*, Rome, 1862.

BONICATTI 1964 M. Bonicatti, *Aspetti dell'umanesimo nella pittura Veneta del 1455-1515*, Rome, 1964.

BOOKER 1963 P.J. Booker, *A History of Engineering Drawings*, London, 1963.

BORA 1976 G. Bora, 'Note cremonesi, II. L'eredità di Camillo e i Campi', *Paragone*, no.311, 1976, p.66, n.9.

BORGHINI 1584 R. Borghini, *Il riposo*, Florence, 1584.

BORGHINI 1967 —, *Il riposo. Saggio biobibliografico e indice analitico*, edited by M. Rosci, 2 vols, Milan, 1967.

BORGHINI 1981 G. Borghini, 'Baldassare Peruzzi. Cesare da Sesto e altre presenze nell'Episcopio di Raffaele Riario ad Ostia', *Quaderni di Palazzo Venezia*, 1, 1981, pp.11–50.

BORRI CRISTELLI 1982 L. Borri Cristelli, 'Alcuni disegni di architettura di Teofilo Torri nel taccuino Soane', *Storia architettura*, 5, 1982, pp.77–84.

BORRI CRISTELLI 1984 —, 'Profilo di Teofilo Torri', *Quaderno dell'Istituto di Storia dell'Arte, Università degli Studi di Siena*, 1984.

BORRI CRISTELLI 1985 —, 'Un architettura da restituire al Vasari. Il tempio di S. Stefano della Vittoria', *Storia architettura*, 8, 1985, pp.37–45.

BORRI CRISTELLI 1986 —, *I disegni della Collezione Torri nella Biblioteca di Arezzo*, Arezzo, 1986.

BORRI CRISTELLI 1995 —, 'Gli affreschi di Santa Maria in Gradi ad Arezzo', *Professione restauratore. Corso di aggiornamento su diagnostica artistica, conservazione preventive e nuove tecnologie applicate al restauro. Arezzo, 1990*, Arezzo, 1995, pp.93–100.

BORSARI 1895 L. Borsari, *Notizie delle scavi*, Rome, 1895.

BORSI 1970 F. Borsi, editor, *Le antichità di Roma*, Rome, 1970.

BORSI 1975 —, *Leon Battista Alberti*, Milan, 1975.

BORSI 1976 —, *Giovanni Antonio Dosio. Roma antica e i disegni di architettura agli Uffizi*, edited by F. Borsi, C. Acidini and G. Morolli, Florence, 1976.

BORSI 1980A —, *L'architettura del principe*, catalogue of an exhibition held at the Ospedale degli Innocenti, Florence, 1980.

BORSI 1980B —, 'Giorgio Vasari il Giovane. Porte e finestre di Firenze e di Roma. Gabinetto Disegni e Stampe degli Uffizi 4715A–4944 A', *Il disegno interrotto. Trattati medicei d'architettura. Documenti inediti di cultura toscana*, vol.IV, 2 vols, Florence, 1980.

BORSI 1989 —, *Bramante*, Milan, 1989.

BORSI & PAMPALONI 1975 F. Borsi and G. Pampaloni, *Monumenti d'Italia. Le piazze*, Novara, 1975.

BOSIO 1632 A. Bosio, *Roma sotterranea. Opera postuma di Antonio Bosio Romano*, Rome, 1632.

BOTTO 1968 I.M. Botto, *Mostra dei disegni di Bernardo Buontalenti*, catalogue of an exhibition held at the Gabinetto Disegni e Stampe degli Uffizi, Florence, 1968.

BOUCHER 1976 B. Boucher, 'Giuseppe Salviati, pittore e matematico', *Arte veneta*, 30, 1976, pp.219–24.

BOUCHER 1981 —, 'Bernini e l'architettura del Cinquecento. La lezione di Baldassare Peruzzi e di Sebastiano Serlio', *Bollettino del Centro Internazionale di Studi di Architettura, Andrea Palladio*, 1981, pp.27–43.

BOUILLON 1821 P. Bouillon, *Musée des antiques. Dessiné et gravé par P. Bouillon avec des notices explicative par J.B. de Sainte Victoire*, 3 vols, Paris, 1821.

BRAHAM & HAGER 1977 A. Braham & H. Hager, *Carlo Fontana. The Drawings at Windsor Castle*, London, 1977.

BRANCA 1629 G. Branca, *Le machine…*, Rome, 1629; edited by L. Firpo, Milan, 1977.

BRANDI 1972 C. Brandi, *La prima architettura barocca*, Bari, 1972.

BREINER 1994 D.M. Breiner, *Vincenzo Scamozzi, 1548–1616. A Catalogue Raisonné*, 2 vols, PhD dissertation, Cornell University, 1994.

BRENZONI 1960 R. Brenzoni, *Fra Giovanni Giocondo Veronese. Verona 1435–Roma 1515*, Florence, 1960.

BRETT 1957 G. Brett, 'A Seventeenth-Century Sketchbook', *Royal Ontario Museum Bulletin of the Division of Art and Archaeology*, 26, 1957, pp.4–10.

BRILLIANT 1963 R. Brilliant, 'Gesture and Hand in Roman Art. The Use of Gesture to Denote Status in Roman Sculpture and Coinage', *Memoirs of the Connecticut Academy of Art and Sciences*, 14, February 1963 (for the reliefs of Trajan's column, see pp.118–27).

BRIQUET 1968 C.M. Briquet, *Les Filigranes. Dictionnaire historique des marques du papier dès leur apparition vers 1282 jusqu'en 1600*, facsimile of the edition of 1907 with supplementary material edited by A. Stevenson, Paper Publications Society, Amsterdam, 1968.

BRITISH ARCHITECTURAL LIBRARY 1994- British Architectural Library, London, *Royal Institute of British Architects. Early Printed Books, 1478–1840. Catalogue of the British Architectural Library Early Imprints Collection*, edited by N. Savage et al., London, 1994-.

BRIZI 1846 O. Brizi, *Ricordi pittorici di Teofilo Torri Aretino, 1602–1609*, Arezzo, 1846.

BRUNETTI 1990 G. Brunetti, editor, *Disegni dei secoli 15 e 16 della Biblioteca Marucelliana di Firenze*, catalogue revised by R. Todros, Rome, 1990.

BRUSCHI 1967 A. Bruschi, 'Orientamento di gusto e indicazione di teoria in alcuni disegni architettonici del Quattrocento', *Quaderni dell'Istituto di Storia dell'Architettura*, series XIV, fasc.79–84, 1967, pp.41–52.

BRUSCHI 1969 —, *Bramante architetto*, Bari, 1969.

BRUSCHI 1977 —, *Bramante*, London, 1977.

BRUSCHI 1992 —, *Libro d'Antonio Labacco appartenente a l'architettura Roma 1569 a cura e con introduzione di Arnado Bruschi, bibliografia essenziale e raffronto tra i rami delle prime stampe di Flavia Colonna*, Milan, 1992.

BUCHER 1979 F. Bucher, *Architektor. The Lodge Books and Sketchbooks of Medieval Architects*, vol.I, New York, 1979.

BUCHTAL 1971 H. Buchtal, *'Historia Troiana'. Studies in the History of Medieval Secular Illustration*, London, 1971.

BUDDENSEIG 1962 T. Buddenseig, 'Die Konstantinsbasilika in einer Zeichnung Francescos di Giorgio und der Marmorkoloss Konstantins des Grossen', *Münchner Jahrbuch der Bildenden Kunst*, 1962, pp.37–48.

BUDDENSEIG 1975 —, 'Bernardo della Volpaia, der Autor des Codex Coner, und seine Stellung im Sangallo-Kreis', *Römisches Jahrbuch für Kunstgeschichte*, 15, 1975, pp.89–108.

BUDDENSEIG 1963 —, 'Die Ziege Amalthea von Riccio und Falconetto', *Jahrbuch der Berliner Museen*, 1963, pp.121–50.

BUDDENSEIG 1986 —, 'Donatellos Knabe mit den Schlangen',

Forma et subtilitas. Festschrift für Wolfgang Schöne zum 75. Geburstag, edited by W. Schlink and M. Sperlich, Berlin and New York, 1986, pp.43–9.

BUKOVINSKÁ, FUCIKOVÁ & KONECNY 1984 B. Bukovinská, E. Fuciková and L. Konecny, 'Zeichnungen von Giulio Romano und seiner Werkstatt in einem vergessenen Sammelband in Prag', *Jahrbuch der Kunsthistorischen Sammlungen in Wien*, 1984, pp.61–186.

BULGARELLI & CERIANA 1996 M. Bulgarelli and M. Ceriana, *All'ombra delle volte. Architettura del quattrocento a Firenze e Venezia*, Milan, 1996.

BUONCOMPAGNI 1862 B. Buoncompagni, *Scritti di Leonardo Pisano matematico del secolo decimo terzo publicati da Baldasarre Boncompagni, vol.II: Pratica geometriae. Oposculi*, Rome, 1862.

BURNETT & SCHOFIELD 1998 A. Burnett and R.V. Schofield, 'Decorating the Colleoni Chapel' (1998; forthcoming).

BURNS 1965-6 H. Burns, 'A Peruzzi Drawing in Ferrara', *Mitteilungen des Kunsthistorischen Institutes in Florenz*, 12, 1965-6, pp.245–70.

BURNS 1974 —, 'Progetti di Francesco di Giorgio per gli conventi di San Bernardino e Santa Chiara di Urbino', *Studi bramanteschi*, Rome, 1974, pp.293–311.

BURNS 1979 —, 'San Lorenzo in Florence before the Building of the New Sacristy. An Early Plan', *Mitteilungen des Kunsthistorischen Institutes in Florenz*, 23, 1979, pp.145–54.

BURNS 1988A —, 'Baldassare Peruzzi and Sixteenth Century Architectural Theory', *Les Traités d'architecture de la Renaissance. Actes du colloque, Tours, 1–11 juillet 1981*, edited by J. Guillaume, Paris, 1988, pp.207–26.

BURNS 1988B —, 'Pirro Ligorio's Reconstruction of Ancient Rome. The ANTEIQVAE VRBIS IMAGO of 1561', *Pirro Ligorio Artist and Antiquarian. Colloquium, Villa i Tatti, Harvard University Center of Italian Renaissance Studies, 10*, edited by R. Gaston, Florence, 1988.

BURY 1976 J.B. Bury, 'The Stylistic Term "Plateresque"', *Journal of the Warburg and Courtauld Institutes*, 39, 1976, pp.199–230.

BURY 1982 J. Bury, 'The Early History of the Explosive Mine', *Fort*, 10, 1982, pp.31–8.

BUZUZU & ROSELLI 1989 A. Buzuzu and R. Roselli, 'La Capella Salviati', *La Chiesa e il Convento di San Marco a Firenze*, vol.I, Florence, 1989.

BYAM SHAW 1976 J. Byam Shaw, *Drawings by Old Masters at Christ Church Oxford*, 2 vols, Oxford, 1976.

BYAM SHAW 1983 —, *The Italian Drawings of the Frits Lugt Collection*, 3 vols, Institut Néerlandais, Paris, 1983.

BYRNE 1977 J.S. Byrne, 'Du Cerceau Drawings', *Master Drawings*, 25, 1977, pp.147–61.

CADOGAN 1983 J.K. Cadogan, 'Reconsidering Some Aspects of Ghirlandaio's Drawings', *Art Bulletin*, 65, 1983, pp.274–90.

CAESARIS 1908 C. Iuli Caesaris, *Belli gallici libri VII…Adiecit galliam antiquam tabula descriptam Bernardus Dinter*, Leipzig, 1908.

CAIN 1985 H.U. Cain, *Römische Marmorkandelaber. Beiträge zur Erschiefsung hellenisticher und Kaiserzeitlicher Skulptur und architektur*, Mainz, 1985.

CAIROLI GIULIANI 1983-7 F. Cairoli Giuliani, '"Mercati" e foro Traiano un fatto di attribuzione', *Quaderni dell'Istituto di Storia dell'Architettura*, 1/10, 1983-7, pp.25–8.

CALZA 1977 R. Calza, editor, *Antichità di Villa Doria Pamphili*, Rome, 1977.

CAMINS 1988 L. Camins, *Renaissance and Baroque Bronzes from the Abbott Guggenheim Collection*, catalogue of an exhibition held at the Fine Art Museum of San Francisco, 1988.

CAMPBELL 1717-25 C. Campbell, *Vitruvius Britannicus or the British Architect*, 3 vols, London, 1717–25.

CAMPBELL 1984 I. Campbell, *Reconstructions of Roman Temples Made in Italy Between 1450 and 1600*, DPhil dissertation, Worcester College, Oxford, 1984.

CANEDY 1976 N.W. Canedy, *The Roman Sketchbook of Girolamo da Carpi*, London, 1976.

CANINA 1832-44 L. Canina, *L'architettura antica descritta e*

dimostrata coi monumenti. Sezione III: Architettura romana, 2 vols, Rome, 1832–44.

CANINA 1848-56 —, *Gli edifizi di Roma anticha*, 6 vols, 1848–56.

CANINA 1853 —, *La prima parte della via Appia dalla porta Capena a Boville*, 2 vols, Rome, 1853.

CAPOVILLA 1908-9 G. Capovilla, 'Giorgio Vasari e gli edifici dell'Ordine Militare di Santo Stefano', *Studi storici*, 17, 1908, pp.305–79; 18, 1909, pp.581–602.

CAPRINO ET AL. 1955 C. Caprino et al., *La colonna di Marco Aurelio*, Rome, 1955.

CARBONERI 1966 N. Carboneri, *Ascanio Vitozzi*, Rome, 1966.

CARBONNEAUX 1963 J. Carbonneaux, *La Sculpture grècque et romaine au Musée du Louvre*, Paris, 1963.

CARETTONI 1940 G.F. Carettoni, *Casinum*, Rome, 1940.

CARROLL 1976 E.A. Carroll, *The Drawings of Rosso Fiorentino*, 2 vols, New York and London, 1976.

CARTER 1774-8 J. Carter, *The Builder's Magazine*, London, 1774–8.

CASAMASSINA & RUBINSTEIN 1993 E. Casamassina and R. Rubinstein, *Antiquarian Drawings from Dosio's Roman Workshop. Biblioteca Nazionale Centrale di Firenze N.A.1159*, Florence, 1993.

CASSATELLA & PANELLA 1990 A. Cassatella and S. Panella, 'Restituzione dell'impianto adrianeo del tempio di Venere e Roma', *Archeologia laziale*, 10/19, 1990, pp.52–4.

CASSIRER 1920 K. Cassirer, 'Zeichnungen Polidoro da Caravaggio in den Berliner Museen', *Jahrbuch der Preussischen Kunstsammlungen*, 1920, pp.344–58.

CASTAGNOLI 1972 F. Castagnoli, editor, *La via Appia*, Rome, 1972.

CATANI 1591 B. Catani, *Pompa funerale*, Rome, 1591.

CECCHI 1976 A. Cecchi, 'Qualche contributo al corpus grafico del Vasari e del suo ambiente', *Il Vasari storiografo e artista. Atti del Congresso internazionale nel iv centenario della Morte, Arezzo–Firenze, 1974*, Florence, 1976.

CECCHI 1977 —, 'Pratica, fierezza e terribilità nelle grottesche di Marco da Faenza in Palazzo Vecchio a Firenze', *Paragone*, no.327, 1977, pp.24–54; no.329, 1977, pp.6–26.

CECCHI 1978 —, 'Nuove acquisizioni per un catalogo dei disegni di Giorgio Vasari', *Antichità viva*, 17, no.1, 1978, pp.52–61.

CECCHI 1985 —, 'Vasari e Rossellino. Un progetto per la sistemazione della tomba della Beata Villana in Santa Maria Novella', *Antichità viva*, 24/1-3, 1985, pp.124–30.

CECCHI 1989 —, 'Alcune aggiunte e precisioni per il Salviati disegnatore', *Antichità viva*, 28/2-3, 1989, pp.38–45.

CECCHI 1990A —, '…Dall ballatoio di Santa Maria del Fiore alle ultime opere', *Antichità viva*, 29/2-3, 1990, pp.40–57.

CECCHI 1990B —, 'Percorso di Baccio d'Agnolo legnaiuolo e architetto fiorentino dagli esordi al Palazzo Borgherini', *Antichità viva*, 29/1, 1990, pp.31–46.

CECCHI 1992 —, 'Disegni inediti o poco noti di Giorgio Vasari', *Kunst des Cinquencento in der Toskana*, edited by M. Cammerer, Munich, 1992, pp.242–8.

CECCHI 1993 —, 'L'estremo omaggio al "Padre e Maestro di Tutte le Arti". Il monumento funebre di Michelangelo', *Il Pantheon di Santa Croce a Firenze*, Florence, 1993, pp.57–82.

CECCHI 1994 —, 'In margine a una recente monografia sul Salviati', *Antichità viva*, 33/1, 1994, pp.12–22.

CELLINI 1857 B. Cellini, *I trattati dell'oreficeria e della scultura. I discorsi e i ricordi intorno all'arte. Le lettere e le suppliche. Le poesie*, edited by G. Milanesi, Florence, 1857.

CENSUS OF ANTIQUE ART Census of Antique Art and Architecture Known in the Renaissance, headquarters at Humbolt Universität, Berlin; Photographic Collections, Warburg Institute, London, and Biblioteca Hertziana, Rome.

CENTRODI 1979-80 G. Centrodi, *La cultura figurativa a Monte San Savino. Orazio Porta pittore e architetto*, tesi di laurea, Facoltà di Magistero, Università degli Studi di Siena, Anno Accademico 1979–80.

CENTRODI 1984 —, 'Orazio Porta', *Quaderni dell'Istituto di Storia dell'Arte, Università degli Studi di Siena*, 1984, pp.78ff.

CENTRODI 1985 —, 'Orazio Porta e le tavole dell'altare del tempio di S. Vittoria', *Notiziario turistico* (Ente Provinciale del Turismo, Arezzo), no.103, 1985, pp.5–7.

CENTRODI 1988 —, *Pittura a Monte San Savino*, Florence, 1988.

CENTRODI 1989 —, 'Chiese e oratori nell'area urbana e nel territorio', *Architettura a Monte San Savino*, Florence, 1989, pp.91–100.

CENTRODI 1990 —, 'Ulisse Giocchi a Santa Maria in Gradi di Arezzo', *Atti e memorie della Accademia Petrarca di Lettere, Arti e Scienze*, 52 (1990), 1992, pp.393–407.

CHACON 1576 A. Chacon, *Historia utriusque belli dacici a Traiano Caesare gesti, ex simulalachris quae in Columna eiusdem Romae visuntur collecta*, Rome, 1576.

CHANTILLY 1983 *Hommage à Raphael*, catalogue of an exhibition held at the Musée Condé, Chantilly, 1983.

CHAPPELL 1992 M.L. Chappell, *Disegni di Lodovico Cigoli (1559–1613)*, Gabinetto Disegni e Stampe degli Uffizi, Florence, 1992.

CHARBONNEAUX 1963 J. Charbonneaux, *La Sculpture grecque et romaine au Musée du Louvre*, Paris, 1963.

CHENEY 1963 I.H. Cheney, *Francesco Salviati (1510–1563)*, PhD dissertation, New York University, 1963; Ann Arbor, MI.

CHEVALIER 1977-8 R. Chevalier, 'Dessins du XVI siècle de la colonne de Trajane dans une collection parisienne', *Rendiconti della Pontificia Accademia Romana di Archeologia*, 50, 1977–8, pp.27ff.

CHIARINI 1972 M. Chiarini, *I disegni italiani di paesaggio dal 1600 al 1750*, Il disegno italiano, Rome, 1972.

CHICAGO 1973 University of Chicago, *A Descriptive Catalogue of the Engravings from the University of Chicago Library's Speculum Romanae Magnificentiae Compiled by the Staff of the Special Collections*, 7 vols, Chicago, 1973 (See SPECULUM, below).

CHIOSSI 1989 C.M. Chiossi, 'Una pianta dell'Hadrianeum nel 1590 di mano di Francesco Capriani da Volterra', *Architettura storia e documenti*, 1/2, 1989, pp.103–8.

CHIUMENTI & BILANCIA 1977A L. Chiumenti and F. Bilancia, *La Campagna romana, antica, medioevale e moderna*, vol.V: *Via Laurentina-Ostiense*, Rome, 1977.

CHIUMENTI & BILANCIA 1977B —, *La Campagna romana, antica, medioevale e moderna*, vol.VI: *Vie Nomentana e Salaria, Portuense e Tiburtina*, Rome, 1977.

CIAMPINI 1600 G. Ciampini, *Vetera monumenta*, Rome, 1690.

CIANCIO ROSSETTO 1982-3 P. Ciancio Rossetto, 'Le maschere del teatro di Marcello', *Bollettino della Commissione archeologica comunale di Roma*, 88, 1982–3, pp.16ff.

CIANCIO ROSETTO & PISANI SARTORIO 1994 P. Ciancio Rosetto and G. Pisani Sartorio, *Teatri greci e romani. Alle origine del linguaggio rappresentato*, 3 vols, Turin, 1994.

CICHORIUS 1896-1900 C. Cichorius, *Die Reliefs der Trajansaule*, 2 vols, Berlin, 1896–1900.

CICOGNARA 1821 L. Cicognara, *Catalogo ragionato dei libri d'arte e d'antichità posseduti dal Conte Cicognara*, Pisa, 1821 (see Fehl, Fehl & Wilson 1989).

CICOGNARA 1824 —, *Storia della scultura del suo risorgimento in Italia fino al secolo di Canova per servire di continuazione all'opere di Winckelmann e di Agincourt*, vol.VI, Prato, 1824.

CINI 1882 G.B. Cini, 'Descrizione dell'apparato fatto in Firenze per le nozze dell'Illustrissimo ed Eccellentissimo Don Francesco de' Medici Principe di Firenze e della Serenissima Regina Giovanna d'Austria', in Vasari 1878–85, vol.VIII, pp.521–622.

CIPOLLA 1965 C.M. Cipolla, *Guns, Sails and Empires. Technological Innovations in the Early Phases of European Expansion, 1400 -1700*, New York, 1965.

CIPOLLONE 1978-80 M. Cipollone, 'Le provincie dell'Hadrianeum. Un tema dell'ideologia imperiale romano', *Annali della Facoltà di Lettere e Filosofia, Università degli Studi di Perugia*, 16–17, 1978–80, pp.41–7.

CLARK 1988 K. Clark, *Leonardo da Vinci*, London, 1988.

CLIFFORD 1984 T. Clifford, 'Stradanus and the "Sala di Penelope"', *Burlington Magazine*, 126, 1984, p.569.

COARELLI 1981 F. Coarelli, *Dintorni di Roma*, Rome, 1981.

COARELLI 1982 —, *Lazio*, Rome, 1982.

COARELLI 1987 —, *I santuari del Lazio in età repubblicana*, Rome, 1987.

COARELLI 1988 —, *Il foro Boario delle origine alla fine della Repubblica*, Rome, 1988.

COFFIN 1960 D.R. Coffin, *The Villa d'Este at Tivoli*, Princeton, 1960.

COFFIN 1964 —, 'Pirro Ligorio on the Nobility of the Arts', *Journal of the Warburg and Courtauld Institutes*, 27, 1964, pp.191–210.

COLINI & BUZZETTI 1986 A.M. Colini and G. Buzzetti, 'Aedes Portuni in Portu Tiberino', *Bullettino della Commissione archeologica comunale di Roma*, 91/1, 1986, pp.7–30.

COLNAGHI 1926 D.E. Colnaghi, *A Dictionary of Florentine Painters from the 13th to the 17th Centuries*, London, 1928; reprinted 1986.

COLLOBI 1938 L. Collobi, 'Taddeo and Federico Zuccari nel Palazzo Farnese a Caprarola', *Critica d'arte*, 3, 1938, pp.70ff.

COLLOBI RAGGHIANTI 1971 L. Collobi Ragghianti, 'Il libro de' disegni del Vasari', *Critica d'arte*, 18/116, 1971, pp.13–65.

COLLOBI RAGGHIANTI 1973 —, 'Il "libro de'disegni" del Vasari. Disegni di architettura', *Critica d'arte*, 20/127, 1973, pp.3–117.

COLLOBI RAGGHIANTI 1974 —, *Il 'Libro de' disegni' del Vasari*, 2 vols, Florence, 1974.

COLONNA 1964 F. Colonna, *Hypnerotomachia Poliphili. Edizione antica e commento a cura di G. Pozzi and A.L. Ciapponi*, Padua, 1964.

COLVIN 1898 S. Colvin, *A Florentine Picture Chronicle*, London, 1898.

CONCINA 1990 E. Concina, *Navis. L'umanesimo sul mare (1470–1740)*, Turin, 1990.

CONFORTI 1993 C. Conforti, *Giorgio Vasari architetto*, Milan, 1993.

CONNORS 1980 J. Connors, *Borromini and the Roman Oratory. Style and Society*, Cambridge, MA, 1980.

CONNORS 1990 —, '*Ars tornandi*. Baroque Architecture and the Lathe', *Journal of the Warburg and Courtauld Institutes*, 53, 1990, pp.217–36.

CONNORS 1992 —, 'Virtuoso Architecture in Cassiano's Rome', *Quaderni Puteani, 3. Cassiano dal Pozzo's Paper Museum*, vol.II, 1992, pp.23–40.

CORBELLINI 1705 G. Corbellini, *Histoire généologique de la Maison de Gondi*, Paris, 1705.

CORBO 1975 A. Corbo, *Fonti per la storia artistica romana al tempo di Clemente VIII*, Rome, 1975.

CORPUS 1876-1902 *Corpus inscriptionum latinarum*, G. Henzen et al. , editors, vol.VI: *Inscriptiones urbis Romae latinae*, 5 vols, Berlin, 1876–1902; vol.XIV: *Inscriptiones latii veteris latinae*, edited by H. Dessau, Berlin, 1887.

CORRADINI 1961 F. Corradini, 'La chiesa monumentale della Ssma Annunziata in Arezzo', *Rivista d'arte*, 34, 1961, pp.107–42.

CORSI MIRAGLIA 1989 C. Corsi Miraglia, 'Architettura a Monte San Savino', *Quaderni savinesi*, 2, 1989.

CORTI 1989 L. Corti, *Vasari. Catalogo completo dei dipinti*, Florence, 1989.

COZZA 1982 L. Cozza, *Tempio di Adriano*, Rome, 1982.

COZZI 1991 M. Cozzi, *Antonio da Sangallo il Vecchio e l'architettura del cinquecento in Valdichiana*, Genoa, 1991.

CRECY & TAYLOR 1821-2 E. Crecy and G.L. Taylor, *The Architectural Antiquities of Rome*, 2 vols, London, 1821–2.

CREMA 1959 L. Crema, 'Architettura Romana', *Enciclopedia classica, sezione III. Archeologia e storia dell'arte classica*, vol.XII, Turin, 1959.

CREMONA 1976 *Cremona raccolte artistiche*, catalogue of an exhibition held at Museo Civico 'ala Ponzone', Cremona, 1976.

CRESCENZIO 1495 P. Crescenzio, *Trattato dell'agricultura*, Venice, 1495.

CRESSEDI 1984 G. Cressedi, 'Il Foro Boario e il Velabro', *Bullettino per la Commissione archeologica comunale di Roma*, no.89, 1984, pp.249–96.

CROUS 1933 J.W. Crous, 'Florentiner Waffenpfeiler und Armilustrium', *Mitteilungen des Deutschen Archäologischen Instituts. Römische Abteilung*, 48, 1933, pp.1–119.

CRUM 1989 R.J. Crum, 'Cosmos. The World of Cosimo. The Iconography of the Uffizi Façade', *Art Bulletin*, 71, 1989, pp.237–53.

CURTI & ZAMPA 1995 M. Curti and P. Zampa, *Introduzione ali cinque ordini dell' architettura. Trattato anonimo della fine del Seicento*, Rome, 1995.

DA COMO 1930 U. Da Como, 'Girolamo Muziano, 1528–1592', *Note e documenti*, Bergamo, 1930 (chapter 14: *La colonna Traiana*, pp.94–100).

DACOS 1962 N. Dacos, 'Les stucs du Colisée', *Latomus*, 21, 1962.

DACOS 1977 —, *Le Logge di Raffaello. Maestro e bottega di fronte all'antico*, Rome, 1977.

DACOS & FURLAN 1989 N. Dacos and C. Furlan, *Giovanni da Udine*, Udine, 1989.

DADDI GIOVANNOZZI 1940 V. Daddi Giovannozzi, 'Di alcuni incisioni per l'apparato per le nozze di Ferdinando de' Medici e Cristina di Lorena', *Rivista d'arte*, 22, 1940, pp.85ff.

DAI FICHE 1991 DAI fiche=*Deutsches Archäologisches Institut. Index der Antikenkunst und Architektur/ Monuments of Greek and Roman Cultural Heritage in the Photographic Collection of the German Archaeological Institute, Rome. Begleitband Regester und Kommenter*, Munich, 1991.

DAICOVICIU 1938 C. D. Daicoviciu, *La Transylvanie dans l'antiquité*, Bucharest, 1938.

DAICOVICIU 1955 —, 'L'état et la culture des Daces', *Nouvelles études d'histoire*, Bucharest, 1955, pp.121–37.

DAL MAS 1988-9 M. Dal Mas, 'Contributo alla conoscenza dell'opera architettonica di Alessandro Vittoria', *Atti del XXIII congresso di storia dell'architettura*, 2 vols, Rome, 1988–9, pp.255–63.

DAL POGGETTO 1972 P. Dal Poggetto, 'La decorazione pittorica della chiesa dell'Inviolata a Riva del Garda e Martino Torri Polacco', *Antichità viva*, 2/5, 1972, pp.8–20.

DALY DAVIS 1980 M. Daly Davis, 'Carpaccio and the Perspective of Regular Bodies', *Prospettiva rinascimentale. Codificazioni e trasgressioni*, edited by M. Dalai Emiliani, Milan, 1980, pp.183–200.

DALY DAVIS 1982 —, 'Beyond the *Primo Libro* of Vincenzo Danti's *Trattato delle perfette proporzioni*', *Mitteilungen des Kunsthistorischen Institutes in Florenz*, 26/1, 1982, pp.63–84.

DALY DAVIS 1989 —, 'Zum Codex Coburgensis. Frühe Archäologie und Humanismus im Kreis des Marcello Cervini', *Antikenzeichnungen und Antikenstudium in Renaissance und Frühbarock. Akten des internationalen Symposions, Coburg, 8-10 September 1986*, edited by R. Harprath and H. Wrede, Mainz, 1989, pp.85–99.

DANTE 1567 V. Dante, *Il primo libro del trattato delle perfette proporzioni di tutte le cose che imitare e ritrarre si possano con l'arte del disegno*, Florence, 1567; reprinted with a commentary in *Trattati d'arte del Cinquecento*, edited by P. Barocchi, vol.I, Bari, 1960, pp.207–69, 324–8.

D'ARCO 1842 C. D'Arco, *Istorie della vita e delle opere di Giulio Pippi Romano*, second edition, Mantua, 1842.

DAREMBERG & SAGLIO 1887 C. Daremberg and F. Saglio, *Dictionnaire des antiquités grecques et romaines*, vol.I/2, Paris, 1887.

DAVIDSON 1967 B. Davidson, 'Danielle da Volterra and the Orsini Chapel, II', *Burlington Magazine*, 108, 1967, pp.553–61.

DAVIDSON 1979 —, 'Pope Paul III's Additions to Raphael's Logge. His *imprese* in the Logge', *Art Bulletin*, 61, 1979, pp.385–404.

DAVIDSON 1983 —, 'The Landscapes of the Vatican Logge from the Reign of Pope Julius III', *Art Bulletin*, 65, 1983, pp.587–602.

DAVIES & HEMSOLL 1983 P. Davies and D. Hemsoll, 'Renaiassance Balusters and the Antique', *Architectural History*, 26, 1983, pp.1–23.

DAVIS 1976 C. Davis, 'Benvenuto Cellini and the Scuola Fiorentina', *North Carolina Museum of Art Bulletin*, 13/4, 1976, pp.1–70.

DAVIS 1985 —, 'Working for Vasari. Vincenzo Danti in Palazzo Vecchio', *Giorgio Vasari. Tra decorazione ambientale e storiografia artistica. Convegno di studi, Arezzo, 8-10 ottobre 1981*, edited by G.C. Garfagnini, Florence, 1985, pp.205–71.

DE ANGELIS 1969 F. De Angelis, *Organi e organisti di S. Maria in Aracoeli, Convento di S. Lorenzo in Panisperna*, Rome, 1969, pp.35–9.

DE ANGELIS D'OSSAT 1940 G. De Angelis d'Ossat, 'Chiesa di S. Costanza', *Palladio*, 4, 1940, pp.44–5.

DE ANGELIS D'OSSAT 1943 —, 'Gli archi triumphali ideati dal Peruzzi per la venuta di Carlo V a Roma', *Capitolium*, 18, 1943, pp.287–94.

DEARBORN MASSAR 1969 P. Dearborn Massar, 'Stefano della Bella's Illustrations for a Fireworks Treatise', *Master Drawings*, 7, 1969, pp.294–303.

DE BAIF 1536 L. de Baif, *Lazari Bayfii annotationis in l.II. de captivis et postliminio reversis, in quibus tractatur de re navali*, Paris, 1536.

DE FRANCISCIS & PANE 1957 A. De Franciscis and R. Pane, *Mausolei romani in Campania*, Naples, 1957.

DEGENHART & SCHMITT 1972 B. Degenhart and A. Schmitt, 'Ein Musterblatt des Jacopo Bellini mit Zeichnungen nach der Antike', *Festschrift Luitpold Dussler*, 1972, pp.139–68.

DEGLI AZZI 1914 Degli Azzi, *Inventario degli Alberti nell'Archivio di Borgo San Sepolcro*, Rocco S. Cassiano, 1914, pp.123–53; reprinted in G.G. Mazzatinti, *Gli archivi della storia d'Italia*, 1988, pp.195ff.

DEICHMANN 1948 F.W. Deichmann, *Fruehchristliche Kirchen in Rom*, Basel, 1948.

DE LA CROIX 1960 H. De la Croix, 'Military Architecture and the Radial City Plan in Sixteenth-Century Italy', *Art Bulletin*, 42, 1960, pp.263–90.

DEL GIOVANELLI 1858 B. Del Giovanelli, *Vita di Alessandro Vittoria*, Trent, 1858.

DELLA PERGOLA 1962 P. Della Pergola, *Villa Borghese*, Rome, 1962.

DELLA TORRE & SCHOFIELD 1994 S. Della Torre and R. Schofield, *Pellegrino Tibaldi architetto e il S. Fedele di Milano. Invenzione e costruzione di una chiesa esemplare*, Milan, 1994.

DELORME 1567 P. Delorme, *Le Premier Tome de l'architecture*, Brussels, 1567; published in *Les Traités d'architecture*, edited by J.M. Pérouse de Monclos, Paris, 1988.

DEL SAGREDO 1526 D. Del Sagredo, *Medidas del Romano*, Toledo, 1526.

DEL VITA 1927 A. Del Vita, *Il libro delle ricordanze di Giorgio Vasari*, Arezzo, 1927.

DEL VITA 1931 —, 'Un opera d'architettura del Vasari poco nota', *Il Vasari*, 4/4, 1931, pp.178–88.

DENKER NESSELRATH 1993 C. Denker Nesselrath, 'Raphael's Loggia', *Raphael in the Apartments of Julius II and Leo X*, edited by G. Cornini *et al.*, Milan, 1993, pp.39–80.

DE ROSSI 1684 G.B. de Rossi, *I cinque libri di architettura di Giovanni Battista Montani Milanese*, 5 vols, Rome, 1684.

DE ROSSI 1968 G.M. de Rossi, 'I monumenti dell'Appia de Porta S. Sebastiano alle Frattocchie', *Capitolium*, 43, 1968, pp.307–28.

DE ROSSI 1969 —, *Torri e castelli medievali della Campagna Romana*, Rome, 1969.

DESGODETZ 1682 A. Desgodetz, *Les Edifices antiques de Rome, dessinés très exactement*, Paris, 1682.

DESGODETZ 1779 —, *Les Edifices antiques de Rome, dessinés très exactement*, Paris, 1779.

DE SPAGNOLIS 1976 M. De Spagnolis, 'Contributi per una nuova lettura del Mausoleo di Adriano', *Bolletino d'arte*, 61, 1976, pp.62–8.

DESSAU 1883 H. Dessau, 'Römische Reliefs beschrieben von Pirro Ligorio', *Sitzungberichten der Königlich preussischen Akademie der Wissenschaften zu Berlin*, 1883, pp.1077–1105.

DESWARTE ROSA 1989 S. Deswarte Rosa, 'Les gravures de monuments antiques d'Antonio Salamanca à l'origine du *Speculum Romanae Magnificentiae*', *Annali di architettura*, no.1, 1989, pp.47–62.

DESWARTE ROSA 1989–91 —, ' Le Cardinal Giovanni Ricci de Montepulciano', *La Ville Médicis Académie de la France à Rome*, edited by A. Chastel and P. Morel, Rome 1989–91, vol.II, pp.111–69.

DEZZI BARDESCHI 1965 M. Dezzi Bardeschi, 'La SS Annunziata d'Arezzo nella continuità creativa di Giuliano da Sangallo', *Marmo*, no.4, 1965, pp.53–100.

DIJON 1980 Musée Magnin, Dijon, *Catalogue des tableaux et dessins italiens*, edited by A. Brejon de Lavergnée, Paris, 1980.

DIZIONARIO BIOGRAFICO DEGLI ITALIANI 1960– *Dizionario biografico degli italiani*, Rome, 1960– (in progress).

DISEGNO DI ARCHITETTURA 1994 *Disegno di architettura*, Milan, 1994.

DOMBART 1922 T. Dombart, *Das palatinische Septizonium zu Rom*, Munich, 1922.

DONATI 1968 L. Donati, 'Polifilo a Roma. Il mausoleo di S Costanza', *La bibliofilia*, 70, 1968, pp.1–38.

DONII 1731 I.B. Donii, *Inscriptiones antiquae*, Florence, 1731.

D'ONOFRIO 1965 C. D'Onofrio, *Gli obelischi di Roma*, Rome, 1965.

D'ONOFRIO 1971 —, *Castel Sant'Angelo*, Rome, 1971.

D'ONOFRIO 1992 —, *Gli obelischi di Roma*, third edition, Rome, 1992.

DOSIO 1569 G.A. Dosio, *Urbis Romae aedificiorum illustrium, quae supersunt reliquiae summa cum diligentia a J.A. Dosio stilo ferreo ut hodie cernuntur descriptae et a J.B. de Cavalieris aenis tabulis incisis representate*, Rome, 1569; reprinted as *Le antichità di Roma*, introduction by F. Borsi, Rome, 1970.

DRÄGER 1994 O. Dräger, *Religionem significare studien zu reich verzierten Römischen Altären und Basen aus Marmor*, Mainz, 1994.

DRAGONI 1759 D.A. Dragoni, *Antichità e ragguardevolezza della venerabil Compagnia della SS Annunziata d'Arezzo e della su chiesa altrimenti detta dipoi di Santa Maria delle Lagrime*, Florence, 1759.

DREYER 1968 P. Dreyer, 'Giulio Mazzoni as a Draughtsman', *Master Drawings*, 6, 1968, pp.21–4.

DUBOIS 1858 P. Dubois, *Collection archéologique de Prince Pierre Soltykoff. Horlogerie*, Paris, 1858.

DU CHOUL 1569 D. Du Choul, *Discours sur la castramétation et discipline militaire des Romains*, Lyon, 1569.

DUPÉRAC 1575 E. Dupérac, *Vestigi dell'antichità di Roma raccolti e ritratti in perspettiva*, Rome, 1575; reprinted 1652.

DÜTSCHKE 1874–82 H. Dütschke, *Antike Bildwerke in ober-italien*, 5 vols (bound in 2 or 3 vols), Leipzig, 1874–82.

EDINBURGH 1985 National Gallery of Scotland, Edinburgh, *Catalogue of Netherlandish Drawings in the National Gallery of Scotland*, 2 vols, Edinburgh, 1985.

EGGER 1902 H. Egger, 'Entwürfe Baldassare Peruzzis für den Einzug Karl V in Rom', *Jahrbuch der Kunsthistorischen Sammlungen des allerhöchsten Kauserhauses*, 23, 1902, pp.1–44.

EGGER 1903 —, *Kritisches Verzeichnis der Sammlung architektonischer Handzeichnungen der k.k. Hof-Bibliothek*, vol.I: *Aufnahmen antiker Baudenkmaler aus dem 15.–18. Jahrhundert*, Vienna, 1903.

EGGER 1905–6 —, with the assistance of C. Huelsen and A. Michaelis, *Codex Escurialensis. Ein Skizzenbuch aus der Werkstatt Domenico Ghirlandaios*, 2 vols, Vienna, 1905–6.

EGGER 1925 —, *Kritisches Verzeichnis der Stadtrömischen Architektur-Zeichnungen Der Albertina*, Vienna, 1925.

EGGER 1911–31 —, *Römishe Veduten Handzeichnungen aus dem XV–XVII Jahrhundert*, 2 vols, Vienna, 1911–31.

EGGER 1948 —, 'Giorgio Vasaris darstellung des Einzuges Gregors XI in Rom', *Zeitschrift für Kunstwissenschaft*, 2/3–4, 1948, pp.43–8.

ENCICLOPEDIA DELL'ARTE ANTICA 1973 *Enciclopedia dell'arte antica, atalante dei complessi figurati e degli ordini architet-tonici*, Rome, 1973, tav.77–107.

EINEDER 1960 G. Eineder, *The Paper Mills of the Austro-Hungarian Empire*, Hilversum, 1960.

EINER 1970 G. Einer, *La fabbrica di S. Agnese in Navona*, Stockholm, 1970.

EISLER 1988 C. Eisler, *The Genius of Jacopo Bellini. The Complete Paintings and Drawings*, New York, 1988.

EISNER 1979 M. Eisner, 'Zur typologie der Mausoleen des Augustus und des Hadrian', *Mitteilungen des Deutschen Archäologischen Instituts. Römische Abteilung*, 86, 1979, pp.319–24.

EISNER 1986 —, *Zur Typologie der Grabbauten im Suburbium Roms*, Mainz, 1986.

ELAM 1985 C. Elam, 'Piazza Strozzi. Two Drawings by Baccio d'Agnolo and the Problems of a Private Renaissance Square', *I Tatti Studies*, 1, 1985, pp.105–35.

ELLIS 1836 H. Ellis, *The British Museum. The Townley Gallery*, 1836.

EQUINI SCHNEIDER 1984 E. Equini Schneider, *La 'Tomba di Nerone' sulla via Cassia. Studio sul sarcofago di Publio Vibio Mariano*, Rome, 1984.

ERICSSON 1980 C.H. Ericsson, *Roman Architecture Expressed in Sketches by Francesco di Giorgio Martini. Studies in Imperial Roman and Early Christian Architecture*, Commentationes humanarum letterarum, vol.LXVI, Helsinki, 1980.

EWBANK 1842 T. Ewbank, *A Descriptive and Historical Account of Hydraulic and Other Machines for Raising Water*, New York, 1842.

FABIANSKI 1990 M. Fabianski, 'Iconography of the Architecture of Ideal Musaea in the Fifteenth to Eighteenth Centuries', *Journal of the History of Collections*, 2/2, 1990, pp.95–134.

FABRICIUS 1587 G. Fabricius, *Roma antiquitatem libri duo ex aere marmoribus saxis membranisve collecti*, second edition, Basel, 1587 (first edition, 1550; reprinted in Graevius 1694–9, vol.III, pp.398–464).

FAGIOLO & MADONNA 1987 M. Fagiolo and M.L. Madonna, *Baldassare Peruzzi. Pittura, scena e architettura nel Cinquecento*, Rome, 1987.

FAIETTI 1992 M. Faietti, 'L'album di disegni italiani del Soanes's Museum di Londra', *Il disegno di architettura*, no.5, 1992, pp.35–53.

FAIETTI & SCAGLIETTA KELESCIAN 1995 M. Faietti and D. Scaglietta Kelescian, *Amico Aspertini*, Modena, 1995.

FALB 1902 R. Falb, *Il taccuino senese di Giuliano da Sangallo*, facsimile edition, Siena, 1902.

FALCIAI 1925 M. Falciai, *Arezzo. La sua storia e i suoi monumenti*, Arezzo, 1925.

FALCIAI 1928 —, *Storia di Arezzo. Dalle origini alla fine del Granducato Lorenese*, Arezzo, 1928.

FANELLI 1973 G. Fanelli, *Firenze architettura e città*, Florence, 1973.

FANTINI BONVICINI 1973 O. Fantini Bonvicini, *Caprarola. Il Palazzo e la Villa Farnese*, Rome, 1973.

FARA 1988 A. Fara, *Bernardo Buontalenti. L'architettura, la guerra e l'elemento geometrico*, Genoa, 1988.

FARA 1995 —, *Bernardo Buontalenti*, Milan, 1995.

FASOLO 1955 F. Fasolo, 'Analisi stilistica del Sacro Bosco', *Quaderni dell'Istituto di Storia dell'Architettura, Facoltà di Architettura, Università di Roma*, nos 7–9, 1955, pp.33–60.

FASOLO 1961 —, *L'opera di Hieronimo e Carlo Rainaldi (1570–1655 e 1611–1691)*, Rome, 1961.

FASOLO 1969 —, 'L'architettura nell'opera pittorica di Giorgio Vasari', *L'architettura nell'Aretino. Atti del XII Congresso di storia dell' architettura, Arezzo, 10–15 settembre 1961*, 1969, pp.215–37.

FEHL, FEHL & WILSON 1989 P. Fehl, R.M. Fehl and L.A. Wilson, *The Cicognara Library. Literary Sources in the History of Art and Kindred Subjects*, Leopoldo Cicognara Program at the University of Illinois Library/Vatican Library, 1989 (a series of microfiches of the books from Cicognara's library, which is now in the Vatican).

FEINBERG 1991 L.J. Feinberg, editor, *From Studio to Studiolo. Florentine Draftsmanship under the First Medici Grand Dukes*, catalogue of an exhibition held at the Allen Memorial Art Museum, Oberlin College, Oberlin, OH, 1991.

FERRANTE 1636 C. Ferrante, *Architettura con diversi ornamenti cavati dall'antico da Gio. Battista Montano milanese*, Rome, 1636.

FERRANTE 1638 —, *Raccolta de'tempij et sepolcri disegnati dall'antico da Gio. Batta. Montano milanese*, Rome, 1638.

FERRI 1885 N. Ferri, *Indice geografico analitico dei disegni di architettura civile e militare esistenti nella Reale Galleria degli Uffizi*, Florence, 1885.

FERRO 1623 G. Ferro, *Teatro d'imprese*, n.p., 1623.

FICKER 1890 J. Ficker, *Die Altchristlichen Bildwerke in Christlichen Museum des Laterans*, Leipzig, 1890.

FICORONI 1744 F. Ficoroni, *Le vestigia e rarità di Roma ricercate e spiegate*, Rome, 1744.

FIECHTER 1906 E.R. Fiechter, 'Der ionische Tempel am Ponte Rotto in Rom (S Maria Egiziaca)', *Mitteilungen des Deutschen Archäologischen Instituts. Römische Abteilung*, 21, 1906, pp.220–79.

FIENGA 1980 D. Fienga, *The 'Antiquarie prospettiche romane composte per Prospectivo Melanese Depictore'. A Document for the Study of the Relationship Between Bramante and Leonardo da Vinci*, PhD dissertation, University of California, 1970; Ann Arbor, MI, 1980.

FINOLI & GRASSI 1972 A.M. Finoli and L. Grassi, editors, *Antonio Averlino detto il Filarete. Tratatto di architettura*, 2 vols, Milan, 1972.

FIORE 1985 F.P. Fiore, 'La traduzione da Vitruvio di Francesco di Giorgio. Note ad un parziale trascrizione', *Architettura, storia e documenti*, 1985, pp.7-30.

FIORELLI 1867-8 G. Fiorelli, *Catalogo del Museo Nazionale di Napoli. Raccolta epigrafica*, 2 vols, Naples, 1867-8.

FIORIO 1985 M.T. Fiorio, *Le chiese di Milano*, Milan, 1985.

FLORENCE 1955 *Disegni di Filippino Lippi*, catalogue of an exhibition held at the Gabinetto Disegni e Stampe degli Uffizi, Florence, 1955.

FLORENCE 1963 *Mostra dei fondatori dell'Accademia delle arti del disegno*, catalogue of an exhibition held at the Gabinetto Disegni e Stampe degli Uffizi, Florence, 1963.

FLORENCE 1964A *Mostra di disegni fiamminghi e olandesi*, catalogue of an exhibition held at the Gabinetto Disegni e Stampe degli Uffizi, Florence, 1964.

FLORENCE 1964B *Mostra di disegni del Vasari e della sua cerchia*, catalogue of an exhibition held at the Gabinetto Disegni e Stampe degli Uffizi, Florence, 1964.

FLORENCE 1966A *Mostra di disegni vasariani. Carri trionfali e costumi per la genealogia degli Dei*, catalogue of an exhibition held at the Gabinetto Disegni e Stampe degli Uffizi, Florence, 1966.

FLORENCE 1966B *Perino del Vaga e la sua cerchia*, catalogue of an exhibition held at the Gabinetto Disegni e Stampe degli Uffizi, Florence, 1966.

FLORENCE 1980A *Committenza e collezionismo medicei*, catalogue of an exhibition held at Palazzo Vecchio, Florence, 1980.

FLORENCE 1980B *Disegni di Bernardino Poccetti*, catalogue of an exhibition held at the Gabinetto Disegni e Stampe degli Uffizi, Florence, 1980.

FLORENCE 1983 *Firenze e la Toscana de' Medici*, catalogue of an exhibition held at Palazzo Pitti, Florence, 1983.

FLORENCE 1984A *Caesar triumphans. Rotoli disegnati e xilografie cinquecentesche da una collezione privata parigina*, catalogue of an exhibition held at the Institut Français de Florence, 1984.

FLORENCE 1984B *Raffaello a Firenze. Dipinte e disegni delle collezione Fiorentine*, catalogue of an exhibition held at Palazzo Pitti, Florence, 1984.

FLORENCE 1984C *Raffaello e l'architettura a Firenze nella prima metà del cinquecento*, catalogue of an exhibition held in Florence, 1984.

FLORENCE 1986A *Santa Croce nell'800*, catalogue of an exhibition held at S. Croce, Florence, 1986.

FLORENCE 1986B *Il seicento fiorentino. Arte a Firenze da Ferdinando I a Cosimo III. Disegno-incisione-scultura-arti minori*, catalogue of an exhibition held at Palazzo Strozzi, Florence, 1986.

FLORENCE 1986-7 Gabinetto Disegni e Stampe degli Uffizi, Florence, *Inventario 2. Disegni esposti*, 2 vols, Florence, 1986-7.

FLORENCE 1988 *Splendori di pietre dure. L'arte di corte nella Firenze dei Granduchi*, catalogue of an exhibition held at Palazzo Pitti, Florence, 1988.

FLORENCE 1992A *L'architettura di Lorenzo il Magnifico*, catalogue of an exhibition held at the Ospedale degli Innocenti, Florence, 1992.

FLORENCE 1992B *Il disegno fiorentino del tempo di Lorenzo il Magnifico*, catalogue of an exhibition held at the Galleria degli Uffizi, Florence, 1992.

FLORENCE 1993 *Philip Pouncey per gli Uffizi*, catalogue of an exhibition held at the Gabinetto dei Disegni e Stampe degli Uffizi, Florence, 1993.

FLORENCE 1996A *L'officina della maniera. Varietà e fierezza nell'arte fiorentina del cinquecento fra le due repubbliche, 1494-1530*, catalogue of an exhibition held at the Galleria degli Uffizi, Florence, 1996.

FLORENCE 1996B *Renaissance Engineers. From Brunelleschi to Leonardo da Vinci*, catalogue of an exhibition held at the Istituto e Museo della Scienza, Palazzo Strozzi, Florence, 1996.

FOCILLON 1918 H. Focillon, *Giovanni Battista Piranesi. Essai de catalogue raisonné de son oeuvre*, Paris, 1918.

FONTANA 1988 V. Fontana, *Fra Giovanni Giocondo architetto, 1433-c.1515*, Vicenza, 1988.

FONTANINI 1762 D. Fontanini, *Lettere scritte a Roma al sig. Abbate Giusto Fontanini intorno a diverse materie di storia letteraria raccolte dall'ab D. Fontanini*, Venice, 1762.

FORLANI TEMPESTI 1977 A. Forlani Tempesti, *Disegni di fabbriche brunelleschiane*, catalogue of an exhibition held at the Gabinetto dei Disegni e Stampe degli Uffizi, Florence, 1977.

FORLATI TAMARO 1953 B. Forlati Tamaro, *Il Museo Archeologico del Palazzo Reale di Venezia*, Venice, 1953.

FORNI 1991 G.M. Forni, 'Monumenti antichi di Roma nei disegni di Alberto Alberti', *Atti dell'Accademia Nazionale dei Lincei*, Memorie, series VIII, vol.XXXIII, 2 vols, 1989, Rome, 1991.

FORSTER & TUTTLE 1971 K.W. Forster and R. Tuttle, 'The Palazzo del Te', *Journal of the Society of Architectural Historians*, 30, 1971, pp.267-93.

FORTUNATI 1858 L. Fortunati, *Relazione generale degli scavi escoperte fatte lungo la via Latina*, Rome, 1858.

FORTUNIO 1583 A. Fortunio, *La cronichetta del Monte San Savino*, Florence, 1583.

FORT WORTH 1994 *The Golden Age of Florentine Drawing. Two Centuries of Disegno from Leonardo to Volterrano*, catalogue of an exhibition held at the Kimbell Art Museum, Fort Worth, TX, 1994.

FOSS 1979 C. Foss, *Ephesus After Antiquity. A Late Antique, Byzantine and Turkish City*, Cambridge, 1979.

FOSSI 1967-8 M. Fossi, *Bartolomeo Ammannati architetto*, Naples, 1967-8.

FOSSI TODOROW 1966 M. Fossi Todorow, *I disegni di Pisanello e della sua cerchia*, Florence, 1966.

FRANZINI 1596 G. Franzini, *Icones statuarum antiquarum urbis Romae*, Rome, 1596.

FRASER 1977 P.M. Fraser, *Rhodian Funerary Monuments*, Oxford, 1977.

FRATI & SEGARIZZI 1911 L. Frati and A. Segarizzi, *Catalogo dei codici Marciani italiani*, vol.II, Modena, 1911.

FRAZER 1964 A.K. Frazer, *Four Late Antique Rotundas. Aspects of Fourth-Century style in Rome*, PhD dissertation, New York University, 1964; Ann Arbor, MI, 1978.

FRAZER 1986 —, (review of Rasch 1984), *American Journal of Archaeology*, 90, 1986, pp.136-8.

FRERICHS 1973 L.C.J. Frerichs, *Italiaanse Tekeningen I de 17 de eeuw*, Rijksprentenkabinet, Rijksmuseum, Amsterdam, 1973.

FRERICHS 1981 —, *Italiaanse Tekeningen II de 15 en de 16 de eeuw*, Amsterdam, 1981.

FREY 1923-40 K. Frey, *Der Literarische Nachlass Giorgio Vasari*, 2 vols, Munich, 1923-30; vol.III, *Neue Briefe von Giorgio Vasari*, edited by H.W. Frey, Burg. M, 1940.

FRIEDLAENDER 1912 W. Friedlaender, *Das Kasino Pius des Vierten*, Leipzig, 1912.

FROMMEL 1967 C.L. Frommel, 'S. Eligio und die Kuppel der Cappella Medici', *Stil und Überlieferung in der Kunst des Abendlandes. Akten des 21 Internationalen Kongresses für Kunstgeschichte, Bonn, 1964*, Berlin, 1967, pp.41-54.

FROMMEL 1967-8 —, *Baldassare Peruzzi. Als Maler und Zeichner*, Vienna and Munich, 1967-8.

FROMMEL 1973 —, *Der römische Palastbau der Hochrenaissance*, 3 vols, Tübingen, 1973.

FROMMEL 1991-2 —, 'Peruzzi römische Anfänge von der "Pseudo-Cronaca-Gruppe" zu Bramante', *Römisches Jahrbuch der Biblioteca Hertziana*, 27-8, 1991-2, pp.137-82.

FROMMEL & ADAMS 1993 C. Frommel and N. Adams, editors, *The Architectural Drawings of Antonio da Sangallo the Younger and His Circle*, vol.I, Cambridge, MA, and London, 1993.

FRONTINUS 1973 S.J. Frontinus, *De acquaeductu urbis Romae*, edited by Cezary Kunderewicz, Leipzig, 1973.

FRUTAZ 1962 A.P. Frutaz, *Le piante di Roma*, 3 vols, Vatican City, 1962.

FUCIKOWÁ 1982 E. Fucikowá, 'Eineige Erwägungen zum werk des Jacopo und Ottavio Strada', *Leids Kunsthistorisch Jaarboek. Rudolf II and His Court*, Delft, 1982, pp.339-53.

FUHRING 1990 P. Fuhring, *Design into Art. Drawings for Architecture and Ornament. The Lodewijck Houthakker Collection*, vol.II, London, 1990.

FUHRING 1992 —, 'Jacob Matham's *Verscheijden cierage*. An Early Seventeenth-Century Model Book of Etchings After the Antique', *Simiolus. Netherlands Quarterly for the History of Art*, 21, 1992, pp.57-84.

GAMUCCI 1565 B. Gamucci, *Libri quattro dell'antichità della città di Roma*, Venice, 1565.

GARFAGNINI 1985 G.C. Garfagnini, editor, *Giorgio Vasari. Tra decorazione ambientale e storiografia artistica. Convegno di studi, Arezzo, 8-10 ottobre 1981*, Florence, 1985.

GARRUCCI 1879 R. Garrucci, *Storia della arte cristiana nei primi otto secoli della Chiese*, vol.V: *Sarcofagi ossi sculture cimiteriali*, Prato, 1879.

GARZELLI 1985 A. Garzelli, *Miniatura fiorentina del Rinascimento, 1440-1525. Un primo censimento*, 2 vols, Florence, 1985.

GAUDIOSO 1975-6 E. Gaudioso, *Michelangelo e l'edicola di Leone X*, catalogue of an exhibition held in Rome, 1975-6.

GAUDIOSO 1976 —, 'I lavori Farnesiani a Castel Sant'Angelo', *Bollettino d'arte*, 61, 1976, pp.21-41, 228-62.

GAYE 1839-40 G. Gaye, *Carteggio inedito d'artisti dei secoli xiv, xv, xvi*, 3 vols, Florence, 1839-40.

GERE 1966 J. Gere, *Mostra di disegni degli Zuccari, Taddeo e Federigo Zuccari e Raffaellino da Reggio*, catalogue of an exhibition held at the Gabinetto Disegni e Stampe degli Uffizi, Florence, 1966.

GERE 1969A —, editor, *Dessins de Taddeo et Federico Zuccaro*, catalogue of an exhibition held at the Cabinet des Dessins, Musée du Louvre, Paris, 1969.

GERE 1969B —, *Taddeo Zuccaro. His Development Studied in His Drawings*, London, 1969.

GERE 1970 —, 'The Lawrence-Phillipps-Rosenbach "Zuccaro Album"', *Master Drawings*, 8, 1970, pp.123-40.

GERNSHEIM W. Gernsheim, 'Corpus Photographicum by Walter Gernsheim', unpublished corpus of photographs of old master drawings in public and private European collections, in progress (the corpus may be consulted in the Print Room of the British Museum, London, and at the Art Institute of New York).

GEYMÜLLER 1891A H. von Geymüller (letter of 14 February 1891), *Transactions of the Royal Institute of British Architects*, new series, 7, 1891, p.93.

GEYMÜLLER 1891B —, 'Trois albums de dessins de Fra Giocondo', *Mélange d'archéologie de l'Ecole française*, 11, 1891, pp.133-58.

GHISETTI GIAVARINA 1990 A. Ghisetti Giavarina, *Aristotele da Sangallo. Architettura scenografia e pittura tra Roma e Firenze nella prima metà del cinquecento. Ipotesi di attribuzione dei disegni raccolti agli Uffizi*, Rome, 1990.

GIGLIOLI 1928 O.H. Giglioli, 'L'arcipretura di Lucignano in Val di Chiana', *Il Vasari*, 6/3, 1928, pp.244-50.

GINORI CONTI 1936 L. Ginori Conti, *L'apparato per le nozze di Francesco de' Medici e di Giovanna d'Austria*, Florence, 1936.

GIORDANO 1988 L. Giordano, 'Il trattato del Filarete e l'architettura lombarda', *Les Traités d'architecture de la Renaissance. Actes du colloque tenu a Tours, 1-11 juillet 1981*, Paris, 1988.

GIORDANO 1990 —, 'L'architettura, 1490-1500', *La Basilica di S. Maria della Croce a Crema*, Milan, 1990, pp.35-79.

GIOVANNONI, NO DATE G. Giovannoni, *La tecnica della costruzione presso i Romani*, n.d.

GIOVANNONI 1904 —, *La Sala Termale della Villa Liciniana e le cupole romane*, Rome, 1904.

GIOVANNONI 1931 —, *Saggi sulla architettura del Rinascimento*, Milan, 1931; second edition, 1935.

GIOVANNONI 1959 —, *Antonio da Sangallo il Giovane*, 2 vols, Rome, 1959.

GIOVANNOZZI 1933 V. Giovannozzi, 'Ricerche su Bernardo Buontalenti', *Rivista d'arte*, 15, 1933, p.326.

GIULIANO 1971 A. Giuliano, 'La Roma di Battista Brunelleschi', *Rendiconti della Accademia di Archeologia, Lettere e Belle Arti*, new series, 46, 1971, pp.43–50.

GIULIANO & CAIROLI 1970 A. Giuliano and F. Cairoli, *Forma Italiae. Regio I. Volumen septimum.* TIBVR. *Pars Prima*, Rome, 1970.

GIUNTI 1564 J. Giunti, 'Esequie del divino Michelangelo Buonarroti' (Florence, 1564) in 'Vita di Michelangelo', Vasari 1878–85, vol.VII, pp.293–5.

GIZZI & GHINI 1990 S. Gizzi and G. Ghini, 'Progetto di recupero della cosidetta tomba degli Orazi e Ciriazi ad Albano', *Quaderni del Centro di Studio per l'archeologia Etrusco-Italica*, vol.XVIII: *La via Appia*, 1990, pp.163ff.

GNECCHI 1912 F. Gnecchi, *I medaglioni romani*, 3 vols, Milan, 1912.

GOLDTHWAITE 1980 R.A. Goldthwaite, *The Building of Renaissance Florence*, Baltimore and London, 1980.

GNOLI 1939 U. Gnoli, *Topografia e topomastica di Roma medioevale e moderna*, Rome, 1939; reprinted 1984.

GOLFETTO 1979 A. Golfetto, 'Das Grabmal des Publicius Bibulus', *Antike Welt Zeitschrift fur Archäologie und Urgeschichte*, 10/4, 1979, pp.56–7.

GOLZIO 1936 V. Golzio, *Raffaello nei documenti nelle testimonianze dei contemporanei e nella letterature del suo secolo*, Vatican City, 1936; reprinted Farnborough, 1971.

GOLZIO & ZANDER 1963 V. Golzio and G. Zander, *Le chiese di Roma dal XI al XVI secolo*, Bologna, 1963.

GOLZIO & ZANDER 1968 —, 'L'arte in Roma nel secolo XV', *Istituto di studi romani. Storia di Roma*, vol.XXVIII, Bologna, 1968.

GOVI 1876 G. Govi, *Intorno a un opusculo rarissimo della fine del secolo XV intitolato Antiquarie Prospettiche Romane composte per prospettivo Milanese dipintore. Richerche del prof. Gilberto Govi, lette alla Reale Accademia dei Lincei il 16 gennaio 1876*, Rome, 1876.

GRABAR 1946 A. Grabar, *Martyrium. Recherches sur le culte des reliques et l'art chrétien antique*, 3 vols, Paris, 1946.

GRAEVIUS 1694-9 J.G. Graevius (Graeve), *Thesaurus antiquitatum Romanorum*, 12 vols, Utrecht, 1694–9.

GRAMBERG 1964 W. Gramberg, *Die Düsseldorfer Skizzenbücher des Guglielmo della Porta*, Berlin, 1964.

GRAMBERG 1984 —, 'Guglielmo della Portas Grabmal für Paul III Farnese in San Pietro in Vaticano', *Römische Jahrbuch für Kunstgeschichte*, 21, 1984, pp.255–364.

GRANGER 1931-4 F. Granger, editor, *Vitruvius on Architecture. Edited from the Harleian Manuscript 2767 and Translated into English*, 2 vols, London and Cambridge, MA, 1931–4.

GRANIERI PHILLIPS 1983 M.A. Granieri Phillips, 'Nuove ricerche sul codice ambrosiano sulle rovine di Roma', *Arte lombarda*, no.64, 1983, pp.5–13.

GRASSINGER 1991 D. Grassinger, *Römische Marmorkratere*, Mainz, 1991.

GRAVETT 1990 C. Gravett, *Medieval Siege Warfare*, London, 1990.

GUDIUS 1731 M. Gudius, *Antiquae inscriptiones quum Graecae tum Latinae olim a Marquardo Gudio collectae*, Leeuwarden, 1731.

GUELFA & BALDI 1892 F. Guelfa and C. Baldi, *Ricerche storico bibliografiche su Monte San Savino*, Siena, 1892.

GUIDONI & MARINO 1972 E. Guidoni and A. Marino, *Territorio e città della Valdichiana*, Rome, 1972.

GUILLAUME 1995 M. Guillaume, 'Un "journal" retrouvé. Alberto Alberti', *Bulletin du Musée de Dijon*, no.1, 1995, pp.17–32.

GUILMARD 1880-81 D. Guilmard, *Les Maîtres ornémantistes. Ecoles française, italiane, allemande et des Pays-Bas*, 2 vols, Paris, 1880–81; reprinted Amsterdam, 1968.

GUKOVSKY 1963 M. Gukovsky, 'Ritrovamento dei tre volumi di disegni attribuiti a Fra Giocondo', *Italia medioevale e umanistica*, 6, 1963, pp.263–9.

GÜNTHER 1988 H. Günther, *Das Studium der antiken*

Architektur in den Zeichnungen der Hochrenaissance, Tübingen, 1988.

GÜNTHER 1989 —, 'Serlio e gli ordini architettonici', *Sebastiano Serlio. Sesto seminario internazionale di storia dell'architettura, Vicenza, 31 agosto–4 settembre 1987*, edited by C. Thoenes, Milan, 1989, pp.154–68.

GÜNTHER 1993 —, 'Studi architettonici senesi del Rinascimento conservati a Vienna', *Il disegno di architettura*, no.7, 1993, pp.42–7.

GUSMAN 1912 P. Gusman, *L'Art décoratif de Rome de la fin de la république au ive siècle*, 3 vols, Paris, 1912.

HAARLEM 1904 Musée Teyler, Haarlem, *Catalogue raisonnée des dessins des écoles française et hollandaise*, Haarlem, 1904.

HAGER 1967-8 H. Hager, 'Zur Planungs und Baugeschichte der Zwillingskirchen auf der Piazza del Popolo. S. Maria di Monte Santo und S. Maria dei Miracoli in Rom', *Römisches Jahrbuch für Kunstgeschichte*, 11, 1967–8, pp.191–306.

HAGER 1981 —, 'Riflessi palladiani nell'architettura barocca romana', *Bollettino del Centro internazionale di studi di architettura Andrea Palladio*, 1981, pp.45–69.

HAHNLOSER 1935 H.R. Hahnloser, *Villard de Honnecourt. Kritische Gesamtausgabe des Bauhüttenbuches ms fr.19013 der Pariser Nationalbibliothek*, Vienna, 1935.

HALFPENNY 1749 W. Halfpenny, *A New and Complete System of Architecture in the Variety of Plans and Elevations of Designs for Convenient and Decorated Houses*, London, 1749.

HALL 1952 A.R. Hall, *Ballistics in the Seventeenth Century*, Cambridge, 1952.

HALL 1979 M.B. Hall, *Renovation and Counter-Reformation. Vasari and Duke Cosimo in Santa Maria Novella and Santa Croce, 1565–1577*, Oxford, 1979.

HALL 1992 J. Hall, *Dictionary of Subjects and Symbols in Art*, London, 1992.

HARPRATH 1984 R. Harprath, 'Ippolito Andreasi as a Draughtsman', *Master Drawings*, 22, 1984, pp.3–28.

HARTT 1958 F. Hartt, *Giulio Romano*, New York, 1958; reprinted 1981.

HASKELL & MONTAGUE 1996- F. Haskell and J. Montague, editors, *The Paper Museum of Cassiano dal Pozzo. A Catalogue Raisonné of the Drawings and Prints in the Royal Library at Windsor, British Museum and Institut de France and Other Collections*, London, 1996, series A, part IX: *Roman Topography and Architecture*, 3 vols; part X: *Renaissance and Later Architecture* (in progress).

HAYWARD 1954 J. Hayward, 'The Howard E. Smith Collection of Cutlery', *Connoisseur*, vol.134, December 1954, pp.164–73.

HAYWARD 1972 —, 'Some Spurious Antique Vase Designs of the Sixteenth Century', *Burlington Magazine*, 114, 1972, pp.378–86.

HAYWARD 1982 —, 'Filippo Orsoni, Designer, and Caremolo Modrone, Armourer of Mantua', *Waffen-und Kostümkunde. Zeitschrift der Gesellschaft für historische Waffen- und Kostümkunde*, no.1, pp.1–16, no.2, pp.87–102, Berlin, 1982.

HEAWOOD 1950 E. Heawood, 'Watermarks, Mainly of the 17th and 18th Centuries', *Monumenta chartae papyraceae historiam illustrantia*, vol.I, Hilversum, 1950.

HEDICKE 1904 R. Hedicke, *Jacques Dubroeucq von Mons ein Niederländische Meister aus der frühzat des Italienischen Einflusses*, Strasbourg, 1904.

HEIKAMP 1964 D. Heikamp, 'Vincenzo de' Rossi disegnatore', *Paragone*, 15, no.169, 1964, pp.38–42.

HEIKAMP 1966 —, 'A Florence la maison de Vasari', *L'Oeil*, 137, 1966, pp.2–9.

HEIKAMP 1969 —, 'Die Arazzeria Medicea im 16 Jahrhundert. Neue studien', *Munchner Jahrbuch der Bildenden Kunst*, 20, 1969, pp.33–77.

HEIKAMP 1978 —, 'Bartolomeo Ammannati's Fountain for the 'Sala Grande' of the Palazzo Vecchio in Florence', *Fons sapientiae. Renaissance Garden Fountains. Dumbarton Oaks Colloquium on the History of Landscape Architecture, v, 1977*, Washington, DC, 1978, pp.115–73

HELBIG 1963-72 W. Helbig, *Führer durch die öffentlichen Sammlungen klassischer Altertümer in Rom*, fourth edition, edited by H. Speier, 4 vols, Rome, 1963–72.

HENNEBERG 1977 J. von Henneberg, 'Emilio dei Cavalieri, Giacomo della Porta and G.B. Montano', *Journal of the Society of Architectural Historians*, 36, 1977, pp.252–5.

HENNEBERG 1990 —, 'I disegni di architettura del Codice Ottoboniano Latino 3110 di Pier Leone Ghezzi', *Miscellanea Bibliotecae Apostolicae Vaticanae*, vol.IV, Vatican City, 1990, pp.79–97.

HENNEBERG 1991 —, 'The Church of Santo Stefano dei Cavalieri in Pisa. New Drawings', *Antichità viva*, 30/1–2, 1991, pp.29–40.

HENNEBERG 1992 —, 'Of Altars and Drawings. Vasari's Project for Santo Stefano dei Cavalieri in Pisa(?)', *Master Drawings*, 30, 1992, pp.201–9.

HERMANN 1964 A. Hermann, 'Porphyra und Pyramide zur Bedeutungsgeschichtlichen Überlieferung eines Baugedankens', *Jahrbuch für Antike und Christentum*, 7, 1964, pp.117–38.

HERO OF ALEXANDRIA 1851 Hero of Alexandria, *The Pneumatics of Hero of Alexandria Translated from the Original Greek by Bennet Woodcroft*, London, 1851; reprinted London and New York, 1971.

HERRMANN FIORE 1983 K. Herrmann Fiore, *Disegni degli Alberti. Il volume 2503 del Gabinetto Nazionale delle Stampe*, catalogue of an exhibition held at the Gabinetto Nazionale delle Stampe, Rome, 1983.

HERSEY 1973 G.L. Hersey, *The Aragonese Arch at Naples, 1443–1475*, New Haven and London, 1973.

HESBERG 1992 H. von Hesberg, *Monumenta. I sepolcri romani e la loro architettura*, Milan, 1992.

HESBERG & PANCIERA 1994 H. von Hesberg and S. Panciera, *Das Mausoleum des Augustus. Der Bau und seine Inschriften*, Munich, 1994.

HESS 1936 J. Hess, 'Le Logge di Gregorio XIII. L'architettura e i caratteri della decorazione', *L'illustrazione Vaticana*, 1936, pp.161–6.

HEWETT 1928 E. Hewett, 'La décoration du palais Sacchetti par Maître Ponce et Marc le Français', *Gazette des beaux-arts*, 70, 1928, pp.213–27.

HEYDENREICH 1931 L.H. Heydenreich, 'Über Oreste Vannocci Biringucci', *Mitteilungen des Kunsthistorischen Institutes in Florenz*, 3, 1931, pp.434–40.

HILL 1978 C. Hill, *15th- and 16th-Century Sculpture in Italy. Part 8: Lombardy, 15th-Century Sculpture*, Courtauld Institute Illustration Archive, vol.II, London, 1978.

HILL 1974 D.R. Hill, *The Book of Knowledge of Ingenious Mechanical Devices by Ibn Al-Razzaz al-Jazari*, Dordrecht, 1974.

HILL 1979 —, *The Book of Ingenious Devices by The Banu (Sons of) Musà bin Shakir*, Dordrecht, 1979.

HILL 1984 —, *A History of Engineering in Classical and Medieval Times*, London and Sydney, 1984.

HILL & POLLARD 1967 G.F. Hill and G. Pollard, *Medals from the Samuel H. Kress Collection. Renaissance Medals at the National Gallery of Art*, London, 1967.

HIND 1909-10 A.M. Hind, *Catalogue of the Early Italian Engravings Preserved in the Department of Prints and Drawings in the British Museum*, 2 vols, London, 1909–10.

HIND 1935 —, *An Introduction to a History of Woodcut with a Detailed Survey of Work Done in the Fifteenth Century*, 2 vols, London, 1935.

HIND 1938 —, *Early Italian Engraving*, part I: *Florentine Engravings and Anonymous Prints of Other Schools*, 4 vols, New York and London, 1938.

HIND 1948 —, *Early Italian Engravings*, part II: *Known Masters Other Than Florentine Monogrammists and Synonymous*, vols V and VI, London, 1948.

HIRST 1967 M. Hirst, 'Daniele da Volterra and the Orsini chapel I', *Burlington Magazine*, 109, 1967, pp.498–509.

HONROTH 1971 M. Honroth, *Stadtrömische Girlanden. Ein Versuch zur Entwicklungsgeschichte Röm*, Vienna, 1971.

HOOVER & HOOVER 1912 H.C. Hoover and L.H. Hoover, *Georgius Agricola. De re metallica. Translated from the First Latin Edition of 1556*, London, 1912.

HOPE 1992 C. Hope, 'The Early History of the *Tempio*

Malatestiano', *Journal of the Warburg and Courtauld Institutes*, 55, 1992, pp.51–154.

HOWARD 1968 S. Howard, 'Pulling Herakles Leg', *Festschrift Ulrich Middeldorf*, Berlin, 1968, pp.402–7.

HUDAL 1928 A. Hudal, *Santa Maria dell'Anima*, Rome, 1928.

HUELSEN 1886 C. Huelsen, *Das Septizodium des Septimus Severus*, Berlin, 1886.

HUELSEN 1896 —, *Cecilia Metella*, Berlin, 1896.

HUELSEN 1900 —, 'Das Grab des Romulus', *Das Humanistische Gymnasium*, 11/3, 1900.

HUELSEN 1902 —, 'Jahresbericht über neue Funde und forchungen zur Topographie der stadt Rom. Neue Reihe 1. Die Ausgrabungen auf dem Forum Romanum', *Mitteilungen des Kaiserlich Deutschen Archäologischen Instituts, Römische Abteilung*, 17, 1902.

HUELSEN 1907 —, *La Roma antica di Ciriaco d'Ancona*, Rome, 1907.

HUELSEN 1910 —, *Il libro di Giuliano da Sangallo. Codice Vaticano Barberiniano Latino 4424*, 2 vols, Leipzig, 1910; second edition, Rome, 1986.

HUELSEN 1912 —, 'Dei lavori archeologici di Giovanni Antonio Dosio', *Ausonia*, 7, 1912, pp.1–100.

HUELSEN 1921 —, 'Das *Speculum Romanae magnificentiae* des Antonio Lafreri', *Collectanea variae doctrinae Leoni S. Olski*, Munich, 1921, pp.121–70.

HUELSEN 1933 —, *Das Skizzenbuch des Giovannantonio Dosio im Staatlichen Kupferstichkabinett zu Berlin*, Berlin, 1933.

HUELSEN & EGGER 1913-16 C. Huelsen and H. Egger, *Die Römische Skizzenbücher von Marten van Heemskerck im Königlichen Kupferstichkabinett zu Berlin*, 2 vols, Berlin, 1913–16

HYMAN 1981 I. Hyman, 'Examining a Fifteenth-Century "Tribute" to Florence', *Art the Ape of Nature. Studies in Honor of H.W. Janson*, Englewood Cliffs, NY, 1981, pp.105–26.

IEZZI 1981 E. Iezzi, 'I colombari dei Liberti di Livia Augusta et di Augusto sull'Appia Antica', *Bollettino della unione storia ed arte*, new series, 24/1–2, 1981, pp.21–32.

ISABELLE 1855 C.E. Isabelle, *Les Edifices circulaires et les dômes*, Paris, 1855.

ISABELLE 1863 —, *Parallèle des salles rondes de l'Italie*, Paris, 1863.

JACOB 1975 S. Jacob, *Italienische Zeichnungen der Kunstbibliothek Berlin. Architektur und Dekoration 16 bis 18 Jahnhundert*, catalogue, Staatliche Museen Preussischer Kulturbesitz, Berlin, 1975.

JAFFÉ 1991 D. Jaffé, 'Daniele da Volterra's Satirical Defence of His Art', *Journal of the Warburg and Courtauld Institutes*, 54, 1991, pp.247–52.

JAFFÉ 1994 M. Jaffé, *The Devonshire Collection of Italian Drawings*, 4 vols, London, 1994.

JAHN 1868 O. Jahn, 'Über die Zeichnungen antiker Monumente im Codex Pighianus', *Jahresberichte der k.Sächsischen Gesellschaft der Wissenschaften su Leipzig*, 20, 1868, pp.161–235.

JAHN 1870 —, text in *Denkschaft der Weiner Akademie der Wissenschafften*, 9, 1870, p.34.

JANSON 1957 H.W. Janson, *The Sculpture of Donatello*, Princeton, 1957; reprinted 1963.

JANZ AND VAN HILTEN 1646 J. Janz and J. van Hilten, *La II parte dell'architettura del Vignola et altri famossi architetti*, Amsterdam, 1646 (published with an edition of Vignola's *Regola*).

JESTAZ 1994 B. Jestaz, editor, *Le Palais Farnèse. L'Ecole française de Rome*, vol.III: *L'Inventaire du Palais et des propiétés Farnèses à Rome en 1644*, Rome, 1994.

JOACHIM & FOLD MCCULLOGH 1979 H. Joachim and S. Fold McCullogh, *Italian Drawings in the Art Institute of Chicago*, Chicago, 1979.

JOANNIDES 1987 P. Joannides, 'Masaccio, Masolino and "Minor" Sculpture', *Paragone*, no.451, 1987, pp.3–24.

JOANNIDES 1993 —, *Masaccio and Masolino. A Complete Catalogue*, London, 1993.

JOHNSON 1963 E.J. Johnson, *Studies on the Use of Herms in Sixteenth-Century Architecture*, MA thesis, Institute of Fine Arts, New York University, 1963.

JUREN 1986 V. Juren, 'Le Codex Chlumschzansky. Un recueil d'inscriptions e de dessins du XVIe siècle', *Monuments et mémoires. Fondation Eugène Piot*, 18, 1986, pp.105–205.

KAMMERER-GROTHAUS 1974 H. Kammerer-Grothaus, 'Der Deus Rediculus im Triopion des Herodes Atticus. Untersuchung am Bau und zu polychromer Ziegelarchitektur des 2 Jh.s.n.Chr. in Latium', *Mitteilungen des Deutschen Archäologischen Instituts. Römische Abteilung*, 81, 1974, pp.131–252.

KAMMERER-GROTHAUS 1979 —, 'Camere sepulchrali de' Liberti e liberte di Livia Augusta et altri Caesari', *Mélange de l'école française a Rome*, no.9, 1979, pp.315–29.

KARWACKA CODINI 1989 E. Karwacka Codini, *Piazza dei Cavalieri, urbanistica e architettura dal medioevo al Novecento*, Florence, 1989.

KAUFMANN 1955 E. Kaufmann, *Architecture in the Age of Reason. Baroque and Post Baroque in England, Italy and France*, Cambridge, 1955.

KEHLE 1992-3 P. Kehle, 'La Piazza Communale e la Piazza Nuova a Ferrara', *Annali d'architettura*, 4–5, 1992–3, pp.178–89.

KEMP 1981 M. Kemp, *Leonardo da Vinci. The Marvellous Works of Nature and Man*, Cambridge, MA, 1981.

KEMP 1990 —, *The Science of Art. Optical Themes in Western Art from Brunelleschi to Seurat*, London and New Haven, 1990.

KEUTNER 1965 H. Keutner, 'Niccolò Tribolo und Antonio Lorenzi. Der Askulapbrunnen im Heilraütergarten der Villa Castello bei Florenz', *Festschrift fur Theodor Müller. Studien zur Geschichte der Europäischen Plastik*, Munich, 1965, pp.240ff.

KIENE 1995 M. Kiene, 'Bartolomeo Ammannati e i Gesuiti', *Bartolomeo Ammannati scultore e architetto, 1511–1592. Atti del convegno Firenze-Lucca, 1994*, edited by N. Rosselli del Turco and F. Salvi, Florence, 1995.

KING 1982 D.J.C. King, 'The Trebuchet and Other Siege Machines', *Château-Gaillard*, 9–10, 1982, pp.457–69.

KLIMA & VETTERS 1953 L. Klima and H. Vetters, *Das lageramphitheater von Carnunthum (Der römische Limes in Oesterreich)*, vol.XX, Vienna, 1953.

KNOBLOCH 1984 E. Knobloch, editor, *Mariano Taccola. De rebus militaribus (De machinis 1449). A Facsimile of Paris Bibliothèque Nationale ms 7239*, Baden-Baden, 1984.

KOCH & SICHTERMANN 1982 G. Koch and H. Sichtermann, *Römische Sarkophage*, Munich, 1982.

KOLB 1988 C. Kolb, 'The Francesco di Giorgio Material in the Zichy Codex', *Journal of the Society of Architectural Historians*, 47, 1988, pp.132–59.

KRANZ 1984 P. Kranz, *Jahreszeiten-Sarcophage Entwicklung und Ikonographie des Motivs der vier Jahreszeiten auf Kaiser-zeitlichen Sarkophagen und Sarkophagdeckeln*, Berlin, 1984.

KRAUTHEIMER 1937 R. Krautheimer, *Corpus basilicarum christianarum Romae. Le basiliche cristiane antiche di Roma. Secoli IV–IX*, vol.I, Vatican City, 1937.

KRAUTHEIMER 1956 —, in collaboration with T. Krautheimer Hess, *Lorenzo Ghiberti*, Princeton, 1956.

KRAUTHEIMER 1965 —, *Early Christian and Byzantine Architecture*, London, 1965.

KRAUTHEIMER 1975 —, *Early Christian and Byzantine Architecture*, revised edition, Harmondsworth, 1975.

KUHN 1990 J. Kuhn, 'Measured Appearances. Documentation and Design in Early Perspective Drawing', *Journal of the Warburg and Courtauld Institutes*, 53, 1990, pp.114–32.

KÜHN-HATTENHAUER 1978 D. Kühn-Hattenhauer, *Das grafische Oeuvre des Francesco Villamena*, dissertation, Freie Universität, Berlin, 1978.

KUMMER 1987 S. Kummer, *Anfänge und ausbreitung der Stuckdekorationen im römischen kirchenraum (1599–1600)*, Tübingen, 1987.

KURTZ 1937 O. Kurtz, 'Giorgio Vasari's Libro de' disegni', *Old Master Drawings*, 12, 1937, pp.1–15.

KYESSER 1967 C. Kyesser, *Aus Eichstatt. Bellifortis*, facsimile, Düsseldorf, 1967.

LABACCO 1552 A. Labacco, *Libro appartenente all'architettura*, Rome, 1552.

LABACCO 1559 —, *Libro appartenente all'architettura*, second edition, Rome, 1559; reprinted with an introduction by A. Bruschi, Milan, 1992.

LACOSTE 1963 H. Lacoste, 'A propos di XIII congrès d'histoire de l'architecture tenu en Sardaigne du 6 au 12 avril 1963', *Bulletin de la classe des beaux-arts*, 1963, pp.167ff.

LAFRERI, SEE SPECULUM

LAMBERINI 1990A D. Lamberini, 'Boboli e l'ingegneria idraulica alla Scuola dei Parigi', *Boboli 90. Atti del Convegno per la salvaguardia e la valorizzazione del giardino, Florence, 9–11 marzo 1989*, 2 vols, Florence, 1990, pp.467–9.

LAMBERINI 1990B —, *Il principe difeso. Vita e opera di Bernardo Puccini*, Florence, 1990.

LANCIANI 1881 R. Lanciani, *Notizie degli scavi*, Rome, 1881, pp.255–94.

LANCIANI (IN THE NAME OF CANNIZZARO) 1882 R. Lanciani, text in *Atti Lincei. Transunti*, 6, 1882, p.281.

LANCIANI 1882 —, *Notizie degli scavi*, Rome, 1882, pp.340–59.

LANCIANI 1891 —, 'Miscellanea topografica. Gli horti ancil-iorvm sul Pincio', *Bullettino della commissione archeologica comunale di Roma*, no.19, 1891, pp.132–55.

LANCIANI 1897 —, *Ruins and Excavations of Ancient Rome. A Companion Book for Students and Travellers*, London, 1897.

LANCIANI 1900 —, 'La raccolta antiquaria di Giovanni Ciampolini', *Bullettino della commissione archeologica comunale di Roma*, no.27, 1899, pp.101–15.

LANCIANI 1901 —, 'Il nuovo frammento della Forma Urbis', *Bullettino della commissione archeologica comunale di Roma*, no.29, 1901, pp.7–19.

LANCIANI 1902-12 —, *Storia degli scavi*, 4 vols, Rome, 1902–12.

LANCIANI 1989-92 —, *Storia degli scavi di Roma e notizie intorno le collezione romane di antichità*, 4 vols, Rome, 1989–92.

LANGEDIJK 1981-7 K. Langedijk, *The Portraits of the Medici, 15th–18th Centuries*, 3 vols, Florence, c.1981–7.

LAUER 1911 P. Lauer, *Le Palais du Latran*, Paris, 1911.

LAUGIER 1765 M.-A. Laugier, *Observations sur l'architecture*, The Hague, 1765.

LAVAGNINO 1962 E. Lavagnino, *La chiesa di Santo Spirito in Sassia e il mutare del gusto a Roma al tempo del Concilio di Trento*, Rome, 1962.

LAZZARONI & MUÑOZ 1908 M. Lazzaroni and A. Muñoz, *Filarete scultore e architetto del secolo XV*, Rome, 1908.

LECCHINI GIOVANNONI 1991 S. Lecchini Giovannoni, *Alessandro Allori*, Turin, c.1991.

LEDOUX 1984 T. Ledoux, 'Castel del Monte (1240-1246) e il *De architectura* di Vitruvio', *Antichità viva*, 23/1, 1984, pp.19–25.

LEON 1971 C. Leon, *Die Bauornamentik des Trajansforum und ihre Stellung in der früh–und mittelkaiserzeitlichen Architekturdekoration Roms*, Vienna, 1971.

LEONARDO 1975-80 Leonardo da Vinci, *Il Codice Atlantico della Biblioteca Ambrosiano da Milano, transcrizione diplo-matica e critica da A. Marinoni*, 12 vols, Florence, 1975–80.

LEONCINI 1987A L. Leoncini, 'Frammenti con trofei navali e strumenti sacrificiali dei Musei Capitolini. Nuova ipotesi ricostruttiva', *Xenia*, no.13, 1987, pp.13–24.

LEONCINI 1987B —, 'Storia e fortuna del cosidetto Fregio di San Lorenzo', *Xenia*, no.14, 1987, pp.59–110.

LEONCINI 1993 —, *Il codice detto del Mantegna. Codex Destailleur Oz III della Kunstbibliothek di Berlino*, Rome, 1993.

LESSMAN 1976 J. Lessman, 'Battista Franco disegnatore di maioliche', *Faenza*, 2, 1976, pp.27ff.

LETAROUILLY 1874 P. Letarouilly, *Edifices de Rome moderne, ou receuil des palais, maisons, églises, couvents et autre monuments publics et particuliers les plus remarquables de la ville de Rome*, 3 vols, Paris, 1874.

LEUPOLD 1724-5 J. Leupold, *Theatrum machinorum…*, 4 vols, Leipzig, 1724–5.

LEVI D'ANCONA 1962 M. Levi d'Ancona, *Miniatura e minia-tori a Firenze del XIV al XVI secolo*, Florence, 1962.

LEWINE 1967 M. Lewine, 'Roman Architectural Practice during Michelangelo's Maturity', *Stil und Überlieferung in*

der Kunst des Abenlandes. Acts of the 21st International Conference for the History of Art, II. Bonn, 1964, Berlin, 1967, pp.20–26.

LIBER PONTIFICALIS 1886-92 Le liber pontificalis. Texte, introduction et commentaire. Par L'Abbé L. Duchesne, 2 vols, Paris, 1886–92.

LICHT 1970 M.M. Licht, 'A Book of Drawings by Nicoletto da Modena', Master Drawings, 8, 1970, pp.379–87.

LICHT 1973 —, 'L'influsso dei disegno del Filarete sui progetti architettonici per teatro e festa (1486–1513)', Arte lombarda, nos 38–9, 1973, pp.91–102.

LICHT 1984 —, L'edificio a pianta centrale. Lo sviluppo del disegno architettonico nel rinascimento, catalogue of an exhibition held at the Gabinetto Disegni e Stampe degli Uffizi, Florence, 1984.

LIGHTBOWN 1986 R. Lightbown, Mantegna, with a Complete Catalogue of the Paintings, Drawings and Prints, Oxford, 1986.

LIGORIO 1723 Pirro Ligorio, 'Descrittione della superba e magnificentissima Villa Tiburtina Hadriana', Thesaurus antiquitatem et historiarum Italiae, vol.VIII/4, edited by J.G. Graevius, Leiden, 1723.

LILLE 1989 Renaissance et Baroque. Dessins italiens du Musée de Lille, catalogue of an exhibition held at the Musée des Beaux-Arts, Lille, 1989.

LIMBURGER 1910 W. Limburger Die Gebäude von Florenz, Leipzig, 1910.

LIPPOLD 1956 G. Lippold, Die Skulpturen des Vatikanischen Museums, 3 vols, Berlin, 1956.

LISSI CARONNA & PRIULI 1977 E. Lissi Caronna and S. Priuli, 'Tempio c.d. della Fortuna Virile. Scavi e restauri', Notizie degli scavi di antichità, no.31, 1977, pp.299–325.

LITTA 1819-82 P. Litta, Famiglie celebri italiane, 5 vols, Milan, 1819–82.

LIVY 1962 Livy, Ab urbe condita libri, edited by W. Weissenborn and H.J. Müller, Berlin, 1962.

LLEWELLYN 1977 N. Llewellyn, 'Two Notes on Diego da Sagredo', Journal of the Warburg and Courtauld Institutes, 40, 1977, pp.292–300.

LLOYD 1968 C. Lloyd, 'Drawings Attributable to Niccolò Tribolo', Master Drawings, 6, 1968, pp.243–5.

LOHNINGER 1909 J. Lohninger, Santa Maria dell'Anima, Rome, 1909.

LONDON 1837 British Museum Print Room, London, 'General Inventory', manuscript, 12 vols, 1837.

LONDON 1954 Anglo-Flemish Art under the Tudors, typescript catalogue of an exhibition held at the British Museum, London, 1954 (Department of Manuscripts, Pamphlet 929, vol.LXII).

LONDON 1956 Courtauld Institute of Art, Handlist of the Courtauld Institute's Collection, London, 1956.

LONDON 1964 The Sir Anthony Blunt Collection, catalogue of an exhibition held at the Courtauld Institute of Art, London, 1964.

LONDON 1971 The Graphic Work of Albrecht Dürer. An Exhibition of Drawings and Prints in Commemoration of the Quintentenary of His Birth, catalogue of an exhibition held at the British Museum, London, 1971.

LONDON 1975 Andrea Palladio. The Portico and the Farmyard, 1508–1580, catalogue of an exhibition held at the Hayward Gallery, Arts Council of Great Britain, London, 1975.

LONDON 1979 Masterpieces of Cutlery and the Art of Eating, catalogue of an exhibition held at the Victoria and Albert Museum, London, 1979.

LONDON 1981 The Splendours of the Gonzaga, catalogue of an exhibition held at the Royal Academy of Arts, London, 1981.

LONDON 1986 Florentine Drawings of the Sixteenth Century, catalogue of an exhibition held at the British Museum, London, 1986.

LONDON 1992 Andrea Mantegna, catalogue of an exhibition held at the Royal Academy of Arts, London, 1992.

LONDON 1993 The Paper Museum of Cassiano dal Pozzo. Quaderni Puteani 4, catalogue of an exhibition held at the British Museum, London, 1993.

LONDON 1995 Soane. Connoisseur and Collector. A Selection of Drawings from Sir John Soane's Collection, catalogue of an exhibition held at Sir John Soane's Museum, London, 1995.

LONDON 1996 Old Master Drawings from the Malcolm Collection, catalogue of an exhibition held at the British Museum, London, 1996.

LORENZEN 1966 E. Lorenzen, Technological Studies in Ancient Metrology, Copenhagen, 1966.

LORENZEN 1970 —, 'Along the Line Where Columns Are Set', vol.II, Copenhagen, 1970.

LOTZ 1940 W. Lotz, 'Eine Deinokrates Darstellung des Francesco di Giorgio', Mitteilungen des Kunsthistorischen Instituts in Florenz, 5, 1940, pp.428–33.

LOTZ 1955 —, 'Die ovalen Kirchenräume des Cinquecento', Römisches Jahrbuch für Kunstgeschichte, 7, 1955, pp.1–99.

LOTZ 1977 W. Lotz, 'The Rendering of the Interior in Architectural Drawing of the Renaissance', Studies in Italian Renaissance Architecture, edited by J.S. Ackerman, W. Chandler Kirwin and H.A. Millon, London and Cambridge, MA, 1977, pp.1–65.

LOWIC 1982 L. Lowic, 'Francesco di Giorgio on the Design of Churches. The Use and Significance of Mathematics in the Trattato', Architectura, 83, 1982, pp.151–63.

LOWIC 1983 —, 'The Meaning and Significance of the Human Analogy in Francesco di Giorgio', Journal of the Society of Architectural Historians, 42, 1983, pp.360–70.

LUCCO 1989-90 M. Lucco, editor, La pittura nel Veneto, 2 vols, Milan, 1989–90.

LUCHS 1977 A. Luchs, Cestello. A Cistercian Church of the Florentine Renaissance, New York and London, 1977.

LUGLI 1953 G. Lugli, 'Edifici rotondi del tardo impero in Roma e Suburbio', Studies Presented to David M. Robinson, vol.II, Saint Louis, 1953, pp.1219ff.

LUGLI 1957 —, La tecnica edilizia romana con particolare riguardo a Roma e Lazio, vol.I, Rome, 1957.

LUGLI 1970 —, Itinerario di Roma antica, Milan, 1970.

LUGT 1921 F. Lugt, Les Marques de collections de dessins et d'estampes, Amsterdam, 1921.

LUGT 1938 —, Répertoire des catalogues de Vente, The Hague, 1938.

LUSCHI 1984 L. Luschi, 'Un edificio funerario della via Prenestina nei disegno degli Uffizi', Prospettiva, 39, 1984, pp.30–37.

LUSCHI 1992 —, 'Pietro Santi Bartoli e le pitture nel mausoleo dei Gordiani', Bollettino d'arte, no.77, 1992, pp.1–14.

LYON 1984 Musée des Arts Décoratifs de Lyon, Dessins du XVIe au XIXe siècle de la collection du Musée des Arts Décoratifs de Lyon, catalogue of an exhibition held at the Salle d'exposition temperaire du Musée historique des tissus, Lyon, 1984.

MACDONALD & PINTO 1995 W.L. Macdonald and J.A. Pinto, Hadrian's Villa and Its Legacy, New Haven and London, 1995.

MACREA 1937 M. Macrea, 'Un disegno inedito del Rinascimento relativo alla colonna Traiana', Ephemeris dacoromana, 7, 1937, pp.77–116.

MADONNA 1976 M.L. Madonna, 'Septem mundi miracula come templi della virtù. Pirro Ligorio e l'interpretazione delle meraviglie', Psicon, 7, 1976, pp.25–63.

MADONNA 1993 —, Roma di Sisto V, Rome, 1993.

MADRID 1991 Biblioteca Nacional, Madrid, Dibujos de arquitectura y ornamentacion de la Biblioteca Nacional. Siglos XVI y XVII, Madrid, 1991.

MAETZKE 1974 A.M. Maetzke, Arte nell'Aretino. Recuperi e restauri dal 1968 al 1974, catalogue of an exhibition held in Arezzo, 1974.

MAFFEI 1506 R. Maffei, Volaterranus. Commentariorum urbanorum libri XXXVIII, Rome, 1506.

MAGNUSON 1958 T. Magnuson, Studies in Roman Quattrocento Architecture, Stockholm, 1958.

MAIURI 1970 A. Maiuri, Campi Flegrei, Rome, 1958; reprinted 1970.

MALAGUZZI VALERI 1904 F. Malaguzzi Valeri, Giovanni Antonio Amadeo, scultore e architetto lombardo (1447-1522), Bergamo, 1904.

MALAGUZZI VALERI 1913 —, La corte di Ludovico il Moro, vol.I: La vita privata e l'arte a Milano nella seconda metà del quattrocento, Milan, 1913.

MALAGUZZI VALERI 1915 —, La corte di Ludovico il Moro, vol.II: Bramante e Leonardo da Vinci, Milan, 1915.

MALAGUZZI VALERI 1917 —, La corte di Ludovico il Moro, vol.III: Gli artisti lombardi, Milan, 1917.

MALAGUZZI VALERI 1923 —, La corte di Ludovico il Moro, vol.IV: Le arti industriali, la lettura, la musica, Milan, 1923.

MALKE 1980 L.S. Malke, Italienische Zeichnungen des 15. und 16. Jahrhunderts. Aus eigenen Beständen. Städelsches Kunstinstitut und Städtische Galerie, Frankfurt am Main, 1980.

MALTESE 1962 C. Maltese, 'Per Leonardo prospettico', Raccolta vinciana, 19, 1962, pp.303–14.

MALTESE 1967 C. Maltese, editor, Francesco di Giorgio. Trattati di architettura, ingegneria e arte militare, 2 vols, transcribed by L. Maltese Degrassi, Milan, 1967.

MALTESE 1980 —, 'La prospettiva curva di Leonardo da Vinci e uno strumento di Baldassare Lanci', Prospettiva rinascimentale. Codificazioni e trasgressioni, edited by M. Dalai Emiliani, vol.I, Milan, 1980, pp.417–25.

MANCA 1992 J. Manca, The Art of Ercole de' Roberti, New York and Cambridge, 1992.

MANCINI 1918 G. Mancini, 'Cosimo Bartoli', Archivio storico italiano, 76, 1918, pp.84–135.

MANDOWSKY & MITCHELL 1963 E. Mandowsky and C. Mitchell, Pirro Ligorio's Roman Antiquities, London, 1963.

MANIERI 1987 M.E. Manieri, 'Note sul significato del tempio di Venere e Roma', Saggi in onore di G. De Angelis d'Ossat, Rome, 1987, pp.47–54.

MANNI 1986 G. Manni, Mobili in Emilia, Modena, 1986.

MANSUELLI 1958-61 G. Mansuelli, Cataloghi dei musei e gallerie d'Italia. Galleria degli Uffizi. Le sculture, 2 vols, Rome 1958–61.

MANTUA 1989 Giulio Romano, catalogue of an exhibition held at Palazzo del Te and Palazzo Ducale, Mantua, 1989.

MANTUA 1994 Leon Battista Alberti, catalogue of an exhibition held at Palazzo del Te, Mantua, 1994.

MANZIO 1834 M. Manzio, Vita de Leonardo Caruso detto il Letterato, Rome, 1834.

MARANI 1979 P.C. Marani, editor, Il Codice Ashburnham 361 della Biblioteca Medicea Laurenziana di Firenze. Trattato di architettura di Francesco di Giorgio Martini, 2 vols, Florence, 1979.

MARANI 1982 —, 'Leonardo e le colonne ad tronchonos. Tracce di un programma iconologico per Ludovico il Moro', Raccolta vinciana, 21, 1982, pp.104–20.

MARANI 1984 —, L'architettura fortificata negli studi di Leonardo da Vinci con il catalogo completo dei disegni, Florence, 1984.

MARCHINI 1974 G. Marchini, 'Su i disegni d'architettura del Vasari', Il Vasari storiografo e artista. Atti del convegno, Arezzo–Florence, 1974, Florence, 1976, pp.101–8.

MARCONI 1968 P. Marconi, 'Una chiave per l'interpretazione dell'urbanistica rinascimentale. La cittadella come micro-cosmo', Quaderni dell'Istituto di Storia dell'Architettura, series XV, fasc.85–90, 1968, pp.53–94.

MARCONI 1973 —, 'La città come forma simbolica', Studi sulla teoria dell'architettura, edited by F.P. Fiore et al., Rome, 1973.

MARCUCCI 1951 L. Marcucci, Mostra di disegni d'arte decorativa, Florence, 1951.

MARI 1991 Z. Mari, Tibur pars quarta, Forma Italia, 35, Florence, 1991.

MARIANI CANOVA 1969 G. Mariani Canova, La miniatura veneta del Rinascimento, Venice, 1969.

MARSDEN 1969 E.W. Marsden, Greek and Roman Artillery. Historical Development, Oxford, 1969.

MARSDEN 1971 —, Greek and Roman Artillery. Technical Treatises, Oxford, 1971.

MARTINDALE 1979 A. Martindale, The Triumphs of Caesar by Andrea Mantegna in the Collection of Her Majesty the Queen at Hampton Court, London, 1979.

MARTINI 1990 C. Martini, Il deposito votivo del tempio di Minerva Medica, Rome, 1990.

MASETTI ZANNINI 1972 G. Masetti Zannini, 'Notizie

biografiche di Guglielmo della Porta in documenti notarili romani', *Commentari*, 23, 1972, pp.299–305.

MATZ 1871 F. Matz, 'Über eine dem Herzog von Coburg-Gotha gehörige Sammlung alter Handzeichnungen nach Antiken', *Monatsberichte der Königlich Preussischen Akademie der Wissenschaften zu Berlin. Philos-hist.Kl.*, October 1871, pp.445–99.

MATZ 1975 F. Matz, *Die Dionysischen Sarkophage*, Berlin 1975.

MATZ & DUHN 1881–2 F. Matz and F. von Duhn, *Antike Bildwerke in Rom*, 3 vols, Leipzig, 1881–2.

MAZOCHIUS 1521 J. Mazochius, *Epigrammata antiquae urbis*, Rome, 1521.

MAZZINI 1965 F. Mazzini, *Affreschi lombardi del quattrocento*, Milan, 1965.

MCANDREW 1980 J. McAndrew, *Venetian Architecture of the Early Renaissance*, Cambridge, MA, 1980.

MCBURNEY 1989 H. McBurney, 'History and Contents of the dal Pozzo Collection in the Royal Library, Windsor Castle', *Cassiano dal Pozzo. Atti del Seminario internazionale di studio, Naples, 18–19 dicembre 1987*, Rome, 1989, pp.75–94.

MCCRORY 1979 M. McCrory, 'Some Gems from the Medici Cabinet of the Cinquecento', *Burlington Magazine*, 121, 1979, pp.511–14.

MCGINTY 1974 A.B. McGinty, *Stradanus. His Role in the Visual Communication of Renaissance Discoveries, Technologies and Values*, PhD dissertation, Tufts University, 1974; Ann Arbor, MI, 1984.

MCTAVISH 1981 D. McTavish, *Giuseppe Porta Called Giuseppe Salviati*, New York and London, 1981.

MELLINI 1566 D. Mellini, *Descrizione dell'entrata della sereniss. Reina Giovanna d'Austria et dell'apparato, fatto in Firenze nella venuta & per le felicissime nozzi di S. Altezza et dell'Illustrissimo, & Eccellentiss. S. Don Francesco de Medici Prencipe di Fiorenza, & di Siena/Scritta da Domenico Mellini*, Florence, 1566.

MEOMARTINI 1880 A. Meomartini, *I monumenti e le opere d'arte della città di Benevento*, Benevento, 1889.

MERCKLIN 1962 E. von Mercklin, *Antike figural Kapitelle*, Berlin, 1962.

METTERNICH & THOENES 1987 F.G.W. Metternich and C. Thoenes, *Die frühen St Peter. Entwürfe, 1505–1514*, Tübingen, 1987.

MEZZATESTA 1985 M.P. Mezzatesta, 'The Façade of Leoni Leoni's House in Milan, the Casa degli Omenoni. The Artist and the Public', *Journal of the Society of Architectural Historians*, 45, 1985, pp.233–49.

MICHAELIS 1882 A. Michaelis, *Ancient Marbles in Great Britain*, Cambridge, 1882.

MICHAELIS 1891 —, 'Storia della collezione capitolina di antichità fino all'inaugurazione del Museo (1734)', *Mitteilungen des Kaiserlich Deutschen Archäologischen Instituts, Römische Abteilung*, 6, 1891, pp.3–66.

MICHAILOVA 1969 M. Michailova, 'Mausolei romano nei disegni di un architetto italiano del rinascimento all' Ermitage di Leningrado', *Palladio*, 19–20, 1969, pp.3–13.

MICHELI 1982 M.E. Micheli, *Giovanni Colonna da Tivoli, 1554*, Rome, 1982.

MICHELINI TOCCI 1962 L. Michelini Tocci, 'Disegni e appunti autographi di Francesco di Giorgio in un Codice del Taccola', *Scritti di storia dell'arte in onore di Mario Salmi*, vol.II, Rome, 1962, pp.201–12.

MICHELINI TOCCI 1989 —, *Das skizzenbuch des Francesco di Giorgio Martini, ms Urb. Lat. 1757*, facsimile, Zürich, 1989.

MILAN 1982 *Zenale e Leonardo. Tradizione e rinnovamento della pittura lombarda*, catalogue of an exhibition held at the Museo Poldi Pezzoli, Milan, 1982.

MILAN 1988 *Arte lombarda del primo quattrocento. Un riesame*, catalogue of an exhibition held at the Pinacoteca di Brera, Milan, 1988.

MILAN 1991 *Le muse e il principe. Arte di corte nel rinascimento padano*, catalogue of an exhibition held at the Museo Poldi Pezzoli, Milan, 1991.

MILLON 1958 H. Millon, 'The Architectural Theory of Francesco di Giorgio', *Art Bulletin*, 40, 1958, pp.257–61.

MISSIRINI 1823 M. Missirini, *Memorie per servire alla storia della Romana Accademia di San Luca fino alla morte di Antonio Canova*, Rome, 1823.

MITCHELL & ROBERTS 1996 P. Mitchell and L. Roberts, *A History of European Picture Frames*, London, 1996.

MOISÈ 1845 F. Moisè, *Santa Croce di Firenze*, Florence, 1845.

MODENA 1978 *Libri di immagini, disegni e incisioni di Giovanni Guerra, Modena, 1544–Roma, 1618*, catalogue of an exhibition held at the Palazzo dei Musei, Modena, 1978.

MONBEIG GOGUEL 1972 C. Monbeig Goguel, *Musée du Louvre, Cabinet des Dessins. Inventaire général des dessins italiens. Vasari et son temps*, Paris, 1972.

MONBEIG GOGUEL 1982 —, 'Chronique Vasarienne', *Revue de l'art*, no.56, 1982, pp.65–80

MONBEIG GOGUEL 1992 —, 'De Vérone à Florence. Sebastiano Vini dessinateur, autour du "Martyre des dix-mille"', *Kunst des Cinquecento in der Toskana*, Munich, 1992.

MONETI 1989 A. Moneti, 'Sebastiano Serlio e il "Barocco" antico. A proposito di un edificio raffigurato nel terzo libro', *Sebastiano Serlio. Sesto Seminario Internazionale di Storia dell'Architettura, Vicenza, 31 agosto–4 settembre 1987*, edited by C. Thoenes, Milan, 1989, pp.149–53.

MONGERI 1880 G. Mongeri, *Le rovine di Roma al principio del secolo XVI. Studi del Bramantino*, Milan, 1880.

MONTFAUÇON 1719 B. Montfauçon, *Antiquité expliquée et représentée en figures*, 15 vols, Paris, 1719; supplement, 1724.

MORCELLI, FEA & VISCONTI 1869 S.A. Morcelli, C. Fea and E.Q. Visconti, *La Villa Albani descritta*, Rome, 1869.

MOREL ET AL. 1989–91 P. Morel et al., *La Ville Médicis, Académie de France de Rome. Ecole française de Rome*, 3 vols, Rome 1989–91.

MOROLLI 1980 G. Morolli, 'Anonimo miscellanea di architettura. I disegni di un "taccuino senese". Biblioteca Comunale degli Intronati di Siena MS L.IV.10', *Il disegno interrotto. Trattati Medicei di architettura. Documenti inediti di cultura Toscana*, vol.IV, 2 vols, Florence, 1980.

MOROLLI 1985 —, 'Vetrus Etruria'. Il mito degli Etruschi nella letteratura architettonica, nell'arte e nella cultura da Vitruvio a Winckelmann*, Florence, 1985.

MOROLLI 1996 —, 'Federico da Montefeltro e Salamone. Alberti, Piero e l'ordine architettonico dei principi-costruttori retrovato', *Città e corte nell'Italia di Piero della Francesca. Urbino, 1992*, edited by C. Cieri Via, Venice, 1996.

MORRESI 1991 M. Morresi, 'Bramante, Enrico Bruni e la parrochiale di Roccaverano', *La Piazza, la chiesa e il parco*, edited by M. Tafuri, Milan, 1991, pp.96–165.

MORRIS 1750 R. Morris, *Rural Architecture*, London, 1750.

MORRIS 1751 —, *The Architectural Remembrances*, London, 1751

MORRIS 1755 —, *Select Architecture*, London, 1755.

MORROGH 1985 A. Morrogh, *Disegni di architetti fiorentini, 1540–1640*, catalogue of an exhibition held at the Gabinetto Disegni e Stampe degli Uffizi, Florence, 1985.

MOSCHINI 1931 V. Moschini, *San Giovanni Decollato*, Le chiese di Roma illustrate, XXVI, Rome, 1931.

MÖSENEDER 1987 K. Möseneder, 'Feuerwerk', *Reallexikon zur deutschen Kunstgeschichte*, vol.XIII, Munich, 1987.

MUCCINI & CECCHI 1991 U. Muccini and A. Cecchi, *The Apartments of Cosimo in Palazzo Vecchio*, Florence, 1991.

MULAZZANI 1978 G.A. Mulazzani, *L'opera completa di Bramantino e Bramante*, Milan, 1978.

MÜNSTER 1558 S. Münster, *Sei libri cosmografia universale*, Basel, 1558 (first published in German, 1544; reprinted eight times before Münster's death in 1552).

MÜNTZ 1878 E. Müntz, 'Notes sur les mosaïques chrétienne d'Italie', *Revue archéologique*, 35, June 1878, pp.352ff.

MURARO 1978 M. Muraro, 'Palazzo Chiericati "Villa Marittima"', *Arte veneta*, 32, 1978, pp.187–94.

MUSSINI 1991 M. Mussini, *Il trattato di Francesco di Giorgio Martini e Leonardo. Il Codice Estense restituito*, Parma, 1991.

NAGLER 1964 A.M. Nagler, *Theatre Festivals of the Medici, 1539–1637*, New Haven, 1964.

NAGLER 1835–52 G.K. Nagler, *Neues Allgemeines Künstler-Lexicon*, 25 vols, Leipzig, 1835–52.

NAGLER 1877–1920 —, *Die Monogrammisten und diejenigen bekannten und unbeckannten Künstler aller Schulen*, 6 vols, Munich, 1877–1920.

NAPLES 1911 *Guida del Museo Nazionale di Napoli*, Naples, 1911.

NAPLES 1988 *Polidoro da Caravaggio fra Napoli e Messina*, catalogue of an exhibition held at the Galleria Nazionale di Capodimonte, Naples, 1988.

NAPLES 1989 Museo Nazionale, Naples, *Le collezione del Museo Nazionale di Napoli*, Rome, 1989.

NASH 1968 E. Nash, *A Pictorial Dictionary of Ancient Rome*, 2 vols, London, 1968.

NESSELRATH 1983 A. Nesselrath, 'Das Liller "Michelangelo" Skizzenbuch', *Kunstchronik*, 36, 1983, pp.46–7.

NESSELRATH 1984 —, 'Raffaello e lo studio dell'antico nel Rinascimento', *Raffaello architetto*, catalogue of an exhibition held at the Palazzo dei Conservatori, Rome, 1984, pp.381–422.

NESSELRATH 1986A —, 'I libri di disegni di antichità. Tentativo di una tipologia', *Memorie dell'antico nell'arte Italiana*, vol.III, Turin, 1986, pp.89–147.

NESSELRATH 1986B —, 'Raphael's Archaeological Method', *Raffaello a Roma. Il convegno di 1983*, Rome, 1986, pp.357–72.

NESSELRATH 1989A —, 'Giovanni da Udine disegnatore', *Bollettino Monumenti. Musei e Galleria Ponteficia*, 9, 1989, pp.237–91.

NESSELRATH 1989B —, 'MONUMENTA ANTIQUA ROMANA. Ein illustrierter Rom–Traktat des Quattrocento', *Antikenzeichnung und Antikenstudium in Renaissance und Frühbarock. Akten des International Symposions, 8–10 September 1982*, Mainz, 1989.

NESSELRATH 1992 —, 'Codex Coner–85 Years On. Cassiano dal Pozzo's Paper Museum', vol.II', *Quaderni puteani*, 3, 1992, pp.145–67.

NESSELRATH 1993 —, *Das Fossombroner Skizzenbuch*, London, 1993.

NETTO-BOL 1976 M.M.L. Netto-Bol, *The So-Called Maarten de Vos Sketchbook of Drawings After the Antique*, Kunsthistorische Studiën van het Nederlands Instituut te Rome, vol.IV, The Hague, 1976.

NEUFFORGE 1757–68 Le Sieur de Neufforge, *Recueil élémentaire d'architecture*, 8 vols., Paris 1757–68.

NEUFFORGE 1772–7 —, *Supplement*, 2 vols, Paris, 1772–7; reprinted Farnborough, 1967.

NEW YORK 1997A *Disegno. Italian Renaissance Designs for the Decorative Arts*, catalogue of an exhibition held at the Cooper-Hewitt Museum, New York, 1997.

NEW YORK 1997B *Filippino Lippi*, catalogue of an exhibition held at the Metropolitan Museum of Art, New York, 1997.

NIBBY 1834 A. Nibby, *Del monumento sepolchrale detto volgarmente degli Orazii e Curatii*, Rome, 1834.

NIBBY 1848–9 —, *Analisi storico-topografico antiquaria della carta de' dintorni di Roma*, 3 vols, Rome, 1848–9.

NICCO FASOLA 1942 G. Nicco Fasola, *Piero della Francesca. De prospectiva pingendi*, Florence, 1942; reprinted Florence, 1984.

NICOLÒ 1989 A. Nicolò, 'Il carteggio puteano. Richerche e aggiornamenti', *Cassiano dal Pozzo. Atti del seminario internazionale di studi, Naples, 18–19 dicembre 1987*, edited by F. Solinas, Rome, 1989, pp.14–24.

NOEHLES 1970 K. Noehles, *La chiesa di SS Luca e Martina*, Rome, 1970.

NOLHAC 1887 P. de Nolhac, *La Bibliothèque de Fulvio Orsini. Contributions à l'histoire des collections d'Italie et à l'étude de la Renaissance*, Paris, 1887.

NOLHAC & SOLERTI 1890 P. de Nolhac and A. Solerti, *Il viaggio in Italia di Enrico III, re di Francia*, Turin, 1890.

NORTHAMPTON 1978 *Antiquity in the Renaissance*, catalogue of an exhibition held at the Smith College Museum of Art, Northampton, MA, 1978.

NOTRE DAME 1970 *The Age of Vasari*, catalogue of an exhibition held at The Art Gallery, University of Notre Dame, IN, 1970.

NOVA 1988 A. Nova, *The Artistic Patronage of Pope Julius III (1550–1555). Profane Imagery and Buildings for the Del Monte Family in Rome*, London and New York, 1988.

NOVA 1984 —, 'The Chronology of the Del Monte Chapel in San Pietro in Montorio', *Art Bulletin*, 66, 1984, pp.150–54.

OBERHUBER 1966 K. Oberhuber, 'Observations on Perino del Vaga as a Draughtsman', *Master Drawings*, 4, 1966, pp.170–84.

OBERHUBER & WALKER 1973 K. Oberhuber and D. Walker, *Sixteenth Century Italian Drawings from the Collection of Janos Scholz*, catalogue of an exhibition held at the National Gallery of Art, Washington, DC, and the Pierpont Morgan Library, New York, 1973.

OECHSLIN 1971 W. Oechslin, 'Pyramide e sphère. Notes sur l'architecture révolutionnaire du XVIII siècle et ses sources Italiennes', *Gazette des beaux-arts*, 77, 1971, pp.201–38.

OECHSLIN 1982 —, 'Dinokrates. Legende und Mythos megalo-maner Architekturstiftung', *Daidalos*, 4, 1982, pp.7–25.

OGILVIE 1965 R.M. Ogilvie, *A Commentary on Livy Books 1–5*, Oxford, 1965.

OLIVATO 1970 L. Olivato, 'Profilo di Giorgio Vasari il Giovane', *Rivista dell'Istituto d'archeologia e storia dell'arte*, 18, 1970, pp.181–229.

OLIVATO 1975 —, 'Galeazzo Alessi e la trattatistica architettonica del Rinascimento', *Galeazzo Alessi e l'architettura del '500. Atti del Convegno, Genoa, 16–20 aprile 1974*, Genoa, 1975, pp.131–40.

OLIVATO 1977 —, 'I codici inediti di Giorgio Vasari il Giovane', *Atti e memorie della Accademia Petrarca di Lettere, Arti e Scienze, vol.xli: 1973–5*, Arezzo, 1977, pp.172–204.

OLIVATO 1978 —, 'Due codici "Veneti" cinquecenteschi d'architettura', *Arte veneta*, 32, 1978, pp.153–60.

OLIVATO 1980 —, 'Trattati inediti o poco noti sulla prospet-tiva e di architettura nelle biblioteche del Veneto', *Prospettiva rinascimentale. Codificazione e tragressioni*, edited by M. Dalai Emiliani, vol.1, Milan, 1980, pp.539–46.

OLSEN 1981 R.J.M. Olsen, 'Brunelleschi's Machines of Paradise and Botticelli's "Mystic Nativity"', *Gazette des beaux-arts*, 97, 1981, pp.183–8.

ONIANS 1988 J. Onians, *Bearers of Meaning. The Classical Orders in Antiquity, the Middle Ages and the Renaissance*, Princeton, 1988.

D'ONOFRIO 1965 C. D'Onofrio, *Gli obeliski di Roma*, Rome, 1965.

OSBORNE 1983 J. Osborne, 'The Earliest Antiquarian Description of Caracalla's Serapeum on the Quirinal Hill in Rome', *Échos du monde classique/Classical Views*, 2, 1983, pp.220–25.

PACE 1973 V. Pace, 'Contributo al catalogo di alcuni pittori dello studiolo di Francesco I', *Paragone*, no.285, 1973, pp.69–70.

PACCAGNINI 1960 G. Paccagnini *Mantova. Le arti*, vol.I, Mantua, 1960.

PACCIANI 1991 R. Pacciani, 'Nuove ricerche su Antonio da Sangallo il Vecchio a Arezzo e a Monte San Savino (1504–1532)', *Annali di architettura*, no.3, 1991, pp.40–57.

PACCIANI 1993 —, 'La costruzione della chiesa della Ssa Annunziata di Arezzo, 1491–1590', *La chiesa di Santissima Annunziata di Arezzo nel 500. centenario della costruzione. Atti del convegno di studi, Accademia Petrarca di Lettere, Arti e Scienze, Arezzo, 1990*, Città di Castello, 1993.

PADUA 1976 *Dopo Mantegna*, catalogue of an exhibition held at the Palazzo della Ragione, Padua, 1976.

PAGAN 1992 Hugh Pagan Ltd, *Catalogue No.15*, London, 1992.

PAGLIARA 1977 P.N. Pagliara, 'Un fonte di illustrazioni del Vitruvio di Fra Giocondo', *Ricerche di storia dell'arte*, 6, 1977, pp.113–20.

PAGLIARA 1986 —, 'Vitruvio da testo a canone', *Memorie dell'antico nell'arte italiana*, edited by S. Settis, vol.III, Turin, 1986, pp.7–82.

PAIS 1979 A.M. Pais, *Il podium del tempio del Divo Adriano a Piazza di Pietra in Roma*, Rome, 1979.

PALAU 1986 A. Palau, 'Les vicissitudes de la collection des manuscrits Grecs de Guillaume Pellicier', *Scriptorium*, 40/1, 1986, pp.32–53.

PALLADIO 1570 A. Palladio, *I quattro libri dell'architettura di Andrea Palladio*, Venice, 1570; anastatic reprint Milan, 1945.

PALLADIO 1573 —, *I commentari di Giulio Cesar*, Venice, 1573.

PANIMOLLE 1984 G. Panimolle, *Gli acquedotti di Roma antica*, Rome, 1984.

PANOFSKY 1943 E. Panofsky, *Albrecht Dürer*, 2 vols, Princeton, 1943.

PAOLETTI DI OSVALDO 1893 P. Paoletti di Osvaldo, *L'architettura e la scultura del Rinascimento in Venezia*, 2 vols, Venice, 1893.

PARIBENI 1929 R. Paribeni, 'La colonna Traiana in un codice del Rinascimento', *Rivista dell'Istituto di archeologia e storia dell'arte*, vol.A, 1929, pp.9–28.

PARIS 1922 Musée du Louvre, Cabinet des Dessins, *Les Dessins d'architecture au Musée du Louvre*, vol. I: *Ecole italienne*, Paris, 1922.

PARIS 1965-6 Petit Palais, *Le XVIIème siècle Européen. Peintures et dessins dans les collections publiques françaises*, Paris, 1965–6.

PARIS 1969 Frits Lugt Collection, Fondation Custodia, *Dessins des paysagistes hollandaises du XVII siècle*, catalogue of an exhibition held at the Institut Néerlandais, Paris, 1969.

PARIS 1972 *Dessins d'architecture du XVeme au XIXeme siècle dans les collections du Musée du Louvre*, catalogue of an exhibition held at the Cabinet des Dessins, Musée du Louvre, Paris, 1972.

PARIS 1975 Musée du Louvre, Cabinet des Dessins, *Dessins italiens de l'Albertina de Vienne*, Paris, 1975.

PARIS 1976 Musée du Louvre, Cabinet des Dessins, *Dessins du Musée des Beaux-Arts de Dijon*, Paris, 1976.

PARIS 1983 *Autour de Raphael. Dessins et peintures du Musée du Louvre*, catalogue of an exhibition held at the Musée du Louvre, Paris, 1983.

PARIS 1996 *Dessins vénitiens de la collection Frits Lugt*, catalogue of an exhibition held at the Frits Lugt Collection, Fondation Custodia, Paris, 1996.

PARKER 1956 K.T. Parker, *Catalogue of the Drawings in the Ashmolean Museum*, vol.II: *The Italian Schools*, Oxford, 1956.

PARMA ARMANI 1973 E. Parma Armani, '"La storia di Ester"' in un libro di schizzi di Giovanni Guerra', *Bollettino linguis-tico per la storia e la cultura regionale*, 4, 1973, pp.82–100.

PARSONS 1968 W.B. Parsons, *Engineers and Engineering in the Renaissance*, London, 1968.

PASQUALITTI 1978 M.G. Pasqualitti, 'La colonna Traiana e i disegni rinascimentali della BIASA. Il monumento traianeo ed il suo significato nei secoli', *Accademie e biblioteche d'Italia*, 46, 1978, pp.157–201.

PASQUI 1882 U. Pasqui, *Nuova guida di Arezzo e de' suoi dintorni*, Arezzo, 1882.

PASQUI & VIVIANI 1925 U. Pasqui and U. Viviani, *Arezzo e dintorni*, Arezzo, 1925.

PASSAVANT 1860-64 J.D. Passavant, *Le Peintre-graveur*, 6 vols in 3, Leipzig, 1860–64.

PASSERINI 1871 L. Passerini, *Geneologia e storia della famiglia Altoviti*, Florence, 1871.

PATETTA 1987 L. Patetta, *L'architettura del quattrocento a Milano*, Milan, 1987.

PAULY 1895 A.F. von Pauly, *Paulys Real-Encyclopädie der classischen Altertumswissenschaft*, edited by G. Wissowa, Stuttgart, 1895.

PAUWELS 1989 Y. Pauwels, 'Les origines de l'ordre composite', *Annali d'architettura*, no.1, 1989, pp.29–46.

PAVOLINO 1983 T. Pavolino, *Ostia*, Bari, 1983.

PEACOCK & WILLIAMS 1986 D.P.S. Peacock and D.F. Williams, *Amphorae and the Roman Economy. An Introductory Guide*, London and New York, 1986.

PECCHIAI 1944 P. Pecchiai, *Acquedotti e fontane di Roma*, Rome, 1944.

PEDRETTI 1978 C. Pedretti, *The Codex Atlanticus of Leonardo da Vinci. A Catalogue of Its Newly Restored Sheets*, New York, 1978.

PELLETIER 1974 A. Pelletier, *Vienne Gallo-Romaine au Bas Empire, 275–468 après J.-C. (Bulletin de la Société des amis de Vienne)*, Lyon, 1974.

PEPPER 1982 S. Pepper, 'The Underground Seige', *Fort*, 10, 1982, pp.31–8.

PEPPER & ADAMS 1986 S. Pepper and N. Adams, *Firearms and Fortifications. Military Architecture and Siege Warfare in Sixteenth-Century Siena*, Chicago and London, 1986.

PEPPER & HUGHES 1978 S. Pepper and Q. Hughes, 'Fortification in Late 15th-Century Italy. The Treatises of Francesco di Giorgio Martini', *British Archaeological Reports. Supplementary Series*, 41, 1978, pp.541–67.

PEREZ SANCHEZ 1972 A.E. Perez Sanchez, *Mostra di disegni spagnoli*, catalogue of an exhibition held at the Gabinetto Disegni e Stampe degli Uffizi, Florence, 1972.

PEREZ SANCHEZ 1986 —, *Historia del dibujo en España. De la edad media a Goya*, Madrid, 1986.

PÉROUSE DE MONTCLOS 1972 J.M. Pérouse de Montclos, editor, *Principes d'analyse scientifique. Architecture, methode et vocabulaire. Inventaire général des monuments et des richesse artistiques de la France*, 2 vols, Paris, 1972.

PERRAT & TRICOU 1956 C. Perrat and J. Tricou, *Souvenirs de voyages en Italie et en Orient. Notes historiques, pièces de vers*, Travaux d'Humanisme et Renaissance, 23, Geneva, 1956.

PHILLIPS 1990 *Old Master Drawings. To Include an Important Group of Drawings from the Pozzo/Albani Collection*, 2 vols, catalogue of a sale held at Phillips, London, 12 December 1990. (There is a complete set of photographs of both Sterling Maxwell albums in the Photographic Collection of the Warburg Institute, London.)

PHILO 1974 Philo, *Pneumatica*, edited by F.D. Prager, Wiesbaden, 1974.

PICARD 1938A C. Picard, 'La génie aux griffons et aux dauphins', *Bulletin de la Société d'archéologie d'Alexandrie*, 32/11, 1938, p.17ff.

PICARD 1938B —, 'Néréides et Sirènes. Observations sur le folklore hellénique de la mer', *Annales de l'École des Hautes Études de Gand*, 2, 1938, pp.127–53.

PICCARD 1961-87 G. Piccard, *Die Wasserzeichenkartai Piccard in Hauptstaatsarchiv Stuttgart*, 15 vols, Stuttgart, 1961–87.

PIERI 1990 S. Pieri, 'L'altare maggiore nella chiesa della SS Annunziata', *Notiziario turistico Arezzo*, 15/163–4, 1990, pp.13–14.

PIERI 1993 —, 'La Compagnia della SS Annunziata dal XIV–XVIII secolo', *La chiesa di Santissima Annunziata di Arezzo nel 500.o della costruzione. Atti del convegno di studi. Accademia Petrarca di Lettere, Arti e Scienze, Arezzo, 1990*, Città di Castello, 1993, pp.23–58.

PIERI & ROMANELLI 1981 S. Pieri and G. Romanelli, *Sub tutela Matris*, catalogue of an exhibition held in Arezzo, 1981.

PILLSBURY 1967 E. Pillsbury, 'Drawings by Vasari and Borghini for the *Apparato* in Florence in 1565', *Master Drawings*, 5, 1967, pp.281–3.

PILLSBURY 1969 —, 'The Temporary Façade on the Palazzo Ricasoli. Borghini, Vasari and Bronzino', *Report and Studies in the History of Art. National Gallery of Art*, 1969, pp.75–83.

PILLSBURY 1969-70 —, 'An Unknown Project for the Palazzo Vecchio Courtyard', *Mitteilungen des Kunsthistorischen Institutes in Florenz*, 14, 1969–70, pp.57–66.

PILLSBURY 1972 —, 'Vasari and His Time', *Master Drawings*, 11, 1973, pp.171–5 (review of Monbeig Goguel 1972).

PILLSBURY 1973A —, *Jacopo Zucchi. His Life and Works*, PhD dissertation, 4 vols, Courtauld Institute of Art, University of London, 1973.

PILLSBURY 1973B —, Vincenzo Borghini as a Draughtsman', *Bulletin of Yale University Art Gallery*, 34, 1973, pp.6–11.

PILLSBURY 1974 —, 'Drawings by Jacopo Zucchi', *Master Drawings*, 12, 1974, pp.3–33

PILLSBURY 1976 —, 'The *Sala Grande* Drawings by Vasari and His Workshop. Some Documents and New Attributions', *Master Drawings*, 14, 1976, pp.127–46.

PILLSBURY 1978 —, 'Vasari's Staircase in the *Palazzo Vecchio*', *Collaboration in Italian Renaissance Art. In Memoriam Charles Seymour Jr*, New Haven and London, 1978, pp.125–41.

PINAROLI 1703 Pinaroli, *Trattato delle cose piu memorabili di Roma, tanto antiche come moderne con l'eruditioni di alcuni statue, e bassi rilievi, palazzi, chiese di detta città*, Rome, 1703 (first edition, 1700).

PINELLI & ROSSI 1971 A. Pinelli and O. Rossi, *Genga architetto. Aspetti della cultura urbinate del primo '500*, Rome, 1971.

PIRANESI 1748 G.B. Piranesi, *Le vedute di Roma*, Rome, 1748.

PIRANESI 1756 —, *Le antichità romane*, Rome, 1756.

PIRANESI 1761 —, *Della magnificenza ed architettura de' Romani*, Rome, 1761.

PIRANESI 1762 —, *Il campo Marzo dell'antica Roma*, Rome, 1762.

PIRANESI 1764 —, *Antichità d'Albano e di Castel Gandolfo*, Rome, 1764.

PIRANESI 1774-9 —, *Trofeo o sia magnifica Colonna Coclide di marmo composta di grossi macigni ove si veggono scolpite le due guerre daciche fatte da Trajano inalzata nel mezzo del gran foro eretto al medesimo imperadore per ordine del senato e popolo romano doppo i suoi trionfi*, Rome, 1774-9.

PIRANESI 1778 —, *Vasi, candelabri, cippi, sarcofagi, tripodi, lucerni ed ornamenti antichi*, Rome, 1778.

PIRINA 1986 C. Pirina, *Le vetrate del Duomo di Milano dai Visconti agli Sforza*, Milan, 1986, pp.119-63.

PISA 1980 *Livorno e Pisa. Due città e un territorio nella politica dei Medici*, catalogue of an exhibition held in Pisa, 1980.

PISTOIA 1980 *Pistoia. Una città nello stato Mediceo*, catalogue of an exhibition held in Pistoia, 1980.

PLANISCIG 1926 L. Planiscig, *Andrea Riccio*, Vienna, 1926.

PLATNER 1929 S.B. Platner, *A Topographical Dictionary of Ancient Rome, Completed and Revised by Thomas Ashby*, Oxford, 1929; reprinted Rome, 1965.

PLUCHART 1889 H. Pluchart, *Notice des dessins, cartons, pastel miniatures et grisailles*, Musée Wicar, Lille, 1889.

PLUMIER 1701 C. Plumier, *L'Art de tourner en perfection par Le P.C. Plumier*, Lyon, 1701.

POCHAT 1980 G. Pochat, 'Architectural Drawings with Scenographic Motifs from Northern Italy, 1500-1510', *Prospettiva rinascimentale. Codificazioni e trasgressioni*, edited by M. Dalai Emiliani, vol.I, Milan, 1980, pp.267-79.

POLACCO 1978 R. Polacco, *Il mausoleo di S. Costanza*, Padua, 1978

POLENI 1739-41 G. Poleni, *Exercitationes Vitruvianae primae; hoc est. J. Poleni commentarius criticus de M. Vitruvii Pollionis*, 3 vols, Padua, 1739-41.

POLI ET AL. 1973 A. Poli et al., *Il recupero di un monumento a Firenze*, Florence, 1973.

POMPONI 1991-2 M. Pomponi, 'La colonna traiana nelle incisioni di P.S. Bartoli. Contributi allo studio del monumento nel XVII secolo', *Rivista dell'istituto d'archeologia e storia dell'arte*, series III, 1991-2, pp.347-77.

POMPONI 1993 —, 'Il restauro seicenteso della Piramide Cestia. Ricerche antiquarie e fortuna delle pitture', *Xenia antiqua*, 2, 1993, pp.149-74.

POPE HENNESSY 1969 J. Pope Hennessy, *Paolo Uccello*, second edition, London, 1969.

POPE HENNESSY 1970 —, *Italian High Renaissance and Baroque Sculpture*, London, 1970.

POPE HENNESSY 1980 —, *The Study and Criticism of Italian Sculpture*, New York, 1980.

POPHAM 1932 A.E. Popham, *Catalogue of the Drawings by Dutch and Flemish Artists in the British Museum*, London, 1932.

POPHAM 1950 —, 'An Unknown Drawing by Dürer', *Art Quarterly*, 13, 1950, p.338.

POPHAM & POUNCEY 1950 A.E. Popham and P. Pouncey, *Italian Drawings in the Department of Prints and Drawings of the British Museum*, London, 1950.

POPHAM & WILDE 1949 A.E. Popham and J. Wilde, *The Italian Drawings of the XV and XVI Centuries in the Collection of His Majesty the King at Windor Castle*, London, 1949.

PORTOGHESI 1973 P. Portoghesi, *Roma barocca*, 1966; reprinted Bari, 1973.

PORTOGHESI 1982 —, *Borromini nella cultura europea*, 1964; reprinted Rome, 1982.

POUNCEY 1964 P. Pouncey, 'Bernard Berenson. I disegni dei pittori fiorentini', *Master Drawings*, 2, 1964, pp.278-92.

POUNCEY & GERE 1962 P. Pouncey and J.A. Gere, *Italian Drawings in the Department of Prints and Drawings of the British Museum. Raphael and His Circle*, 2 vols, London, 1962.

POUNCEY & GERE 1983 —, *Italian Drawings in the Department of Prints and Drawings of the British Museum. Artists*

Working in Rome, c.1550-c.1640, London, 1983.

POZZO 1700 A. Pozzo, *Prospettiva de' pittori e architetti*, Rome, 1700.

PRACCHI 1991 V. Pracchi, 'La raccolta Martinelli al Castello Sforzesco di Milan', *Il disegno di architettura*, no.4, 1991, pp.9-23; and Bedon pp.29-33.

PRAGER & SCAGLIA 1972 F.D. Prager and G. Scaglia, *Mariano Taccola and His Book De ingeneis*, Cambridge, MA, 1972.

PRAGER, SCAGLIA & MONTAG 1984 F.D. Prager, G. Scaglia and U. Montag, editors, *Mariano Taccola. De ingeneis, Books I and II. On Engines and Addenda (The Notebook)*, 2 vols, Wiesbaden, 1984.

PRANDI 1942-3 A. Prandi, 'Osservazioni su S. Costanza', *Pontificia Accademia Romana d'Archeologia. Rendiconti*, 19, 1942-3, pp.281-304.

PROCACCI 1969 U. Procacci, 'L'architettura nell'Aretino. Il medio e il tardo Rinascimento', *L'architettura nell'Aretino. Atti del XII Congresso di storia dell'architettura, Arezzo, 1961*, Rome, 1969, pp.123-151.

PROCOPIUS 1905-13 Procopius, *Procopii Ceasariensis opera omnia*, edited by J. Haury, 3 vols, Leipzig, 1905-13.

PROFUMO 1992 R. Profumo, *Tratatto prattico di prospettiva di Ludovico Cardi, detto Cigoli. Manoscritto ms 2660a del Gabinetto dei Disegni e delle Stampe degli Uffizi*, Rome, 1992.

PROMIS 1841 C. Promis, *Dell'arte dell'ingegnere e dell' artiglieria in Italia dalla sua origine sino al principio del XVI secolo. Memorie storiche*, 2 vols, Turin, 1841.

PROMIS 1874 —, 'Biografie di ingegnieri militari italiani', *Miscellanea di storia italiana*, vol.XIV, Turin, 1874, pp.575ff.

PRZYBOROWSKI 1982 C. Przyborowski, *Die Ausstattung der Fürstenkapelle an der Basilika von San Lorenzo in Florenz*, doctoral dissertation, Technische Universität, Berlin, 1982.

PUPPI 1971 L. Puppi, *Michele Sanmicheli, architetto di Verona*, Padua, 1971.

PUPPI 1978 —, 'Maestro J. Francesco Fortuna Padoano ditto el Sole, architetto', *Bollettino del Museo Civico di Padova*, 67, 1978, pp.43-58.

PUPPI 1987 —, 'Il problema dell'eredità di Baldassare Peruzzi. Jacopo Meleghino, il "mistero" di Francesco Sanese e Sebastiano Serlio', *Baldassare Peruzzi. Pittura, scena e architettura nel cinquecento*, edited by M. Fagiolo and M.L. Madonna, Rome, 1987, pp.491-501.

QUILICI 1968 L. Quilici, 'La valle della Caffarella e il Triopio di Ercole Attico', *Capitolium*, 63/9-10, 1968, pp.329ff.

QUILICI 1972 —, 'Antichità della campagna romana, 5. La tomba di Cecilia Metella', *Bullettino della unione storia ed arte*, 15, 1972, pp.34-40.

QUILICI 1977A —, *La via Appia*, Rome, 1977.

QUILICI 1977B —, *La via Prenestina*, Rome, 1977.

QUILICI 1978 —, *La via Latina da Roma a Castel Savelli*, Rome, 1978.

RADI 1619-40 B. Radi, *Disegni varii di deposti o sepulcri*, 2 vols, Rome, 1619-40.

RAKOB 1973 F. Rakob, *Der Rundtempel am Tiber in Rom*, Mainz, 1973.

RAMELLI 1588 A. Ramelli, *Le diverse et artificiose machine*, Paris, 1588.

RAMELLI 1976 A. Ramelli, *Le diverse et artificiose machine*, Paris, 1588; as *The Various and Ingenious Machines of Agostino Ramelli*, edited by M. Teach Gnudi, Baltimore and London, 1976.

RASCH 1984 J.J. Rasch, *Das Maxentius-Mausoleum an der Via Appia in Rom*, Mainz, 1984 (for reviews, see Tolotti 1984 and Frazer 1986).

RASCH 1993 —, *Das mausoleum bei Tor de' Schiavi in Rom*, Mainz, 1993.

RAVELLI 1978 L. Ravelli, *Polidoro Caldara da Caravaggio*, 2 vols, Bergamo, 1978.

RAYMOND & SCHRODER 1974 V. Raymond and S.J. Schroder, 'Graeco Roman Antipolis on the French Riviera', *Antipolis. A Journal of Mediterranean Archaeology*, 1, 1974, pp.1-6.

REDIG DE CAMPOS 1967 D. Redig de Campos, *I palazzi Vaticani*, Bologna, 1967.

REEDER 1992 J.C. Reeder, 'Typology and Idealogy in the

Mausoleum of Augustus', *Tumulus and Tholos*, 2, 1992, pp.265-307.

REGGIORI 1970 F. Reggiori, *L'Abbazia di Chiaravalle*, Milan, 1970.

REINACH 1902 S. Reinach, *L'album de Pierre Jacques, sculpteur de Reims dessiné a Rome de 1572 à 1577*, Paris, 1902.

RENNES 1990 *Disegno. Les Dessins italiens du Musée de Rennes*, catalogue of an exhibition held at the Musée des Beaux-Arts, Rennes, 1990 (contains an inventory of the collection edited by P. Ramade).

REPETTI 1833-46 E. Repetti, *Dizionario geografico fisico storico della Toscana*, 6 vols, Florence, 1833-46.

RESPIGHI 1933 L. Respighi, 'Rinvenimento di antichi frammenti nel pavimento della basilica Vaticana', *Rendiconti della Pontificia Accademia Romana di Archeologia*, 9, 1933, pp.119-27

RESTORELLI 1989 R. Restorelli, 'Notizie istoriche spettanti alla nobil terra di Montesansavino ed agli eccellenti personaggi', published in 'Architettura a Monte San Savino', *Quaderni savinesi*, 2, 1989, pp.21-37.

RETI 1963 L. Reti, 'Francesco di Giorgio Martini's Treatise on Engineering and Its Plagiarists', *Technology and Culture*, 4/3, 1963, pp.287-98.

RETI 1974 —, *Leonardo da Vinci. The Madrid Codices*, 5 vols, New York, 1974.

RICCI 1929 C. Ricci, *Il mercato di Traiano*, Rome, 1929.

RICCY 1787 G. Riccy, *Memorie storiche dell'antichissima città di Alba Longa e dell'Albano moderno*, Rome, 1787.

RICHA 1754-62 G. Richa, *Notizie istoriche delle chiese fiorentine divise ne' suoi quartieri*, 10 vols, Florence, 1754-62.

RICHARDSON 1830 C.J. Richardson, *Manuscript Catalogue of the Sir John Soane's Library*, 1830.

RICHARDSON 1992 L. Richardson, Jr, *A New Topographical Dictionary of Ancient Rome*, Baltimore, 1992.

RICHTER 1898 O. Richter, 'Der Castortemple am Forum Romanum', *Jahrbuch des Deutschen Archäologischen Instituts*, 13, 1898, pp.87-114.

RIGGS 1977 T.A. Riggs, *Hieronymous Cock, Printmaker and Publisher*, New York and London, 1977.

RINGBECK 1989 B. Ringbeck, *Giovanni Battista Soria. Architekt Scipione Borgheses*, Münster, 1989.

RIPOSTELLI 1904 G. Ripostelli, *La via Appia dalla Porta Capena al grande sepolcro dei Missala e cotta al V miglio*, Rome, 1904.

RIPOSTELLI & MARUCCHI 1908 G. Ripostelli and H. Marucchi, *Via Appia à l'époque Romaine et de nos jours. Histoire et description*, Rome, 1908; reprinted Amsterdam, 1967.

RIVOIRA 1921 G.T. Rivoira, *Architettura romana*, Milan, 1921.

ROBERT 1890-1919 C. Robert, *Die antiken Sarcophagereliefs*, vol.II: *Mythologische Cyklen*, 1890; vol.III: *Einzel Mythen*, 3 vols, DAI, Berlin, 1897-1919.

ROBERTSON 1993 C. Robertson, 'Bramantino. Prospectivo melanese depictore', *Giovanni Antonio Amadeo: scultura e architettura del suo tempo*, edited by J. Shell and L. Castelfranchi, Milan, 1993, pp.377-93.

ROCA DE AMICIS 1985 A. Roca de Amicis, 'Il "Discorso…nel disegnare et edificare le chiese" di Domenico Tibaldi', *Storia architettura. Rivista d'architettura e restauro*, 8, 1985, pp.43-54.

RODAKIEWICZ 1940 E. Rodakiewicz, 'The *editio princeps* of Roberto Valturio's *De re militari* in Relation to the Dresden and Munich Manuscripts', *Maso Finiguerra*, 1940, pp.15-81.

RODRIGUEZ ALMEIDA 1981 E. Rodriguez Almeida, *Forma urbis marmoreo. Aggiornamento generale 1980*, Rome, 1981.

ROFFET, NO DATE J. Roffet, *C'est l'ordre qui a été tenu la nouvelle e joyeuse entrée que très hault, très excellent et très puissant prince, le roy.henry deuzième… Paris MXXLIX, A Paris chez Jacques Roffet dict le Faulcheur*, n.d.

ROISECCO 1745 Roisecco, *Roma antica e moderna*, Rome, 1745.

ROISECCO 1765-6 —, *Roma antica e moderna*, Rome, 1765-6.

ROME 1956 *Mostra di disegni dell'Istituto Nazionale di Archeologia e Storia dell'Arte*, catalogue of an exhibition held at Palazzo Braschi, Rome, 1956.

ROME 1978 *Catalogue no.3*, Catalogue of an exhibition held at Galleria Arco Farnese, Rome, 1978.

ROME 1979 Museo Nazionale Romano, *Le sculture*, edited by A. Giuliano, vol.I/1, Rome, 1979.

ROME 1981A *Gli affreschi di Paolo III a Castel Sant'Angelo, 1543–1548*, catalogue of an exhibition held at Castel S. Angelo, Rome, 1981.

ROME 1981B *Le palais Farnèse. L'Ecole française de Rome*, 3 vols, Rome, 1981.

ROME 1981C Museo Nazionale Romano, *Le sculture*, edited by A. Giuliano, vol.I/2, Rome, 1981.

ROME 1982A *L'imagine di San Francesco nella Contrariforma*, catalogue, Rome, 1982.

ROME 1982B Museo Nazionale Romano, *Le sculture*, edited by A. Giuliano, vol.I/3, Rome, 1982.

ROME 1983A *Disegni dall'antico dei secoli XVI e XVII*, catalogue of an exhibition held at the Gabinetto Nazionale di Disegni e Stampe, Rome, 1983.

ROME 1983B Museo Nazionale Romano, *Le sculture*, edited by A. Giuliano, vol.I/4 and 5, Rome, 1983.

ROME 1984A *Raffaello architetto*, catalogue of an exhibition held at the Museo de' Conservatori, Rome 1984.

ROME 1984B Museo Nazionale Romano, *Le sculture*, edited by A. Giuliano, vol.I/7.1 and 7.2, Rome, 1984.

ROME 1984C *Villa Giulia*, catalogue of an exhibition held at the Chiesa di S. Rita, Rome, 1984.

ROME 1985 Museo Nazionale Romano, *Le sculture*, edited by A. Giuliano, vols I/8.1 and I/8.2, Rome, 1985.

ROME 1986A *Disegni italiani del tempo di Pisanello*, catalogue of an exhibition held at the Gabinetto Nazionale di Disegni e Stampe, Rome, 1986.

ROME 1986B Museo Nazionale Romano, *Le sculture*, edited by A. Giuliano, vol.I/6, Rome, 1987.

ROME 1987 Museo Nazionale Romano, *Le sculture*, edited by A. Giuliano, vol.I/9, Rome, 1987.

ROME 1988A *Da Pisanello alla nascita dei Musei Capitolini. L'antico a Roma alla vigilia del Rinascimento*, catalogue of an exhibition held at the Musei Capitolini, Rome, 1988.

ROME 1988B *Il fregio della Colonna Trajana e gli artisti francesi da Luigi XVI a Napoleone I*, catalogue of an exhibition held at the Accademia della Francia, Rome, 1988.

ROME 1988C Museo Nazionale Romano, *Le sculture*, edited by A. Giuliano, vol.I/10, Rome, 1988.

ROME 1991 Museo Nazionale Romano, *Le sculture*, edited by A. Giuliano, vol.I/11, Rome, 1991.

ROME 1992 *Da van Heemskerck a van Vittel. Disegni fiaminghi e olandesi del XVI–XVII secolo dalle collezioni del Gabinetto dei Disegni e delle Stampe*, catalogue of an exhibition held at Noorbrabants Museum, S'-Hertegenbosch, and at the Istituto Nazionale per la Grafica, Gabinetto Nazionale Disegni e Stampe, Rome, 1992.

ROSEMBERG & PRAT 1994 P. Rosemberg and L.-A. Prat, *Nicolas Poussin, 1594–1665. Catalogue raisonné des dessins*, 2 vols, 1994.

ROSENAUER 1972 A. Rosenauer, 'Eine nicht zur Ausführung gelangter Entwurf Domenico Ghirlandaios für die Capella Sassetti', *Weiner Jahrbuch für Kunstgeschichte*, 25, 1972, pp.187–96.

ROSENAUER 1993 —, *Donatello*, Milan, 1993.

ROSENFELD 1989 M.N. Rosenfeld, 'From Drawn to Printed Model Book. Jaques Androuet Du Cerceau and the Transmission of Ideas from Designer to Patron, Master Mason and Architect in the Renaissance', *Revue d'art canadienne/Canadian Art Review*, 16/2, 1989, pp.131–46.

ROSENTHAL 1962 E. Rosenthal, 'The House of Andrea Mantegna in Mantua', *Gazette des beaux-arts*, 60, 1962, pp.327–48.

RÖTHLISBERGER 1957 M. Röthlisberger, 'Un libro inedito del Rinascimento lombardo con disegni architettonici', *Palladio. Rivista di storia dell'architettura*, nos 2–3, 1957, pp.95–100.

ROTILI 1985 M. Rotili, *Benevento romano e longobardo*, 1985.

ROTONDI 1970 P. Rotondi, *Francesco di Giorgio nel Palazzo Ducale di Urbino*, Novilara, 1970.

ROTUNDO 1980 F. Rotundo, 'Architettura religiosa nel territorio senese e grossetano negli anni 1555–1609', *I Medici*

e lo stato Senese, 1555–1609. Storia e territorio, catalogue of an exhibition held in Siena, 1980.

ROULLET 1972 A. Roullet, *The Egyptian and Egyptianising Monuments of Imperial Rome*, Leiden, 1972.

ROUSSELLE 1976 A. Rousselle, 'Un nouveau plan moderne d'Antibes. L'enceinte Romaine et L'amphithéâtre', *Revue archéologique de Narbonnaise*, 9, 1976, pp.143–56.

ROVETTA 1986 A. Rovetta, 'Cultura architettonica e cultura umanista a Milano durante il soggiorno di Bramante. Note sullo studio dell'antico', *Arte lombarda*, no.78, 1986, pp.81–93.

ROVETTA 1993 —, 'La cultura antiquaria a Milano negli anni settanta del quattrocento', *Giovanni Antonio Amadeo. Scultura e architettura del suo tempo*, edited by J. Shell and L. Castelfranchi, Biblioteca dell'Archivio Storico Lombardo, Milan, 1993, pp.323–420.

ROY 1929 M. Roy, 'Collaboration de Philibert de Lorme aux préparatifs de l'entrée de Henry II à Paris et du sacre de Cathérine de Médicis en 1549', *Artistes et monuments de la Renaissance en France. Recherches nouvelles et documents inédits*, vol.I, edited by M. Roy, 1929, pp.183–390.

RUGGIERI 1987 G.F. Ruggieri, 'Il tempio di Portumno nel Foro Boario', *Bollettino della unione storia ed arte*, 30, 1987, pp.16–22.

RUMPF 1939 A. Rumpf, *Die Meerwesen auf den antiken Sarkophag-reliefs*, Berlin, 1939.

RYKWERT 1988 J. Rykwert, 'On the Oral Tradition of Architectural Theory', *Les Traités d'architecture de la renaissance. Actes du colloque, Tours, 1–11 juillet 1981*, Paris, 1988, pp.31–48.

RYKWERT & ENGEL 1994 J. Rykwert and A. Engel, editors, *Leon Battista Alberti*, catalogue of an exhibition held at the Palazzo del Te, Mantua, 1994.

SAALMANN 1993 H. Saalmann, *Filippo Brunelleschi. The Buildings*, London, 1993.

SABATELLI ET AL. 1992 F. Sabatelli *et al.*, *La cornice italiana dal Rinascimento al Neoclassico*, Milan, 1992.

SABBADINI 1931 R. Sabbadini, *Carteggio di Giovanni Aurispa*, Rome, 1931.

SABBATINI 1955 N. Sabbatini, *Pratica di fabricar scene e machine ne' teatri*, edited by E. Povoledo, Rome, 1955 (first edition, Pesaro, 1638).

SACRIPANTI 1965-6 M. Sacripanti, 'Il mausoleo di S. Costanza in Roma', *L'architettura. Cronache e storia*, 2, 1965–6, pp.750–57.

SALERNO ET AL. 1973 A. Salerno et al., *Via Giulia*, Rome, 1973.

SALMI 1916 M. Salmi, *Elenco degli edifici monumentali*, vol.XXXVI: *Provincia di Arezzo*, Rome, 1916.

SALMI 1951 —, *La basilica di San Salvatore di Spoleto*, Florence, 1951.

SALMI 1961 —, *Chiese romaniche della Toscana*, Milan, 1961.

SALMI 1971 —, *Civiltà artistica della terra aretina*, Novara, 1971.

SALVAGNINI 1978 G. Salvagnini, 'Giorgio Vasari il Giovane, architetto o cortigiano', *Granducato*, 10, 1978, pp.33ff.

SALVAGNINI 1983 —, *Gherardo Mechini architetto di sua altezza*, Florence, 1983.

SALVESTRINI 1969-74 A. Salvestrini, editor, *Pietro Leopoldo. Relazioni sul governo della Toscana*, 3 vols, Florence, 1969–74.

SALVIATI 1552 G. Salviati, *Regola di far perfettamente col compasso la voluta et del capitello Ionico et ogni altra sorte*, Venice, 1552.

SANDKLEFF & SELLING 1976 A. Sandkleff and D. Selling, 'The Heating of Classical Thermae', *Opuscula Romana*, 11, 1976, pp.123–5.

SANDRAERT 1684 J. Sandraert, *Romae antiquae et nova theatrum*, Nurnberg, 1684.

SASLOW 1996 J.M. Saslow, *Florentine Festival as Theatrum Mundi. The Medici Wedding of 1589*, New Haven and London, 1996.

SATKOWSKY 1979 L.G. Satkowsky, *Studies on Vasari's Architecture*, New York and London, 1979.

SATKOWSKY 1985 —, 'The Palazzo Del Monte in Monte San Savino and the Codex Geymüller', *Renaissance Studies in Honor of Craig Hugh Smyth*, 2 vols, 1985, pp.635–60.

SATKOWSKY 1993 —, *Giorgio Vasari, Architect and Courtier*, Princeton, 1993.

SAUNIER 1902 C. Saunier, *Les Conquêtes artistiques de la Révolution et de l'Empire. Reprise et abandons des Alliés en 1815, leurs conséquences sur les musées d'Europe*, Paris, 1902.

SAXL 1940-41 F. Saxl, 'The Classical Inscription in Renaissance Art and Politics. Bartolomaeus Fontius. *Liber monumentorum romanae urbis et aliorum locorum*', *Journal of the Warburg Institute*, 4, 1940–41, pp.19–46.

SBARDELLA 1922 A. Sbardella, *Il Lazio primitivo e l'ager praenestinus*, Rome, 1922.

SCAGLIA 1970 G. Scaglia, 'Fantasy Architecture of *Roma antica*', *Arte lombarda*, no.15, part 2, 1970, pp.9–24.

SCAGLIA 1971 —, *Mariano Taccola. De machinis. An Engineering Treatise of 1449. Facsimile of Codex Latinus Monacensis, 28 800 in the Bayerische Staatsbibliothek, München*, 2 vols, Weisbaden, 1971.

SCAGLIA 1978 —, 'Architectural Drawings by Giovanbattista Alberti in the Circle of Francesco di Giorgio Martini', *Architectura*, no.8, 1978, pp.104–24.

SCAGLIA 1980 —, 'Autour de Francesco di Giorgio Martini, ingénieur e dessinateur', *Revue de l'art*, 48, 1980, pp.7–25.

SCAGLIA 1981 —, *Alle origini degli studi tecnologici di Leonardo (Lettura Vinciana, XX; Vinci, 20 April 1980)*, Florence, 1981.

SCAGLIA 1991 —, 'The 'Sepolcro dorico' and Bartolomeo de Rocchi da Brianza's Drawing of it on the Aurelian Wall Between the Porta Flaminia and the Tiber River', *Arte lombarda*, nos 96–7, 1991, pp.107–16.

SCAGLIA 1991-2 —, 'Drawings of "Roma antica" in a Vitruvius edition of the Metropolitan Museum of Art, Part I', *Römisches Jahrbuch der Biblioteca Hertziana*, 27/8, 1991–2, pp.61–136 (for part II, see Scaglia 1994).

SCAGLIA 1992A —, 'The Etruscology of Sienese and Florentine Artists and Humanists. Antonio da Sangallo il Giovane, Baldassare Peruzzi, Sallustio Peruzzi and Cosimo Bartoli', *Palladio*, no.10, 1992, pp.21–36.

SCAGLIA 1992B —, *Francesco di Giorgio. Checklist and History of Manuscripts and Drawings in Autographs and Copies from ca.1470–1687 and Renewed Copies (1764–1839)*, London and Toronto, 1992.

SCAGLIA 1992C —, 'Il frontespizio di Nerone, la casa Colonna e la scala di età romana antica in un disegno nel Metropolitan Museum di New York', *Bollettino d'arte*, no.72, 1992, pp.35–62.

SCAGLIA 1992-3 —, 'Drawings of the Roman Antiquities in the Metropolitan Museum and in the Album Houfe Ampthill', *Annali di architettura*, nos 4–5, 1992–3, pp.9–21.

SCAGLIA 1994 —, 'Catalogue of the Addenda Architect's Drawings. Drawings of the Same Site by Other Artists and Selected Bibliography', *Römische Jahrbuch der Biblioteca Hertziana*, no.29, 1994, pp.99–127 (for Part I, see Scaglia 1991–2).

SCAGLIA 1995 —, 'Eleven Facsimile Drawings of the Pantheon's Vestibule and the Interior in Relation to the Codex Escurialensis and Giuliano da Sangallo's Libro Drawings', *Architectura*, 25/1, 1995, pp.9ff.

SCAMOZZI 1615 V. Scamozzi, *L'idea della architettura universale*, Venice, 1615; anastatic reprint Bologna, 1982.

SCHILLING 1970 E. Schilling, *The German Drawings in the Collection of HM the Queen at Windsor (Appendix, 'Italian Drawings')*, London and New York, 1970.

SCHAEFER 1981 S. Schaefer, 'The Invention of Gunpowder', *Journal of the Warburg and Courtauld Institutes*, 44, 1981, pp.209–11.

SCHEDEL 1493 H. Schedel, *De hystoriis etatum mundi*, Nurnberg, 1493.

SCHIAPARELLI 1983 A. Schiaparelli, *La Casa Fiorentina e i suoi arredi nei secoli XIV e XV*, Florence, 1983.

SCHMIDT 1970 W. Schmidt, editor, *Dialoge, Kopie, Variation und Metamorphose alter Kunst in Graphik und Zeichnungen van 15 Jahrhundert bis zur Gegenwart*, Kupferstich-Kabinett, Staatlichen Kunstsammlungen, Dresden, 1970.

SCHMITT 1974 A. Schmitt, 'Zur Wiederbelebung der Antike

im Trecento', *Mitteilungen des Kunsthistorischen Institutes in Florenz*, 18, 1974, pp.167–288.

SCHOFIELD 1980 R.V. Schofield, 'Giovanni da Tolentino Goes to Rome. A Description of the Antiquities of Rome in 1490', *Journal of the Warburg and Courtauld Institutes*, 43, 1980, pp.246–56.

SCHOFIELD 1982 —, 'Ludovico il Moro and Vigevano', *Arte lombarda*, no.62, 1982, pp.93–140.

SCHOFIELD 1986 —, 'Bramante and Amadeo at Santa Maria delle Grazie in Milan', *Arte lombarda*, no.78, 1986, pp.41–58.

SCHOFIELD 1989 —, 'Florentine and Roman Elements in Bramante's Milanese Architecture', *Florence and Milan. Comparisons and Relations. Acts of Two Conferences Held at Villa I Tatti, Florence, 1982 and 1984*, edited by S. Bertelli, N. Rubinstein and H.C. Smyth, Florence, 1989, pp.201–22.

SCHOFIELD 1992 —, 'Avoiding Rome. An Introduction to Lombard Sculptors and the Antique', *Arte lombarda*, no.100, 1992, pp.29–44.

SCHOFIELD 1993 —, 'Amadeo's System', *Giovanni Antonio Amadeo: scultura e architettura del suo tempo*, edited by J. Shell and L. Castelfranchi, Milan, 1993, pp.125–56.

SCHOLTEN 1904 H.J. Scholten, *Musée Teyler à Haarlem. Catalogue raisonné des dessins des écoles française et hollandaise*, Haarlem, 1904.

SCHREIBER 1880 T. Schreiber, *Die antiken Bildwerke der Villa Ludovisi*, Leipzig, 1880.

SCHREIBER 1885 —, 'Das neapler Diarium des Cassiano dal Pozzo', *Berichte der Königlich sächsasischen Akademie der Wissenschaften (Phil.–Hist. Classe)*, 36, 1885, pp.93–118.

SCHROTER 1987-8 E. Schroter, 'Eine unveröffentlichte Sueton-Handschrift in Göttingen aus dem Atelier des Bartolomeo Sanvito. Aur Sueton-Illustration des 15 Jahrhunderts in Padua und Rom', *Jahrbuch der Berliner Museen*, 29, 1987–8, pp.71–121.

SCHULZ 1961 J. Schulz, 'Vasari at Venice', *Burlington Magazine*, 103, 1961, pp.500–11.

SCHUMACHER 1987 W.N. Schumacher, 'Die Konstantinischen Esedra–Basiliken', *Die Katakomben 'Santi Marcellino e Pietro'. Repertorium der Malereien*, edited by J.G. Deckers, H.R. Seeliger and G. Mietke, Münster, 1987, pp.132–82.

SCHWEIKHART 1986 G. Schweikhart, *Der Codex Wolfegg. Zeichnungen nach der Antike von Amico Aspertini*, London, 1986.

SCORZA 1981 R.A. Scorza, 'Vincenzo Borghini and "invenzione". The Florentine "apparato" of 1565', *Journal of the Warburg and Courtauld Institutes*, 44, 1981, pp.57–75.

SCORZA 1984 —, 'A "modello" by Stradano for the "Sala di Penelope" in the Palazzo Vecchio', *Burlington Magazine*, 126, 1984, pp.433–7 (see also letter by T. Clifford, p.569).

SCORZA 1985 —, 'A New Drawing for the Florentine "Apparato"of 1565. Borghini, Butteri and the Tuscan Poets', *Burlington Magazine*, 127, 1985, pp.887–90.

SCORZA 1991 —, 'A Florentine Sketchbook. Architecture, Apparati and the Accademia del Disegno', *Journal of the Warburg and Courtauld Institutes*, 54, 1991, pp.172–85.

SCOTTI 1832-7 L. Scotti, 'Catalogo dei disegni originali di pittori, scultori ed architetti che si conservano nella Imperiale e Reale Galleria di Firenze', 1832–7 (manuscript catalogue).

SEBREGONDI 1986 L. Sebregondi, 'Francesco Buonarroti, cavaliere gerosolimitano e architetto dilettante', *Rivista d'arte*, 38, 1986, pp.49–86.

SEDLMAYR 1952 H. Sedlmayr, 'Fischer von Erlach und Bernini', *Das Münster*, 5, 1952, pp.267–73.

SENECAL 1990 R. Senecal, 'A Note on Daniele da Volterra's Capella Orsini in Santissima Trinità dei Monti and Its Impact on Sixteenth-Century Chapel Decoration', *Paragone*, new series, 41/23(487), 1990, pp.88–96.

SÉNÉCHAL 1996 P. Sénéchal, 'Le premier inventaire des antiques du Palais Farnèse', *Mélange de l'école française de Rome*, 108, 1996, pp.241–64.

SERENA 1927 A. Serena, 'Fra Giocondo Veronese', *Miscellanea di studi critici in onore di Vincenzo Crescini*, Cividale, 1927, pp.533–54.

SERLIO 1540 S. Serlio, *Architettura e prospettiva*, Venice, 1540.

SERLIO 1559 —, *Architettura e prospettiva*, Venice, 1559.

SERLIO 1584 —, *Architettura e prospettiva*, Venice, 1584.

SERLIO 1611 —, *Architettura et prospettiva. Translated out of Italian into Dutch and out of Dutch into English by Robert Peake*, London, 1611.

SERLIO 1619 —, *Tutte l'opere d'architettura et prospettiva di Sebastiano Serlio Bolognese*, Venice, 1619; reprinted Farnborough, 1964.

SETTIS 1984 S. Settis, editor, *Memoria dell'antico nell'arte Italiana*, vol.I, Turin, 1984.

SETTIS 1986 —, 'Continuità, distanza, conoscenza. Tre usi dell'antico', *Memorie dell'antico nell'arte italiana*, vol.III, edited by S. Settis, Turin, 1986, pp.375–486.

SETTIS 1988 S. Settis, editor, *La colonna Traiana*, Turin, 1988.

SHEARMAN 1977 J. Shearman, 'Raphael, Rome and the Codex Escurialensis', *Master Drawings*, 15, 1977, pp.107–46.

SHELL 1993 J. Shell, 'Amadeo, the Montegazza and the Façade of the Certosa in Pavia', *Giovanni Antonio Amadeo. Scultura e architettura del suo tempo in Biblioteca dell' archivio storico lombardo*, edited by J. Shell and L. Castelfranchi, Milan, 1993, pp.189–222.

SHOEMAKER 1975 I.H. Shoemaker, *Filippino Lippi as a Draughtsman*, PhD dissertation, Columbia University, 1975; University Microfilms, Ann Arbor, MI, 1975.

SICHTERMANN 1992 H. Sichtermann, *Die mythologischen Sarkofage. Teil 2. Apollon bis Grazien*, Berlin, 1992

SIENA 1980 *L'arte a Siena sotto i Medici, 1555–1609*, catalogue of an exhibition held in Siena, 1980.

SIENA 1990 *Domenico Beccafumi e il suo tempo*, catalogue of an exhibition held at Chiesa di S. Agostino, Siena, 1990.

SIENA 1991 *Prima di Leonardo. Cultura delle macchine a Siena nel Rinascimento*, catalogue of an exhibition held at the Magazzini del Sale, Siena, 1991.

SIENA 1993A *Francesco di Giorgio architetto*, catalogue of an exhibition held at the Magazzini del Sale, Siena, 1993.

SIENA 1993B *Francesco di Giorgio e il Rinascimento a Siena, 1450–1500*, catalogue of an exhibition held at Chiesa di S. Agostino, Siena, 1993.

SIGNORINI 1881 E. Signorini, *I monumenti cremonesi della decadenza romana alla fine del secolo*, 18/2, Milan, 1881.

SINGER ET AL. 1956 C. Singer et al., *A History of Technology*, 8 vols, Oxford, 1956.

SINN 1987 F. Sinn, *Stadrömische Marmorurnen*, Mainz, 1987.

SMITH 1971 N.A.F. Smith, *Dams*, London, 1971.

SMITH 1975 —, *Man and Water*, London, 1975.

SMITH 1977 G. Smith, *The Casino of Pius iv*, Princeton, 1977.

SOANE 1788 J. Soane, *Plans, Elevations and Sections of Buildings Executed in Various Counties*, London, 1788.

SOEDAL & FOLEY 1979 W. Soedal and B. Foley, 'Ancient Catalpults', *Scientific American*, 240/3, 1979, pp.150–60.

SORIA 1624A G.B. Soria, *Architettura con diversi ornamenti cavati dal antico da Gio. Battista Montano*, Rome, 1624.

SORIA 1624B —, *Scielta di varii tempietti antichi. Con le piante et alzatte desegnati in prospettiva D.M. Gio. Batta. Montano Milanese*, Rome, 1624.

SORIA 1625 —, *Diversi ornamenti capricciosi per depositi o altari, utilissimi a virtuosi. Novamente inventati da M. Giovanbatista Montano*, Rome, 1625.

SORIA 1628 —, *Tabernacoli diversi, novamente inventati da M. Giovanbatista Montano*, Rome, 1628.

SOTHEBY'S 1989A *Catalogue of the Sale of Old Master Drawings*, catalogue of a sale held at Sotheby's, London, 27 April 1989.

SOTHEBY'S 1989B *The Clifford Collection*, catalogue of a sale held at Sotheby's, London, 3 July 1989.

SPALDING 1979 J. Spalding, 'Santi di Tito's Frescos in SS Annunziata', *Gazette des beaux-arts*, 93, 1979, pp.147–52.

SPARTI 1989 D.L. Sparti, 'Criteri museografici nella collezione dal Pozzo alla luce di ducumentazione inedita', *Cassiano dal Pozzo. Atti del seminario internazionale di studi, Naples, 18–19 dicembre 1987*, Rome, 1989, pp.221–40.

SPARTI 1990 —, 'Carlo Antonio dal Pozzo (1606–1689). An Unknown Collector', *Journal of the History of Collections*, 2, 1990, pp.7–19.

SPARTI 1992 —, *Le collezione dal Pozzo. Storia di una famiglia e del suo museo nella Roma seicentesca*, Collezionismo e storia dell'arte, studi e fonti, I, Scuola Normale Superiore di Pisa, Modena, 1992.

SPECULUM *Speculum Romanae magnificentiae*, Rome, 1573–7. (A series of engravings of the 16th and 17th centuries brought together under the title page published by Antonio Lafreri. The engravings fall into two categories, the first published by Antonio Lafreri and by his successor Claudio Ducchetti, which were reconstructed in Huelsen 1921. The engravings include individual engravings as well as sets such as Dupérac's *I vestigi[…]* and Hieronymous Cock's *Praecipua aliquot Romanae antiquitatis ruinarum monimenta*, Cavallieri's engravings of Roman statuary and Montano's plates for the orders.)

SPENCER 1958 J. Spencer, 'Filarete and Central Plan Architecture', *Journal of the Society of Architectural Historians*, 1958, pp.10–18.

SPEZIALE 1932 G.C. Speziale, 'Navi Medicee', *Dedalo*, 12, 1932, pp.854–81.

SQUADRILLI 1975 T. Squadrilli, 'Il mausoleo di Adriano', *Capitolium*, 50/7–8, 1975, pp.20–31.

STAMPFLE 1968 F. Stampfle, 'A Ceiling Design by Vasari', *Master Drawings*, 6, 1968, pp.266–71.

STANDRING 1992 T.J. Standring, 'Observations on the dal Pozzo Library and Its Organisation', *Quaderni puteani*, 3, 1992, pp.92–100.

STANLEY 1987 D.J. Stanley, 'The Apse Mosaics at Santa Costanza', *Mitteilungen des Deutschen Archäologischen Instituts, Römische Abteilung*, 94, 1987, pp.29–42.

STANLEY 1994 —, 'New Discoveries at Santa Costanza', *Dunbarton Oaks Papers*, 48, 1994, pp.257–61.

STATIUS 1569 A. Statius, *Illustrum virorum ut extant in urbe expressi vultus*, Rome, 1569.

STEGMANN & GEYMÜLLER 1885-1908 C. von Stegmann and H. von Geymüller, *Die Architektur der Renaissance in Toskana*, 2 vols, Munich, 1885–1908.

STEINBY 1993-6 E.M. Steinby, *Lexicon topographicum urbis Romae*, 3 vols, Rome, 1993–6.

STELAND 1989 A.C. Steland, *Die Zeichnungen des Jan Asselijn*, Fridingen, 1989.

STERN 1958 H. Stern, 'Les mosaiques de l'église de Sainte-Constance à Rome', *Dumbarton Oaks Papers*, 12, 1958, pp.157–218.

STEVENSON 1888 H. Stevenson, 'Il Settizonio Severiano e la distruzione dei suoi avanzi sotto Sisto V', *Bullettino della Commissione Archeologica Comunale di Roma*, 6/8, 1888, pp.260–61, 269–98.

STINGER 1978 C. Stinger, 'Ambrogio Traversari and the "Tempio degli Scolari" at S. Maria degli Angeli in Florence', *Essays Presented to Myron P. Gilmore*, vol.I, Florence, 1978, pp.271–86.

STRADA 1617-18 J. Strada, *Künstlicher Abriss allerband Wasser-Wind, Ross -und-Handmühlen*, part I, Frankfurt am Main, 1617–18.

STRADANUS 1588 Stradanus, Jan van der Straet, *Nova reperta*, 1588.

STRONG 1913 E. Strong, 'Six Drawings from the Column of Trajan with the Date 1467', *Papers of the British School at Rome*, 4, 1913, pp.174–83.

STRONG 1953 D.E. Strong, 'Late Hadrianic Architectural Ornament in Rome', *Papers of the British School at Rome*, 21, 1953, pp.118–51.

STRONG 1965 —, 'Some Unknown Sculptures. The First Published Account of the Sculpture in Willian Waldorf Astor's Italian Gardens at Hever Castle', *Connoisseur*, 158, 1965, pp.215–25.

STRONG 1994A —, *Roman Museums. Selected Papers on Roman Art and Architecture*, London, 1994.

STRONG 1994B —, 'Some Observations of Early Roman Corinthian', *Roman Museum*, 1994, pp.171–86.

STRONG 1994C —, 'The Temple of Castor in the Forum Romanum', *Roman Museum*, 1994, pp.121–70.

STRONG & WARD-PERKINS 1960 D.E. Strong and J. Ward-Perkins, 'The Round Temple in the Forum Boarium',

Papers of the British School at Rome, 28, 1960, pp.7–30.

STUART JONES 1912-26 H. Stuart Jones, *A Catalogue of the Ancient Sculptures in the Municipal Collections of Rome*, 2 vols, Oxford, 1912–26.

STUCHY 1989 R.A. Stuchy, 'Frans Floris Basler Skizzen und das Problem der Antikenergänzung im mittleren 16 Jahrhundert', *Antikenzeichnung und Antikenstudium in Renaissance und Frübarock. Acts of a Conference held in Coburg, 1986*, edited by R. Harprath and H. Wrede, Mainz, 1989.

STUTTGART 1977 *Italienische Zeichnungen, 1500–1800*, catalogue of an exhibition held at the Staatsgalerie, Stuttgart, 1977.

STUTTGART 1979 *Zeichnungen in Deutschland*, catalogue of an exhibition held at the Staatsgalerie, Stuttgart, 1979.

STUVERAS 1969 R. Stuveras, *Le putto dans l'art romain*, Brussels, 1969.

SWAGER 1975 K. Swager, 'Herkunfte und Anfänge in Rom', *Jahrbuch für Kunstgeschichte*, 15, 1975, pp.111–45.

TAFI 1978 A. Tafi, *Immagini di Arezzo. Guida storico artistica*, Arezzo, 1978, pp.397–407.

TAFURI 1966 M. Tafuri, *L'architettura del mannierismo nel Cinquecento europeo*, Rome, 1966.

TAIT 1966 A. Tait, *Robert Adam. The Creative Mind. From the Sketch to the Finished Drawing*, catalogue of an exhibition held at the Sir John Soane's Museum, London, 1996.

TARDY 1981 Tardy, *French Clocks the World Over. Part One. From Their Beginnings to the Louis xv–Louis xvi. Transition Period*, Paris, 1981.

TAYLOR & CRECY 1821-2 G.L. Taylor and E. Crecy, *The Architectural Antiquities of Rome*, 2 vols, London, 1821–2.

TEDESCHI GRISANTI 1977 G. Tedeschi Grisanti, *'I trofei di Mario'. Il ninfeo dell'Acqua Giulia sull'Esquilino*, Rome, 1977.

TEDESCHI GRISANTI 1980 —, 'Il fregio con delfini e conchiglie della Basilica Neptuni. Uno spoglio romano al Camposanto Monumentale di Pisa', *Rendiconti dell'Accademia Nazionale dei Lincei*, series VIII, no.35, 1980, pp.181–92.

TEDESCHI GRISANTI 1983 —, '"Dis manibus, pili epitaffi e altre cose antiche". Un codice inedito di disgni di Giovannantonio Dosio', *Bollettino d'arte*, 18, 1983, pp.69–102.

TEODORESCU 1923 D.M. Teodorescu, *Cercetari archeologice in Montii Hunedoarei cluj*, 1923 (contains resumé in French).

TESSARI 1995 C. Tessari, *Baldassare Peruzzi. Il progetto dell'antico*, Milan, 1995.

TESTAGUZZA 1970 O. Testaguzza, *Portus–Illustrazione dei porti di Claudio e Traino e della città di Porto a Fiumicino*, Rome, 1970.

THÉVENOT 1693 M. Thévenot, *Veterum matematicorum …opera*, Paris, 1693.

THIEM 1957-9 G. Thiem, 'Studien zu Jan van der Straet, Genennt Stradanus', *Mitteilungen des Kunsthistorischen Institutes in Florenz*, 8, 1957–9, pp.88–111.

THIEM 1960 —, 'Vasari's Entwürfe für die Gemälde in der Sala Grande des Palazzo Vecchio zu Florenz', *Zeitschrift für Kunstgeschichte*, 1960, pp.97–135.

THIEM 1976A —, 'Neue funde zu Vasaris Dekorationen in Palazzo Vecchio', *Il Vasari storiografo e artista. Atti del congresso, Arezzo-Firenze, 1974*, Florence, 1976.

THIEM 1976B . T. Thiem, 'Montecassino. An Example of Planning in the Vitruvian Circle', *Opuscula romana*, 11, 1976, pp.127–42.

THIEM & THIEM 1964 G. Thiem and C. Theim, *Toskanische Fassaden- Dekoration*, Munich, 1964.

THIEME & BECKER 1907-52 U. Thieme and F. Becker, *Allgemeines Lexikon der Bildenden Kunstler von der Antike aus zur Gegenwart*, 37 vols, Leipzig, 1907–52.

THOENES 1983 C. Thoenes, 'Vignolas "Regola delli cinque ordini"', *Römisches Jahrbuch für Kunstgeschichte*, 20, 1983, pp.347–76.

THORNTON 1973 M.E.K. Thornton, 'The Round Temple Beside the Tiber', *Archaeological News*, 2, 1973, pp.8–15.

THORNTON 1991 P. Thornton, *The Italian Renaissance Interior, 1400–1600*, New York, 1991.

THORNTON & DOREY 1992 P. Thornton and H. Dorey, *A Miscellany from Sir John Soane's Collection*, London, 1992.

THURLEY 1993 S. Thurley, *The Royal Palaces of Tudor England and Court Life, 1460–1547*, New Haven and London, 1993.

TIBERIA 1971 V. Tiberia, 'S. Giuseppe dei Falegnami. Notizie storiche', *Palladio*, 21, 1971, pp.184–8.

TIETZE 1905 H. Tietze, *Beschreibendes Verzeichnis der Illuminierten Handschriften in Oesterreich*, vol.II: *Die Illuminierten Handschriften in Salzburg*, Leipzig, 1905.

TIETZE 1948 —, *Tintoretto. The Paintings and Drawings*, London, 1948.

TIMOFIEWITSCH 1968 W. Timofiewitsch, 'Ein Entwurf für den altar der scuola di San Rocco in Venedig', *Festschrift Ulrich Middeldorf*, edited by A. Kosegarten and P. Taylor, 2 vols, Berlin, 1968, pp.342–9.

TÖBELMANN 1923 F. Töbelmann, in collaboration with E.R Fiechter and C. Huelsen, *Römische Gebalke*, vol.I, Heidelberg, 1923.

TOCA 1971 M. Toca, 'Osservazioni sul cosidetto "taccuino senese" di Baldassare Peruzzi', *Annali della Scuola Normale Superiore di Pisa*, 1971, pp.161–79.

DE TOLNAY 1975-80 C. de Tolnay, *Corpus dei disegni di Michelangelo*, 4 vols, Novara, 1975–80.

TOLOMEI 1581 C. Tolomei, *Le lettere di M. Claudio Tolomei libri sette*, Venice, 1581.

TOLOTTI 1982 F. Tolotti, 'Le basiliche cimiteriali con deambulatorio del suburbio romano. Questione ancora aperta', *Mitteilungen des Deutschen Archäologischen Instituts. Römische Abteilung*, 89, 1982, pp.153–211.

TOLOTTI 1984 —, *Rivista di archeologia cristiana*, 60/3–4, 1984, pp.386–95 (review of Rasch 1984).

TOMEI 1942 P. Tomei, *L'architettura a Roma nel quattrocento*, Rome, 1942.

TOMASSETTI 1910-79 G. Tomassetti, *La campagna romana antica, medioevale e moderna*, vols II–V, Rome, 1910–79.

TOMASSETTI 1979 —, *La campagna romana antica, medioevale e moderna*, edited by L. Chiumenti and F. Bilancia, vols II–V, Florence, 1979.

TORMO 1940 E. Tormo, *Os desenhos das antigualhas que vio Francisco d'Ollanda pintor Portugués (…1539–1540…)*, facsimile, Madrid, 1940.

TRIONFI HONORATI 1975 M. Trionfi Honorati, 'Un tabernacolo ligneo su disegno del Vasari e l'intagliatore Alberto Alberti', *Antichità viva*, 16/6, 1975, pp.57–61.

TRIONFI HONORATI 1992 —, 'L'arredo ligneo nelle Marche tra il 1570 e il 1620 circa', *Le arti nelle Marche al tempo di Sisto v*, Milan, 1992, pp.59–60.

TUDOR 1931 D. Tudor, *Podul lui Traiana dela Drobeta*, Craców, 1931 (contains resumé in French, pp.41–6).

TURCAN 1988 R. Turcan, *Religions romaines*, vol.II: *Le culte*, Leiden, 1988.

TURCAN-DÉLÉANI 1958 M. Turcan-Déléani, 'Les monuments représentés sur la colonne trajane. Schématisme et realisme', *Mélanges d'archéologie et d'histoire. École française de Rome*, 70, 1958, pp.149–76.

TURIN 1987 Biblioteca Reale, Turin, *Il Codice Varia 124 della Biblioteca Reale di Torino miniato da Cristoforo de Predis*, 2 vols, Turin, 1987.

TUTTLE 1994 R. Tuttle, 'Baldassare Peruzzi e il suo progetto di completamento della basilica Petroniana', *Una basilica per una città sei secoli in S. Petronio. Atti di un convegno di studi per il vi centenario di fondazione della Basilica di S. Petronio (1390–1990), Bologna, 1–3 ottobre 1990*, edited by M. Fanti and D. Lensi, Bologna, 1994, pp.243–50.

UGURGIERI AZZOLINI 1649 I. Ugurgieri Azzolini, *Le pompe Sanesi o'vero relazione delli huomini, e donne illustri di Siena e suo Stato*, 2 vols, Pistoia, 1649.

URSINUS 1570 F. Ursinus, *Imagines et elogia virorum illustrium et eruditorum ex antiquis lapidibus et numismatibus expressa, cum annotationibus ex biblioteca Fulvi Ursini*, Rome, 1570.

USIMBARDI 1880 P. Usimbardi, 'Istoria del Gran Duca Ferdinando I', *Archivio storico italiano*, edited by G. Saltini, vols V–VI, 1880, pp.371–401.

VACCARIO 1610 A. Vaccario, *I portali di Michelangelo*, Rome, 1610 (contains engravings by G.B. Montano).

VALENTINI & ZUCCHETTI 1940-53 R. Valentini and G. Zucchetti, editors, *Codice topografico della Città di Roma*, 4 vols, Rome, 1940–53.

VALONE 1972 C. Valone, *Giovanni Antonio Dosio and His Patrons*, PhD dissertation, Northwestern University, 1972.

VALONE 1976 —, 'Giovanni Antonio Dosio. The Roman Years', *Art Bulletin*, 58, 1976, pp.528–41.

VALONE 1977 —, 'Paul IV, Guglielmo della Porta and the Rebuilding of San Silvestro al Quirinale', *Master Drawings*, 15, 1977, pp.243–55.

VALORI 1985 S. Valori, *I disegni di Antichità in Italia nei disegni dell'Albertina*, Rome, 1985.

VALTIERI 1977 S. Valtieri, *La genesi urbana di Viterbo e la crescita della città nel medioevo e nel 1500*, Rome, 1977.

VALTIERI 1986 —, 'L'originario impianto a croce non inscritta di S. Eligio degli Orefici a Roma', *Raffaello a Roma. Atti del convegno, Rome, 1983*, Rome, 1986, pp.323–30.

VALTURIUS 1472 R. Valturius, *De re militari*, Verona, 1472.

VALTURIUS 1532 —, *De re militari*, Paris, 1532.

VAN GELDER 1971 J.G van Gelder, 'Jan de Bisschop, 1628–1671', *Oud Holland*, 86, 1971, pp.201–88.

VAN DE VELDE 1975 C. van de Velde, *Frans Floris (1519/20–1570). Leven en werken*, Brussels, 1975.

VARRO 1912 M.T. Varro, *Marcus Terentius Varro Rerum rusticarum*, edited by G. Goetz, Leipzig, 1912.

VASARI 1967 G. Vasari, *Le vite de' piu eccellenti pittori scultori e architettori* (1568 edition), edited by P. della Pergola, L. Grassi and G. Previtali, Novara, 1967.

VASARI 1878-85 —, *Le vite de' piu eccellenti pittori, scultori ed architetti scritte da Giorgio Vasari pittore aretino con nuove annotazioni e commenti di Gaetano Milanesi*, 9 vols, Florence, 1878–85.

VASORI 1981 O. Vasori, *I monumenti antichi in Italia nei disegni degli Uffizi*, Rome, 1981.

VATICAN 1984 *Raffaello in Vaticano*, catalogue of an exhibition held at the Vatican, 1984.

VELTMANN 1979 K.H. Veltmann, 'Military Surveying and Topography. The Practical Dimension of Renaissance Linear Perspective', *Junta de investigacões científicas do ultramar*, 1979, pp.341ff.

VELTMANN 1986 —, in collaboration with K.D. Keele, *Linear Perspective and the Visual Dimensions of Science and Art*, Munich, 1986.

VENDITTI 1982 A. Venditti, 'L'attività di Giovanni Battista Montano', *Bullettino della unione di storia ed arte*, no.625, 1982, pp.21–37.

VENICE 1994 *Renaissance Architecture from Brunelleschi to Michangelo. The Representation of Architecture*, catalogue of an exhibition held at Palazzo Grassi, Venice, 1994.

VENTURI 1934-6 A. Venturi, *Storia del arte italiana*, vol.IX/7: *La pittura del cinquecento*; vol.XI/1: *La scultura del cinquecento*, vol.II, Milan, 1934–6.

VENUTI 1724 N.M. Venuti, *Esequie di Luigi i cattolico Re di Spagna celebrate in Firenze nella chiesa di S Maria Novella il di xxvi ottobre MCCCIVI*, Florence, 1724.

VERANI 1937 C. Verani, '"Le ricordanze"' di Teofilo Torri pittore aretino', *Atti e memorie del Accademia Petrarca, Arezzo*, 1937, pp.145–76.

VERHEYEN 1967 E. Verheyen, 'Jacopo Strada's Mantuan Drawings', *Art Bulletin*, 49, 1967, pp.62–70.

VERMEULE 1960 C.C. Vermeule, 'The Dal Pozzo-Albani Drawings of Classical Antiquities in the Royal Library at Windor Castle', *Transactions of the American Philosophical Society*, new series, 50/5, 1960, pp.5–78.

VERMEULE 1966 —, 'The Dal Pozzo-Albani Drawings of Classical Antiquities in the Royal Library at Windor Castle', *Transactions of the American Philosophical Society*, new series, 56/2, 1966, pp.5–77.

VERMEULE 1975 —, 'Sir John Soane's Museum. Catalogue of the Classical Antiquities', London, 1953; manuscript catalogue revised in typescript, Boston, 1975.

VIENNA 1992-5 Albertina, Vienna, *Die italienischen Zeichnungen der Albertina. Generalverzeichnis*, by V. Birke

and J. Kertész, 3 vols, Vienna, 1992–5.

VIENNA 1990 Kunsthistorisches Museum, Vienna, *Katalog der Leibrüstkammer*, part II: *Der Zeitraum von 1530–1560*, Vienna, 1990.

VILLAMENA 1617 F. Villamena, *Alcune opere d'architettura di Iacomo Barotio da Vignola et poste in luce da Francesco Villamena*, Rome, 1617.

VIRGILI 1984 P. Virgili, 'A proposito del mausoleo di Augusto. Baldassare Peruzzi aveva ragione', *Archeologia laziale*, 6, 1984, pp.209–12.

VISCONTI 1885 C.L. Visconti, *I monumenti del Museo Torlonia di sculture antiche*, Rome, 1885.

VISIOLI 1989 M. Visioli, 'Tipologie architettoniche dei portali lombardi del primo Rinascimento', *Bolletino della Società Pavese di storia patria*, 1989, pp.99–117.

VITERBO 1983 *Il quattrocento a Viterbo*, catalogue of an exhibition held in Viterbo, 1983.

VITRUVIUS 1511 Vitruvius, *Vitruvius per Iocundum solito castigatior factus cum figuris et tabula ut iam legi et intelligi possit*, edited by Giovanni da Verona called Fra Giocondo, Venice, 1511.

VITRUVIUS 1521 —, *Di Lucio Vitruvio Pollione libri dece traducti de latino in vulgare afigurati*, edited by C. Caesariano, Como, 1521.

VITRUVIUS 1556 —, *Vitruvio tradotti & commentati da Mon.s Daniele Barbaro eletto Patriarca di Aquileia da lui riveduti & ampliati; & hora in piu commoda forma ridotta*, edited by D. Barbaro, Venice, 1556.

VITRUVIUS 1567 —, *Vitruvio tradotti & commentati da Mon.s Daniele Barbaro eletto Patriarca di Aquileia da lui riveduti & ampliati; & hora in piu commoda forma ridotta*, edited by D. Barbaro, second edition, Venice, 1567; reprinted Milan, 1987 (edited by M. Tafuri).

VITRUVIUS 1931–4 —, *Vitruvius on Architecture. Edited from the Harleian Manuscript 2767 and Translated into English*, edited by F. Granger, 2 vols, London and Cambridge, MA, 1931–4.

VITRUVIUS 1986 —, *Vitruve de l'architecture. Livre x. Texte établi*, edited by L. Callebat, Paris, 1986.

VITZHUM 1963 W. Vitzhum, 'The *Accademia del Disegno* at the Uffizi', *Master Drawings*, 1, 1963, pp.57–8.

VODOZ 1929 E. Vodoz, 'La Chiesa di S. Maria in Grado d'Arezzo', *Il Vasari*, 2/3, 1929, pp.223–6.

VOGTHERR 1938 H. Vogtherr, *Ein Frembs und wunderbars Kunstbuechlin*, Strasbourg, 1938.

VOSS 1920 H. Voss, *Malerei des Barock in Rom*, Berlin, 1920.

VOSS 1913 —, 'Jacopo Zucchi. Ein vergessener Meister der florentinisch-römischen Spätrenaissance', *Zeitschrift für Bildende Kunst*, new series, 24, 1913, pp.151–62.

WALKER 1990 S. Walker, *Catalogue of Roman Sarcophagi in the British Museum*, Corpus of Sculptures of the Roman World, Great Britain, vol.II/2, London, 1990.

WALLACE 1994 W.E. Wallace, *Michelangelo at San Lorenzo. The Genius as Entrepreneur*, Cambridge, 1994.

WALTERS 1899 H.B. Walters, *Catalogue of the Bronzes, Greek, Roman and Etruscan in the Department of Greek and Roman Antiquities*, London, 1899.

WARBURG 1932 A. Warburg, 'I costumi teatrali per gli intermezzi del 1589. I disegni di Bernardo Buontalenti e il "Libro de' conti" di Emilio de' Cavalieri 1895', *Gesammelte Schriften*, edited by G. Bing, Leipzig, 1932, pp.259–300, 394–441; reprinted Liechtenstein, 1969.

WARD-JACKSON 1979 P. Ward-Jackson, *Victoria and Albert Museum. Italian Drawings*, vol.I, London, 1979.

WARD-PERKINS 1952 J. Ward-Perkins, 'The Shrine of St Peter's and Its Twelve Spiral Columns', *Journal of Roman Studies*, 42, 1952, pp.21–3.

WARNCKE 1979 C.P. Warncke, *Die ornamentale Groteske in Deutschland, 1500 –1650*, 2 vols, Berlin, 1979.

WATERFIELD 1996 G. Waterfield, *Soane and Death. The Tombs and Monuments of Sir John Soane*, catalogue of an exhibition held at Dulwich Picture Gallery, London, 1996.

WATKIN 1972 D. Watkin, editor, *Sale Catalogues of the Libraries of Eminent Persons*, vol.IV:*Architects*, Christie's, London, 1972.

WATKIN 1996 —, *Sir John Soane. Enlightenment Thought and the Royal Academy Lectures*, Cambridge, 1996.

WEEGE 1913 F. Weege, 'Das Goldene Haus des Nero–Neue Funde und Forschungen', *Jahrbuch des Deutschen Archäologischen Instituts*, 28, 1913, pp.127–244.

WEGNER 1966 M. Wegner, *Schmuckbasen des antiken Rom*, Münster, 1966.

WEISZ 1982 J.S. Weisz, *Pittura e Misericordia. The Oratory of San Giovanni Decollato in Rome*, PhD dissertation, Harvard University; Ann Arbor, MI, 1982.

WEITZMANN 1952 K. Weitzmann, 'The Greek Sources of Islamic Illustration', *Archaeologica orientalia in Memoriam Ernst Herzfeld*, Locust Valley, NY, 1952, pp.244ff.

WEITZMANN 1959 —, *Ancient Book Illumination*, Martin Classical Lectures, vol.XVI, Oberlin College and Princeton University, Cambridge, MA, 1959.

WELCH 1995 E.S. Welch, *Art and Authority in Renaissance Milan*, New Haven and London, 1995.

WELLENS 1962 R. Wellens, *Jacques Du Broecq, sculpteur et architecte de la Renaissance*, Brussels, 1962.

WELLER 1943 A.S. Weller, *Francesco di Giorgio, 1439–1501*, Chicago, 1943.

WELPLY 1792 W.H. Welply, *Notes and Queries*, January 1792.

WESCHER 1867 C. Wescher, *La Poliorcétique des Grecs*, Paris, 1867.

WHITFIELD 1938 J.H. Whitfield, 'A Newly Discovered Dürer Drawing for the Ashmolean', *Old Master Drawings*, no.13, December 1938, pp.31–4.

WICKERSHAM CRAWFORD 1913 J.P. Wickersham Crawford, 'Inedited Letters of Fulvio Orsini to Antonio Agustin', *Publications of the Modern Language Association of America*, 28, 1913, p.585.

WIDERKEHR 1991–2 L. Widerkehr, 'Jacob Matham Goltzii Privignus. Jacob Matham graveur et ses rapport avec Hendrick Goltzius', *Goltzius Studies. Nederlands Kunsthistorisch Jaarboek*, 42, 1991–2, pp.219–60.

WIKANDER 1979 O. Wikander, 'Watermills in Ancient Rome', *Opuscula romana*, 12, 1979, pp.13–36.

WILPERT 1929–32 G. Wilpert, *I sarcofagi cristiani antichi*, 2 vols, Rome, 1929–32.

WILSON JONES 1988 M.Wilson Jones, 'Palazzo Massimo and Baldassare Peruzzi's Approach to Architectural Design', *Architectural History*, 31, 1988, pp.58–106.

WILSON JONES 1989 —, 'Designing the Corinthian Order', *Journal of Roman Archaeology*, 2, 1989, pp.35–69.

WILTON-ELY 1994 J. Wilton-Ely, *Giovanni Battista Piranesi. The Complete Etchings*, 2 vols, London, 1994.

WINDFELD-HANSEN 1954 H. Windfeld-Hansen, 'Edifices antiques à plan central d'après les architects de la Renaissances et baptistères paléochrétiens', *Atti del v congresso internazionale di Archeologia Cristiana, Aix-en-Provence, 1954*.

WINDFELD-HANSEN 1965 —, 'Les couloirs annulaires dans l'architecture funéraire antique', *Acta ad archaelogium et artium historiam Pertinentia Institutum Romanum Norvegiae*, 2, 1965, pp.35–64.

WINDFELD-HANSEN 1969 —, 'L'hexaconque funeraire de l'area sub divo du cimitière de Pretaxtat a Rome', *Acta ad archaeologiam et artium historian Pertinentia Institutum Romanorum Norvegiae*, 4, 1969, pp.61–93.

WINNEFELD 1895 H. Winnefeld, *Die Villa des Hadrian bei Tivoli*, Berlin, 1895.

WINNER 1967 M. Winner, *Zeichner sehen die Antike, Europaische Handzeichnungen, 1450–1800*, catalogue of an exhibition held at the Staatliche Museen Kupferstichkabinett, Berlin, 1967.

WINNER 1986 —, 'Disputa und Schule von Athen', *Raffaello a Roma. Acts of a Conference, 1983*, Rome, 1986.

WISCH 1990 B. Wisch, 'The Roman Church Triumphant. Pilgrimage, Penance and Processing. Celebrating the Holy Year of 1575', *'All the World's a Stage…' Art and Pageantry in the Renaissance and Baroque*, part 1: *Triumphal Celebrations and the Rituals of Statecraft*, edited by B. Wisch and S. Scott Munshower, *Papers in Art History from The Pennsylvania State University*, 6, 1990, pp.82–117.

WITTKOWER 1952 R. Wittkower, *The Drawings of the Caracci in the Collection of Her Majesty the Queen at Windsor Castle*, London, 1952.

WITTKOWER 1960 —, *Disegni del Le Ruine di Roma e come anticamente erano*, Milan, 1960.

WITTKOWER 1965 —, *Art and Architecture in Italy, 1600–1700*, London, 1965.

WITTKOWER & WITTKOWER 1964 R. Wittkower and M. Wittkower, *The Divine Michelangelo. The Florentine Academy's Homage on His Death in 1564. A Facsimile Edition of 'Esequie del Divino Michelangelo Buonarroti'*, Florence, 1564; London, 1964.

WOLTERS 1976 W. Wolters, *La scultura veneziana gotica, 1300–1400*, 2 vols, Venice, 1976.

WOODS MARSDEN 1988 J. Woods Marsden, *The Gonzaga and Pisanello's Arthurian Frescos*, Princeton, 1988.

WOODWARD 1996 D. Woodward, *Catalogue of Watermarks in Italian Printed Maps, ca1540–1600*, Chicago, 1996.

WREDE 1972 H. Wrede, *Die spätantike Hermengalerie von Welschbillig*, Berlin, 1972.

WREDE & HARPRATH 1986 H. Wrede and R. Harprath, *Der Codex Coburgensis. Das erst systematische Archäologiebuch. Römische Antiken-Nachzeichnungen aus Mitte des 16 Jahrhunderts*, catalogue of an exhibition held at the Kunstsammlungen der Veste Coburg, 1986.

WURM 1965 H. Wurm, *Der Palazzo Massimi delle Colonne*, Berlin, 1965.

WURM 1984 —, *Baldassare Peruzzi, Architekturzeichnungen*, Tübingen, 1984.

ZANDER 1958-62 G. Zander, 'Le invenzione architettoniche di Giovanni Battista Montano Milanese (1534–1621)', *Quaderni dell'Istituto di Storia dell'architettura*, no.30, 1958, pp.1–21; nos 49–50, 1962, pp.1–32.

ZANGHERI 1980 L. Zangheri, 'Anonimo Variorum architectorum delinationes portarum et fenestrarum, Quae in Urbe Florentiae Reperiuntur. Biblioteca Apostolica Vaticana Reg. Lat.1282', *Il disegno interrotto. Trattati Medicei d'architettura. Documenti inediti di cultura toscana*, vol.IV, 2 vols, Florence, 1980.

ZEISING 1614-21 H. Zeising, *Theatri Machinarum, so in sechs Theil bestehend*, Leipzig, 1614–21.

ZERI 1981 F. Zeri, editor, *Storia dell'arte italiana*, vol.II: *Dall cinquecento all'ottocento*, vol.I, Turin, 1981.

ZEVI 1960 B. Zevi, *Biagio Rossetti. Architetto Ferrarese, il primo urbanista moderno europeo*, Turin, 1960.

ZIÓLKOWSKI 1988 A. Ziólkowski, 'Mummius' Temple of Hercules Victor and the Round Temple on the Tiber', *Phoenix*, no.42, 1988, pp.309–33.

ZONCA 1607 V. Zonca, *Nuovo teatro di macchine e edifici*, Padua, 1607.

ZONGHI 1953 A. Zonghi, *Zonghi's Watermarks*, vol.III in E.J. Labarre, *Collections of Works and Documents Illustrating the History of Paper*, Hilversum, 1953.

ZORZI 1958 G.G. Zorzi, *I disegni delle antichità di Andrea Palladio*, Venice, 1958.

ZORZI 1965-6 —, 'Un nuovo soggiorno di Alessandro Vittoria nel vicentino e i suoi rapporti con Lorenzo Rubini e suoi figli Virgilio e Agostino', *Arte veneta*, 19, 1965, pp.83–94; 20, 1966, pp.157–76.

ZORZI 1967 —, *Le chiese e i ponti di Andrea Palladio*, Venice, 1967.

ZORZI 1969 —, *Le ville e i teatri di Andrea Palladio*, Vicenza, 1969.